THE SOCIETY OF PUBLICATION DESIGNERS 2010
45th Publication Design Annual

45th Publication Design Annual

COVER AND BOOK DESIGN
Todd Albertson & Tom Brown
(Weapon of Choice)

CONTRIBUTING DESIGN
Dian Holton, Lesley Q. Palmer, Lisa Thé

The Judges

(From top, left to right)

Competition Co-Chairs:
DEBRA BISHOP, *CD, More.* CASEY TIERNEY, *DP, Real Simple.*

Captain: GAIL ANDERSON, *CD-Design, SpotCo.* FLORIAN BACHLEDA, *CD, FB Design/Latina.*
DIRK BARNETT, *CD, Maxim.* AMY BERKLEY, *PE, Field & Stream.* DARREN CHING, *CD, PDN.*
Captain: SCOTT DADICH, *CD, WIRED.* CLAUDIA DE ALMEIDA, *AD, More.*
KEN DELAGO, *DD, Golf Digest.* KRISTINA DIMATTEO, *AD.*
JESSICA DIMSON, *PE, Departures.*
CHRIS DOUGHERTY, *DP, People.* ANDREA DUNHAM, *DD, People.*
Captain: AREM DUPLESSIS, *DD, The New York Times magazines.*
JANET FROELICH, *CD, Real Simple.* EDDIE GUY, *Illustrator.*
DAVID HARRIS, *DD, Vanity Fair.* LUKE HAYMAN, *Partner, Pentagram.*
JOE HUTCHINSON, *AD, Rolling Stone.* **Captain:** *Nathalie Kirshseh, AD, W.*
JOSH KLENERT, *CD, Clear Channel Online.*

The Judges

(From top, left to right)

AMY KOBLENZER, *PE.* **Captain:** LAURIE KRATOCHVIL, *Visual Consultant.*
CRISWELL LAPPIN, *CD, Metropolis.* MATTHEW LENNING, *Consulting DD.*
JEREMY LESLIE, *Editor, magCulture.com.*
DEBBIE MILLMAN, *Principal, Sterling Brands.* PATRICK MITCHELL, *CD, PlutoMedia.*
ROBERT NEWMAN, *The Man at Robert Newman Design.* MICHAEL NORSENG, *DP, Esquire.*
Magazine of the Year Chair: BRUCE RAMSAY. EDEL RODRIGUEZ, *Illustrator.*
Captain: DORA SOMOSI, *DP, GQ.* SIUNG TJIA, *CD, ESPN The Magazine.*
MAISIE TODD, *PE, ESPN The Magazine.* GAEL TOWEY, *CCO, Martha Stewart Living Omnimedia.*
TJ TUCKER, *CD, Texas Monthly.* ZANA WOODS, *Sr. PE, WIRED.*

Photographs by GLENN GLASSER

THE VOLUNTEERS OF THE PUB 45 ANNUAL JUDGING
CAPTAIN: Nancy Stamatopoulos. Hannah Anderson, Shaun Baron, Christine Bower-Wright,
Alyssa Crawford, Marc Davila, Lauren Heffron, Brad Hughes, Mike Ley, Gina Maniscalco,
Grace Martinez, Ryan Mesina, Ryan Moore, Andrea Nasca, Elizabeth Neal, Kathy Nguyen,
Adri Ramdeane, Kim Sall, Jill Serra, Jason Sfetko, Alex Spacher, Faith Stafford,
Lisa Vosper, David Zamdmer

Digital Judges
(from left)
NATALIE HANSEN, *Executive Creative Director, CNET.*
Chair: JEREMY LACROIX, *Creative Director, CBS Interactive.*
BRIAN ELLIS MARTIN, *Executive Creative Director, CNN Digital/CNN.com.*
JASON TREAT, *Art Director, The Atlantic.com.* SEAN VILLAFRANCA, *Design Director, Time.com.*
KHOI VINH, *Design Director, NYTimes.com/ Author, Subtraction.com.*

Magazine of the Year
GOLD MEDAL *SILVER MEDAL* MERIT AWARD
AND
Members' Choice

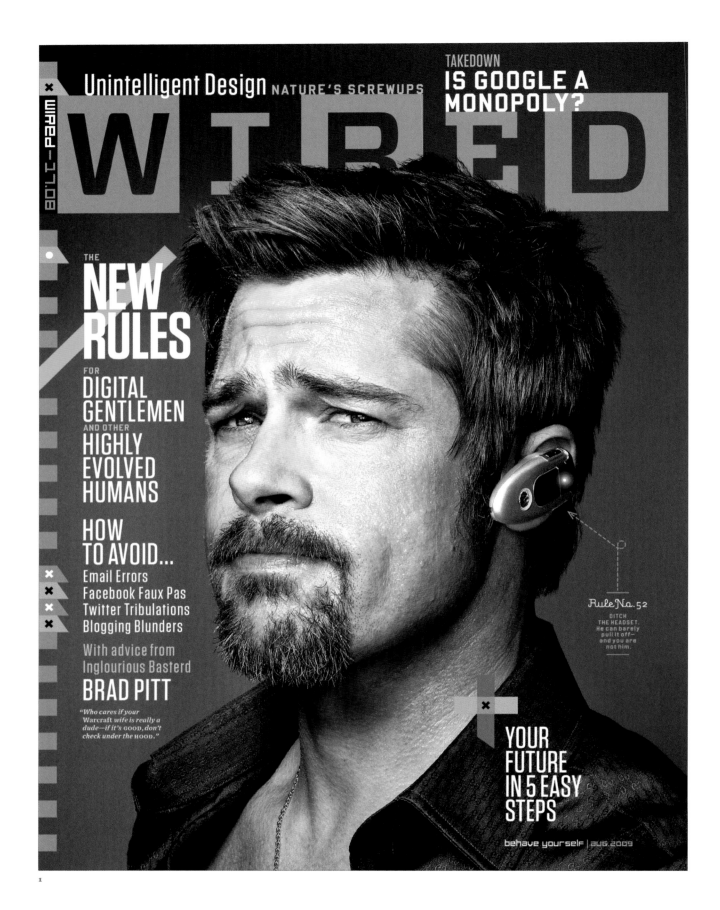

1

1 **WIRED**

CREATIVE DIRECTOR: Scott Dadich. DESIGN DIRECTOR: Wyatt Mitchell. ART DIRECTORS: Carl De Torres, Maili Holiman, Christy Sheppard, Margaret Swart.
DESIGNERS: Walter C. Baumann, Victor Krumennacher, Erik Carnes. ILLUSTRATORS: Stephen Doyle, Paul Pope, Nishant Choski, Robert F. Lang, Luke Hayman,
Christoph Niemann, Jason Lee, Siggi Eggertson, Chris Ware. SENIOR PHOTO EDITOR: Zana Woods. PHOTO EDITOR: Carolyn Rauch. DEPUTY PHOTO EDITOR:
Anna Goldwater Alexander. ASSOCIATE PHOTO EDITOR: Sarah Filippi. PHOTOGRAPHERS: Dan Winters, Tom Schierlitz, Art Streiber, Mark Seliger, Jens Mortensen,
Uta Kögelsberger, Joe Pugliese. EDITOR-IN-CHIEF: Chris Anderson. PUBLISHER: Condé Nast Publications, Inc. ISSUES: March 2009, May 2009, August 2009.
CATEGORY: Magazine of the Year

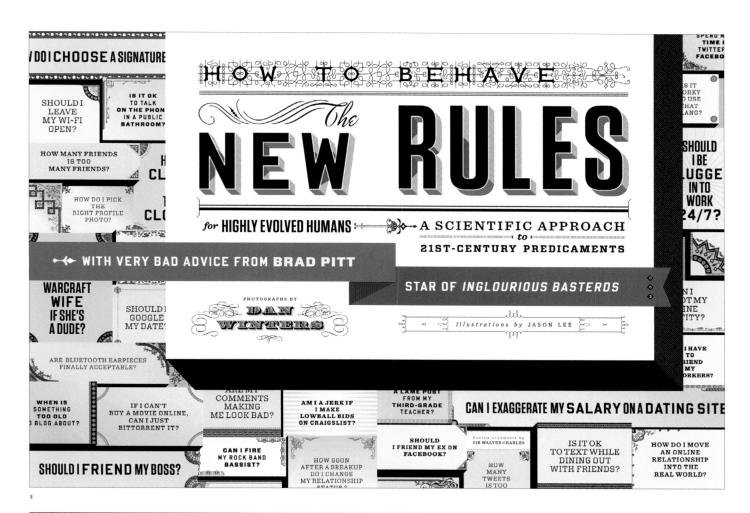

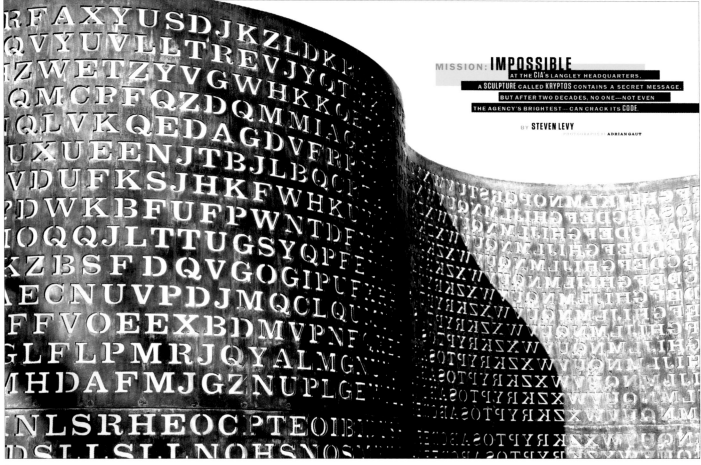

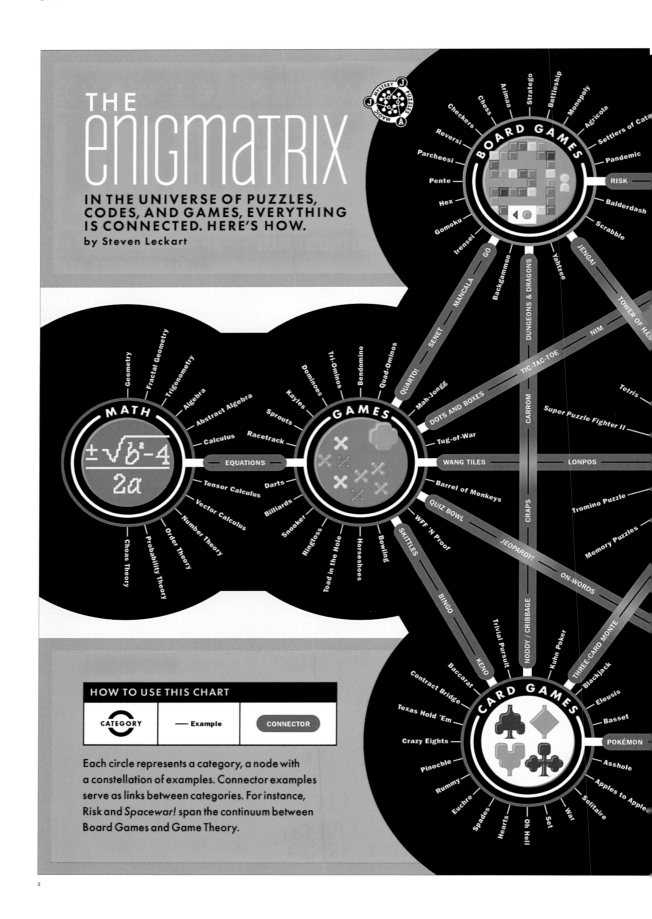

THE enigmatRIX

IN THE UNIVERSE OF PUZZLES, CODES, AND GAMES, EVERYTHING IS CONNECTED. HERE'S HOW.
by Steven Leckart

HOW TO USE THIS CHART

| CATEGORY | —— Example | CONNECTOR |

Each circle represents a category, a node with a constellation of examples. Connector examples serve as links between categories. For instance, Risk and *Spacewar!* span the continuum between Board Games and Game Theory.

1 **WIRED**

CREATIVE DIRECTOR: Scott Dadich. DESIGN DIRECTOR: Wyatt Mitchell. ART DIRECTORS: Carl De Torres, Maili Holiman, Christy Sheppard, Margaret Swart. DESIGNERS: Walter C. Baumann, Victor Krumennacher, Erik Carnes. ILLUSTRATORS: Stephen Doyle, Paul Pope, Nishant Choski, Robert F. Lang, Luke Hayman, Christoph Niemann, Jason Lee, Siggi Eggertson, Chris Ware. SENIOR PHOTO EDITOR: Zana Woods. PHOTO EDITOR: Carolyn Rauch. DEPUTY PHOTO EDITOR: Anna Goldwater Alexander. ASSOCIATE PHOTO EDITOR: Sarah Filippi. PHOTOGRAPHERS: Dan Winters, Tom Schierlitz, Art Streiber, Mark Seliger, Jens Mortensen, Uta Kögelsberger, Joe Pugliese. EDITOR-IN-CHIEF: Chris Anderson. PUBLISHER: Condé Nast Publications, Inc. ISSUES: March 2009, May 2009, August 2009. CATEGORY: Magazine of the Year

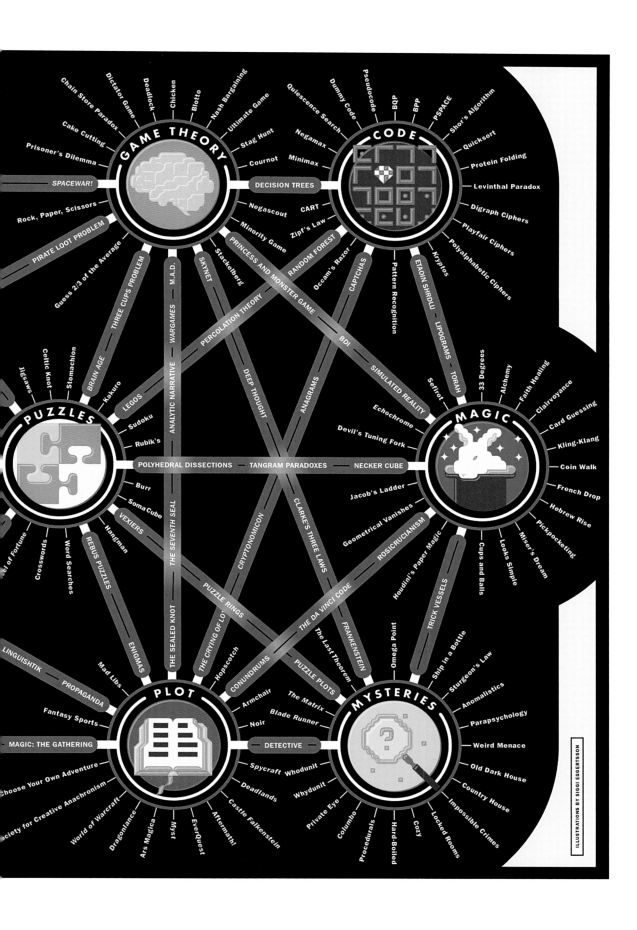

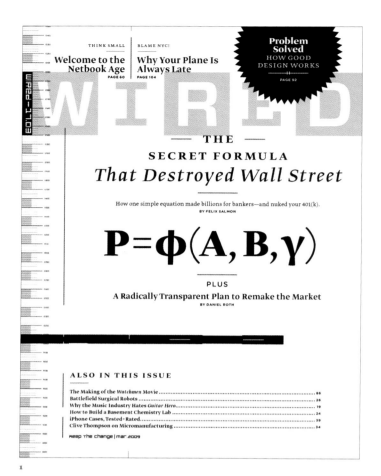

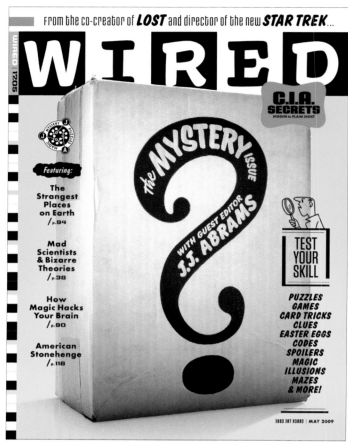

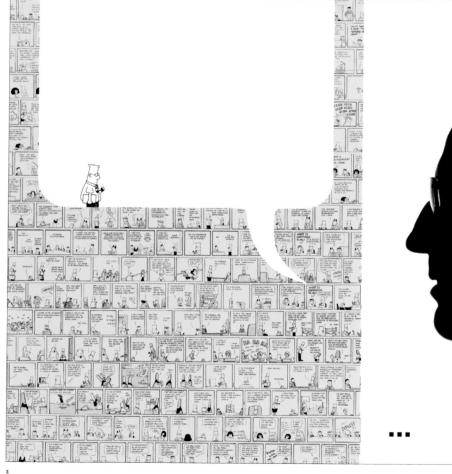

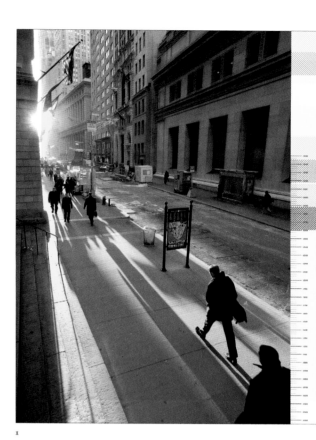

The financial world doesn't need new regulations. It needs radical transparency. Make companies report results in easy to understand, easy to crunch numbers—and let investors do the rest.

BY DANIEL ROTH

THE
Road Map
FOR
RECOVERY

⸱⸱⸱

1

In the mid-'80s, Wall Street turned to the quants—brainy financial engineers—to invent new ways to boost profits. Their methods for minting money worked brilliantly…until one of them devastated the global economy.

BY FELIX SALMON

A
Formula
FOR
DISASTER

⸱⸱⸱

1

1 **WIRED**

CREATIVE DIRECTOR: Scott Dadich. DESIGN DIRECTOR: Wyatt Mitchell. ART DIRECTORS: Carl De Torres, Maili Holiman, Christy Sheppard, Margaret Swart. DESIGNERS: Walter C. Baumann, Victor Krumennacher, Erik Carnes. ILLUSTRATORS: Stephen Doyle, Paul Pope, Nishant Choski, Robert F. Lang, Luke Hayman, Christoph Niemann, Jason Lee, Siggi Eggertson, Chris Ware. SENIOR PHOTO EDITOR: Zana Woods. PHOTO EDITOR: Carolyn Rauch. DEPUTY PHOTO EDITOR: Anna Goldwater Alexander. ASSOCIATE PHOTO EDITOR: Sarah Filippi. PHOTOGRAPHERS: Dan Winters, Tom Schierlitz, Art Streiber, Mark Seliger, Jens Mortensen, Uta Kögelsberger, Joe Pugliese. EDITOR-IN-CHIEF: Chris Anderson. PUBLISHER: Condé Nast Publications, Inc. ISSUES: March 2009, May 2009, August 2009. CATEGORY: Magazine of the Year

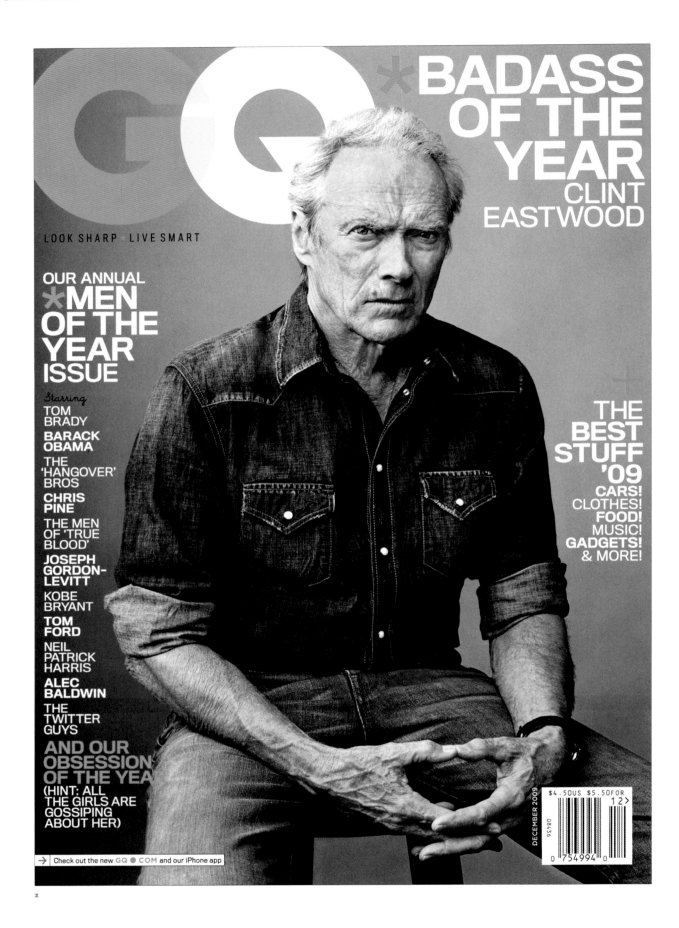

2

2 **GQ**

DESIGN DIRECTOR: Fred Woodward. ART DIRECTORS: Anton Ioukhnovets, Thomas Alberty. DESIGNERS: Chelsea Cardinal, Drue Wagner, Delgis Canahuate.
ILLUSTRATORS: Jean-Phillipe Delhomme, Zohar Lazar, John Ueland, Colin Tunstall, Gary Taxali, Bruce Hutchison. DIRECTOR OF PHOTOGRAPHY: Dora Somosi.
PHOTO EDITORS: Krista Prestek, Justin O'Neill, Jesse Lee, Jolanta Bielat, Emily Blank. PHOTOGRAPHERS: Eric Ray Davidson, Tom Schierlitz, Peggy Sirota,
Martin Schoeller, Paula Kudacki. CREATIVE DIRECTOR, FASHION: Jim Moore. EDITOR-IN-CHIEF: Jim Nelson. PUBLISHER: Condé Nast Publications Inc.
ISSUES: June 2009, July 2009, December 2009 CATEGORY: Magazine of the Year

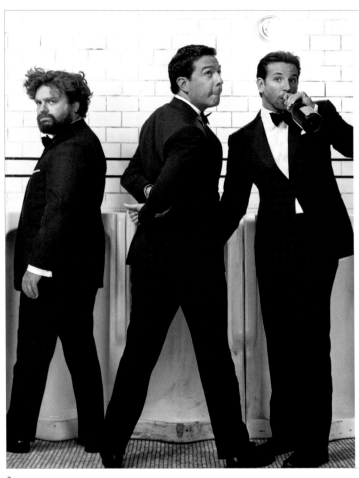

● *FUNNYMEN*
▶ The 'Hangover' Guys

Zach Galifianakis | Ed Helms | Bradley Cooper

12/09 GQ 241

IC⊙N

When the most legendary badass in Hollywood decides
he wants to make a sprawling, costly film about
rugby and South Africa, well, who's gonna stop him?
(Even when he titles it, um, *Invictus*.) MICHAEL HAINEY
talks to Clint Eastwood about the well-earned art of
doing whatever the hell you want

Clint
EASTWOOD

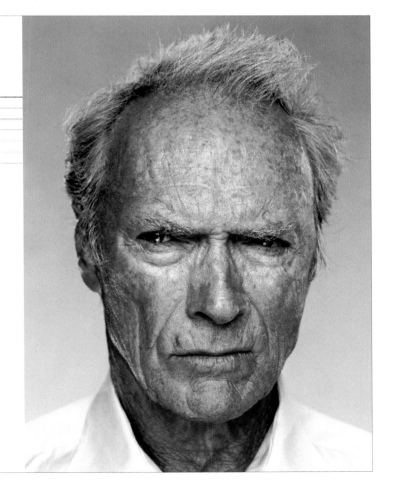

CLINT EASTWOOD, pure and simple? Here it is.
He gives a guy hope.
 For all of us who have wondered if we'd ever
achieve our dreams—when in our head all we
can hear is the tick, tick, tick of the clock and
that goddamned voice saying, "It's too late.
You're too old to go for it. You'll never achieve
it"—there's Clint. In this youth-obsessed world,
the guy is the patron saint of late bloomers.
 Think about it: His breakthrough role—
playing the Man with No Name in those
spaghetti Westerns? He's in his midthirties
when he does those. He doesn't direct his first
movie, the still riveting *Play Misty for Me*, until
he's 40. And *Dirty Harry*? He's 41 when he
makes that (and even then, he gets the role
only after Sinatra pulls out).
 But here's where things get really crazy. In
1993 he shows up at the Academy Awards with
Unforgiven. He is 62 and has never won an
Oscar. The film wins four, including Best Picture
and Best Director.
 And then this happens: The guy doesn't hang
it up—he only starts getting stronger. He goes

182 GQ 12/09

LARRY KING LIVES!

BY
CHRIS HEATH

YES, HE'S HEARD ALL THE JOKES ABOUT HIS AGE, AND NO, HE MAY NOT BE THE MOST PREPARED JOURNALIST ON THE PLANET. BUT AT 75, AMERICA'S MOST DURABLE BROADCASTER HAS OTHER THINGS ON HIS MIND—RECOUPING THE $2.8 MILLION HE LOST TO BERNIE MADOFF, CONTROLLING HIS TEMPER DURING HIS SONS' LITTLE LEAGUE GAMES, AND FIGURING OUT HOW TO LIVE FOREVER

PHOTOGRAPHS BY
NADAV KANDER

152 GQ 06.09

2

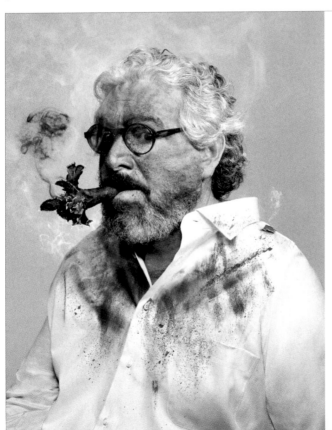

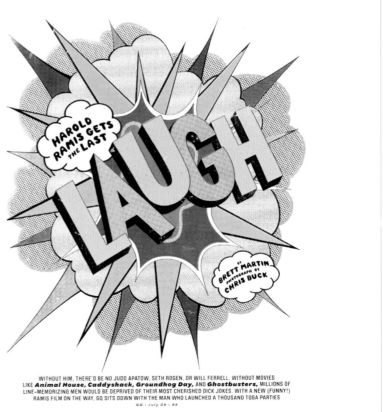

HAROLD RAMIS GETS THE LAST LAUGH

BY
BRETT MARTIN
PHOTOGRAPH BY
CHRIS BUCK

WITHOUT HIM, THERE'D BE NO JUDD APATOW, SETH ROGEN, OR WILL FERRELL. WITHOUT MOVIES LIKE **Animal House, Caddyshack, Groundhog Day,** AND **Ghostbusters,** MILLIONS OF LINE-MEMORIZING MEN WOULD BE DEPRIVED OF THEIR MOST CHERISHED DICK JOKES. WITH A NEW (FUNNY!) RAMIS FILM ON THE WAY, GQ SITS DOWN WITH THE MAN WHO LAUNCHED A THOUSAND TOGA PARTIES

GQ · July 09 · 65

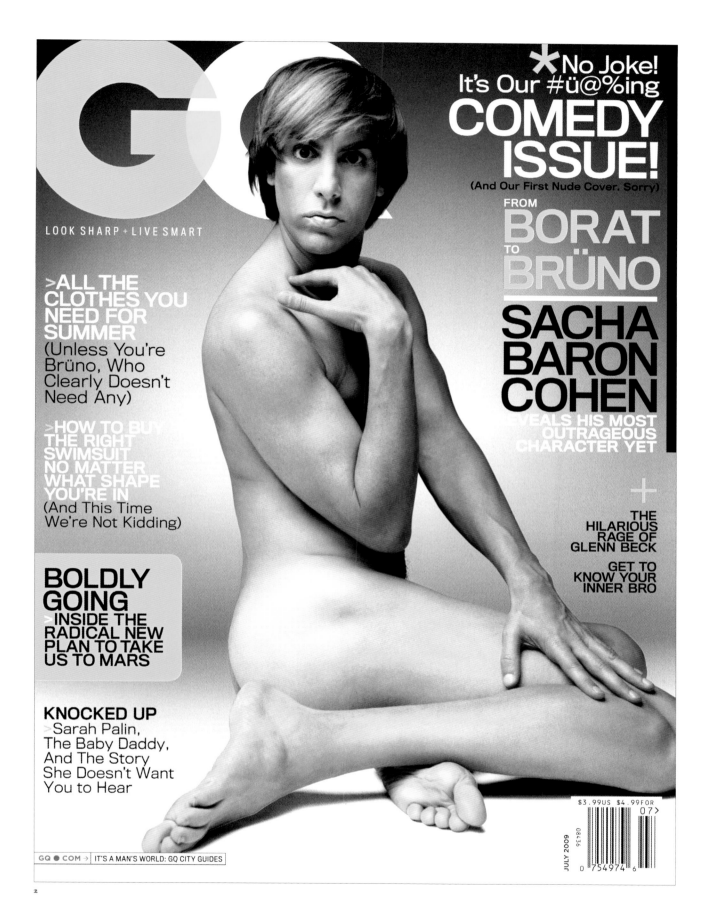

DESIGN DIRECTOR: Fred Woodward. ART DIRECTORS: Anton Ioukhnovets, Thomas Alberty. DESIGNERS: Chelsea Cardinal, Drue Wagner, Delgis Canahuate. ILLUSTRATORS: Jean-Phillipe Delhomme, Zohar Lazar, John Ueland, Colin Tunstall, Gary Taxali, Bruce Hutchison. DIRECTOR OF PHOTOGRAPHY: Dora Somosi. PHOTO EDITORS: Krista Prestek, Justin O'Neill, Jesse Lee, Jolanta Bielat, Emily Blank. PHOTOGRAPHERS: Eric Ray Davidson, Tom Schierlitz, Peggy Sirota, Martin Schoeller, Paula Kudacki. CREATIVE DIRECTOR, FASHION: Jim Moore. EDITOR-IN-CHIEF: Jim Nelson. PUBLISHER: Condé Nast Publications Inc. ISSUES: June 2009, July 2009, December 2009 CATEGORY: Magazine of the Year

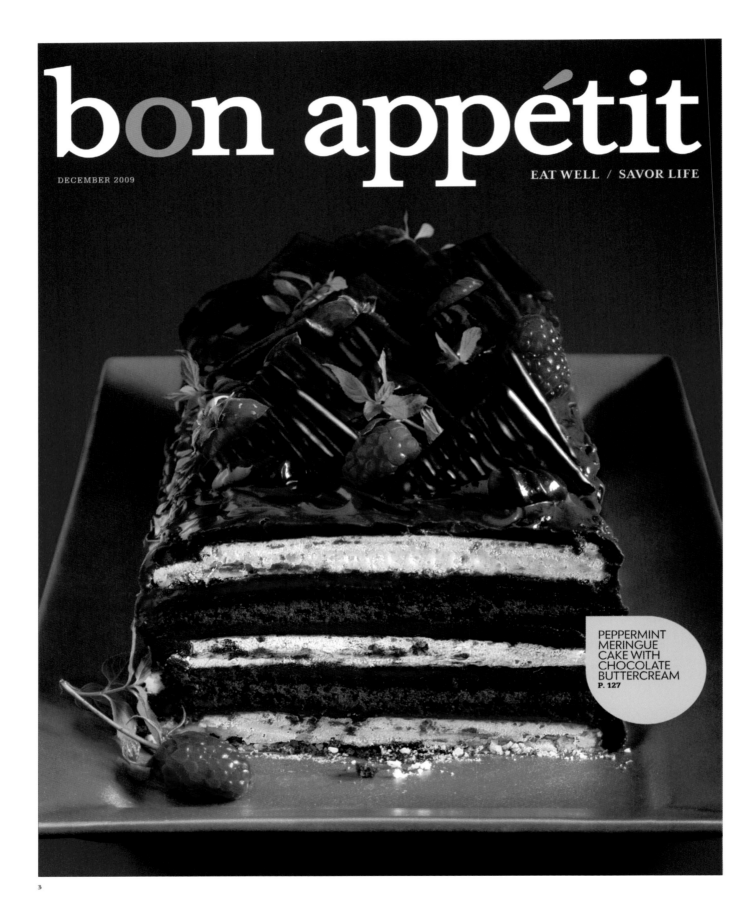

bon appétit

DECEMBER 2009

EAT WELL / SAVOR LIFE

PEPPERMINT
MERINGUE
CAKE WITH
CHOCOLATE
BUTTERCREAM
P. 127

3

3 *Bon Appétit*

DESIGN DIRECTOR: Matthew Lenning. ART DIRECTORS: Robert Festino, Tom O'Quinn. DESIGNER: John Muñoz. ILLUSTRATORS: Christoph Niemann, Matthew Woodson, MASA, Belle Mellor, Nick Dewar, Heads of State, Serge Bloch. DIRECTOR OF PHOTOGRAPHY: Bailey Franklin. ASSOCIATE PHOTO EDITOR: Angelica Mistro. PHOTOGRAPHERS: Craig Cutler, Lisa Hubbard, Patricia Heal, Hans Gissinger, Kenji Toma, Misha Gravenor, Levi Brown, Jake Chessum, Andrea Chu, Nigel Cox, Jamie Chung, Elinor Carucci, Ture Lillegraven, Sian Kennedy. EDITOR-IN-CHIEF: Barbara Fairchild. PUBLISHER: Condé Nast Publications, Inc. ISSUES: July 2009, September 2009, December 2009. CATEGORY: Magazine of the Year

2.
THE MADOFF EXILES

BY ROBERT KOLKER

Victims of the $65 billion Ponzi scheme feel cast out, denied justice, forgotten. They're angry at just about everyone, including, in some cases, themselves.

"I feel like roadkill—just left on the side of the road."
Maureen Ebel
LOST:
$7.3 million

MAUREEN EBEL STARTED the year working five jobs. She took care of a friend's elderly mother in the morning, then cleaned the woman's house in the afternoon. She worked for another friend in her clothing store, drove people to the airport and on errands, and worked the cash register at a food stand. "I said, 'If I can earn $25 tonight, that's $25 I didn't have before.'"

She sold some jewelry, an Oriental rug, a favorite painting. Friends gave her envelopes with cash, unsolicited, as much as $2,000. Every trip to the grocery store became an exercise in money-saving. "Two-for-one was my favorite thing: I'd go down the aisles, looking for canned goods." With winter coming, she bought an electric blanket to keep the price of heat down. She has a gas fireplace, but the tank is empty, and she's not sure she wants to spend $200 to fill it. "That's something that makes you say, 'Well.'"

She planned on enrolling in a class to reactivate her nurse's license—she was 60 years old and had let it lapse years earlier—but then another friend called. "His secretary of eighteen and a half years got sick and could no longer work, and he said, 'Would you like to try it?' And I said absolutely, even though I didn't know Excel, or Word, or PowerPoint, or QuickBooks. I said, 'I can learn. I can make it work.'" Ebel makes $42,000 a year now. "I'm very grateful for my job," she says. "But I sit in a windowless office from 8:30 in the morning until five at night. It's the windowless part of it that gets to me."

Ebel has spent a lot of time with her lawyer this year. She has felt by turns angry, de-

36 NEW YORK | OCTOBER 5, 2009 *Photographs by Marco Grob* 37

4

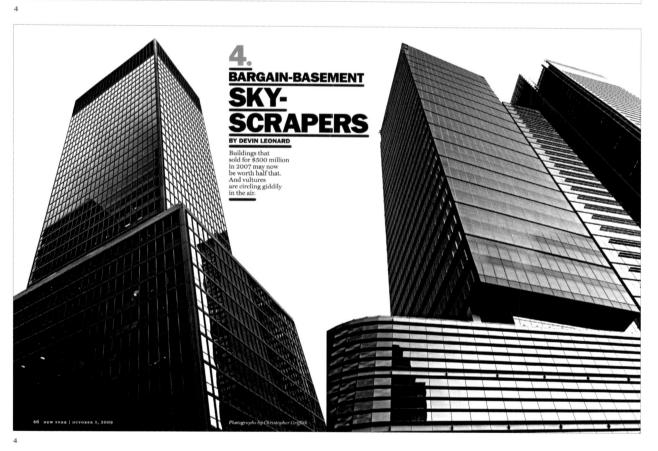

4.
BARGAIN-BASEMENT SKY-SCRAPERS

BY DEVIN LEONARD

Buildings that sold for $500 million in 2007 may now be worth half that. And vultures are circling giddily in the air.

46 NEW YORK | OCTOBER 5, 2009 *Photographs by Christopher Griffith*

4

4 *New York*

DESIGN DIRECTOR: Chris Dixon. ART DIRECTOR: Randy Minor. DESIGNERS: Randy Minor, Hitomi Sato, Hilary Fitzgibbons, John Sheppard, Macon York, Jeff Glendenning, Stevie Remsberg, Gluekit, Shane Harrison, Jordan Domont. ILLUSTRATORS: Darrow, Riccardo Vecchio, Mark Nerys, Jason Lee, Kyungduk Kim, Rodrigo Corral, André Carrilho, Matthew Woodson. DIRECTOR OF PHOTOGRAPHY: Jody Quon. PHOTO EDITORS: Leana Alagia, Alex Pollack, Caroline Smith, Lea Golis, Nadia Lachance. PHOTOGRAPHERS: Hannah Whitaker, Brigitte Lacombe, Marcus Bleasdale, John Keatley, Tierney Gearon, Marco Grob, Christopher Griffith, Jake Chessum, Andy Ryan, Edward Keating, Spencer Heyfron, Dean Kaufman, Andreas Laszlo Konrath, Pej Behdarvand, Nigel Parry, Valerie Belin, Gueorgui Pinkhassov. EDITOR-IN-CHIEF: Adam Moss. PUBLISHER: New York Magazine Holdings, LLC. ISSUES: March 2, 2009, August 24, 2009, October 5, 2009. CATEGORY: Magazine of the Year

SPECIAL INAUGURATION ISSUE

The New York Times Magazine
JANUARY 18, 2009

OBAMA'S PEOPLE

PHOTOGRAPHS BY NADAV KANDER

5

The New York Times Magazine

THE 9TH ANNUAL YEAR IN IDEAS

27

5

DATATECTURE

Flickr. MySpace. iTunes. Gmail.
In our hyperconnected, superfast age, how can the Internet
data centers we've built keep up?
BY TOM VANDERBILT

It began with an Xbox game.

On a recent rainy evening in Brooklyn, I was at a friend's house playing (a bit sheepishly, given my incipient middle age) Call of Duty: World at War. Scrolling through the game's menus, I noticed a screen for Xbox Live, which allows you to play against remote users via broadband. The number of Call of Duty players online at that moment? More than 66,000.

Walking home, I ruminated on the number. Sixty-six thousand is the population of a small city — Muncie, Ind., for one. Who and where was this invisible metropolis? What infrastructure was needed to create this city of ether?

We have an almost inimical incuriosity when it comes to infrastructure. It tends to feature in our thoughts only when it's not working. The Google search results that are returned in 0.15 seconds were once a stirring novelty but soon became just another assumption in our lives, like the air we breathe. Yet whose day would proceed

PHOTOGRAPHS BY SIMON NORFOLK

Known for its bean and spearmint fields, Quincy, Wash., is also home to rows of servers in a 500,000-square-foot data center that Microsoft built in 2006.

10

5

5 **The New York Times Magazine**

DESIGN DIRECTOR: Arem Duplessis. ART DIRECTOR: Gail Bichler. DESIGNERS: Cathy Gilmore-Barnes, Nancy Harris Roumey, Hilary Greenbaum, Aviva Michaelov, Robert Vargas, Ian Allen, Leslie Kwok. DIRECTOR OF PHOTOGRAPHY: Kathy Ryan. PHOTO EDITORS: Clinton Cargill, David Carthas, Joanna Milter, Marvin Orellana, Kira Pollack, Luise Stauss. PUBLISHER: The New York Times Company. ISSUES: January 18, 2009, June 14, 2009, December 13, 2009. CATEGORY: Magazine of the Year

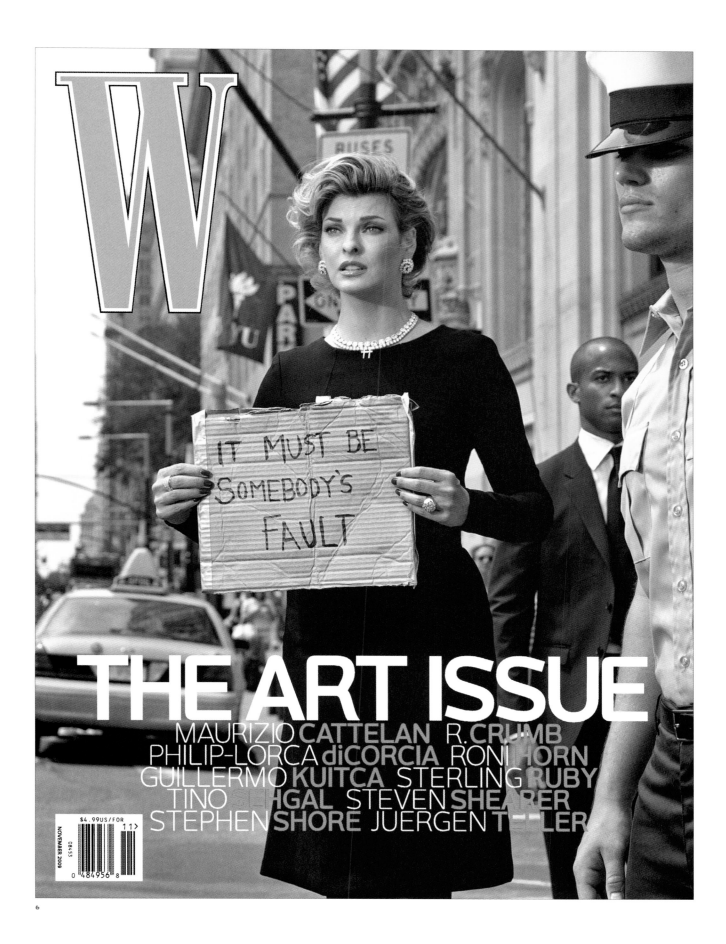

IT MUST BE SOMEBODY'S FAULT

THE ART ISSUE
MAURIZIO CATTELAN R. CRUMB
PHILIP-LORCA diCORCIA RONI HORN
GUILLERMO KUITCA STERLING RUBY
TINO SEHGAL STEVEN SHEARER
STEPHEN SHORE JUERGEN TELLER

$4.99US/FOR
NOVEMBER 2009
C8453
11>
0 484956 8

6

DESIGN DIRECTOR: Edward Leida. ART DIRECTOR: Nathalie Kirsheh. DESIGNERS: Laura Konrad, Gina Maniscalco.
PHOTO EDITOR: Nadia Vellam. PHOTOGRAPHERS: Chuck Close, Steven Klein, Maurizio Cattelan.
PUBLISHER: Condé Nast Publications Inc. ISSUES: February 2009, March 2009, November 2009. CATEGORY: Magazine of the Year

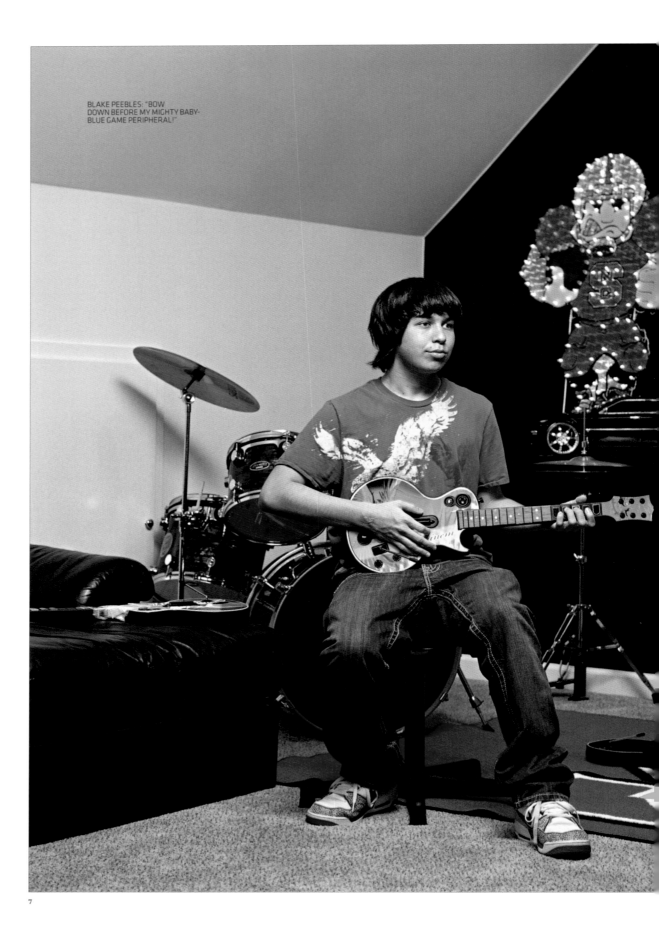

BLAKE PEEBLES: "BOW
DOWN BEFORE MY MIGHTY BABY-
BLUE GAME PERIPHERAL!"

7

7 **Blender Magazine**

CREATIVE DIRECTOR: Dirk Barnett. ART DIRECTORS: Robert Vargas, Claudia de Almeida.
DIRECTOR OF PHOTOGRAPHY: David Carthas. PHOTO EDITORS: Chris Ehrmann, Rory Walsh. EDITOR-IN-CHIEF: Joe Levy.
PUBLISHER: Alpha Media Group. ISSUES: February 2009, March 2009, April 2009. CATEGORY: Magazine of the Year

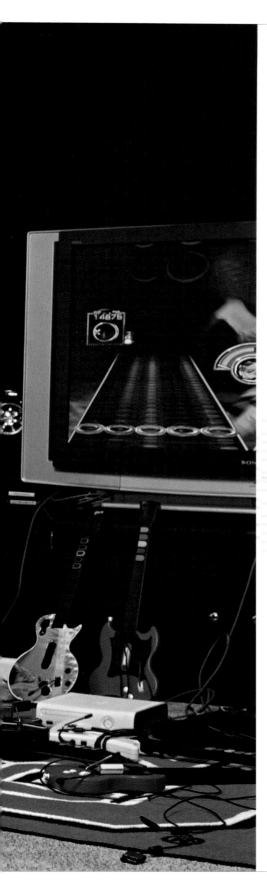

LIKE MOST 16-YEAR-OLDS,
BLAKE PEEBLES WANTS TO PLAY
GUITAR HERO ALL DAY LONG.
UNLIKE MOST 16-YEAR-OLDS,
HE'S CONVINCED HIS PARENTS TO LET HIM
DROP OUT OF SCHOOL TO DO JUST THAT

BY DAVID KUSHNER
PHOTOGRAPHS BY DANIELLE LEVITT

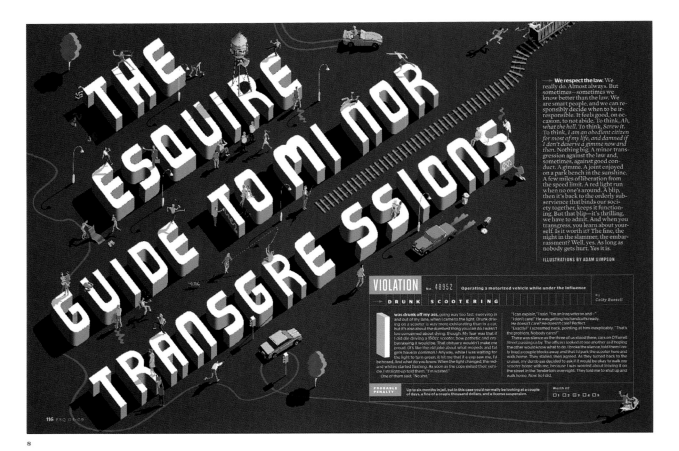

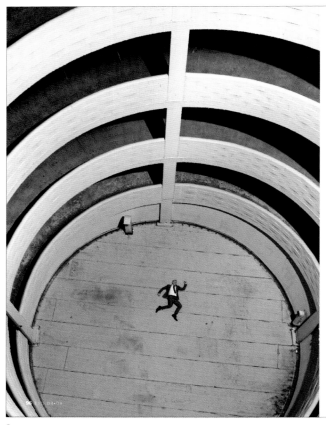

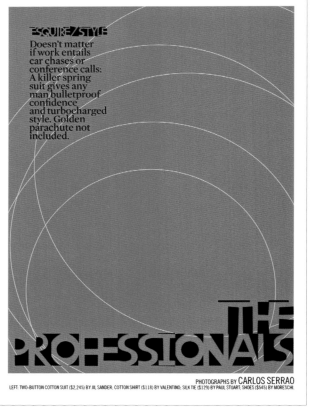

8

8

8 *Esquire*

DESIGN DIRECTOR: David Curcurito. ART DIRECTOR: Darhil Crooks. ASSOCIATE ART DIRECTORS: Erin Jang, Soni Khatri.
PHOTO DIRECTOR: Michael Norseng. PHOTO EDITOR: Alison Unterreiner. PHOTO COORDINATOR: Whitney Tressel.
PUBLISHER: The Hearst Corporation-Magazines Division. ISSUES: March 2009, April 2009, September 2009. CATEGORY: Magazine of the Year

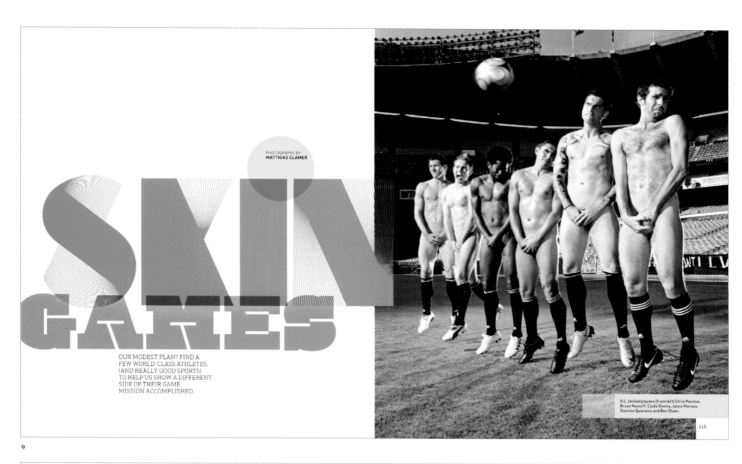

PHOTOGRAPHS BY
MATTHIAS CLAMER

OUR MODEST PLAN? FIND A
FEW WORLD CLASS ATHLETES
(AND REALLY GOOD SPORTS)
TO HELP US SHOW A DIFFERENT
SIDE OF THEIR GAME.
MISSION ACCOMPLISHED.

D.C. United players (from left) Chris Pontius,
Bryan Namoff, Clyde Simms, Jaime Moreno,
Santino Quaranta and Ben Olsen.

115

9

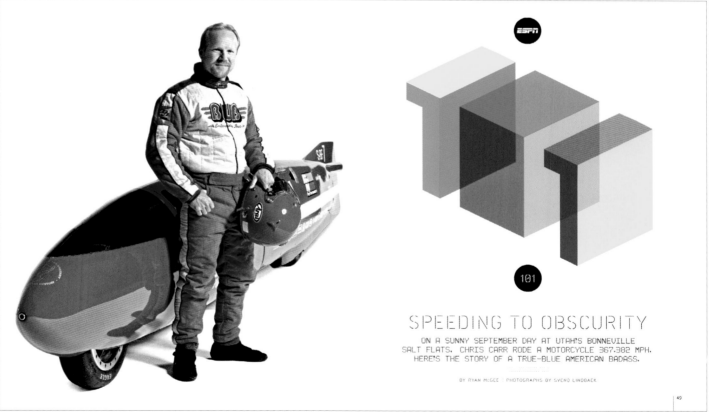

101

SPEEDING TO OBSCURITY

ON A SUNNY SEPTEMBER DAY AT UTAH'S BONNEVILLE
SALT FLATS, CHRIS CARR RODE A MOTORCYCLE 367.382 MPH.
HERE'S THE STORY OF A TRUE-BLUE AMERICAN BADASS.

BY RYAN McGEE : PHOTOGRAPHS BY SVEND LINDBAEK

49

9

9 **ESPN The Magazine**

CREATIVE DIRECTOR: Siung Tjia. ART DIRECTOR: Jason Lancaster. DIRECTOR OF PHOTOGRAPHY: Catriona Ni Aolain.
PHOTO EDITORS: Jennifer Aborn, Amy McNulty, Maisie Todd, Nancy Weisman. PUBLISHER: The Walt Disney Publishing Company.
ISSUES: October 19, 2009, November 2, 2009, December 16, 2009. CATEGORY: Magazine of the Year

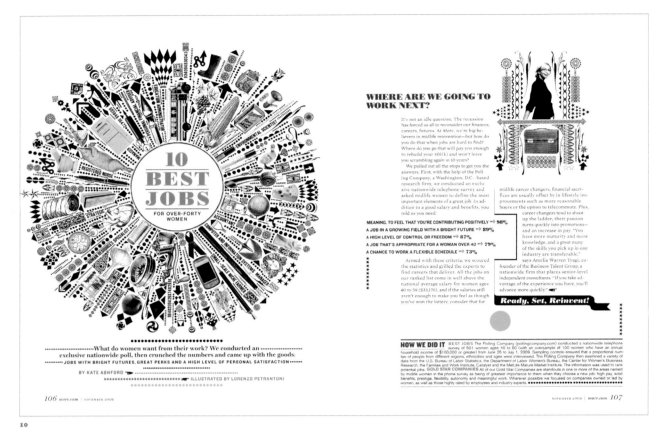

10

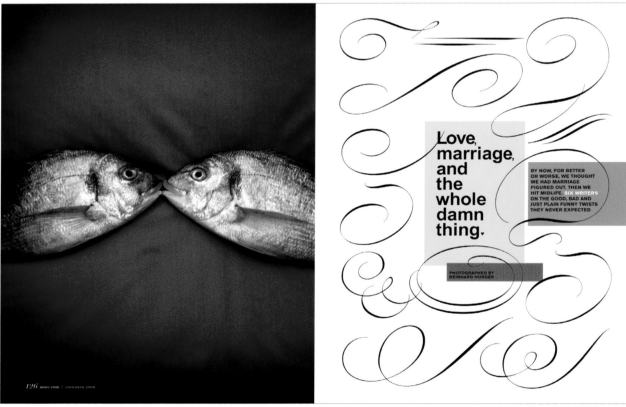

10

10 *More*

CREATIVE DIRECTOR: Debra Bishop. ART DIRECTORS: Claudia de Almeida, Jose G. Fernandez, Cybele Grandjean. DESIGNERS: Susanne Bamberger, Jenn McManus, Faith Stafford. ILLUSTRATOR: Lorenzo Petrantoni. DIRECTORS OF PHOTOGRAPHY: Stacey Baker, Jennifer Laski. PHOTO EDITORS: Daisy Cajas, Natalie Gialluca. PHOTOGRAPHERS: Ruven Afanador, Jessica Antola, Kenji Aoki, Levi Brown, Nigel Cox, Gentl & Hyers, Liz Von Hoene, Reinhard Hunger, Dean Isidro, Mel Karch, Brigitte Lacombe, Charles Masters, David Meredith, Stephanie Sinclair, Katherine Wolkoff, Troy Word. EDITOR-IN-CHIEF: Lesley Jane Seymour. PUBLISHER: Meredith Corporation. ISSUES: June 2009, September 2009, November 2009. CATEGORY: Magazine of the Year

REAL SIMPLE
| life made easier |

A MONTH OF EASY DINNERS

Your stress-free plan for delicious weeknight meals

21 smart, real-life laundry strategies
How to save on groceries, winter coats, and Halloween supplies
The complete appliance troubleshooting guide

11 *Real Simple*

CREATIVE DIRECTOR: Janet Froelich. DESIGN DIRECTOR: Cybele Grandjean. ART DIRECTOR: Ellene Wundrok. DESIGNERS: Jamie Dannecker, Elsa Mehary, Jessica Weit, Tracy Walsh, Heather Saltzman. DIRECTOR OF PHOTOGRAPHY: Casey Tierney. PHOTO EDITORS: Lauren Epstein, Lindsay Dougherty Rogers, Susan Getzendanner, Brian Madigan. EDITOR-IN-CHIEF: Kristin Van Ogtrop. PUBLISHER: Time Inc. ISSUES: October 2009, November 2009, December 2009 CATEGORY: Magazine of the Year

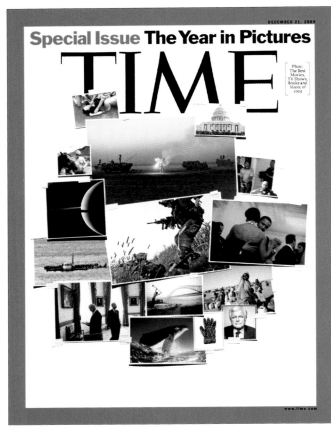

12

Hoping for a rebound *The chairman works out on the Fed's squash court, which has been converted for basketball*

12

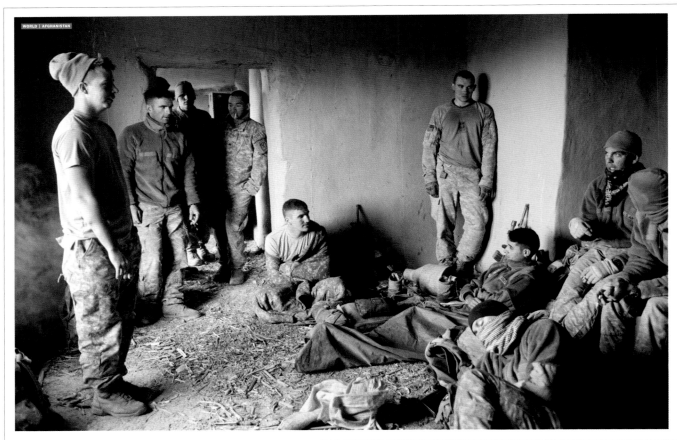

12

12 **TIME**

ART DIRECTORS: Arthur Hochstein, D.W. Pine. DIRECTOR OF PHOTOGRAPHY: Kira Pollack. PUBLISHER: Time Inc.
ISSUES: October 12, 2009, December 21, 2009, December 28, 2009 – January 4, 2010. CATEGORY: Magazine of the Year

PERVASIVE COMPUTING
TUTTO UN NUOVO MONDO
INTORNO A NOI

DI GIANCARLO DOTTO
FOTO DI CIRO FRANK SCHIAPPA

NEL CUORE DEL FRIULI SI PENSA SEMPRE PIÙ IN
PICCOLO. ROBERTO SIAGRI, PASSIONALE INVENTORE
DI EUROTECH, PREVEDE E SPERIMENTA COMPUTER
MINUSCOLI E ONNIPRESENTI E INFORMAZIONI CHE
VOLERANNO ATTORNO A NOI SOTTO FORMA DI POLVERE
INTELLIGENTE. IL SOGNO DI UN VISIONARIO? MICA
TANTO, SE PENSIAMO A ZYPAD, UN MICRO-PC DA POLSO
SIMILE A QUELLO CHE IN AMERICA HA PERMESSO AGLI
ELETTORI DISABILI DI VOTARE DA CASA PER OBAMA O
MCCAIN, OPPURE A QUELLO CHE FA MARCIARE I TRENI A
HONG KONG, PERCHÉ AD AMARO, A DUE PASSI DA UDINE,
IL FUTURO (IN MINIATURA) È GIÀ INCOMINCIATO.

13

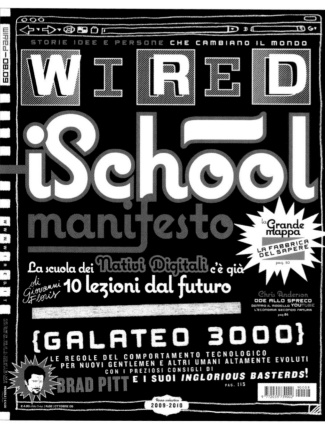

13

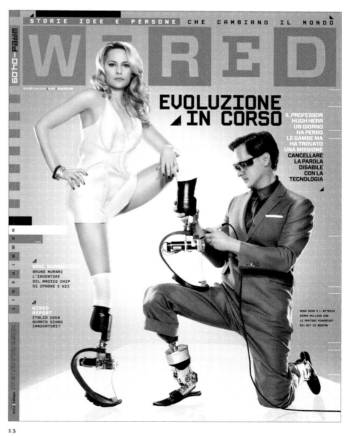

13

13 **WIRED Italy**

ART DIRECTOR: David Moretti. DESIGNERS: David Moretti, Bianca Milani, Daniela Sanziani. PHOTO EDITOR: Francesca Morosini.
EDITOR-IN-CHIEF: Riccardo Luna. PUBLISHER: Condé Nast Italia. ISSUES: June 2009, October 2009, December 2009. CATEGORY: Magazine of the Year

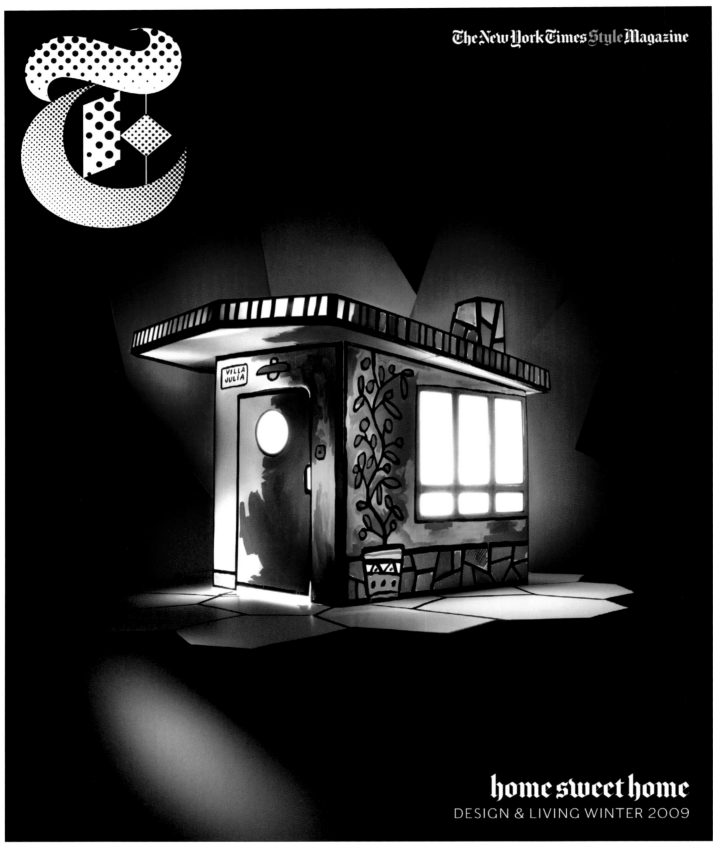

14 T, The New York Times Style Magazine

CREATIVE DIRECTOR: David Sebbah. SENIOR ART DIRECTOR: Christopher Martinez. DESIGNER: Natalie Do. DIRECTOR OF PHOTOGRAPHY: Kathy Ryan. SENIOR PHOTO EDITOR: Judith Puckett-Rinella. PHOTO EDITOR: Scott Hall. PUBLISHER: The New York Times Company. CATEGORY: Magazine of the Year

STITCH

THE WORK

karyn valino

big city craft

Karyn Valino creates
a community for craft
in her Toronto store,
the workroom.

15

SKETCHBOOK

*Guylaine Couture
by Karen Klassen*

les cahiers
de guylaine
Couture.

AIMER
AUTANT

GUYLAINE

lumineuse

NUMBER

je suis comme

COUTURE

PANNE

LÀ OÙ ÇA FAIT MAL...

MIND

Guylaine Couture has been teaching graphic design for the past 20 years and maintains a freelance practice with select clients. She also creates hand-bound collage sketchbooks and artist's books. The Montreal artist grew up with a father who was both architect and artist; being surrounded by art books from a very young age has no doubt influenced Guylaine's study of graphic design and inspired her to begin making books of her own.

She describes the relationship between creating sketchbooks and doing graphic design as having "two parallel lives." Although she uses computers on a regular basis for her design work, the tactile nature of collage—cutting, pasting, drawing, and painting—is an important aspect of the medium that feeds her creativity. She enjoys the speed with which she can create a collage, often creating 2 or 4 at a time, spending roughly 15 minutes on each, lending the small works spontaneity and a sense of playfulness.

Guylaine describes how her work evolves organically: "I never plan anything but the format, and I work with whatever is on my

15

15 **UPPERCASE** *Magazine*

CREATIVE DIRECTOR: Janine Vangool. DESIGNER: Janine Vangool. ILLUSTRATOR: Blanca Gomez. DIRECTOR OF PHOTOGRAPHY: Janine Vangool.
PHOTOGRAPHERS: Vicky Lam, Adrian Gaut. STYLING BY: Christina Yan. EDITOR-IN-CHIEF: Janine Vangool. PUBLISHER: UPPERCASE.
ISSUES: April 2009, July 2009, October 2009. CATEGORY: Magazine of the Year

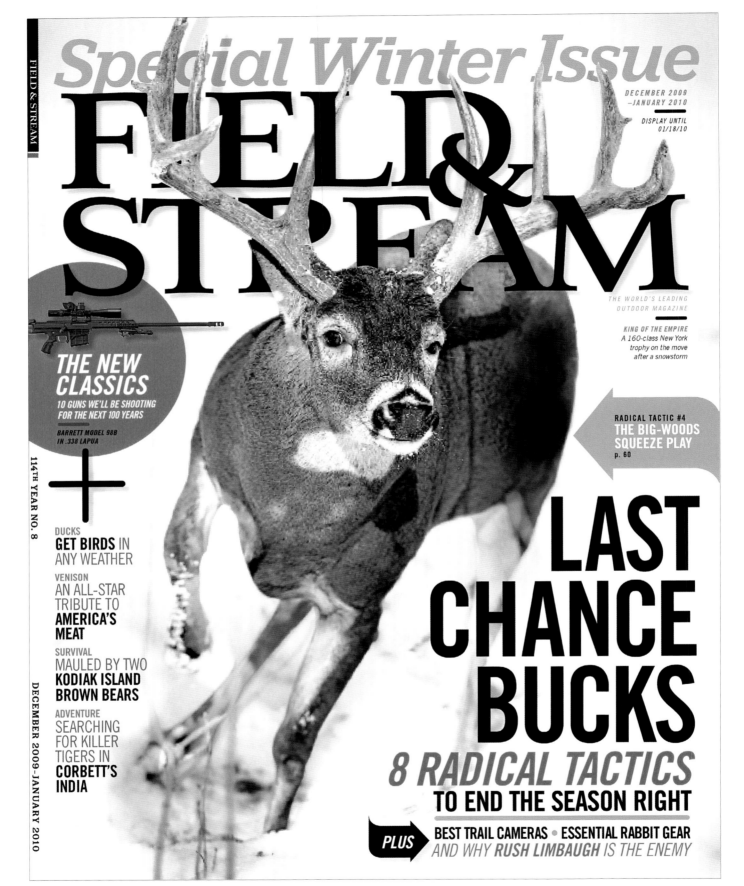

Special Winter Issue

FIELD & STREAM

FIELD & STREAM

DECEMBER 2009
–JANUARY 2010

DISPLAY UNTIL
01/18/10

THE WORLD'S LEADING
OUTDOOR MAGAZINE

KING OF THE EMPIRE
*A 160-class New York
trophy on the move
after a snowstorm*

**THE NEW
CLASSICS**
*10 GUNS WE'LL BE SHOOTING
FOR THE NEXT 100 YEARS*

**BARRETT MODEL 98B
IN .338 LAPUA**

114TH YEAR NO. 8

DECEMBER 2009–JANUARY 2010

RADICAL TACTIC #4
**THE BIG-WOODS
SQUEEZE PLAY**
p. 60

DUCKS
GET BIRDS IN
ANY WEATHER

VENISON
AN ALL-STAR
TRIBUTE TO
**AMERICA'S
MEAT**

SURVIVAL
MAULED BY TWO
**KODIAK ISLAND
BROWN BEARS**

ADVENTURE
SEARCHING
FOR KILLER
TIGERS IN
**CORBETT'S
INDIA**

LAST
CHANCE
BUCKS
8 RADICAL TACTICS
TO END THE SEASON RIGHT

PLUS BEST TRAIL CAMERAS • ESSENTIAL RABBIT GEAR
*AND WHY **RUSH LIMBAUGH** IS THE ENEMY*

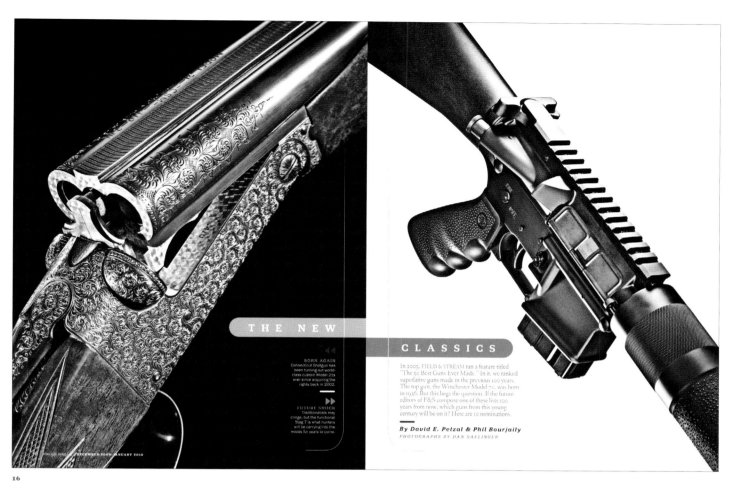

THE NEW CLASSICS

BORN AGAIN
Connecticut Shotgun has been turning out world-class custom Model 21s ever since acquiring the rights back in 2002.

▶▶

FUTURE SHOCK
Traditionalists may cringe, but the functional Stag 7 is what hunters will be carrying into the woods for years to come.

In 2005, FIELD & STREAM ran a feature titled "The 50 Best Guns Ever Made." In it, we ranked superlative guns made in the previous 100 years. The top gun, the Winchester Model 70, was born in 1936. But this begs the question: If the future editors of F&S compose one of these lists 100 years from now, which guns from this young century will be on it? Here are 10 nominations.

By David E. Petzal & Phil Bourjaily
PHOTOGRAPHS BY DAN SAELINGER

16

16

16 *Field & Stream*

ART DIRECTOR: Neil Jamieson. DESIGNER: Mike Ley. DIRECTOR OF PHOTOGRAPHY: Amy Berkley. PHOTO EDITOR: Caitlin Peters.
PUBLISHER: Bonnier Corporation. ISSUE: December 2009/January 2010. CATEGORY: Design: Entire Issue

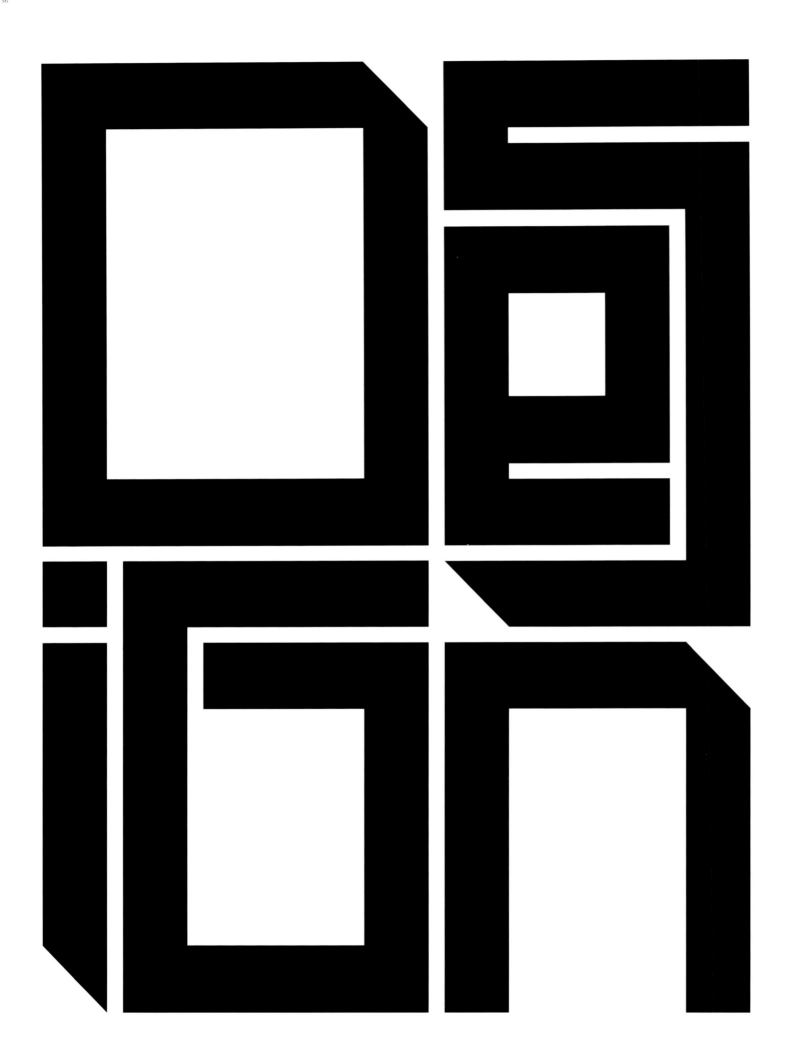

Design

ENTIRE ISSUE *COVER* SECTION *SERVICE* NON-CELEBRITY PROFILE
CELEBRITY/ENTERTAINMENT PROFILE NEWS/REPORTAGE
TRAVEL/FOOD/STILL LIFE FASHION/BEAUTY *TRADE/CORPORATE*
EDUCATIONAL/INSTITUTIONAL *REDESIGN*

38

SECTION:
design

AWARD:
gold

CATEGORY:
cover

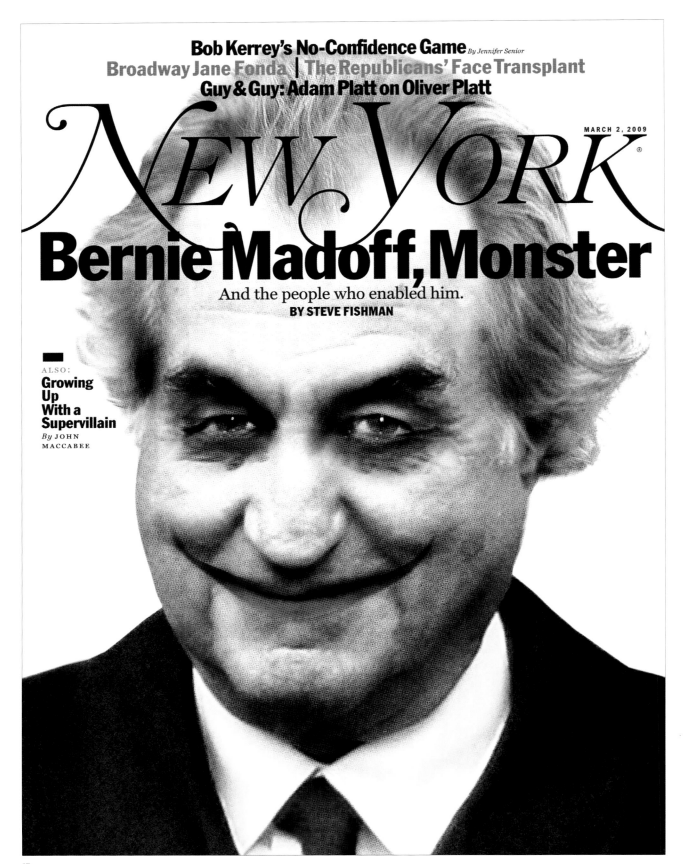

Bob Kerrey's No-Confidence Game *By Jennifer Senior*

Broadway Jane Fonda | The Republicans' Face Transplant

Guy & Guy: Adam Platt on Oliver Platt

NEW YORK

MARCH 2, 2009

Bernie Madoff, Monster
And the people who enabled him.
BY STEVE FISHMAN

ALSO:
Growing Up With a Supervillain
By JOHN MACCABEE

17

17 **New York**

DESIGN DIRECTOR: Chris Dixon. ART DIRECTOR: Randy Minor. DESIGNER: Chris Dixon. ILLUSTRATOR: Darrow. DIRECTOR OF PHOTOGRAPHY: Jody Quon.
EDITOR-IN-CHIEF: Adam Moss. PUBLISHER: New York Magazine Holdings, LLC. ISSUE: March 2, 2009. CATEGORY: Design: Cover

SECTION:
design

AWARD:
gold

CATEGORY:
section (single month)

39

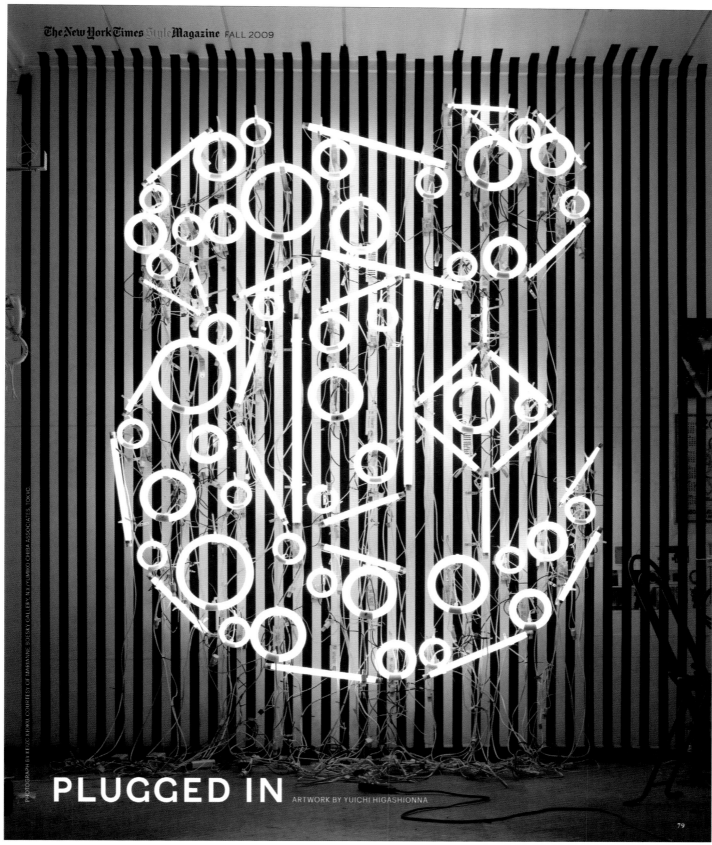

The New York Times Style Magazine FALL 2009

PHOTOGRAPH BY KEIZO KIOKU, COURTESY OF MARIANNE BOESKY GALLERY, N.Y./YUMIKO CHIBA ASSOCIATES, TOKYO.

PLUGGED IN ARTWORK BY YUICHI HIGASHIONNA

79

18

18 *T, The New York Times Style Magazine*

CREATIVE DIRECTOR: David Sebbah. SENIOR ART DIRECTOR: Christopher Martinez. DESIGNER: Natalie Do. ILLUSTRATOR: Yuichi Higashionna.
SENIOR PHOTO EDITOR: Judith Puckett-Rinella. PHOTO EDITOR: Scott Hall. PHOTOGRAPHER: Keizo Kioku. PUBLISHER: The New York Times Company.
ISSUE: October 4, 2009. CATEGORY: Design: Section (single month)

40 SECTION:
design

AWARD:
gold

CATEGORY:
entire issue

FROM the co-creator of **LOST** and director of the new **STAR TREK**...

WIRED

WIRED | 17.05

C.I.A. SECRETS
HIDDEN in PLAIN SIGHT

the **MYSTERY** ISSUE
WITH GUEST EDITOR **J.J. ABRAMS**

Featuring:

The Strangest Places on Earth
/ p.94

Mad Scientists & Bizarre Theories
/ p.38

How Magic Hacks Your Brain
/ p.90

American Stonehenge
/ p.118

TEST YOUR SKILL

**PUZZLES
GAMES
CARD TRICKS
CLUES
EASTER EGGS
CODES
SPOILERS
MAGIC
ILLUSIONS
MAZES
& MORE!**

CRACK THE CODE | MAY 2009

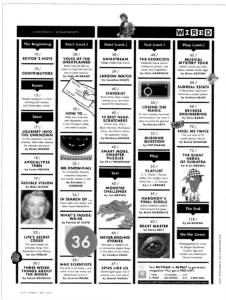

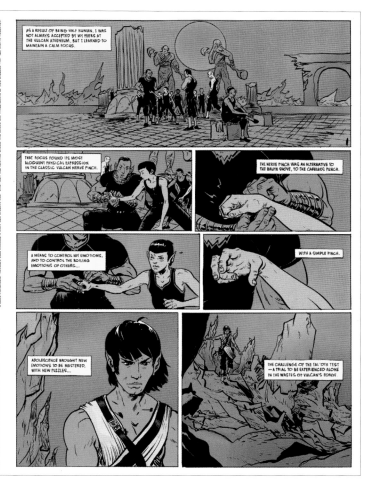

17 1 22 16 8 6 4 34 18 55 14 93

20 11 18 18 10 14 54 5 6 11 10 13

7 7 5 18 22 7 5 6 30 12 6 19 2 22 5

24 15 12 13 1 8 2 1 117 2 17 1 17

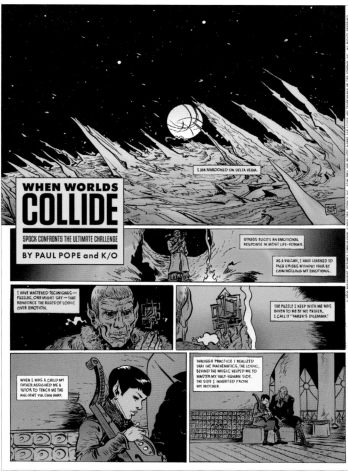

19 **WIRED**

CREATIVE DIRECTOR: Scott Dadich. DESIGN DIRECTOR: Wyatt Mitchell. ART DIRECTORS: Carl DeTorres, Maili Holiman. ASSOCIATE ART DIRECTORS: Christy Sheppard, Margaret Swart. DESIGNERS: Walter C. Baumann, Victor Krumennacher. ILLUSTRATORS: Nishant Choksi, T.J. Tucker, Paul Pope, Ed Ruscha, House Industries, Chris Ware, Dustin Edward Arnold, Steve Sanford, Stephen Doyle, Robert F. Lang, Siggi Eggertson, Jason Lee, Christoph Niemann, J.J. Sedelmaier, Sam Potts. SENIOR PHOTO EDITOR: Zana Woods. DEPUTY PHOTO EDITOR: Anna Goldwater Alexander. ASSOCIATE PHOTO EDITOR: Sarah Filippi. PHOTOGRAPHERS: Dan Winters, Dwight Eschliman, Mark Seliger, Adrian Gaut, Uta Kogelsberger, Carlos Serrao, David Lynch, Joe Pugliese, Tim Morris, Jens Mortensen, Randal Ford. EDITOR-IN-CHIEF: Chris Anderson. PUBLISHER: Condé Nast Publications, Inc. ISSUE: May 2009. CATEGORY: Design: Entire Issue

42

SECTION:
design

AWARD:
gold

CATEGORY:
service

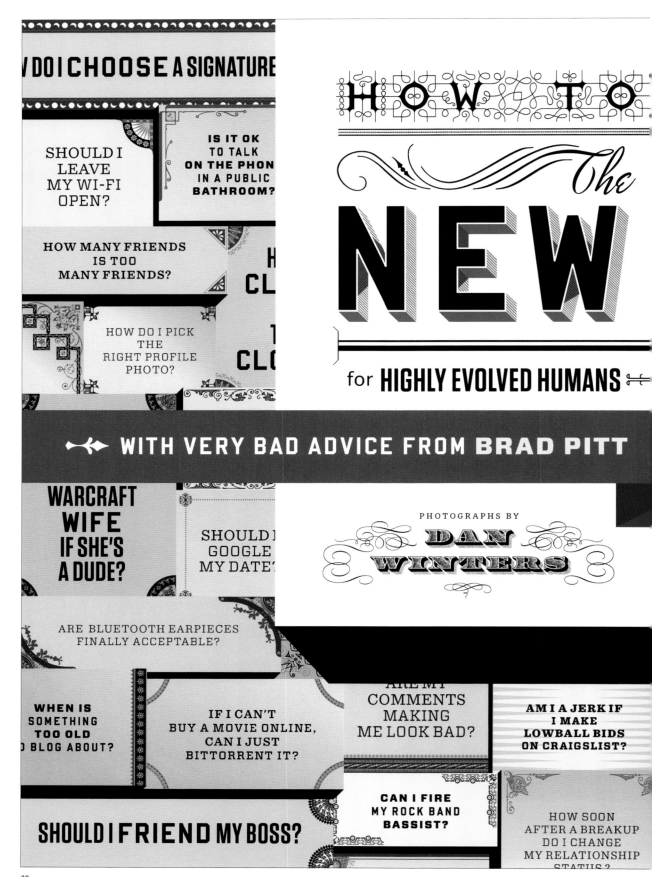

HOW DO I CHOOSE A SIGNATURE

SHOULD I LEAVE MY WI-FI OPEN?

IS IT OK TO TALK ON THE PHONE IN A PUBLIC BATHROOM?

HOW MANY FRIENDS IS TOO MANY FRIENDS?

HOW DO I PICK THE RIGHT PROFILE PHOTO?

HOW TO The NEW for HIGHLY EVOLVED HUMANS

WITH VERY BAD ADVICE FROM BRAD PITT

PHOTOGRAPHS BY DAN WINTERS

WARCRAFT WIFE IF SHE'S A DUDE?

SHOULD I GOOGLE MY DATE?

ARE BLUETOOTH EARPIECES FINALLY ACCEPTABLE?

WHEN IS SOMETHING TOO OLD TO BLOG ABOUT?

IF I CAN'T BUY A MOVIE ONLINE, CAN I JUST BITTORRENT IT?

ARE MY COMMENTS MAKING ME LOOK BAD?

AM I A JERK IF I MAKE LOWBALL BIDS ON CRAIGSLIST?

CAN I FIRE MY ROCK BAND BASSIST?

SHOULD I FRIEND MY BOSS?

HOW SOON AFTER A BREAKUP DO I CHANGE MY RELATIONSHIP STATUS?

20

CREATIVE DIRECTOR: Scott Dadich. DESIGN DIRECTOR: Wyatt Mitchell. ART DIRECTORS: Maili Holimann, Carl DeTorres. DESIGNER: Walter C. Baumann.
EDITOR-IN-CHIEF: Chris Anderson PUBLISHER: Condé Nast Publications, Inc. ISSUE: August 2009. CATEGORY: Design: Feature: Service (single/spread)

BEHAVE

RULES

A SCIENTIFIC APPROACH
to
21ST-CENTURY PREDICAMENTS

STAR OF *INGLOURIOUS BASTERDS*

0
8
3

Illustrations by JASON LEE

SPEND M
TIME (
TWITTER
FACEBO

S IT
ORKY
D USE
CHAT
ANG?

SHOULD
I BE
LUGGE
IN TO
WORK
24/7?

N I
OT MY
INE
TITY?

I HAVE
TO
RIEND
MY
ORKERS?

A LAME POST
FROM MY
THIRD-GRADE
TEACHER?

CAN I EXAGGERATE MY SALARY ON A DATING SITE

**SHOULD
I FRIEND MY EX ON
FACEBOOK?**

Custom ornaments by
SIR WALTER CHARLES

HOW
MANY
TWEETS
IS TOO

IS IT OK
TO TEXT WHILE
DINING OUT
WITH FRIENDS?

HOW DO I MOVE
AN ONLINE
RELATIONSHIP
INTO THE
REAL WORLD?

44 SECTION:
design

AWARD:
gold

CATEGORY:
service (story)
celebrity/entertainment profile (story)

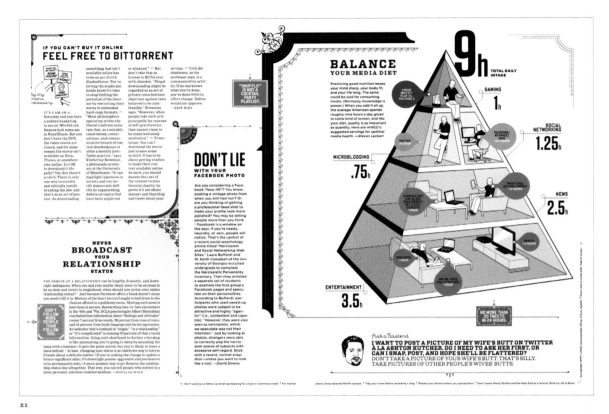

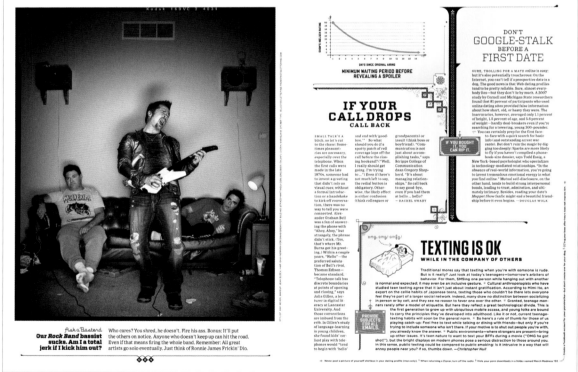

21 **WIRED**
CREATIVE DIRECTOR: Scott Dadich. DESIGN DIRECTOR: Wyatt Mitchell.
ART DIRECTOR: Maili Holiman. DESIGNERS: Maili Holiman,
Carl DeTorres, Walter C. Baumann. ILLUSTRATOR: Jason Lee.
PHOTO EDITOR: Carolyn Rauch. PHOTOGRAPHER: Dan Winters.
EDITOR-IN-CHIEF: Chris Anderson. PUBLISHER: Condé Nast Publications,
Inc. ISSUE: August 2009. CATEGORY: Design: Feature: Service (story)

22 **WIRED**
CREATIVE DIRECTOR: Scott Dadich. DESIGN DIRECTOR: Wyatt Mitchell.
ART DIRECTOR: Maili Holiman. DESIGNERS: Maili Holiman,
Carl DeTorres, Walter C. Baumann. ILLUSTRATOR: Jason Lee.
PHOTO EDITOR: Carolyn Rauch. PHOTOGRAPHER: Dan Winters.
EDITOR-IN-CHIEF: Chris Anderson. PUBLISHER: Condé Nast Publications,
Inc. ISSUE: August 2009. CATEGORY: Design: Feature: Celebrity/
Entertainment Profile (story)

SECTION:
design

AWARD:
gold

CATEGORY:
non-celebrity profile

45

MEET
ONLINE FRIENDS
IN THE
REAL WORLD
(BEWARE: IT WILL BE WEIRD.)

Say you're traveling and finally get to meet a longtime e-pal from your fantasy baseball league ... in person. Over drinks, though, years of easy online banter and *Bull Durham* in-jokes are replaced by awkward silences. Shifting an Internet friendship into the real world can be trickier than hitting a knuckleball. ■ Often, the trouble isn't what you're saying but how you're saying it. Language is more than words. It also includes kinesics (body language) and paralanguage (pitch, tone, and wordless noises). And not everyone interprets these signals the same way, says Nancy Baym, who studies online communications at the University of Kansas. If you and your buddy aren't on the same wavelength, the flood of ambiguous nonverbal cues can lead to misunderstanding and befuddlement. ■ Of course, it might simply be that your online pal is different in person. With all his snappy posts and ripostes, you may have come to think of him as quick-witted. But what's fast in message-board land can feel slower than dialup in a face-to-face exchange. "Sometimes good online socializers are shy in person," Baym says. "Their medium is the written word." ■ One way to ease the transition, she suggests, is to open a limited, private, nontext channel before you meet in person. Pick up the phone or start a video chat. This will help you learn to interpret one another in a low-pressure situation. Or you could always just sit across the table from each other and send text messages. Hey, it works for tweens. *—Mathew Honan*

> HUNGER AND FATIGUE ARE NOT INTERESTING STATUS UPDATES.

LEAVE
YOUR WI-FI OPEN

EVERYONE WITH A Wi-Fi network has had to wrestle with this conundrum: Should you leave your network open for anyone to use, or is that asking for trouble? — Let's start by dispensing with the legalities. Unless your ISP is one of a handful that officially don't care, knowingly letting a neighbor share your connection likely violates your terms of service. Of course, it's hard to prove that you did something knowingly, as long as Flanders isn't paying you. — Even so, you should share your Wi-Fi. Recent brain research suggests that altruistic behavior stimulates the same primitive reward center as sex and food. Now, keeping your signal open won't give you an orgasm, but we know that doing unto others—even small acts like

this—feels good. So unless it starts messing with your Hulu feeds of *Dollhouse*, why not let the neighbors hop aboard? It's not like you pay by the packet. It's even in your self-interest: the more people leave their networks open, the better your odds of finding a hookup when you need one. — Worried about exposing your data to evildoers? Well, there's more danger in leaving your machine unprotected than your network. Just think of all the times you've surfed the Web in coffee shops and airports. There is a small risk that someone will use your bandwidth for nefarious activities, but just because we don't live in a world that's 100 percent safe doesn't mean we should lock everything down. — A Comcast exec might object to a "leave it open"

Wi-Fi policy. After all, we can't let *everyone* piggyback—and by enabling some people to avoid paying, aren't signal-sharers just raising prices for the rest of us? That would be the case in a competitive market—rather than one ruled by a monopoly or duopoly (depending on your city) that charges more, for crappier service,

then almost anywhere else in the industrialized world. (Average broadband speed in Japan: 63.6 Mbps. In the UK: less than 5 Mbps.) Plus, in a business with high fixed costs and low variable costs, what matters is that *enough* people pay. Sounds irrational, but it should be familiar: It's the NPR model. *—Lucas Graves*

ELEMENTS OF VIRAL VIDEO

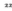

DRUNK / BATHTUB / PET — LOL!

DRUNK / BATHTUB / FARM ANIMAL — EWWW!

Never read the manual first. *Avoid looking at other people's screens.* *Don't waterboard terror suspects.* *Nobody cares how good your uncompressed audio files are.*

SEEK OUT YOUR COWORKERS
ON FACEBOOK

friends with health benefits

SO YOU FINALLY SCORED a new job and you're wondering if you should connect with your colleagues on Facebook? Go ahead. Yes, even with all those embarrassing photos linked to your profile. (No, don't delete the ones from spring break '97, when you hooked up with a bear hong every night.) Friending your coworkers actually makes good business sense. According to London Business School professor Lynda Gratton, companies in which employees feel they know each other personally tend to be more innovative—it helps them jell as a team. In any case, not friending people won't protect you from mortifying revelations. We're all been blogging and Flickring and tweeting for quite a while now; anything potentially compromising about you will eventually make the rounds. So own it. Revealing awkward photos and posts yourself is the best way to limit their impact. Show that you don't take yourself too seriously and you're less likely to invite ridicule. *—ANGELA WATERCUTTER*

> THE DRIVER CONTROLS THE IPOD.

Ask a Bastard **Is it OK to look at pornography at work?** Don't just *look* at it at work, bring in your old porn mags and scan them there! It's like converting your vinyl to MP3s. Fill up your hard drive, and when you need a break from spreadsheets, just open a favorite pictorial.

◆◆◆

22

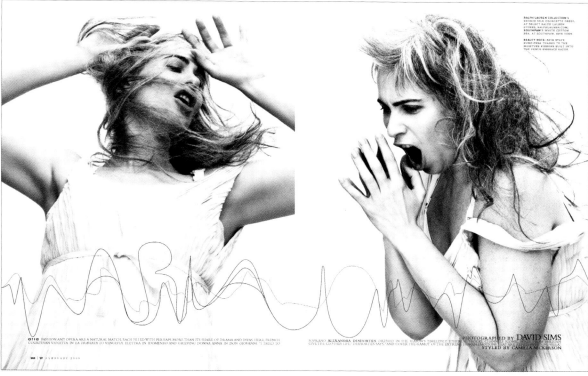

RALPH LAUREN COLLECTION'S BRONZE SILK CROQUETTE DRESS, AT SELECT RALPH LAUREN STORES, RALPHLAUREN.COM. SOUTHPAW'S WHITE COTTON BRA, AT SOUTHPAW, NEW YORK

BEAUTY NOTE: SKIN STAYS BUMP-FREE THANKS TO THE MOISTURE RIBBONS BUILT INTO THE VENUS EMBRACE RAZOR.

aria FASHION AND OPERA ARE A NATURAL MATCH, EACH FILLED WITH PERHAPS MORE THAN ITS SHARE OF DRAMA AND DIVAS. HERE, FRENCH COURTESAN VIOLETTA IN *LA TRAVIATA* TO VENGEFUL ELETTRA IN *IDOMENEO* AND GRIEVING DONNA ANNA IN *DON GIOVANNI* TO JILTED DI...

SOPRANO **ALEXANDRA DESHORTIES**, DRESSED IN THE SEASON'S TIMELESSLY ETHEREAL GODDESS GOWNS. "AN OPERA SINGER HAS TO GIVE THE CLOTHES LIFE," DESHORTIES SAYS, "AND COVER THE GAMUT OF THE EXTREME HUMAN EMOTIONS THAT ARE SO PRESENT IN OPERA."

PHOTOGRAPHED BY **DAVID SIMS**
STYLED BY **CAMILLA NICKERSON**

150 | W | FEBRUARY 2009

23

23 **W**

DESIGN DIRECTOR: Edward Leida. ART DIRECTOR: Nathalie Kirsheh.
DESIGNER: Nathalie Kirsheh. PHOTOGRAPHER: David Sims.
PUBLISHER: Condé Nast Publications Inc. ISSUE: February 2009.
CATEGORY: Design: Feature: Non-Celebrity Profile (single/spread)

46

SECTION:
design

AWARD:
gold

CATEGORY:
non-celebrity profile (story)

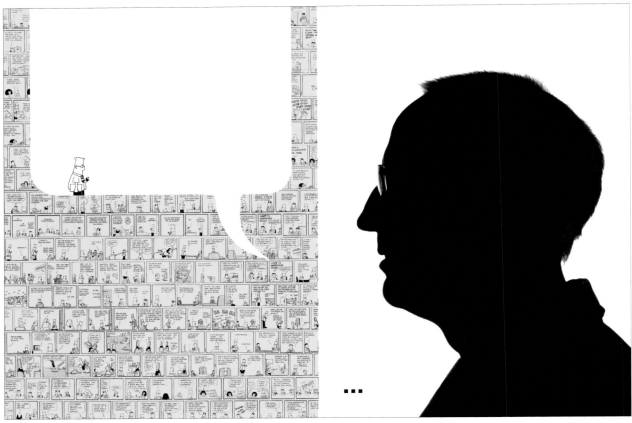

24

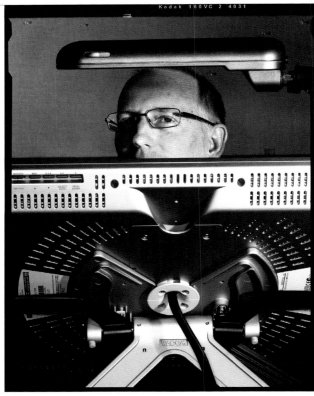

When a mysterious illness rendered *Dilbert* creator Scott Adams mute, the result was anything but comic. Inside the artist's struggle to regain his voice.

SPEECHLESS

BY BRIAN RAFTERY
PHOTOGRAPHS BY DAN WINTERS

The rules changed all the time—sometimes day to day, sometimes hour to hour—and whenever he tried to recite them, people thought, "This guy is nuts." ¶ The rules dictated when and where Scott Adams, the chief engineer of the *Dilbert* comic empire, was allowed to speak. He could neither control them nor predict exactly when they'd go into effect. All he knew was that he'd woken up one morning and found that his voice had turned against him, imposing a set of bizarre restrictions. ¶ Take the rule about crowds. If Adams was at a party with friends, he'd open his mouth to talk, only to find the words tumbling out in a raspy, imperceptible staccato, chopping off sentences before they had a chance to form. If he tried to say, "Tomorrow is my birthday," for example, it would morph into a weak "Ma robf sss ma birfday." But if he was on the lecture circuit, delivering a prepared speech to a crowd of thousands, he could stand behind the podium and—"Hello?"—his voice would whir back to life, if only for the hour he was onstage. ¶ There was also the rule about being alone. Adams might be sitting at the desk in his Bay Area office, working on a new *Dilbert* strip, when suddenly he'd be able to form words. He'd call out to others in the house—"I can talk!"—but the

moment somebody stepped into the room, his voice evaporated.

Then there was the rule about the rules themselves. For some reason, if Adams were to explain his condition to you, his speech would suddenly become clear and strong. Change the topic, however, and his voice would jumble again.

But if you were to place a video camera in front of him and have him talk into it—well, in that case, he could be relatively lucid about anything.

That one still baffles him.

The rules took effect in April 2005, while the 48-year-old Adams was on vacation in San Diego with then-girlfriend (now wife) Shelly Miles and her two kids. One day, he woke up with what felt like severe laryngitis. He'd suffered from allergies for

years, and he had similar throat issues almost every spring.

"Not a big deal," he thought, shrugging it off.

He returned home to Dublin, California, a well-behaved suburb 35 miles east of San Francisco. Days passed, then weeks, but Adams still couldn't summon his voice. His doctors examined him for bronchitis and polyps—and any other condition they could think of—but they were unable to find the cause. A psychologist checked him for signs of a breakdown, because what else could it be? She offered him a regimen of antianxiety medications; Adams declined.

Meanwhile, his speech was getting worse. What began as a hoarse whisper devolved into a string of garbled, phonetic shards that sounded like he was talking

115

24 **WIRED**

CREATIVE DIRECTOR: Scott Dadich. DESIGN DIRECTOR: Wyatt Mitchell. ART DIRECTOR: Margaret Swart. DESIGNER: Margaret Swart.
PHOTO EDITOR: Carolyn Rauch. PHOTOGRAPHER: Dan Winters. EDITOR-IN-CHIEF: Chris Anderson. PUBLISHER: Condé Nast Publications, Inc.
ISSUE: August 2009. CATEGORY: Design: Feature: Non-Celebrity Profile (story)

SECTION:
design

AWARD:
gold

CATEGORY:
section (series of months)

47

$\mathcal{Esquire}$ CONTENTS

January 2009 / vol. 151 / no. 1

California "We've come this far, let's not ruin it by thinking." **Clint Eastwood,** *pg. 72.*

THE MEANING *of* LIFE 2009

Wisdom and crazy talk from every state of the Union. Political leaders, entertainers, soldiers, athletes, scientists, toll-booth collectors—what they've learned.

Alabama
"What makes humanity is not reason. Our emotions are what make us human."
E. O. Wilson,
pg. 112.

Montana
"Of course you know my mother. She slit her throat with a razor."
Peter Fonda,
pg. 100.

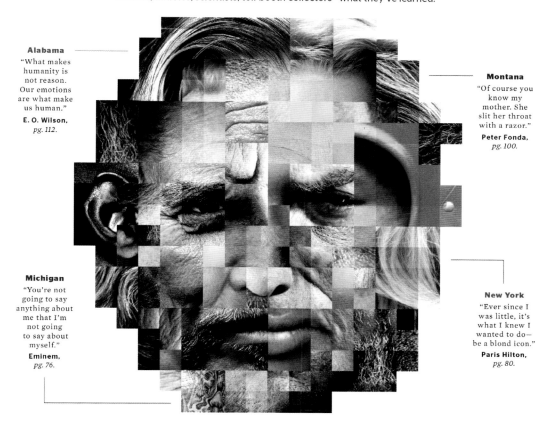

Michigan
"You're not going to say anything about me that I'm not going to say about myself."
Eminem,
pg. 76.

New York
"Ever since I was little, it's what I knew I wanted to do— be a blond icon."
Paris Hilton,
pg. 80.

Alaska Dianne M. Keller, *pg. 95.* **Arizona** Alice Cooper, *pg. 79.* **Arkansas** Wesley Clark, *pg. 98.* **Colorado** Duane "Dog" Chapman, *pg. 104.* **Connecticut** Chloë Sevigny, *pg. 102.* **Delaware** Gary Forester, *pg. 97.* **Florida** Jeb Bush, *pg. 98.* **Georgia** Evander Holyfield, *pg. 107.* **Hawaii** Woody Harrelson, *pg. 84.* **Idaho** Warren Miller, *pg. 79.* **Illinois** Bob Newhart, *pg. 116.* **Indiana** Larry Bird, *pg. 83.* **Iowa** Cloris Leachman, *pg. 81.* **Kansas** Charles Koch, *pg. 114.* **Kentucky** Harry Dean Stanton, *pg. 89.* **Louisiana** Kimberly Roberts, *pg. 88.* **Maine** George Johnson, *pg. 110.* **Maryland** Philip Glass, *pg. 86.* **Massachusetts** Rory Stewart, *pg. 99.* **Minnesota** Steve Zahn, *pg. 117.* **Mississippi** Shepard Smith, *pg. 114.* **Missouri** John Goodman, *pg. 90.* **Nebraska** Conor Oberst, *pg. 101.* **Nevada** Wayne Newton, *pg. 92.* **New Hampshire** Bode Miller, *pg. 103.* **New Jersey** Steven Van Zandt, *pg. 82.* **New Mexico** Bill Richardson, *pg. 78.* **North Carolina** Charlie Daniels, *pg. 93.* **North Dakota** Chuck Klosterman, *pg. 94.* **Ohio** Jim Brown, *pg 103.* **Oklahoma** Toby Keith, *pg. 106.* **Oregon** Gus Van Sant, *pg. 87.* **Pennsylvania** Dwight Schrute, *pg. 89.* **Rhode Island** The Farrelly brothers, *pg. 109.* **South Carolina** Jesse Jackson, *pg. 108.* **South Dakota** Gerard Baker, *pg. 92.* **Tennessee** Phil Bredesen, *pg. 101.* **Texas** Josh Hamilton, *pg. 113.* **Utah** Brent Scowcroft, *pg. 96.* **Vermont** Luis Guzman, *pg. 97.* **Virginia** Lon Solomon, *pg. 95.* **Washington** Quincy Jones, *pg. 111.* **West Virginia** Chuck Yeager, *pg. 77.* **Wisconsin** Les Paul, *pg. 115.* **Wyoming** Rulon Gardner, *pg. 109.*

{ continued on page 6 }

ON THE COVER: CLINT EASTWOOD PHOTOGRAPHED EXCLUSIVELY FOR ESQUIRE BY NIGEL PARRY. COTTON T-SHIRT BY BANANA REPUBLIC. STYLING BY DEBORAH HOPPER. GROOMING BY JOANNEL CLEMENTE.

5

25 *Esquire*

DESIGN DIRECTOR: David Curcurito. ART DIRECTOR: Darhill Crooks. ASSOCIATE ART DIRECTORS: Erin Jang, Soni Khatri.
PHOTO DIRECTOR: Michael Norseng. PUBLISHER: The Hearst Corporation-Magazines Division. ISSUES: January 2009, April 2009, June 2009.
CATEGORY: Design: Section (series of months)

48 SECTION:
design

AWARD:
gold

CATEGORY:
celebrity/entertainment profile

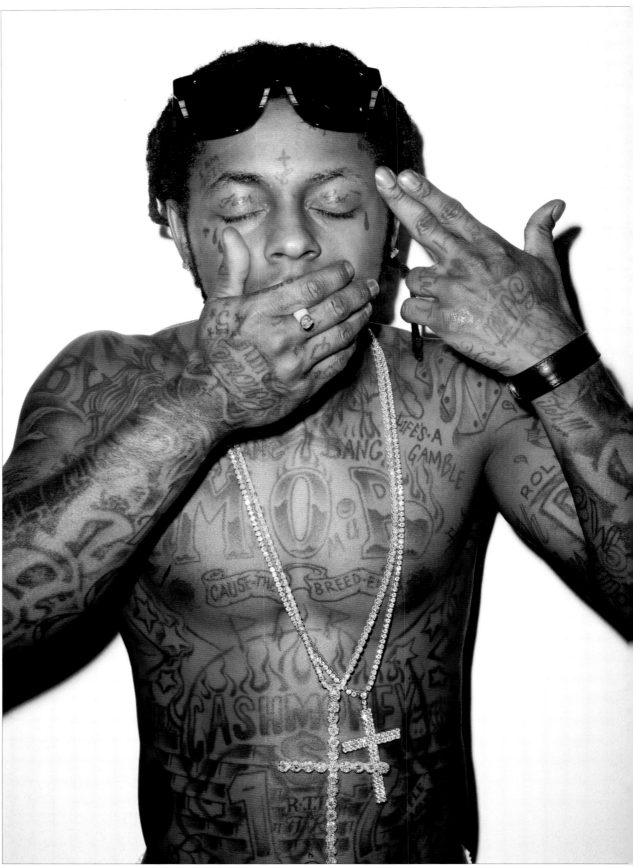

26

DESIGN DIRECTOR: Fred Woodward. DESIGNER: Chelsea Cardinal. ILLUSTRATOR: Chelsea Cardinal. DIRECTOR OF PHOTOGRAPHY: Dora Somosi.
PHOTO EDITOR: Justin O'Neill. PHOTOGRAPHER: Terry Richardson. PUBLISHER: Condé Nast Publications Inc. ISSUE: January 2009.
CATEGORY: Design: Feature: Celebrity/Entertainment Profile (single/spread)

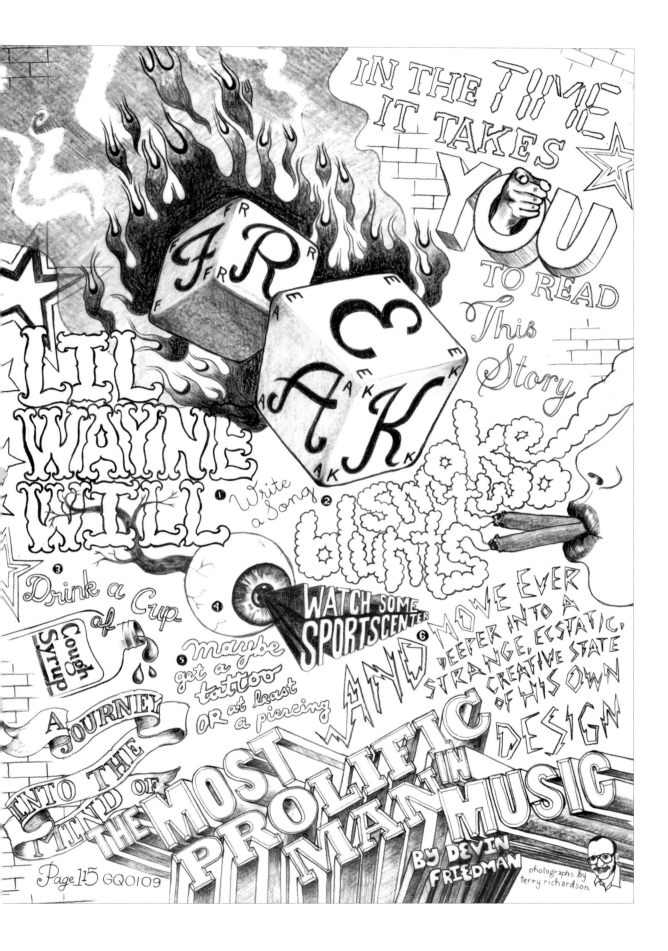

50

SECTION:
design

AWARD:
gold

CATEGORY:
**trade/corporate
news/reportage**

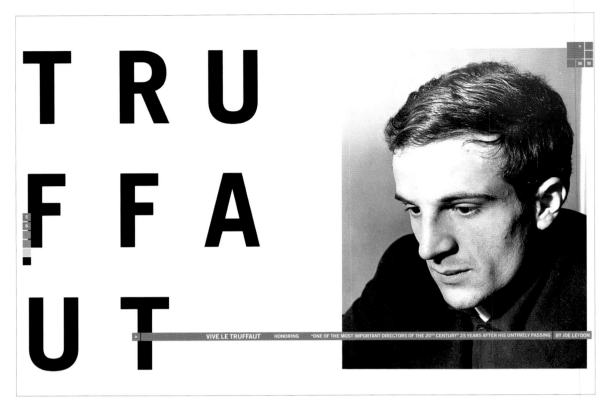

27

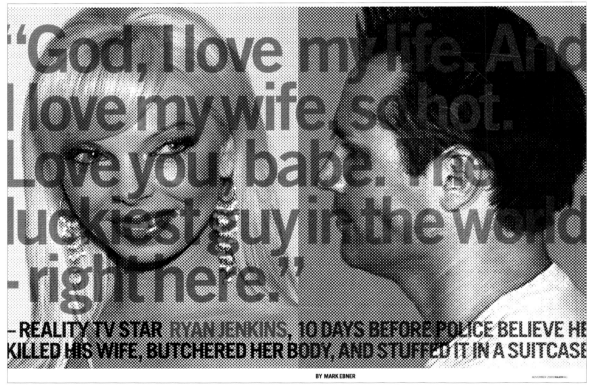

28

27 *Moviemaker*

ART DIRECTOR: Rob Hewitt. DESIGNER: Rob Hewitt.
STUDIO: Curious Outsider. EDITOR-IN-CHIEF: Timothy E. Rhys.
PUBLISHER: Moviemaker LLC. CLIENT: Moviemaker. ISSUE: Fall 2009
CATEGORY: Design: Cover, Entire Issue, Single/Spread or Story

28 *Maxim*

CREATIVE DIRECTOR: Dirk Barnett. DESIGNER: Billy Sorrentino.
ILLUSTRATOR: Eric Heinz. EDITOR-IN-CHIEF: Joe Levy.
PUBLISHER: Alpha Media Group. ISSUE: November 2009.
CATEGORY: Design: Feature: News/Reportage (single/spread)

SECTION:
design

AWARD:
gold

CATEGORY:
news/reportage (story)

51

29

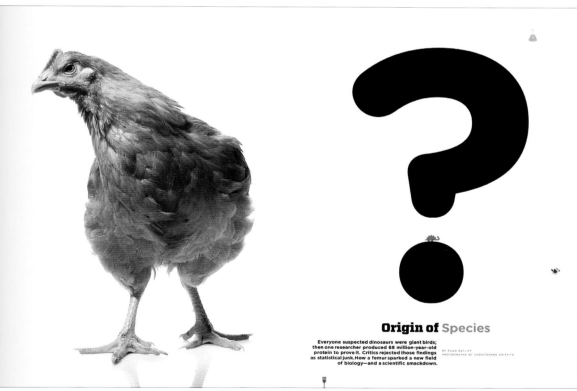

Origin of Species

Everyone suspected dinosaurs were giant birds; then one researcher produced 68 million-year-old protein to prove it. Critics rejected those findings as statistical junk. How a femur sparked a new field of biology—and a scientific smackdown.

BY EVAN RATLIFF
PHOTOGRAPHS BY CHRISTOPHER GRIFFITH

29

29 **WIRED**

CREATIVE DIRECTOR: Scott Dadich. DESIGN DIRECTOR: Wyatt Mitchell. ART DIRECTOR: Maili Holiman. DESIGNER: Maili Holiman.
ILLUSTRATOR: Peter Grundy. DEPUTY PHOTO EDITOR: Anna Goldwater Alexander. PHOTOGRAPHER: Christopher Griffith.
EDITOR-IN-CHIEF: Chris Anderson. PUBLISHER: Condé Nast Publications, Inc. ISSUE: July 2009. CATEGORY: Design: Feature: News/Reportage (story)

52

SECTION:
design

AWARD:
gold

CATEGORY:
fashion/beauty

The Biggest Loser

{ Help for Thinning Hair }

BY *Annemarie Iverson* PHOTOGRAPHED BY *Plamen Petkov*

98 more.com | APRIL 2009

30

CREATIVE DIRECTOR: Debra Bishop. DESIGNER: Jenn McManus. DIRECTOR OF PHOTOGRAPHY: Jennifer Laski. PHOTO EDITOR: Natalie Gialluca.
PHOTOGRAPHER: Plamen Petkov. EDITOR-IN-CHIEF: Lesley Jane Seymour. PUBLISHER: Meredith Corporation. ISSUE: April 2009.
CATEGORY: Design: Feature: Fashion/Beauty (single/spread)

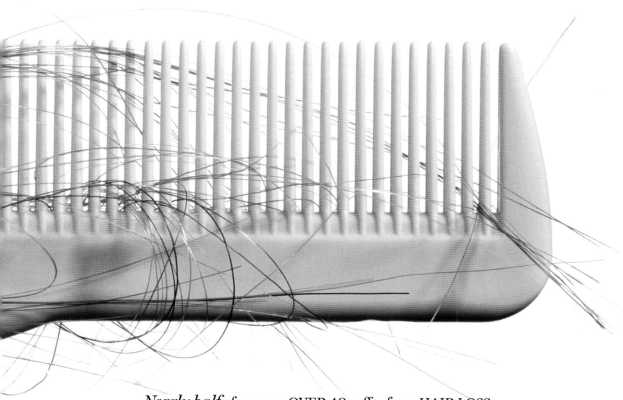

Nearly half of women OVER 40 suffer from HAIR LOSS, but take note: It's *not inevitable*. Here's how you can prevent future SHEDDING and even *regrow* what's been lost

I HAD THYROID IMBALANCE hair loss in my twenties, postpartum thinning twice in my thirties, big-time strand shedding after the death of my father in my early forties, and now, at 47, visible thinning three months after suffering a fever of 104. No actual scalp peeking through as of this morning, thank god, just stringy gobs of lifeless blond in the comb.

So when New York City dermatologist David Orentreich, MD, tells me

that nearly 50 percent of women will experience hair loss by age 50, I am unsurprised—and utterly empathetic. While a man's baldness can symbolize power, success and virility (note such chrome domes as athlete-mogul Michael Jordan, actor Bruce Willis, billionaire investor Ron Perelman and short, rich Harry Goldenblatt, Charlotte's second husband on *Sex and the City*), women's sexual attractiveness has always sprung—historically, anthropologically and culturally—from gorgeous, shiny, plentiful hair.

WHAT CAUSES THE *fall*out

SO WHERE DID it all go, that mass of thick, hormonally hopped-up high school hair? At puberty—decades before we can appreciate it or have the money and good taste to properly deal with it—we are blessed with the fullest mane of our entire lives. Then, inexorably, the strands begin to diminish, not just in number but also in diameter and in their ability to grow

54

SECTION:
design

AWARD:
gold

CATEGORY:
fashion/beauty (story)

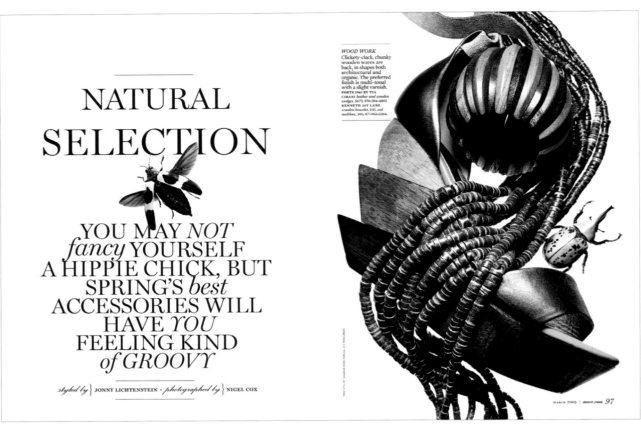

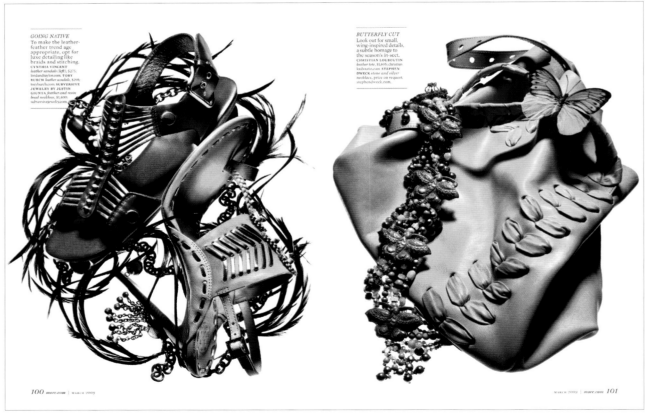

31 **More**

CREATIVE DIRECTOR: Debra Bishop. DESIGNER: Debra Bishop. DIRECTOR OF PHOTOGRAPHY: Jennifer Laski.
PHOTO EDITOR: Daisy Cajas. PHOTOGRAPHER: Nigel Cox. EDITOR-IN-CHIEF: Lesley Jane Seymour.
PUBLISHER: Meredith Corporation. ISSUE: March 2009 CATEGORY: Design: Feature: Fashion/Beauty (story)

SECTION:
design

AWARD:
gold

CATEGORY:
travel/food/still life (story)

55

DESIGN
CONSTRAINTS

PHOTOGRAPHY
JASON PIETRA

ILLUSTRATIONS
BRYAN CHRISTIE DESIGN

Design Under Constraint

10.875 INCHES

16 INCHES

YOU'RE LOOKING AT A BOX...

... A 16- by 10.875-inch rectangle containing precisely 174 square inches of possibility, made from two sheets of paper glued and bound together. Legendary magazine art director and Pentagram partner D. J. Stout calls the science of filling this box with artful compositions of type and images "variations on a rectangle." That is, in any given issue of a magazine—this one, for example—subjects and stories will change, but as a designer, you're still dealing with the same ol' blank white box. At wired, our design team sees this constraint as our daily bread. On every editorial page, we use words and pictures to overcome the particular restric-

tions of paper and ink: We can't animate the infographics (yet). We can't embed video or voice-over (yet). We can't add sound effects or music (yet). But for all that we can't do in this static medium, we find enlightenment and wonder in its possibilities. This is a belief most designers share. In fact, the worst thing a designer can hear is an offhand "Just do whatever you want." That's because designers understand the power of limits. Constraint offers an unparalleled opportunity for growth and innovation. Think of a young tree, a sapling. With water and sunshine, it can grow tall and strong. But include some careful pruning early in its development—removing

low-hanging branches—and the tree will grow taller, stronger, faster. It won't waste precious resources on growth that doesn't serve its ultimate purpose. The same principle applies to design. Given fewer resources, you have to make better decisions. For proof, just consider these cultural and technological high points of the last century: Piet Mondrian helped usher in modernism by limiting himself to 90-degree angles and primary colors. Miles Davis conceived *Kind of Blue* without the use of a single chord. More recently, the very iPhone on which you listen to Davis' landmark album is a one-buttoned example of restraint in pursuit of an ideal, while the sublimely

simple Google homepage is forever limited to 28 words. The idea of operating within constraints—of making more with less—is especially relevant these days. From Wall Street to Detroit to Washington, the lack of limits has proven to be a false freedom. With all the economic gloom, you might not be blamed for feeling that the boundless American frontier seems a little less expansive. But we believe that this is our hour of opportunity. In the following pages, we explore a few of our favorite constraints. In each case, the imposition of limits doesn't stifle creativity—it enables it. —SCOTT DADICH, *Creative Director,* WIRED

32

YEAR
1998

WEIGHT
4.1 OUNCES

TALK TIME
2 HOURS 50 MINUTES

PLASTIC SAVED
2.1 GRAMS PER BOTTLE

BOTTLED WATER SALES IN 06
8.3 BILLION GALLONS (2007)

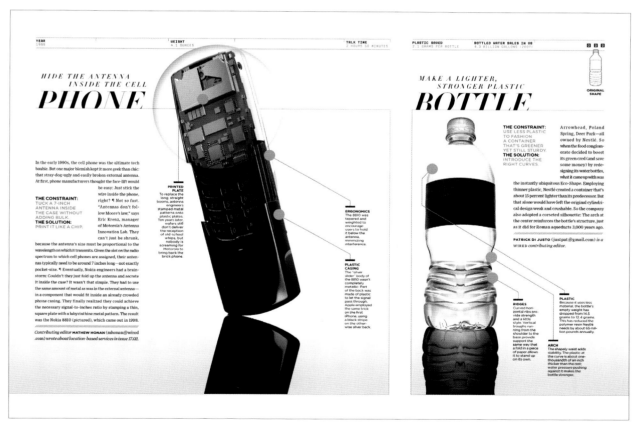

HIDE THE ANTENNA
INSIDE THE CELL
PHONE

In the early 1990s, the cell phone was the ultimate tech baubie. But one major blemish kept it more geek than chic: that stray-dog-ugly and easily broken external antenna. At first, phone manufacturers thought the face-lift would be easy: Just stick the wire inside the phone, right? Not so fast. "Antennas don't follow Moore's law," says Eric Krenz, manager of Motorola's Antenna Innovation Lab. They can't just be shrunk,

THE CONSTRAINT:
TUCK A 7-INCH ANTENNA INSIDE THE CASE WITHOUT ADDING BULK.
THE SOLUTION:
PRINT IT LIKE A CHIP.

because the antenna's size must be proportional to the wavelength on which it transmits. Given the slot on the radio spectrum to which cell phones are assigned, their antennas typically need to be around 7 inches long—not exactly pocket-size. Eventually, Nokia engineers had a brainstorm: Couldn't they just fold up the antenna and secrete it inside the case? It wasn't that simple. They had to use the same amount of metal as was in the external antenna—in a component that would fit inside an already crowded phone casing. They finally realized they could achieve the necessary signal-to-inches ratio by stamping a thin, square plate with a labyrinthine metal pattern. The result was the Nokia 8810 (pictured), which came out in 1998.

Contributing editor MATHEW HONAN (mhonan@wired .com) wrote about location-based services in issue 17.02.

PRINTED PLATE
To replace the long, straight booms, antenna engineers stamped metal patterns onto plastic plates. Ten years later, wafers still don't deliver the reception of old-school whips, but nobody is screaming for Motorola to bring back the brick phone.

ERGONOMICS
The 8810 was tapered and weighted to encourage users to hold it below the antenna, minimizing interference.

PLASTIC CASING
The "silver slider" body of the 8810 wasn't completely metallic. Part of the back was made of plastic to let the signal pass through. Apple employed the same trick on the first iPhone, using a black stripe on the otherwise silver back.

ORIGINAL SHAPE

MAKE A LIGHTER,
STRONGER PLASTIC
BOTTLE

THE CONSTRAINT:
USE LESS PLASTIC TO FASHION A CONTAINER THAT'S GREENER YET STILL STURDY.
THE SOLUTION:
INTRODUCE THE RIGHT CURVES.

Arrowhead, Poland Spring, Deer Park—all owned by Nestlé. So when the food conglomerate decided to boost its green cred (and save some money) by redesigning its water bottles, what it came up with was the instantly ubiquitous Eco-Shape. Employing thinner plastic, Nestlé created a container that's about 15 percent lighter than its predecessor. But that alone would have left the original cylindrical design weak and crushable. So the company also adopted a corseted silhouette: The arch at the center reinforces the bottle's structure, just as it did for Roman aqueducts 3,000 years ago.

PATRICK DI JUSTO (justpat@gmail.com) is a WIRED contributing editor.

RIDGES
Curved horizontal ribs provide strength and a little style. Vertical troughs running from the shoulder to the base provide support the same way that a fold in a piece of paper allows it to stand up on its own.

ARCH
The shapely waist adds stability. The plastic at the curve is about one-thousandth of an inch thicker than the rest; water pressure pushing against it makes the bottle stronger.

PLASTIC
Because it uses less material, the bottle's empty weight has dropped from 14.5 grams to 12.4 grams. This has reduced the polymer resin Nestlé needs by about 65 million pounds annually.

32

32 **WIRED**

CREATIVE DIRECTOR: Scott Dadich. DESIGN DIRECTOR: Wyatt Mitchell. ART DIRECTOR: Maili Holiman. DESIGNERS: Maili Holiman, Christy Sheppard. ILLUSTRATOR: Bryan Christie Design. PHOTO EDITOR: Carolyn Rauch. PHOTOGRAPHER: Jason Pietra. EDITOR-IN-CHIEF: Chris Anderson. PUBLISHER: Condé Nast Publications, Inc. ISSUE: March 2009. CATEGORY: Design: Feature: Travel/Food/Still Life (story)

56

SECTION:
design

AWARD:
gold

CATEGORY:
travel/food/still life (story)
educational/institutional

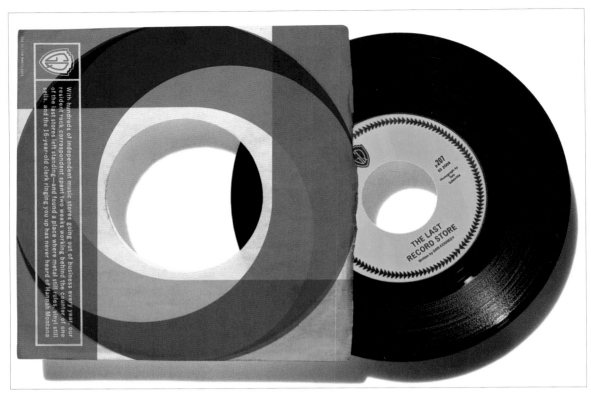

33

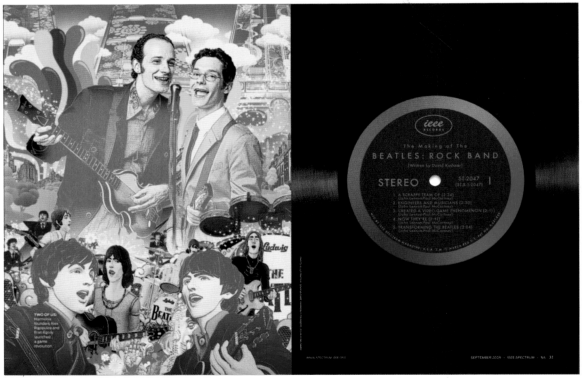

34

33 GQ

DESIGN DIRECTOR: Fred Woodward. DESIGNER: Drue Wagner.
DIRECTOR OF PHOTOGRAPHY: Dora Somosi.
PHOTO EDITORS: Krista Prestek, Jolanta Bielat.
PHOTOGRAPHER: Tom Schierlitz.
PUBLISHER: Condé Nast Publications Inc. ISSUE: March 2009.
CATEGORY: Design: Feature: Travel/Food/Still Life (single/spread)

34 IEEE Spectrum

ART DIRECTORS: Mark Montgomery, Michael Solita.
DESIGNER: Michael Solita. ILLUSTRATOR: Sean McCabe.
PHOTO EDITOR: Randi Silberman.
PHOTOGRAPHER: Joshua Dalsimer. EDITOR-IN-CHIEF: Susan Hassler
PUBLISHER: IEEE. ISSUE: September 2009.
CATEGORY: Design: Cover, Entire Issue, Single/Spread or Story

SECTION:
design

AWARD:
gold

CATEGORY:
redesign

35 **Worth**

CREATIVE DIRECTOR: Yolanda Yoh. DESIGN DIRECTOR: Dean Sebring. DESIGNERS: Valerie Sebring, Alvaro Diaz-Rubio, Timonthy Wooten, Michael Dudnick. ILLUSTRATORS: Brian Stauffer, Doug Boehm, Kevin Sprouls. PHOTO EDITORS: Olivia Lambert, Amanda Silversmith. PHOTOGRAPHERS: Jonathan Beckerman, Amani Willet. EDITOR-IN-CHIEF: Richard Bradley. PUBLISHER: Sandow Media. ISSUE: October/November 2009. CATEGORY: Redesign

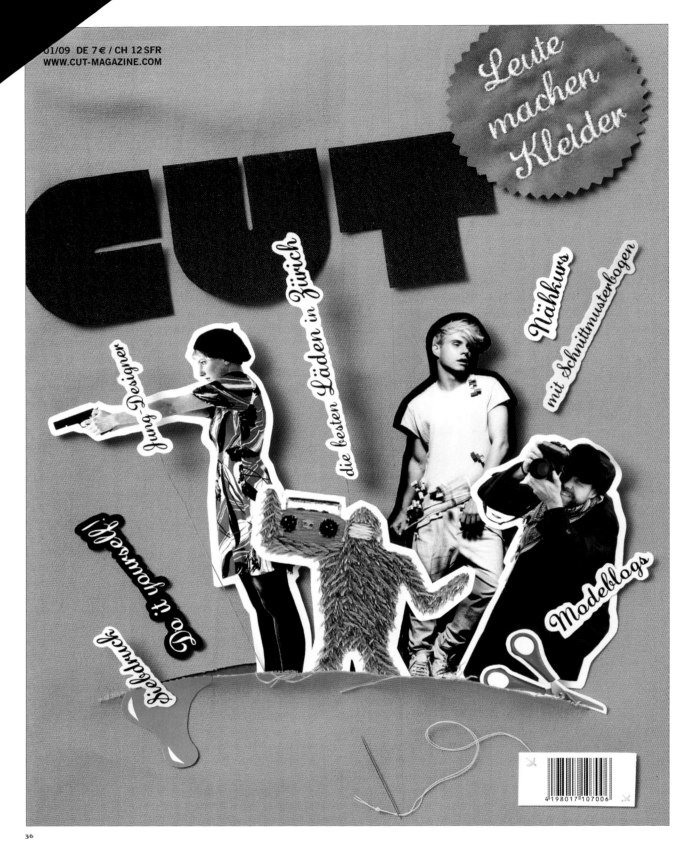

36

36 **CUT - Leute machen Kleider**

ART DIRECTOR: Lucie Schmid. DESIGNERS: Lucie Schmid, Marta Olesniewicz. ILLUSTRATORS: Franziska Misselwitz, Harold Lazaro. PHOTO EDITOR: Anja Kellner.
PHOTOGRAPHERS: Gabriela Neeb, Stefan Milev, Dennis Pernath, Nico Schaerer, Matti Hillig, Hans Döring. STUDIO: Independent Medien-Design.
EDITOR-IN-CHIEF: Anja Kellner. PUBLISHER: moser verlag GmbH. ISSUE: March 4, 2009 ISSUE: 1. CATEGORY: Design: Entire Issue

SECTION:
design

AWARD:
silver

CATEGORY:
**cover
section (single month)**

59

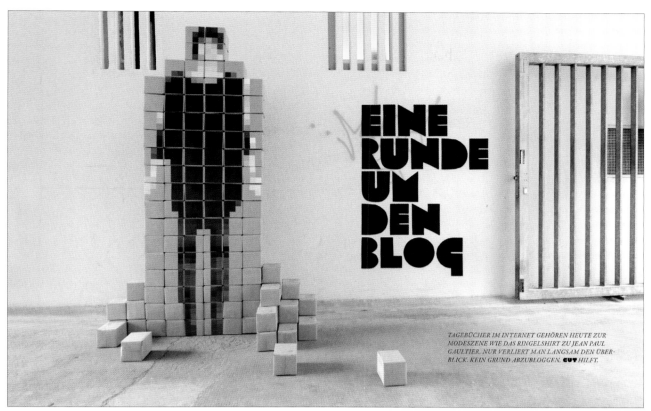

36

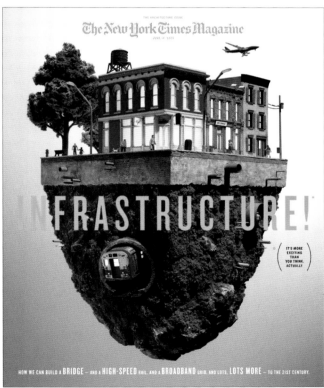

37

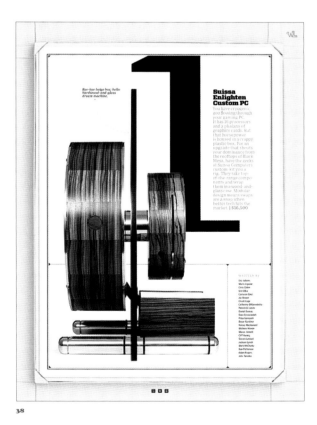

38

37 *The New York Times Magazine*

DESIGN DIRECTOR: Arem Duplessis.
DEPUTY ART DIRECTOR: Gail Bichler.
DESIGNER: Leo Jung. ILLUSTRATOR: Thomas Doyle.
DIRECTOR OF PHOTOGRAPHY: Kathy Ryan.
PHOTO EDITOR: Luise Stauss. PHOTOGRAPHER: Tom Schierlitz.
PUBLISHER: The New York Times Company.
ISSUE: June 14, 2009. CATEGORY: Design: Cover

38 **WIRED**

CREATIVE DIRECTOR: Scott Dadich. DESIGN DIRECTOR: Wyatt Mitchell.
ART DIRECTOR: Margaret Swart. ILLUSTRATORS: EightHourDay,
Origami, Robert Lang. SENIOR PHOTO EDITOR: Zana Woods.
ASSOCIATE PHOTO EDITOR: Sarah Fillipi.
PHOTOGRAPHER: Zachary Zavislak. EDITOR-IN-CHIEF: Chris Anderson.
PUBLISHER: Condé Nast Publications, Inc. ISSUE: December 2009.
CATEGORY: Design: Section (single month)

60

SECTION:
design

AWARD:
silver

CATEGORY:
section (single month)

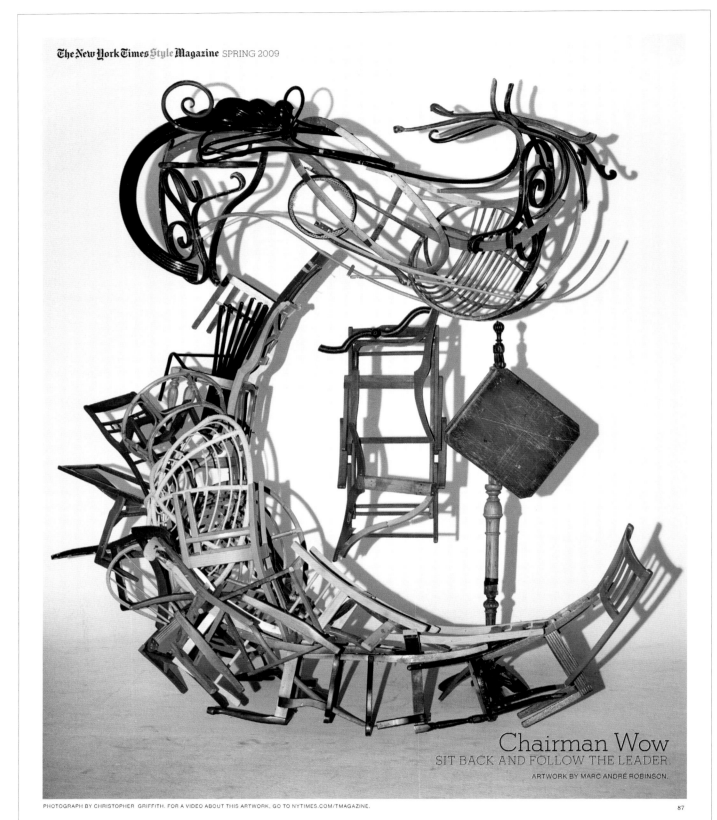

The New York Times Style Magazine SPRING 2009

Chairman Wow
SIT BACK AND FOLLOW THE LEADER.
ARTWORK BY MARC ANDRÉ ROBINSON.

PHOTOGRAPH BY CHRISTOPHER GRIFFITH. FOR A VIDEO ABOUT THIS ARTWORK, GO TO NYTIMES.COM/TMAGAZINE.

87

39

39 *T, The New York Times Style Magazine*

CREATIVE DIRECTOR: David Sebbah. SENIOR ART DIRECTOR: Christopher Martinez.
DESIGNER: Natalie Do. ILLUSTRATOR: Marc André Robinson.
SENIOR PHOTO EDITOR: Judith Puckett-Rinella. PHOTO EDITOR: Scott Hall.
PHOTOGRAPHER: Christopher Griffith. PUBLISHER: The New York Times Company.
ISSUE: March 8, 2009. CATEGORY: Design: Section (single month)

SECTION:
design

AWARD:
silver

CATEGORY:
**section (series of months)
service**

61

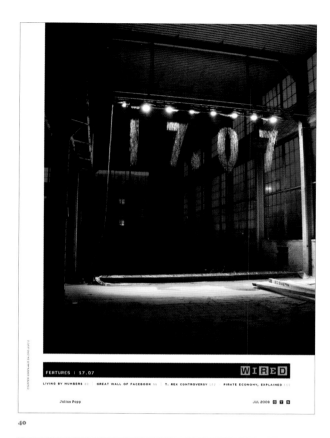

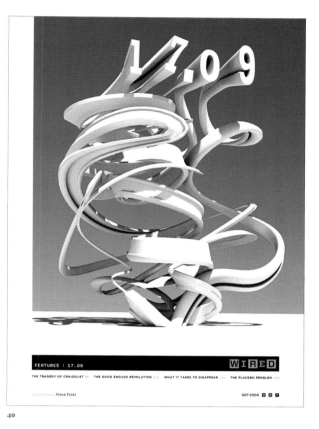

40

40

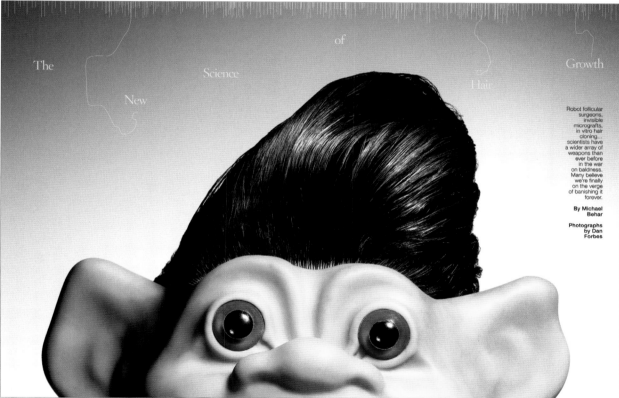

41

40 WIRED

CREATIVE DIRECTOR: Scott Dadich. DESIGN DIRECTOR: Wyatt Mitchell.
ART DIRECTORS: Carl DeTorres, Maili Holiman. ASSOCIATE ART DIRECTORS:
Christy Sheppard, Margaret Swart. DESIGNERS: Walter C. Baumann, Victor
Krumennacher. ILLUSTRATOR: Vince Frost. SENIOR PHOTO EDITOR:
Zana Woods. PHOTO EDITOR: Carolyn Rauch. DEPUTY PHOTO EDITOR:
Anna Goldwater Alexander. PHOTOGRAPHER: Julius Popp. ASSOCIATE PHOTO
EDITOR: Sarah Fillipi. EDITOR-IN-CHIEF: Chris Anderson. PUBLISHER:
Condé Nast Publications, Inc. CATEGORY: Design: Section (series of months)

41 Best Life

DESIGN DIRECTOR: Brandon Kavulla. DESIGNERS: Brandon Kavulla,
Heather Jones. DIRECTOR OF PHOTOGRAPHY: Ryan Cadiz.
PHOTO EDITOR: Jeanne Graves. PHOTOGRAPHER: Dan Forbes.
PUBLISHER: Rodale Inc. ISSUE: March 2009.
CATEGORY: Design: Feature: Service (single/spread)

62

SECTION:
design

AWARD:
silver

CATEGORY:
service (story)

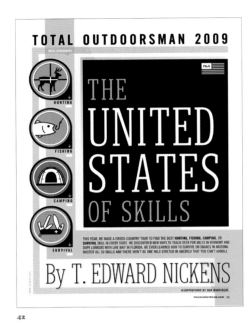

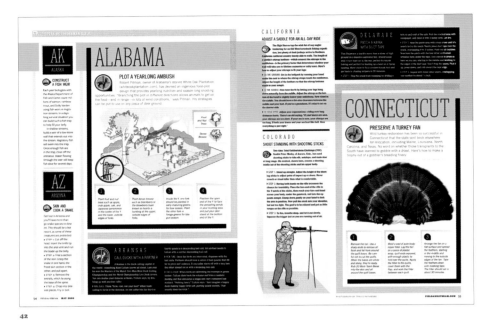

42

42

42

ART DIRECTOR: Neil Jamieson. ILLUSTRATORS: Dan Marsiglio, Alan Kikuchi. DIRECTOR OF PHOTOGRAPHY: Amy Berkley. PHOTOGRAPHERS: Travis Rathbone, Dan Saelinger, Cliff Gardiner, John Keller. PUBLISHER: Bonnier Corporation. ISSUE: May 2009. CATEGORY: Design: Feature: Service (story)

SECTION:
design

AWARD:
silver

CATEGORY:
celebrity/entertainment profile (story)

63

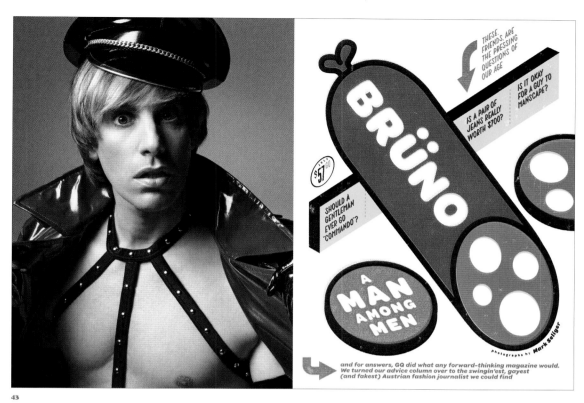

43 **GQ**

DESIGN DIRECTOR: Fred Woodward. DESIGNER: Anton Ioukhnovets. DIRECTOR OF PHOTOGRAPHY: Dora Somosi. PHOTO EDITOR: Krista Prestek.
PHOTOGRAPHER: Mark Seliger. PUBLISHER: Condé Nast Publications Inc. ISSUE: July 2009. CATEGORY: Design: Feature: Celebrity/Entertainment Profile (story)

64 SECTION:
design

AWARD:
silver

CATEGORY:
celebrity/entertainment profile

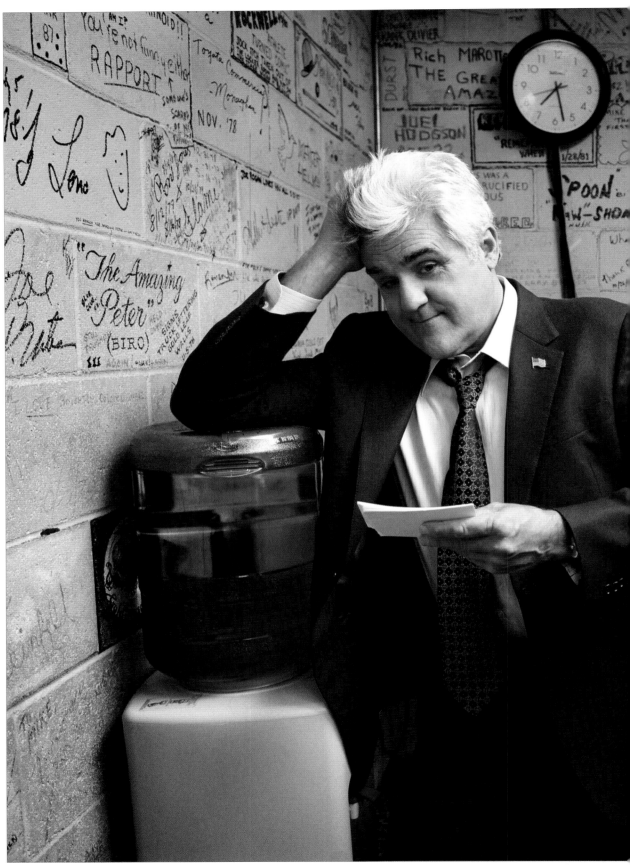

44

DESIGN DIRECTOR: Fred Woodward. DESIGNER: Chelsea Cardinal. DIRECTOR OF PHOTOGRAPHY: Dora Somosi. PHOTO EDITOR: Krista Prestek.
PHOTOGRAPHER: Mark Seliger. PUBLISHER: Condé Nast Publications Inc. ISSUE: May 2009. CATEGORY: Design: Feature: Celebrity/Entertainment Profile (single/spread)

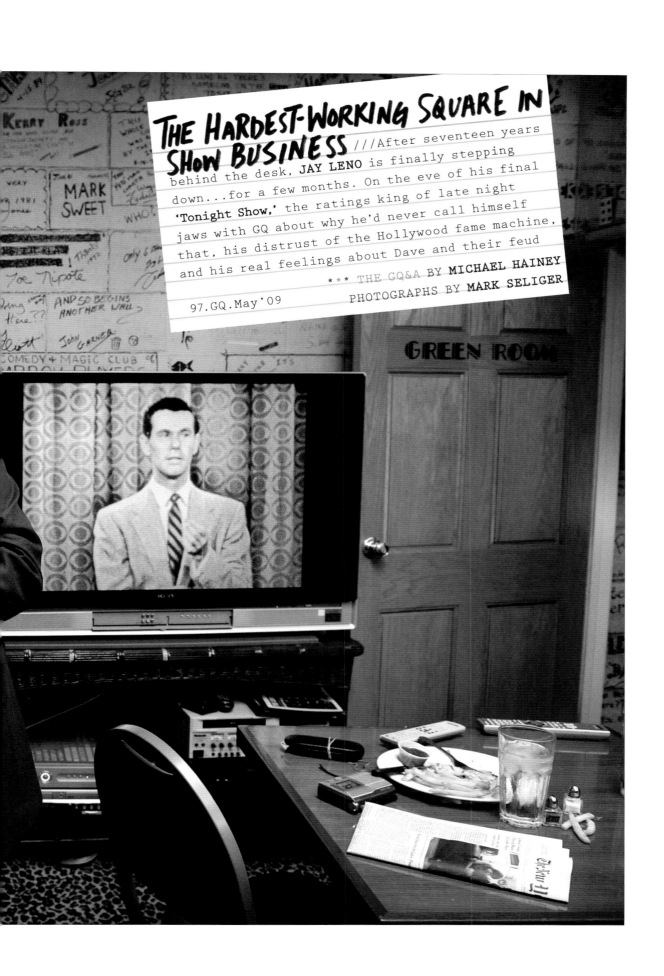

THE HARDEST-WORKING SQUARE IN SHOW BUSINESS

///After seventeen years behind the desk, **JAY LENO** is finally stepping down...for a few months. On the eve of his final 'Tonight Show,' the ratings king of late night jaws with GQ about why he'd never call himself that, his distrust of the Hollywood fame machine, and his real feelings about Dave and their feud

* * * THE GQ&A BY **MICHAEL HAINEY**

PHOTOGRAPHS BY **MARK SELIGER**

97.GQ.May'09

66

SECTION:
design

AWARD:
silver

CATEGORY:
non-celebrity profile (story)
non-celebrity profile

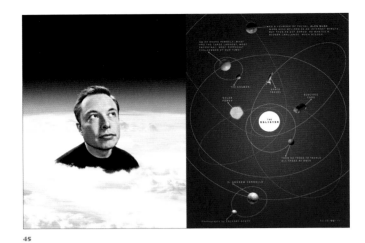

45

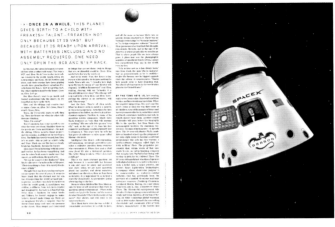

45

46

DESIGN DIRECTOR: Fred Woodward. DESIGNERS: Thomas Alberty,
Bryan Christie Design. DIRECTOR OF PHOTOGRAPHY: Dora Somosi.
PHOTO EDITOR: Emily Blank. PHOTOGRAPHER: Zachary Scott.
PUBLISHER: Condé Nast Publications Inc. ISSUE: February 2009.
CATEGORY: Design: Feature: Non-Celebrity Profile (story)

DESIGN DIRECTOR: Edward Leida. ART DIRECTOR: Nathalie Kirsheh.
DESIGNER: Nathalie Kirsheh. PHOTOGRAPHER: Marina Cicogna.
PUBLISHER: Condé Nast Publications Inc. ISSUE: April 2009.
CATEGORY: Design: Feature: Non-Celebrity Profile (single/spread)

SECTION:
design

AWARD:
silver

CATEGORY:
news/reportage
news/reportage (story)

67

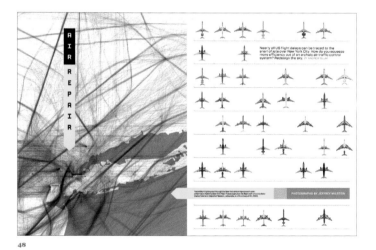

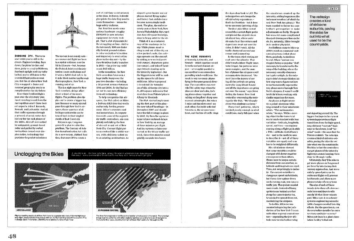

47 **The New York Times Magazine**

DESIGN DIRECTOR: Arem Duplessis. ART DIRECTOR: Gail Bichler.
DESIGNER: Gail Bichler. ILLUSTRATOR: Carin Goldberg.
PUBLISHER: The New York Times Company. ISSUE: September 13, 2009.
CATEGORY: Design: Feature: News/Reportage (single/spread)

48 **WIRED**

CREATIVE DIRECTOR: Scott Dadich. DESIGN DIRECTOR: Wyatt Mitchell.
ART DIRECTOR: Carl DeTorres. DESIGNERS: Carl DeTorres,
Walter C. Baumann. DEPUTY PHOTO EDITOR: Anna Goldwater Alexander.
PHOTOGRAPHER: Jeffrey Milstein. EDITOR-IN-CHIEF: Chris Anderson.
PUBLISHER: Condé Nast Publications, Inc. ISSUE: March 2009.
CATEGORY: Design: Feature: News/Reportage (story)

SECTION:
design

AWARD:
silver

CATEGORY:
travel/food/still life
travel/food/still life (story)

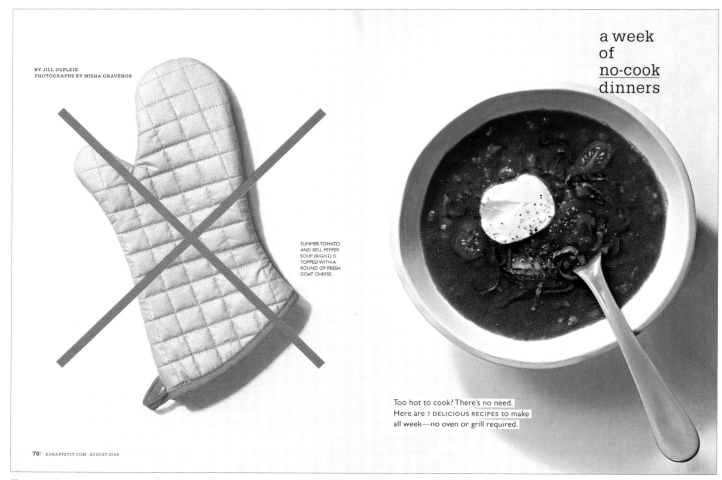

a week
of
no-cook
dinners

BY JILL DUPLEIX
PHOTOGRAPHS BY MISHA GRAVENOR

SUMMER TOMATO
AND BELL PEPPER
SOUP (RIGHT) IS
TOPPED WITH A
ROUND OF FRESH
GOAT CHEESE.

Too hot to cook? There's no need.
Here are 7 DELICIOUS RECIPES to make
all week—no oven or grill required.

78/ BONAPPETIT.COM: AUGUST 2009

49

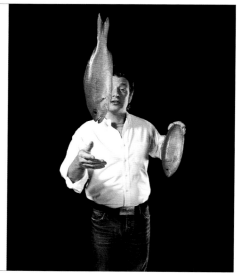

50

50

49 Bon Appétit

DESIGN DIRECTOR: Matthew Lenning.
ART DIRECTORS: Robert Festino, Tom O'Quinn. DESIGNER: John Muñoz.
DIRECTOR OF PHOTOGRAPHY: Bailey Franklin.
PHOTO EDITOR: Angelica Mistro. PHOTOGRAPHER: Misha Gravenor.
EDITOR-IN-CHIEF: Barbara Fairchild.
PUBLISHER: Condé Nast Publications, Inc. ISSUE: August 2009.
CATEGORY: Design: Feature: Travel/Food/Still Life (single/spread)

50 The New York Times Magazine

DESIGN DIRECTOR: Arem Duplessis. ART DIRECTOR: Gail Bichler.
DEPUTY ART DIRECTOR: Leo Jung. DESIGNERS: Leo Jung, Hilary
Greenbaum, Aviva Michaelov, Robert Vargas, Leslie Kwok. ILLUSTRATORS:
Will Cotton, Jacob Magraw-Mickelson, Roger Kent, Sarah Illenberger.
DIRECTOR OF PHOTOGRAPHY: Kathy Ryan. PHOTOGRAPHERS:
Olaf Blecker, Reinhard Hunger, Mitchell Feinberg, Mark Peterson, Dru
Donovan. PUBLISHER: The New York Times Company. ISSUE: October 11,
2009. CATEGORY: Design: Feature: Travel/Food/Still Life (story)

SECTION:
design

AWARD:
silver

CATEGORY:
fashion/beauty (story)

69

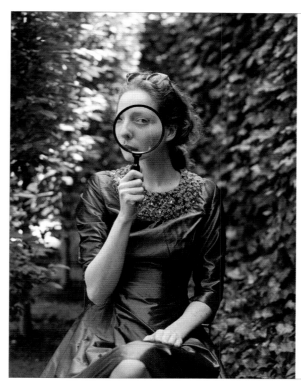

9

BEAUTY *Myths*

Apply *sunscreen* 30 minutes before going out in the sun. To *DEEP CLEAN* pores, you should see an aesthetician. For *glowing skin*, you must use a face mask once a week. Wrong, *WRONG* and wrong, says ELLEN MARMUR, MD, chief of the dermatology and cosmetic surgery division at Mount Sinai Medical Center in New York. In this adaptation from her new book, *Simple Skin Beauty*, Marmur clears up some common *complexion* misconceptions

PHOTOGRAPHED BY *Rodney Smith*

OCTOBER 2009 | more.com **131**

51

For radiant skin, an AT-HOME MASK must be part of your regimen

Only a SPA FACIAL will deep clean your pores
I hate to be a spoilsport, but deep cleaning is a myth, and facials are completely unnecessary, although they are wonderfully luxurious. If they're enjoyable and make you feel better about how you look, they could be worth the time and money, but they are not directly medicinal. As for extractions, they are tricky and superfluous and can even be unsafe. Although extractions seem to miraculously (but sometimes painfully) take away the gunk in your pores, it's basically a manual form of exfoliation (removing the keratin plugs from your pores). Plus, putting so much pressure on the pore can push oil and benign bacteria so far down into the skin that they burst out the bottom into your skin tissue. This rupture can cause inflammation and may ultimately leave a scar or a cyst, especially if your skin is dark.

Wearing FOUNDATION WITH SUNSCREEN will protect you from UV rays
Applying makeup that contains SPF is better than no protection at all, but it's not as effective as wearing a facial lotion with sunscreen. Why? Most of us desire a natural, less-is-more look with our makeup, but less is not more when it comes to sun protection. Unless your makeup is spackled on, you're not getting enough protection from it. It's better to think of SPF makeup as something you apply over your daily sunscreen or moisturizer to boost UV protection. Likewise, using a mineral powder foundation, which usually contains the sun block titanium dioxide, isn't enough on its own, but it's a brilliant way to reapply sunscreen during the day and touch up your makeup at the same time.

No. **3**

Masks feel rejuvenating, and I relish the thought of putting one on and relaxing in front of the TV. Of course, the odds of that happening (with four kids, a crazy schedule and a husband who would laugh himself silly at seeing me covered in blue or green gook) are slim to none. But so are the chances that a mask—whether it's one that moisturizes or a clay mask intended to soak up oil—can do something really transformative or long-lasting to my skin. Can a mask super-moisturize your face and seal in the hydration? Yes, but only until the mask is rinsed off. The truth is, a mask is like lip balm for your face: an occlusive film over the surface that provides a nice, temporary fix.

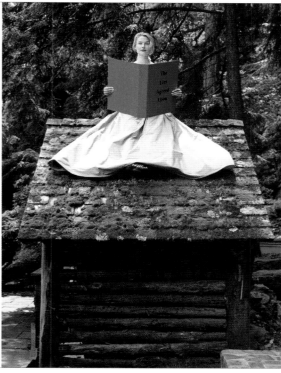

Natural or ORGANIC INGREDIENTS are safer for your skin
Organic face products can produce the same results as their synthetic counterparts, which means they also have the potential to be irritating. Most people don't realize that natural ingredients are still chemicals. For example, the medical term for vitamin C is ascorbic acid, so when you see "vitamin C" on a label, be aware that it's technically a chemical. Also, certain ingredients—botanicals and pure essential oils, such as tea tree oil, menthol and especially citrus (natural citric acid)—can trigger an allergic reaction or irritation. Fungi extract contains kojic acid (a natural skin-lightener), and papaya and pineapple enzymes exfoliate the skin because they are alpha-hydroxy acids. These acids, elements can be even stronger in their natural forms, so it's important to test any product—even a natural one—on the inside of your arm before using it on your face. »

132 more.com | OCTOBER 2009

51

51 *More*

CREATIVE DIRECTOR: Debra Bishop. DESIGNER: Jenn McManus.
DIRECTOR OF PHOTOGRAPHY: Stacey Baker. PHOTO EDITOR: Daisy Cajas.
PHOTOGRAPHER: Rodney Smith. EDITOR-IN-CHIEF: Lesley Jane Seymour.
PUBLISHER: Meredith Corporation. ISSUE: October 2009.
CATEGORY: Design: Feature: Fashion/Beauty (story)

70 SECTION:
design

AWARD:
silver

CATEGORY:
fashion/beauty

52 Cookie

HEAD
●

OF
●

THE

!
●

CLASS

Three signs that fall is really here: a chill in the air, the chime of
the school bell, and a bounty crop of cool haircuts and exciting styles designed to make
all lengths, textures, and personalities shine.

WRITTEN BY **MARTA TOPRAN** PHOTOGRAPHY BY **PLATON**

128 | COOKIE *september 09* | COOKIEMAG.COM

52

52 **Cookie**

DESIGN DIRECTOR: Kirby Rodriguez. ART DIRECTOR: Kristina DiMatteo. DESIGNERS: Nicolette Berthelot, Shanna Greenberg.
DIRECTOR OF PHOTOGRAPHY: Darrick Harris. PHOTO EDITOR: Linda Denahan. PHOTOGRAPHER: Platon. PUBLISHER: Condé Nast Publications Inc.
ISSUE: September 2009. CATEGORY: Design: Feature: Fashion/Beauty (single/spread)

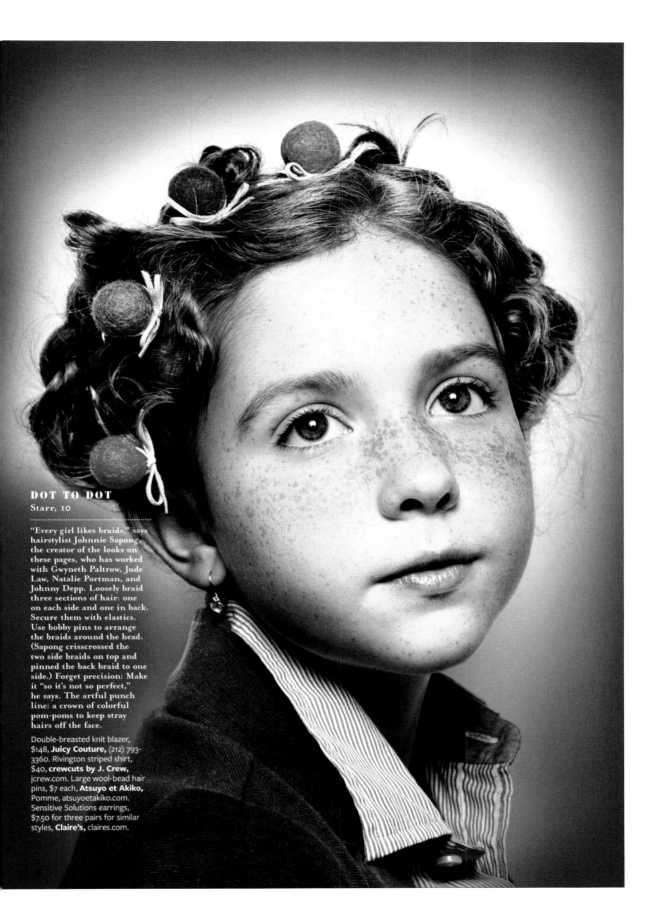

DOT TO DOT
Starr, 10

"Every girl likes braids," says hairstylist Johnnie Sapong, the creator of the looks on these pages, who has worked with Gwyneth Paltrow, Jude Law, Natalie Portman, and Johnny Depp. Loosely braid three sections of hair: one on each side and one in back. Secure them with elastics. Use bobby pins to arrange the braids around the head. (Sapong crisscrossed the two side braids on top and pinned the back braid to one side.) Forget precision: Make it "so it's not so perfect," he says. The artful punch line: a crown of colorful pom-poms to keep stray hairs off the face.

Double-breasted knit blazer, $148, **Juicy Couture,** (212) 793-3360. Rivington striped shirt, $40, **crewcuts by J. Crew,** jcrew.com. Large wool-bead hair pins, $7 each, **Atsuyo et Akiko,** Pomme, atsuyoetakiko.com. Sensitive Solutions earrings, $7.50 for three pairs for similar styles, **Claire's,** claires.com.

72

SECTION:
design

AWARD:
silver

CATEGORY:
**trade/corporate
educational/institutional**

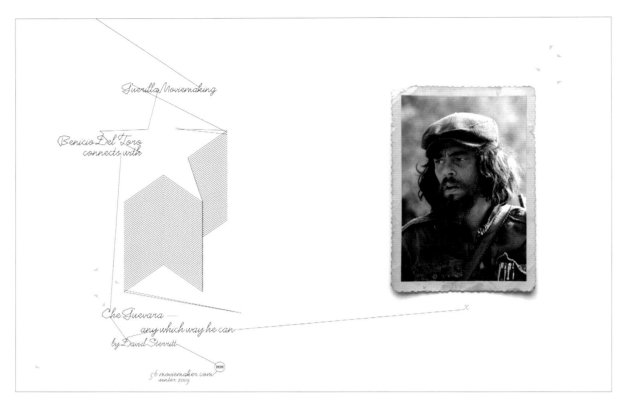

53

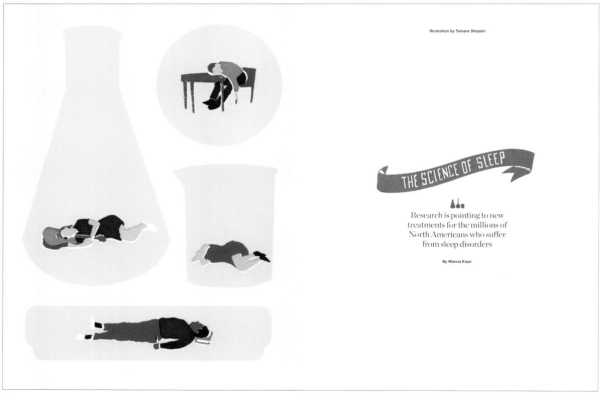

54

53 *Moviemaker*

ART DIRECTOR: Rob Hewitt. DESIGNER: Rob Hewitt.
STUDIO: Curious Outsider. EDITOR-IN-CHIEF: Timothy E. Rhys.
PUBLISHER: Moviemaker LLC. CLIENT: Moviemaker. ISSUE: Winter 2009.
CATEGORY: Design: Cover, Entire Issue, Single/Spread or Story

54 *U of T Magazine*

CREATIVE DIRECTORS: Claire Dawson, Fidel Peña.
DESIGNER: Clarie Dawson. ILLUSTRATOR: Tamara Shopsin.
STUDIO: Underline Studio. PUBLISHER: University of Toronto.
CLIENT: University of Toronto. ISSUE: Spring 2009.
CATEGORY: Design: Cover, Entire Issue, Single/Spread or Story

SECTION:
design

AWARD:
silver

CATEGORY:
redesign

73

55

55

55

55 **Maxim**

CREATIVE DIRECTOR: Dirk Barnett. ART DIRECTORS: Sean Johnston, Billy Sorrentino. DESIGNER: Chandra Illick.
DIRECTOR OF PHOTOGRAPHY: Toby Kaufman. PHOTO EDITORS: Marya Gullo, Antonella D'Agostino, Leslie Simmons.
EDITOR-IN-CHIEF: Joe Levy. PUBLISHER: Alpha Media Group. ISSUE: December 2009. CATEGORY: Redesign

74

SECTION:
design

AWARD:
merit

CATEGORY:
cover

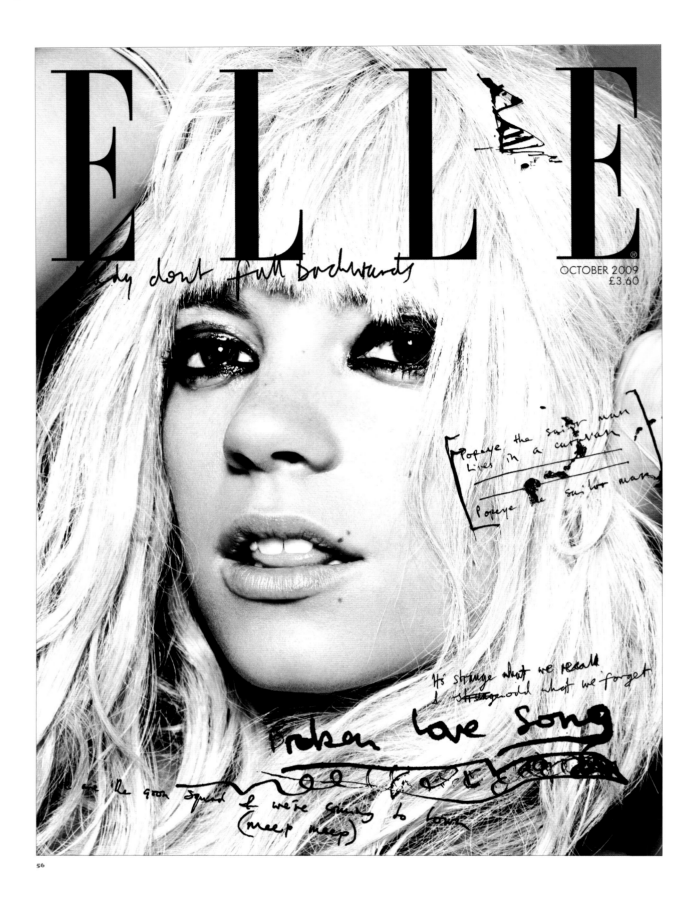

56

56 **Elle (UK)**

CREATIVE DIRECTOR: Marissa Bourke. ART DIRECTORS: Tom Meredith, Jo Goodby. DESIGNER: Elizabeth Villabona.
ILLUSTRATOR: Pete Doherty. DIRECTOR OF PHOTOGRAPHY: Rankin. PHOTOGRAPHER: Rankin.
PUBLISHER: Hachette Filipacchi Magazines, Inc. ISSUE: October 2009. CATEGORY: Design: Cover.

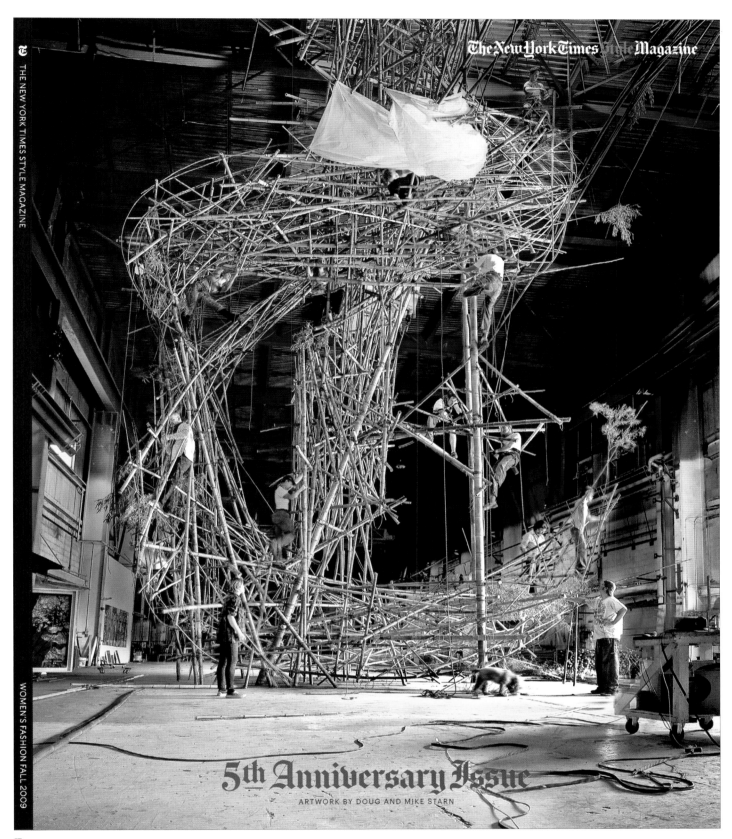

THE NEW YORK TIMES STYLE MAGAZINE

WOMEN'S FASHION FALL 2009

5th Anniversary Issue
ARTWORK BY DOUG AND MIKE STARN

57

57 *T, The New York Times Style Magazine*

CREATIVE DIRECTOR: David Sebbah. SENIOR ART DIRECTOR: Christopher Martinez. DESIGNER: Natalie Do. ILLUSTRATOR: Doug and Mark Starn.
SENIOR PHOTO EDITOR: Judith Puckett-Rinella. PHOTO EDITOR: Scott Hall. PHOTOGRAPHER: Doug and Mark Starn. PUBLISHER: The New York Times Company.
ISSUE: August 16, 2009. CATEGORY: Design: Cover

76

SECTION:
design

AWARD:
merit

CATEGORY:
cover

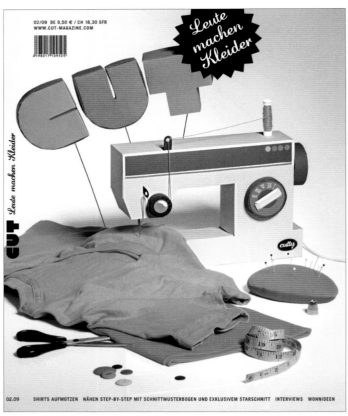

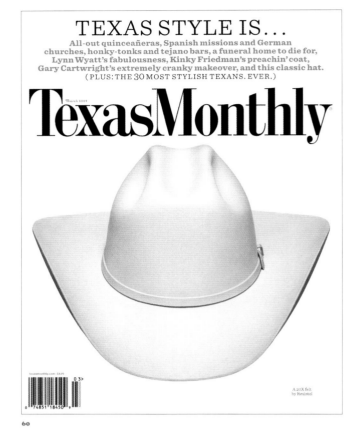

58

60

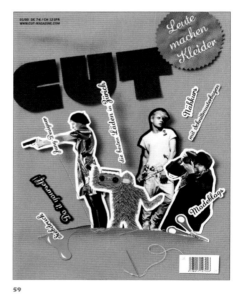

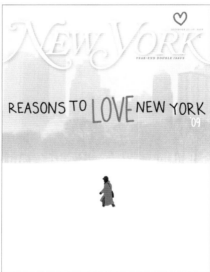

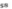

59

61

62

58 *CUT - Leute machen Kleider*

ART DIRECTOR: Lucie Schmid. DESIGNER: Lucie Schmid. DIRECTOR
OF PHOTOGRAPHY: Lucie Schmid. PHOTOGRAPHER: Denis Pernath.
STUDIO: Independent Medien Design. PUBLISHER: moser verlag GmbH.
ISSUE: September 18, 2009. ISSUE: 2. CATEGORY: Design: Cover

59 *CUT - Leute machen Kleider*

ART DIRECTOR: Lucie Schmid. DESIGNERS: Lucie Schmid, Marta Olesniewicz.
DIRECTOR OF PHOTOGRAPHY: Lucie Schmid. PHOTOGRAPHER: Hans
Döring. STUDIO: Independent Medien Design. EDITOR-IN-CHIEF: Anja Keller.
PUBLISHER: moser verlag GmbH. CLIENT: moser verlag GmbH.
ISSUE: March 4, 2009. ISSUE: 1. CATEGORY: Design: Cover

60 *Texas Monthly*

CREATIVE DIRECTOR: T.J. Tucker. DESIGNER: T.J. Tucker. PHOTO
EDITOR: Leslie Baldwin. PHOTOGRAPHER: Adam Voorhes. PUBLISHER:
Emmis Publishing. ISSUE: March 2009. CATEGORY: Design: Cover.

61 *New York*

DESIGN DIRECTOR: Chris Dixon. ART DIRECTOR: Randy Minor.
DESIGNER: Chris Dixon. ILLUSTRATOR: Michael De Feo. DIRECTOR
OF PHOTOGRAPHY: Jody Quon. PHOTO EDITOR: Caroline Smith.
PHOTOGRAPHER: Mitchell Funk, Getty Images. EDITOR-IN-CHIEF:
Adam Moss. PUBLISHER: New York Magazine Holdings, LLC.
ISSUE: December 21-28, 2009. CATEGORY: Design: Cover

62 *WIRED*

CREATIVE DIRECTOR: Scott Dadich. DESIGN DIRECTOR: Wyatt Mitchell.
DESIGNER: Scott Dadich. ILLUSTRATORS: T.J. Tucker, House Industries,
Nishant Choksi. SENIOR PHOTO EDITOR: Zana Woods.
PHOTOGRAPHER: Dwight Eschliman. EDITOR-IN-CHIEF: Chris Anderson.
PUBLISHER: Condé Nast Publications, Inc. ISSUE: May 2009.
CATEGORY: Design: Cover

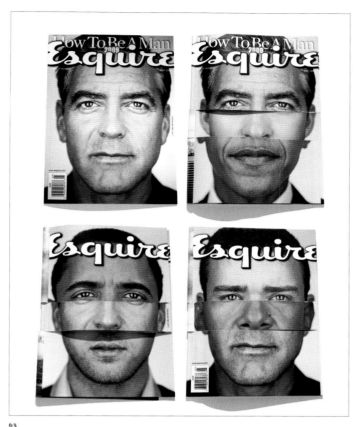

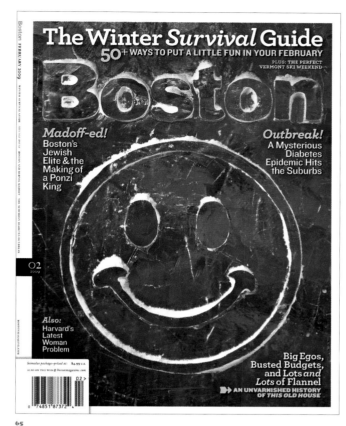

63

65

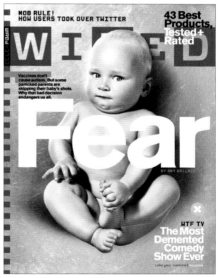

64

66

67

63 *Esquire*

DESIGN DIRECTOR: David Curcurito. ART DIRECTOR: Darhil Crooks.
ASSOCIATE ART DIRECTORS: Erin Jang, Soni Khatri. PHOTO DIRECTOR:
Michael Norseng. PHOTO EDITOR: Alison Unterreiner. PHOTO COORDINATOR:
Whitney Tressel. PHOTOGRAPHER: Martin Schoeller. PUBLISHER: The Hearst
Corporation-Magazines Division. ISSUE: May 2009. CATEGORY: Design: Cover

64 **WIRED**

CREATIVE DIRECTOR: Scott Dadich. DESIGN DIRECTOR: Wyatt Mitchell.
DESIGNER: Scott Dadich. SENIOR PHOTO EDITOR: Zana Woods. PHOTOGRAPHER:
Olaf Blecker. EDITOR-IN-CHIEF: Chris Anderson. PUBLISHER: Condé Nast
Publications, Inc. ISSUE: November 2009. CATEGORY: Design: Cover

65 *Boston Magazine*

CREATIVE DIRECTOR: Patrick Mitchell. ART DIRECTOR: Susannah Haesche.
DESIGNERS: Ashley Bond, Heather Burke, Betsy Halsey. PHOTOGRAPHER: Eric
Kulin. PUBLISHER: Metrocorp. ISSUE: February 2009. CATEGORY: Design: Cover

66 **WIRED**

CREATIVE DIRECTOR: Scott Dadich. DESIGN DIRECTOR: Wyatt Mitchell.
DESIGNER: Scott Dadich. EDITOR-IN-CHIEF: Chris Anderson.
PUBLISHER: Condé Nast Publications, Inc. ISSUE: March 2009.
CATEGORY: Design: Cover

67 **WIRED Italy**

ART DIRECTOR: David Moretti. DESIGNER: David Moretti.
PHOTO EDITOR: Francesca Morosini. PHOTOGRAPHER: Dan Winters.
EDITOR-IN-CHIEF: Riccardo Luna. PUBLISHER: Condé Nast Italia.
ISSUE: December 2009. CATEGORY: Design: Cover

78

SECTION:
design

AWARD:
merit

CATEGORY:
cover

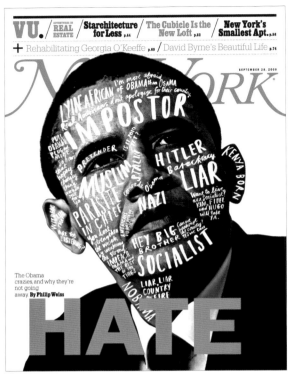

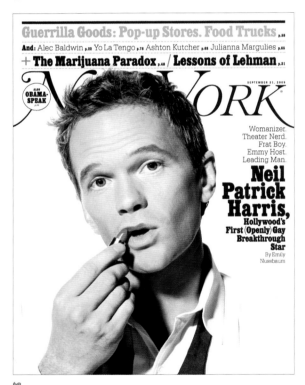

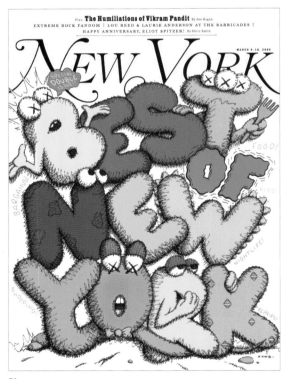

68 ***New York***

DESIGN DIRECTOR: Chris Dixon. ART DIRECTOR: Randy Minor.
DESIGNER: Chris Dixon. ILLUSTRATORS: Todd St. John, HunterGatherer.
DIRECTOR OF PHOTOGRAPHY: Jody Quon. EDITOR-IN-CHIEF:
Adam Moss. PUBLISHER: New York Magazine Holdings, LLC.
ISSUE: December 14, 2009. CATEGORY: Design: Cover

69 ***New York***

DESIGN DIRECTOR: Chris Dixon. ART DIRECTOR: Randy Minor.
DESIGNER: Chris Dixon. DIRECTOR OF PHOTOGRAPHY: Jody Quon.
PHOTO EDITOR: Lea Golis. PHOTOGRAPHER: Art Streiber.
EDITOR-IN-CHIEF: Adam Moss. PUBLISHER: New York Magazine Holdings,
LLC. ISSUE: November 21, 2009. CATEGORY: Design: Cover

70 ***New York***

DESIGN DIRECTOR: Chris Dixon. ART DIRECTOR: Randy Minor.
DESIGNER: Chris Dixon. ILLUSTRATOR: Marion Deuchars.
DIRECTOR OF PHOTOGRAPHY: Jody Quon.
PHOTOGRAPHER: Mannie Garcia. EDITOR-IN-CHIEF: Adam Moss.
PUBLISHER: New York Magazine Holdings, LLC. ISSUE: November 28, 2009.
CATEGORY: Design: Cover

71 ***New York***

DESIGN DIRECTOR: Chris Dixon. ART DIRECTOR: Randy Minor.
ILLUSTRATOR: Kaws. DIRECTOR OF PHOTOGRAPHY: Jody Quon.
EDITOR-IN-CHIEF: Adam Moss. PUBLISHER: New York Magazine
Holdings, LLC. ISSUE: March 9-16, 2009. CATEGORY: Design: Cover

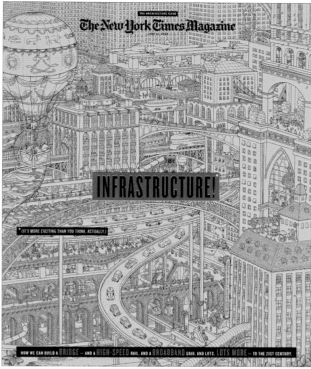

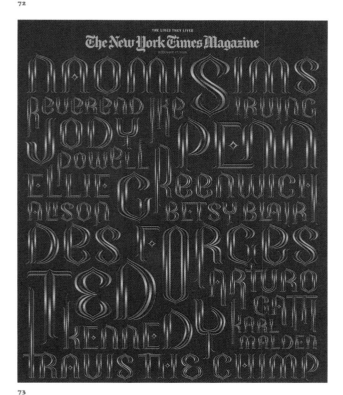

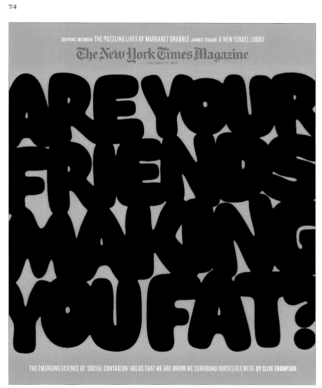

72 *The New York Times Magazine*

DESIGN DIRECTOR: Arem Duplessis. ART DIRECTOR: Gail Bichler.
DEPUTY ART DIRECTOR: Leo Jung. ILLUSTRATOR: IC4Design.
PUBLISHER: The New York Times Company. ISSUE: June 14, 2009.
CATEGORY: Design: Cover

73 *The New York Times Magazine*

DESIGN DIRECTOR: Arem Duplessis. ART DIRECTOR: Gail Bichler.
DESIGNER: Nancy Harris Rouemy. ILLUSTRATORS: Nancy Harris Rouemy,
Patrick Griffin. PUBLISHER: The New York Times Company.
ISSUE: December 27, 2009. CATEGORY: Design: Cover

74 *The New York Times Magazine*

DESIGN DIRECTOR: Arem Duplessis. DEPUTY ART DIRECTOR: Gail Bichler.
PUBLISHER: The New York Times Company. ISSUE: January 18, 2009.
CATEGORY: Design: Cover

75 *The New York Times Magazine*

DESIGN DIRECTOR: Arem Duplessis. ART DIRECTOR: Gail Bichler.
ILLUSTRATOR: Chester Jenkins. PUBLISHER: The New York Times Company.
ISSUE: September 13, 2009. CATEGORY: Design: Cover

80

SECTION:
design

AWARD:
merit

CATEGORY:
cover

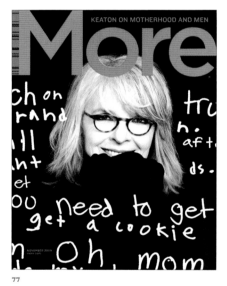

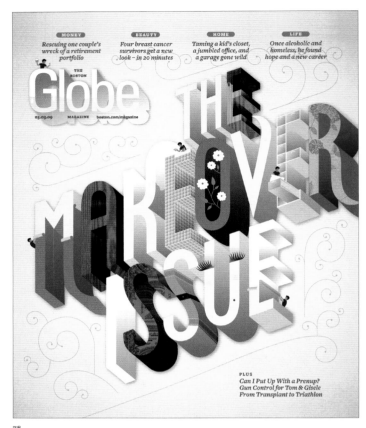

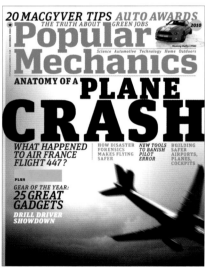

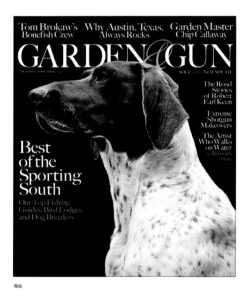

76

78

77

79

80

76 *Outside*

CREATIVE DIRECTOR: Hannah McCaughey. ART DIRECTORS:
John McCauley, Chris Philpot. PHOTO EDITORS: Amy Feitelberg,
Amy Silverman. PHOTOGRAPHER: Dan Winters. PUBLISHER:
Mariah Media, Inc. ISSUE: November 2009 CATEGORY: Design: Cover

77 *More*

CREATIVE DIRECTOR: Debra Bishop. ART DIRECTOR: Claudia de Almeida.
DESIGNER: Debra Bishop. DIRECTOR OF PHOTOGRAPHY: Stacey Baker.
PHOTO EDITOR: Daisy Cajas. PHOTOGRAPHER: Ruven Afanador.
EDITOR-IN-CHIEF: Lesley Jane Seymour. PUBLISHER: Meredith Corporation.
ISSUE: November 2009. CATEGORY: Design: Cover

78 *The Boston Globe Magazine*

DESIGN DIRECTOR: Chin Wang. ART DIRECTOR: Josue Evilla.
ILLUSTRATOR: Jessica Hische. PUBLISHER: The New York Times.
ISSUE: May 3, 2009. CATEGORY: Design: Cover

79 *Popular Mechanics*

DESIGN DIRECTOR: Michael Lawton. DESIGNER: Michael Lawton.
DIRECTOR OF PHOTOGRAPHY: Allyson Torrisi.
PHOTOGRAPHER: Doug Ball PUBLISHER: The Hearst Corporation-
Magazines Division. ISSUE: December 2009. CATEGORY: Design: Cover

80 *Garden & Gun*

ART DIRECTOR: Marshall McKinney. DESIGNER: Richie Swann.
DIRECTOR OF PHOTOGRAPHY: Maggie Brett Kennedy.
PHOTOGRAPHER: Andy Anderson. ISSUE: December 2009/January 2010.
CATEGORY: Design: Cover.

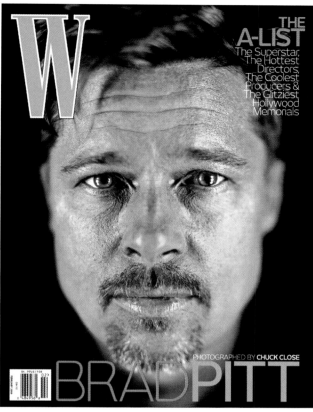

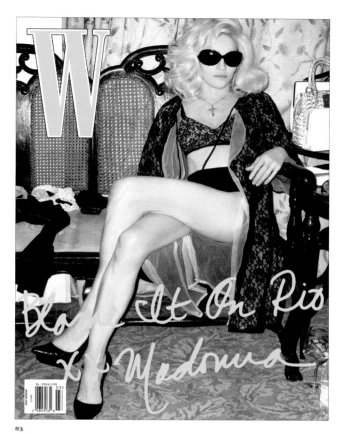

81

83

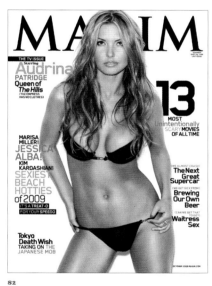

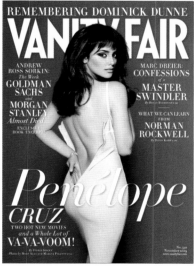

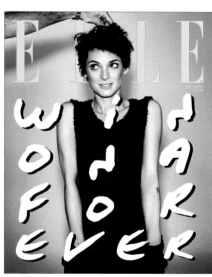

82

84

85

81 **W**

DESIGN DIRECTOR: Edward Leida. ART DIRECTOR: Nathalie Kirsheh.
DESIGNER: Nathalie Kirsheh. PHOTOGRAPHER: Chuck Close.
PUBLISHER: Condé Nast Publications Inc. ISSUE: February 2009.
CATEGORY: Design: Cover

82 *Maxim*

CREATIVE DIRECTOR: Dirk Barnett. DESIGNER: Dirk Barnett.
PHOTO EDITOR: Marya Gullo. PHOTOGRAPHER: Steve Shaw.
EDITOR-IN-CHIEF: Joe Levy. PUBLISHER: Alpha Media Group.
ISSUE: October 2009.CATEGORY: Design: Cover

83 **W**

DESIGN DIRECTOR: Edward Leida. ART DIRECTOR: Nathalie Kirsheh.
DESIGNER: Nathalie Kirsheh. PHOTOGRAPHER: Steven Klein.
PUBLISHER: Condé Nast Publications Inc. ISSUE: March 2009.
CATEGORY: Design: Cover

84 *Vanity Fair*

DESIGN DIRECTOR: David Harris. ART DIRECTOR: Julie Weiss.
DIRECTOR OF PHOTOGRAPHY: Susan White. PHOTOGRAPHERS:
Mert Alas, Marcus Piggott. PUBLISHER: Condé Nast Publications Inc.
ISSUE: November 2009. CATEGORY: Design: Cover

85 *Elle Magazine UK*

CREATIVE DIRECTOR: Marissa Bourke. ART DIRECTORS:
Tom Meredith, Jo Goodby. DESIGNER: Elizabeth Villabona.
DIRECTOR OF PHOTOGRAPHY: Matthias Vriens McGrath.
PHOTOGRAPHER: Matthias Vriens McGrath. PUBLISHER: Hachette
Filipacchi Magazines, Inc. ISSUE: July 2009. CATEGORY: Design: Cover

SECTION:
design

AWARD:
merit

CATEGORY:
cover

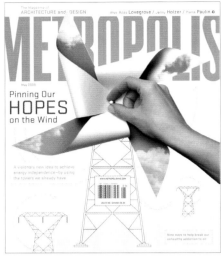

86

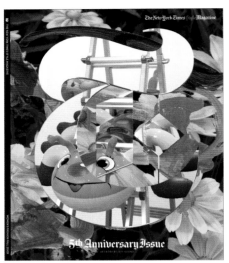

88

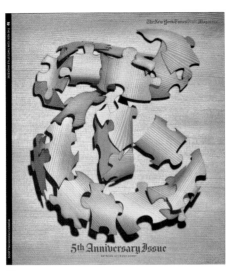

90

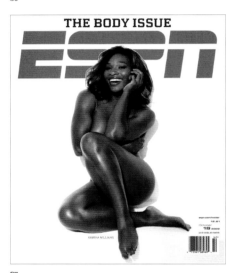

87

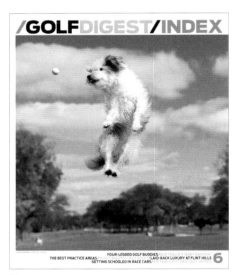

89

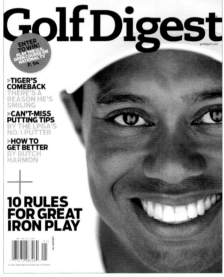

91

86 *Metropolis*

CREATIVE DIRECTOR: Criswell Lappin.
ART DIRECTORS: Dungjai Pungauthaikan, Lisa Maione.
DESIGNERS: Collins, John Fulbrook,
Timonthy Goodman.
PHOTO EDITOR: Sarah Palmer.
PHOTOGRAPHER: Christopher McLallen.
PUBLISHER: Bellerophon Publications.
ISSUE: May 2009.
CATEGORY: Design: Cover

87 *ESPN The Magazine*

CREATIVE DIRECTOR: Siung Tjia.
DIRECTOR OF PHOTOGRAPHY: Catriona Ni Aolain.
PUBLISHER: The Walt Disney Publishing Company.
ISSUE: October 19, 2009.
CATEGORY: Design: Cover

88 *T, The New York Times Style Magazine*

CREATIVE DIRECTOR: David Sebbah.
SENIOR ART DIRECTOR: Christopher Martinez.
DESIGNER: Natalie Do.
PHOTO EDITOR: Scott Hall.
SENIOR PHOTO EDITOR: Judith Puckett-Rinella.
ARTIST: Jeff Koons.
PUBLISHER: The New York Times Company.
ISSUE: August 16, 2009.
CATEGORY: Design: Cover

89 *Golf Digest Index*

DESIGN DIRECTOR: Ken DeLago.
DESIGNER: Ken DeLago.
DIRECTOR OF PHOTOGRAPHY: Christian Iooss.
PHOTOGRAPHER: Geof Kern.
PUBLISHER: Condé Nast Publications Inc.
ISSUE: Spring 2009.
CATEGORY: Design: Cover

90 *T, The New York Times Style Magazine*

CREATIVE DIRECTOR: David Sebbah.
SENIOR ART DIRECTOR: Christopher Martinez.
DESIGNER: Natalie Do.
SENIOR PHOTO EDITOR: Judith Puckett-Rinella.
PHOTO EDITOR: Scott Hall.
ARTIST: Frank Gehry.
PUBLISHER: The New York Times Company.
ISSUE: August 16, 2009.
CATEGORY: Design: Cover

91 *Golf Digest*

DESIGN DIRECTOR: Ken DeLago.
DESIGNER: Ken DeLago.
DIRECTOR OF PHOTOGRAPHY: Christian Iooss.
PHOTOGRAPHER: Don Furore.
PUBLISHER: Condé Nast Publications Inc.
ISSUE: January 2009.
CATEGORY: Design: Cover

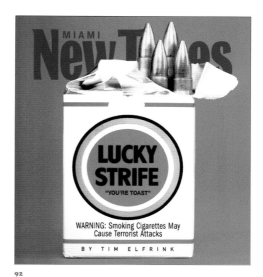

92

94

96

93

95

97

92 Miami New Times

ART DIRECTOR: Pam Shavalier.
DESIGNER: Pam Shavalier.
PHOTOGRAPHER: Colby Katz.
PUBLISHER: Miami New Times.
ISSUE: July 2, 2009.
CATEGORY: Design: Cover

93 Good

DESIGN DIRECTOR: Scott Stowell.
DESIGNERS: Ryan Thacker, Scott Stowell.
ILLUSTRATOR: Ryan Thacker.
STUDIO: Open.
PUBLISHER: Good Worldwide, Inc.
CLIENT: Good Magazine.
ISSUE: Spring 2009.
CATEGORY: Design: Cover

94 Elephant Magazine

DESIGN DIRECTOR: Matt Willey
DESIGNER: Matt Willey
ILLUSTRATOR: Peoro Inoue
PUBLISHER: Frame Publishers
ISSUE: Winter 2009
CATEGORY: Design: Cover

95 Rolling Stone

ART DIRECTOR: Joseph Hutchinson.
DESIGNERS: Joseph Hutchinson,
Chip Kidd, Jim Parkinson.
CONCEPT: Chip Kidd.
PUBLISHER: Wenner Media.
ISSUE: December 24, 2009 - January 7, 2010.
CATEGORY: Design: Cover

96 Prefix Photo

CREATIVE DIRECTORS: Clarie Dawson, Fidel Peña,
Scott McLeod.
DESIGNER: Emily Tu.
STUDIO: Underline Studio.
PUBLISHER: Prefix Institute of Contemporary Art.
CLIENT: Prefix Institute of Contemporary Art.
ISSUE: November 2009.
CATEGORY: Design: Cover

97 Sports Illustrated

DESIGN DIRECTOR: Christopher Hercik.
ART DIRECTOR: Ed Truscio.
PHOTOGRAPHER: Steve Fine.
PUBLISHER: Time Inc.
ISSUE: March 23, 2009.
CATEGORY: Design: Cover

84

SECTION:
design

AWARD:
merit

CATEGORY:
cover

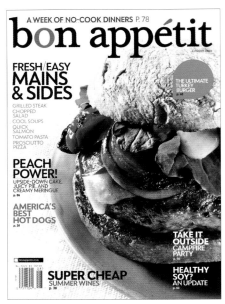

98

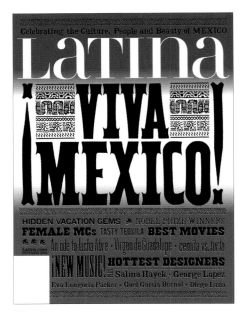

100

102

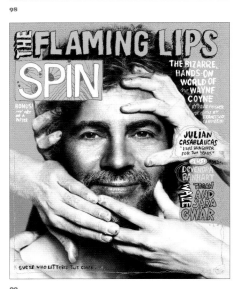

99

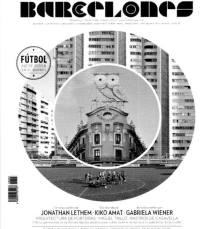

101

103

98 Condé Nast Portfolio

DESIGN DIRECTOR: Robert Priest.
ART DIRECTOR: Grace Lee.
DESIGNERS: Robert Priest, Grace Lee.
ILLUSTRATOR: Ji Lee.
DIRECTOR OF PHOTOGRAPHY: Karen Frank.
PUBLISHER: Condé Nast Publications Inc.
ISSUE: December 2008/January 2009.
CATEGORY: Design: Cover

99 SPIN

CREATIVE DIRECTOR: Devin Pedzwater.
ART DIRECTOR: Ian Robinson.
ILLUSTRATOR: Wayne Coyne.
DIRECTOR OF PHOTOGRAPHY: Michelle Egiziano.
PHOTO EDITOR: Jennifer Edmondson.
PHOTOGRAPHER: Francesco Carrozzini.
PUBLISHER: Spin Media LLC.
ISSUE: November 2009.
CATEGORY: Design: Cover

100 Bon Appétit

DESIGN DIRECTOR: Matthew Lenning.
ART DIRECTORS: Robert Festino, Tom O'Quinn.
DESIGNER: John Muñoz.
DIRECTOR OF PHOTOGRAPHY: Bailey Franklin.
PHOTO EDITOR: Angelica Mistro.
PHOTOGRAPHER: Nigel Cox.
EDITOR-IN-CHIEF: Barbara Fairchild.
PUBLISHER: Condé Nast Publications, Inc.
ISSUE: August 2009.
CATEGORY: Design: Cover

101 Barcelonés

CREATIVE DIRECTOR: Louis-Charles Tiar.
ART DIRECTOR: Quique Ciria. DESIGNER: Raül Vicent.
PHOTOGRAPHERS: Caterina Barjau, Bito Cels.
EDITORS-IN-CHIEF: Mónica Escudero, Ruben Pujol.
PUBLISHER: REVISTAS EXCLUSIVAS S.L.
ISSUE: Autumn 2009-Winter 2010.
CATEGORY: Design: Cover

102 Latina

CREATIVE DIRECTOR: Florian Bachleda.
DESIGN DIRECTOR: Denise See.
ART DIRECTOR: Jesse Reyes.
DIRECTOR OF PHOTOGRAPHY: George Pitts.
PHOTO EDITOR: Jennifer Sargent.
STUDIO: FB Design.
PUBLISHER: Latina Media Ventures.
CLIENT: Latina Magazine.
CATEGORY: Design: Cover

103 Ocala Magazine

ILLUSTRATOR: Josh Clark.
PHOTOGRAPHER: Djamel E. Ramoul.
EDITORIAL + CREATIVE: Jamie Ezra Mark.
PUBLISHER: Special Publications.
ISSUE: August 2009.
CATEGORY: Design: Cover

104

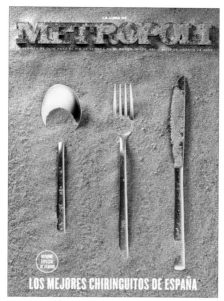

106

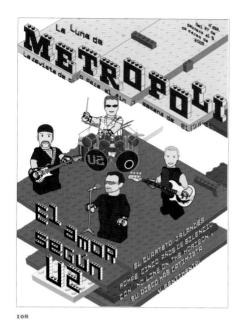

108

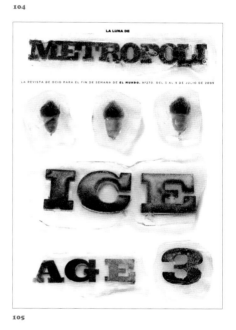

105

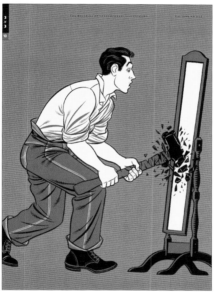

107

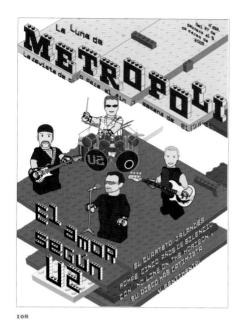

109

104 *Metropoli*

CREATIVE DIRECTOR: Rodrigo Sanchez.
DESIGNER: Rodrigo Sanchez.
PUBLISHER: Unidad Editorial S.A.
ISSUE: December 2009.
CATEGORY: Design: Cover

105 *Metropoli*

CREATIVE DIRECTOR: Rodrigo Sanchez.
DESIGNER: Rodrigo Sanchez.
PHOTOGRAPHER: Àngel Decerril.
PUBLISHER: Unidad Editorial S.A.
ISSUE: July 3, 2009.
CATEGORY: Design: Cover

106 *Metropoli*

CREATIVE DIRECTOR: Rodrigo Sanchez.
DESIGNER: Rodrigo Sanchez.
PHOTOGRAPHER: Àngel Decerril.
PUBLISHER: Unidad Editorial S.A.
ISSUE: August 7, 2009.
CATEGORY: Design: Cover

107 *3x3, The Magazine of Contemporary Illustration*

DESIGN DIRECTOR: Charles Hively.
ART DIRECTOR: Charles Hively.
ILLUSTRATOR: Nick Dewar.
STUDIO: HivelyDesigns.
PUBLISHER: 3x3 Magazine.
ISSUE: October 2009.
CATEGORY: Design: Cover

108 *Metropoli*

CREATIVE DIRECTOR: Rodrigo Sanchez.
DESIGNER: Rodrigo Sanchez.
ILLUSTRATOR: Antonio Castillo.
PUBLISHER: Unidad Editorial S.A.
ISSUE: February 27, 2009.
CATEGORY: Design: Cover

109 *The Washington Post*

CREATIVE DIRECTOR: Dennis Brack.
DESIGN DIRECTOR: Greg Manifold.
ART DIRECTORS: Chris Rukan, Marianne Seregi.
PUBLISHER: The Washington Post Co.
ISSUE: September 3, 2009.
CATEGORY: Design: Cover

86

SECTION:
design

AWARD:
merit

CATEGORY:
entire issue

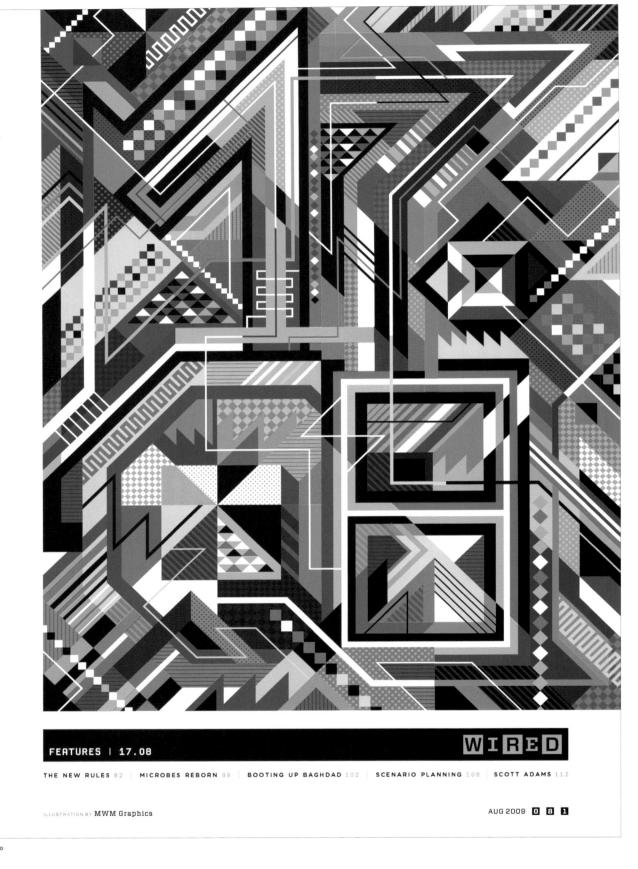

110 **WIRED**

CREATIVE DIRECTOR: Scott Dadich. DESIGN DIRECTOR: Wyatt Mitchell. ART DIRECTORS: Carl DeTorres, Maili Holiman.
ASSOCIATE ART DIRECTORS: Christy Sheppard, Margaret Swart. DESIGNERS: Walter C. Holiman, Victor Krumennacher.
ILLUSTRATORS: Jason Lee, MWM Graphics, The Department of Information Design at Copenhagen, Zohar Lazar, Oliver Jeffers, Noma Bar, Stephen Doyle,
Mr. Bingo SENIOR PHOTO EDITOR: Zana Woods. PHOTO EDITOR: Carolyn Rauch. DEPUTY PHOTO EDITOR: Anna Goldwater Alexander
ASSOCIATE PHOTO EDITOR: Sarah Filippi. PHOTOGRAPHERS: Dan Winters, Mitchell Feinberg, Brian Finke, Nathan Kirkman, David Clugston, Jeff Mermelsein,
Jens Mortensen. EDITOR-IN-CHIEF: Chris Anderson. PUBLISHER: Condé Nast Publications, Inc. ISSUE: August 2009. CATEGORY: Design: Entire Issue

110

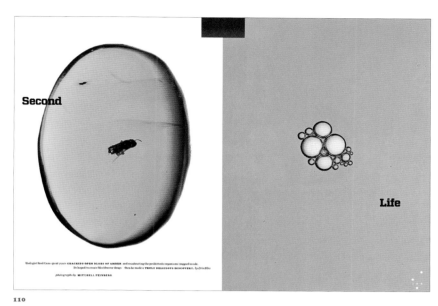

110

111

111

112

112

111 **The New York Times Magazine**

DESIGN DIRECTOR: Arem Duplessis. ART DIRECTOR: Gail Bichler.
DEPUTY ART DIRECTOR: Leo Jung. DESIGNERS: Hilary Greenbaum,
Gail Bichler, Leo Jung, Nancy Harris Rouemy, Leslie Kwok, Robert Vargas.
ILLUSTRATORS: Noma Bar, Mr. Bingo, Andrew Blauvelt, Sarah Illenberger,
Marc Johns, Jan Kallweit, Nick Kaloterakis, Himi Kozue, LaMosca, Lauren Nassef,
Open, Celeste Prevost, Cath Riley. DIRECTOR OF PHOTOGRAPHY: Kathy Ryan.
PHOTO EDITOR: David Carthas. PHOTOGRAPHER: Reinhard Hunger.
PUBLISHER: The New York Times Company. ISSUE: December 13, 2009.
CATEGORY: Design: Entire Issue

112 **Elephant Magazine**

DESIGN DIRECTOR: Matt Willey.
DESIGNER: Matt Willey.
PHOTOGRAPHERS: Giles Revell, Julian Anderson.
PUBLISHER: Frame publishers.
ISSUE: Winter 2009
CATEGORY: Design: Entire Issue

88

SECTION:
design

AWARD:
merit

CATEGORY:
entire issue

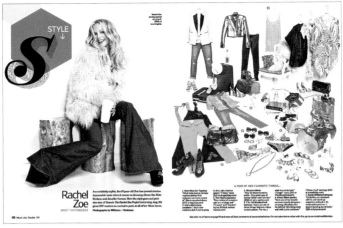

113

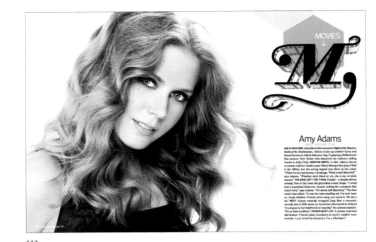

113

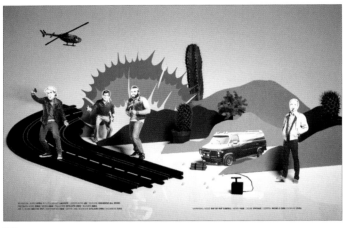

114

114

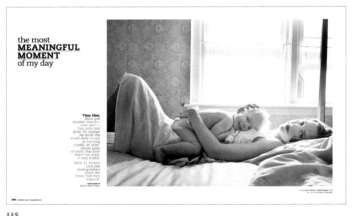

115

115

113 *Entertainment Weekly*

DESIGN DIRECTOR: Brian Anstey.
ART DIRECTOR: Heather Haggerty.
DESIGNERS: Eve Binder, Eric Paul, Michael Schnaidt, Evan Campisi, Jennifer Laga, Jackie Blum.
ILLUSTRATORS: Kagan McLeod, Josue Evilla, John Ueland, Gluekit, Kirsten Ulve, Seb Lester.
DIRECTOR OF PHOTOGRAPHY: Lisa Berman.
PHOTO EDITORS: Sarah Czeladnicki, Richard Maltz, Michele Romero, Louisa Anderson, Kristine Chin, Rachael Lieberman, Suzanne Regan. PHOTOGRAPHERS: Jake Chessum, Ture Lillegraven, Martin Schoeller, Cliff Watts, Matthias Vriens, Williams + Hirakawa, Jeff Lipsky, Kang Kim, Brigitte Lacombe. MANAGING EDITOR: Jess Cagle.
PUBLISHER: Time Inc. ISSUE: June 26, 2009.
CATEGORY: Design: Entire Issue.

114 *CUT - Leute machen Kleider*

ART DIRECTORS: Lucie Schmid, Marta Olesniewicz.
DESIGNERS: Lucie Schmid, Marta Olesniewicz, Miriam Bloching.
ILLUSTRATORS: Franziska Misselwitz, Julia Krusch, Ulrike Meutzner, Simone Niedermeier, Harold Lazaro.
PHOTO EDITOR: Anja Kellner.
PHOTOGRAPHERS: Gabriela Neeb, Johannes Rodach, Denis Pernath, Fabian Beger, Matti Hillig, Heiko Dreher, Frank Kalero.
STUDIO: Independent Medien Design.
EDITOR-IN-CHIEF: Anja Kellner.
PUBLISHER: moser verlag GmbH.
ISSUE: September 18, 2009. ISSUE: 2.
CATEGORY: Design: Entire Issue

115 *Real Simple*

CREATIVE DIRECTOR: Janet Froelich.
DESIGN DIRECTOR: Cybele Grandjean.
ART DIRECTORS: Elsa Mehary, Jamie Dannecker.
DESIGNERS: Jessica Weit, Tracy Walsh, Heather Saltzman.
DIRECTOR OF PHOTOGRAPHY: Casey Tierney.
PHOTO EDITORS: Lauren Epstein, Lindsay Dougherty Rogers, Susan Getzendanner, Brian Madigan.
EDITOR-IN-CHIEF: Kristin Van Ogtrop.
PUBLISHER: Time Inc.
ISSUE: November 2009
CATEGORY: Design: E.ntire Issue

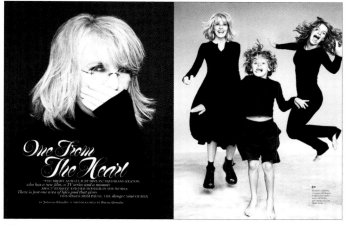
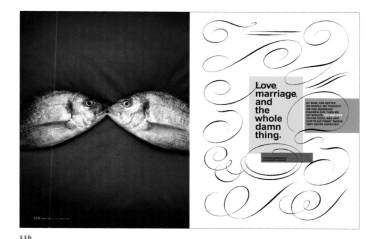

116

116

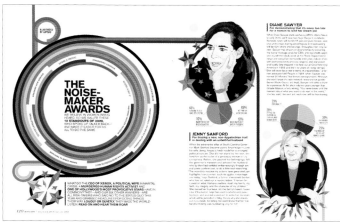

117

117

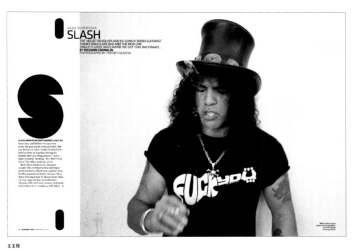
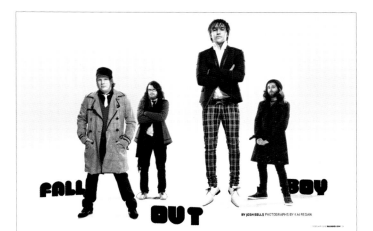

118

118

116 *More*

CREATIVE DIRECTOR: Debra Bishop.
ART DIRECTOR: Claudia de Almeida.
DESIGNERS: Susanne Bamberger, Jenn McManus, Faith Stafford.
ILLUSTRATOR: Lorenzo Petrantoni.
DIRECTOR OF PHOTOGRAPHY: Stacey Baker.
PHOTO EDITORS: Daisy Cajas, Natalie Gialluca.
PHOTOGRAPHERS: Ruven Afanador, Kenji Aoki, Reinhard Hunger, David Meredith, Katherine Wolkoff, Troy Word.
EDITOR-IN-CHIEF: Lesley Jane Seymour.
PUBLISHER: Meredith Corporation.
ISSUE: November 2009.
CATEGORY: Design: Entire Issue

117 *More*

CREATIVE DIRECTOR: Debra Bishop.
ART DIRECTOR: Claudia de Almeida.
DESIGNERS: Susanne Bamberger, Jenn McManus, Faith Stafford.
ILLUSTRATOR: UPSO.
DIRECTOR OF PHOTOGRAPHY: Stacey Baker.
PHOTO EDITORS: Daisy Cajas, Natalie Gialluca.
PHOTOGRAPHERS: Kenji Aoki, Ditte Isager, Dean Isidro, David Meredith, Matthew Rolston.
EDITOR-IN-CHIEF: Lesley Jane Seymour.
PUBLISHER: Meredith Corporation.
ISSUE: December 2009/January 2010.
CATEGORY: Design: Entire Issue

118 *Blender Magazine*

CREATIVE DIRECTOR: Dirk Barnett.
ART DIRECTORS: Robert Vargas, Claudia de Almeida.
DIRECTOR OF PHOTOGRAPHY: David Carthas.
PHOTO EDITORS: Chris Ehrmann, Rory Walsh.
EDITOR-IN-CHIEF: Joe Levy. PUBLISHER: Alpha Media Group. ISSUE: February 2009.
CATEGORY: Design: Entire Issue

90

SECTION:
design

AWARD:
merit

CATEGORY:
entire issue

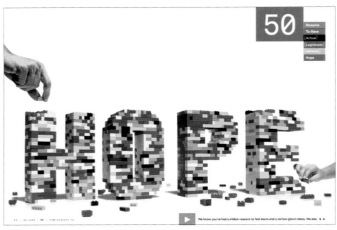

119

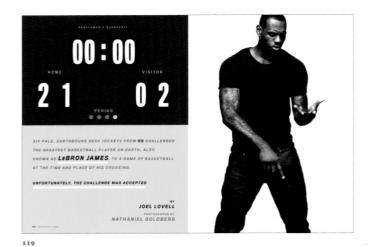

119

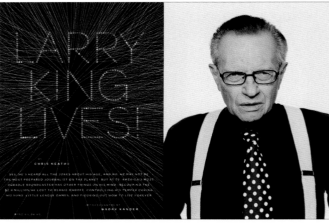

120

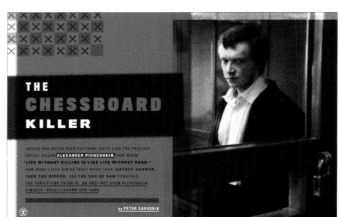

120

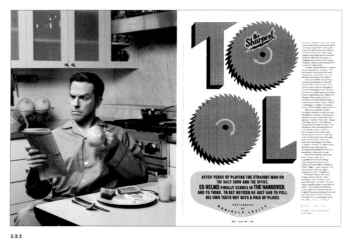

121

121

119 **GQ**

DESIGN DIRECTOR: Fred Woodward.
ART DIRECTORS: Anton Ioukhnovets, Thomas Alberty.
DESIGNERS: Chelsea Cardinal, Drue Wagner, Delgis
Canahuate, Eve Binder. ILLUSTRATORS: Christine
Berrie, Jean-Philippe Delhomme, John Ritter, Zohar
Lazar, Tamara Shopsin, Bryan Christie Design, Ward
Sutton, John Ueland, Colin Tunstall, Gary Taxali, Bruce
Hutchison. DIRECTOR OF PHOTOGRAPHY:
Dora Somosi. PHOTO EDITORS: Krista Prestek, Justin
O'Neill, Jesse Lee, Jolanta Bielat, Emily Blank.
PHOTOGRAPHERS: Eric Ray Davidson, Ditte Isager,
Marc Hom, Tom Schierlitz, Nathaniel Goldberg, Zachary
Scott, Peggy Sirota, Martin Schoeller, Alexi Lubomirski,
Paula Kudacki, Carter Smith, Ditte Isager. CREATIVE
DIRECTOR, FASHION: Jim Moore. EDITOR-IN-CHIEF:
Jim Nelson. PUBLISHER: Condé Nast Publications Inc.
ISSUE: February 2009. CATEGORY: Design: Entire Issue

120 **GQ**

DESIGN DIRECTOR: Fred Woodward.
ART DIRECTORS: Anton Ioukhnovets, Thomas Alberty.
DESIGNERS: Chelsea Cardinal, Drue Wagner, Delgis
Canahuate. ILLUSTRATORS: Bruce Hutchison, Brown
Bird Design, Jean-Philippe Delhomme, John Ritter,
Zohar Lazar, Brian Cronin, Knickerbocker Design, Colin
Tunstall, John Ueland, Gary Taxali. DIRECTOR OF
PHOTOGRAPHY: Dora Somosi. PHOTO EDITORS:
Krista Prestek, Justin O'Neill, Jesse Lee, Jolanta Bielat,
Emily Blank. PHOTOGRAPHERS: Mitchell Fienberg,
Eric Ray Davidson, Richard Burbridge, Nigel Cox, Tom
Schierlitz, James Kirkland, Mark Seliger, Geof Kern,
Peter Rad, Terry Richardson, Ditte Isager, Ben Watts,
Michel Comte, Nadav Kander, Carter Smith, Paola
Kudacki, Christopher Lamarca. CREATIVE DIRECTOR,
FASHION: Jim Moore. EDITOR-IN-CHIEF: Jim Nelson.
PUBLISHER: Condé Nast Publications Inc.
ISSUE: June 2009. CATEGORY: Design: Entire Issue

121 **GQ**

DESIGN DIRECTOR: Fred Woodward.
ART DIRECTORS: Anton Ioukhnovets, Thomas Alberty.
DESIGNERS: Chelsea Cardinal, Drue Wagner, Delgis
Canahuate. ILLUSTRATORS: Zohar Lazar, Quickhoney,
Jason Lee, Colin Tunstall, John Ueland, Jean-Philippe
Delhomme, Gary Taxali, Bruce Hutchison.
DIRECTOR OF PHOTOGRAPHY: Dora Somosi.
PHOTO EDITORS: Krista Prestek, Justin O'Neill,
Jesse Lee, Jolanta Bielat. PHOTOGRAPHERS: Mitchell
Feinberg, Jill Greenberg, Mark Seliger, Chris Buck,
Danielle Levitt, Paola Kudacki, Ben Hassett, Ture
Lillegraven, Robert Polidori, Tom Schierlitz, Eric Ray
Davidson, David S. Allee, Nigel Cox, Scott Schuman.
CREATIVE DIRECTOR, FASHION: Jim Moore.
EDITOR-IN-CHIEF: Jim Nelson.
PUBLISHER: Condé Nast Publications Inc.
ISSUE: July 2009. CATEGORY: Design: Entire Issue

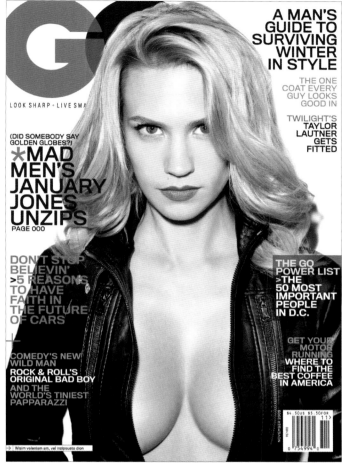

122

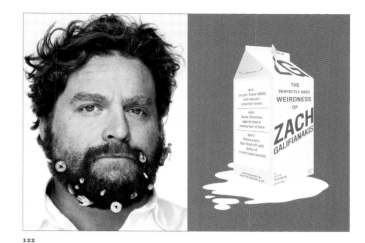

122

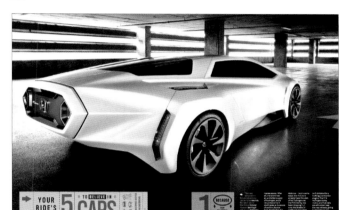

122

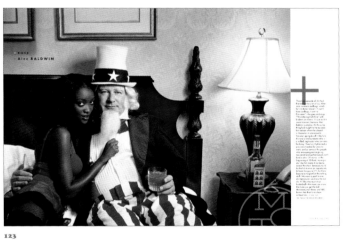

123

123

122 **GQ**

DESIGN DIRECTOR: Fred Woodward.
ART DIRECTORS: Anton Ioukhnovets, Thomas Alberty.
DESIGNERS: Chelsea Cardinal, Drue Wagner, Delgis
Canahuate. ILLUSTRATORS: Agnés Decourchelle,
Bruce Hutchison, QuickHoney, Zohar Lazar, Brown Bird
Design, John Ueland, Colin Tunstall. DIRECTOR OF
PHOTOGRAPHY: Dora Somosi. PHOTO EDITORS:
Krista Prestek, Justin O'Neill, Jesse Lee, Jolanta Bielat.
PHOTOGRAPHERS: Paola Kudacki, Eric Ray Davidson,
Tom Schierlitz, Scott Schuman, Robert Maxwell, Nigel
Cox, Chris Granger, Terry Richardson, Mauricio Alejo,
Lauren Greenfield, Peggy Sirota, Christopher Griffith,
Martin Schoeller, Ben Watts. CREATIVE DIRECTOR,
FASHION: Jim Moore. EDITOR-IN-CHIEF: Jim Nelson.
PUBLISHER: Condé Nast Publications Inc. ISSUE:
November 2009. CATEGORY: Design: Entire Issue

123 **GQ**

DESIGN DIRECTOR: Fred Woodward.
ART DIRECTORS: Anton Ioukhnovets, Thomas Alberty.
DESIGNERS: Chelsea Cardinal, Drue Wagner, Delgis
Canahuate. ILLUSTRATORS: Agnés Decourchelle, Jean-
Philippe Delhomme, QuickHoney, John Ritter, Zohar
Lazar, Chris Friedman, Knickerbocker Design, John
Ueland, Colin Tunstall, Bruce Hutchison, Gary Taxali.
DIRECTOR OF PHOTOGRAPHY: Dora Somosi.
PHOTO EDITORS: Krista Prestek, Justin O'Neill, Jesse
Lee, Jolanta Bielat, Emily Blank. PHOTOGRAPHERS:
Tom Schierlitz, Eric Ray Davidson, Scott Schuman, The
Selby, Nigel Cox, Robert Maxwell, Chris Buck, Martin
Schoeller, Mark Abrahams, Nathaniel Goldberg, Mark
Seliger, Roland Bello, Peggy Sirota, Matthias Ziegler.
CREATIVE DIRECTOR, FASHION: Jim Moore.
EDITOR-IN-CHIEF: Jim Nelson. PUBLISHER: Condé
Nast Publications Inc. ISSUE: December 2009.
CATEGORY: Design: Entire Issue

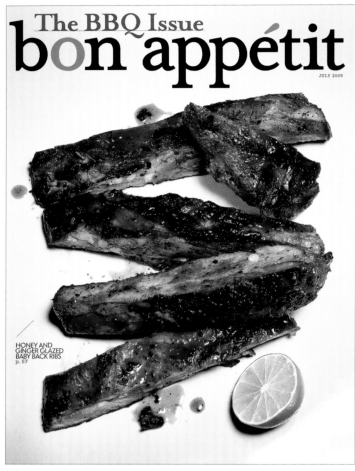

124

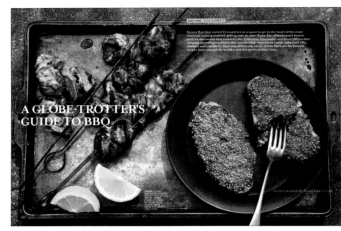

242

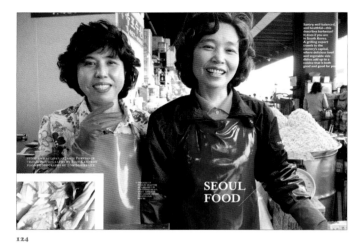

124

125

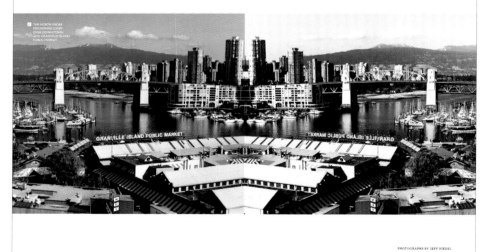

125

124 *Bon Appétit*

DESIGN DIRECTOR: Matthew Lenning.
ART DIRECTORS: Robert Festino, Tom O'Quinn.
DESIGNER: John Muñoz. ILLUSTRATORS:
Christoph Niemann, Heads of State, Serge Bloch, MASA.
DIRECTOR OF PHOTOGRAPHY: Bailey Franklin.
PHOTO EDITOR: Angelica Mistro.
PHOTOGRAPHERS: Craig Cutler, Mark Heithoff,
Randy Harris, Kenji Toma, Christian Stoll, Elinor
Carucci, Hans Gissinger, Richard Foulser, Yoko Inoue,
Sian Kennedy. EDITOR-IN-CHIEF: Barbara Fairchild.
PUBLISHER: Condé Nast Publications, Inc.
ISSUE: July 2009. CATEGORY: Design: Entire issue

125 *Bon Appétit*

DESIGN DIRECTOR: Matthew Lenning.
ART DIRECTORS: Robert Festino, Tom O'Quinn.
DESIGNER: John Muñoz. ILLUSTRATORS: Christoph
Niemann, Arthur Mount, MASA. DIRECTOR OF
PHOTOGRAPHY: Bailey Franklin. PHOTO EDITOR:
Angelica Mistro. PHOTOGRAPHERS: Nigel Cox,
John Huet, Levi Brown, Lisa Hubbard, Kiyoshi Togashi,
Christian Stoll, Andrea Chu, Misha Gravenor,
Gail Albert Halaban, Jeff Riedel.
EDITOR-IN-CHIEF: Barbara Fairchild.
PUBLISHER: Condé Nast Publications, Inc.
ISSUE: August 2009. CATEGORY: Design: Entire Issue

126

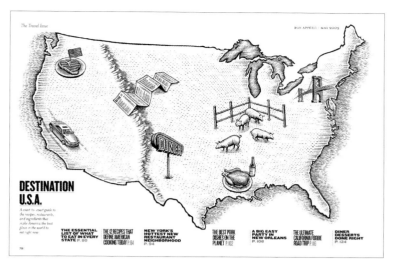

126

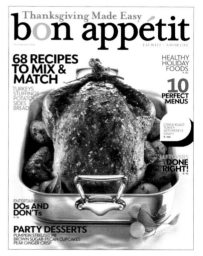

127

127

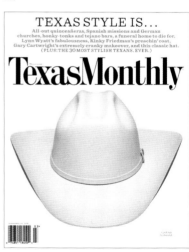

128

128

126 *Bon Appétit*

DESIGN DIRECTOR: Matthew Lenning.
ART DIRECTORS: Robert Festino, Tom O'Quinn.
DESIGNER: John Muñoz. ILLUSTRATORS: Christoph
Niemann, Masa, Olivier Kugler, Douglas Smith, Michael
Halbert. DIRECTOR OF PHOTOGRAPHY:
Bailey Franklin. PHOTO EDITOR: Angelica Mistro.
PHOTOGRAPHERS: Antonis Achilleos, Patricia Heal,
Jamie Chung, Jake Chessum, Hans Gissinger,
Ture Lillegraven, Lisa Kereszi, Brian Finke.
EDITOR-IN-CHIEF: Barbara Fairchild.
PUBLISHER: Condé Nast Publications, Inc.
ISSUE: May 2009. CATEGORY: Design: Entire Issue

127 *Bon Appétit*

DESIGN DIRECTOR: Matthew Lenning.
ART DIRECTORS: Robert Festino, Tom O'Quinn.
DESIGNER: John Muñoz. ILLUSTRATORS:
Christoph Niemann, Edel Rodriguez, Arthur Mount,
MASA, Serge Bloch. DIRECTOR OF PHOTOGRAPHY:
Bailey Franklin. PHOTO EDITOR: Angelica Mistro.
PHOTOGRAPHERS: Richard Pierce, Elinor Carucci,
Levi Brown, Steve Cohen, Lisa Hubbard, Patricia Heal,
Kiyoshi Togashi. EDITOR-IN-CHIEF: Barbara Fairchild.
PUBLISHER: Condé Nast Publications, Inc.
ISSUE: November 2009.
CATEGORY: Design: Entire Issue

128 *Texas Monthly*

CREATIVE DIRECTOR: T.J. Tucker.
ART DIRECTORS: Andi Beierman, Caleb Bennett.
ILLUSTRATORS: Dirk Fowler, Jack Unruth,
Jude Buffum, Heather Hale.
PHOTO EDITOR: Leslie Baldwin.
PHOTOGRAPHERS: Adam Voorhes, Leann Mueller,
Sarah Wilson, Jeff Wilson.
PUBLISHER: Emmis Publishing.
ISSUE: March 2009.
CATEGORY: Design: Entire Issue

94

SECTION:
design

AWARD:
merit

CATEGORY:
entire issue

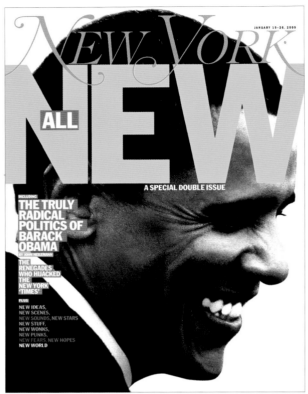

129

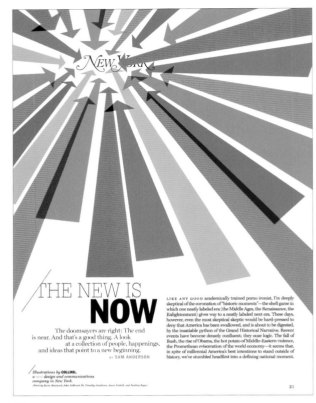

129

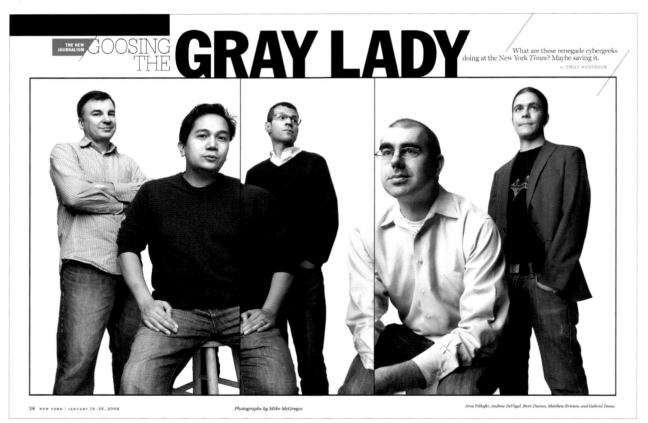

129

129 **New York**

DESIGN DIRECTOR: Chris Dixon. ART DIRECTOR: Randy Minor. DESIGNERS: Randy Minor, Hitomi Sato, Kate Elazegui, Hilary
Fitzgibbons, Carol Hayes, Stevie Remsberg. ILLUSTRATOR: Collins. DIRECTOR OF PHOTOGRAPHY: Jody Quon. PHOTO EDITORS:
Leana Alagia, Alex Pollack, Caroline Smith, Lea Golis, Nadia Lachance. PHOTOGRAPHER: Mike McGregor. EDITOR-IN-CHIEF: Adam Moss.
PUBLISHER: New York Magazine Holdings, LLC. ISSUE: January 16-26, 2009. CATEGORY: Design: Entire Issue

130

130

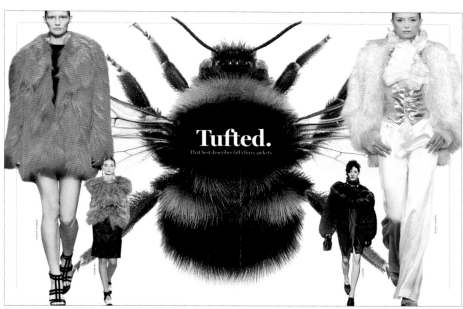

131

131

130 **New York**

DESIGN DIRECTOR: Chris Dixon. ART DIRECTOR: Randy Minor.
DESIGNERS: Randy Minor, Hitomi Sato, Hilary Fitzgibbons, John Sheppard,
Stevie Remsberg. DIRECTOR OF PHOTOGRAPHY: Jody Quon.
PHOTO EDITORS: Leana Alagia, Caroline Smtih, Nadia Lachance, Lea Golis.
PHOTOGRAPHERS: Bert Stern, Hannah Whitaker, Guy Aroch.
EDITOR-IN-CHIEF: Adam Moss. PUBLISHER: New York Magazine
Holdings, LLC. ISSUE: February 23, 2009. CATEGORY: Design: Entire Issue

131 **New York**

DESIGN DIRECTOR: Chris Dixon. ART DIRECTOR: Randy Minor.
DESIGNERS: Randy Minor, Hitomi Sato, Hilary Fitzgibbons, Macon York,
Stevie Remsberg. DIRECTOR OF PHOTOGRAPHY: Jody Quon.
PHOTO EDITORS: Leana Alagia, Alex Pollack, Caroline Smith, Lea Golis,
Nadia Lachance. PHOTOGRAPHERS: Marcus Bleasdale, John Keatley.
EDITOR-IN-CHIEF: Adam Moss. PUBLISHER: New York Magazine
Holdings, LLC. ISSUE: August 24, 2009. CATEGORY: Design: Entire Issue

96

SECTION:
design

AWARD:
merit

CATEGORY:
entire issue

132

132

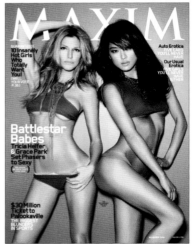

133

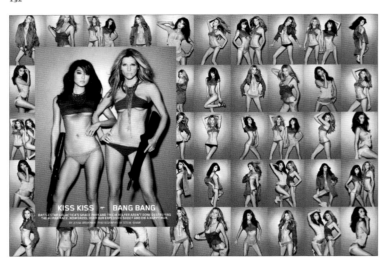

133

134

134

132 Maxim

CREATIVE DIRECTOR: Dirk Barnett.
ART DIRECTORS: Sean Johnston, Billy Sorrentino.
DESIGNER: Chandra Illick.
DIRECTOR OF PHOTOGRAPHY: Toby Kaufman.
PHOTO EDITORS: Marya Gullo, Antonella D'Agastino,
Leslie Simmons. EDITOR-IN-CHIEF: Joe Levy.
PUBLISHER: Alpha Media Group.
ISSUE: December 2009.
CATEGORY: Design: Entire Issue

133 Maxim

CREATIVE DIRECTOR: Dirk Barnett.
ART DIRECTORS: Sean Johnston, Billy Sorrentino.
DESIGNER: Chandra Illick.
DIRECTOR OF PHOTOGRAPHY: Toby Kaufman.
PHOTO EDITORS: Marya Gullo, Antonella D'Agastino,
Leslie Simmons. EDITOR-IN-CHIEF: Joe Levy.
PUBLISHER: Alpha Media Group.
ISSUE: November 2009.
CATEGORY: Design: Entire Issue

134 Field & Stream

ART DIRECTOR: Neil Jamieson.
DESIGNER: Mike Ley.
DIRECTOR OF PHOTOGRAPHY: Amy Berkley.
PHOTO EDITOR: Caitlin Peters.
PUBLISHER: Bonnier Corporation.
ISSUE: December 2009/January 201.0
CATEGORY: Design: Entire Issue

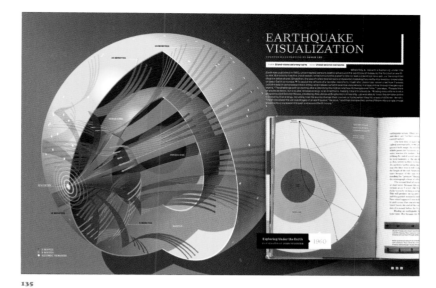

135

135

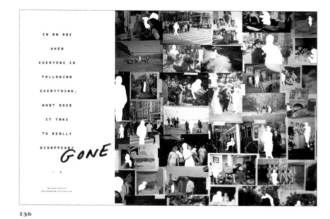

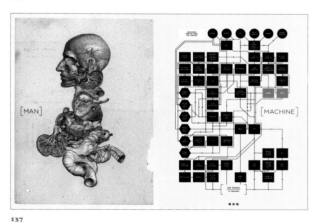

136

136

137

137

135 **WIRED**

CREATIVE DIRECTOR: Scott Dadich.
DESIGN DIRECTOR: Wyatt Mitchell.
ART DIRECTORS: Carl DeTorres, Maili Holiman.
ASSOCIATE ART DIRECTOR: Christy Sheppard,
Margaret Swart. DESIGNERS: Walter C. Baumann,
Victor Krumennacher, Erik Carnes. ILLUSTRATORS:
Stephen Doyle, Christoph Niemann, Jason Lee, Bryan
Christie, Justin Wood, Tavis Coburn, David Drummond.
SENIOR PHOTO EDITOR: Zana Woods. PHOTO
EDITOR: Carolyn Rauch. DEPUTY PHOTO EDITOR:
Anna Goldwater Alexander. ASSOCIATE PHOTO
EDITOR: Sarah Filippi. PHOTOGRAPHERS:
Jill Greenberg, Nigel Perry, Andrew Zuckerman,
Peter Yang, Tim Morris, Ofaf Blecker.
EDITOR-IN-CHIEF: Chris Anderson. PUBLISHER:
Condé Nast Publications, Inc. ISSUE: November 2009.
CATEGORY: Design: Entire Issue

136 **WIRED**

CREATIVE DIRECTOR: Scott Dadich.
DESIGN DIRECTOR: Wyatt Mitchell.
ART DIRECTORS: Carl DeTorres, Maili Holiman
ASSOCIATE ART DIRECTORS: Christy Sheppard,
Margaret Swart. DESIGNERS: Walter C. Baumann,
Victor Krumennacher. ILLUSTRATORS: Jason Lee,
Christoph Niemann, Todd St. John, Eddie Guy, John
Cuneo, Oliver Jeffers, SimpleScott, Luke Hayman, Lisa
Strausfeld, Matt Willey, Khoi Vinh, Quickhoney, Nathan
Sawaya. SENIOR PHOTO EDITOR: Zana Woods.
PHOTO EDITOR: Carolyn Rauch. DEPUTY PHOTO
EDITOR: Anna Goldwater Alexander. ASSOCIATE
PHOTO EDITOR: Sarah Filippi. PHOTOGRAPHERS:
Platon, Kenji Aoki, Nick Veasey, Joe Pugliese, Tom
Schierlitz, Tim Morris, Jens Mortensen, Jamie Chung.
EDITOR-IN-CHIEF: Chris Anderson. PUBLISHER:
Condé Nast Publications, Inc. ISSUE: September 2009.
CATEGORY: Design: Entire Issue

137 **WIRED**

CREATIVE DIRECTOR: Scott Dadich.
DESIGN DIRECTOR: Wyatt Mitchell.
ART DIRECTORS: Carl DeTorres, Maili Holiman.
ASSOCIATE ART DIRECTORS: Christy Sheppard,
Margaret Swart. DESIGNERS: Walter C. Baumann,
Victor Krumennacher, Erik Carnes.
ILLUSTRATORS: Arem Duplessis, Dan Winters, Oliver
Jeffers, Riccardo Vecchio, Stephen Doyle, Christoph
Niemann, EightHourDay, Robert Lang, Alan Dye, Mr.
Bingo, Lamosca. SENIOR PHOTO EDITOR:
Zana Woods. DEPUTY PHOTO EDITOR: Anna
Goldwater Alexander. ASSOCIATE PHOTO EDITOR:
Sarah Filippi. PHOTOGRAPHERS: Zachary Zavislak, Joe
Pugliese, Tom Schierlitz, Tim Morris, Randall Mesdon,
Art Streiber. EDITOR-IN-CHIEF: Chris Anderson.
PUBLISHER: Condé Nast Publications, Inc.
ISSUE: December 2009.
CATEGORY: Design: Entire Issue

98 SECTION:
design

AWARD:
merit

CATEGORY:
entire issue

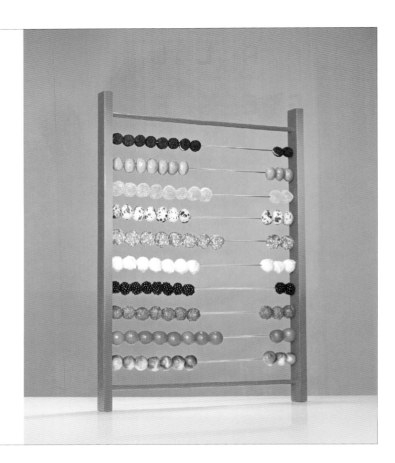

138

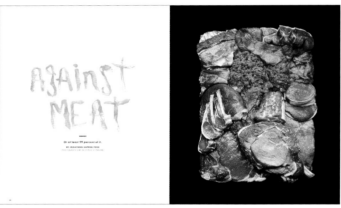

138

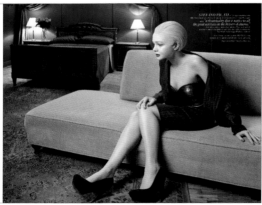

139

138 **The New York Times Magazine**

DESIGN DIRECTOR: Arem Duplessis.
ART DIRECTOR: Gail Bichler.
DEPUTY ART DIRECTOR: Leo Jung.
DESIGNERS: Gail Bichler, Leo Jung, Nancy Harris
Rouemy, Hilary Greenbaum, Aviva Michaelov, Leslie
Kuok, Rob Vargas.
DIRECTOR OF PHOTOGRAPHY: Kathy Ryan.
PUBLISHER: The New York Times Company.
ISSUE: October 11, 2009.
CATEGORY: Design: Entire Issue

139 **T, The New York Times Style
Magazine**

CREATIVE DIRECTOR: David Sebbah.
SENIOR ART DIRECTOR: Christopher Martinez.
DESIGNERS: Natalie Do, Jamie Bartolacci, Nicole
Huganir, Robert Vargas.
DIRECTOR OF PHOTOGRAPHY: Kathy Ryan.
SENIOR PHOTO EDITOR: Judith Puckett-Rinella.
PHOTO EDITOR: Scott Hall.
PUBLISHER: The New York Times Company.
ISSUE: August 16, 2009.
CATEGORY: Design: Entire Issue

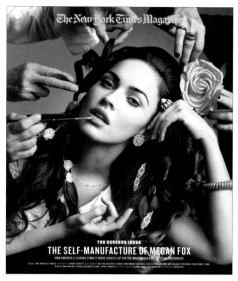

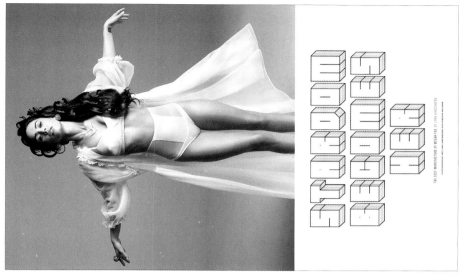

140

140

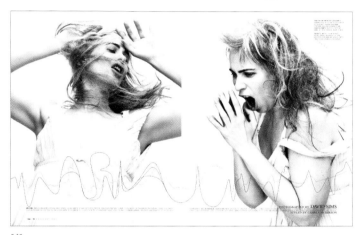

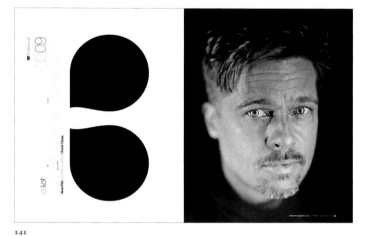

141

141

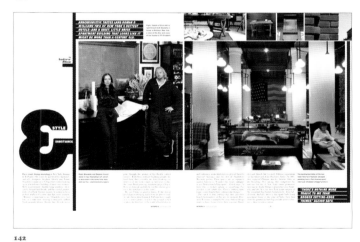

142

142

140 *The New York Times Magazine*
DESIGN DIRECTOR: Arem Duplessis.
ART DIRECTOR: Gail Bichler.
DEPUTY ART DIRECTOR: Leo Jung.
DESIGNERS: Gail Bichler, Robert Vargas, Leo Jung,
Nancy Harris Rouemy, Hilary Greenbaum, Aviva
Michaelov, Leslie Kwok. ILLUSTRATOR: Olly Moss.
DIRECTOR OF PHOTOGRAPHY: Kathy Ryan.
PHOTO EDITOR: Joanna Milter. PUBLISHER:
The New York Times Company. ISSUE: November 15,
2009. CATEGORY: Design: Entire Issue

141 **W**
CREATIVE DIRECTOR: Dennis Freedman.
DESIGN DIRECTOR: Edward Leida.
ART DIRECTOR: Nathalie Kirsheh.
DESIGNERS: Gina Maniscalco, Laura Konrad.
PHOTO EDITOR: Nadia Vellam.
PHOTOGRAPHERS: Chuck Close, Mert Alas, Marcus
Piggott, Craig McDean, David Sims, Simon Watson.
PUBLISHER: Condé Nast Publications Inc.
ISSUE: February 2009. CATEGORY: Design: Entire Issue

142 *Metropolis*
CREATIVE DIRECTOR: Criswell Lappin.
ART DIRECTORS: Dungjai Pungauthaikan, Lisa Maione.
PHOTO EDITOR: Sarah Palmer.
PHOTOGRAPHER: Tim Hursley.
PUBLISHER: Bellerophon Publications.
ISSUE: July/August 2009.
CATEGORY: Design: Entire Issue

100

SECTION:
design

AWARD·
merit

CATEGORY:
entire issue

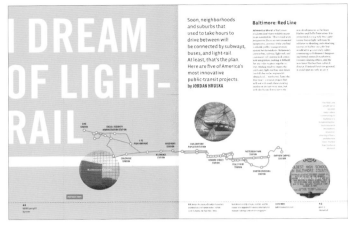

143

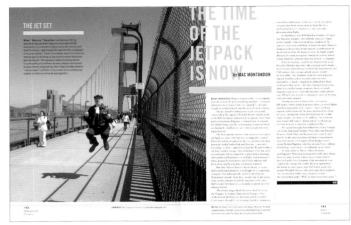

143

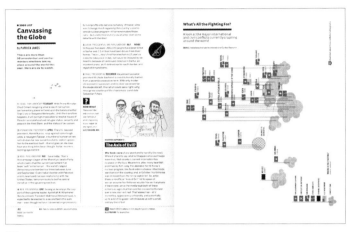

144

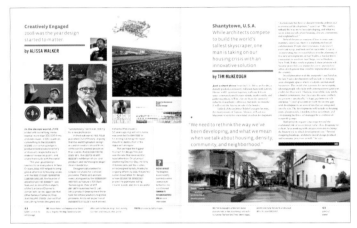

144

145

145

143 **Good**

DESIGN DIRECTOR: Scott Stowell.
DESIGNERS: Ryan Thacker, Scott Stowell, Carol Hayes,
Lucia Vera Gehrenbeck, Robert A. Di Ieso Jr.
STUDIO: Open.
PUBLISHER: Good Worldwide, Inc.
CLIENT: Good Magazine.
ISSUE: Spring 2009.
CATEGORY: Design: Entire Issue

144 **Good**

DESIGN DIRECTOR: Scott Stowell. DESIGNERS:
Robert A. Di Ieso Jr., Serifcan Özcan, Ryan Thacker.
PHOTO EDITOR: Amrit Richmond.
STUDIO: Open.
PUBLISHER: Good Worldwide, Inc.
CLIENT: Good Magazine.
ISSUE: January/February 2009.
CATEGORY: Design: Entire Issue

145 **Nylon**

ART DIRECTOR: Michael Pangilinan. DESIGNERS:
Kristin Eddington, Nicole Michalek, Alexander Chow.
ILLUSTRATORS: Marco Cibola, Reed Burgoyne,
Esra Røise, Timothy McSweeney.
DIRECTOR OF PHOTOGRAPHY: Stephen Walker.
PHOTO EDITOR: Evelien Joos. PHOTOGRAPHERS:
Erin Barry, David Canning, Tara Darby, Jeanne
Detallante, Jon Drever, Bon Duke, Lauren Dukoff,
Selby Duncan, Emir Eralp, Adam Fedderly, Julia Galdo,
Catherine Goldschmidt, Crystal Gwyn, Henry Hargreaves,
Dororthy Hong, Jonathon Kambouris, Marley Kate, Kate
Lacey, Brooke Nipar, Jason Nocito, Ysa Pérez, Mike
Piscitelli, Emily Richmond, Nicholas Routzen, Lele Saveri,
Mu Sun, Elizabeth Weinberg.
EDITOR-IN-CHIEF: Marvin Scott Jarrett.
PUBLISHER: Nylon LLC. ISSUE: September 2009.
CATEGORY: Design: Entire Issue

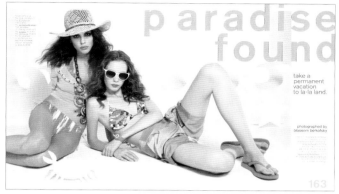

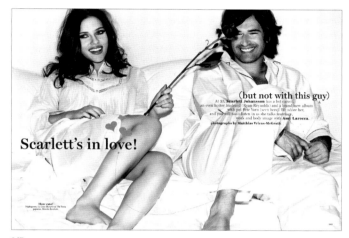

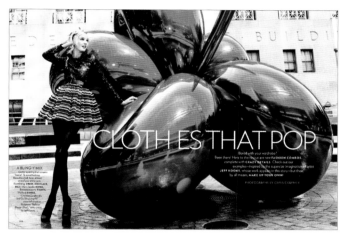

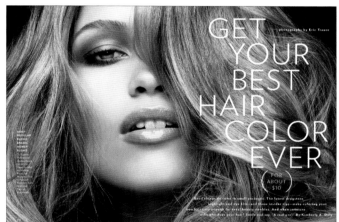

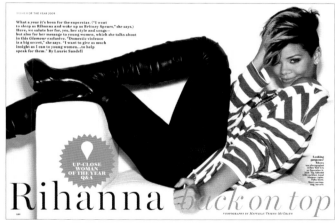

146 *Nylon*

ART DIRECTOR: Michael Pangilinan.
PUBLISHER: Nylon LLC.
ISSUE: December 2009/January 2010.
CATEGORY: Design: Entire Issue

47 *Glamour*

DESIGN DIRECTOR: Geraldine Hessler.
ART DIRECTOR: Theresa Griggs.
DESIGNERS: Sarah Viñas, Noah Dreier, Amaya Taveras,
William Hooks.
DIRECTOR OF PHOTOGRAPHY: Suzanne Donaldson.
PHOTOGRAPHER: Matthias Vriens-McGrath.
PUBLISHER: Condé Nast Publications Inc.
ISSUE: November 2009.
CATEGORY: Design: Entire Issue

148 *Glamour*

DESIGN DIRECTOR: Geraldine Hessler.
ART DIRECTOR: Theresa Griggs.
DESIGNERS: Sarah Vinas, Noah Dreier.
DIRECTOR OF PHOTOGRAPHY: Suzanne Donaldson.
PHOTOGRAPHER: Matthias Vriens-McGrath.
PUBLISHER: Condé Nast Publications Inc.
ISSUE: December 2009.
CATEGORY: Design: Entire Issue

102

SECTION:
design

AWARD:
merit

CATEGORY:
service

149

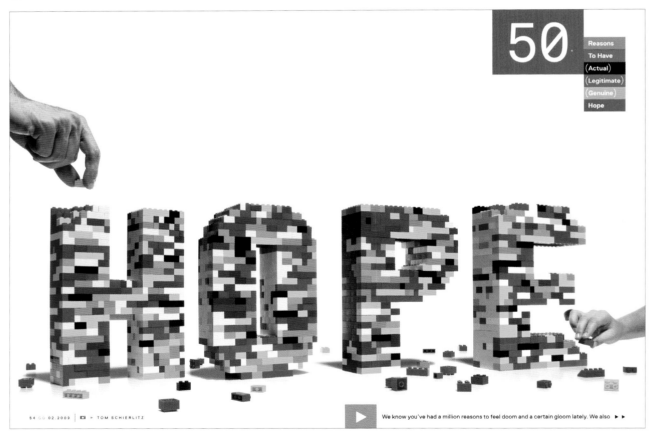

150

149 *Psychology Today*

CREATIVE DIRECTOR: Edward Levine. PHOTOGRAPHER: James Worrell.
STUDIO: Levine Design Inc. PUBLISHER: Sussex Publishers. ISSUE: September/
October 2009. CATEGORY: Design: Feature: Service (single/spread)

150 **GQ**

DESIGN DIRECTOR: Fred Woodward. DESIGNER: Anton Ioukhnovets.
DIRECTOR OF PHOTOGRAPHY: Dora Somosi. PHOTO EDITOR: Jesse Lee.
PHOTOGRAPHER: Tom Schierlitz. PUBLISHER: Condé Nast Publications Inc.
ISSUE: February 2009. CATEGORY: Design: Feature: Service (single/spread)

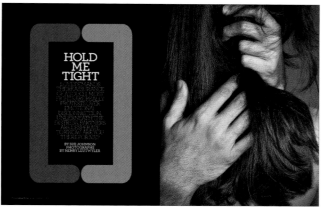

151

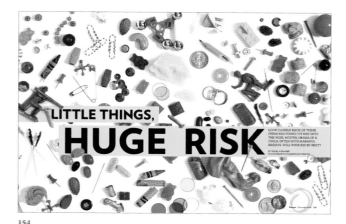

154

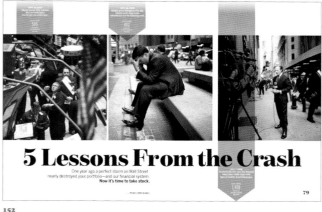

152

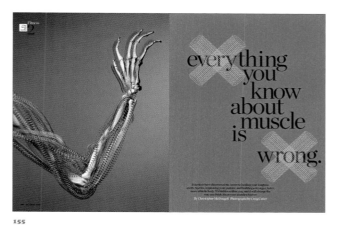

155

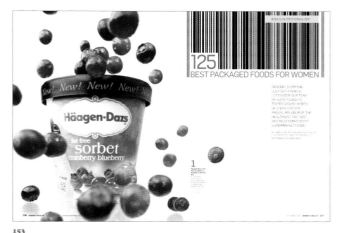

153

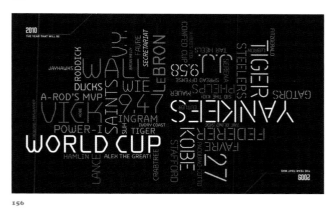

156

151 *Psychology Today*

CREATIVE DIRECTOR: Edward Levine.
ART DIRECTOR: Katherine Bigelow.
DIRECTOR OF PHOTOGRAPHY: Claudia Stefezius.
PHOTOGRAPHER: Henry Leutwyler.
STUDIO: Levine Design Inc.
PUBLISHER: Sussex Publishers.
ISSUE: January/February 2009.
CATEGORY: Design: Feature: Service (single/spread)

152 *Money*

DESIGN DIRECTOR: Kate Elazegui.
DESIGNER: Scott Weiss.
DIRECTOR OF PHOTOGRAPHY: Don Kinsella.
PHOTOGRAPHER: Fred Conrad.
PUBLISHER: Time Inc.
ISSUE: September 2009.
CATEGORY: Design: Feature: Service (single/spread)

153 *Women's Health*

CREATIVE DIRECTOR: Andrea Dunham.
ART DIRECTOR: Lan Yin Bachelis.
DIRECTOR OF PHOTOGRAPHY: Sarah Rozen.
PHOTO EDITOR: Andrea Verdone.
PHOTOGRAPHER: Adam Levey.
EDITOR-IN-CHIEF: Michele Promaulayko.
PUBLISHER: Rodale Inc.
ISSUE: September 2009.
CATEGORY: Design: Feature: Service (single/spread)

154 *Parents Magazine*

CREATIVE DIRECTOR: Andrea Amadio.
ART DIRECTOR: Jessica Power.
DESIGNER: Amanda Kirk.
DIRECTOR OF PHOTOGRAPHY: Annemarie Muscatella.
PHOTO EDITOR: Lily Alt.
PHOTOGRAPHER: Marko Metzinger.
EDITOR-IN-CHIEF: Dana Points.
PUBLISHER: Meredith. ISSUE: December 2009.
CATEGORY: Design: Feature: Service (single/spread)

155 *Men's Health*

DESIGN DIRECTOR: Brandon Kavulla.
DIRECTOR OF PHOTOGRAPHY: Brenda Milis.
DEPUTY DIRECTOR OF PHOTOGRAPHY:
Jeanne Graves.
PHOTOGRAPHER: Craig Cutler.
PUBLISHER: Rodale Inc.
ISSUE: October 2009.
CATEGORY: Design: Feature: Service (single/spread)

156 *ESPN The Magazine*

CREATIVE DIRECTOR: Siung Tjia.
DIRECTOR OF PHOTOGRAPHY: Catriona Ni Aolain.
PUBLISHER: The Walt Disney Publishing Company.
ISSUE: December 14, 2009.
CATEGORY: Design: Feature: Service (single/spread)

SECTION:
design

AWARD:
merit

CATEGORY:
service

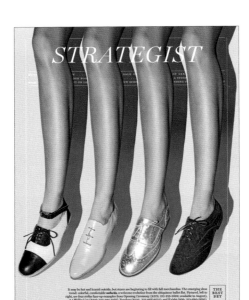

157

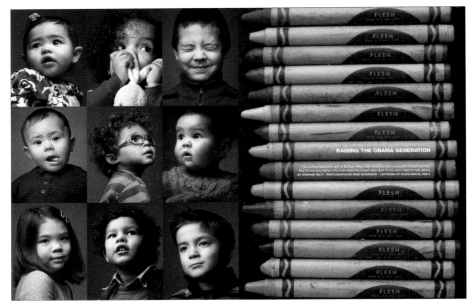

158

159

157 **New York**

DESIGN DIRECTOR: Chris Dixon
ART DIRECTOR: Randy Minor.
DESIGNER: Hilary Fitzgibbons.
DIRECTOR OF PHOTOGRAPHY: Jody Quon.
PHOTO EDITOR: Caroline Smith. PHOTOGRAPHER:
Hannah Whitaker. EDITOR-IN-CHIEF: Adam Moss.
PUBLISHER: New York Magazine Holdings, LLC.
ISSUE: August 3, 2009.
CATEGORY: Design: Feature: Service (single/spread)

158 **Best Life**

DESIGN DIRECTOR: Brandon Kavulla. ART
DIRECTORS: Dena Verdesca, Brandon Kavulla.
DESIGNER: Dena Verdesca. DIRECTOR OF
PHOTOGRAPHY: Ryan Cadiz. PHOTO EDITOR: Jeanne
Graves. PHOTOGRAPHER: Mike McGregor.
PUBLISHER: Rodale Inc. ISSUE: March 2009.
CATEGORY: Design: Feature: Service (single/spread)

159 **Popular Mechanics**

DESIGN DIRECTOR: Michael Lawton.
DIRECTOR OF PHOTOGRAPHY: Allyson Torrisi.
PHOTOGRAPHER: Fredrik Broden.
Sr. ART DIRECTOR: Peter Herbert.
EDITOR-IN-CHIEF: James B. Meigs.
PUBLISHER: The Hearst Corporation-Magazines
Division. ISSUE: April 2009.
CATEGORY: Design: Feature: Service (single/spread)

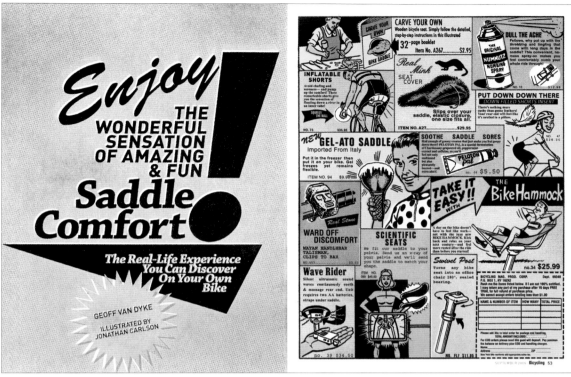

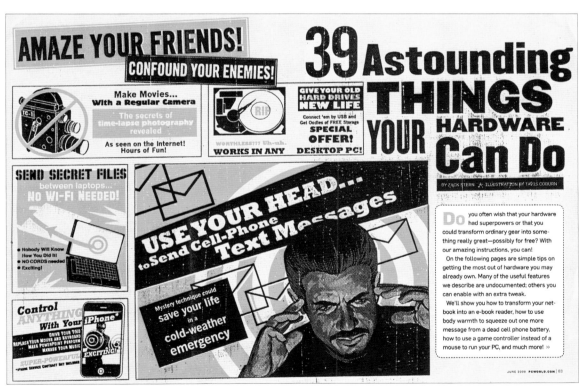

160 **Bicycling Magazine**

DESIGN DIRECTOR: David Speranza.
ART DIRECTOR: Erin Benner.
DESIGNER: Ashley Freeby.
ILLUSTRATOR: Jonathan Carlson.
DIRECTOR OF PHOTOGRAPHY: Stacey Emenecker.
PHOTO EDITOR: Kaitlin Marron.
PUBLISHER: Rodale. ISSUE: September 2009.
CATEGORY: Design: Feature: Service (single/spread)

161 **PC World**

ART DIRECTOR: Beth Kamoroff.
DESIGNER: Beth Kamoroff
ILLUSTRATOR: Tavis Coburn.
PUBLISHER: PC World Comunications, Inc.
ISSUE: June 2009.
CATEGORY: Design: Feature: Service (single/spread)

106

SECTION:
design

AWARD:
merit

CATEGORY:
service (story)

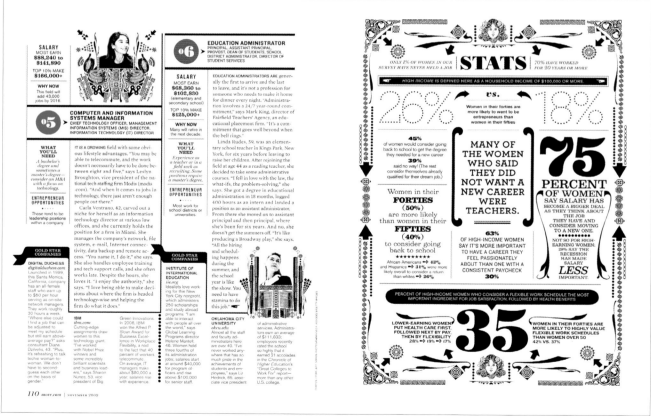

162 **More**

CREATIVE DIRECTOR: Debra Bishop. ART DIRECTOR: Claudia de Almeida. DESIGNER: Claudia de Almeida. ILLUSTRATOR: Lorenzo Petrantoni.
DIRECTOR OF PHOTOGRAPHY: Stacey Baker. PHOTO EDITOR: Natalie Gialluca. EDITOR-IN-CHIEF: Lesley Jane Seymour. PUBLISHER: Meredith Corporation.
ISSUE: November 2009. CATEGORY: Design: Feature: Service (story)

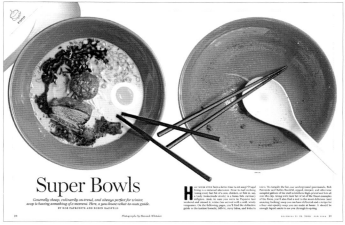

Super Bowls

Generally cheap, culinarily on-trend, and always perfect for winter. soup is having something of a moment. Here, a you-know-what-to-eat guide.

BY ROB PATRONITE AND ROBIN RAISFELD

Photographs by Hannah Whitaker

163

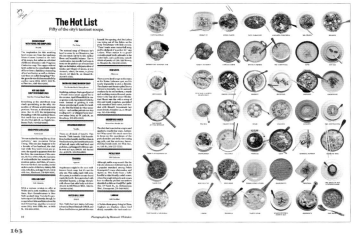

The Hot List
Fifty of the city's tastiest soups.

Photographs by Hannah Whitaker

163

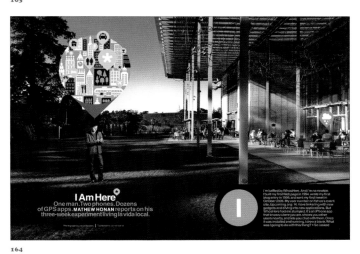

I Am Here
One man. Two phones. Dozens of GPS apps. MATHEW HONAN reports on his three-week experiment living la vida local.

164

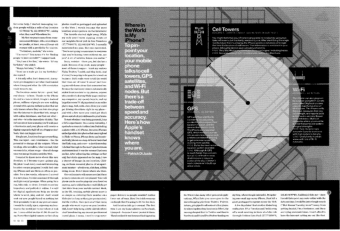

164

Esquire's ALL-YOU-CAN-EAT Breakfast

165

165

163 **New York**

DESIGN DIRECTOR: Chris Dixon.
ART DIRECTOR: Randy Minor.
DESIGNER: Hilary Fitzgibbons.
ILLUSTRATOR: John Burgoyne.
DIRECTOR OF PHOTOGRAPHY: Jody Quon.
PHOTO EDITOR: Alex Pollack.
PHOTOGRAPHER: Hannah Whitaker.
EDITOR-IN-CHIEF: Adam Moss.
PUBLISHER: New York Magazine Holdings, LLC.
ISSUE: December 21-28, 2009.
CATEGORY: Design: Feature: Service (story)

164 **WIRED**

CREATIVE DIRECTOR: Scott Dadich.
DESIGN DIRECTOR: Wyatt Mitchell.
ART DIRECTOR: Carl DeTorres.
DESIGNERS: Carl DeTorres, Walter C. Baumann.
DEPUTY PHOTO EDITOR: Anna Goldwater Alexander.
PHOTOGRAPHER: Jason Madera.
EDITOR-IN-CHIEF: Chris Anderson.
PUBLISHER: Condé Nast Publications, Inc.
ISSUE: February 2009.
CATEGORY: Design: Feature: Service (story)

165 **Esquire**

DESIGN DIRECTOR: David Curcurito.
ART DIRECTOR: Darhil Crooks.
ASSOCIATE ART DIRECTORS: Erin Jang, Soni Khatri.
PHOTO DIRECTOR: Michael Norseng.
PHOTO EDITOR: Alison Unterreiner.
PHOTO COORDINATOR: Whitney Tressel.
PHOTOGRAPHERS: Joao Canziani, Marcus Nilsson, Adam Levy.
PUBLISHER: The Hearst Corporation-Magazines Division. ISSUE: March 2009.
CATEGORY: Design: Feature: Service (story)

108

SECTION:
design

AWARD:
merit

CATEGORY:
service (story)

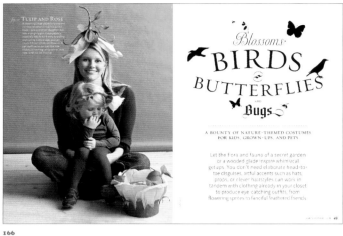

166

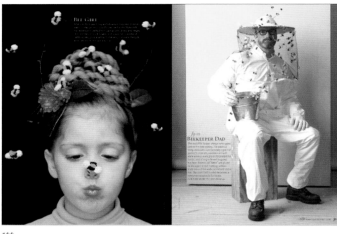

166

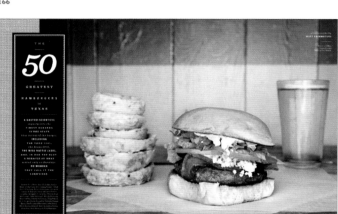

167

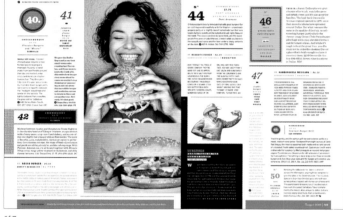

167

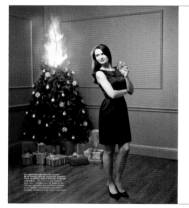

168

168

166 **Martha Stewart: Halloween**

CREATIVE DIRECTOR: Eric A. Pike.
ART DIRECTOR: William van Roden.
DESIGNER: Matthew Papa.
PUBLISHER: Martha Stewart Living Omnimedia.
ISSUE: August 31- November 1, 2009.
CATEGORY: Design: Feature: Service (story)

167 **Texas Monthly**

CREATIVE DIRECTOR: T.J. Tucker.
ART DIRECTOR: Caleb Bennett.
DESIGNER: Caleb Bennett.
ILLUSTRATOR: Bruce Hutchison.
PHOTO EDITOR: Leslie Baldwin.
PHOTOGRAPHER: Matt Rainwaters.
PUBLISHER: Emmis Publishing.
ISSUE: August 2009.
CATEGORY: Design: Feature: Service (story)

168 **Real Simple**

CREATIVE DIRECTOR: Janet Froelich.
DESIGN DIRECTOR: Cybele Grandjean.
ART DIRECTOR: Cybele Grandjean.
DESIGNER: Cybele Grandjean.
DIRECTOR OF PHOTOGRAPHY: Casey Tierney.
PHOTO EDITOR: Karen Frank.
PHOTOGRAPHER: Fredrik Broden.
PUBLISHER: Time Inc.
ISSUE: November 2009.
CATEGORY: Design: Feature: Service (story)

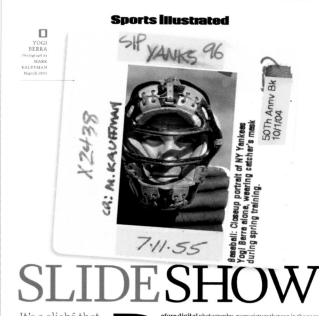

169

169

169

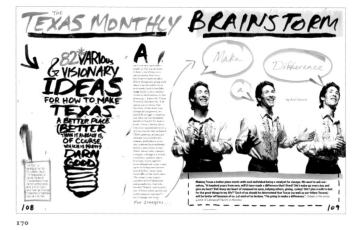

170

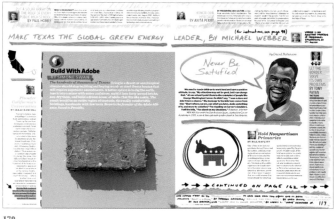

170

169 *Sports Illustrated*

DESIGN DIRECTOR: Christopher Hercik.
DESIGNER: Stephen Skalocky.
CONTRIBUTING DESIGN DIRECTOR: Steve Hoffman
PUBLISHER: Time Inc.
ISSUE: May 11, 2009.
CATEGORY: Design: Feature: Service (story)

170 *Texas Monthly*

CREATIVE DIRECTOR: T.J. Tucker.
ART DIRECTOR: Caleb Bennett.
DESIGNER: Caleb Bennett.
ILLUSTRATORS: Jennifer Daniel, Thomas Fuchs, Kevin Hand, Tamara Shopsin, Serge Bloch, Jason Munn.
PHOTO EDITOR: Leslie Baldwin.
PHOTOGRAPHER: Leann Mueller.
PUBLISHER: Emmis Publishing.
ISSUE: May 2009.
CATEGORY: Design: Feature: Service (story)

171

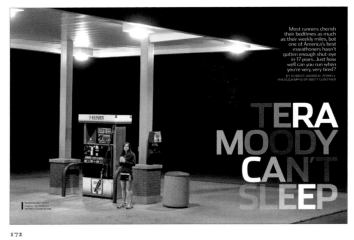

172

173

171 **Atlanta**

DESIGN DIRECTOR: Eric Capossela.
DESIGNER: Eric Capossela.
PHOTOGRAPHER: Platon / CPI Syndication.
EDITOR-IN-CHIEF: Steve Fennessy.
PUBLISHER: Emmis Communications.
ISSUE: October 2009. CATEGORY: Design: Feature:
Non-Celebrity Profile (single/spread).

172 **Runner's World**

DESIGN DIRECTOR: Kory Kennedy.
DEPUTY ART DIRECTOR: Marc Kauffman.
ASSISTANT ART DIRECTOR: Lee Williams.
PHOTO EDITOR: Andrea Maurio.
ASSOCIATE PHOTO EDITOR: Nick Galac.
ASSISTANT PHOTO EDITOR: Meg Hess.
PHOTOGRAPHER: Matt Gunther.
PRODUCTION COORDINATOR: Carly Migliori.
PUBLISHER: Rodale Inc. ISSUE: September 2009.
CATEGORY: Design: Feature: Non-Celebrity Profile
(single/spread)

173 **Minnesota Monthly**

CREATIVE DIRECTOR: Brian Johnson.
DESIGNER: Brian Johnson.
PUBLISHER: Greenspring Media Group.
ISSUE: February 2009.
CATEGORY: Design: Feature: Non-Celebrity Profile
(single/spread)

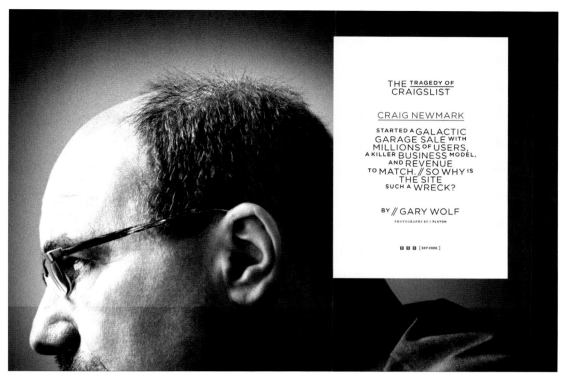

THE TRAGEDY OF CRAIGSLIST

CRAIG NEWMARK

STARTED A GALACTIC GARAGE SALE WITH MILLIONS OF USERS, A KILLER BUSINESS MODEL, AND REVENUE TO MATCH. // SO WHY IS THE SITE SUCH A WRECK?

BY // GARY WOLF

PHOTOGRAPHS BY // PLATON

[SEP 2009]

174

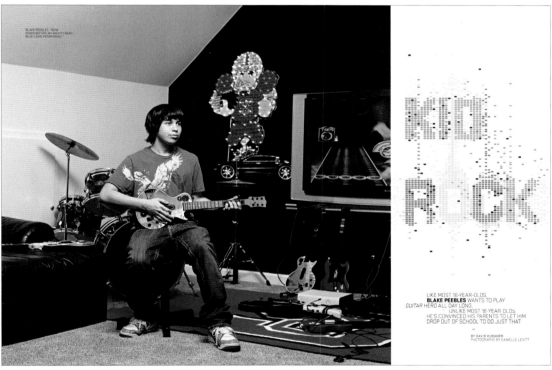

LIKE MOST 16-YEAR-OLDS, **BLAKE PEEBLES** WANTS TO PLAY *GUITAR HERO* ALL DAY LONG. UNLIKE MOST 16-YEAR-OLDS, HE'S CONVINCED HIS PARENTS TO LET HIM DROP OUT OF SCHOOL TO DO JUST THAT

BY DAVID KUSHNER
PHOTOGRAPHS BY DANIELLE LEVITT

175

174 **WIRED**

CREATIVE DIRECTOR: Scott Dadich.
DESIGN DIRECTOR: Wyatt Mitchell.
ART DIRECTOR: Carl DeTorres.
DESIGNERS: Scott Dadich, Carl DeTorres.
SENIOR PHOTO EDITOR: Zana Woods.
PHOTO EDITOR: Carolyn Rauch.
PHOTOGRAPHER: Platon.
EDITOR-IN-CHIEF: Chris Anderson.
PUBLISHER: Condé Nast Publications, Inc.
ISSUE: September 2009. CATEGORY: Design:
Feature: Non-Celebrity Profile (single/spread)

175 *Blender*

CREATIVE DIRECTOR: Dirk Barnett.
DESIGNER: Claudia de Almeida.
PHOTO EDITOR: David Carthas.
PHOTOGRAPHER: Danielle Levitt.
PUBLISHER: Alpha Media Group.
ISSUE: February 2009.
CATEGORY: Design: Feature:
Non-Celebrity Profile (single/spread)

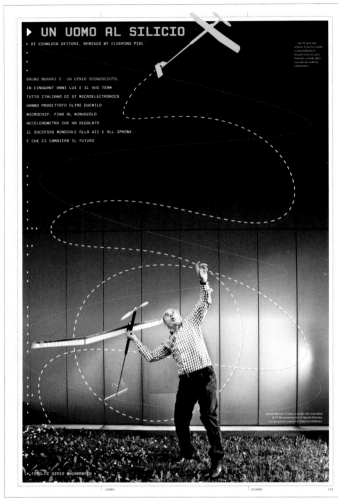

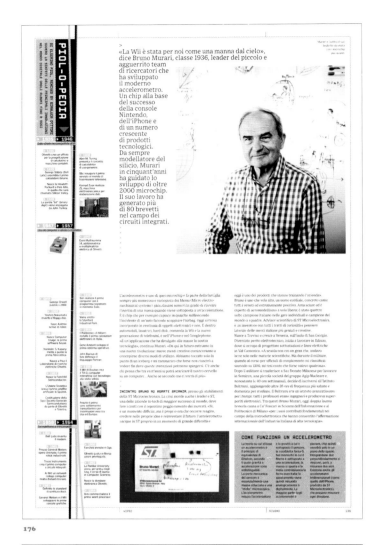

176

176

177

177

176 **WIRED Italy**

ART DIRECTOR: David Moretti.
DESIGNERS: David Moretti, Bianca Milani, Daniela Sanziani.
PHOTO EDITOR: Francesca Morosini.
PHOTOGRAPHER: Sirio Magnabosco.
EDITOR-IN-CHIEF: Riccardo Luna.
PUBLISHER: Condé Nast Italia. ISSUE: June 2009.
CATEGORY: Design: Feature: Non-Celebrity Profile (story)

177 **Rides**

CREATIVE DIRECTOR: Evan Gubernick.
ART DIRECTOR: David Zamdmer. DESIGNER: David Zamdmer.
DIRECTOR OF PHOTOGRAPHY: Tony Harmer.
PHOTO EDITOR: Andrew Link. PHOTOGRAPHER: Robert Kerian.
EDITOR-IN-CHIEF: William Gock. PUBLISHER: Harris.
ISSUE: December 2009/January 2010.
CATEGORY: Design: Feature: Non-Celebrity Profile (story)

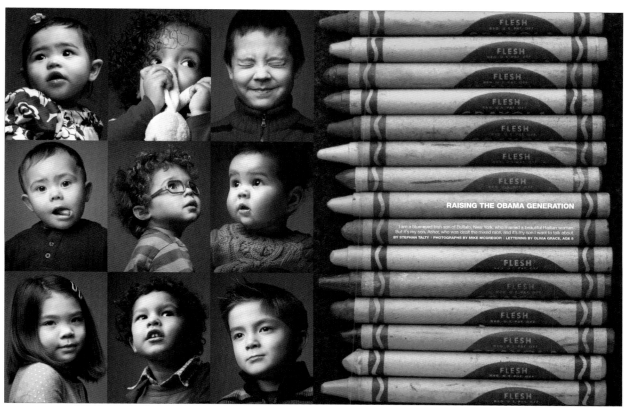

RAISING THE OBAMA GENERATION

I am a blue-eyed Irish son of Buffalo, New York, who married a beautiful Haitian woman. But it's my son, Asher, who was dealt the mixed race, and it's my son I want to talk about.
BY STEPHAN TALTY | PHOTOGRAPHS BY MIKE McGREGOR | LETTERING BY OLIVIA GRACE, AGE 8

178

SEIJAN ASHER CHRISTOPHER

his family. How, though he was as smart as any of his kids, he came to America and put in 30 years as a construction worker (which is not a job you want to have in the wintertime in Buffalo because that's what men without high school degrees did. How Marie's father, a civil engineer in Haiti, had to drive a taxi in New York City because his credentials weren't accepted here. How my mother worked as a nurse's aide, and 400 miles away, Asher's Haitian grandmother spent her days as a nurse. How they all saved money to send every one of their kids to college, but how my parents couldn't justify spending money on themselves.

I will tell Asher the story of how, when we returned to Ireland in 1979, I found my father out behind his old house, patching hay into a stack, with tears running down his face. One doesn't talk about tears in Irish-Catholic families, but perhaps they were for his father, who had died without ever meeting his grandkids.

That's what I want Asher to be proud of, the struggles my parents hardly even mentioned. I would rather Asher have my father's kindness than his eyes.

When it comes down to it, I want Asher to think of himself as black, first and foremost. That's how people will look at him. The more nuanced biography can come later in the conversation, if he cares to discuss it. Now, when he plays a video game on my iPhone, he always chooses the bearded white dude as his character. I've found myself nudging him toward the black guy. "Hey, what about this one?" I'll say. "He looks cool." Asher looks and shakes his head.

I know why. My son wants to look like me and be like me, and that is very sweet. But one day he won't be able to. Even at the risk of his rejecting me one day (I've thought about the moment when I'll walk up on him and his black friends to find a love), stricken look in his eyes), I want him to be proud of being black. He's likely to need it.

Raising Asher has made me more thoughtful about these things, and more driven too. But it has also made me harder in some ways. When I see young black dudes dressed like thugs and hanging out on local street corners—a rotten cliché, I know, but there really are black kids dressed in thug wear, hanging out on street corners half a mile from where I live—I have a different reaction now. Before, I felt a sting of sympathy for their place in life. I still hope there lives will change, but now what comes first is this thought: *Man, my kid will not be standing out there, if I have to drag him off the corner myself.* (My wife, I'm sure, will beat me to it.) I can't afford to ignore those young men just because I might otherwise come off as racist. The stakes are too high.

I recall something a young black guy said to my wife's sister on their first date. Watching some African-American men acting up at the restaurant they were eating in, he turned to her and said, "Listen, I want to get something straight. I'm a black man, *but I ain't no nigger.*" I don't ever want Asher to say that; I don't want him to believe something called a nigger even exists. But someday he will probably have to push back on black peers who want him to be more street. His skin color makes it seemingly inevitable. He could do worse than my sister-in-law's date.

But I don't want him to be whitewashed either, like that black dude at college who wore bow ties, sang tenor in the a cappella group, and was the only pledge of color at Psi U. For that reason, we won't be moving to Maine or the deep Midwest anytime soon,

I worry about teaching him the difference between plain rudeness and racism, something I often find mysterious myself.

thanks, although I once thought of raising a family there. Those places are just too white. Asher will grow up with people who look like him...and like me too.

We've made sure Asher has people to look up to on both sides of the family. He spends most weekdays with his Haitian grandmother, who lives five minutes away. My wife's family is very close. Growing up, when Marie complained that she wanted to go out with her friends, her mother would ask, "What do you need friends for? You have cousins." Asher has cousins, as well as aunts and uncles and family friends galore from which to choose. Marie reads him bedtime stories in French and chastises him in Creole when he's bad, as her mother did. The culture will be passed down.

But even in the year of our first black president, I dread some of the things that are coming, like the first time some white kid (or his parent) rejects Asher. I can foresee broken bones or harsh words. I want to be a model of strength and self-restraint for my son, but I don't think I will be able to bring it off—not the first time anyway. Black fathers go through this every day, there's no reason I should be exempt.

I worry about being too tough on him, but I don't ever want my son to be hurt if someone asks him to get his or her car at a wedding or mistakes him for a waiter. I worry about teaching him the difference between plain rudeness and racism, something I often find mysterious myself. I will have to explain why his mother winces when he goes to play with the white girls in his class and leaves the black girls alone.

Asher will do whatever he wants in the world, I'm sure. He's surrounded by love and ambition and the immigrant work ethics of two families. What I worry about is failing him, that he will need help one day and I will not know how to fix what is wrong. I just hope that I will be the equal of my father, a man who came to a harsh new world and did the right thing so consistently that he made it seem as if there were no possible option. And I hope I can pass down his goodness for Asher to have as his own. —

Asher, age 3

Asher's sister Delphine, 6 months

THE RAINBOW PROHIBITION
How to talk to your kids about that thing everybody's afraid to talk about

The very thing that makes talking to young children so much fun (their complete lack of self-awareness) can send a dad scrambling for a trapdoor when the topic turns to race. Even an innocent observation on ethnicity, when rendered in public, can convince strangers that you're raising Archie Bunker Jr. Your normal first instinct: Hush the kid up and bury the race issue with a comment such as "Not answering a child's questions about race conveys the message that something is wrong with discussing racial differences," says child psychologist Allison Briscoe-Smith, PhD, a professor at Pacific Graduate School of Psychology, who has focused much of her studies on understanding children's perceptions of race. "Instead, research suggests that parents should be proactive and use their children's curiosity as a way to begin the conversation." Here are three key points to get you started:

DETERMINE YOUR OWN HANG-UPS
If you're not comfortable talking about race, your kids will notice and it will feel like something taboo when you bring it up, says Carmen Van Kerckhove, founder and publisher of AntiRacistParent.com, a great resource for parents who want to talk about race with their kids. Find out where your hang-ups are by talking more openly about race with your spouse or peers and tuning in for the specific topics that make you uncomfortable—and then educate yourself by reading a book or two on the subject (try "Why Are All the Black Kids Sitting Together in the Cafeteria?" A Psychologist Explains the Development of Racial Identity, by Beverly Daniel Tatum). By the time your have to deal with your kids' questions, the answers will come naturally, so you won't give the impression that race conversations are something strange or off-limits.

DON'T BE DEFENSIVE
Kids often make blunt statements about racial differences, and while they're embarrassing for parents to overhear, they're just signs of natural curiosity, not inherent racism. The last thing you should do is shush your child or act as if he or she did something wrong by saying that your child "didn't mean that at home," says Briscoe-Smith. "Instead, react by asking questions and engaging in a conversation about the comment," she advises. This may feel awkward at first, but if you start an open discussion and include the other child or adult, it is the perfect opportunity to talk about race.

DIVERSIFY THE ENVIRONMENT
Make talking about race easy by fostering an environment in which the subject comes up freely—especially if you live in an area that isn't racially diverse, says Van Kerckhove. Don't limit your children to dolls and action figures with your skin color; diversify the toy box. And make sure your kids are watching TV shows that feature children of various ethnicities. "Television can be one of the best ways to bring up the subject of race with kids," says Van Kerckhove. "You can ask them questions and answer theirs." —LINDSEY ABRIHAS SETZ

BestLifeOnline.com **97**

178

DESIGN DIRECTOR: Brandon Kavulla. ART DIRECTOR: Dena Verdesca.
DESIGNERS: Dena Verdesca, Brandon Kavulla.
DIRECTOR OF PHOTOGRAPHY: Ryan Cadiz.
PHOTO EDITOR: Jeanne Graves.
PHOTOGRAPHER: Mike McGregor. LETTERING: Olivia Grace.
PUBLISHER: Rodale Inc. ISSUE: March 2009.
CATEGORY: Design: Feature: Non-Celebrity Profile (story)

114

SECTION:
design

AWARD:
merit

CATEGORY:
non-celebrity profile (story)

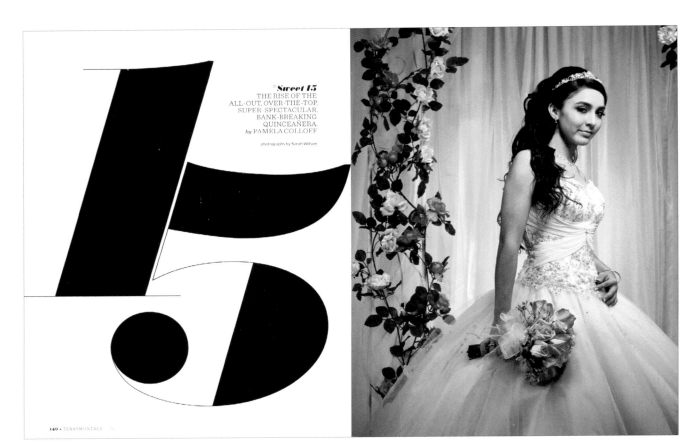

"Sweet 15
THE RISE OF THE
ALL-OUT, OVER-THE-TOP,
SUPER-SPECTACULAR,
BANK-BREAKING
QUINCEAÑERA.
by PAMELA COLLOFF

photographs by Sarah Wilson

140 • TEXASMONTHLY

179

Elizabeth's upcoming quinceañera, the "sweet fifteen" celebration that would mark her transition into adulthood and reaffirm her commitment to Catholicism.

"Everything is going to be pink," Elizabeth was saying. "And there's going to be a chocolate fountain and an ice sculpture that looks like a diamond—" She could hardly get the words out fast enough. She was pretty and petite, with a luminous complexion and dark brown hair that ran all the way down her back. "My court is going to do a waltz with me, and then we're going to do the cha-cha, but a hip-hop version," she said. "I have the most amazing choreographer."

Bertha smiled at her daughter's enthusiasm. "When I was her age, I wanted a sweet sixteen—something really *American*, you know?" she told me. She was thin and high energy; when she spoke, she emphasized her words with her hands. "But things have changed so much. Now most of Elizabeth's friends are having quinceañeras. She went to four just last month."

Elizabeth nodded wearily and then exhaled. "Some girls ask for a trip instead, or they want a car," she said. "But you can always take a trip. And you have to get a car when you go to college, anyway."

"Oh, really?" Bertha said, turning in her chair. "You have to get a car?"

"I'm just saying—you only turn fifteen once," Elizabeth said. "It's now or never. You only get one chance to have a quinceañera."

Bertha laughed. "My quinceañera was much simpler than Elizabeth's will be," she said. "My mom made my dress. The party was in the parish hall of our church, and my family prepared the food—mole, beans, and rice. We had mariachis, but I didn't have a court, so I just danced with my cousins." She sighed. "It was perfect, but Elizabeth's quinceañera has to be more than perfect," she said.

"Mom, it will be amazing," Elizabeth said.

"I'm in the position that I can offer her more than I had, and I'm proud that I can do that," Bertha explained. She was a receptionist at a local bank, she told me, and her husband was in construction. "We're not rich, but we've been saving for this for a long time," she said.

"Mom's been thinking about my quinceañera since the day I was born," Elizabeth added.

he theme is going to be pink diamonds," Elizabeth Miranda was telling me, trying to make herself heard over the mariachis who were serenading a nearby table. We were sitting in the corner of a mostly empty Mexican restaurant in McAllen, and Elizabeth was wearing pink sweatpants, a pink hoodie, a pink T-shirt, pink-and-white Nikes, and pink nail polish. Even the tiny rubber bands on her braces were pink. It was two weeks before her fifteenth birthday, and she and her mother, Bertha Lopez, had agreed to meet me to discuss

148 • TEXASMONTHLY

"It's true," Bertha said. "In my family, you *have* to have a quinceañera. There's no getting out of it. I never gave her an option."

"I always wanted one, anyway," Elizabeth said. "I mean, I'm proud of my culture. And I wanted a pretty dress. And a big party."

"A quinceañera is like a wedding without the groom and the commitment," Bertha said. "But you still have all the stress, all the money ..." She leaned closer and lowered her voice. "Elizabeth actually had the audacity to ask me the other day. 'So, Mom, what are you going to give me for my birthday?' And I was like, 'Are you serious?'"

"You know, a nice dinner, a cake ..." Elizabeth said, giggling.

"Mind you, I've been planning this party for a year and a half," Bertha said. "We went out two hundred invitations, and I glued fifteen pink rhinestones onto every single one. I've glued them onto forks, cake plates, champagne flutes. Our kitchen is covered in pink rhinestones. My husband walked in the other night and said, 'You didn't do any of this when we got married!' And I said, 'That was just our wedding,'" she remembered, laughing. "'This is our daughter's quinceañera.'"

had come to the Rio Grande Valley in hopes of understanding why lavish quinceañeras have suddenly become so popular. What used to be a simple, down-home tradition—a pale pink dress, a blessing at the church, and a backyard fiesta with some barbacoa and a norteño band and *papel picado* for decoration—has morphed into something grander, pricier, showier, more American. Just a decade ago, no one could have foreseen the stretch Hummves, the catered sit-down dinners for four hundred, the grand entrances on carriages and thrones, the smoke machines and light shows and music videos starring the birthday girl, the baroque

OPENING SPREAD ELIZABETH MIRANDA, PHOTOGRAPHED ON DECEMBER 11, 2008, IN McALLEN. THIS PAGE QUINCEAÑERA GOWNS AT BELLISSIMA, IN McALLEN, WHICH WAS SPUN OFF FROM A BRIDAL STORE AFTER THE QUINCEAÑERA BOOM.

TEXASMONTHLY • 143

179

179 **Texas Monthly**

CREATIVE DIRECTOR: T.J. Tucker. ART DIRECTOR: Caleb Bennett. DESIGNER: Caleb Bennett. PHOTO EDITOR: Leslie Baldwin. PHOTOGRAPHER: Sarah Wilson.
PUBLISHER: Emmis Publishing. ISSUE: March 2009. CATEGORY: Design: Feature: Non-Celebrity Profile (story)

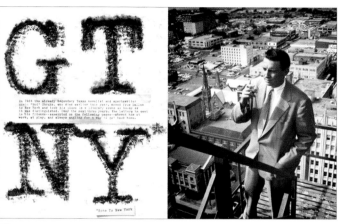

Masters of Mid-Century California Modernism

One day in 1949, Evelyn and Jerome Ackerman, young newlywed art students, went to the Detroit Institute of Arts to see "For Modern Living," an exhibition organized by the architect Alexander Girard that surveyed the new wave of postwar design. What they saw dazzled them. "It opened our eyes," Jerome, now 89, remembers. "It was something. There was Eames furniture, V'Soške carpets, Kurt Versen lighting. We walked through all that and just said, wow." Here, for their generation, was a fresh and exciting,

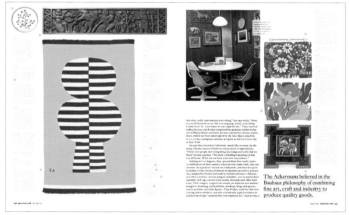

The Ackermans believed in the Bauhaus philosophy of combining fine art, craft and industry to produce quality goods.

180 *Texas Monthly*
CREATIVE DIRECTOR: T.J. Tucker.
ART DIRECTOR: Andi Beierman.
DESIGNER: Andi Beierman.
PHOTO EDITOR: Leslie Baldwin.
PHOTOGRAPHERS: Michael Thad Carter,
Caleb Bennett. PUBLISHER: Emmis Publishing.
ISSUE: April 2009. CATEGORY: Design: Feature:
Non-Celebrity Profile (story)

181 *Texas Monthly*
CREATIVE DIRECTOR: T.J. Tucker.
ART DIRECTOR: Andi Beierman.
DESIGNER: Andi Beierman.
PHOTO EDITOR: Leslie Baldwin.
PHOTOGRAPHER: Randal Ford.
PUBLISHER: Emmis Publishing.
ISSUE: November 2009 CATEGORY: Design:
Feature: Non-Celebrity Profile (story)

182 *American Craft Magazine*
CREATIVE DIRECTOR: Jeanette Abbink.
DESIGNERS: Natasha Chandani, Jeanette Abbink.
PHOTOGRAPHER: Anne Cussack.
STUDIO: Rational Beauty.
EDITOR-IN-CHIEF: Andrew Wagner.
PUBLISHER: American Craft Council.
CLIENT: American Craft Council.
ISSUE: June/July 2009. CATEGORY: Design:
Feature: Non-Celebrity Profile (story).

116

SECTION:
design

AWARD:
merit

CATEGORY:
celebrity/entertainment profile

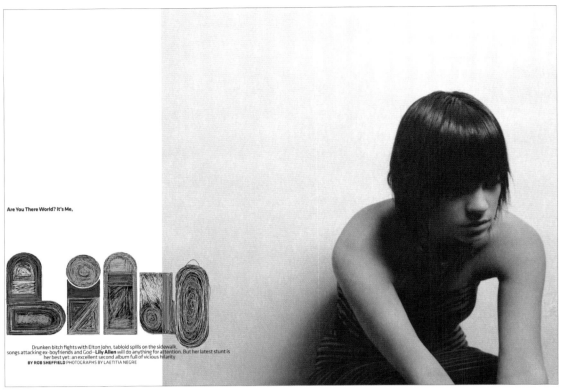

183

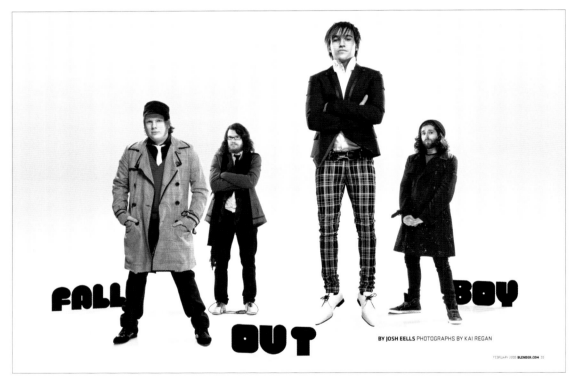

184

183 Blender

CREATIVE DIRECTOR: Dirk Barnett. DESIGNER: Dirk Barnett.
DIRECTOR OF PHOTOGRAPHY: David Carthas.
PHOTO EDITOR: Chris Ehrmann. PHOTOGRAPHER: Laetitia Negre.
PUBLISHER: Alpha Media Group. ISSUE: March 2009.
CATEGORY: Design: Feature: Celebrity/Entertainment Profile (single/spread)

184 Blender Magazine

CREATIVE DIRECTOR: Dirk Barnett. DESIGNERS: Dirk Barnett,
Claudia de Almeida. DIRECTOR OF PHOTOGRAPHY: David Carthas.
PHOTO EDITORS: Chris Ehrmann, Rory Walsh.
PHOTOGRAPHER: Kai Regan. EDITOR-IN-CHIEF: Joe Levy.
PUBLISHER: Alpha Media Group. ISSUE: February 2009.
CATEGORY: Design: Feature: Celebrity/Entertainment Profile (single/spread)

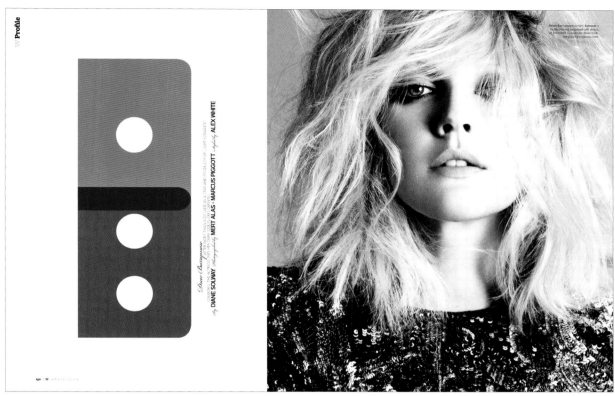

185

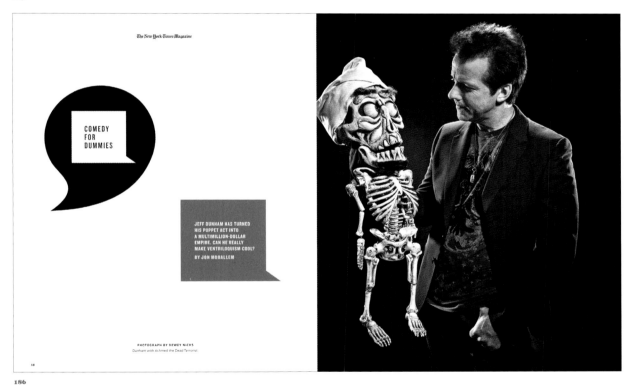
186

185 **W**
DESIGN DIRECTOR: Edward Leida. ART DIRECTOR: Nathalie Kirsheh.
DESIGNER: Nathalie Kirsheh. PHOTOGRAPHERS: Mert Alas,
Marcus Piggott. PUBLISHER: Condé Nast Publications Inc.
ISSUE: April 2009. CATEGORY: Design: Feature: Celebrity/Entertainment
Profile (single/spread)

186 ***The New York Times Magazine***
DESIGN DIRECTOR: Arem Duplessis. ART DIRECTOR: Gail Bichler.
DESIGNER: Robert Vargas. DIRECTOR OF PHOTOGRAPHY: Kathy Ryan.
PHOTO EDITOR: Clinton Cargill. PHOTOGRAPHER: Dewey Nicks.
PUBLISHER: The New York Times Company. ISSUE: November 1, 2009.
CATEGORY: Design: Feature: Celebrity/Entertainment Profile (single/spread)

118

SECTION
design

AWARD:
merit

CATEGORY:
celebrity/entertainment profile

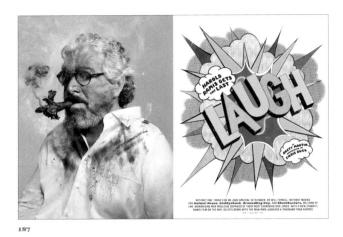

187

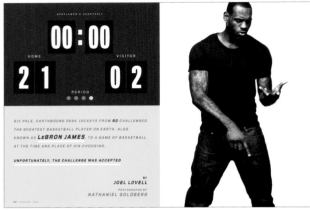

190

188

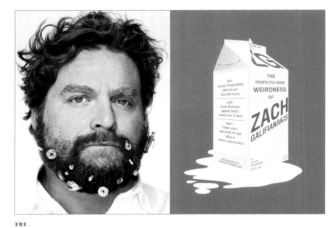

191

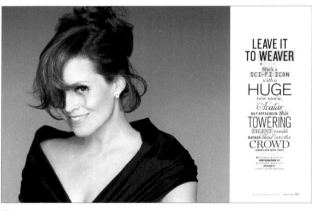

189

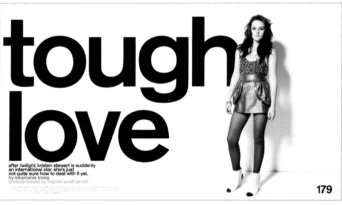

192

187 **GQ**

DESIGN DIRECTOR: Fred Woodward.
DESIGNER: Anton Ioukhnovets.
DIRECTOR OF PHOTOGRAPHY: Dora Somosi.
PHOTO EDITOR: Krista Prestek.
PHOTOGRAPHER: Chris Buck.
PUBLISHER: Condé Nast Publications Inc.
ISSUE: July 2009.
CATEGORY: Design: Feature: Celebrity/Entertainment
Profile (single/spread)

188 **GQ**

DESIGN DIRECTOR: Fred Woodward.
DESIGNER: Anton Ioukhnovets.
DIRECTOR OF PHOTOGRAPHY: Dora Somosi.
PHOTO EDITOR: Justin O'Neill
PUBLISHER: Condé Nast Publications .Inc.
ISSUE: September 2009.
CATEGORY: Design: Feature: Celebrity/Entertainment
Profile (single/spread)

189 **More**

CREATIVE DIRECTOR: Debra Bishop.
ART DIRECTOR: Claudia de Almeida.
DESIGNER: Claudia de Almeida.
DIRECTOR OF PHOTOGRAPHY: Stacey Baker.
PHOTO EDITOR: Daisy Cajas.
PHOTOGRAPHER: Matthew Rolston.
EDITOR-IN-CHIEF: Lesley Jane Seymour.
PUBLISHER: Meredith Corporation. ISSUE: December
2009/January 2010. CATEGORY: Design: Feature:
Celebrity/Entertainment Profile (single/spread)

190 **GQ**

DESIGN DIRECTOR: Fred Woodward.
DESIGNER: Thomas Alberty.
DIRECTOR OF PHOTOGRAPHY: Dora Somosi.
PHOTOGRAPHER: Nathaniel Goldberg.
CREATIVE DIRECTOR, FASHION: Jim Moore.
PUBLISHER: Condé Nast Publications Inc.
ISSUE: February 2009. CATEGORY: Design: Feature:
Celebrity/Entertainment Profile (single/spread)

191 **GQ**

DESIGN DIRECTOR: Fred Woodward.
DESIGNER: Chelsea Cardinal.
DIRECTOR OF PHOTOGRAPHY: Dora Somosi.
PHOTOGRAPHER: Martin Shoeller.
PUBLISHER: Condé Nast Publications Inc.
ISSUE: November 2009.
CATEGORY: Design: Feature: Celebrity/Entertainment
Profile (single/spread)

192 **Nylon**

ART DIRECTOR: Michael Pangilinan.
DESIGNER: Michael Pangilinan.
DIRECTOR OF PHOTOGRAPHY: Stephen Walker.
PHOTO EDITOR: Minh Nguyen.
PHOTOGRAPHER: Marvin Scott Jarrett.
PUBLISHER: Nylon LLC.
ISSUE: March 2009.
CATEGORY: Design: Feature: Celebrity/Entertainment
Profile (single/spread)

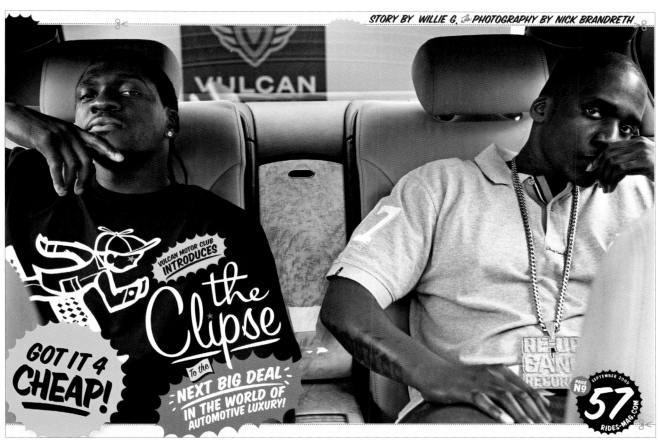

193

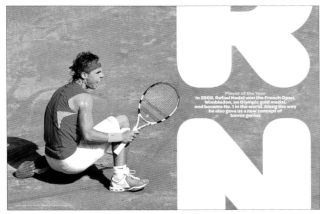

194

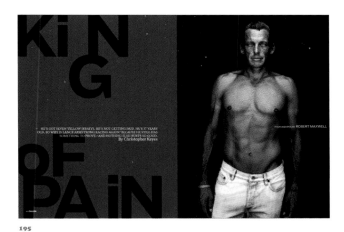

195

193 *Rides*

CREATIVE DIRECTOR: Evan Gubernick.
ART DIRECTOR: David Zamdmer.
DESIGNER: David Zamdmer.
DIRECTOR OF PHOTOGRAPHY: Tony Harmer.
PHOTO EDITOR: Andrew Link.
PHOTOGRAPHER: Nick Brandreth.
EDITOR-IN-CHIEF: William Gock.
PUBLISHER: Harris.
ISSUE: September 2009.
CATEGORY: Design: Feature: Celebrity/Entertainment
Profile (single/spread)

194 *Tennis*

CREATIVE DIRECTOR: Gary Stewart.
ASSOCIATE ART DIRECTOR: Jason Sfetko.
PHOTO EDITOR: David Rosenberg.
PHOTOGRAPHER: Getty Images.
PUBLISHER: Miller Sports Group LLC.
ISSUE: January/February 2009.
CATEGORY: Design: Feature: Celebrity/Entertainment
Profile (single/spread)

195 *Outside*

CREATIVE DIRECTOR: Hannah McCaughey.
ART DIRECTORS: John McCauley, Chris Philpot.
PHOTO EDITOR: Amy Feitelberg.
PHOTOGRAPHER: Robert Maxwell.
PUBLISHER: Mariah Media, Inc.
ISSUE: February 2009.
CATEGORY: Design: Feature: Celebrity/Entertainment
Profile (single/spread)

120 SECTION:
design

AWARD:
merit

CATEGORY:
celebrity/entertainment profile (story)

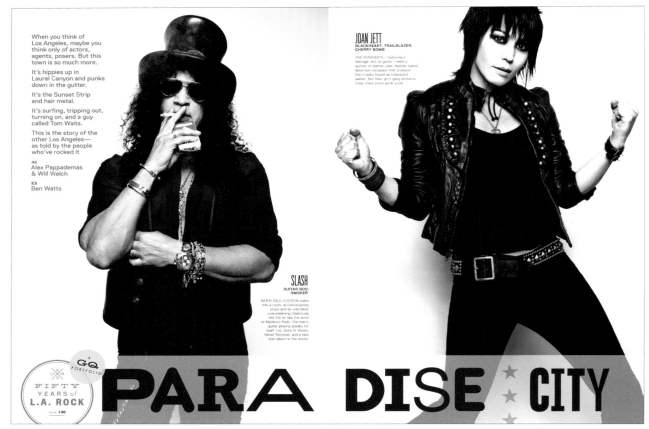

When you think of
Los Angeles, maybe you
think only of actors,
agents, posers. But this
town is so much more.

It's hippies up in
Laurel Canyon and punks
down in the gutter.

It's the Sunset Strip
and hair metal.

It's surfing, tripping out,
turning on, and a guy
called Tom Waits.

This is the story of the
other Los Angeles—
as told by the people
who've rocked it

Alex Pappademas
& Will Welch

Ben Watts

JOAN JETT
BLACKHEART, TRAILBLAZER,
CHERRY BOMB

THE RUNAWAYS—featuring a
teenage Jett on guitar—were a
quintet of leather-clad, feather-haired
demimon escapees that producer
Kim Fowley hyped as Hollywood
jailbait. But their grrrl-gang anthems
made them proto-punk icons.

SLASH
GUITAR GOD,
SMOKER

WHEN SAUL HUDSON walks
into a room, all conversation
stops and an unbridled,
overwhelming Slashitude
fills the air like the smell
of Marlboro Reds. The man's
guitar playing speaks for
itself, too: Guns N' Roses,
Velvet Revolver, and a new
solo album in the works.

PARA DISE ★ CITY

A GQ PORTFOLIO

FIFTY
YEARS of
L.A. ROCK
First **130**

196

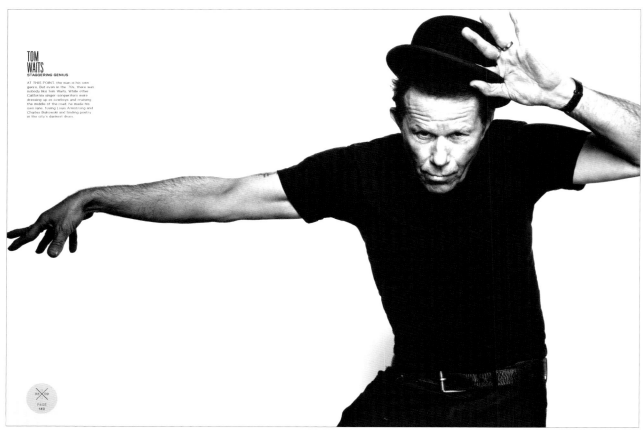

**TOM
WAITS**
STAGGERING GENIUS

AT THIS POINT, the man is his own
genre. But even in the '70s, there was
nobody like Tom Waits. While other
California singer-songwriters were
dressing up as cowboys and cruising
the middle of the road, he made his
own lane, fusing Louis Armstrong and
Charles Bukowski and finding poetry
in the city's darkest dives.

PAGE
140

196

DESIGN DIRECTOR: Fred Woodward. DESIGNER: Thomas Alberty. DIRECTOR OF PHOTOGRAPHY: Dora Somosi. PHOTO EDITOR: Krista Prestek.
PHOTOGRAPHER: Ben Watts. PUBLISHER: Condé Nast Publications Inc. ISSUE: March 2009. CATEGORY: Design: Feature: Celebrity/Entertainment Profile (story)

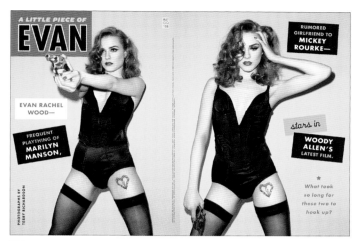

197

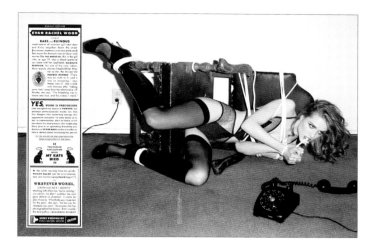

197

198

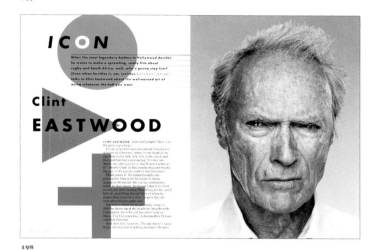

198

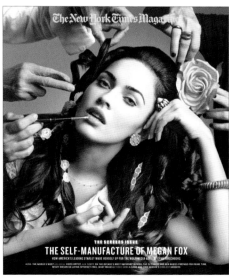

199

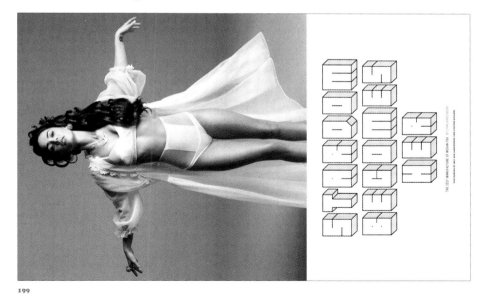

199

197 *GQ*

DESIGN DIRECTOR: Fred Woodward.
DESIGNER: Chelsea Cardinal.
DIRECTOR OF PHOTOGRAPHY: Dora Somosi.
PHOTOGRAPHER: Terry Richardson.
PUBLISHER: Condé Nast Publications Inc.
ISSUE: May 2009. CATEGORY: Design: Feature:
Celebrity/Entertainment Profile (story)

198 *GQ*

DESIGN DIRECTOR: Fred Woodward.
DESIGNER: Thomas Alberty.
DIRECTOR OF PHOTOGRAPHY: Dora Somosi.
PHOTO EDITORS: Krista Prestek, Justin O'Neill,
Jesse Lee, Jolanta Bielat, Emily Blank.
PHOTOGRAPHER: Martin Schoeller.
CREATIVE DIRECTOR, FASHION: Jim Moore.
PUBLISHER: Condé Nast Publications Inc.
ISSUE: December 2009. CATEGORY: Design: Feature:
Celebrity/Entertainment Profile (story)

199 *The New York Times Magazine*

DESIGN DIRECTOR: Arem Duplessis.
ART DIRECTOR: Gail Bichler.
DESIGNERS: Gail Bichler, Robert Vargas.
DIRECTOR OF PHOTOGRAPHY: Kathy Ryan.
PHOTOGRAPHERS: Inez van Lamsweerde,
Vinoodh Matadin.
PUBLISHER: The New York Times Company.
ISSUE: November 15, 2009. CATEGORY: Design:
Feature: Celebrity/Entertainment Profile (story)

122

SECTION:
design

AWARD:
merit

CATEGORY:
celebrity/entertainment profile (story)

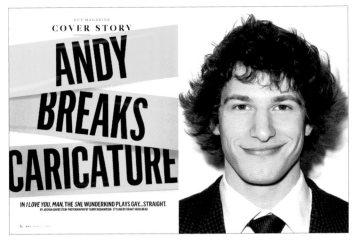

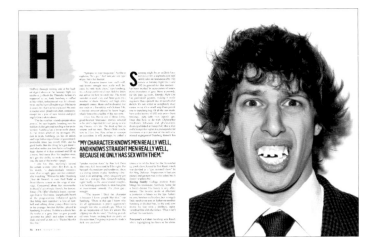

200

200

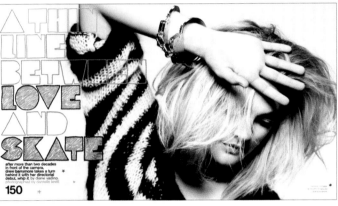

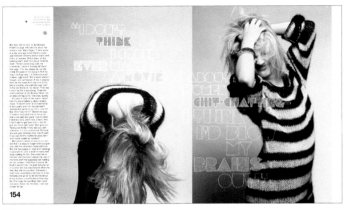

201

201

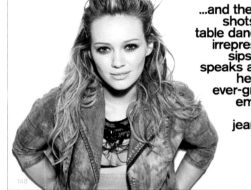

202

202

200 *Out*

CREATIVE DIRECTOR: David Gray.
ART DIRECTOR: Nick Vogelson.
DESIGNER: Jason Seldon.
DIRECTOR OF PHOTOGRAPHY: Annie Chia.
PHOTO EDITOR: Jason Rogers.
PHOTOGRAPHER: Terry Richardson.
EDITOR-IN-CHIEF: Aaron Hicklin
PUBLISHER: Here Media
ISSUE: March 2009. CATEGORY: Design: Feature:
Celebrity/Entertainment Profile (story)

201 *Nylon*

ART DIRECTOR: Michael Pangilinan.
DIRECTOR OF PHOTOGRAPHY: Stephen Walker.
PHOTOGRAPHER: Danielle Levitt.
PUBLISHER: Nylon LLC.
ISSUE: October 2009.
CATEGORY: Design: Feature: Celebrity/Entertainment
Profile (story)

202 *Nylon*

ART DIRECTOR: Michael Pangilinan.
DESIGNER: Michael Pangilinan.
DIRECTOR OF PHOTOGRAPHY: Stephen Walker.
PHOTO EDITOR: Evelien Joos.
PHOTOGRAPHER: Marvin Scott Jarrett.
PUBLISHER: Nylon LLC.
ISSUE: December 2009/January 2010.
CATEGORY: Design: Feature: Celebrity/Entertainment
Profile (story)

the revolution will be televised

consider this your tv guide.

203

30 rock
jack mcbrayer

Much like what has been not-so-subtly suggested about Tracy Morgan and his character, Tracy Jordan, on the Tina Fey-penned *30 Rock*, the Georgia Peach who is Jack McBrayer does not fall very far from Kenneth "The Page" Parcell's tree. The most obvious difference between McBrayer and Parcell is the bright Sunday morning in Los Angeles is the healthy glow he has recently acquired.

"I've gotten a little too tan this summer. I think I will have happily passed Tina Fey off," says McBrayer, laughing a contagious, lilting laugh that bounces along happily and ends in a few little squeaks. "She doesn't think that a page who's working 18 hours a day would have a nice, radiant tan like I do."

McBrayer recently returned from a trip to Hawaii, where he stayed at the same resort at which he filmed *Forgetting Sarah Marshall* a few years ago. It was a much-needed vacation, he says, which is easy to believe, given the momentum *30 Rock* seems to have gained in the past year, over its third season.

What started as a brilliant, under-appreciated show with a cult following ("I remember being so scared that I was going to make Alec Baldwin angry," McBrayer says of the early days) has quite deservedly snowballed into a brilliant, widely appreciated sitcom with a worldwide fanbase. This year alone it earned 22 Emmy nominations.

Not that McBrayer seems particularly pleased by it. "I'm just happy to have a job," he says. "TV, film, cater waiter—whatever pays the bills. I'm just going to keep on working as long as they're hiring." And there goes that laugh again.

PARK IT! Aubrey Plaza, or April Ludgate, on NBC's Amy Poehler-led *Parks and Recreation*, shares her shortlist of things she'd be happiest to find in a park.

1. A razor scooter with light-up wheels
2. A waterslide
3. A calm baby
4. A genie in a bag
5. An old woman who turns out to be me from the future

how i met your mother
cobie smulders

The concept of the sitcom *How I Met Your Mother* is a rather sentimental one: A father narrates the show from the future (voiced by Bob Saget), explaining to his children how he and their mother became acquainted, with the stories played out by the couple and their friends in present-day New York City.

That mother, Robin, is played by Canadian actress Cobie Smulders. The rest of the energetic, quip-prone ensemble (Jason Segel, Alyson Hannigan, and Neil Patrick Harris) often recalls some other Friends in New York City who once ruled the laugh track (except in this case, they wile away their time in a Midtown sports bar, not Central Perk).

"I'd never really done comedy before and wasn't very comfortable with making people laugh. Now it seems like comedic parts are all that's coming at me," Smulders says, shrugging her shoulders and smiling. "It's a great thing to go to work and just try to make people laugh. If you fall on your face, you just try something else. I've learned a lot of humility through that process."

Now entering its fifth season, it seems *HIMYM* has finally hit its stride in a way that allows it to stand on its own outside of a catchy premise. "Now with TV shows, you sort of need to start with a gimmick," explains Smulders. "But by this point, we hope that people are more interested in the characters." MR

Season 5 of *How I Met Your Mother* premieres Sept. 21 on CBS.

203

ART DIRECTOR: Michael Pangilinan. DESIGNER: Michael Pangilinan. DIRECTOR OF PHOTOGRAPHY: Stephen Walker. PHOTO EDITOR: Evelien Joos. PHOTOGRAPHERS: Lauren Dukoff, Dorothy Hong, Tara Darby. EDITOR-IN-CHIEF: Marvin Scott Jarrett. PUBLISHER: Nylon LLC. ISSUE: September 2009. CATEGORY: Design: Feature: Celebrity/Entertainment Profile (story)

124

SECTION:
design

AWARD:
merit

CATEGORY:
celebrity/entertainment profile (story)

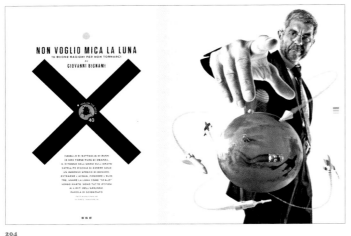

204

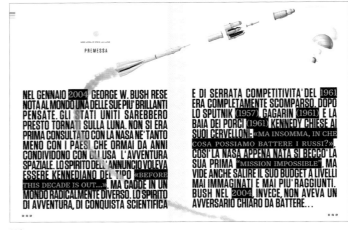

204

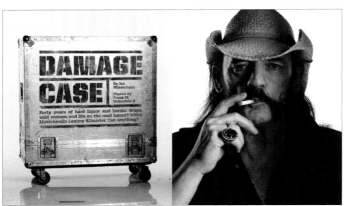

205

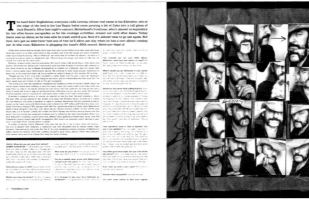

205

206

206

204 **WIRED Italy**

ART DIRECTOR: David Moretti.
DESIGNERS: David Moretti, Bianca Milani,
Daniela Sanziani.
ILLUSTRATOR: Mirco Tangherlini.
PHOTO EDITOR: Francesca Morosini.
PHOTOGRAPHER: Max & Douglas.
EDITOR-IN-CHIEF: Riccardo Luna.
PUBLISHER: Condé Nast Italia.
ISSUE: July 2009. CATEGORY: Design: Feature:
Celebrity/Entertainment Profile (story)

205 **Inked**

CREATIVE DIRECTOR: Todd Weinberger.
DIRECTOR OF PHOTOGRAPHY: Marya Gullo.
PHOTO EDITOR: Josh Clutter.
PHOTOGRAPHER: Frank W. Ockenfels 3.
PUBLISHER: Pinchazo Publishing.
ISSUE: December 2009. CATEGORY: Design: Feature:
Celebrity/Entertainment Profile (story)

206 **WIRED**

CREATIVE DIRECTOR: Scott Dadich.
DESIGN DIRECTOR: Wyatt Mitchell.
ART DIRECTOR: Maili Holiman.
DESIGNERS: Maili Holiman, Victor Krumennacher.
PHOTO EDITOR: Carolyn Rauch.
PHOTOGRAPHER: Jill Greenberg.
EDITOR-IN-CHIEF: Chris Anderson.
PUBLISHER: Condé Nast Publications, Inc.
ISSUE: November 2009. CATEGORY: Design: Feature:
Celebrity/Entertainment Profile (story)

207

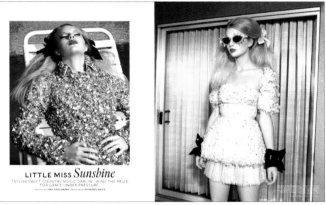

207

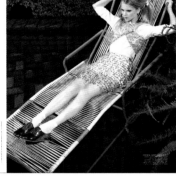

208

208

207 *Latina*

CREATIVE DIRECTOR: Florian Bachleda
DESIGN DIRECTOR: Denise See.
DIRECTOR OF PHOTOGRAPHY: George Pitts.
PHOTO EDITOR: Jennifer Sargent.
STUDIO: FB Design.
PUBLISHER: Latina Media Ventures.
CLIENT: Latina Magazine. CATEGORY: Design:
Feature: Celebrity/Entertainment Profile (story)

208 *T, The New York Times Style Magazine*

CREATIVE DIRECTOR: David Sebbah.
SENIOR ART DIRECTOR: Christopher Martinez.
DESIGNER: Christopher Martinez.
SENIOR PHOTO EDITOR: Judith Puckett-Rinella.
PHOTOGRAPHER: Raymond Meier.
PUBLISHER: The New York Times Company.
ISSUE: December 6, 2009. CATEGORY: Design: Feature:
Celebrity/Entertainment Profile (story)

126

SECTION:
design

AWARD:
merit

CATEGORY:
news/reportage

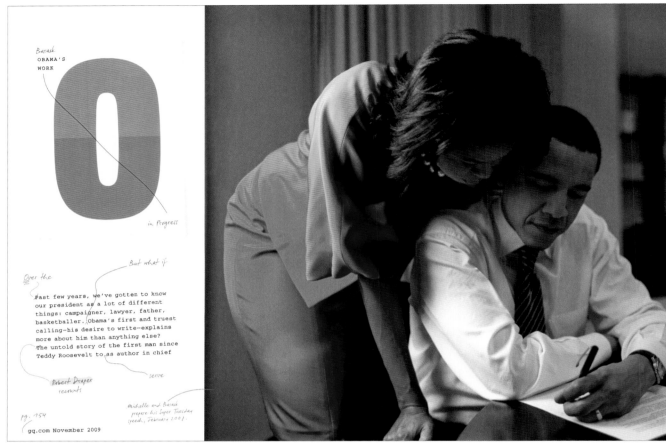

209

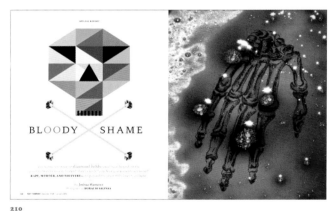

210

211

209 *GQ*

DESIGN DIRECTOR: Fred Woodward.
DESIGNER: Colin Tunstall.
DIRECTOR OF PHOTOGRAPHY: Dora Somosi.
PHOTO EDITOR: Jolanta Bielat.
PUBLISHER: Condé Nast Publications Inc.
ISSUE: November 2009. CATEGORY: Design: Feature:
News/Reportage (single/spread)

210 *Fast Company*

ART DIRECTOR: Dean Markadakis.
DEPUTY ART DIRECTOR: Jana Meier Roberts.
DIRECTOR OF PHOTOGRAPHY: Meghan Hurley.
PHOTOGRAPHER: Horacio Salinas.
PUBLISHER: Mansueto Ventures, LLC.
ISSUE: December 2009/January 2010. CATEGORY:
Design: Feature: News/Reportage (single/spread)

211 *The New York Times Magazine*

DESIGN DIRECTOR: Arem Duplessis.
ART DIRECTOR: Gail Bichler.
DESIGNERS: Leslie Kwok, Gail Bichler.
ILLUSTRATOR: Mickey Duzyj.
PUBLISHER: The New York Times Company.
ISSUE: October 4, 2009. CATEGORY: Design: Feature:
News/Reportage (single/spread)

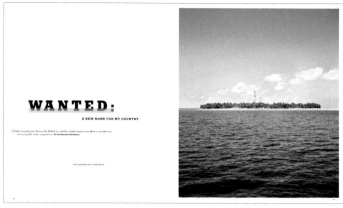

212

213

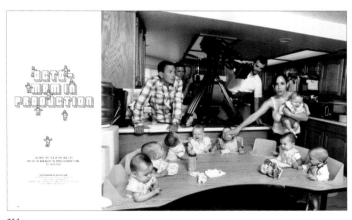

214

215

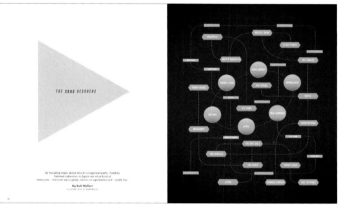

216

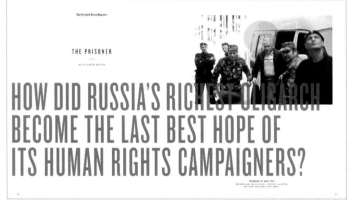

217

212 *The New York Times Magazine*

DESIGN DIRECTOR: Arem Duplessis.
DEPUTY ART DIRECTOR: Gail Bichler.
DIRECTOR OF PHOTOGRAPHY: Kathy Ryan.
PHOTO EDITOR: Clinton Cargill.
PHOTOGRAPHER: Chiara Goia.
PUBLISHER: The New York Times Company.
ISSUE: May 10, 2009. CATEGORY: Design: Feature:
News/Reportage (single/spread)

213 *The New York Times Magazine*

DESIGN DIRECTOR: Arem Duplessis.
ART DIRECTOR: Gail Bichler.
DESIGNER: Robert Vargas.
ILLUSTRATOR: Andrew Rae.
PUBLISHER: The New York Times Company.
ISSUE: September 20, 2009. CATEGORY: Design:
Feature: News/Reportage (single/spread)

214 *The New York Times Magazine*

DESIGN DIRECTOR: Arem Duplessis.
ART DIRECTOR: Gail Bichler.
DESIGNERS: Gail Bichler, Robert Vargas.
DIRECTOR OF PHOTOGRAPHY: Kathy Ryan.
PHOTO EDITOR: Joanna Milter.
PHOTOGRAPHER: Gillian Laub.
PUBLISHER: The New York Times Company.
ISSUE: November 15, 2009. CATEGORY: Design:
Feature: News/Reportage (single/spread)

215 *The New York Times Magazine*

DESIGN DIRECTOR: Arem Duplessis.
ART DIRECTOR: Gail Bichler.
DIRECTOR OF PHOTOGRAPHY: Kathy Ryan.
PHOTO EDITOR: Luise Stauss.
PHOTOGRAPHER: Tom Schierlitz.
PUBLISHER: The New York Times Company.
ISSUE: July 19, 2009. CATEGORY: Design: Feature:
News/Reportage (single/spread)

216 *The New York Times Magazine*

DESIGN DIRECTOR: Arem Duplessis.
ART DIRECTOR: Gail Bichler.
DESIGNER: Robert Vargas.
ILLUSTRATOR: Workbench.
PUBLISHER: The New York Times Company.
ISSUE: October 18, 2009. CATEGORY: Design: Feature:
News/Reportage (single/spread)

217 *The New York Times Magazine*

DESIGN DIRECTOR: Arem Duplessis.
ART DIRECTOR: Gail Bichler.
DEPUTY ART DIRECTOR: Leo Jung.
DIRECTOR OF PHOTOGRAPHY: Kathy Ryan.
PHOTO EDITOR: Luise Stauss.
PHOTOGRAPHER: James Hill .
PUBLISHER: The New York Times Company.
ISSUE: November 22, 2009. CATEGORY: Design:
Feature: News/Reportage (single/spread)

128

SECTION:
design

AWARD:
merit

CATEGORY:
news/reportage

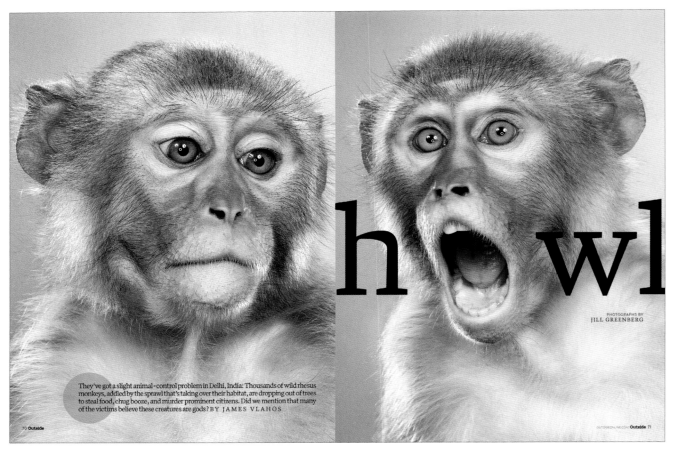

218

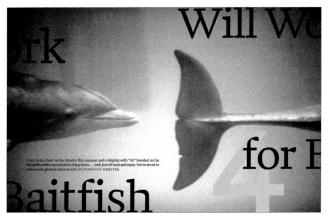

219

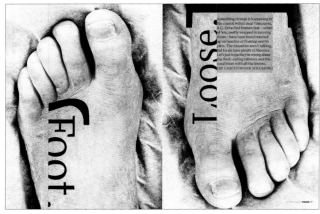

220

218 ***Outside***

CREATIVE DIRECTOR: Hannah McCaughey.
ART DIRECTORS: John McCauley, Chris Philpot.
PHOTO EDITOR: Amy Feitelberg.
PHOTOGRAPHER: Jill Greenberg.
PUBLISHER: Mariah Media, Inc.
ISSUE: February 2009 CATEGORY: Design: Feature:
News/Reportage (single/spread)

219 ***Outside***

CREATIVE DIRECTOR: Hannah McCaughey.
ART DIRECTORS: John McCauley, Chris Philpot.
PHOTO EDITORS: Amy Feitelberg, Amy Silverman.
PHOTOGRAPHER: Image Source - Corbis.
PUBLISHER: Mariah Media, Inc.
ISSUE: July 2009. CATEGORY: Design: Feature: News/
Reportage (single/spread)

220 ***Outside***

CREATIVE DIRECTOR: Hannah McCaughey.
ART DIRECTORS: John McCauley, Chris Philpot.
PHOTO EDITORS: Amy Feitelberg, Amy Silverman.
PHOTOGRAPHER: Barrett Forster - Getty.
PUBLISHER: Mariah Media, Inc.
ISSUE: October 2009. CATEGORY: Design: Feature:
News/Reportage (single/spread)

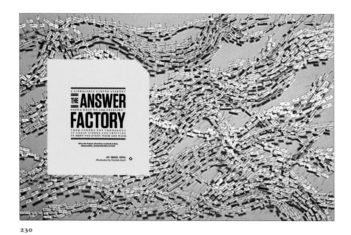

230

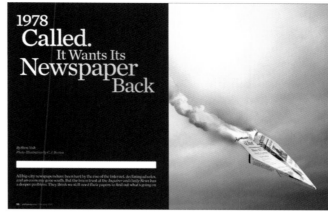

233

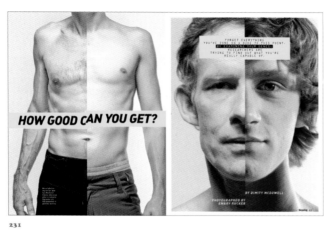

231

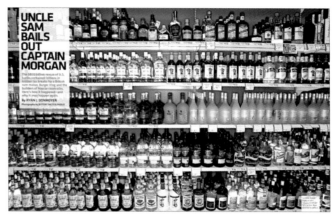

234

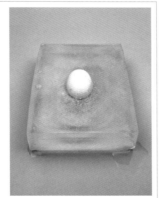

232

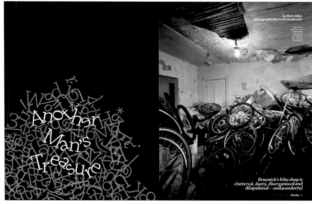

235

230 **WIRED**

CREATIVE DIRECTOR: Scott Dadich.
DESIGN DIRECTOR: Wyatt Mitchell.
ILLUSTRATOR: Stephen Doyle.
EDITOR-IN-CHIEF: Chris Anderson.
PUBLISHER: Condé Nast Publications, Inc.
ISSUE: November , 2009. CATEGORY: Design:
Feature: News/Reportage (single/spread)

231 *Bicycling Magazine*

DESIGN DIRECTOR: David Speranza.
ART DIRECTOR: Erin Benner.
DESIGNER: Ashley Freeby.
DIRECTOR OF PHOTOGRAPHY: Stacey Emenecker.
PHOTO EDITOR: Kaitlin Marron.
PHOTOGRAPHER: Embry Rucker.
PUBLISHER: Rodale. ISSUE: September 2009.
CATEGORY: Design: Feature: News/Reportage
(single/spread)

232 *Atlanta Magazine*

DESIGN DIRECTOR: Eric Capossela.
DESIGNER: Eric Capossela.
PHOTOGRAPHER: Kevin Van Aelst.
EDITOR-IN-CHIEF: Steve Fennessy.
PUBLISHER: Emmis Communications Corp.
ISSUE: May 2009. CATEGORY: Design: Feature:
News/Reportage (single/spread)

233 *Philadelphia Magazine*

DESIGN DIRECTOR: Michael McCormick.
DESIGNER: Andrew Zahn.
ILLUSTRATOR: C.J. Burton.
DIRECTOR OF PHOTOGRAPHY: Zoey Sless-Kitain
PUBLISHER: Metrocorp. ISSUE: February 2009.
CATEGORY: Design: Feature: News/Reportage
(single/spread)

234 *Bloomberg Markets*

ART DIRECTOR: John Genzo.
DEPUTY ART DIRECTOR: Evelyn Good.
DESIGNERS: Kam Tai, Ken Palmer, Cody Schneider.
DIRECTOR OF PHOTOGRAPHY: Eric Godwin.
PHOTO EDITORS: Blakely Blackford, Beth Warn.
PHOTOGRAPHER: Jeffrey Salter/Redux.
PUBLISHER: Bloomberg L.P.
ISSUE: August 2009. CATEGORY: Design: Feature:
News/Reportage (single/spread)

235 *Bicycling Magazine*

DESIGN DIRECTOR: David Speranza.
ART DIRECTOR: Erin Benner.
DESIGNER: Ashley Freeby.
DIRECTOR OF PHOTOGRAPHY: Stacey Emenecker.
PHOTO EDITOR: Kaitlin Marron.
PHOTOGRAPHER: Scott Goldsmith.
PUBLISHER: Rodale. ISSUE: December 2009.
CATEGORY: Design: Feature: News/Reportage
(single/spread)

130

SECTION·
design

AWARD·
merit

CATEGORY·
news/reportage (story)

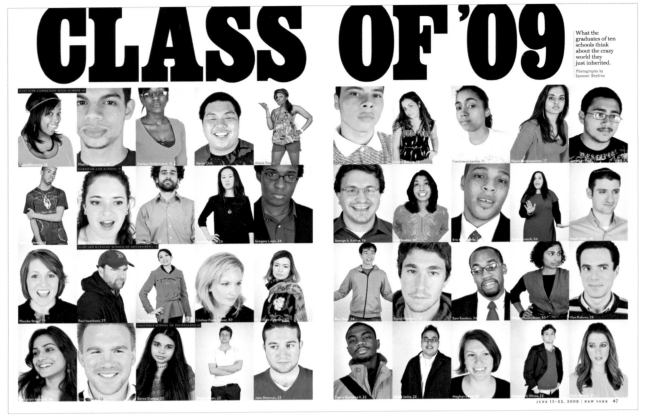

236

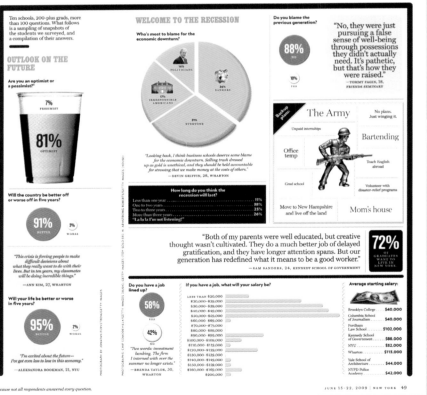

236

236 **New York**

DESIGN DIRECTOR: Chris Dixon. ART DIRECTOR: Randy Minor. DESIGNER: Randy Minor. DIRECTOR OF PHOTOGRAPHY: Jody Quon.
PHOTO EDITOR: Caroline Smith. PHOTOGRAPHER: Spencer Heyfron. EDITOR-IN-CHIEF: Adam Moss. PUBLISHER: New York Magazine Holdings, LLC.
ISSUE: June 15 - 22, 2009. CATEGORY: Design: Feature: News/Reportage (story)

237

WALKING
ON
THE
MOON
●

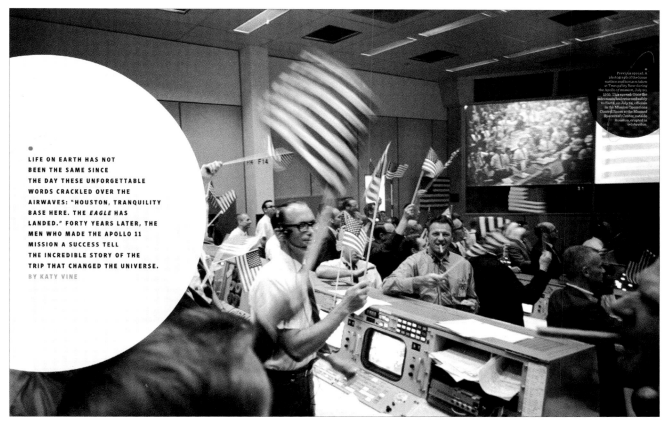

● LIFE ON EARTH HAS NOT
BEEN THE SAME SINCE
THE DAY THESE UNFORGETTABLE
WORDS CRACKLED OVER THE
AIRWAVES: "HOUSTON, TRANQUILITY
BASE HERE. THE *EAGLE* HAS
LANDED." FORTY YEARS LATER, THE
MEN WHO MADE THE APOLLO 11
MISSION A SUCCESS TELL
THE INCREDIBLE STORY OF THE
TRIP THAT CHANGED THE UNIVERSE.
BY KATY VINE

Previous spread: A
photograph of the lunar
surface and horizon taken
at Tranquility Base during
the Apollo 17 mission, July 20,
1969. This spread: Once the
astronauts had returned safely
to Earth, on July 24, officials
in the Mission Operations
Control Room at the Manned
Spacecraft Center, outside
Houston, erupted in
celebration.

237

237 **Texas Monthly**

CREATIVE DIRECTOR: T.J. Tucker. ART DIRECTOR: Caleb Bennett. DESIGNER: Caleb Bennett. PHOTO EDITOR: Leslie Baldwin.
PUBLISHER: Emmis Publishing. ISSUE: July 2009 CATEGORY: Design: Feature: News/Reportage (story)

132

SECTION:
design

AWARD:
merit

CATEGORY:
news/reportage (story)

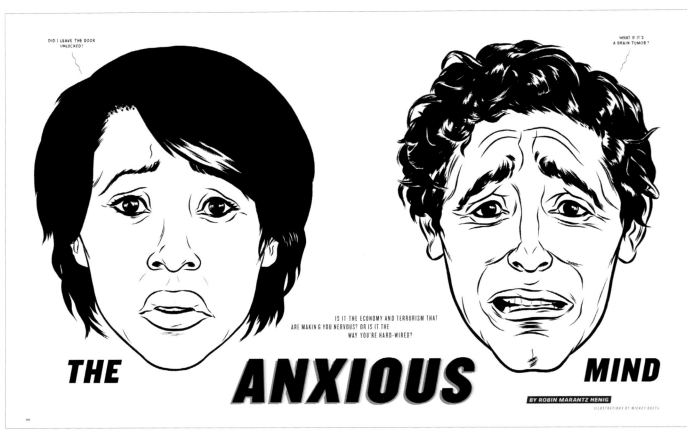

DID I LEAVE THE DOOR UNLOCKED?

WHAT IF IT'S A BRAIN TUMOR?

IS IT THE ECONOMY AND TERRORISM THAT
ARE MAKING YOU NERVOUS? OR IS IT THE
WAY YOU'RE HARD-WIRED?

THE ANXIOUS MIND

BY ROBIN MARANTZ HENIG

ILLUSTRATIONS BY MICKEY DUZYJ

stumbled upon a gigantic room "loaded with prose summaries of what these children were like from the age of 1 month on," he told me recently. He knew a treasure trove when he saw one.

Among these prose summaries, which ultimately Kagan and a colleague, Howard Moss, turned into the book "Birth to Maturity," were descriptions indicating that babies had different innate temperaments. Kagan studiously ignored this finding; it didn't fit with his left-leaning politics, which saw all individuals as born inherently the same — blank slates, to use the

paper made a splash at the time. "There are two kinds of great research," Susan Engel, a developmental psychologist at Williams College, told me when I discussed Kagan's study with her. "There's research that is counterintuitive, that shows you something you'd never guess on your own, and there's research that shows you irrefutably what you had an intuition about, something you thought was true but didn't have evidence to support." Kagan's research was of the second type, she says: "a beautiful, elegant experimental demonstration of an old intuition."

SOME OF THE BABIES GAZED CONTENTEDLY THROUGHOUT THE BATTERY OF NOVEL STIMULI. OTHERS WERE IN CONSTANT MOTION, KICKING AND MOVING THEIR ARMS FITFULLY, FURROWING THEIR BROWS, ARCHING THEIR BACKS OR CRYING IF THEY WERE REALLY UPSET.

old terminology — and capable of achieving anything if afforded the right social, economic and educational opportunities. "I was so resistant to awarding biology much influence, I didn't follow up on the inhibited temperaments I was seeing," he told me. It took another 20 years of listening to arguments about nature versus nurture for Kagan finally to entertain the possibility that some behavior might be attributed to genes.

BY THE TIME Kagan moved to Harvard in 1964, the notion of an inborn temperament was on the ascent, in part because of the findings of Stella Chess and Alexander Thomas of New York University, who divided children into three categories: easy children, difficult children and those who were slow to warm up. Remembering the Fels data, Kagan embarked on his own longitudinal study of temperament. In 1979, he screened about 400 preschoolers, exposing them to new toys and new people in a laboratory playroom, videotaping them and coding their behavior. About 15 percent ended up in the group Kagan called "behaviorally inhibited": wary, subdued, tending to hover near their mothers. Another 15 percent were "behaviorally uninhibited." They were the fearless ones, who ran around trying to play with every new toy and chatting happily with the examiner. When Kagan talks about such children, he uses one of his favorite words: "ebullient."

Over the next five years, 107 of these children — half of them timid, half bold — came back to the lab for more testing. (To keep environmental differences to a minimum, Kagan restricted his sample to children who were white, middle class and healthy at birth.) Their behavior was again recorded and again coded. Temperament, it turned out, tended to be stable over those five years, at least in children who started out at the extremes. There was a shift toward the middle between ages 2 and 7, but only 3 of the 107 changed categories completely from uninhibited to inhibited or vice versa. In addition, the most inhibited 7-year-olds showed some physiological differences that indicated an exaggerated response to stress.

Kagan and his colleagues, Nancy Snidman and J. Steven Reznick, published their results in Science in 1988. The physiological measurements led them to believe something biological was at work. Their hypothesis: the inhibited children were "born with a lower threshold" for arousal of various brain regions, in particular the amygdala, the hypothalamus and the hypothalamic-pituitary-adrenal axis, the circuit responsible for the stress hormone cortisol.

Though its findings seem almost self-evident today, the Science

But these subjects were preschoolers when Kagan first met them, already too old for him to know how much to attribute to nature rather than nurture. Couldn't the inhibited children somehow have been raised to be wary? So the following year, Kagan began a new study that he said he hoped would minimize the effects of the environment. He recruited infants who were just 4 months old, planning to categorize them according to temperament and to follow them as they grew to see whether temperament in infancy predicted anything about subsequent personality.

How to measure temperament in babies so young, at an age when some parents are still wondering whether a smile means happiness or gas? Kagan couldn't measure the amygdala directly, so he looked for signs of its rampant firing that would be meaningful — and measurable — in infants. Since projections from the amygdala connect it to brain regions that control motor activity and the autonomic nervous system (heartbeat, breathing and other involuntary actions), he reasoned that if the amygdala was highly reactive, it would show up as increased motor activity, fretting and crying, as well as increases in heart rate, respiration and blood pressure.

Showing that a few physical measurements could offer insight into a baby's psyche was one of Kagan's real contributions. "Where his work had so much depth was not only in the longitudinal follow-up," says Joan Kaufman, a Yale psychologist who was a research assistant at Harvard when the study began, "but in thinking about the behavioral phenotype of an inborn temperament and really assessing it with such rigor."

Kagan brought about 500 babies — as before, all white, middle class and healthy — into the laboratory, placed them in infant seats in front of a video camera and exposed them to a series of novel stimuli. He showed them a schematic face that emitted words in a synthetic voice designed to be what he called "discrepant but not terrifying." He dangled a dancing mobile with plastic Winnie the Pooh characters — again, nothing scary, but something new. He brought to their noses a cotton swab that had been dipped in diluted alcohol. The battery of novel stimuli took 45 minutes. Some of the babies gazed contentedly throughout. Others were in constant motion, kicking and moving their arms fitfully, furrowing their brows, arching their backs or crying if they were really upset.

Kagan and his research assistants again looked at videotapes and coded movements and cries. Based on the final tally, each infant was categorized as either low-reactive, high-reactive or somewhere in between. The low-reactives were the classic easy babies, the ones who

WHAT IF THERE'S A TERRORIST ON THE SUBWAY?

take unfamiliarity in stride. The high-reactives, among them Baby 19, thrashed and whimpered when exposed to the same unfamiliar things. It was clear, as they twisted about in their infant seats, that these babies were high-maintenance, difficult to comfort.

About 40 percent were low-reactive, and about 20 percent were high-reactive. Kagan brought most of them, as well as those with intermediate temperament, back for testing at ages 1 and 2. About half of them — primarily those at each extreme — returned for further testing at ages 4, 7, 11 and 15. That pattern continues to this day, even after Kagan retired in 2000 and handed over his records to a collaborator, Carl Schwartz, an adolescent psychiatrist at Harvard and Massachusetts General Hospital, who tested some of Kagan's subjects when they were 18 or 21.

By the earliest assessments, certain patterns had already emerged. At age 4, children who had been high-reactive were four times as likely to be behaviorally inhibited as those who had been low-reactive. By age 7, almost

half of the jittery babies had developed symptoms of anxiety — fear of thunder or dogs or darkness, extreme shyness in the classroom or playground — compared with just 10 percent of the more easygoing ones. About one in five of the high-reactive babies were consistently inhibited and fearful at every visit up to the age of 7.

"Fear is an incredibly heterogeneous construct," says Daniel Pine, a child psychiatrist at the National Institute of Mental Health. Pine collaborates on the two longitudinal studies and functional M.R.I. scans on subjects at the University of Maryland, conducting psychiatric interviews and functional M.R.I. scans on subjects at several stages. "Fear of social things is different from fear of physical things." The same brain circuitry is probably involved in both, he said, but different fears tend to show up at different points in development: fear of things like clowns, balloons or spiders emerging early in life; fear of things like social situations with peers emerging later. In addition, it's relatively easy to avoid the physical things that frighten you; if you're afraid of dogs,

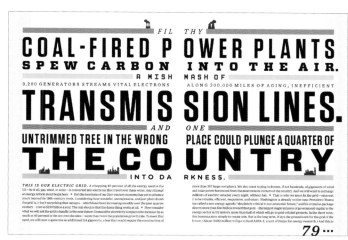

239

239

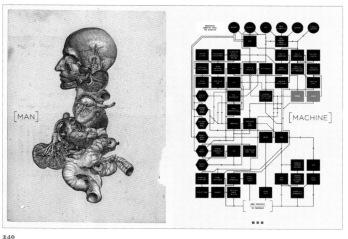

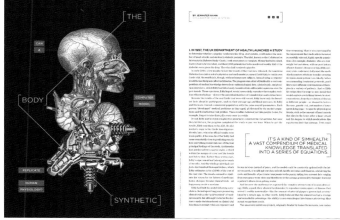

240

240

238 _The New York Times Magazine_
DESIGN DIRECTOR: Arem Duplessis.
ART DIRECTOR: Gail Bichler.
DESIGNERS: Gail Bichler, Leslie Kwok.
ILLUSTRATOR: Mickey Duzyj.
PUBLISHER: The New York Times Company.
ISSUE: October 4, 209.
CATEGORY: Design: Feature: News/Reportage (story)

239 _WIRED_
CREATIVE DIRECTOR: Scott Dadich.
DESIGN DIRECTOR: Wyatt Mitchell.
ART DIRECTOR: Christy Sheppard.
ILLUSTRATOR: Lamosca.
PHOTOGRAPHER: James Day.
EDITOR-IN-CHIEF: Chris Anderson.
PUBLISHER: Condé Nast Publications, Inc.
ISSUE: April 2009.
CATEGORY: Design: Feature: News/Reportage (story)

240 _WIRED_
CREATIVE DIRECTOR: Scott Dadich.
DESIGN DIRECTOR: Wyatt Mitchell.
ART DIRECTOR: Carl DeTorres.
ILLUSTRATOR: Dan Winters.
EDITOR-IN-CHIEF: Chris Anderson.
PUBLISHER: Condé Nast Publications, Inc.
ISSUE: December 2009.
CATEGORY: Design: Feature: News/Reportage (story)

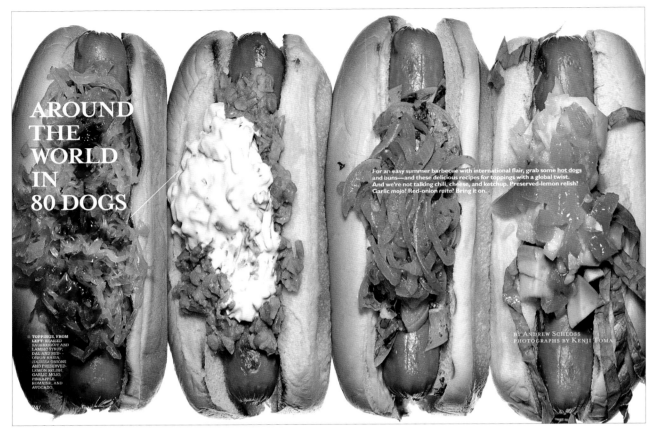

241

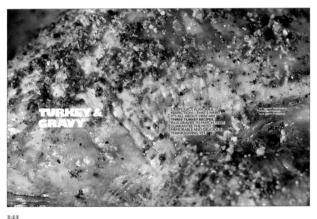
242

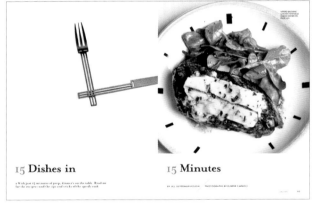
243

241 *Bon Appétit*

DESIGN DIRECTOR: Matthew Lenning.
ART DIRECTORS: Robert Festino, Tom O'Quinn.
DESIGNER: John Muñoz. DIRECTOR OF
PHOTOGRAPHY: Bailey Franklin. PHOTO EDITOR:
Angelica Mistro. PHOTOGRAPHER: Kenji Toma.
EDITOR-IN-CHIEF: Barbara Fairchild.
PUBLISHER: Condé Nast Publications, Inc.
ISSUE: July 2009. CATEGORY: Design: Feature: Travel/
Food/Still Life (single/spread)

242 *Bon Appétit*

DESIGN DIRECTOR: Matthew Lenning.
ART DIRECTORS: Robert Festino, Tom O'Quinn.
DESIGNER: John Muñoz.
DIRECTOR OF PHOTOGRAPHY: Bailey Franklin.
PHOTO EDITOR: Angelica Mistro.
PHOTOGRAPHER: Elinor Carucci.
EDITOR-IN-CHIEF: Barbara Fairchild.
PUBLISHER: Condé Nast Publications, Inc.
ISSUE: November 2009. CATEGORY: Design: Feature:
Travel/Food/Still Life (single/spread)

243 *Bon Appétit*

DESIGN DIRECTOR: Matthew Lenning.
ART DIRECTORS: Robert Festino, Tom O'Quinn.
DESIGNER: John Muñoz.
DIRECTOR OF PHOTOGRAPHY: Bailey Franklin.
PHOTO EDITOR: Angelica Mistro.
PHOTOGRAPHER: Elinor Carucci.
EDITOR-IN-CHIEF: Barbara Fairchild.
PUBLISHER: Condé Nast Publications, Inc.
ISSUE: June 2009. CATEGORY: Design: Feature:
Travel/Food/Still Life (single/spread)

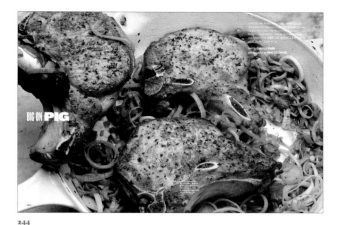

244

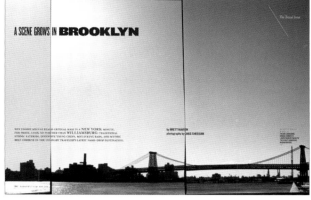

247

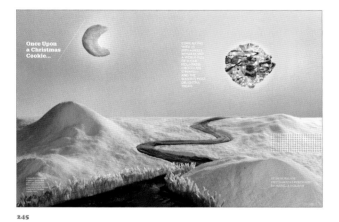

245

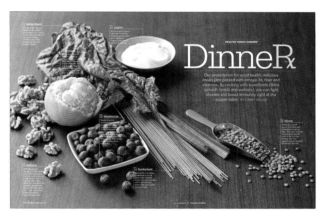

248

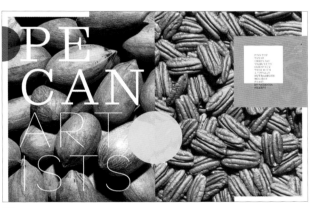

246

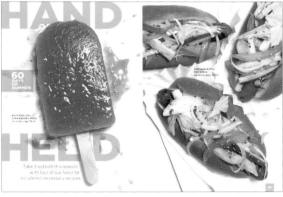

249

244 Bon Appétit

DESIGN DIRECTOR: Matthew Lenning.
ART DIRECTORS: Robert Festino, Tom O'Quinn.
DESIGNER: John Muñoz.
DIRECTOR OF PHOTOGRAPHY: Bailey Franklin.
PHOTO EDITOR: Angelica Mistro.
PHOTOGRAPHER: Hans Gissinger.
EDITOR-IN-CHIEF: Barbara Fairchild.
PUBLISHER: Condé Nast Publications, Inc.
ISSUE: May 2009. CATEGORY: Design: Feature:
Travel/Food/Still Life (single/spread)

245 Bon Appétit

DESIGN DIRECTOR: Matthew Lenning.
ART DIRECTORS: Robert Festino, Tom O'Quinn
DESIGNER: John Muñoz.
DIRECTOR OF PHOTOGRAPHY: Bailey Franklin
PHOTO EDITOR: Angelica Mistro.
PHOTOGRAPHER: Isabelle Bonjean.
EDITOR-IN-CHIEF: Barbara Fairchild.
PUBLISHER: Condé Nast Publications, Inc.
ISSUE: December 2009. CATEGORY: Design: Feature:
Travel/Food/Still Life (single/spread)

246 Texas Monthly

CREATIVE DIRECTOR: T.J. Tucker.
ART DIRECTOR: Caleb Bennett.
DESIGNER: Caleb Bennett.
PHOTO EDITOR: Leslie Baldwin.
PHOTOGRAPHER: Tom Schierlitz.
PUBLISHER: Emmis Publishing.
ISSUE: November 2009. CATEGORY: Design: Feature:
Travel/Food/Still Life (single/spread)

247 Bon Appétit

DESIGN DIRECTOR: Matthew Lenning.
ART DIRECTORS: Robert Festino, Tom O'Quinn.
DESIGNER: John Muñoz. DIRECTOR OF
PHOTOGRAPHY: Bailey Franklin.
PHOTO EDITORS: Angelica Mistro, Sara McOsker.
PHOTOGRAPHER: Jake Chessum.
EDITOR-IN-CHIEF: Barbara Fairchild.
PUBLISHER: Condé Nast Publications, Inc.
ISSUE: May 2009. CATEGORY: Design: Feature:
Travel/Food/Still Life (single/spread)

248 Family Circle Magazine

CREATIVE DIRECTOR: Karmen Lizzul.
ART DIRECTORS: Karmen Lizzul, Samantha J. Bednarek.
DESIGNER: Samantha J. Bednarek.
DIRECTOR OF PHOTOGRAPHY: Tina Anderson.
PHOTO EDITOR: Susan Hennessey.
PHOTOGRAPHER: Charles Schiller.
PUBLISHER: Meredith. ISSUE: January 2009.
CATEGORY: Design: Feature: Travel/Food/Still Life
(single/spread)

249 Everyday Food

CREATIVE DIRECTOR: Eric A. Pike.
ART DIRECTOR: Alberto Capolino.
DESIGNER: Kirsten Hilgendorf.
DIRECTOR OF PHOTOGRAPHY: Heloise Goodman.
PHOTO EDITORS: Mary Cahill, Sara Parks.
PHOTOGRAPHER: Marcus Nilsson.
EDITOR-IN-CHIEF: Anna Last.
PUBLISHER: Martha Stewart Omnimedia.
ISSUE: July/August 2009. CATEGORY: Design: Feature:
Travel/Food/Still Life (single/spread)

136

SECTION:
design

AWARD:
merit

CATEGORY:
travel/food/still life

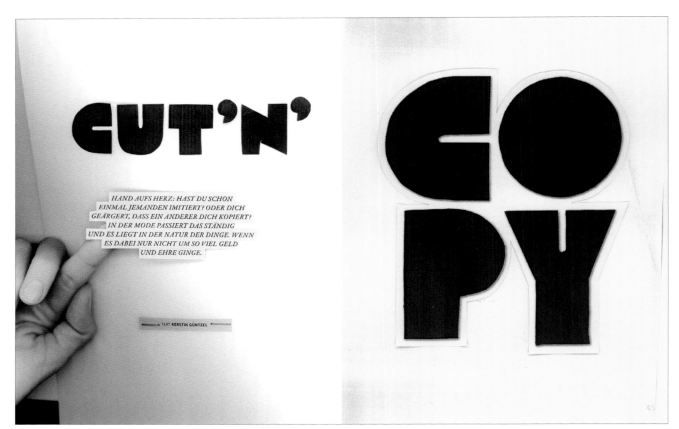

250

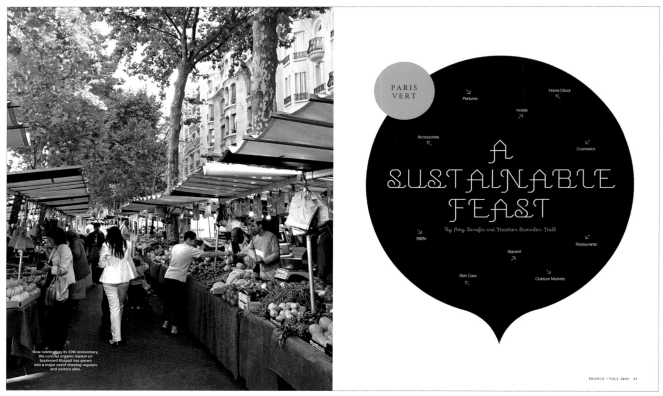

251

250 CUT - Leute machen Kleider

ART DIRECTOR: Lucie Schmid. DESIGNERS: Marta Olesniewicz,
Miriam Bloching. STUDIO: Independent Medien-Design.
EDITOR-IN-CHIEF: Anja Kellner. PUBLISHER: moser verlag GmbH.
ISSUE: September 18, 2009. ISSUE: 2. CATEGORY: Design: Feature:
Travel/Food/Still Life (single/spread)

251 France Magazine

ART DIRECTOR: Todd Albertson. DESIGNER: Todd Albertson.
PHOTO EDITOR: Patrick Nazer. STUDIO: Todd Albertson Design.
EDITOR-IN-CHIEF: Karen Taylor. PUBLISHER: French-American Cultural
Foundation. CLIENT: France Magazine. ISSUE: Fall 2009.
CATEGORY: Design: Feature: Travel/Food/Still Life (single/spread)

252

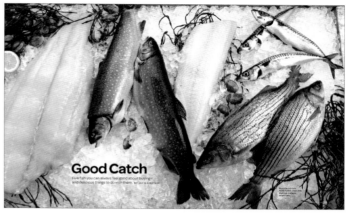

255

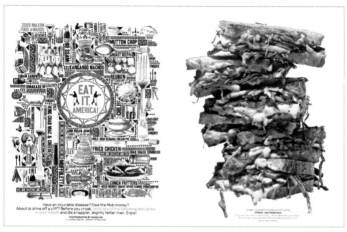

253

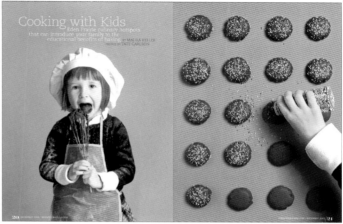

256

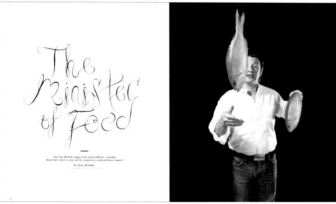

254

252 *Clase Premier*

ART DIRECTOR: Rodrigo Castillo Bonner. DESIGNER: Rodrigo Castillo Bonner.
PHOTO EDITOR: Fernanda Carrasco Espino. PHOTOGRAPHER: Adam Wiseman.
CLIENT: Aeroméxico. ISSUE: August 2009
CATEGORY: Design: Feature: Travel/Food/Still Life (single/spread)

253 *Maxim*

CREATIVE DIRECTOR: Dirk Barnett. DESIGNERS: Dirk Barnett, Billy Sorrentino.
PHOTO EDITOR: Rebecca Horn. PHOTOGRAPHER: Lorenzo Petrantoni.
EDITOR-IN-CHIEF: Joe Levy. PUBLISHER: Alpha Media Group.ISSUE: August 2009.
CATEGORY: Design: Feature: Travel/Food/Still Life (single/spread)

254 *The New York Times Magazine*

DESIGN DIRECTOR: Arem Duplessis. ART DIRECTOR: Gail Bichler.
DESIGNER: Hilary Greenbaum. ILLUSTRATOR: Jacob Magraw-Mickelson.
DIRECTOR OF PHOTOGRAPHY: Kathy Ryan.
PHOTO EDITOR: Luise Stauss. PHOTOGRAPHER: Olaf Blecker.
PUBLISHER: The New York Times Company. ISSUE: October 11, 2009.
CATEGORY: Design: Feature: Travel/Food/Still Life (single/spread)

255 *Fine Cooking*

ART DIRECTOR: Don Morris. DESIGNER: Pamela Winn.
PHOTO EDITOR: Kelly Gearity. PHOTOGRAPHER: Scott Phillips.
FOOD STYLIST: Frank Melodia. EDITOR-IN-CHIEF: Laurie Glenn Buckle.
PUBLISHER: The Taunton Press. ISSUE: October/November 2009.
CATEGORY: Design: Feature: Travel/Food/Still Life (single/spread)

256 *Eden Prairie Magazine*

CREATIVE DIRECTOR: Bryan Nanista. ART DIRECTOR: Jenna Akre.
DESIGNER: Jenna Akre. PHOTOGRAPHER: Tate Carlson.
PUBLISHER: Tiger Oak Publications. ISSUE: December 2009.
CATEGORY: Design: Feature: Travel/Food/Still Life (single/spread)

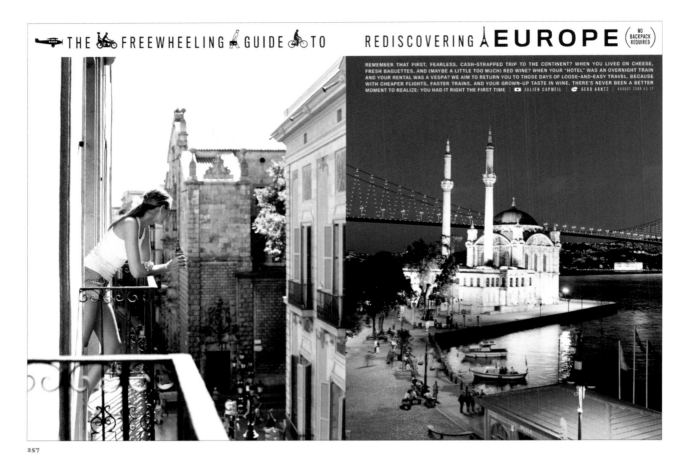

257

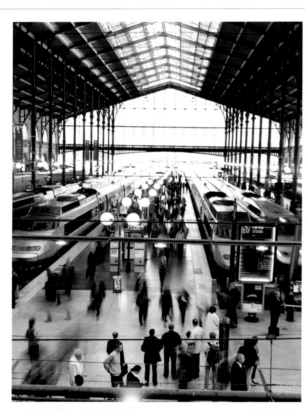

257

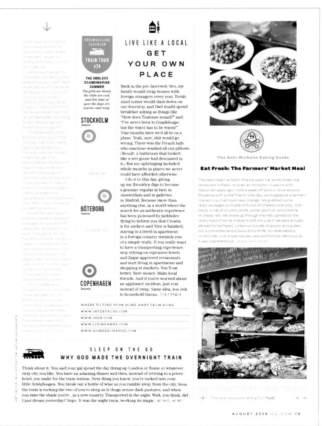

DESIGN DIRECTOR: Fred Woodward. DESIGNER: Anton Ioukhnovets. ILLUSTRATOR: Gerd Arntz. DIRECTOR OF PHOTOGRAPHY: Dora Somosi.
PHOTO EDITORS: Jesse Lee, Krista Prestek. PHOTOGRAPHER: Julien Capmeil. PUBLISHER: Condé Nast Publications Inc. ISSUE: August 2009.
CATEGORY: Design: Feature: Travel/Food/Still Life (story)

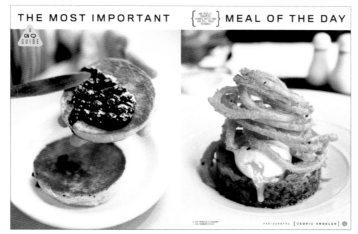

THE MOST IMPORTANT {AND DOTS/ THE ARE CHEAPEST MANNER DIRTY/ THE MOST FROM THE TRULY BED MEAL/FEATURES} MEAL OF THE DAY

258

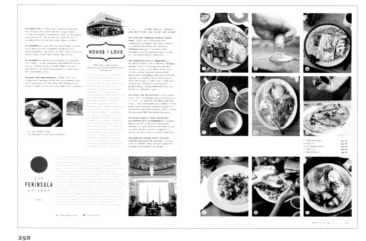

258

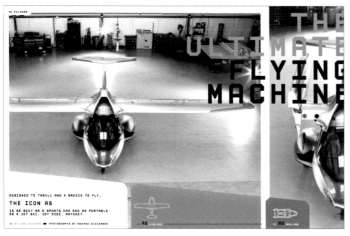

THE ICON A5

DESIGNED TO THRILL AND A BREEZE TO FLY.

IS AS SEXY AS A SPORTS CAR AND AS PORTABLE AS A JET SKI. JOY RIDE, ANYONE?

259

259

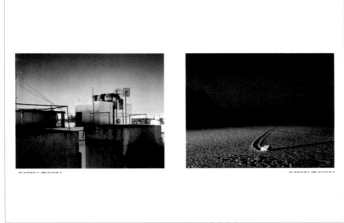

260

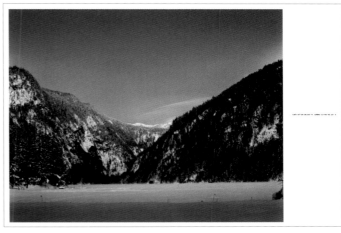

260

258 GQ

DESIGN DIRECTOR: Fred Woodward.
DESIGNER: Anton Ioukhnovets.
DIRECTOR OF PHOTOGRAPHY: Dora Somosi.
PHOTO EDITOR: Justin O'Neill.
PHOTOGRAPHER: Cedric Angeles.
PUBLISHER: Condé Nast Publications Inc.
ISSUE: March 2009. CATEGORY: Design: Feature:
Travel/Food/Still Life (story)

259 WIRED

CREATIVE DIRECTOR: Scott Dadich.
DESIGN DIRECTOR: Wyatt Mitchell.
ART DIRECTOR: Carl DeTorres.
PHOTO EDITOR: Zana Woods.
PHOTOGRAPHER: Andrew Zuckerman.
EDITOR-IN-CHIEF: Chris Anderson.
PUBLISHER: Condé Nast Publications, Inc.
ISSUE: January 2009. CATEGORY: Design:
Feature: Travel/Food/Still Life (story)

260 WIRED

CREATIVE DIRECTOR: Scott Dadich.
DESIGN DIRECTOR: Wyatt Mitchell.
ART DIRECTOR: Maili Holiman.
PHOTO EDITOR: Anna Alexander.
PHOTOGRAPHER: Uta Kögelsberger.
EDITOR-IN-CHIEF: Chris Anderson.
PUBLISHER: Condé Nast Publications, Inc.
ISSUE: May 2009. CATEGORY: Design:
Feature: Travel/Food/Still Life (story)

140

SECTION:
design

AWARD:
merit

CATEGORY:
travel/food/still life (story)

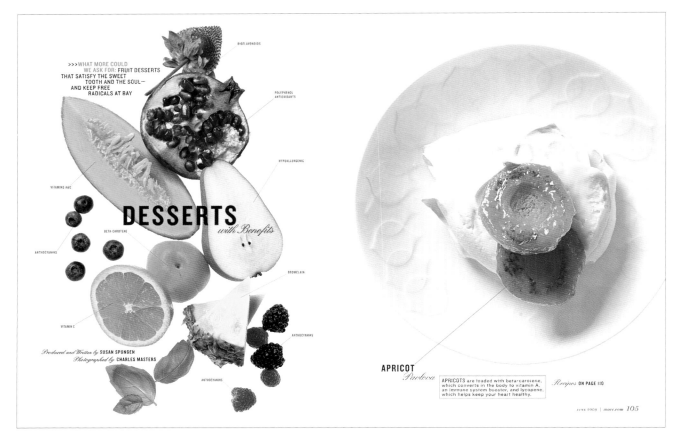

261

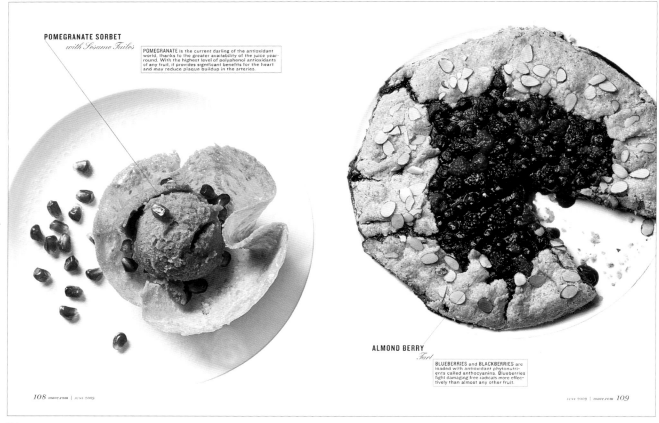

261

261 *More*

CREATIVE DIRECTOR: Debra Bishop. DESIGNER: Debra Bishop. DIRECTOR OF PHOTOGRAPHY: Stacey Baker. PHOTO EDITOR: Natalie Gialluca.
PHOTOGRAPHER: Charles Masters. EDITOR-IN-CHIEF: Lesley Jane Seymour. PUBLISHER: Meredith Corporation. ISSUE: June 2009.
CATEGORY: Design: Feature: Travel/Food/Still Life (story)

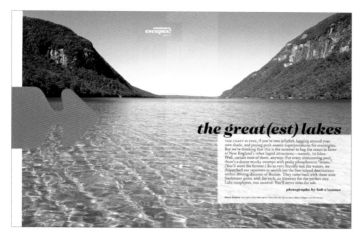

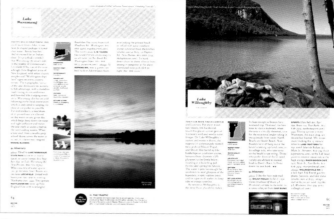

262

262

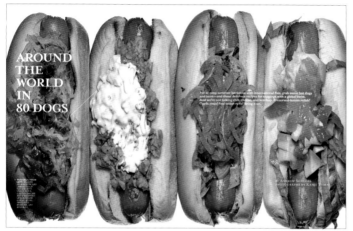

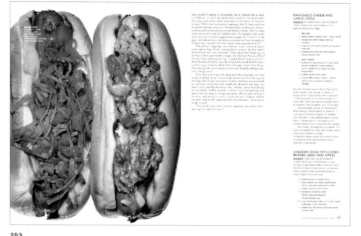

263

263

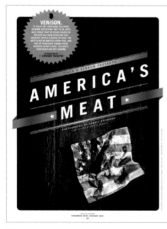
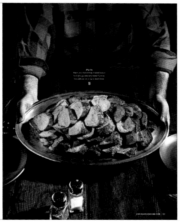

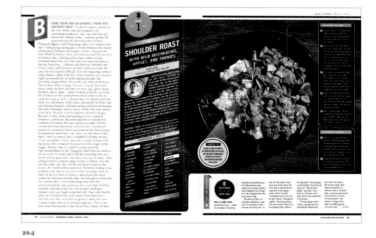

264

264

262 Boston Magazine

CREATIVE DIRECTOR: Patrick Mitchell.
ART DIRECTOR: Susannah Haesche.
DESIGNERS: Ashley Bond, Heather Burke, Betsy Halsey.
PHOTOGRAPHER: Bob O'Connor.
PUBLISHER: Metrocorp.
ISSUE: June 2009. CATEGORY: Design: Feature:
Travel/Food/Still Life (story)

263 Bon Appétit

DESIGN DIRECTOR: Matthew Lenning.
ART DIRECTORS: Robert Festino, Tom O'Quinn.
DESIGNER: John Muñoz.
DIRECTOR OF PHOTOGRAPHY: Bailey Franklin.
PHOTO EDITOR: Angelica Mistro.
PHOTOGRAPHER: Kenji Toma.
EDITOR-IN-CHIEF: Barbara Fairchild.
PUBLISHER: Condé Nast Publications, Inc.
ISSUE: July 2009. CATEGORY: Design: Feature:
Travel/Food/Still Life (story)

264 Field & Stream

ART DIRECTOR: Neil Jamieson.
DIRECTOR OF PHOTOGRAPHY: Amy Berkley.
PHOTOGRAPHER: Travis Rathbone.
FOOD STYLING: Roscoe Betsill.
PUBLISHER: Bonnier Corporation.
ISSUE: December 2009/January 2010.
CATEGORY: Design: Feature:
Travel/Food/Still Life (story)

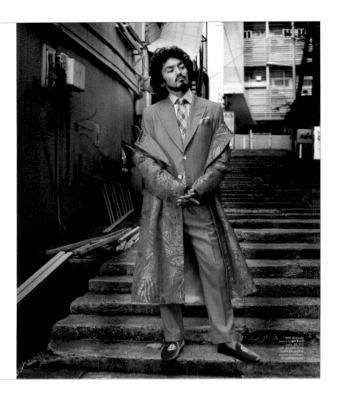

265

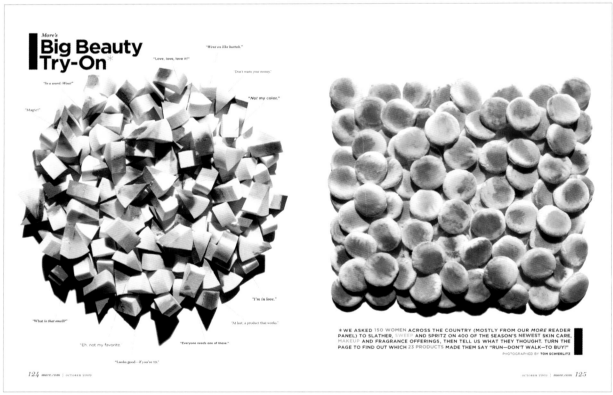

266

265 **The New York Times Magazine**

DESIGN DIRECTOR: Arem Duplessis.
ART DIRECTOR: Gail Bichler.
DESIGNER: Nancy Harris Rouemy.
DIRECTOR OF PHOTOGRAPHY: Kathy Ryan.
PHOTO EDITOR: Scott Hall.
PHOTOGRAPHER: Norbert Schoerner.
PUBLISHER: The New York Times Company.
ISSUE: February 1, 2009.
CATEGORY: Design: Feature: Fashion/Beauty
(single/spread)

266 **More**

CREATIVE DIRECTOR: Debra Bishop.
ART DIRECTOR: Cybele Grandjean.
DESIGNER: Cybele Grandjean.
DIRECTOR OF PHOTOGRAPHY: Stacey Baker.
PHOTO EDITOR: Natalie Gialluca.
PHOTOGRAPHER: Tom Schierlitz.
EDITOR-IN-CHIEF: Lesley Jane Seymour.
PUBLISHER: Meredith Corporation.
ISSUE: October 2009.
CATEGORY: Design: Feature: Fashion/Beauty
(single/spread)

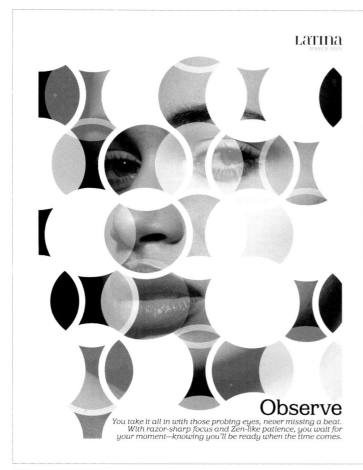

Observe

You take it all in with those probing eyes, never missing a beat. With razor-sharp focus and Zen-like patience, you wait for your moment—knowing you'll be ready when the time comes.

267

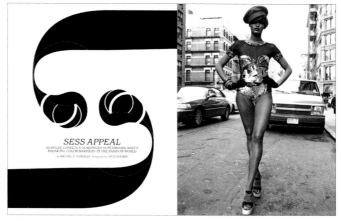

268

269

267 *Latina*

CREATIVE DIRECTOR: Florian Bachleda.
DESIGN DIRECTOR: Denise See.
DIRECTOR OF PHOTOGRAPHY: George Pitts.
PHOTO EDITOR: Jennifer Sargent.
STUDIO: FB Design.
PUBLISHER: Latina Media Ventures.
CLIENT: Latina Magazine.
CATEGORY: Design: Feature: Fashion/Beauty
(single/spread)

268 *Latina*

CREATIVE DIRECTOR: Florian Bachleda.
DESIGN DIRECTOR: Denise See.
DIRECTOR OF PHOTOGRAPHY: George Pitts.
PHOTO EDITOR: Jennifer Sargent.
STUDIO: FB Design.
PUBLISHER: Latina Media Ventures.
CLIENT: Latina Magazine.
CATEGORY: Design: Feature: Fashion/Beauty
(single/spread)

269 *Latina*

CREATIVE DIRECTOR: Florian Bachleda.
DESIGN DIRECTOR: Denise See.
DIRECTOR OF PHOTOGRAPHY: George Pitts.
PHOTO EDITOR: Jennifer Sargent.
STUDIO: FB Design.
PUBLISHER: Latina Media Ventures.
CLIENT: Latina Magazine.
CATEGORY: Design: Feature: Fashion/Beauty
(single/spread)

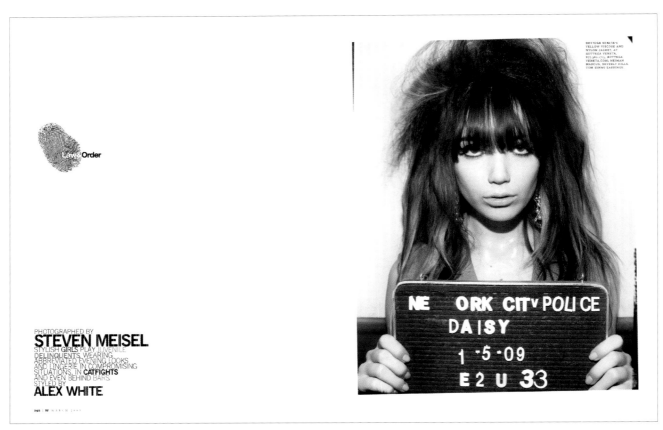

270

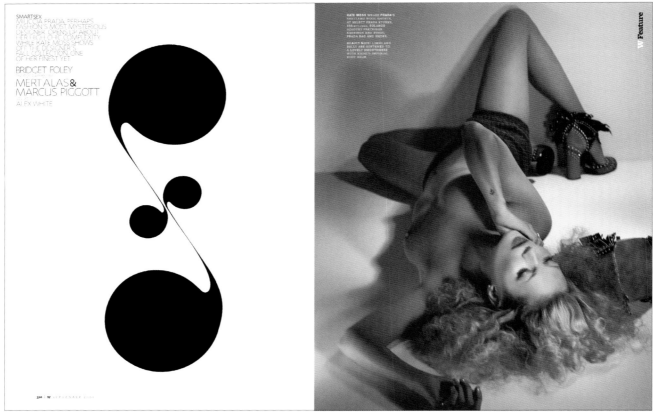

271

270 **W**

DESIGN DIRECTOR: Edward Leida. ART DIRECTOR: Nathalie Kirsheh.
DESIGNER: Edward Leida. PHOTOGRAPHER: Steven Meisel.
PUBLISHER: Condé Nast Publications Inc. ISSUE: March 2009.
CATEGORY: Design: Feature: Fashion/Beauty (single/spread)

271 **W**

DESIGN DIRECTOR: Edward Leida. ART DIRECTOR: Nathalie Kirsheh.
DESIGNER: Edward Leida. PHOTOGRAPHERS: Mert Alas, Marcus Piggott.
PUBLISHER: Condé Nast Publications Inc. ISSUE: September 2009.
CATEGORY: Design: Feature: Fashion/Beauty (single/spread)

272

275

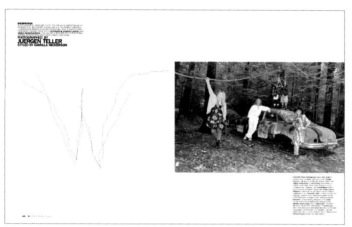

273

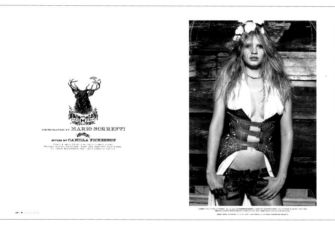

274

276

272 **W**

DESIGN DIRECTOR: Edward Leida.
ART DIRECTOR: Nathalie Kirsheh.
DESIGNER: Edward Leida.
PHOTOGRAPHER: Craig McDean.
PUBLISHER: Condé Nast Publications Inc.
ISSUE: June 2009.
CATEGORY: Design: Feature:
Fashion/Beauty (single/spread)

273 **W**

DESIGN DIRECTOR: Edward Leida.
ART DIRECTOR: Nathalie Kirsheh.
DESIGNER: Nathalie Kirsheh.
PHOTOGRAPHER: Juergen Teller.
PUBLISHER: Condé Nast Publications Inc.
ISSUE: September 2009.
CATEGORY: Design: Feature: Fashion/Beauty
(single/spread)

274 **W**

DESIGN DIRECTOR: Edward Leida.
ART DIRECTOR: Nathalie Kirsheh.
DESIGNER: Edward Leida.
PHOTOGRAPHER: Mario Sorrenti.
PUBLISHER: Condé Nast Publications Inc.
ISSUE: April 2009.
CATEGORY: Design: Feature: Fashion/Beauty
(single/spread)

275 **W**

DESIGN DIRECTOR: Edward Leida.
ART DIRECTOR: Nathalie Kirsheh.
DESIGNER: Nathalie Kirsheh.
PHOTOGRAPHER: Juergen Teller.
PUBLISHER: Condé Nast Publications Inc.
ISSUE: March 2009.
CATEGORY: Design: Feature: Fashion/Beauty
(single/spread)

276 **W**

DESIGN DIRECTOR: Edward Leida.
ART DIRECTOR: Nathalie Kirsheh.
DESIGNER: Edward Leida.
PHOTOGRAPHER: Steven Klein.
PUBLISHER: Condé Nast Publications Inc.
ISSUE: August 2009.
CATEGORY: Design: Feature: Fashion/Beauty
(single/spread)

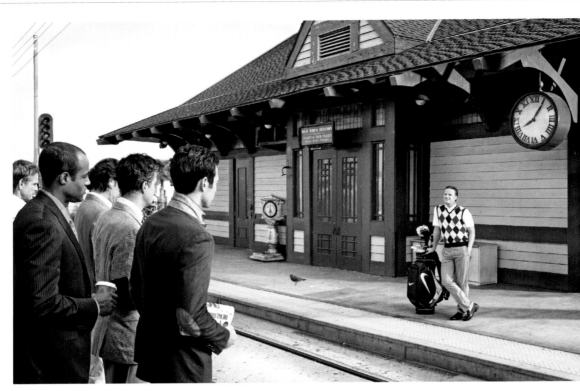

FASHION

COVER
TO
COVER

New Yorker classics, revisited.

PHOTOGRAPHS BY
ART STREIBER

STYLED BY
MARTY HACKEL

277

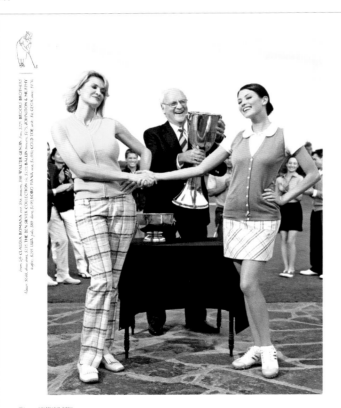

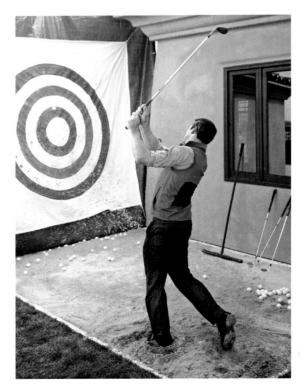

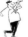

277

277 *Golf Digest Index*

DESIGN DIRECTOR: Ken DeLago. DESIGNER: Marne Mayer. DIRECTOR OF PHOTOGRAPHY: Ryan Cline. PHOTOGRAPHER: Art Streiber.
PUBLISHER: Condé Nast Publications Inc. ISSUE: Spring 2009. CATEGORY: Design: Feature: Fashion/Beauty (story)

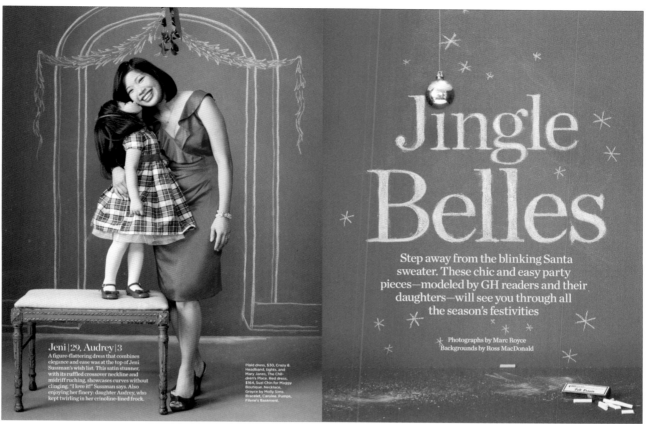

Jeni | 29, Audrey | 3
A figure-flattering dress that combines elegance and ease was at the top of Jeni Sussman's wish list. This satin stunner, with its ruffled crossover neckline and midriff ruching, showcases curves without clinging. "I love it!" Sussman says. Also enjoying her finery: daughter Audrey, who kept twirling in her crinoline-lined frock.

Plaid dress, $30, Crazy 8. Headband, tights, and Mary Janes, The Children's Place. Red dress, $164, Suzi Chin for Maggy Boutique. Necklace, Grayce by Molly Sims. Bracelet, Carolee. Pumps, Filene's Basement.

Jingle Belles

Step away from the blinking Santa sweater. These chic and easy party pieces—modeled by GH readers and their daughters—will see you through all the season's festivities

Photographs by Marc Royce
Backgrounds by Ross MacDonald

278

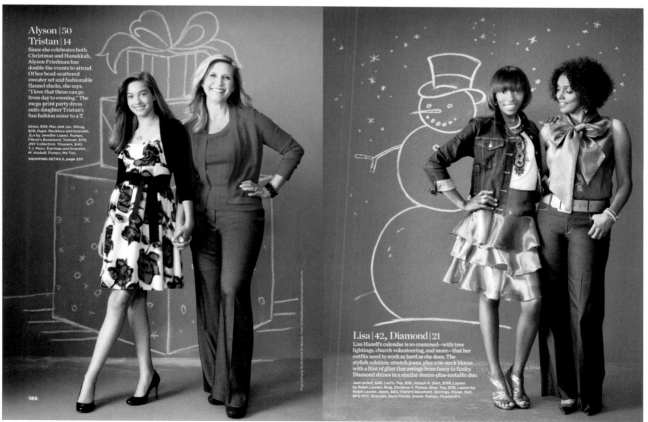

Alyson | 50
Tristan | 14
Since she celebrates both Christmas and Hanukkah, Alyson Friedman has double the events to attend. Of her bead-scattered sweater set and fashionable flannel slacks, she says, "I love that these can go from day to evening." The mega-print party dress suits daughter Tristan's fun fashion sense to a T.

Dress, $99, Mac and Jac. Shrug, $28, Hype. Necklace and bracelet, JLo by Jennifer Lopez. Pumps, Filene's Basement. Twinset, $119, JNY Collection. Trousers, $40, T.J. Maxx. Earrings and bracelet, M. Haskell. Pumps, Me Too.
SHOPPING DETAILS, page 250

Lisa | 42, Diamond | 21
Lisa Hazell's calendar is so crammed—with tree lightings, church volunteering, and more—that her outfits need to work as hard as she does. The stylish solution: stretch jeans, plus a tie-neck blouse with a hint of glint that swings from fancy to funky. Diamond shines in a similar denim-plus-metallic duo.

Jean jacket, $48, Levi's. Top, $58, Joseph A. Skirt, $199, Lauren by Ralph Lauren. Ring, Christina V. Pumps, Nina. Top, $119, Lauren by Ralph Lauren. Jeans, $60, Filene's Basement. Earrings, Monet. Belt, BFD NYC. Bracelet, Sissi Family Jewels. Pumps, Chatwick's.

186

278

278 **Good Housekeeping**

DESIGN DIRECTOR: Courtney Murphy. ART DIRECTORS: Trent Johnson, Laura Baer. DESIGNER: Laura Baer. ILLUSTRATOR: Ross MacDonald. DIRECTOR OF PHOTOGRAPHY: Bill Swan. PHOTO EDITOR: Jean Lee. PHOTOGRAPHER: Marc Royce. EDITOR-IN-CHIEF: Rosemary Ellis. PUBLISHER: The Hearst Corporation-Magazine Division. ISSUE: December 2009. CATEGORY: Design: Feature: Fashion/Beauty (story)

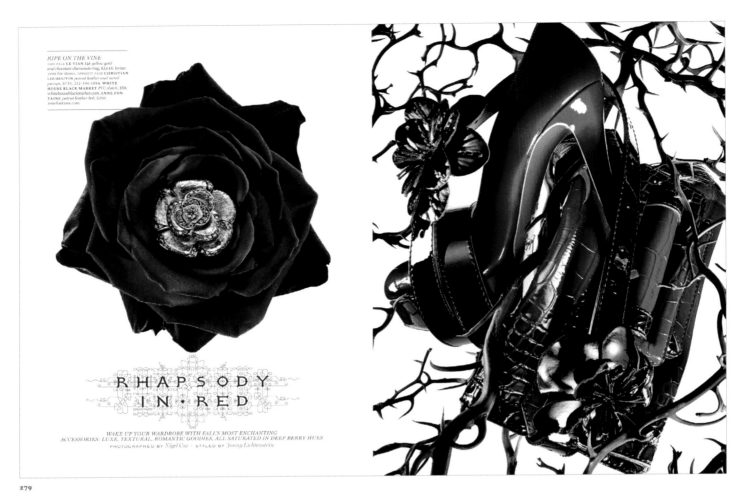

RIPE ON THE VINE
THIS PAGE **LE VIAN** 14k yellow gold and chocolate diamond ring, $3,648; levian.com for stores. OPPOSITE PAGE **CHRISTIAN LOUBOUTIN** patent leather and metal pumps, $735; 212-396-1884. **WHITE HOUSE BLACK MARKET** PVC clutch, $58; whitehouseblackmarket.com. **ANNE FONTAINE** patent leather belt, $380; annefontaine.com.

RHAPSODY IN·RED

WAKE UP YOUR WARDROBE WITH FALL'S MOST ENCHANTING
ACCESSORIES: LUXE, TEXTURAL, ROMANTIC GOODIES, ALL SATURATED IN DEEP BERRY HUES
PHOTOGRAPHED BY *Nigel Cox* · STYLED BY *Jenny Lichtenstein*

279

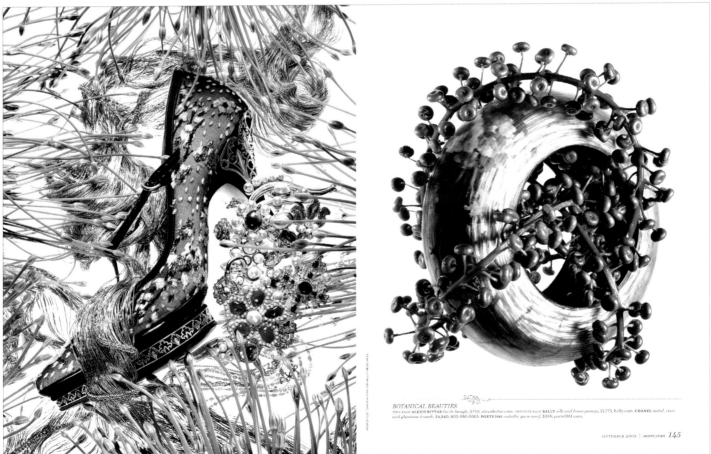

BOTANICAL BEAUTIES
THIS PAGE **ALEXIS BITTAR** lucite bangle, $350; alexisbittar.com. OPPOSITE PAGE **BALLY** silk and brass pumps, $1,775; bally.com. **CHANEL** metal, resin and glasstone brooch, $4,840; 800-550-0005. **PORTS 1961** metallic yarn scarf, $395; ports1961.com.

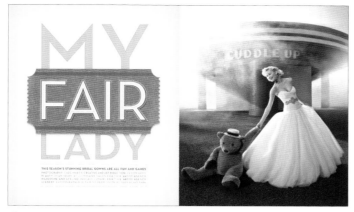

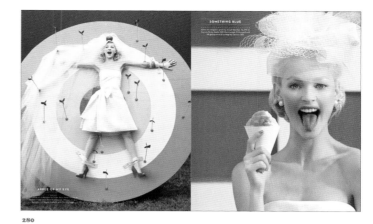

280

280

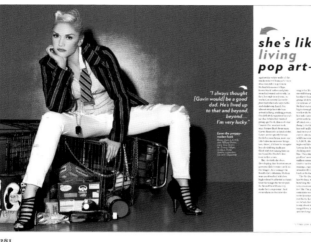

281

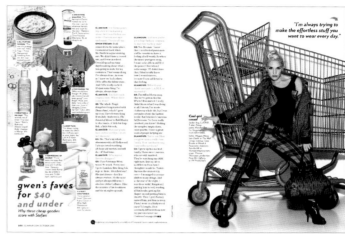

281

150 SECTION:
design

AWARD:
merit

CATEGORY:
redesign

282

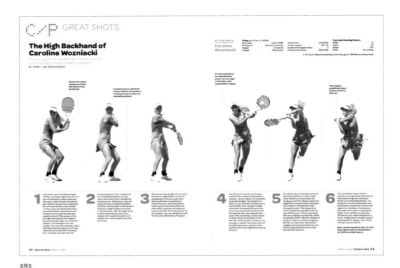

282

283

283

284

284

282 *Tennis*

DESIGN DIRECTOR: Gary Stewart.
ART DIRECTOR: Luke Hayman.
DESIGNERS: Luke Hayman, Rami Moghadam.
STUDIO: Pentagram Design, Inc.
EDITOR-IN-CHIEF: James Martin.
PUBLISHER: Miller Sports Group LLC.
CLIENT: Tennis Magazine.
ISSUE: January/February 2009.
CATEGORY: Redesign

283 *Nylon*

ART DIRECTOR: Michael Pangilinan. DESIGNERS:
Nicole Michalek, Kristin Eddington, Alex Chow.
ILLUSTRATORS: Elizabeth Riccardi,
Fumi Mini Nakamura, Benbo George. DIRECTOR OF
PHOTOGRAPHY: Stephen Walker. PHOTO EDITOR:
Minh Nguyen. PHOTOGRAPHERS: Ian Allen, Will
Anderson, Belen Aquino, Zack Arias, Cass Bird, Linda
Brownlee, Leo Cackett, David Canning, Denneth Capello,
Ben Clark, Katie Coleslaw, Kate Cox, Bon Duke, Ale
Formenti, Jermaine Francis, Julia Galdo, Julian Gilbert,
Brantley Gutierrez, Toby Hudson, Jonathon Karnbouris,
Rob Kulisek, Robin Laananen, Kate Lacey, Jeremy
Liebman, Sebastian Lucrecio, Magnus Klackenstam/B-
Martin, John Maxwell IV. EDITOR-IN-CHIEF:
Marvin Scott Jarrett. PUBLISHER: Nylon LLC.
ISSUE: July 2009. CATEGORY: Redesign

284 *The New York Times Magazine*

DESIGN DIRECTOR: Arem Duplessis.
ART DIRECTOR: Gail Bichler.
DESIGNERS: Cathy Gilmore-Barnes,
Nancy Harris Rouemy, Hilary Greenbaum,
Ian Allen, Leslie Kwok, Robert Vargas.
DIRECTOR OF PHOTOGRAPHY: Kathy Ryan.
PHOTO EDITORS: Clinton Cargill,
David Carthas, Joanna Milter, Marvin Orellana,
Kira Pollack, Luise Stauss.
PUBLISHER: The New York Times Company.
ISSUE: October 4, 2009.
CATEGORY: Redesign

285

285

286

Linda Threadgill:
Conceptualizing
Ornament
A penetrating
investigation into
the nature of
ornamentation

286

287

287

285 *Money*

DESIGN DIRECTOR: Kate Elazegui.
DESIGNERS: Mike Smith, Scott Weiss,
April Bell, Ingrid Gonzalez.
DIRECTOR OF PHOTOGRAPHY: Ryan Cadiz.
PHOTO EDITORS: Betsy Keating, Ryan Mesina.
PUBLISHER: Time Inc.
ISSUE: October 2009.
CATEGORY: Redesign

286 *Metalsmith Magazine*

ART DIRECTOR: Luke Hayman.
DESIGNERS: Luke Hayman, Rami Moghadam.
STUDIO: Pentagram Design, Inc.
EDITOR-IN-CHIEF: Suzanne Ramljak.
PUBLISHER: Society of North American Goldsmiths.
CLIENT: Metalsmith Magazine.
ISSUE: Vol 29,No 1 /2009.
CATEGORY: Redesign

287 *Boston Magazine*

CREATIVE DIRECTOR: Patrick Mitchell
ART DIRECTOR: Susannah Haesche
DESIGNERS: Ashley Bond, Heather Burke, Betsy Halsey
ILLUSTRATOR: Andrew Bannecker
PHOTOGRAPHERS: Jill Greenberg, David Yellen
PUBLISHER: Metrocorp
ISSUE: January 2009
CATEGORY: Redesign

152

SECTION:
design

AWARD:
merit

CATEGORY:
section (single month)

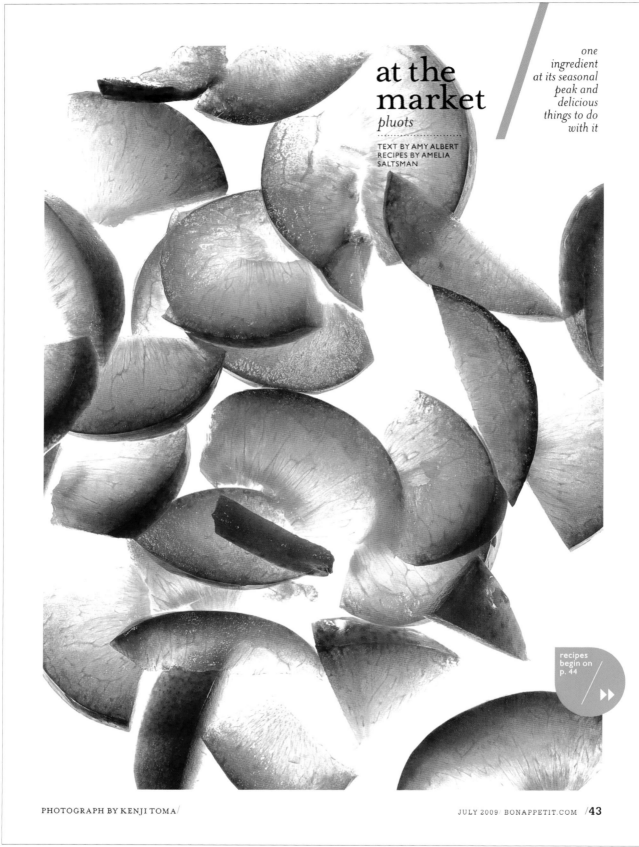

at the market
pluots

one
ingredient
at its seasonal
peak and
delicious
things to do
with it

TEXT BY AMY ALBERT
RECIPES BY AMELIA
SALTSMAN

recipes
begin on
p. 44
▶▶

PHOTOGRAPH BY KENJI TOMA

JULY 2009 / BONAPPETIT.COM / **43**

288 **Bon Appétit**

DESIGN DIRECTOR: Matthew Lenning. ART DIRECTORS: Robert Festino, Tom O'Quinn. DESIGNER: John Muñoz. DIRECTOR OF PHOTOGRAPHY: Bailey Franklin.
PHOTO EDITOR: Angelica Mistro. PHOTOGRAPHER: Kenji Toma. EDITOR-IN-CHIEF: Barbara Fairchild. PUBLISHER: Condé Nast Publications, Inc.
ISSUE: July 2009. CATEGORY: Design: Section (single month)

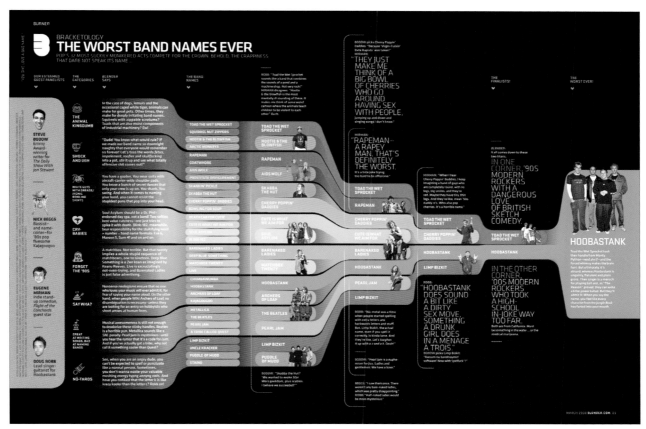

289

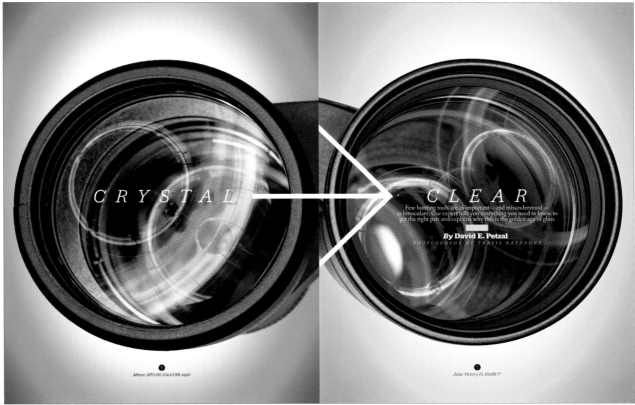

290

289 Blender

CREATIVE DIRECTOR: Dirk Barnett. ART DIRECTOR: Robert Vargas.
DESIGNER: Robert Vargas. PHOTO EDITOR: David Carthas.
EDITOR-IN-CHIEF: Joe Levy. PUBLISHER: Alpha Media Group.
CATEGORY: Design: Section (single month)

290 Field & Stream

ART DIRECTOR: Neil Jamieson.
DIRECTOR OF PHOTOGRAPHY: Amy Berkley.
PHOTOGRAPHER: Travis Rathbone. PUBLISHER: Bonnier Corporation.
ISSUE: August 2009 CATEGORY: Design: Section (single month)

154

SECTION:
design

AWARD:
merit

CATEGORY:
section (single month)

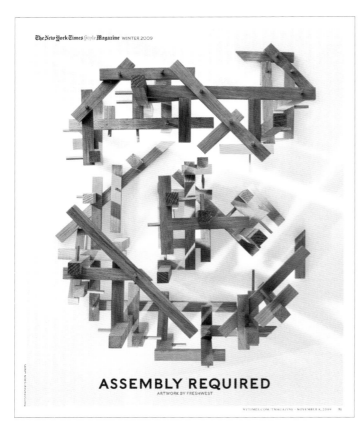

291

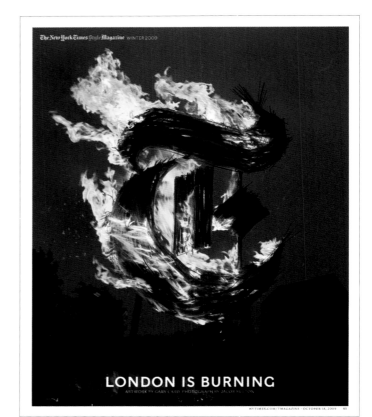

293

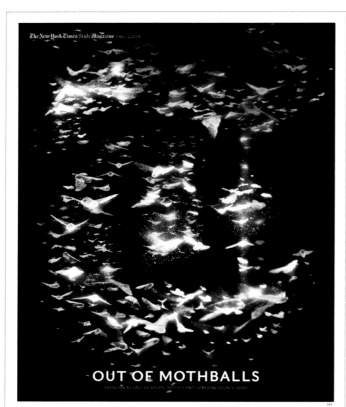

292

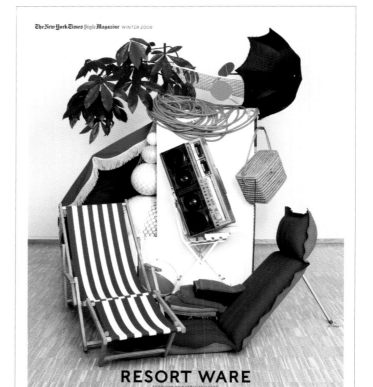

294

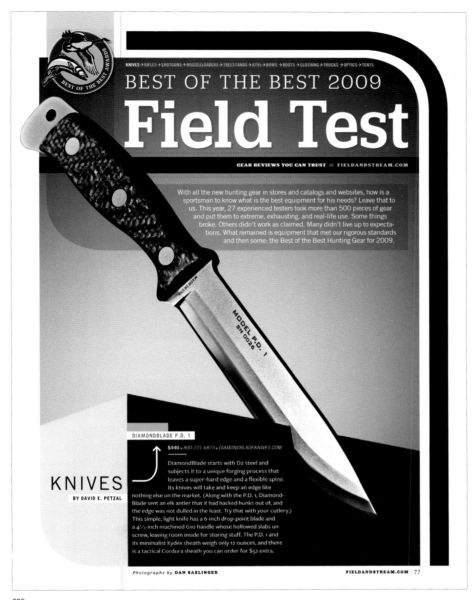

295

296

297

291 *T, The New York Times Style Magazine*

CREATIVE DIRECTOR: David Sebbah. SENIOR ART DIRECTOR: Christopher Martinez. DESIGNER: Natalie Do. SENIOR PHOTO EDITOR: Judith Puckett-Rinella. PHOTO EDITOR: Scott Hall. PHOTOGRAPHER: Simon Sandys. ARTIST: Freshwest. PUBLISHER: The New York Times Company. ISSUE: November 8, 2009. CATEGORY: Design: Section (single month)

292 *T, The New York Times Style Magazine*

CREATIVE DIRECTOR: David Sebbah. SENIOR ART DIRECTOR: Christopher Martinez. DESIGNER: Natalie Do. SENIOR PHOTO EDITOR: Judith Puckett-Rinella. PHOTO EDITOR: Scott Hall. ARTISTS: United Visual Artists, Tom Hingston Studio. PUBLISHER: The New York Times Company. ISSUE: September 13, 2009. CATEGORY: Design: Section (single month)

293 *T, The New York Times Style Magazine*

CREATIVE DIRECTOR: David Sebbah. SENIOR ART DIRECTOR: Christopher Martinez. DESIGNER: Natalie Do. ILLUSTRATOR: Gary Card. PHOTO EDITOR: Natasha Lunn. PHOTOGRAPHER: Jacob Sutton. PUBLISHER: The New York Times Company. ISSUE: October 18, 2009. CATEGORY: Design: Section (single month)

294 *T, The New York Times Style Magazine*

CREATIVE DIRECTOR: David Sebbah. SENIOR ART DIRECTOR: Christopher Martinez. DESIGNER: Natalie Do. PHOTOGRAPHER: Katrin Schacke. SENIOR PHOTO EDITOR: Judith Puckett-Rinella. PHOTO EDITOR: Scott Hall. PUBLISHER: The New York Times Company. ISSUE: November 22, 2009. CATEGORY: Design: Section (single month)

295 *Field & Stream*

ART DIRECTOR: Neil Jamieson. DIRECTOR OF PHOTOGRAPHY: Amy Berkley. PHOTOGRAPHER: Dan Saelinger. PUBLISHER: Bonnier Corporation. ISSUE: September 2009 CATEGORY: Design: Section (single month)

296 *More*

CREATIVE DIRECTOR: Debra Bishop. ART DIRECTOR: Claudia de Almeida. DESIGNER: Claudia de Almeida. ILLUSTRATORS: August Heffner, Quickhoney, Jameson Simpson, Riccardo Vecchio, Jeff Wack. DIRECTOR OF PHOTOGRAPHY: Stacey Baker. PHOTO EDITOR: Natalie Gialluca. PHOTOGRAPHER: Jens Mortensen. EDITOR-IN-CHIEF: Lesley Jane Seymour. PUBLISHER: Meredith Corporation. ISSUE: November 2009. CATEGORY: Design: Section (single month)

297 *Real Simple*

CREATIVE DIRECTOR: Janet Froelich. DESIGN DIRECTOR: Cybele Grandjean. DESIGNERS: Tracy Walsh, Jamie Dannecker, Elsa Mehary, Jessica Weit. DIRECTOR OF PHOTOGRAPHY: Casey Tierney. PHOTO EDITORS: Lindsay Dougherty Rogers, Lauren Epstein, Susan Getzendanner. PHOTOGRAPHERS: Christopher Bucklow, José Picayo. PUBLISHER: Time Inc. ISSUE: December 2009. CATEGORY: Design: Section (single month)

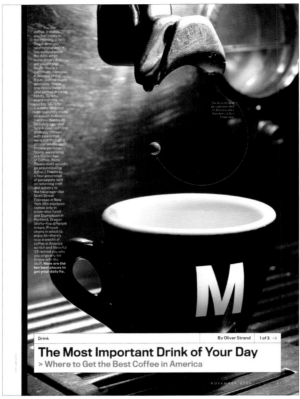

298

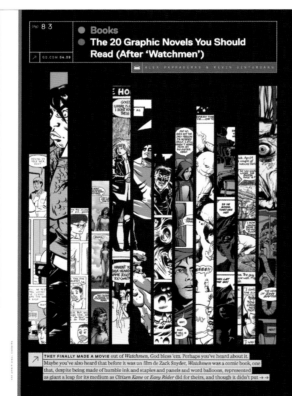

299

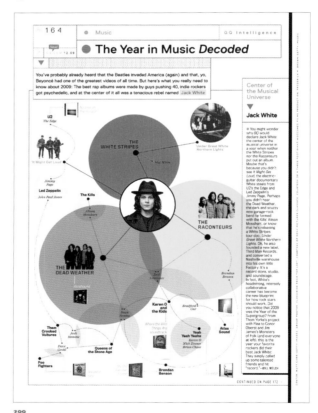

299

298 **GQ**

DESIGN DIRECTOR: Fred Woodward. ART DIRECTOR: Anton Ioukhnovets.
DESIGNERS: Chelsea Cardinal, Drue Wagner, Delgis Canahuate.
DIRECTOR OF PHOTOGRAPHY: Dora Somosi. PHOTO EDITORS:
Justin O'Neill, Jesse Lee. PHOTOGRAPHERS: Nigel Cox, Jeff Wenzel.
PUBLISHER: Condé Nast Publications Inc.
ISSUES: March 2009, May 2009, June 2009, September 2009, November 2009.
CATEGORY: Design: Section (series of months)

299 **GQ**

DESIGN DIRECTOR: Fred Woodward. ART DIRECTOR: Anton Ioukhnovets.
DESIGNERS: Chelsea Cardinal, Drue Wagner, Thomas Alberty,
Delgis Canahuate. ILLUSTRATOR: Zohar Lazar.
DIRECTOR OF PHOTOGRAPHY: Dora Somosi. PHOTO EDITORS:
Krista Prestek, Justin O'Neill, Jesse Lee, Jolanta Bielat, Emily Blank.
PUBLISHER: Condé Nast Publications Inc.
ISSUES: April 2009, September 2009, November 2009, December 2009.
CATEGORY: Design: Section (series of months)

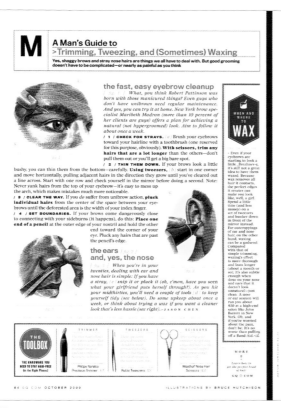

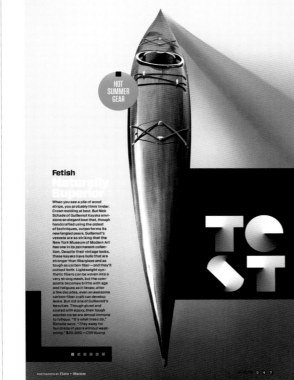

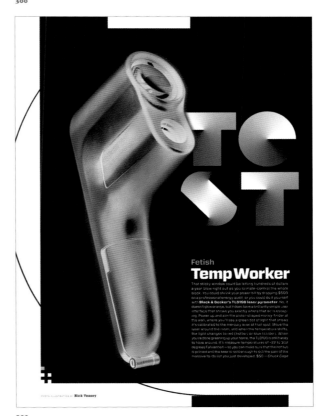

300

300

301

301

300 *GQ*

DESIGN DIRECTOR: Fred Woodward. ART DIRECTOR: Anton Ioukhnovets. DESIGNERS: Delgis Canahuate, Drue Wagner, Chelsea Cardinal. ILLUSTRATORS: mckibillo, Bruce Hutchison. DIRECTOR OF PHOTOGRAPHY: Dora Somosi PHOTO EDITORS: Jesse Lee, Justin O'Neill, Jolanta Bielat. PHOTOGRAPHERS: Nigel Cox, Jeff Wenzel. CREATIVE DIRECTOR, FASHION: Jim Moore. EDITOR-IN-CHIEF: Jim Nelson. PUBLISHER: Condé Nast Publications Inc. ISSUE: March, April, Sept., Oct., Nov. 2009. CATEGORY: Design: Section (series of months)

301 **WIRED**

CREATIVE DIRECTOR: Scott Dadich. DESIGN DIRECTOR: Wyatt Mitchell. ART DIRECTOR: Margaret Swart. DESIGNER: Margaret Swart. SENIOR PHOTO EDITOR: Zana Woods. ASSOCIATE PHOTO EDITOR: Sarah Filippi. PHOTOGRAPHERS: Floto + Warner, Nick Veasey. EDITOR-IN-CHIEF: Chris Anderson. PUBLISHER: Condé Nast Publications, Inc. CATEGORY: Design: Section (series of months)

158

SECTION:
design

AWARD:
merit

CATEGORY:
section (series of months)

PASSION PIT

Boston dance poppers light up blogs with a homemade EP, make Rick Rubin boogie

302

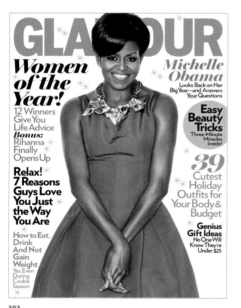

303

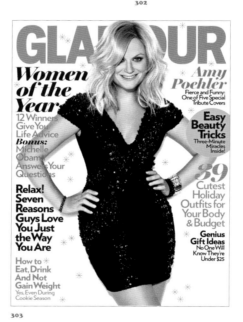

303

303

302 **SPIN**

CREATIVE DIRECTOR: Devin Pedzwater.
ART DIRECTOR: Ian Robinson. DESIGNER: Liz Macfarlane.
DIRECTOR OF PHOTOGRAPHY: Michelle Egiziano.
PHOTO EDITOR: Jennifer Edmondson. PUBLISHER: Spin Media LLC.
ISSUES: August 2009, November 2009, December 2009.
CATEGORY: Design: Section (series of months)

303 **Glamour**

DESIGN DIRECTOR: Geraldine Hessler.
DIRECTOR OF PHOTOGRAPHY: Suzanne Donaldson.
PHOTOGRAPHER: Matthias Vriens-McGrath.
PUBLISHER: Condé Nast Publications Inc.
ISSUE: December 2009. CATEGORY: Design: Section (series of months)

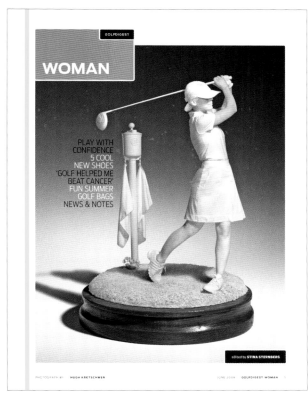

304

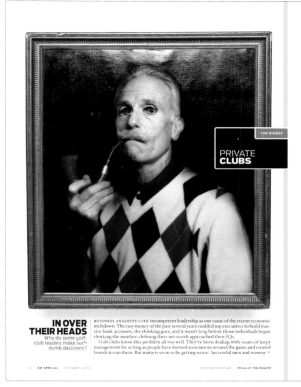

304

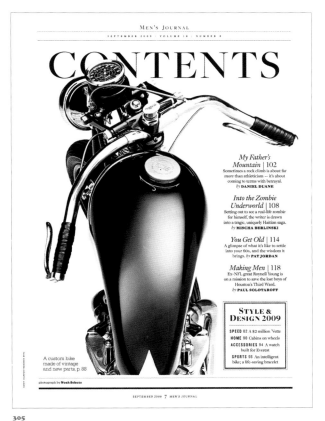

305

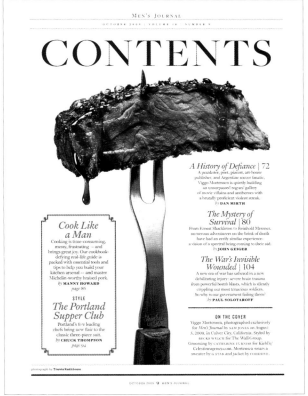

305

304 **Golf Digest**

DESIGN DIRECTOR: Ken DeLago. DESIGNER: Marne Mayer.
ILLUSTRATOR: Jameson Simpson.
DIRECTOR OF PHOTOGRAPHY: Christian Iooss.
PHOTOGRAPHERS: James Wojcik, Geof Kern, Philip Toledano,
Hugh Kretschmer. PUBLISHER: Condé Nast Publications Inc.
ISSUE: April, June, September, October, December 2009.
CATEGORY: Design: Section (series of months)

305 **Men's Journal**

CREATIVE DIRECTOR: Paul Martinez. ART DIRECTOR: Damian Wilkinson.
DESIGNERS: Paul Martinez, Damian Wilkinson, Burgan Shealy.
DIRECTOR OF PHOTOGRAPHY: Michelle Wolfe.
PHOTO EDITORS: Jennifer Santana, Michelle Wolfe.
PUBLISHER: Wenner Media LLC. ISSUES: September 2009, October 2009,
November 2009. CATEGORY: Design: Section (series of months)

SECTION:
design

AWARD:
merit

CATEGORY:
section (series of months)

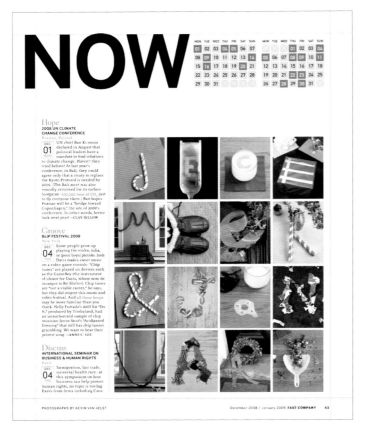

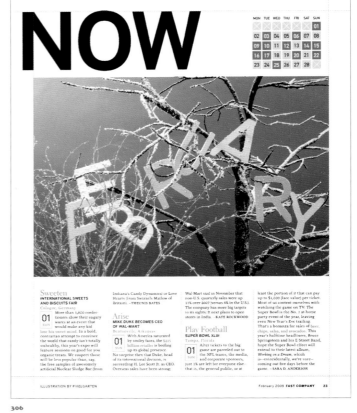

306

306

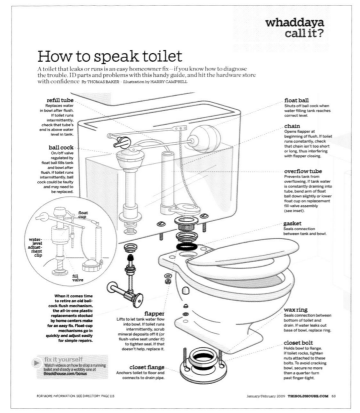

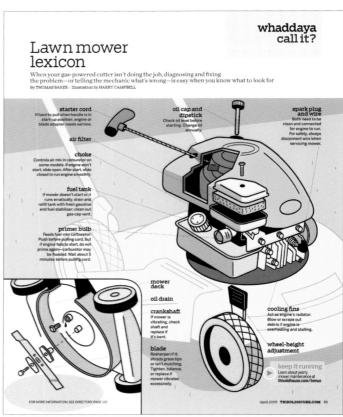

306

306

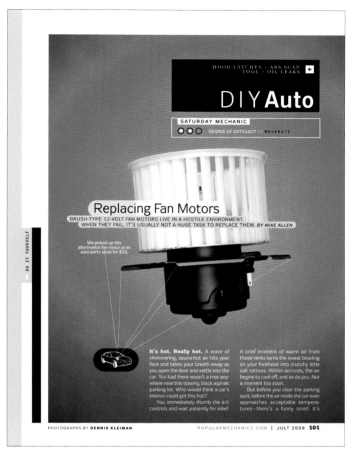

307

308

162

SECTION:
design

AWARD:
merit

CATEGORY:
trade/corporate

Once Upon a Time... doors were **left unlocked** and **kids** could be left unattended; "Gigi" was the **reigning** high school **musical** and the **hot** reality show was "**American Bandstand**;" Jack and Jackie were the exciting young couple in the **White House** and **Lassie** was the pup that had **tongues** wagging; America's next top **model** was Twiggy **and** Sandra Dee was the **girl** next door; Hula Hoops and Frisbees made the **world** go 'round and **malt shops** were the center of the universe; moms gathered the **family** together for **dinner** every night and fathers knew best.

Mini-me dressing skips a generation as traditional infant and toddler apparel mimics the styling found in grandma and grandpa's closet. Photography by Augustus Butera.

On baby: **Petit Lem** striped cardigan and skirt with attached leggings; **Pediped** shoes, hair bow by **No Slippy Hair Clippy**. Vintage clothing and accessories (worn throughout) provided by Perennial Clothing, Inc.

309

| FEATURE | ECO-CURRICULUM | By B.J. NOVITSKI
Photographs by DARREN BRAUN

the new green U

design educators are choosing different paths for guiding tomorrow's architects toward a carbon-free future.

48 September + October 2009. www.greensourcemag.com

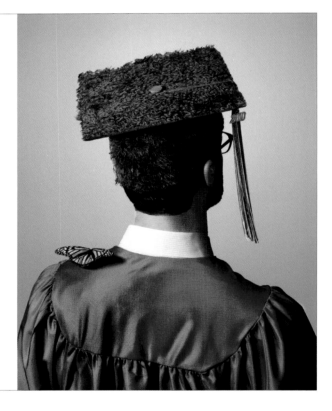

310

309 **Earnshaw's**

CREATIVE DIRECTOR: Nancy Campbell.
ART DIRECTOR: Trevett McCandliss. DESIGNER: Trevett McCandliss.
PHOTOGRAPHER: Augustus Butera. EDITOR-IN-CHIEF: Caletha Crawford.
PUBLISHER: Symphony Publishing. ISSUE: May 2009.
CATEGORY: Design: Cover, Entire Issue, Single/Spread or Story

310 **GreenSource**

CREATIVE DIRECTOR: Francesca Messina. ART DIRECTOR: Ted Keller.
PHOTOGRAPHER: Darren Braun. PUBLISHER: McGraw-Hill Construction.
ISSUE: September/October 2009.
CATEGORY: Design: Cover, Entire Issue, Single/Spread or Story

311

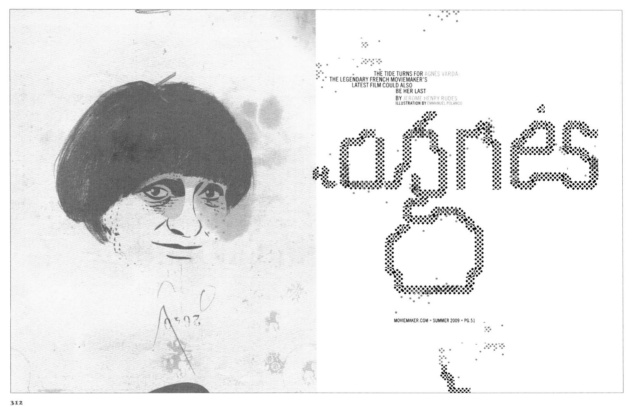

312

311 *Moviemaker*

ART DIRECTOR: Rob Hewitt. DESIGNER: Rob Hewitt.
ILLUSTRATOR: James Dawe. STUDIO: Curious Outsider.
EDITOR-IN-CHIEF: Timothy E. Rhys. PUBLISHER: Moviemaker LLC.
CLIENT: Moviemaker. ISSUE: Spring 2009.
CATEGORY: Design: Cover, Entire Issue, Single/Spread or Story

312 *Moviemaker*

ART DIRECTOR: Rob Hewitt. DESIGNER: Rob Hewitt.
ILLUSTRATOR: Emmanuel Polanco. STUDIO: Curious Outsider.
EDITOR-IN-CHIEF: Timothy E. Rhys. PUBLISHER: Moviemaker LLC.
CLIENT: Moviemaker. ISSUE: Summer 2009.
CATEGORY: Design: Cover, Entire Issue, Single/Spread or Story

164

SECTION:
design

AWARD:
merit

CATEGORY:
trade/corporate

313

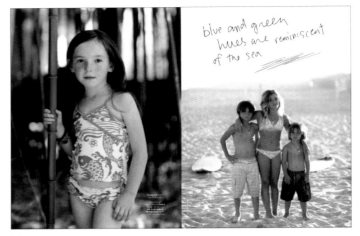

313

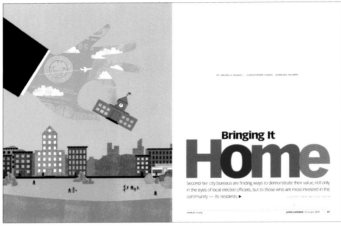

314

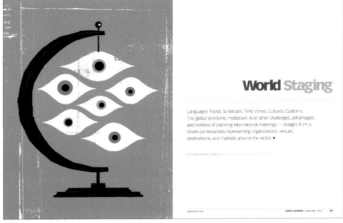

316

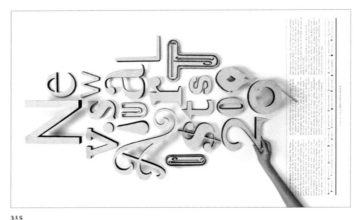

315

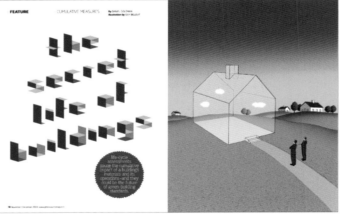

317

313 *Earnshaw's*

CREATIVE DIRECTOR: Nancy Campbell. ART DIRECTOR: Trevett McCandliss.
DESIGNER: Trevett McCandliss. PHOTOGRAPHER: Olivier Pascaud. EDITOR-
IN-CHIEF: Caletha Crawford. PUBLISHER: Symphony Publishing. ISSUE: August
2009. CATEGORY: Design: Cover, Entire Issue, Single/Spread or Story

314 *PCMA Convene*

CREATIVE DIRECTOR: Mitch Shostak. ART DIRECTOR: Roger J. Greiner.
ILLUSTRATOR: Michael Austin. STUDIO: Shostak Studios. PUBLISHER:
Professional Convention Management Association. CLIENT: PCMA. ISSUE:
February 2009. CATEGORY: Design: Cover, Entire Issue, Single/Spread or Story

315 *Print*

ART DIRECTOR: Kristina DiMatteo. DESIGNER: Jessica Walsh.
PHOTOGRAPHER: Jessica Walsh. ASSOCIATE ART DIRECTOR: Jessica Walsh.
PUBLISHER: F & W Media. ISSUE: April 2009.
CATEGORY: Design: Cover, Entire Issue, Single/Spread or Story

316 *PCMA Convene*

CREATIVE DIRECTOR: Mitch Shostak. ART DIRECTOR: Roger J. Greiner.
ILLUSTRATOR: The Heads of State. STUDIO: Shostak Studios.
PUBLISHER: Professional Convention Management Association.
CLIENT: PCMA. ISSUE: September 2009.
CATEGORY: Design: Cover, Entire Issue, Single/Spread or Story

317 *GreenSource*

CREATIVE DIRECTOR: Francesca Messina. ART DIRECTOR: Ted Keller.
ILLUSTRATOR: Guy Billout. PUBLISHER: McGraw-Hill Construction.
ISSUE: November/December 2009.
CATEGORY: Design: Cover, Entire Issue, Single/Spread or Story

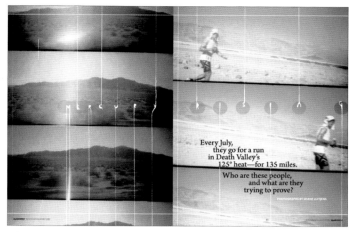

318

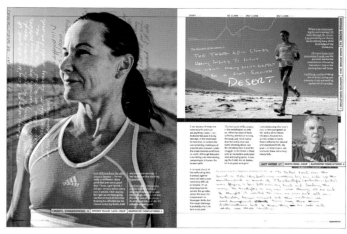

318

319

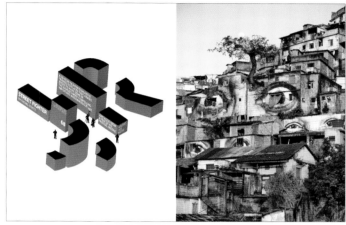

321

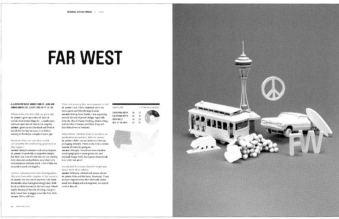

320

318 *MyMidwest*

CREATIVE DIRECTOR: Michael Keating. ART DIRECTOR: Shane Luitjens.
PHOTOGRAPHER: Shane Luitjens. PUBLISHER: Ink.
ISSUE: November/December 2009. CATEGORY: Design: Cover, Entire Issue,
Single/Spread or Story

319 *Hemispheres*

ART DIRECTOR: Rob Hewitt. DESIGNERS: Ellie Clayman, Rob Hewitt.
PHOTO EDITOR: Erin Giunta. PHOTOGRAPHER: Fiona Aboud.
EDITOR-IN-CHIEF: Aaron Gell. PUBLISHER: Ink Publishing.
ISSUE: December 2009. CATEGORY: Design: Cover, Entire Issue,
Single/Spread or Story

320 *Print*

ART DIRECTOR: Alice Cho. DESIGNERS: Alice Cho, Jessica Walsh.
PHOTOGRAPHER: Henry Hargreaves.
ASSOCIATE ART DIRECTOR: Jessica Walsh.
PUBLISHER: F & W Media.ISSUE: December 2009
CATEGORY: Design: Cover, Entire Issue, Single/Spread or Story

321 *Hemispheres*

ART DIRECTOR: Rob Hewitt. DESIGNERS: Rob Hewitt, Ellie Clayman.
PHOTO EDITOR: Erin Giunta. EDITOR-IN-CHIEF: Aaron Gell.
PUBLISHER: Ink Publishing. ISSUE: October 2009
CATEGORY: Design: Cover, Entire Issue, Single/Spread or Story

166

SECTION:
design

AWARD:
merit

CATEGORY:
educational/institutional

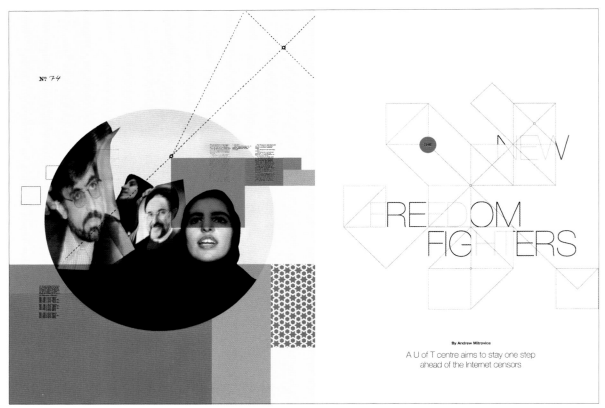

322

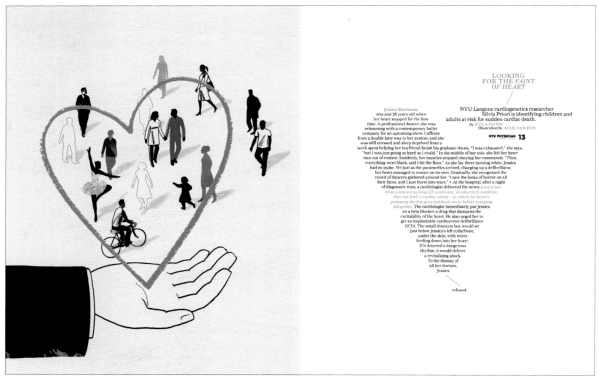

323

322 *U of T Magazine.*

CREATIVE DIRECTORS: Claire Dawson, Fidel Peña.
DESIGNER: Clarie Dawson. ILLUSTRATOR: Cristiana Couceiro.
STUDIO: Underline Studio. PUBLISHER: University of Toronto.
CLIENT: University of Toronto. ISSUE: August 2009.
CATEGORY: Design: Cover, Entire Issue, Single/Spread or Story

323 *NYU Physician*

ART DIRECTOR: Rob Hewitt. DESIGNER: Rob Hewitt.
ILLUSTRATOR: Aude Van Ryn. STUDIO: Curious Outsider.
EDITOR-IN-CHIEF: Frank W. Lopez. PUBLISHER: NYU Langone.
CLIENT: NYU Langone Medical Center. ISSUE: Spring 2009.
CATEGORY: Design: Cover, Entire Issue, Single/Spread or Story

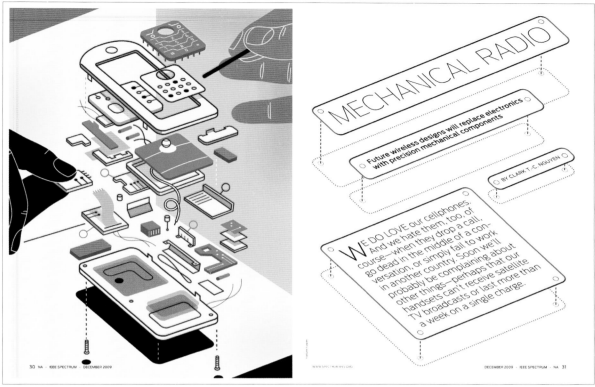

324

325

324 IEEE Spectrum

ART DIRECTORS: Mark Montgomery, Michael Solita.
DESIGNER: Michael Solita. ILLUSTRATOR: Harry Campbell.
PHOTO EDITOR: Randi Silberman. EDITOR-IN-CHIEF: Susan Hassler.
PUBLISHER: IEEE. ISSUE: December 2009.
CATEGORY: Design: Cover, Entire Issue, Single/Spread or Story

325 IEEE Spectrum

ART DIRECTORS: Mark Montgomery, Michael Solita.
DESIGNER: Michael Solita. PHOTO EDITOR: Randi Silberman
PHOTOGRAPHER: Joshua Dalsimer. EDITOR-IN-CHIEF: Susan Hassler.
PUBLISHER: IEEE. ISSUE: November 2009.
CATEGORY: Design: Cover, Entire Issue, Single/Spread or Story

Photography

ENTIRE ISSUE *COVER* SECTION *SERVICE* NON-CELEBRITY PROFILE
CELEBRITY/ENTERTAINMENT PROFILE NEWS/REPORTAGE
TRAVEL/FOOD/STILL LIFE FASHION/BEAUTY *TRADE/CORPORATE*
EDUCATIONAL/INSTITUTIONAL *PHOTO-ILLUSTRATION*

170

SECTION:
photography

AWARD:
gold

CATEGORY:
cover

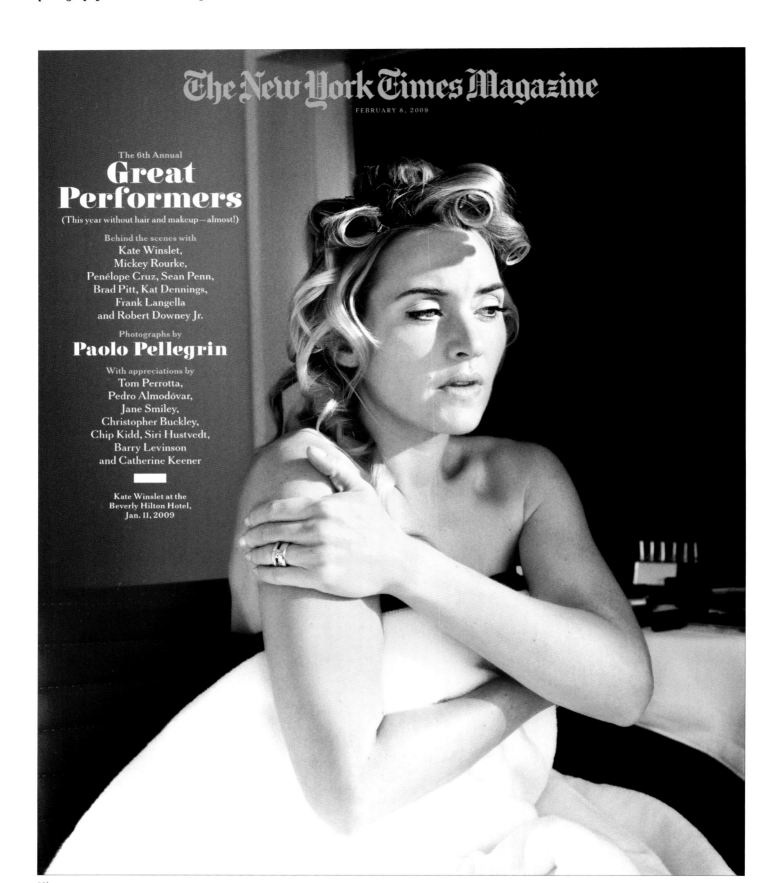

The New York Times Magazine

FEBRUARY 8, 2009

The 6th Annual

Great Performers

(This year without hair and makeup—almost!)

Behind the scenes with
Kate Winslet,
Mickey Rourke,
Penélope Cruz, Sean Penn,
Brad Pitt, Kat Dennings,
Frank Langella
and Robert Downey Jr.

Photographs by

Paolo Pellegrin

With appreciations by
Tom Perrotta,
Pedro Almodóvar,
Jane Smiley,
Christopher Buckley,
Chip Kidd, Siri Hustvedt,
Barry Levinson
and Catherine Keener

Kate Winslet at the
Beverly Hilton Hotel,
Jan. 11, 2009

326

DESIGN DIRECTOR: Arem Duplessis. DEPUTY ART DIRECTOR: Gail Bichler. DIRECTOR OF PHOTOGRAPHY: Kathy Ryan. PHOTO EDITOR: Kira Pollack.
PHOTOGRAPHER: Paolo Pellegrin. PUBLISHER: The New York Times Company. ISSUE: February 8, 2009. CATEGORY: Photo: Cover

SECTION:
photography

AWARD:
gold

CATEGORY:
entire issue

171

>Maurizio Cattelan

THE LATE ARTIST **MAURIZIO CATTELAN** IS BEST KNOWN FOR HIS SUBVERSIVE, HYPER-REALISTIC SCULPTURES—INCLUDING DEPICTIONS OF POPE JOHN PAUL II BEING FELLED BY A METEORITE, A CHILD-SIZE HITLER KNEELING IN PRAYER AND A SUICIDAL SQUIRREL. FOR W'S ART ISSUE, HE CONCEIVED A POLITICALLY AND RELIGIOUSLY CHARGED PORTFOLIO FEATURING SUPERMODEL **LINDA EVANGELISTA**. "SHE'S A REAL ACTRESS," SAYS CATTELAN OF EVANGELISTA. "AT THE END, SHE WAS SO TUNED IN THAT SHE NEEDED NO MORE INDICATIONS, NO WORDS, AND SHE KNEW WHAT WE WANTED." A NEW PIECE BY CATTELAN IS INCLUDED IN "POP LIFE: ART IN A MATERIAL WORLD," AN EXHIBITION AT THE TATE MODERN IN LONDON THAT RUNS THROUGH JANUARY 17. IN FEBRUARY A SHOW FOCUSING ON HIS LARGE-SCALE WORKS WILL OPEN AT THE MENIL COLLECTION IN HOUSTON. CATTELAN COCREATED THE FAIR IN BERLIN, IN 2006, AND LIVES IN NEW YORK AND MILAN.

Curated by **DENNIS FREEDMAN**
Photographed by **PIERPAOLO FERRARI**
Styled by **CAMILLA NICKERSON**

Rena Lange's silk blouse, at Saks Fifth Avenue, 877.551.SAKS, saks.com. De Beers earrings.

327

>Tino Sehgal

By DANIELLE STEIN

Photographed by PHILIP-LORCA diCORCIA

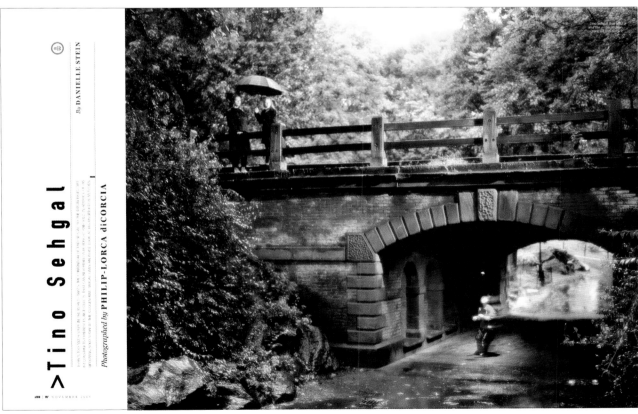

Tino Sehgal (born 1976 and lives in Berlin), creates "situations" or live encounters.

327

CREATIVE DIRECTOR: Dennis Freedman. DESIGN DIRECTOR: Edward Leida. ART DIRECTOR: Nathalie Kirsheh. DESIGNERS: Laura Konrad, Gina Maniscalco. PHOTO EDITOR: Nadia Vellam. PHOTOGRAPHER: Maurizio Cattelan. PUBLISHER: Condé Nast Publications Inc. ISSUE: November 2009. CATEGORY: Photo: Entire Issue

172

SECTION:
photography

AWARD:
gold

CATEGORY:
section (single month)

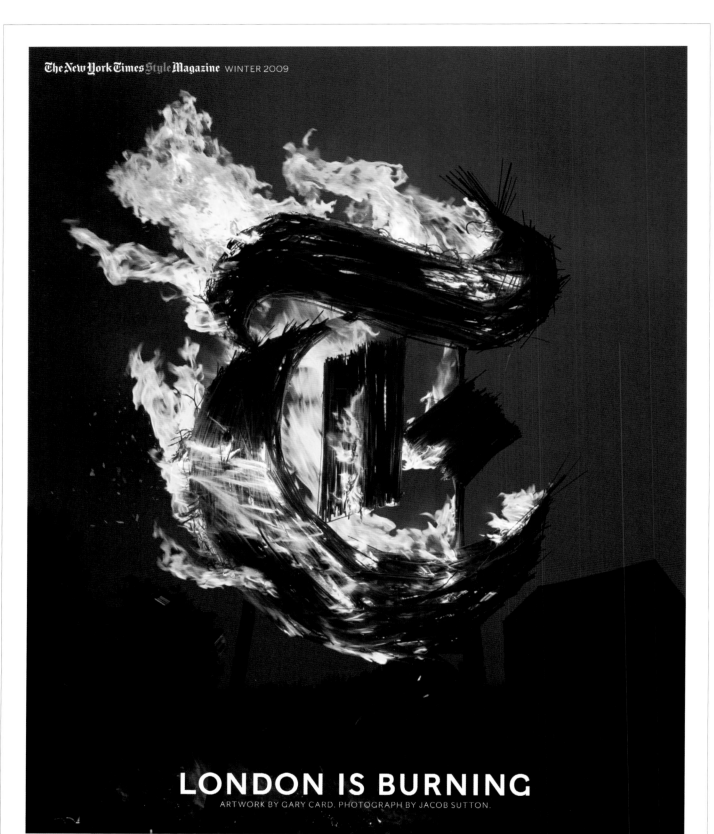

The New York Times Style Magazine WINTER 2009

LONDON IS BURNING
ARTWORK BY GARY CARD. PHOTOGRAPH BY JACOB SUTTON.

NYTIMES.COM/TMAGAZINE · OCTOBER 18, 2009 53

328

328 _T, The New York Times Style Magazine_

CREATIVE DIRECTOR: David Sebbah. SENIOR ART DIRECTOR: Christopher Martinez. DESIGNER: Natalie Do. PHOTO EDITOR: Natasha Lunn. PUBLISHER: The New York Times Company. ISSUE: October 18, 2009. CATEGORY: Photo: Section (single month)

SECTION:
photography

AWARD:
gold

CATEGORY:
**section (series of months)
service**

173

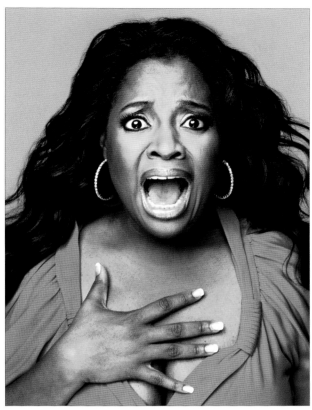

329

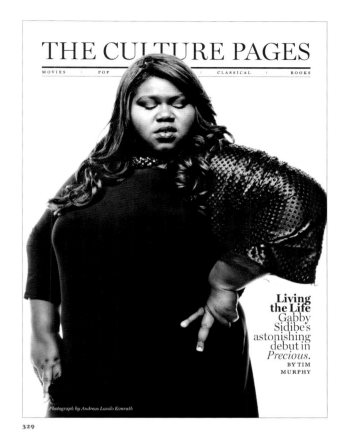

329

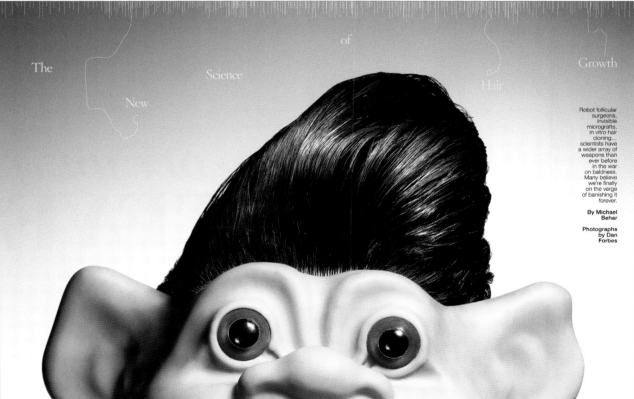

330

329 *New York*

DESIGN DIRECTOR: Chris Dixon. DIRECTOR OF PHOTOGRAPHY: Jody Quon. PHOTO EDITORS: Lea Golis, Alex Pollack. PHOTOGRAPHERS: Andreas Laszlo Konrath, Marco Grob, Robert Maxwell, Pej Behdarvand, Ruven Afanador. EDITOR-IN-CHIEF: Adam Moss. PUBLISHER: New York Magazine Holdings, LLC. CATEGORY: Photo: Section (series of months)

330 *Best Life*

DESIGN DIRECTOR: Brandon Kavulla. DESIGNERS: Brandon Kavulla, Heather Jones. DIRECTOR OF PHOTOGRAPHY: Ryan Cadiz. PHOTO EDITOR: Jeanne Graves. PHOTOGRAPHER: Dan Forbes. PUBLISHER: Rodale Inc. ISSUE: March 2009. CATEGORY: Photo: Feature: Service (single/spread)

SECTION:
photography

AWARD:
gold

CATEGORY:
service (story)
non-celebrity profile

YOU
CAN
TACKLE
THE
LAUNDRY

(AND HAVE
TIME AND
ENERGY
TO SPARE)

WRITTEN BY
LESLEY ALDERMAN
PHOTOGRAPHS BY
CHRISTOPHER GRIFFITH

When it comes to striking dread into the hearts of women, Halloween has got nothing on laundry day. The horrors are endless, readers told Real Simple in a recent survey: huge mountains of dirty clothes (like the frightful one here); children and husbands who treat the floor—and the bedpost and the kitchen table—as hampers; and heavy basketloads that threaten to land you in the chiropractor's office. But while laundry may never be one of your favorite activities, it can be made less daunting. Here, find smart, helpful tips from real women and experts who have solved a slew of ghastly scenarios. And consider your laundry nightmares over.

331

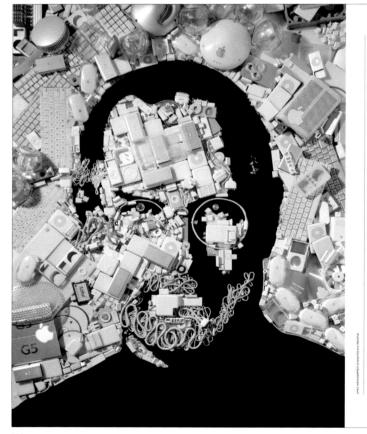

The DECADE of
STEVE

How Apple's
imperious, brilliant CEO
transformed
American business.

By ADAM LASHINSKY

PORTRAIT CREATED BY MEGAN CAPONETTO
PHOTOGRAPH BY CHRISTOPHER GRIFFITH

November 23, 2009 FORTUNE 93

332

331 *Real Simple*

CREATIVE DIRECTOR: Janet Froelich. DESIGNER: Jamie Dannecker.
DIRECTOR OF PHOTOGRAPHY: Casey Tierney. PHOTO EDITOR: Lindsay
Dougherty Rogers. PHOTOGRAPHER: Christopher Griffith. PUBLISHER:
Time Inc. ISSUE: October 2009. CATEGORY: Photo: Feature: Service (story)

332 *Fortune*

CREATIVE DIRECTOR: John Korpics. DESIGNER: Deanna Lowe.
DIRECTOR OF PHOTOGRAPHY: Mia Diehl. PHOTO EDITOR: Armin Harris.
PHOTOGRAPHER: Christopher Griffith. PUBLISHER: Time Inc. ISSUE: November
23, 2009. CATEGORY: Photo: Feature: Non-Celebrity Profile (single/spread)

SECTION:
photography

AWARD:
gold

CATEGORY:
non-celebrity profile (story)

175

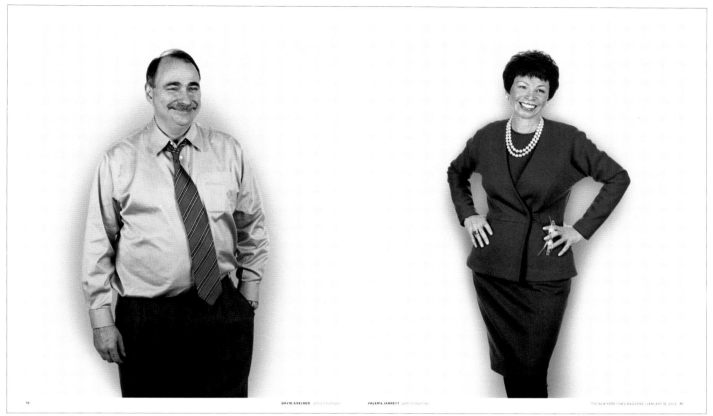

333

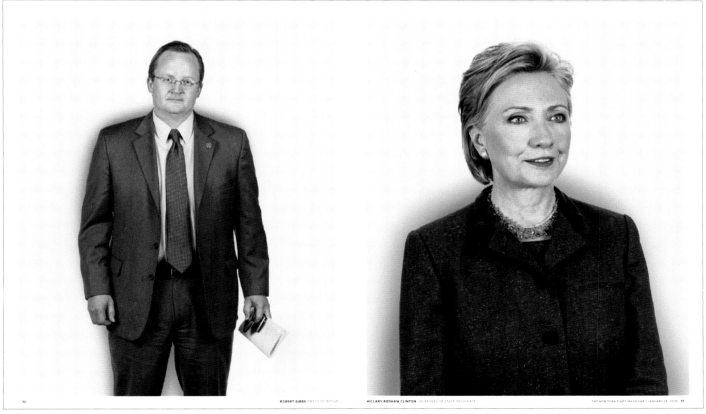

333 **The New York Times Magazine**

DESIGN DIRECTOR: Arem Duplessis. ART DIRECTOR: Gail Bichler. DEPUTY ART DIRECTOR: Leo Jung. DESIGNER: Hilary Greenbaum.
DIRECTOR OF PHOTOGRAPHY: Kathy Ryan. PHOTO EDITORS: Kira Pollack, Kathy Ryan. PHOTOGRAPHER: Nadav Kander.
PUBLISHER: The New York Times Company. ISSUE: January 18, 2009. CATEGORY: Photo: Feature: Non-Celebrity Profile (story)

176

SECTION:
photography

AWARD:
gold

CATEGORY:
**celebrity/entertainment profile
news/reportage**

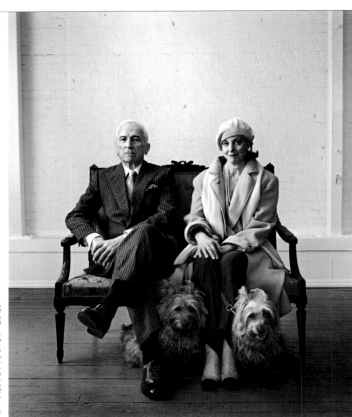

A
NONFICTION MARRIAGE

After the massage parlors,
after the affair, after the scandalous book
that nearly broke up his family,
Gay Talese is writing a new opus—about
his relationship with his wife.

By
Jonathan Van Meter

IT ISN'T UNTIL our third interview that I notice Gay Talese has been sitting underneath a painting of a naked woman with a rainbow coming out of her vagina. We are in the otherwise staid living room of his townhouse in the East Sixties, the home where he and his wife, Nan, the publisher of Nan A. Talese/Doubleday books, have lived for half a century. In fact, in June they will celebrate their 50th wedding anniversary, an impressive milestone for any couple, but perhaps few more so than this one. This legendary literary marriage—in all of its baroque complexity—has taken place entirely under this roof. It is here where they began their life together as a couple in their mid-twenties, when the five-story brownstone was like a tenement and Gay lived in 3F, a studio they both still refer to as his "bachelor pad"; this is where they raised their two daughters, Pamela and Catherine, and slowly took over every apartment in the building before finally buying it in 1973; this

is where they have held innumerable book parties for Nan's celebrated authors; and this is where Gay has done much of the writing—the historic *Esquire* pieces, the best sellers with biblical titles—that brought him fame, fortune, and no small amount of personal agony.

What's absurd about the fact that I missed the rainbow vagina painting is that the subject of our conversation is, in so many words, sex. This month, Ecco re-published *Thy Neighbor's Wife*, with a foreword by Katie Roiphe (along with a new edition of *Honor Thy Father*, foreword by Pete Hamill). The book, originally published in 1980, is about the sexual revolution, which Talese believed would be the most important cultural shift in decades, and which he spent most of the seventies intimately researching. It's the research itself—particularly Talese's tendency to take the participant-observer concept to the extreme—that turned out to be the unintended legacy of the project. "If you want to write about orgies," says Talese,

18

Photograph by Mary Ellen Mark

334

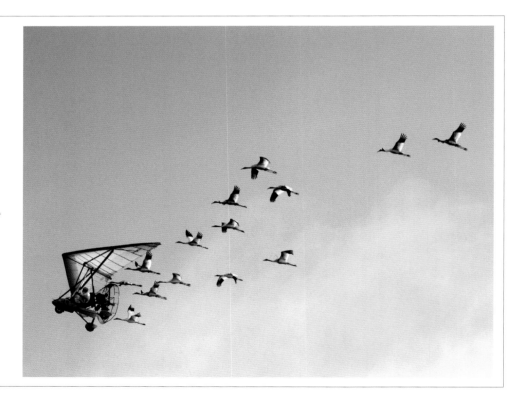

Rescue Flight

In a bid to save the endangered
whooping crane, biologists and self-taught
conservationists are donning hooded
costumes and taking to the skies to lead the birds on
their annual migration. Is the only
remaining way of saving the natural world
to stage-manage it?

By Jon Mooallem

People started gathering at the Lighthouse Missionary Baptist Church in southwestern Kentucky before sunrise. First there were just a few, sealed in their cars with the heat blasting, but before long there were close to 100, standing in the parking lot in multiple coats. It was the first Friday in December, 23 degrees at dawn and nearly windless. Everyone was looking up.

Operation Migration's four ultralight planes floated into view over some oak and maple trees, then passed over the small, white chapel. An ultralight is powered by a massive rear propeller. In the sky, it looks like a scaled-down Formula

Photographs by Mark Peterson
This Way Survival: An ultralight plane piloted by an Operation
Migration team member guiding whooping cranes from Wisconsin to
their winter nesting grounds in Florida.

30

335

334 **New York**

DESIGN DIRECTOR: Chris Dixon. DIRECTOR OF PHOTOGRAPHY: Jody Quon. PHOTO EDITOR: Lea Golis. PHOTOGRAPHER: Mary Ellen Mark. EDITOR-IN-CHIEF: Adam Moss. PUBLISHER: New York Magazine Holdings, LLC. ISSUE: May 4, 2009. CATEGORY: Photo: Feature: Celebrity/ Entertainment Profile (single/spread)

335 **The New York Times Magazine**

DESIGN DIRECTOR: Arem Duplessis. ART DIRECTOR: Gail Bichler. DESIGNER: Gail Bichler. DIRECTOR OF PHOTOGRAPHY: Kathy Ryan. PHOTOGRAPHER: Mark Peterson. PUBLISHER: The New York Times Company. ISSUE: February 22, 2009. CATEGORY: Photo: Feature: News/ Reportage (single/spread)

SECTION:
photography

AWARD:
gold

CATEGORY:
celebrity/entertainment profile (story)

177

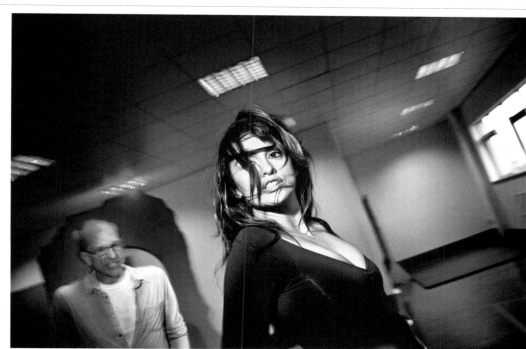

PEDRO ALMODÓVAR ON

Penélope
Cruz

From the first time I saw Penélope Cruz — in the film "Jamón, Jamón," her debut with the Spanish director Bigas Luna, in 1992 — I knew I wanted to work with her. I remember Penélope walking sulkily in front of Javier Bardem, who was following her on a motorbike. Her way of walking, of talking, of looking at him, of getting angry with him, was so real, so natural and personal that you couldn't take your eyes off her. Fortunately, Penélope hasn't lost the freshness and flair of her early days, as she has just shown, playing opposite the same actor, curiously enough, 16 years later in "Vicky Cristina Barcelona."

Despite my intense desire to work with her, I didn't manage to do so until five years after "Jamón, Jamón." I wondered whether to give her the leading role in "Live...

With photographer John Dyer at a 4-dance rehearsal for the film "Nine," London Nov. 15, 2008

336

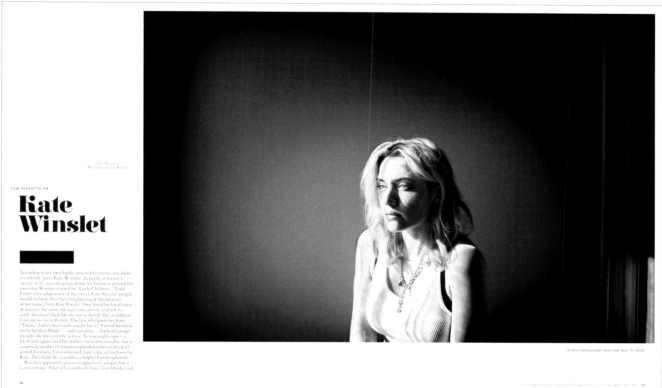

TOM PERROTTA ON

Kate
Winslet

According to my own highly unscientific survey, just about everybody loves Kate Winslet. Actually, it wasn't a survey at all, just me going about my business around the time that Winslet starred in "Little Children," Todd Field's film adaptation of my novel. *Kate Winslet!* people would exclaim, their faces brightening at the mention of her name. *I love Kate Winslet!* They loved her for all sorts of reasons. *She seems like such a nice person, so down-to-earth. She doesn't look like she starves herself. She's so different from one movie to the next.* The fans who knew her from "Titanic" hadn't necessarily caught her in "Eternal Sunshine of the Spotless Mind" — and vice versa — but both groups thought she was a terrific actress. As you might expect, a lot of men appreciated her fearless on-screen sexuality, but a surprising number of women responded to her on this level as well. I estimate, I was informed, have a special fondness for Kate. *They think she's a goddess,* a helpful friend explained.

Winslet's apparently universal appeal isn't unique, but it is mysterious. After all, everybody loves Tom Hanks and...

At the Chelsea Hotel, New York, Nov. 19, 2008

336

336 **The New York Times Magazine**

DESIGN DIRECTOR: Arem Duplessis. ART DIRECTOR: Gail Bichler. DEPUTY ART DIRECTOR: Leo Jung. DESIGNERS: Hilary Greenbaum, Cathy Gilmore-Barnes, Ian Allen. DIRECTOR OF PHOTOGRAPHY: Kathy Ryan. PHOTO EDITOR: Kira Pollack. PHOTOGRAPHER: Paolo Pellegrin. PUBLISHER: The New York Times Company. ISSUE: February 8, 2009. CATEGORY: Photo: Feature: Celebrity/Entertainment Profile (story)

178

SECTION:
photography

AWARD:
gold

CATEGORY:
news/reportage (story)

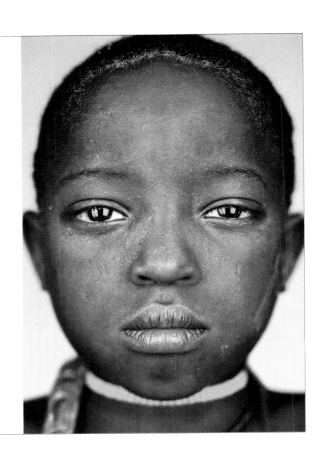

THEY GROW NO FOOD, RAISE NO LIVESTOCK, AND LIVE WITHOUT
RULES OR CALENDARS. THEY ARE LIVING A HUNTER-GATHERER EXISTENCE
THAT IS LITTLE CHANGED FROM 10,000 YEARS AGO. WHAT DO
THEY KNOW THAT WE'VE FORGOTTEN?

THE HADZA

BY MICHAEL FINKEL

PHOTOGRAPHS BY MARTIN SCHOELLER

Like his ancestors, young Nija will grow up to roam
the wildlands around Lake Eyasi in northern Tanzania—if outside
pressures don't curtail his people's freedom first.

94

337

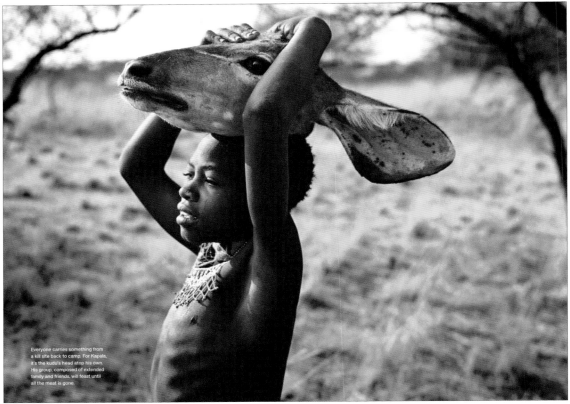

Everyone carries something from
a kill site back to camp. For Kapala,
it's the kudu's head atop his own.
His group, composed of extended
family and friends, will feast until
all the meat is gone.

337

337 **National Geographic**

DESIGN DIRECTOR: David Whitmore. ART DIRECTOR: John Baxter.
DIRECTOR OF PHOTOGRAPHY: David Griffin. PHOTO EDITOR: Todd
James. PHOTOGRAPHER: Martin Schoeller. EDITOR-IN-CHIEF: Chris Johns.
PUBLISHER: National Geographic Society. ISSUE: December 2009.
CATEGORY: Photo: Feature: News/Reportage (story)

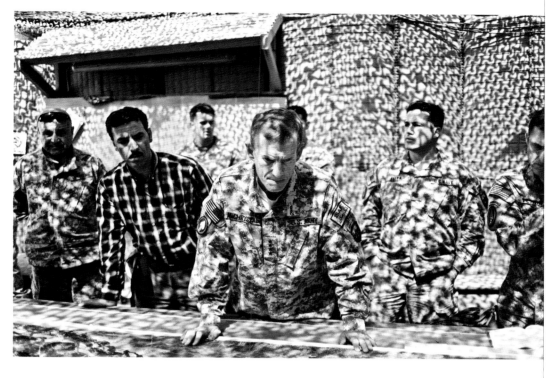

IS IT
JUST TOO LATE —
POLITICALLY
AND MILITARILY —
FOR GEN. STANLEY
McCHRYSTAL
TO WIN IN
AFGHANISTAN?

HIS
LONG
WAR

BY DEXTER FILKINS

PHOTOGRAPHS BY
PETER VAN AGTMAEL

PLOTTING THE COURSE
General McChrystal meets with U.S.
and Afghan commanders at Forward Operating
Base Delhi in Helmand Province.

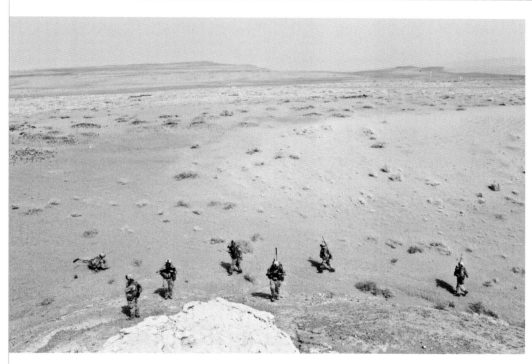

A PERILOUS WALK
Marines on patrol en route to
Mian Poshteh. Minutes later, a bomb that was
buried in the road exploded.

came, through the head-high corn. Delgado turned to one of his buddies, Cpl. John Shymanik, 22.
"They didn't get us today," Delgado said.
"They're still trying, though," Shymanik said.

STANLEY MCCHRYSTAL SAT at the head of a U-shaped bank of tables in a sealed room at Bagram Airfield, a main hub of the war. He was surrounded by five giant video screens. On each screen was another general — American, German, Dutch, French, Italian each commanding a different part of Afghanistan. It was McChrystal's morning briefing, known as the commander's update.

One by one, the generals scrolled through the events from the day before: a roadside bomb in Khost, small-arms fire in Ghazni, a British soldier killed in Helmand Province. Then one of the European generals started talking about an airstrike. A group of Taliban insurgents had attacked a coalition convoy, and the soldiers called for air support. A Hellfire missile, the European general said, obliterated an Afghan compound. The general — he cannot be named because of the confidentiality of the meeting — was moving on to the next topic when McChrystal stopped him.

"Can you come back to that, please?" McChrystal said.
McChrystal's voice is higher than you would expect for a four-star general.
"Yes, sir," the European general said.
"We just struck a compound," McChrystal said. "I would like for you to explain to me the process you used to shoot a Hellfire missile into a compound that might have had civilians in it."

The European commander looked at an aide and muttered something. The killing of Afghan civilians, usually caused by inadvertent American and NATO airstrikes, has become the most sensitive issue between the Afghans and their Western guests. Each time civilians are killed, the Taliban launch a campaign of very public propaganda.

"Were there civilians in that compound?" McChrystal asked. He was leaning into the microphone on the table.
The commander started to talk, but McChrystal kept going.
"Who made that decision?" McChrystal said.
An aide handed the European general a sheaf of papers.
"I'm sorry, but the system is not responsive enough for us to get that kind of information that quickly," the general said.
McChrystal's face began to tighten. Generals tend to treat one another with the utmost deference.
"We bomb a compound, and I don't know about it until the next morning?" McChrystal said. "Don't just tell me, 'Yeah, it's O.K.' I want to know about it. I'm being a hard-ass about it."
The European general looked down at his papers.
"It seems it was not a Hellfire missile but a 500-pound bomb," he said.
McChrystal took off his reading glasses and looked around the room — at the video screens and the other American officers.
"Gentlemen, we need to understand the implications of what we are doing," he said. "Air power contains the seeds of

338 *The New York Times Magazine*

DESIGN DIRECTOR: Arem Duplessis. ART DIRECTOR: Gail Bichler.
DEPUTY ART DIRECTOR: Leo Jung. DESIGNER: Leo Jung.
DIRECTOR OF PHOTOGRAPHY: Kathy Ryan. PHOTO EDITOR: Clinton
Cargill. PHOTOGRAPHER: Peter van Agtmael. PUBLISHER: The New York
Times Company. ISSUE: October 18, 2009.
CATEGORY: Photo: Feature: News/Reportage (story)

SECTION:
photography

AWARD:
gold

CATEGORY:
travel/food/still life (story)

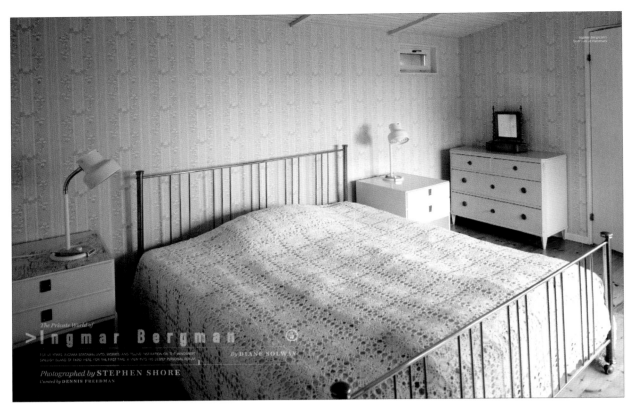

339

339

339 W

DESIGN DIRECTOR: Edward Leida. ART DIRECTOR: Nathalie Kirsheh.
DESIGNER: Nathalie Kirsheh. PHOTO EDITOR: Nadia Vellam. PHOTOGRAPHER:
Stephen Shore. PUBLISHER: Condé Nast Publications Inc. ISSUE: November 2009.
CATEGORY: Photo: Feature: Travel/Food/Still Life (story)

SECTION:
photography

AWARD:
gold

CATEGORY:
**travel/food/still life
fashion/beauty**

181

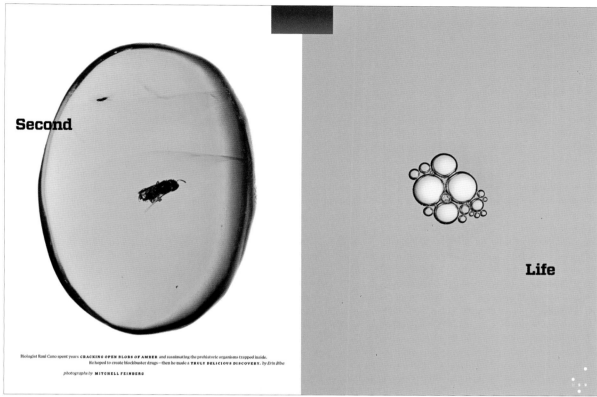

340

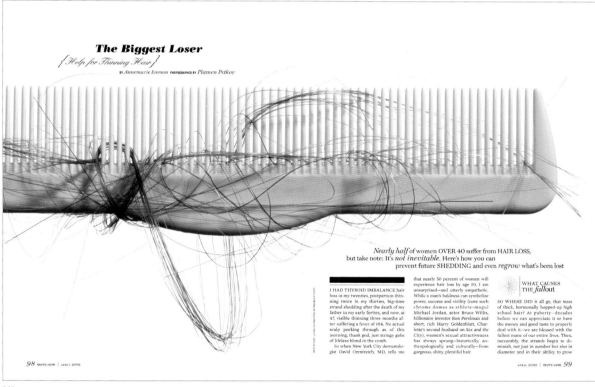

341

340 WIRED

CREATIVE DIRECTOR: Scott Dadich. DESIGN DIRECTOR: Wyatt Mitchell.
ART DIRECTOR: Christy Sheppard. DESIGNER: Christy Sheppard. DEPUTY
PHOTO EDITOR: Anna Goldwater Alexander. PHOTOGRAPHER: Mitchell
Feinberg. EDITOR-IN-CHIEF: Chris Anderson. PUBLISHER: Condé Nast
Publications, Inc. ISSUE: August 2009.CATEGORY: Photo: Feature: Travel/
Food/Still Life (single/spread)

341 *More*

CREATIVE DIRECTOR: Debra Bishop. ART DIRECTOR: Jose G. Fernandez.
DESIGNER: Jenn McManus. DIRECTOR OF PHOTOGRAPHY: Jennifer
Laski. PHOTO EDITOR: Natalie Gialluca. PHOTOGRAPHER: Plamen
Petkov. EDITOR-IN-CHIEF: Lesley Jane Seymour. PUBLISHER: Meredith
Corporation. ISSUE: April 2009. CATEGORY: Photo: Feature: Fashion/Beauty
(single/spread)

182 SECTION:
photography

AWARD:
gold

CATEGORY:
fashion/beauty (story)

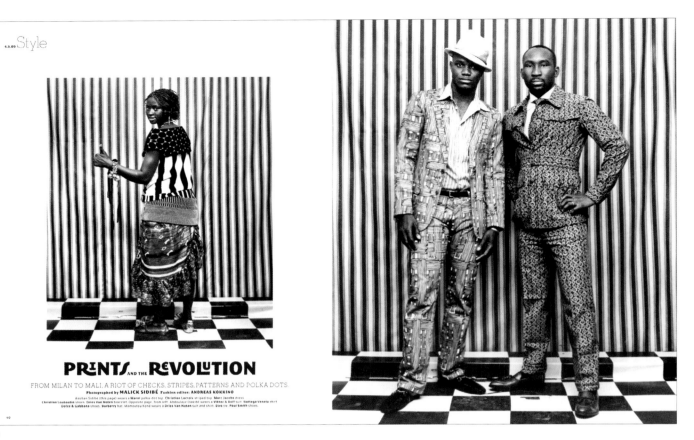

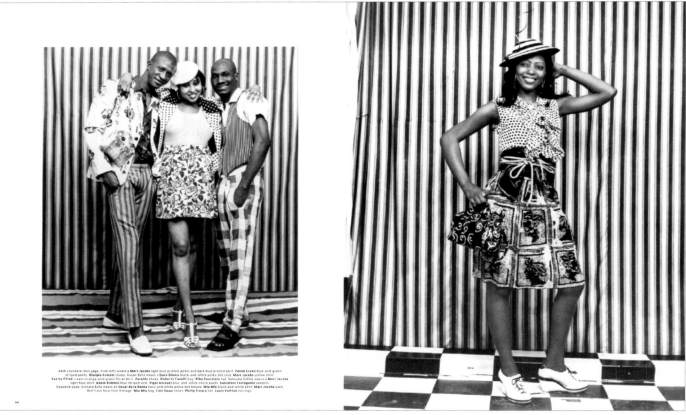

342 *The New York Times Magazine*

DESIGN DIRECTOR: Arem Duplessis. ART DIRECTOR: Gail Bichler. DESIGNER: Nancy Harris Rouemy. DIRECTOR OF PHOTOGRAPHY: Kathy Ryan. PHOTO EDITOR: Scott Hall. PHOTOGRAPHER: Malick Sidibé. PUBLISHER: The New York Times Company. ISSUE: April 5, 2009. CATEGORY: Photo: Feature: Fashion/Beauty (story)

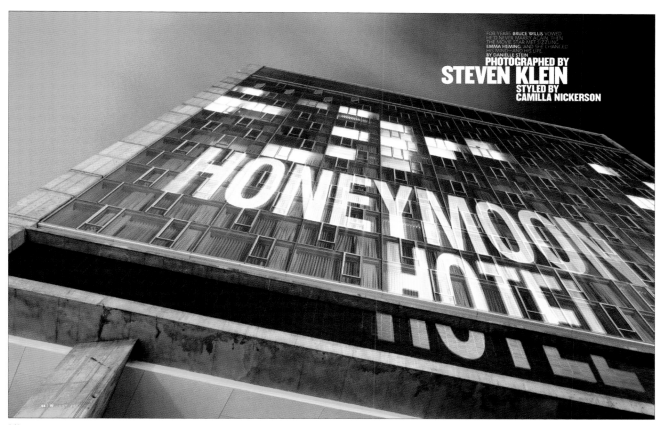

FOR YEARS **BRUCE WILLIS** VOWED
HE'D NEVER MARRY AGAIN. THEN
THE MOVIE STAR MET SIZZLING
EMMA HEMING, AND SHE CHANGED
HIS MIND—AND HIS LIFE.
BY DANIELLE STEIN

PHOTOGRAPHED BY
STEVEN KLEIN
STYLED BY
CAMILLA NICKERSON

343

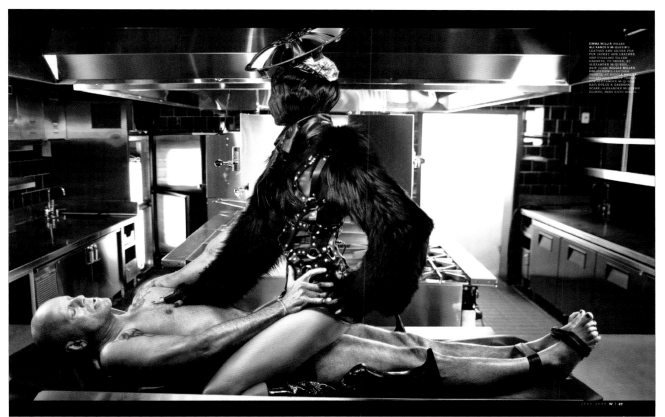

343

343 **W**

CREATIVE DIRECTOR: Dennis Freedman. DESIGN DIRECTOR: Edward Leida. ART DIRECTOR: Nathalie Kirsheh. PHOTOGRAPHER: Steven Klein. PUBLISHER: Condé Nast Publications Inc. ISSUE: July 2009. CATEGORY: Photo: Feature: Fashion/Beauty (story)

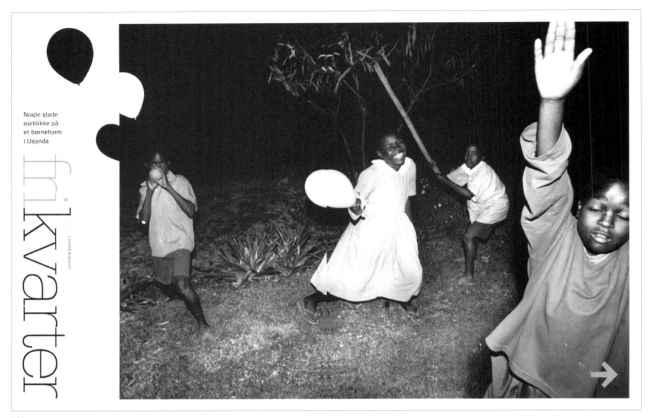

Nogle glade
øjeblikke på
et børnehjem
i Uganda

frikvarter

344

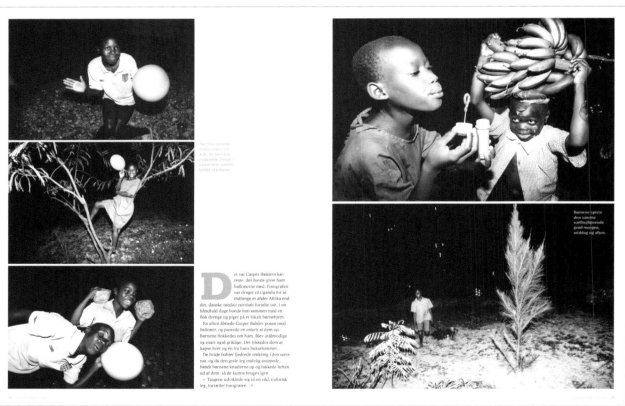

344

DESIGN DIRECTOR: Torsten Hogh Rasmussen. PHOTOGRAPHER: Casper Balslev. EDITOR-IN-CHIEF: Andreas Fugl Thøgersen. PUBLISHER: DSB. ISSUE: July 2009.
CATEGORY: Photo: Cover, Entire Issue, Single/Spread or Story

SECTION:
photography

AWARD:
gold

CATEGORY:
photo-illustration

185

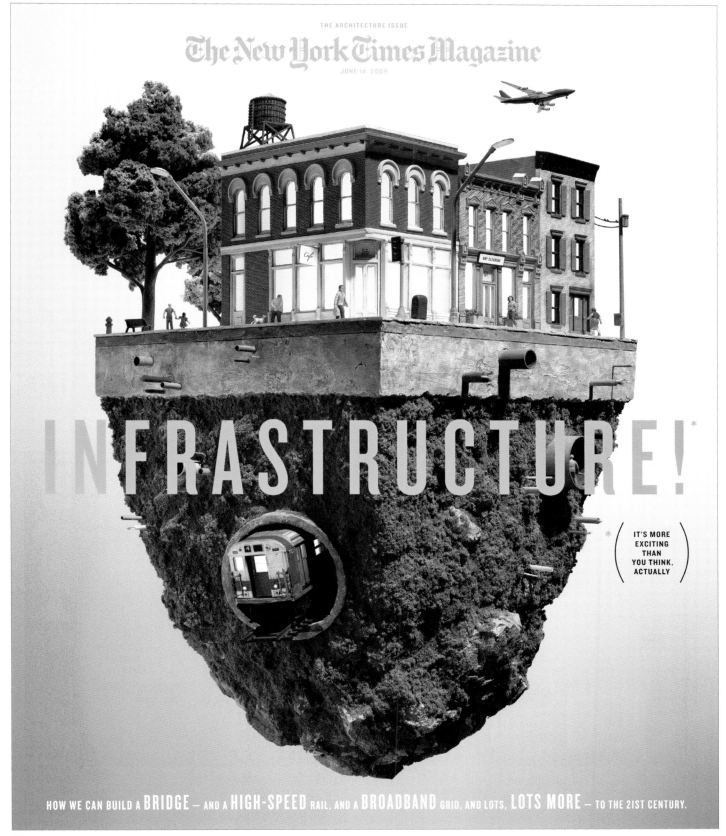

345 **The New York Times Magazine**

DESIGN DIRECTOR: Arem Duplessis. ART DIRECTOR: Gail Bichler. DESIGNER: Leo Jung. ILLUSTRATOR: Thomas Doyle. DIRECTOR OF PHOTOGRAPHY: Kathy Ryan. PHOTO EDITOR: Luise Stauss. PHOTOGRAPHER: Tom Schierlitz. PUBLISHER: The New York Times Company. ISSUE: June 14, 2009. CATEGORY: Photo-Illustration: Single/Spread/Story

SECTION:
photography

AWARD:
silver

CATEGORY:
cover

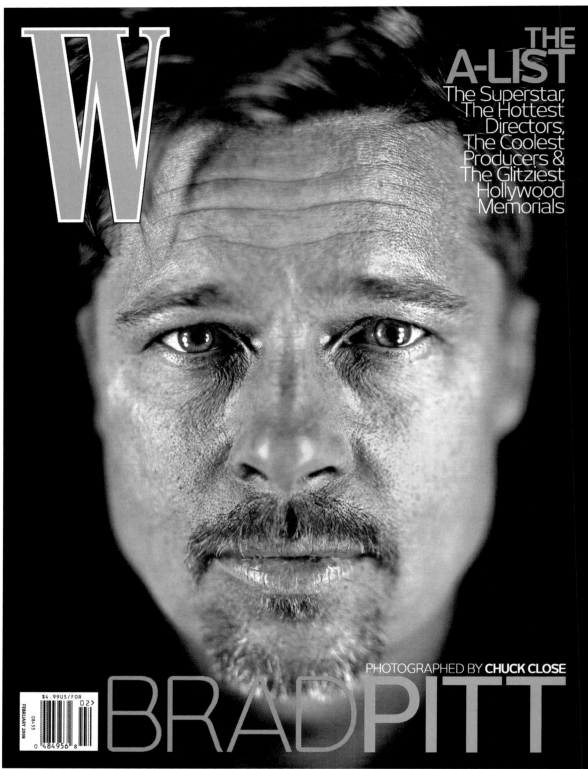

THE A-LIST
The Superstar,
The Hottest
Directors,
The Coolest
Producers &
The Glitziest
Hollywood
Memorials

PHOTOGRAPHED BY **CHUCK CLOSE**

BRADPITT

$4.99US/FOR
FEBRUARY 2009

346

CREATIVE DIRECTOR: Dennis Freedman. DESIGN DIRECTOR: Edward
Leida. ART DIRECTOR: Nathalie Kirsheh. DESIGNER: Nathalie Kirsheh.
PHOTOGRAPHER: Chuck Close. PUBLISHER: Condé Nast Publications Inc.
ISSUE: February 2009. CATEGORY: Photo: Cover

SECTION:
photography

AWARD:
silver

CATEGORY:
**entire issue
section (single month)**

187

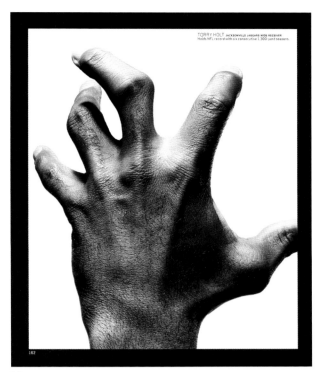

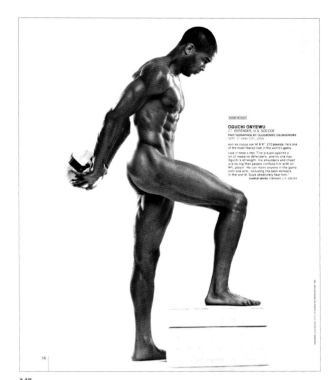

347

347

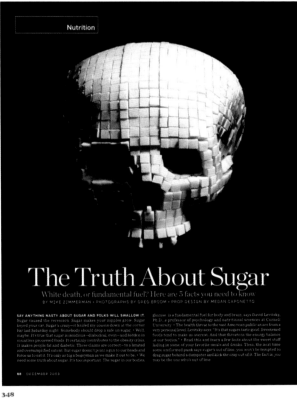

348

348

347 **ESPN The Magazine**

CREATIVE DIRECTOR: Siung Tjia. ART DIRECTOR: Jason Lancaster.
DIRECTOR OF PHOTOGRAPHY: Catriona Ni Aolain. PHOTO
EDITORS: Jennifer Aborn, Amy McNulty, Maisie Todd, Nancy Weisman.
PHOTOGRAPHERS: Jamie Chung, James White, James Dimmock, Olugbenro
Ogunsemore, Jeff Riedel, Naomi Harris, Sheryl Nields, Sarah Friedman,
Matthias Clamer, Max Aguilera-Helwig, Christopher Griffith, Christian Weber,
Patrick Giardino, Alessandra Petlin, Danielle Levitt, Ben Watts. PUBLISHER:
The Walt Disney Publishing Company. ISSUE: October 19, 2009. CATEGORY:
Photo: Entire Issue

348 **Men's Health**

DESIGN DIRECTOR: Brandon Kavulla. ART DIRECTOR: Vikki Nestico.
DESIGNERS: Ian Brown, Bradley R. Hughes. DIRECTOR OF
PHOTOGRAPHY: Brenda Milis. PHOTO EDITORS: Jeanne Graves, Michelle
Stark, Ayla Christman, Mark Haddad. PHOTOGRAPHERS: Greg Broom,
Bartholomew Cooke. PUBLISHER: Rodale Inc. ISSUE: December 2009.
CATEGORY: Photo: Section (single month)

SECTION:
photography

AWARD:
silver

CATEGORY:
section (single month)

FEATURES | 17.04

WIRED

FIX THE GRID 76 | **BRAIN ATLAS** 88 | **WORLD'S BIGGEST DIAMOND HEIST** 96 | **TERMINATOR IS BACK** 104 | **PERFECT MEMORY WOMAN** 110

PHOTOGRAPH BY **Spencer Higgins**

APR 2009 **0 7 5**

349

349 **WIRED**

CREATIVE DIRECTOR: Scott Dadich. DESIGN DIRECTOR: Wyatt Mitchell. ART DIRECTOR: Carolyn Rauch. PHOTO EDITOR: Carolyn Rauch. PHOTOGRAPHER: Spencer Higgins. EDITOR-IN-CHIEF: Chris Anderson. PUBLISHER: Condé Nast Publications, Inc. ISSUE: April 2009. CATEGORY: Photo: Section (single month)

SECTION:
photography

AWARD:
silver

CATEGORY:
section (series of months)

189

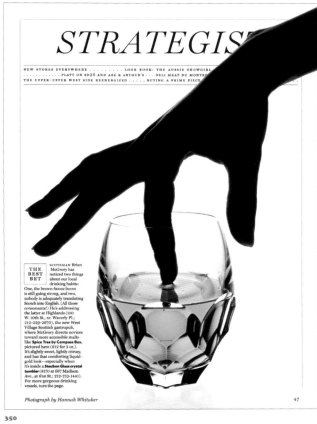

350

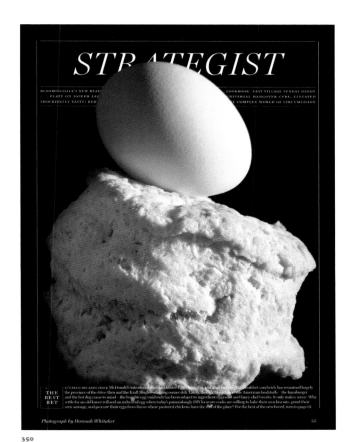

350

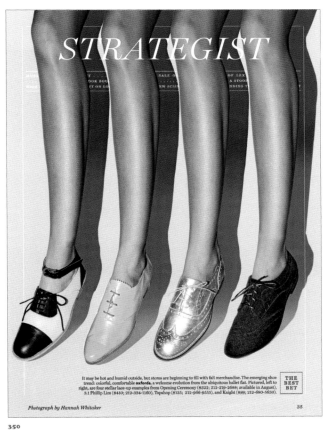

350

350

350 *New York*

DESIGN DIRECTOR: Chris Dixon. DIRECTOR OF PHOTOGRAPHY: Jody Quon. PHOTO EDITORS: Caroline Smith, Alex Pollack. PHOTOGRAPHER: Hannah Whitaker.
EDITOR-IN-CHIEF: Adam Moss. PUBLISHER: New York Magazine Holdings, LLC. CATEGORY: Photo: Section (series of months)

190

SECTION:
photography

AWARD:
silver

CATEGORY:
service
non-celebrity profile

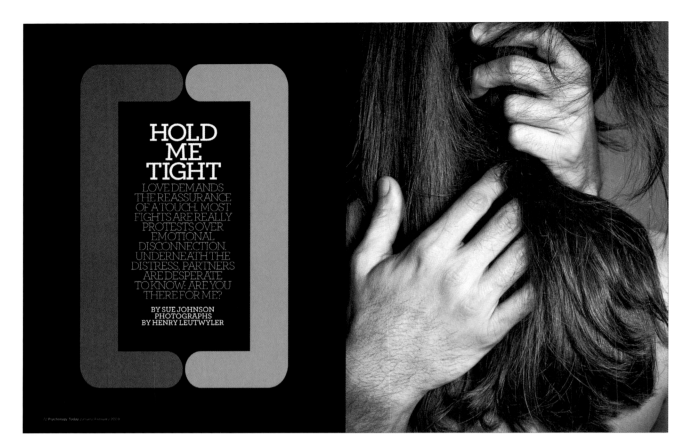

351

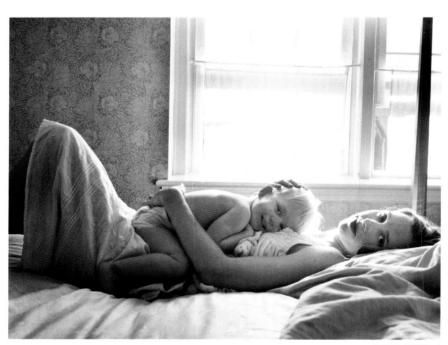

352

351 **Psychology Today**

CREATIVE DIRECTOR: Edward Levine. DIRECTOR OF PHOTOGRAPHY:
Claudia Stefezius. PHOTOGRAPHER: Henry Leutwyler. STUDIO: Levine Design
Inc. PUBLISHER: Sussex Publishers. CLIENT: Psychology Today. ISSUE:
January/February 2009. CATEGORY: Photo: Feature: Service (single/spread)

352 **Real Simple**

CREATIVE DIRECTOR: Janet Froelich. DESIGN DIRECTOR: Cybele Grandjean.
DIRECTOR OF PHOTOGRAPHY: Casey Tierney. PHOTOGRAPHER: Jessica
Todd Harper. PUBLISHER: Time Inc. ISSUE: November 2009. CATEGORY:
Photo: Feature: Non-Celebrity Profile (single/spread)

SECTION:
photography

AWARD:
silver

CATEGORY:
service (story)

191

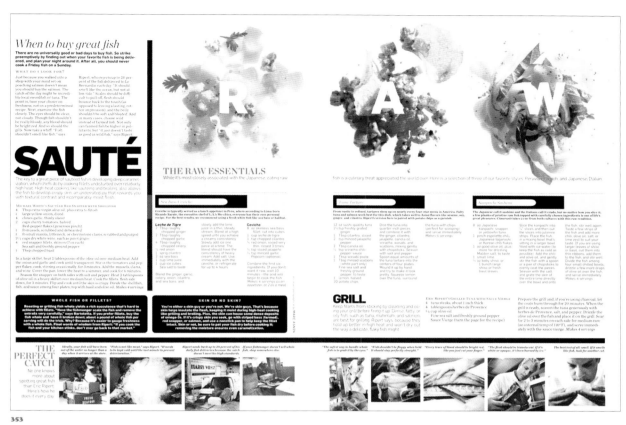

353

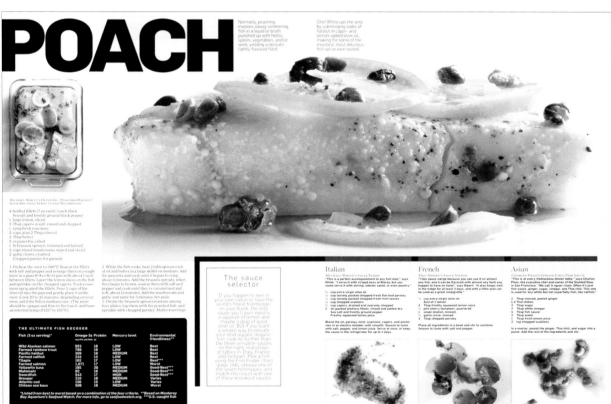

353

353 Men's Health

DESIGN DIRECTOR: Brandon Kavulla. DESIGNER: Brandon Kavulla. ILLUSTRATOR: datatickler. DIRECTOR OF PHOTOGRAPHY: Brenda Milis. PHOTO EDITOR: Michelle Stark. PHOTOGRAPHER: Romulo Yanes. PUBLISHER: Rodale Inc. ISSUE: November 2009. CATEGORY: Photo: Feature: Service (story)

192

SECTION:
photography

AWARD
silver

CATEGORY:
non-celebrity profile (story)

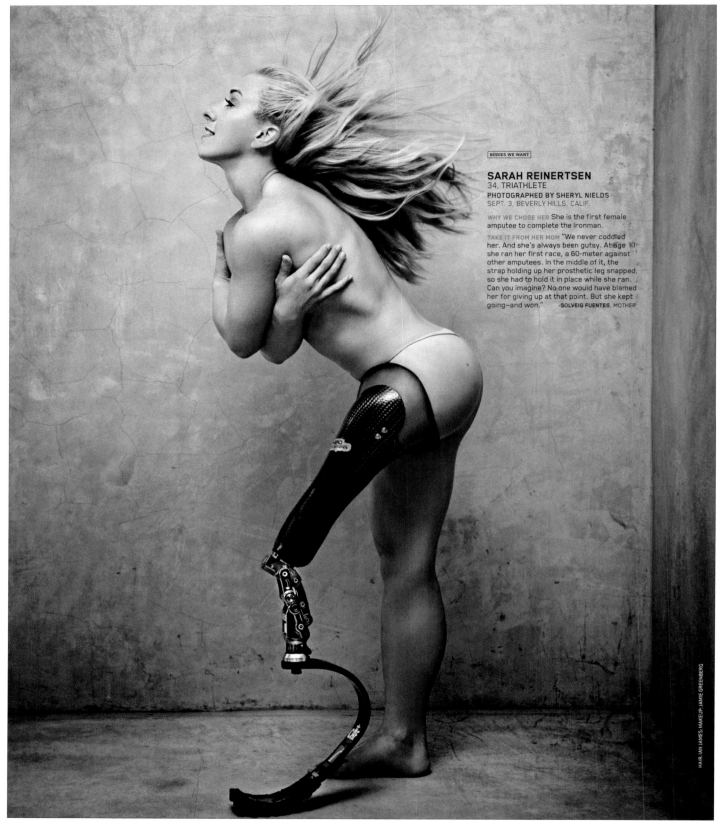

BODIES WE WANT

SARAH REINERTSEN
34, TRIATHLETE
PHOTOGRAPHED BY SHERYL NIELDS
SEPT. 3, BEVERLY HILLS, CALIF.

WHY WE CHOSE HER She is the first female amputee to complete the Ironman.

TAKE IT FROM HER MOM "We never coddled her. And she's always been gutsy. At age 11 she ran her first race, a 60-meter against other amputees. In the middle of it, the strap holding up her prosthetic leg snapped, so she had to hold it in place while she ran. Can you imagine? No one would have blamed her for giving up at that point. But she kept going—and won." —SOLVEIG FUENTES, MOTHER

HAIR: IAN JAMES. MAKEUP: JAMIE GREENBERG

354

CREATIVE DIRECTOR: Siung Tjia. DIRECTOR OF PHOTOGRAPHY: Catriona Ni Aolain. PHOTO EDITORS: Maisie Todd, Nancy Weisman. PHOTOGRAPHERS: Christian Weber, James Dimmock, Sheryl Nields, Sarah A. Friedman, Ben Watts, James White, Olugbenro Ogunsemore, Rennio Maifredi, Christopher Griffith, Danielle Levitt, Jeff Riedel, Alessandra Petlin, Marco Gob, Patrik Giardino. PUBLISHER: The Walt Disney Publishing Company. ISSUE: October 19, 2009. CATEGORY: Photo: Feature: Non-Celebrity Profile (story)

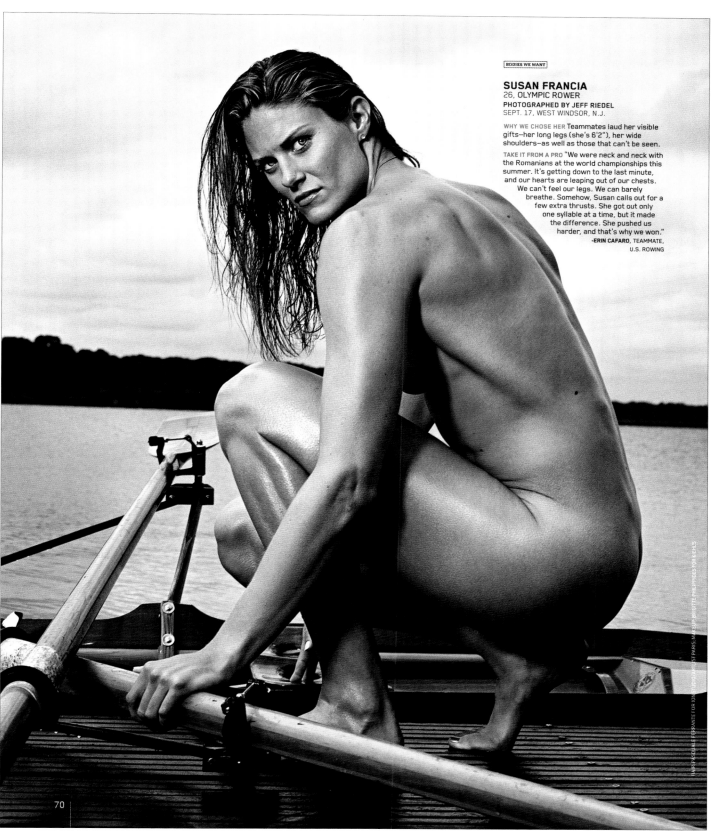

SUSAN FRANCIA
26, OLYMPIC ROWER
PHOTOGRAPHED BY JEFF RIEDEL
SEPT. 17, WEST WINDSOR, N.J.

WHY WE CHOSE HER Teammates laud her visible gifts—her long legs (she's 6'2"), her wide shoulders—as well as those that can't be seen.

TAKE IT FROM A PRO "We were neck and neck with the Romanians at the world championships this summer. It's getting down to the last minute, and our hearts are leaping out of our chests. We can't feel our legs. We can barely breathe. Somehow, Susan calls out for a few extra thrusts. She got out only one syllable at a time, but it made the difference. She pushed us harder, and that's why we won."
—ERIN CAFARO, TEAMMATE, U.S. ROWING

HAIR: PASCUALE FERRANTE FOR TONI&GUY/AUGUST PARIS. MAKEUP: BRIGITTE PHILIPPIDES FOR KIEHL'S

194

SECTION:
photography

AWARD:
silver

CATEGORY:
celebrity/entertainment profile
celebrity/entertainment profile (story)

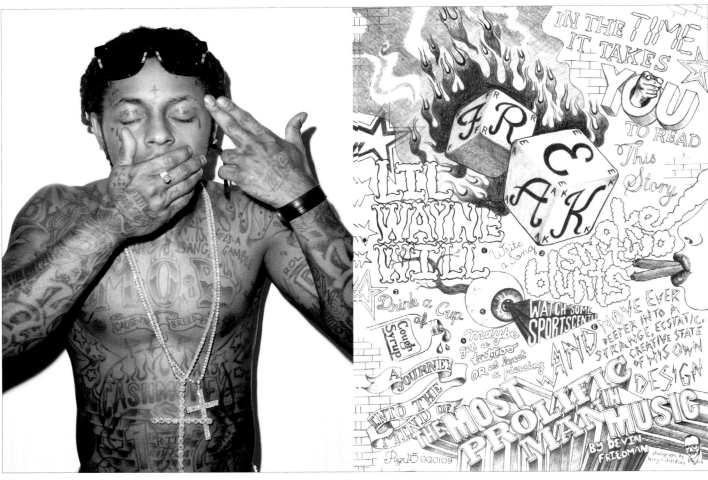

355

356

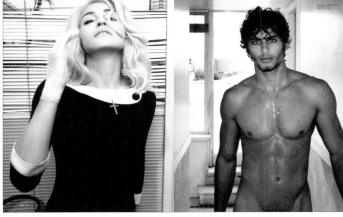

356

355 **GQ**

DESIGN DIRECTOR: Fred Woodward. DESIGNER: Chelsea Cardinal.
DIRECTOR OF PHOTOGRAPHY: Dora Somosi. PHOTOGRAPHER: Terry
Richardson. CREATIVE DIRECTOR, FASHION: Jim Moore. PUBLISHER:
Condé Nast Publications Inc. ISSUE: January 2009. CATEGORY: Photo:
Feature: Celebrity/Entertainment Profile (single/spread)

356 **W**

CREATIVE DIRECTOR: Dennis Freedman. DESIGN DIRECTOR: Edward
Leida. ART DIRECTOR: Nathalie Kirsheh. DESIGNER: Edward Leida.
PHOTOGRAPHER: Steven Klein. PUBLISHER: Condé Nast Publications Inc.
ISSUE: March 2009. CATEGORY: Photo: Feature: Celebrity/Entertainment
Profile (story)

SECTION:
photography

AWARD:
silver

CATEGORY:
news/reportage

195

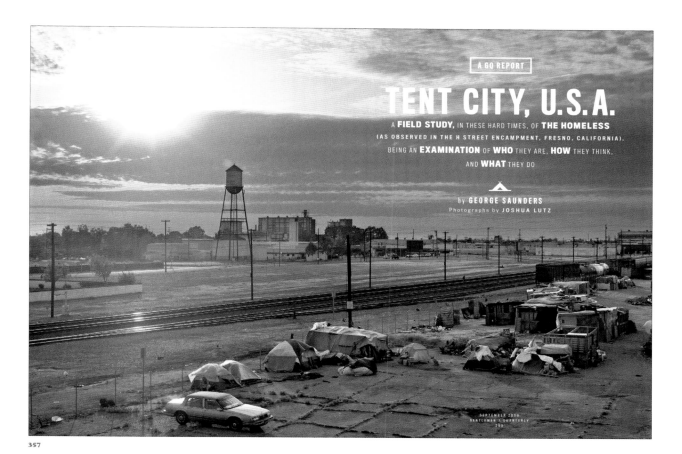

357

358

357 **GQ**

DESIGN DIRECTOR: Fred Woodward. DESIGNER: Thomas Alberty.
DIRECTOR OF PHOTOGRAPHY: Dora Somosi. PHOTO EDITORS: Justin
O'Neill, Emily Blank. PHOTOGRAPHER: Joshua Lutz. PUBLISHER: Condé
Nast Publications Inc. ISSUE: September 2009. CATEGORY: Photo: Feature:
News/Reportage (single/spread)

358 **The New York Times Magazine**

DESIGN DIRECTOR: Arem Duplessis. ART DIRECTOR: Gail Bichler.
DESIGNER: Leo Jung. DIRECTOR OF PHOTOGRAPHY: Kathy Ryan.
PHOTO EDITOR: Joanna Milter. PHOTOGRAPHER: Anthony Almeida-
Danziger Projects. PUBLISHER: The New York Times Company. ISSUE:
November 1, 2009. CATEGORY: Photo: Feature: News/Reportage (single/spread)

196

SECTION:
photography

AWARD:
silver

CATEGORY:
news/reportage (story)

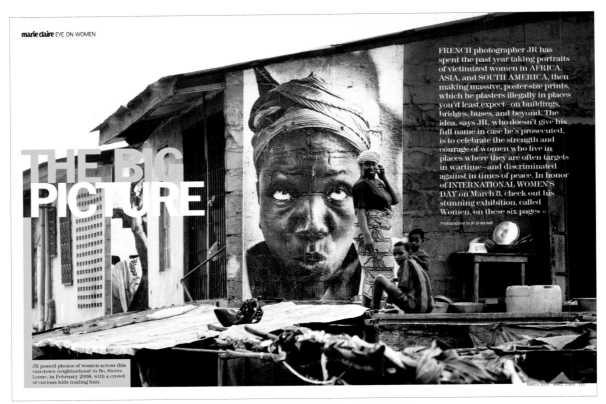

marie claire EYE ON WOMEN

THE BIG PICTURE

FRENCH photographer JR has spent the past year taking portraits of victimized women in AFRICA, ASIA, and SOUTH AMERICA, then making massive, poster-size prints, which he plasters illegally in places you'd least expect—on buildings, bridges, buses, and beyond. The idea, says JR, who doesn't give his full name in case he's prosecuted, is to celebrate the strength and courage of women who live in places where they are often targets in wartime—and discriminated against in times of peace. In honor of INTERNATIONAL WOMEN'S DAY on March 8, check out his stunning exhibition, called Women, on these six pages »

Photographed by JR (jr-art.net)

JR posted photos of women across this run-down neighborhood in Bo, Sierra Leone, in February 2008, with a crowd of curious kids trailing him.

MARCH 2009 · MARIE CLAIRE 121

359

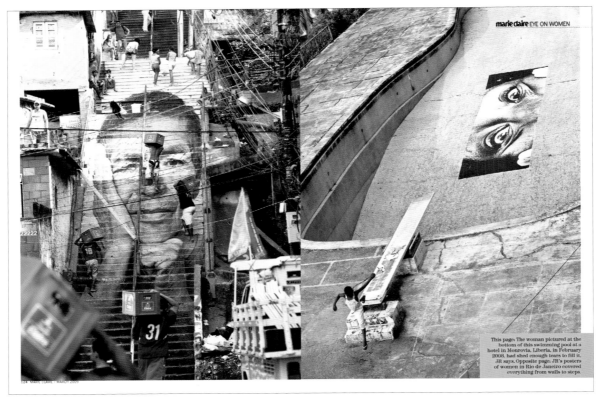

marie claire EYE ON WOMEN

This page The woman pictured at the bottom of this swimming pool at a hotel in Monrovia, Liberia, in February 2008, had shed enough tears to fill it, JR says. Opposite page: JR's posters of women in Rio de Janeiro covered everything from walls to steps.

124 MARIE CLAIRE · MARCH 2009

359

359 *Marie Claire*

CREATIVE DIRECTOR: Suzanne Sykes. DESIGN DIRECTOR: Kristin Fitzpatrick. ART DIRECTOR: Shannon Casey. DESIGNER: Elizabeth Schlossberg. DIRECTOR OF PHOTOGRAPHY: Alix Campbell. PHOTO EDITOR: Andrea Volbrecht. PHOTOGRAPHER: JR. Editorial Coordinator Marie Bazin. EDITOR-IN-CHIEF: Joanna Coles. PUBLISHER: The Hearst Corporation-Magazines Division. ISSUE: March 2009. CATEGORY: Photo: Feature: News/Reportage (story)

SECTION:
photography

AWARD:
silver

CATEGORY:
travel/food/still life
travel/food/still life (story)

197

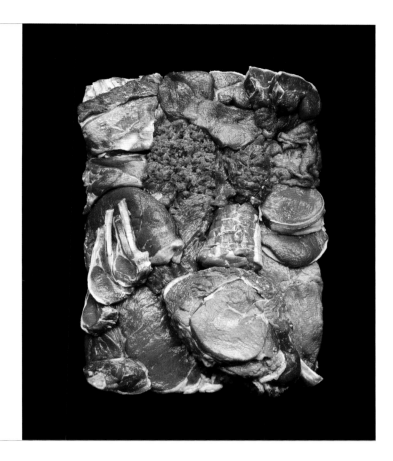

360

361

361

360 **The New York Times Magazine**

DESIGN DIRECTOR: Arem Duplessis. ART DIRECTOR: Gail Bichler.
DESIGNER: Aviva Michaelov. DIRECTOR OF PHOTOGRAPHY: Kathy
Ryan. PHOTO EDITOR: Luise Stauss. PHOTOGRAPHER: Mitchell Feinberg.
PUBLISHER: The New York Times Company. ISSUE: October 11, 2009.
CATEGORY: Photo: Feature: Travel/Food/Still Life (single/spread)

361 **WIRED**

CREATIVE DIRECTOR: Scott Dadich. DESIGN DIRECTOR: Wyatt Mitchell.
ART DIRECTOR: Maili Holiman. DESIGNER: Maili Holiman. DEPUTY
PHOTO EDITOR: Anna Goldwater Alexander. PHOTOGRAPHER: Uta
Kogelsberger. EDITOR-IN-CHIEF: Chris Anderson. PUBLISHER: Condé Nast
Publications, Inc. ISSUE: May 2009. CATEGORY: Photo: Feature: Travel/
Food/Still Life (story)

198

SECTION:
photography

AWARD:
silver

CATEGORY:
fashion/beauty
fashion/beauty (story)

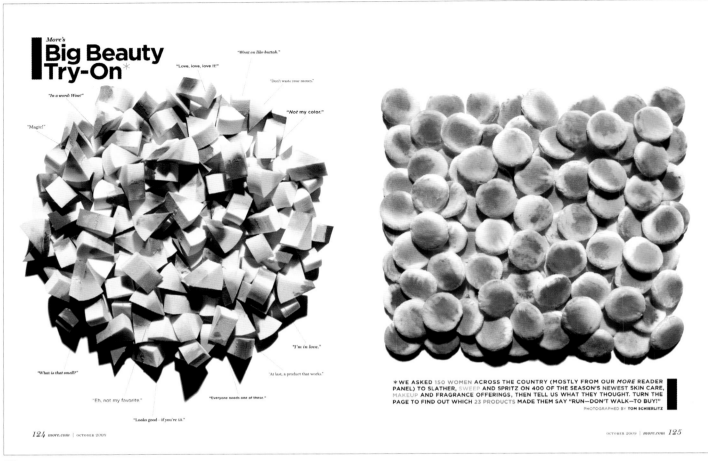

362

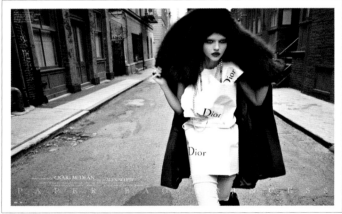

363

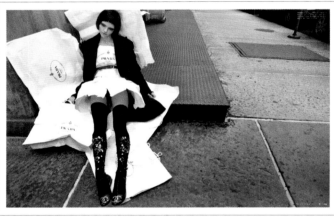

363

362 **More**

CREATIVE DIRECTOR: Debra Bishop. ART DIRECTOR: Cybele Grandjean.
DESIGNER: Cybele Grandjean. DIRECTOR OF PHOTOGRAPHY: Stacey
Baker. PHOTO EDITOR: Natalie Gialluca. PHOTOGRAPHER: Tom
Schierlitz. EDITOR-IN-CHIEF: Lesley Jane Seymour. PUBLISHER: Meredith
Corporation. ISSUE: October 2009. CATEGORY: Photo: Feature: Fashion/
Beauty (single/spread)

363 **W**

DESIGN DIRECTOR: Edward Leida. ART DIRECTOR: Nathalie Kirsheh.
DESIGNER: Edward Leida. PHOTOGRAPHER: Craig McDean. PUBLISHER:
Condé Nast Publications Inc. ISSUE: September 2009. CATEGORY: Photo:
Feature: Fashion/Beauty (story)

SECTION:
photography

AWARD:
silver

CATEGORY:
corporate/trade

199

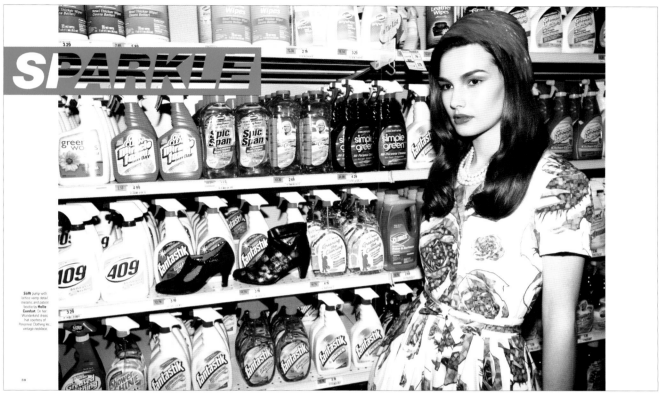

SP**ARKLE**

Sōft pump with
lattice vamp detail
metallic and patent
bootie by **Helle
Comfort**. On her:
Wunderkind dress,
hat courtesy of
Perennial Clothing Inc.,
vintage necklace.

364

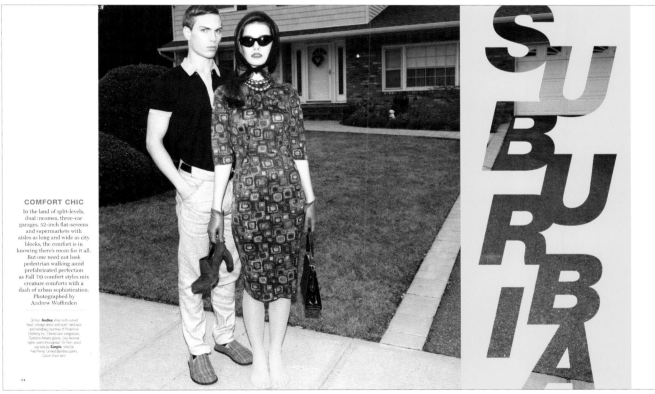

COMFORT CHIC

In the land of split-levels,
dual incomes, three-car
garages, 52-inch flat-screens
and supermarkets with
aisles as long and wide as city
blocks, the comfort is in
knowing there's room for it all.
But one need not look
pedestrian walking amid
prefabricated perfection
as Fall '09 comfort styles mix
creature comforts with a
dash of urban sophistication.
Photographed by
Andrew Woffinden.

On her: **Audley** shoe with curved
heel, vintage dress and scarf, necklace
and handbag courtesy of Perennial
Clothing Inc.; Derek Lam sunglasses;
Carolina Amato gloves, Leg Avenue
tights worn throughout. On him: plaid
slip-ons by **Simple**; shirt by
Fred Perry; United Bamboo jeans,
Calvin Klein belt.

S
U
B
U
R
B
I
A

364

CREATIVE DIRECTOR: Nancy Campbell. ART DIRECTOR: Trevett McCandliss.
DESIGNER: Trevett McCandliss. PHOTOGRAPHER: Andrew Woffinden.
EDITOR-IN-CHIEF: Greg Dutter. PUBLISHER: Symphony Publishing. ISSUE:
March 2009. CATEGORY: Photo: Cover, Entire Issue, Single/Spread or Story

200

SECTION:
photography

AWARD:
merit

CATEGORY:
cover

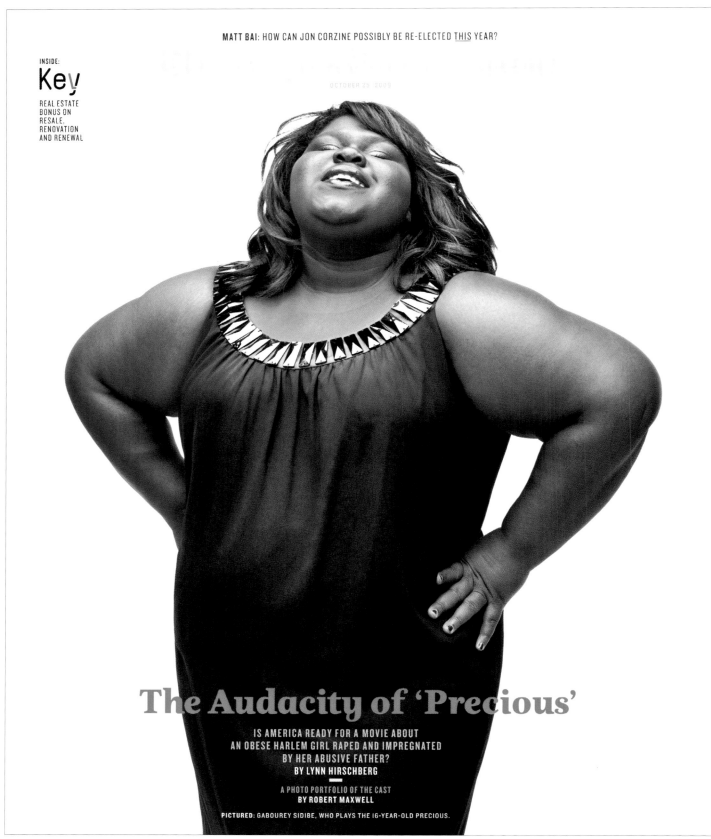

MATT BAI: HOW CAN JON CORZINE POSSIBLY BE RE-ELECTED <u>THIS</u> YEAR?

INSIDE:

Key

REAL ESTATE
BONUS ON
RESALE,
RENOVATION
AND RENEWAL

OCTOBER 25, 2009

The Audacity of 'Precious'

IS AMERICA READY FOR A MOVIE ABOUT
AN OBESE HARLEM GIRL RAPED AND IMPREGNATED
BY HER ABUSIVE FATHER?
BY LYNN HIRSCHBERG
—
A PHOTO PORTFOLIO OF THE CAST
BY ROBERT MAXWELL

PICTURED: GABOUREY SIDIBE, WHO PLAYS THE 16-YEAR-OLD PRECIOUS.

365 **The New York Times Magazine**

DESIGN DIRECTOR: Arem Duplessis. ART DIRECTOR: Gail Bichler. DIRECTOR OF PHOTOGRAPHY: Kathy Ryan. PHOTO EDITOR: Joanna Milter. PHOTOGRAPHER: Robert Maxwell. PUBLISHER: The New York Times Company. ISSUE: October 25, 2009. CATEGORY: Photo: Cover

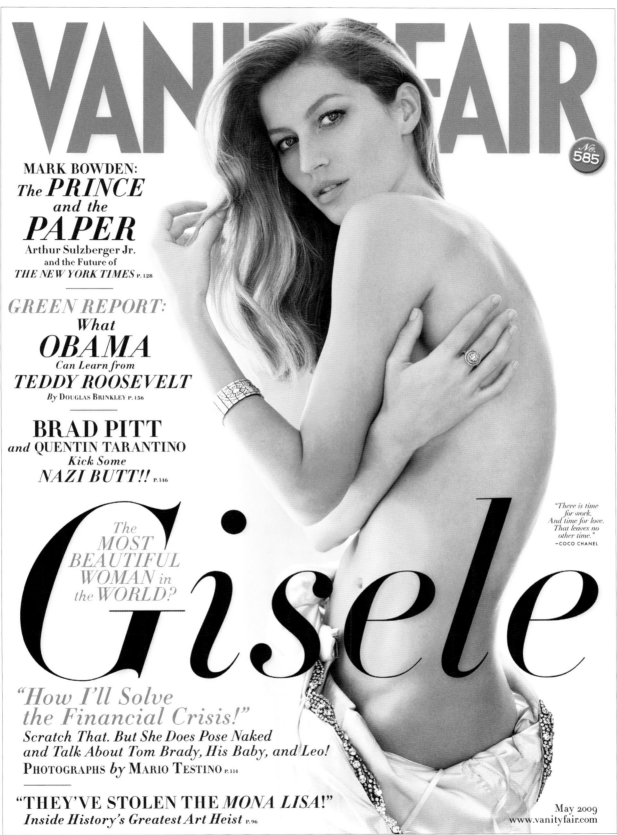

VANITY FAIR

No. 585

MARK BOWDEN:
The **PRINCE**
and the
PAPER
Arthur Sulzberger Jr.
and the Future of
THE NEW YORK TIMES P. 128

GREEN REPORT:
What
OBAMA
Can Learn from
TEDDY ROOSEVELT
By DOUGLAS BRINKLEY P. 156

BRAD PITT
and QUENTIN TARANTINO
Kick Some
NAZI BUTT!! P. 146

The
MOST
BEAUTIFUL
WOMAN *in*
the **WORLD?**

Gisele

*"There is time
for work.
And time for love.
That leaves no
other time."*
—COCO CHANEL

*"How I'll Solve
the Financial Crisis!"*
*Scratch That. But She Does Pose Naked
and Talk About Tom Brady, His Baby, and Leo!*
PHOTOGRAPHS *by* MARIO TESTINO P. 114

"THEY'VE STOLEN THE *MONA LISA*!**"**
Inside History's Greatest Art Heist P. 96

May 2009
www.vanityfair.com

366

DESIGN DIRECTOR: David Harris. ART DIRECTOR: Julie Weiss. DIRECTOR OF PHOTOGRAPHY: Susan White. PHOTOGRAPHER: Mario Testino. PUBLISHER: Condé Nast Publications Inc. ISSUE: May 2009. CATEGORY: Photo: Cover

202

SECTION:
photography

AWARD:
merit

CATEGORY:
cover

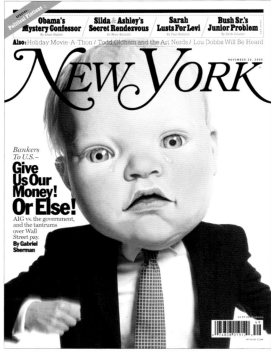

367

369

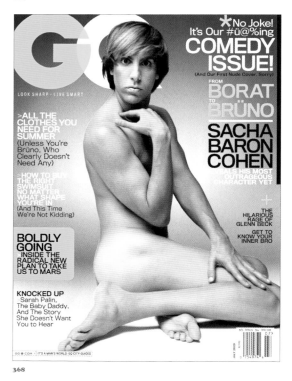
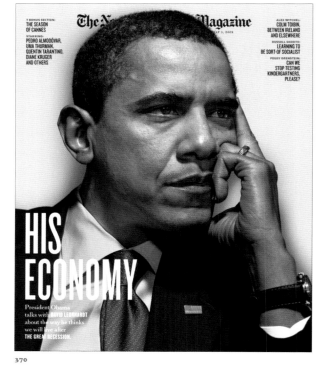

368

370

367 **New York**

DESIGN DIRECTOR: Chris Dixon. DIRECTOR OF PHOTOGRAPHY: Jody Quon. PHOTOGRAPHER: Donat. EDITOR-IN-CHIEF: Adam Moss. PUBLISHER: New York Magazine Holdings, LLC. ISSUE: November 30, 2009. CATEGORY: Photo: Cover

368 **GQ**

DESIGN DIRECTOR: Fred Woodward. DESIGNER: Thomas Alberty. DIRECTOR OF PHOTOGRAPHY: Dora Somosi. PHOTO EDITOR: Krista Prestek. PHOTOGRAPHER: Mark Seliger. CREATIVE DIRECTOR, FASHION: Jim Moore. PUBLISHER: Condé Nast Publications Inc. ISSUE: July 2009. CATEGORY: Photo: Cover

369 **New York**

DESIGN DIRECTOR: Chris Dixon. DIRECTOR OF PHOTOGRAPHY: Jody Quon. PHOTO EDITOR: Lea Golis. PHOTOGRAPHER: Art Streiber. EDITOR-IN-CHIEF: Adam Moss. PUBLISHER: New York Magazine Holdings, LLC. ISSUE: September 21, 2009. CATEGORY: Photo: Cover

370 **The New York Times Magazine**

DESIGN DIRECTOR: Arem Duplessis. ART DIRECTOR: Gail Bichler. DIRECTOR OF PHOTOGRAPHY: Kathy Ryan. PHOTO EDITOR: Kira Pollack. PHOTOGRAPHER: Nadav Kander for the New York Times. PUBLISHER: The New York Times Company. ISSUE: May 3, 2009. CATEGORY: Photo: Cover

371

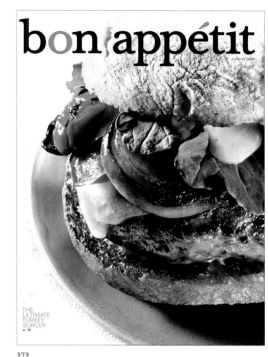

373

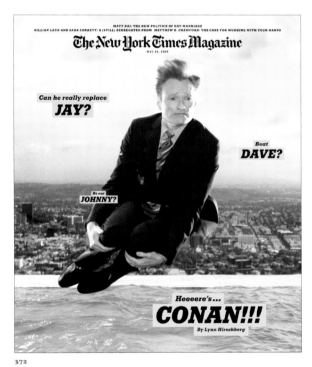

372

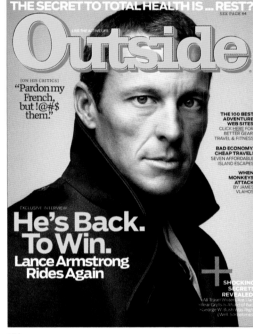

374

371 *Real Simple*

CREATIVE DIRECTOR: Janet Froelich. DESIGN DIRECTOR:
Cybele Grandjean. DIRECTOR OF PHOTOGRAPHY: Casey Tierney.
PHOTOGRAPHER: José Picayo. Stylist Jeffrey W. Miller. PUBLISHER: Time
Inc. ISSUE: November 2009. CATEGORY: Photo: Cover

372 *The New York Times Magazine*

DESIGN DIRECTOR: Arem Duplessis. ART DIRECTOR: Gail Bichler.
DESIGNER: Gail Bichler. DIRECTOR OF PHOTOGRAPHY: Kathy Ryan.
PHOTO EDITOR: Kira Pollack. PHOTOGRAPHER: Dewey Nicks for the New
York Times. PUBLISHER: The New York Times Company. ISSUE: May 24,
2009. CATEGORY: Photo: Cover

373 *Bon Appétit*

DESIGN DIRECTOR: Matthew Lenning. ART DIRECTORS: Robert Festino,
Tom O'Quinn. DESIGNER: John Muñoz. DIRECTOR OF PHOTOGRAPHY:
Bailey Franklin. PHOTO EDITOR: Angelica Mistro. PHOTOGRAPHER:
Nigel Cox. EDITOR-IN-CHIEF: Barbara Fairchild. PUBLISHER: Condé Nast
Publications, Inc. ISSUE: August 2009. CATEGORY: Photo: Cover

374 *Outside*

CREATIVE DIRECTOR: Hannah McCaughey. ART DIRECTORS:
John McCauley, Chris Philpot. PHOTO EDITOR: Amy Feitelberg.
PHOTOGRAPHER: Robert Maxwell. PUBLISHER: Mariah Media, Inc.
ISSUE: February 2009. CATEGORY: Photo: Cover

204

SECTION:
photography

AWARD:
merit

CATEGORY:
cover

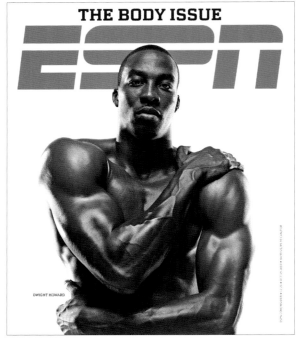

375

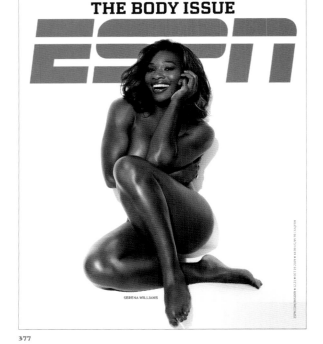

377

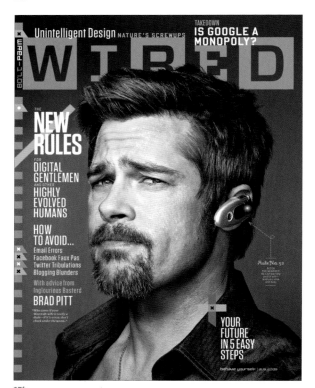

376

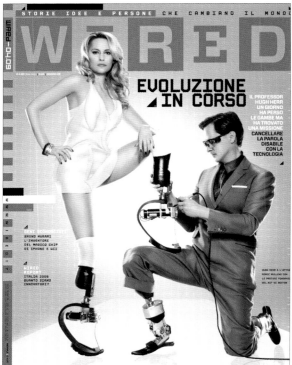

378

375 **ESPN The Magazine**

CREATIVE DIRECTOR: Siung Tjia. DIRECTOR OF PHOTOGRAPHY:
Catriona Ni Aolain. PHOTO EDITOR: Nancy Weisman. PHOTOGRAPHER:
Olugbenro Ogunsemore. PUBLISHER: The Walt Disney Publishing Company.
ISSUE: October 19, 2009. CATEGORY: Photo: Cover

376 **WIRED**

CREATIVE DIRECTOR: Scott Dadich. DESIGN DIRECTOR: Wyatt Mitchell.
PHOTO EDITOR: Carolyn Rauch. DESIGN DIRECTOR: Dan Winters.
EDITOR-IN-CHIEF: Chris Anderson. PUBLISHER: Condé Nast Publications,
Inc. ISSUE: August 2009. CATEGORY: Photo: Cover

377 **ESPN The Magazine**

CREATIVE DIRECTOR: Siung Tjia. DIRECTOR OF PHOTOGRAPHY:
Catriona Ni Aolain. PHOTO EDITOR: Nancy Weisman. PHOTOGRAPHER:
James White. PUBLISHER: The Walt Disney Publishing Company.
ISSUE: October 19, 2009. CATEGORY: Photo: Cover

378 **WIRED Italy**

ART DIRECTOR: David Moretti. DESIGNER: David Moretti.
PHOTO EDITOR: Francesca Morosini. PHOTOGRAPHER: Jill Greenberg.
EDITOR-IN-CHIEF: Riccardo Luna. PUBLISHER: Condé Nast Italia.
ISSUE: June 2009. CATEGORY: Photo: Cover

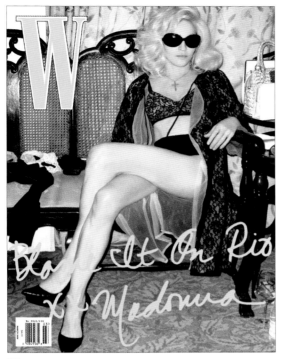

379

381

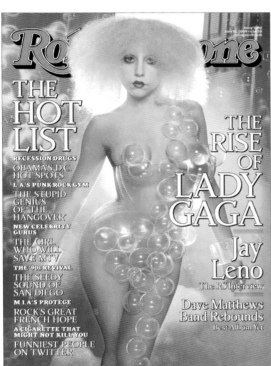

380

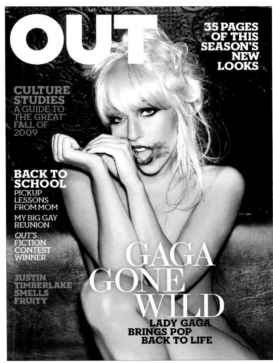

382

379 **W**

DESIGN DIRECTOR: Edward Leida. ART DIRECTOR: Nathalie
Kirsheh. DESIGNER: Nathalie Kirsheh. PHOTOGRAPHER: Steven Klein.
PUBLISHER: Condé Nast Publications Inc. ISSUE: March 2009. CATEGORY:
Photo: Cover

380 *Rolling Stone*

ART DIRECTOR: Joseph Hutchinson. DESIGNER: Joseph Hutchinson.
DIRECTOR OF PHOTOGRAPHY: Jodi Peckman. PHOTOGRAPHER: David
LaChapelle. PUBLISHER: Wenner Media. ISSUE: June 11, 2009. CATEGORY:
Photo: Cover

381 **W**

DESIGN DIRECTOR: Edward Leida. ART DIRECTOR: Nathalie Kirsheh.
DESIGNER: Nathalie Kirsheh. PHOTOGRAPHER: Maurizio Cattelan.
PUBLISHER: Condé Nast Publications Inc. ISSUE: November 2009.
CATEGORY: Photo: Cover

382 *Out*

CREATIVE DIRECTOR: David Gray. ART DIRECTOR: Nick Vogelson.
DESIGNER: Jason Seldon. DIRECTOR OF PHOTOGRAPHY: Annie Chia.
PHOTO EDITOR: Jason Rogers. PHOTOGRAPHER: Ellen von Unwerth.
EDITOR-IN-CHIEF: Aaron Hicklin. PUBLISHER: Here Media. ISSUE:
September 2009. CATEGORY: Photo: Cover

206

SECTION:
photography

AWARD:
merit

CATEGORY:
cover

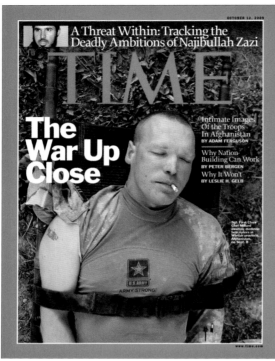

383

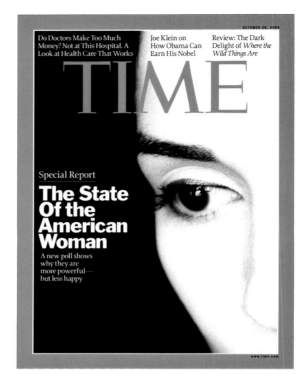

385

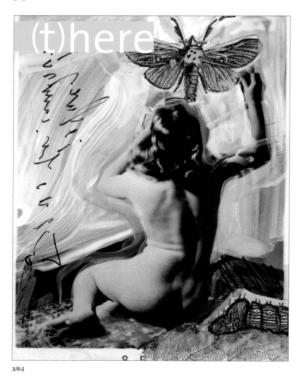

384

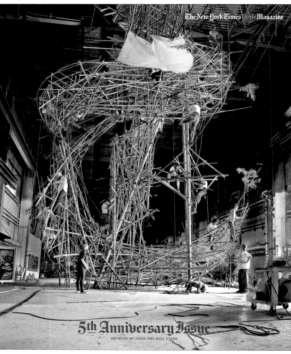

386

383 **TIME**

ART DIRECTOR: Arthur Hochstein. PHOTOGRAPHER: Adam Ferguson — VII
Mentor Program for TIME. DEPUTY PICTURE EDITOR: Dietmar Liz-Lepiorz.
PUBLISHER: Time Inc. ISSUE: October 12, 2009. CATEGORY: Photo: Cover

384 **(t)here**

CREATIVE DIRECTOR: Christopher Wieliczko. DESIGN DIRECTOR: Jason
Makowski. ILLUSTRATOR: Karoline Schleh. EDITOR-IN-CHIEF: Jason
Makowski. PUBLISHER: There Media, Inc. ISSUE: Volume 11, 2009. CATEGORY:
Photo: Cover

385 **TIME**

ART DIRECTOR: Arthur Hochstein. DIRECTOR OF PHOTOGRAPHY: Kira
Pollack. PHOTOGRAPHER: Ralph Gibson for TIME. PUBLISHER: Time Inc.
ISSUE: October 26, 2009. CATEGORY: Photo: Cover

386 **T, The New York Times Style Magazine**

CREATIVE DIRECTOR: David Sebbah. SENIOR ART DIRECTOR:
Christopher Martinez. ARTIST: Doug and Mike Starn. SENIOR PHOTO
EDITOR: Judith Puckett-Rinella. PUBLISHER: The New York Times
Company. ISSUE: August 16, 2009. CATEGORY: Photo: Cover

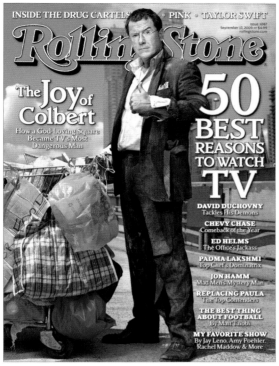

387

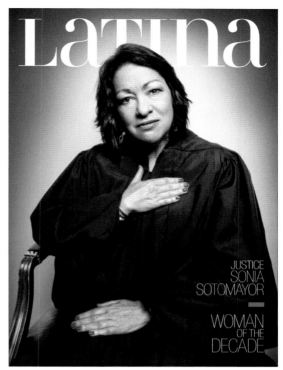

389

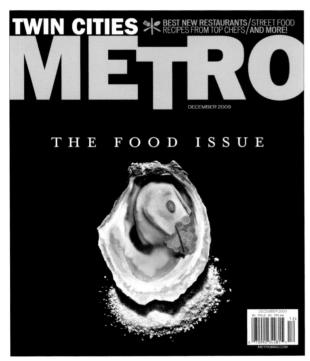

388

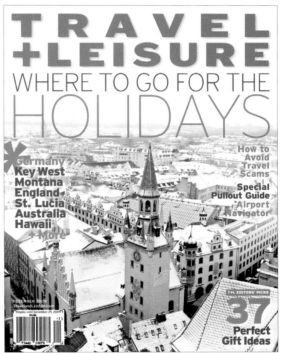

390

387 *Rolling Stone*

ART DIRECTOR: Joseph Hutchinson. DESIGNER: Joseph Hutchinson.
DIRECTOR OF PHOTOGRAPHY: Jodi Peckman. PHOTOGRAPHER: Martin
Schoeller. STUDIO: Martin Schoeller, LLC. PUBLISHER: Wenner Media.
ISSUE: September 17, 2009. CATEGORY: Photo: Cover

388 *Twin Cities METRO Magazine*

ART DIRECTOR: Bryan Nanista. DESIGNER: Bryan Nanista.
PHOTOGRAPHER: Tate Carlson. PUBLISHER: Tiger Oak Publicaitons.
ISSUE: December 2009.CATEGORY: Photo: Cover

389 *Latina*

CREATIVE DIRECTOR: Florian Bachleda DESIGN DIRECTOR: Denise See.
DIRECTOR OF PHOTOGRAPHY: George Pitts. PHOTO EDITOR: Jennifer
Sargent. STUDIO: FB Design. PUBLISHER: Latina Media Ventures.
CLIENT: Latina Magazine. CATEGORY: Photo: Cover

390 *Travel + Leisure*

CREATIVE DIRECTOR: Bernard Scharf. ART DIRECTORS: Mark
Maltais, Katharine Van Itallie. DESIGNER: Mark Maltais. DIRECTOR
OF PHOTOGRAPHY: Katie Dunn. PHOTO EDITOR: Whitney Lawson.
PHOTOGRAPHER: Christian Kerber. PUBLISHER: American Express
Publishing Co. ISSUE: December 2009. CATEGORY: Photo: Cover

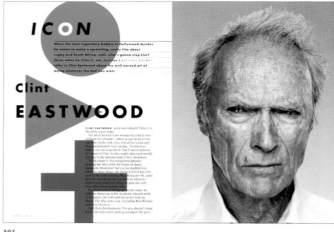

391

391

392

391 *GQ*

DESIGN DIRECTOR: Fred Woodward. ART DIRECTORS: Anton
Ioukhnovets, Thomas Alberty. DESIGNERS: Chelsea Cardinal, Drue Wagner,
Delgis Canahuate. ILLUSTRATORS: Zohar Lazar, Agnés Decourchelle, Jean-
Philippe Delhomme, QuickHoney, Andy Friedman, Knickerbocker Design, John
Ritter, John Ueland, Bruce Hutchison. DIRECTOR OF PHOTOGRAPHY:
Dora Somosi. PHOTO EDITORS: Krista Prestek, Jusin O'Neill, Jesse Lee,
Jolanta Bielat, Emily Blank. PHOTOGRAPHERS: Tom Schierlitz, Eric Ray
Davidson, Scott Schuman, The Selby, Nigel Cox, Robert Maxwell, Chris Buck,
Martin Schoeller, Mark Abrahams, Nathaniel Goldberg, Mark Seliger, Roland
Bello, Peggy Sirota, Matthais Ziegler. CREATIVE DIRECTOR, FASHION:
Jim Moore. EDITOR-IN-CHIEF: Jim Nelson. PUBLISHER: Condé Nast
Publications Inc. ISSUE: December 2009. CATEGORY: Photo: Entire Issue

392 *New York*

DESIGN DIRECTOR: Chris Dixon. DIRECTOR OF PHOTOGRAPHY:
Jody Quon. PHOTO EDITORS: Alex Pollack, Caroline Smith, Lea Golis,
Leana Alagia, Nadia LaChance, Jackie Ladner. PHOTOGRAPHERS: Hannah
Whitaker, Bert Stern, Tierney Gearon, Jake Chessum, Spencer Heyfron, Guy
Aroch, Alexi Lubomirski, Jason Nocito, Cass Bird. EDITOR-IN-CHIEF: Adam
Moss. PUBLISHER: New York Magazine Holdings, LLC. ISSUE: February 23,
2009. CATEGORY: Photo: Entire Issue

393

393

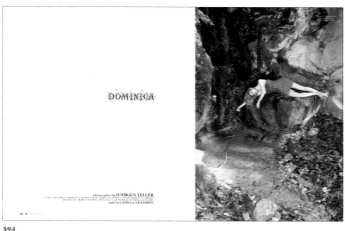
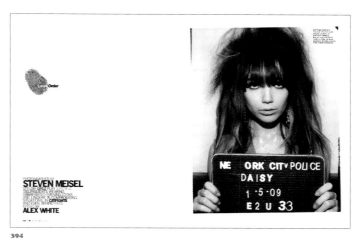

394

394

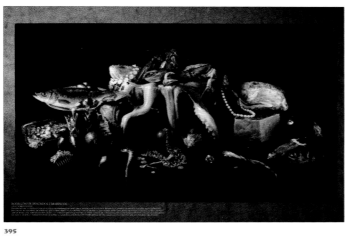
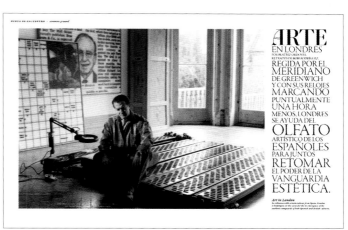

395

395

393 **The New York Times Magazine**

DESIGN DIRECTOR: Arem Duplessis. ART DIRECTOR: Gail Bichler. DEPUTY ART DIRECTOR: Leo Jung. DESIGNERS: Leo Jung, Cathy Gilmore-Barnes, Nancy Harris Rouemy, Hilary Greenbaum, Ian Allen. DIRECTOR OF PHOTOGRAPHY: Kathy Ryan. PHOTO EDITORS: Kira Pollack, Kathy Ryan. PUBLISHER: The New York Times Company. ISSUE: January 18, 2009. CATEGORY: Photo: Entire Issue

394 **W**

CREATIVE DIRECTOR: Dennis Freedman. DESIGN DIRECTOR: Edward Leida. ART DIRECTOR: Nathalie Kirsheh. DESIGNERS: Laura Konrad, Gina Maniscalco. PHOTO EDITOR: Nadia Vellam. PHOTOGRAPHER: Steven Klein. PUBLISHER: Condé Nast Publications Inc. ISSUE: March 2009. CATEGORY: Photo: Entire Issue

395 **MADRIZ**

CREATIVE DIRECTOR: Louis-Charles Tiar. ART DIRECTOR: Sonia Bilbao. DESIGNER: Quique Ciria. ILLUSTRATOR: Jorge Diezma. PHOTOGRAPHERS: Fernando Maselli, Robi Rodríguez. PUBLISHER: Revistas Exclusivas S.L. ISSUE: Spring-Summer 2009. CATEGORY: Photo: Entire Issue

210

SECTION:
photography

AWARD:
merit

CATEGORY:
entire issue

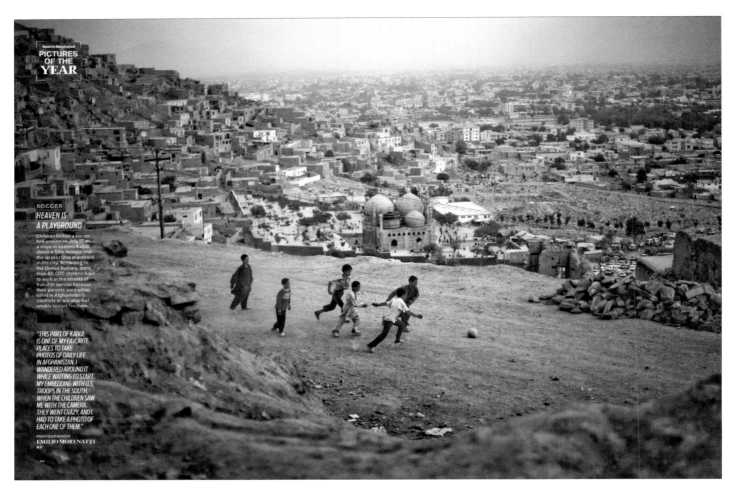

396

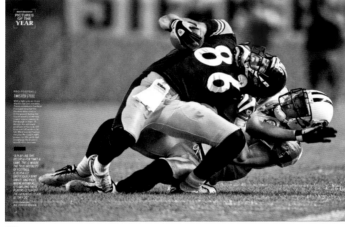

396

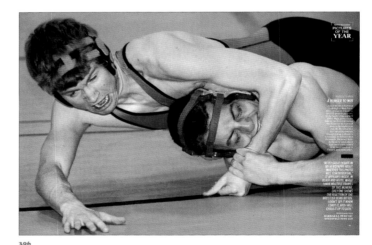

396

396 *Sports Illustrated*

DESIGN DIRECTOR: Christopher Hercik. DESIGNER: Stephen Skalocky.
PHOTO EDITOR: Jimmy Colton. PUBLISHER: Time Inc. ISSUE: December
11, 2009. CATEGORY: Photo: Entire Issue

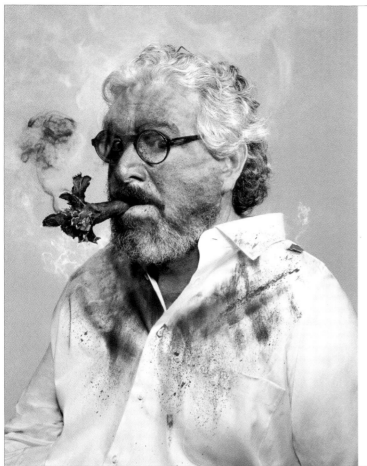

397

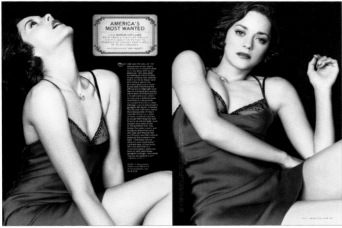

397

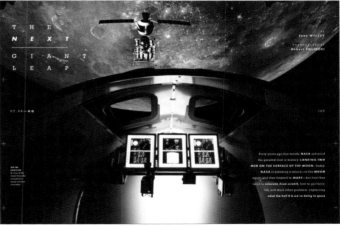

397

397 *GQ*

DESIGN DIRECTOR: Fred Woodward. ART DIRECTORS: Anton Iouknovets, Thomas Alberty. DESIGNERS: Delgis Canahuate, Drue Wagner, Chelsea Cardinal. ILLUSTRATORS: Jean-Philippe Delhomme, Zohar Lazar, QuickHoney, Jason Lee, John Ueland, Bruce Hutchison. DIRECTOR OF PHOTOGRAPHY: Dora Somosi. PHOTO EDITORS: Krista Prestek, Justin O'Neill, Jesse Lee, Jolanta Bielat, Emily Blank. PHOTOGRAPHERS: Mark Seliger, Mitchell Feinberg, Tom Schierlitz, David S. Allee, Nigel Cox, Scott Schuman, Ben Hassett, Ture Lillegraven, Eric Ray Davidson, Jill Greenberg, Chris Buck, Danielle Levitt, Paola Kudacki, Robert Polidori. CREATIVE DIRECTOR, FASHION: Jim Moore. EDITOR-IN-CHIEF: Jim Nelson. PUBLISHER: Condé Nast Publications Inc. ISSUE: July 2009. CATEGORY: Photo: Entire Issue

212

SECTION:
photography

AWARD:
merit

CATEGORY:
entire issue

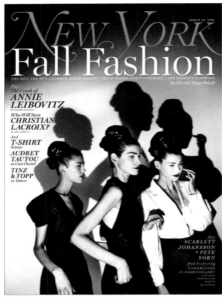

398

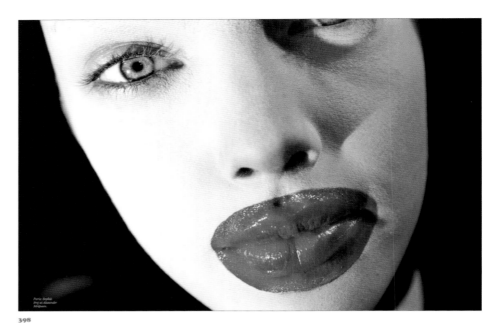

398

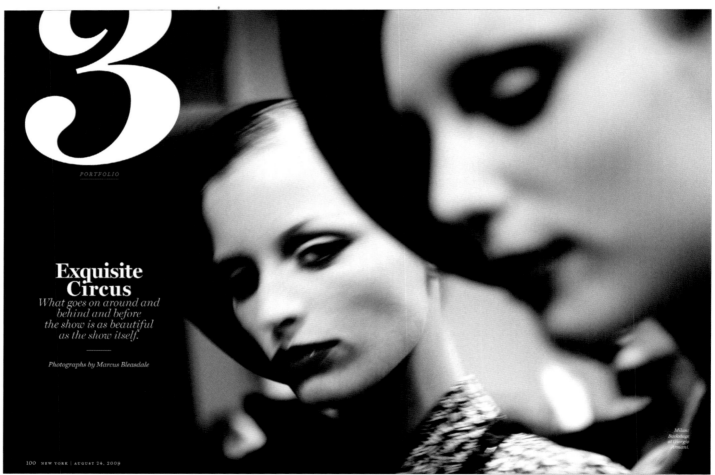

398

398 **New York**

DESIGN DIRECTOR: Chris Dixon. DIRECTOR OF PHOTOGRAPHY: Jody Quon. PHOTO EDITORS: Alex Pollack, Caroline Smith, Lea Golis, Leana Alagia, Nadia Lachance, Jackie Ladner. PHOTOGRAPHERS: Hannah Whitaker, Marcus Bleasdale, John Keatley, Gueorgui Pinkhassov, Valérie Belin, Nigel Parry, Pej Behdarvand, Max Vadukul, Spencer Heyfron. EDITOR-IN-CHIEF: Adam Moss. PUBLISHER: New York Magazine Holdings, LLC. ISSUE: August 24, 2009. CATEGORY: Photo: Entire Issue

THE CULTURE PAGES

TV | MOVIES | ART | MUSIC | BOOKS | POP

**Scenes From
a Marriage**
Julianna
Margulies enters
Silda Spitzer
territory with
The Good Wife.
BY EMMA
ROSENBLUM

Photograph by Ruven Afanador

399

THE SPLITTING IMAGE OF POT

On the one hand, marijuana is practically legal—more mainstream, accessorized, and taken for granted than ever before. On the other, kids are getting busted in the city in record numbers. Guess which kids. **By Mark Jacobson**

Photographs by Horacio Salinas

SEPTEMBER 21, 2009 | NEW YORK 45

399

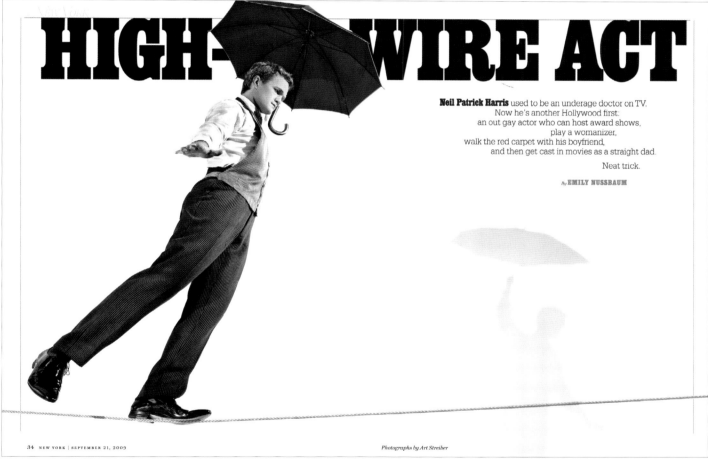

HIGH-WIRE ACT

Neil Patrick Harris used to be an underage doctor on TV.
Now he's another Hollywood first:
an out gay actor who can host award shows,
play a womanizer,
walk the red carpet with his boyfriend,
and then get cast in movies as a straight dad.

Neat trick.

By **EMILY NUSSBAUM**

34 NEW YORK | SEPTEMBER 21, 2009

Photographs by Art Streiber

399

399 **New York**

DESIGN DIRECTOR: Chris Dixon. DIRECTOR OF PHOTOGRAPHY: Jody Quon. PHOTO EDITORS: Alex Pollack, Caroline Smith, Lea Golis, Leano Alagia, Nadia Lachance. PHOTOGRAPHERS: Hannah Whitaker, Art Streiber, Horacio Salinas, Ruven Afanador, Spencer Heyfron, Ruven Afanador, Marcus Bleasdale, Edward Keating. EDITOR-IN-CHIEF: Adam Moss. PUBLISHER: New York Magazine Holdings, LLC. ISSUE: September 21, 2009. CATEGORY: Photo: Entire Issue

214

SECTION:
photography

AWARD:
merit

CATEGORY:
section (single issue)

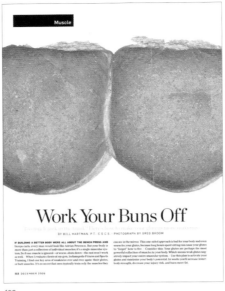

400

402

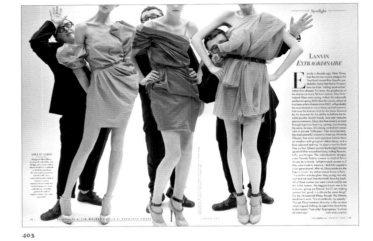

404

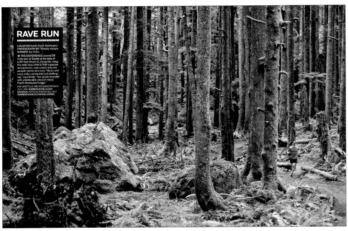

401

403

400 *Bon Appétit*

DESIGN DIRECTOR: Matthew Lenning. ART DIRECTORS: Robert Festino, Tom O'Quinn. DESIGNER: John Muñoz. DIRECTOR OF PHOTOGRAPHY: Bailey Franklin. PHOTO EDITOR: Angelica Mistro. PHOTOGRAPHER: Levi Brown. EDITOR-IN-CHIEF: Barbara Fairchild. PUBLISHER: Condé Nast Publications, Inc. ISSUE: March 2009. CATEGORY: Photo: Section (single month)

401 *Runner's World*

DESIGN DIRECTOR: Kory Kennedy. DEPUTY ART DIRECTOR: Marc Kauffman. ASSISTANT ART DIRECTOR: Lee Williams. PHOTO EDITOR: Andrea Maurio. ASSOCIATE PHOTO EDITOR: Nick Galac. ASSISTANT PHOTO EDITOR: Meg Hess. PHOTOGRAPHER: Timothy Kemple. PRODUCTION COORDINATOR: Carly Migliori. PUBLISHER: Rodale Inc. ISSUE: May 2009. CATEGORY: Photo: Section (single month)

402 *Men's Health*

DESIGN DIRECTOR: Brandon Kavulla. ART DIRECTOR: Vikki Nestico. DESIGNER: Ian Brown. DIRECTOR OF PHOTOGRAPHY: Brenda Milis. DEPUTY DIRECTOR OF PHOTOGRAPHY: Jeanne Graves. PHOTOGRAPHER: Greg Broom. PUBLISHER: Rodale Inc. ISSUE: December 2009. CATEGORY: Photo: Section (single month)

403 *Vanity Fair*

DESIGN DIRECTOR: David Harris. ART DIRECTOR: Julie Weiss. DIRECTOR OF PHOTOGRAPHY: Susan White. PHOTOGRAPHER: Tim Walker. PUBLISHER: Condé Nast Publications Inc. ISSUE: December 2009. CATEGORY: Photo: Section (single month)

404 **MADRIZ**

CREATIVE DIRECTOR: Louis-Charles Tiar. ART DIRECTOR: Sonia Bilbao. DESIGNER: Quique Ciria. PHOTOGRAPHER: Fernando Maselli. PUBLISHER: Revistas Exclusivas S.L. ISSUE: Spring-Summer 2009. CATEGORY: Photo: Section (single month)

SECTION:
photography

AWARD:
merit

CATEGORY:
section (series of months)

215

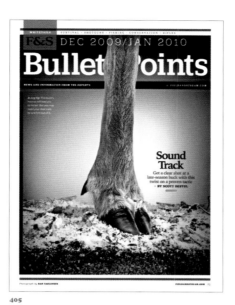

405

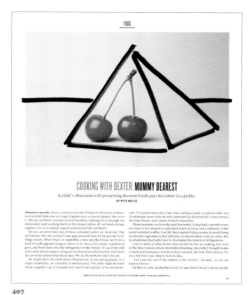

405

407

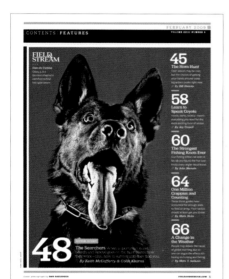

406

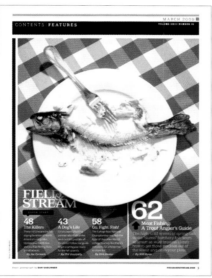

406

408

405 *Field & Stream*

ART DIRECTOR: Neil Jamieson. DESIGNER: Mike Ley. DIRECTOR OF PHOTOGRAPHY: Amy Berkley. ASSOCIATE PHOTO EDITOR: Caitlin Peters. PHOTOGRAPHERS: Dan Saelinger, Gorman & Gorman, Travis Rathbone. PUBLISHER: Bonnier Corporation. ISSUES: March 2009, August 2009, September 2009, December 2009/January 2010. CATEGORY: Photo: Section (series of months)

406 *Field & Stream*

CREATIVE DIRECTOR: Neil Jamieson. DESIGNER: Mike Ley. DIRECTOR OF PHOTOGRAPHY: Amy Berkley. ASSOCIATE PHOTO EDITOR: Caitlin Peters. PHOTOGRAPHERS: Dan Saelinger, Travis Rathbone, Chris Crisman. FOOD STYLING: Roscoe Betsill. PUBLISHER: Bonnier Corporation. ISSUE: Feb, March, April, July, Dec 09/Jan 10. CATEGORY: Photo: Section (series of months)

407 *The New York Times Magazine*

DESIGN DIRECTOR: Arem Duplessis. ART DIRECTOR: Gail Bichler. DESIGNERS: Cathy Gilmore-Barnes, Gail Bichler, Julia Moburg, Aviva Michaelov. ILLUSTRATOR: Tamara Shopsin. DIRECTOR OF PHOTOGRAPHY: Kathy Ryan. PHOTOGRAPHER: Jason Fulford. PUBLISHER: The New York Times Company. ISSUES: July 12, 2009, August 9, 2009. CATEGORY: Photo: Section (series of months)

408 *Departures*

CREATIVE DIRECTOR: Bernard Scharf. DESIGN DIRECTOR: Adam Bookbinder. PHOTO EDITOR: Jessica Dimson. PHOTOGRAPHER: James Wojcik. ASSOCIATE ART DIRECTOR: Lou Corredor. DEPUTY PHOTO EDITOR: Michael Shome. PUBLISHER: American Express Publishing Co. ISSUES: March 2009, May 2009, December 2009. CATEGORY: Photo: Section (series of months)

SECTION:
photography

AWARD:
merit

CATEGORY:
section (series of months)

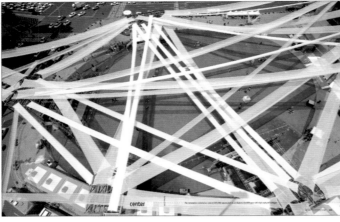

409

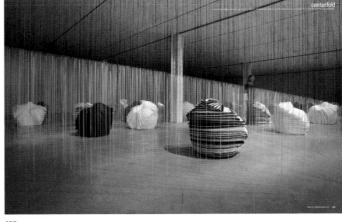

409

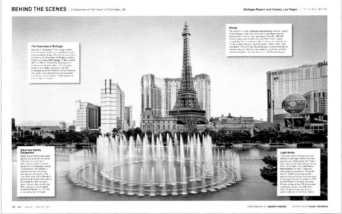

410

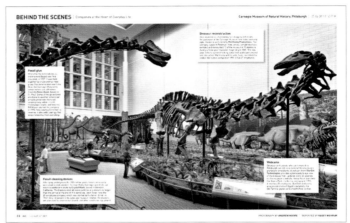

410

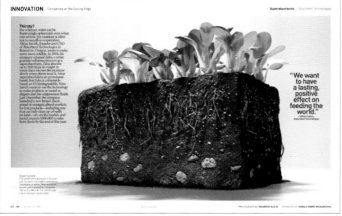

411

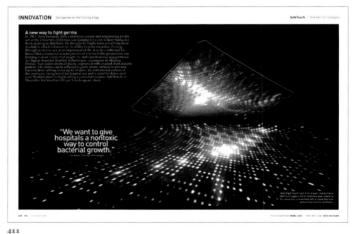

411

409 **Interior Design**

CREATIVE DIRECTOR: Cindy Allen. DESIGNERS:
Zigeng Li, Karla Lima, Giannina Macias. PHOTO
EDITOR: Helene Oberman. PUBLISHER: Reed Business
Information. ISSUES: April 2009, July 2009. CATEGORY:
Photo: Section (series of months)

410 **Inc.**

CREATIVE DIRECTOR: Blake Taylor. ART DIRECTOR:
Sarah Garcea. DIRECTOR OF PHOTOGRAPHY: Travis
Ruse. PHOTOGRAPHER: Andrew Moore. PUBLISHER:
Mansueto Ventures. ISSUES: January/February 2009,
March 2009, July/August 2009. CATEGORY: Photo:
Section (series of months)

411 **Inc.**

CREATIVE DIRECTOR: Blake Taylor. DESIGNERS:
Blake Taylor, Sarah Garcea, Jason Mischka. DIRECTOR
OF PHOTOGRAPHY: Travis Ruse. PHOTOGRAPHERS:
Mauricio Alejo, Nigel Cox. PUBLISHER: Mansueto
Ventures. ISSUES: May 2009, July/August 2009, November
2009. CATEGORY: Photo: Section (series of months)

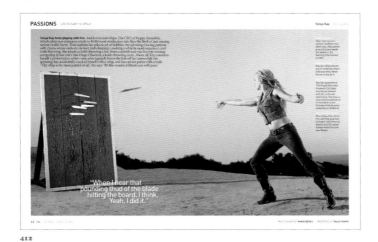

412

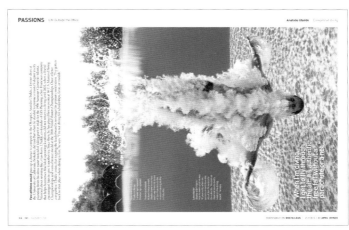

412

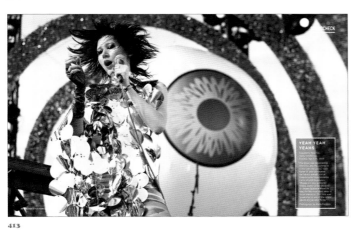

413

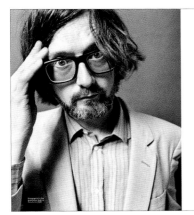

414

414

412 *Inc.*

CREATIVE DIRECTOR: Blake Taylor. ART DIRECTOR: Jason Mischka. DIRECTOR OF PHOTOGRAPHY: Travis Ruse. PHOTO EDITOR: Monique Perreault. PHOTOGRAPHERS: Rod McLean, Randi Berez. PUBLISHER: Mansueto Ventures. ISSUES: March 2009, November 2009, December 2009/January 2010. CATEGORY: Photo: Section (series of months)

413 *SPIN*

CREATIVE DIRECTOR: Devin Pedzwater. ART DIRECTOR: Ian Robinson. DESIGNER: Liz Macfarlane. DIRECTOR OF PHOTOGRAPHY: Michelle Egiziano. PHOTO EDITOR: Jennifer Edmondson. PHOTOGRAPHERS: Noah Abrams, Zach Cordner, PJ Sykes, Frank Hamilton. PUBLISHER: Spin Media LLC. ISSUES: June 2009, November 2009, October 2009. CATEGORY: Photo: Section (series of months)

414 *SPIN*

CREATIVE DIRECTOR: Devin Pedzwater. ART DIRECTOR: Ian Robinson. DESIGNER: Liz Macfarlane. DIRECTOR OF PHOTOGRAPHY: Michelle Egiziano. PHOTO EDITOR: Jennifer Edmondson. PHOTOGRAPHERS: Kenneth Cappello, Philip Gay, Ture Lillegraven. PUBLISHER: Spin Media LLC. ISSUES: February 2009, April 2009, June 2009. CATEGORY: Photo: Section (series of months)

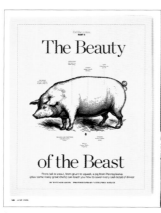
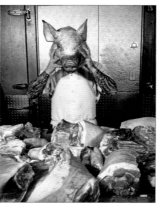

415

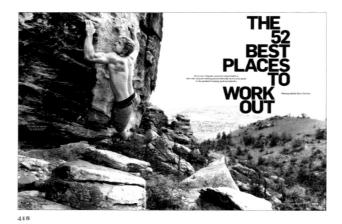

418

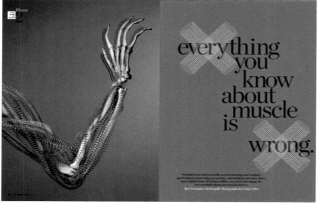

416

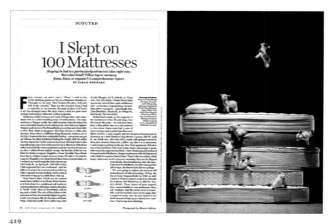

419

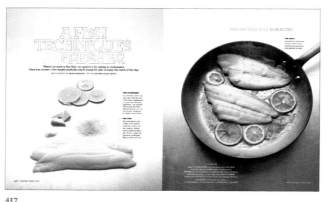

417

420

415 *Men's Health*

DESIGN DIRECTOR: Brandon Kavulla. DESIGNER: Brandon Kavulla. DIRECTOR OF PHOTOGRAPHY: Brenda Milis. DEPUTY DIRECTOR OF PHOTOGRAPHY: Lila Garnett. PHOTOGRAPHER: Nathaniel Welch. PUBLISHER: Rodale Inc. ISSUE: June 2009. CATEGORY: Photo: Feature: Service (single/spread)

416 *Men's Health*

DESIGN DIRECTOR: Brandon Kavulla. DESIGNER: Brandon Kavulla. DIRECTOR OF PHOTOGRAPHY: Brenda Milis. DEPUTY DIRECTOR OF PHOTOGRAPHY: Jeanne Graves. PHOTOGRAPHER: Craig Cutler. PUBLISHER: Rodale Inc. ISSUE: October 2009. CATEGORY: Photo: Feature: Service (single/spread)

417 *Martha Stewart Living*

CREATIVE DIRECTOR: Eric A. Pike. DESIGN DIRECTOR: James Dunlinson. ART DIRECTOR: Matthew Axe. DESIGNER: Jeffrey Kurtz. DIRECTOR OF PHOTOGRAPHY: Heloise Goodman. PHOTOGRAPHER: Hans Gissinger. STYLISTS: Tanya Graff, Lucinda Scala Quinn. EDITOR-IN-CHIEF: Michael Boodro. PUBLISHER: Martha Stewart Living Omnimedia. ISSUE: April 2009. CATEGORY: Photo: Feature: Service (single/spread)

418 *Men's Health*

DESIGN DIRECTOR: Brandon Kavulla. DESIGNER: Dena Verdesca. DIRECTOR OF PHOTOGRAPHY: Brenda Milis. DEPUTY DIRECTOR OF PHOTOGRAPHY: Mark Haddad. PHOTOGRAPHER: Kurt Markus. PUBLISHER: Rodale Inc. ISSUE: September 2009. CATEGORY: Photo: Feature: Service (single/spread)

419 *New York*

DESIGN DIRECTOR: Chris Dixon. DIRECTOR OF PHOTOGRAPHY: Jody Quon. PHOTO EDITOR: Alex Pollack. PHOTOGRAPHER: Horacio Salinas. EDITOR-IN-CHIEF: Adam Moss. PUBLISHER: New York magazine Holdings, LLC. ISSUE: February 16, 2009. CATEGORY: Photo: Feature: Service (single/spread)

420 *Men's Health*

DESIGN DIRECTOR: Brandon Kavulla. DESIGNER: Brandon Kavulla. DIRECTOR OF PHOTOGRAPHY: Brenda Milis. DEPUTY DIRECTOR OF PHOTOGRAPHY: Michelle Stark. PHOTOGRAPHER: Romulo Yanes. PUBLISHER: Rodale Inc. ISSUE: November 2009. CATEGORY: Photo: Feature: Service (single/spread)

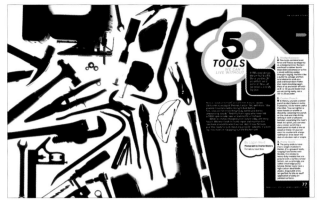

421

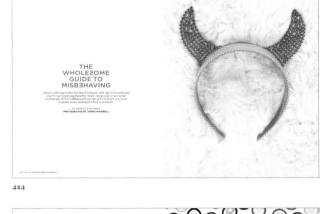

424

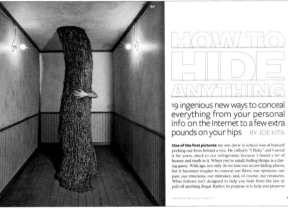

422

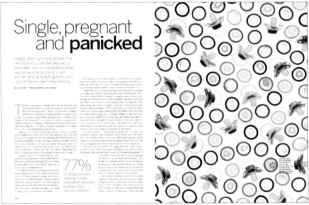

425

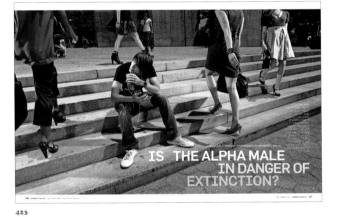

423

426

421 **Popular Mechanics**

DESIGN DIRECTOR: Michael Lawton. DIRECTOR OF
PHOTOGRAPHY: Allyson Torrisi. PHOTOGRAPHER:
Charles Masters. PUBLISHER: The Hearst Corporation-
Magazines Division. ISSUE: May 2009.
CATEGORY: Photo: Feature: Service (single/spread)

422 **Reader's Digest**

CREATIVE DIRECTOR: Hannu Laakso. ART
DIRECTORS: Dean Abatemarco, Dean Abatemarco
DESIGNER: Victoria Nightingale. DIRECTOR OF
PHOTOGRAPHY: Bill Black. PHOTOGRAPHER:
Dan Winters. EDITOR-IN-CHIEF: Peggy Northrop.
PUBLISHER: Reader's Digest Association. ISSUE: April
2009. CATEGORY: Photo: Feature: Service (single/
spread)

423 **Women's Health**

CREATIVE DIRECTOR: Andrea Dunham. ART
DIRECTORS: Lan Yin Bachelis, Nicole Mazur.
DIRECTOR OF PHOTOGRAPHY: Sarah Rozen.
PHOTO EDITOR: Andrea Verdone. PHOTOGRAPHER:
Nathaniel Welch. PUBLISHER: Rodale Inc. ISSUE:
September 2009. CATEGORY: Photo: Feature: Service
(single/spread)

424 **Psychology Today**

CREATIVE DIRECTOR: Edward Levine.
DIRECTOR OF PHOTOGRAPHY: Claudia Stefezius.
PHOTOGRAPHER: James Worrell. STUDIO: Levine
Design Inc. PUBLISHER: SUSSEX PUBLISHERS:
ISSUE: September/October 2009. CATEGORY: Photo:
Feature: Service (single/spread)

425 **Self**

CREATIVE DIRECTOR: Cynthia Searight. ART
DIRECTOR: Petra Kobayashi. DESIGNER: Page
Edwards. DIRECTOR OF PHOTOGRAPHY: Jean
Cabacungan-Jarvis. PHOTO EDITOR: Jean Cabacungan-
Jarvis. PHOTOGRAPHER: Levi Brown. EDITOR-
IN-CHIEF: Lucy Danziger. PUBLISHER: Condé Nast
Publications Inc. ISSUE: March 2009. CATEGORY:
Photo: Feature: Service (single/spread)

426 **Best Life**

DESIGN DIRECTOR: Brandon Kavulla. DESIGNER:
Brandon Kavulla. DIRECTOR OF PHOTOGRAPHY:
Ryan Cadiz. PHOTOGRAPHER: Jamie Chung.
PUBLISHER: Rodale Inc. ISSUE: February 2009.
CATEGORY: Photo: Feature: Service (single/spread)

220

SECTION:
photography

AWARD:
merit

CATEGORY:
service (story)

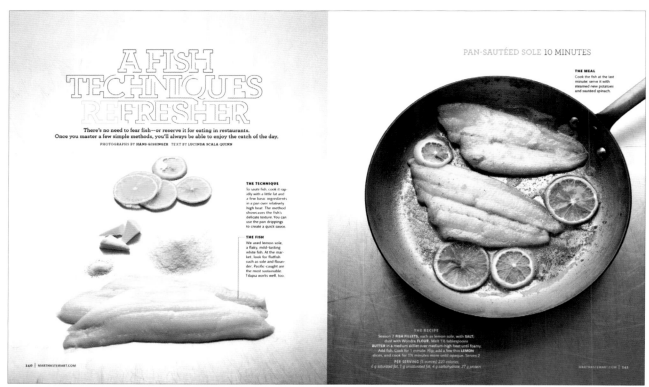

427

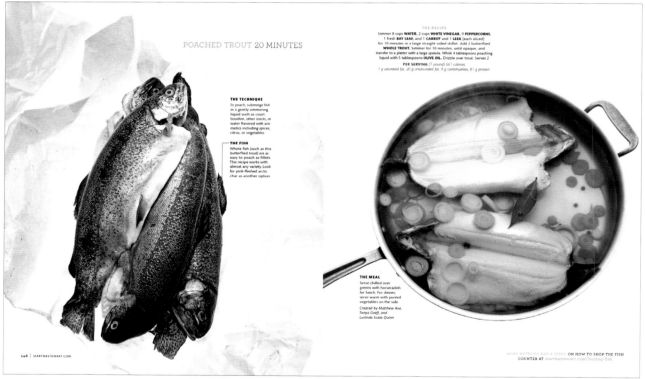

427

427 *Martha Stewart Living*

CREATIVE DIRECTOR: Eric A. Pike. DESIGN DIRECTOR: James
Dunlinson. ART DIRECTOR: Matthew Axe. DESIGNER: Jeffrey Kurtz.
DIRECTOR OF PHOTOGRAPHY: Heloise Goodman. PHOTOGRAPHER:
Hans Gissinger. STYLISTS Tanya Graff, Lucinda Scala Quinn. EDITOR-IN-
CHIEF: Michael Boodro. PUBLISHER: Martha Stewart Living Omnimedia.
ISSUE: April 2009. CATEGORY: Photo: Feature: Service (story)

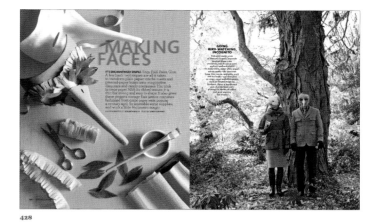

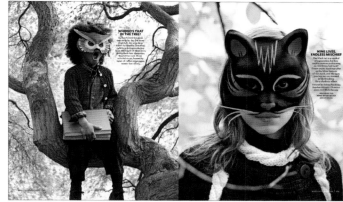

428

428

429

429

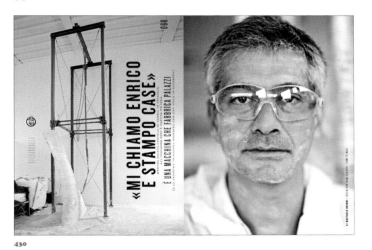

430

430

428 *Martha Stewart Living*

CREATIVE DIRECTOR: Eric A. Pike. DESIGN
DIRECTOR: James Dunlinson. ART DIRECTOR: Stephen
Johnson. DESIGNER: Stephen Johnson. DIRECTOR OF
PHOTOGRAPHY: Heloise Goodman. PHOTOGRAPHER:
Roland Bello. STYLISTS: Sabine Feuilloley, Blake Ramsey.
EDITOR-IN-CHIEF: Gael Towey. PUBLISHER: Martha
Stewart Living Omnimedia. ISSUE: October 2009.
CATEGORY: Photo: Feature: Service (story)

429 WIRED Italy

ART DIRECTOR: David Moretti. DESIGNERS: David
Moretti, Bianca Milani, Daniela Sanziani. PHOTO
EDITOR: Francesca Morosini. PHOTOGRAPHER:
Christopher Lamarca. EDITOR-IN-CHIEF: Riccardo
Luna. PUBLISHER: Condé Nast Italia. ISSUE: November
2009. CATEGORY: Photo: Feature: Service (story)

430 WIRED Italy

ART DIRECTOR: David Moretti. DESIGNERS:
David Moretti, Bianca Milani, Daniela Sanziani.
ILLUSTRATOR: Masa. PHOTO EDITOR: Francesca
Morosini. PHOTOGRAPHER: Ciro Frank Schiappa.
EDITOR-IN-CHIEF: Riccardo Luna. PUBLISHER: Condé
Nast Italia. ISSUE: October 2009. CATEGORY: Photo:
Feature: Service (story)

222

SECTION:
photography

AWARD:
merit

CATEGORY:
non-celebrity profile

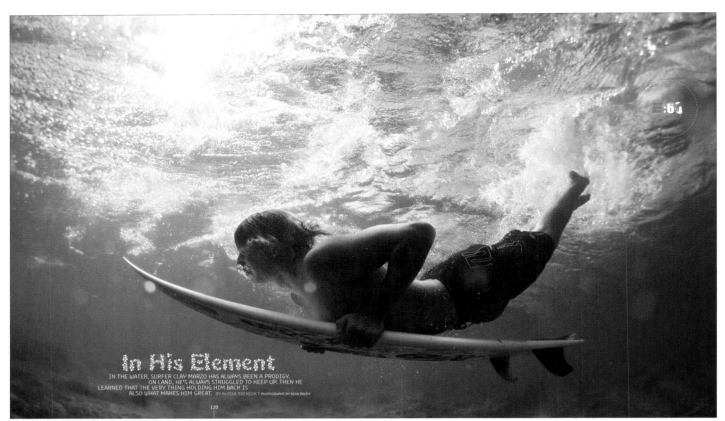

431

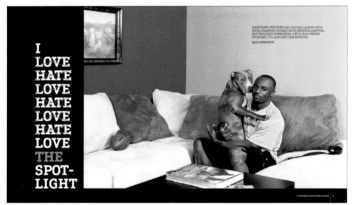

432

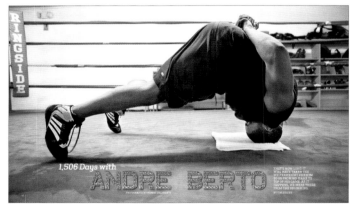

433

431 **ESPN The Magazine**

CREATIVE DIRECTOR: Siung Tjia. DIRECTOR OF
PHOTOGRAPHY: Catriona Ni Aolain. PHOTO EDITOR:
Jennifer Aborn. PHOTOGRAPHER: Sean Davey.
PUBLISHER: The Walt Disney Publishing Company.
ISSUE: September 7, 2009. CATEGORY: Photo: Feature:
Non-Celebrity Profile (single/spread)

432 **ESPN The Magazine**

CREATIVE DIRECTOR: Siung Tjia. DIRECTOR OF
PHOTOGRAPHY: Catriona Ni Aolain. PHOTO EDITOR:
Jennifer Aborn. PHOTOGRAPHER: Stefan Ruiz.
PUBLISHER: The Walt Disney Publishing Company.
ISSUE: July 13, 2009. CATEGORY: Photo: Feature: Non-
Celebrity Profile (single/spread)

433 **ESPN The Magazine**

CREATIVE DIRECTOR: Siung Tjia. DIRECTOR OF
PHOTOGRAPHY: Catriona Ni Aolain. PHOTO EDITOR:
Nancy Weisman. PHOTOGRAPHER: Robert Delahanty.
PUBLISHER: The Walt Disney Publishing Company.
ISSUE: January 12, 2009. CATEGORY: Photo: Feature:
Non-Celebrity Profile (single/spread)

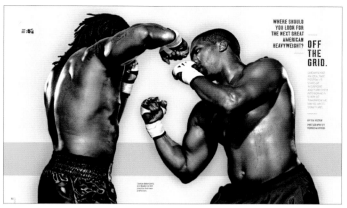

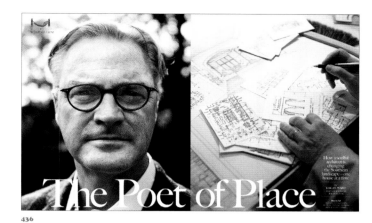

434

436

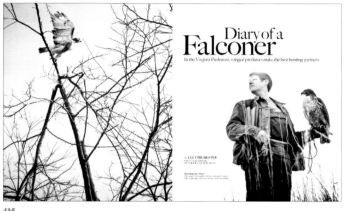

435

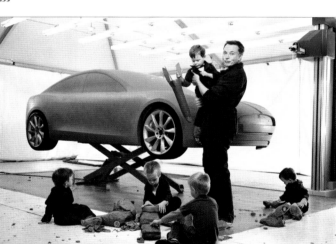

437

438

434 *ESPN The Magazine*

CREATIVE DIRECTOR: Siung Tjia.
ART DIRECTOR: Jason Lancaster.
DIRECTOR OF PHOTOGRAPHY: Catriona Ni Aolain.
PHOTOGRAPHER: Rennio Maifredi.
PUBLISHER: The Walt Disney Publishing Company.
ISSUE: December 28, 2009. CATEGORY: Photo: Feature:
Non-Celebrity Profile (single/spread)

435 *Garden & Gun*

ART DIRECTOR: Marshall McKinney. DESIGNER:
Richie Swann. DIRECTOR OF PHOTOGRAPHY: Maggie
Brett Kennedy. PHOTOGRAPHER: Peter Frank Edwards.
ISSUE: February/March 2009. CATEGORY: Photo:
Feature: Non-Celebrity Profile (single/spread)

436 *Garden & Gun*

ART DIRECTOR: Marshall McKinney. DESIGNER:
Richie Swann. DIRECTOR OF PHOTOGRAPHY: Maggie
Brett Kennedy. PHOTOGRAPHER: Joe Pugliese. ISSUE:
February/March 2009. CATEGORY: Photo: Feature:
Non-Celebrity Profile (single/spread)

437 *The New Yorker*

VISUALS EDITOR: Elisabeth Biondi. PHOTO EDITOR:
Honore Brown. PHOTOGRAPHER: Martin Schoeller.
STUDIO: Martin Schoeller LLC. EDITOR-IN-CHIEF:
David Remnick. PUBLISHER: Condé Nast Publications
Inc. CLIENT: The New Yorker. ISSUE: August 24, 2009.
CATEGORY: Photo: Feature: Non-Celebrity Profile
(single/spread)

438 *Inked*

CREATIVE DIRECTOR: Todd Weinberger.
DIRECTOR OF PHOTOGRAPHY: Marya Gullo.
PHOTO EDITOR: Josh Clutter. PHOTOGRAPHER:
Raina and Wilson. PUBLISHER: Pinchazo Publishing.
ISSUE: January 2009. CATEGORY: Photo: Feature: Non-
Celebrity Profile (single/spread)

224

SECTION:
photography

AWARD
merit

CATEGORY:
non-celebrity profile

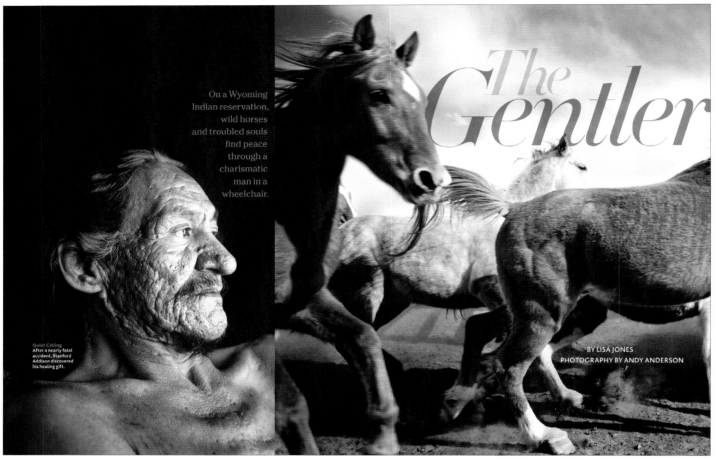

On a Wyoming
Indian reservation,
wild horses
and troubled souls
find peace
through a
charismatic
man in a
wheelchair.

The
Gentler

Quiet Calling
After a nearly fatal
accident, Stanford
Addison discovered
his healing gift.

BY LISA JONES
PHOTOGRAPHY BY ANDY ANDERSON

439

LAST DAYS
OF THE
FRENCH
CHEF

Critics say he needs to change. Customers
say he needs to change. His staff says he needs to
change. But change, as Georges Perrier will
tell you, can be very, very hard

By Michael Callahan
PHOTOGRAPHY BY CHRIS CRISMAN

440

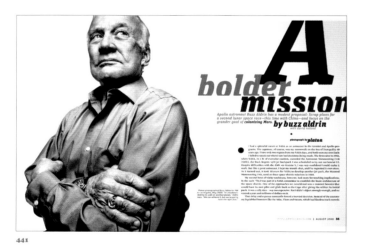

A
bolder
mission

Apollo astronaut Buzz Aldrin has a modest proposal: Scrap plans for
a second lunar space race—this time with China—and focus on the
grander goal of colonizing Mars. *by buzz aldrin*
with david hinson

photograph by platon

441

439 Spirit Magazine

CREATIVE DIRECTOR: Kevin de Miranda. DESIGN
DIRECTORS: Brody Price, Emily Kimbro. PHOTO
EDITOR: Lauren Chesnutt. PHOTOGRAPHER: Andy
Anderson. ISSUE: May 2009. CATEGORY: Photo:
Feature: Non-Celebrity Profile (single/spread)

440 Philadelphia Magazine

DESIGN DIRECTOR: Michael McCormick. DESIGNER:
Jesse Southerland. DIRECTOR OF PHOTOGRAPHY:
Zoey Sless-Kitain. PHOTO EDITOR: Jessica Hawkes.
PHOTOGRAPHER: Chris Crisman. PUBLISHER:
Metrocorp. ISSUE: December 2009. CATEGORY: Photo:
Feature: Non-Celebrity Profile (single/spread)

441 Popular Mechanics

DESIGN DIRECTOR: Michael Lawton. DIRECTOR OF
PHOTOGRAPHY: Allyson Torrisi. PHOTOGRAPHER:
Platon. PUBLISHER: The Hearst Corporation-Magazines
Division. ISSUE: August 2009. CATEGORY: Photo:
Feature: Non-Celebrity Profile (single/spread)

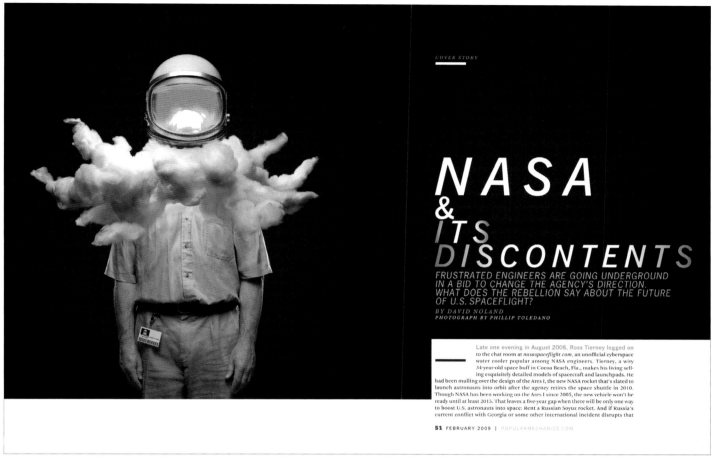

442

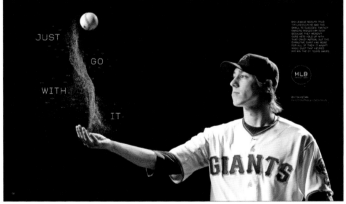

443

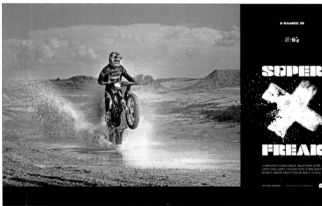

444

442 Popular Mechanics

DESIGN DIRECTOR: Michael Lawton. DIRECTOR OF PHOTOGRAPHY: Allyson Torrisi. PHOTOGRAPHER: Phillip Toledano. PUBLISHER: The Hearst Corporation-Magazines Division. ISSUE: February 2009. CATEGORY: Photo: Feature: Non-Celebrity Profile (single/spread)

443 ESPN The Magazine

CREATIVE DIRECTOR: Siung Tjia. DIRECTOR OF PHOTOGRAPHY: Catriona Ni Aolain. PHOTO EDITOR: Jennifer Aborn. PHOTOGRAPHER: Zach Gold. PUBLISHER: The Walt Disney Publishing Company. ISSUE: March 9, 2009. CATEGORY: Photo: Feature: Non-Celebrity Profile (single/spread)

444 ESPN The Magazine

CREATIVE DIRECTOR: Siung Tjia. DIRECTOR OF PHOTOGRAPHY: Catriona Ni Aolain. PHOTO EDITOR: Jennifer Aborn. PHOTOGRAPHER: Adam Weiss. PUBLISHER: The Walt Disney Publishing Company. ISSUE: July 27, 2009. CATEGORY: Photo: Feature: Non-Celebrity Profile (single/spread)

226

photography

SECTION:

AWARD:
merit

CATEGORY:
non-celebrity profile (story)

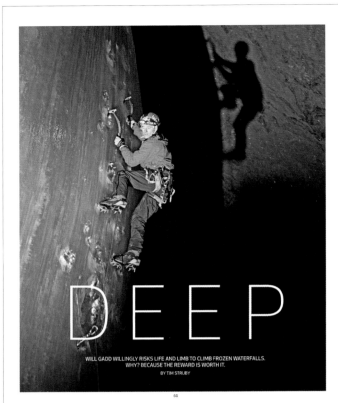

DEEP

WILL GADD WILLINGLY RISKS LIFE AND LIMB TO CLIMB FROZEN WATERFALLS.
WHY? BECAUSE THE REWARD IS WORTH IT.
BY TIM STRUBY

60

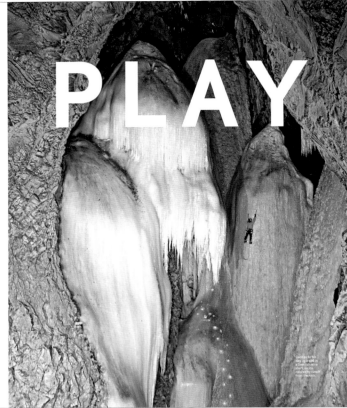

PLAY

445

ICE CLIMBING | DEEP PLAY

Deep play: a pursuit "in which the stakes are so high that it is ... irrational for men to engage in it at all."
—Jeremy Bentham, philosopher, 1748-1832

"ANOTHER DAY AT the office," Will Gadd sighs as he trudges along a tight, snow-covered, boot-packed trail. By "office," the 41-year-old ice climber means he's outside in the cold, in terrain that's less than hospitable. Could be a skyscraper-size frozen waterfall in Nepal, ice caves in Sweden or even an iceberg off the coast of Canada. On this December morning, he's on a trail in British Columbia's Kootenay National Park, a 45-minute drive from his home in Canmore, Alberta. A few ticks past 9 a.m., after a 20-minute hike, he enters Haffner Creek, a narrow canyon with towering walls of rock sheathed in blue, gray and white. Gadd drops his pack on the ground, slips metal crampons over his boots, grabs a pair of aluminum ice axes and grins.

"Could be worse, huh?"

It could be much worse. Gadd stands at the base of the 40-foot-high frozen waterfall and looks up. He kicks footholds with his crampons and swings his axes overhead, driving the points deep into the ice. He pulls with his arms and pushes with his legs, then kicks his feet and swings the axes again. Within minutes he's 20 feet above the ground and headed higher, without ropes or other protection in case his toes slip on the ice crumbles. Who would blame him for thinking of Chris Hunnicutt, the 32-year-old outdoorsman who, during a 2007 climb in Utah's Provo Canyon, slipped and fell to

his death? Or climbing vet Ivo Minkov, who died at age 29 after a fall last March in British Columbia's Yoho National Park? Or Hari Berger, the three-time world champion ice climber who, at 34, was fatally buried under an ice collapse in 2006?

After a five-minute round-trip to the top of the falls, Gadd is back on horizontal ground, and back to talking. "I've known over a dozen people who were killed while climbing," he says. "I knew Hari.

Gadd has won his share of events, such as the Ouray Ice Festival in 2006, but he'd rather blaze more extreme routes.

web a week earlier. When he describes it, he sounds like Tom Sawyer crossed with Indiana Jones: "There's a cave, and frozen mist, and overhanging ice, and no one's ever done it."

Gadd knows that he'll scout the monster in a few days. What he doesn't yet know is that he'll then plan to return in February with a helicopter, ski plane, photographer, cinematographer and small crew of climbers, all to help document what could be one of the toughest ice climbs ever. And the most dangerous.

A day after Haffner, Gadd is tucked into a booth at Canmore's Summit Cafe, a local breakfast joint with chalkboard menus on the walls. "Another of my offices," he jokes. It's 10 a.m., and he's just finished a large coffee and his second piece of Nicorette. Canmore is to ice climbing what Oahu's North Shore is to surfing, and just about everyone who comes through the door says hello to Gadd, one of the most recognizable climbers in town, with his beanpole, 5'11" frame, Roman nose and bulbous knuckles. And he has a response for them all. While climbers generally fall into one of two categories—crunchy stoners or sullen loner—Gadd is a type-A yapper. He's also a thinker and a showman, as happy discussing Ayn Rand's laissez-faire philosophy as he is

He was a good dude and one of the world's best climbers. That's why not a day goes by when I don't think about getting killed. When I stop thinking about it, that's when I'll worry."

Gadd is training here today—up and down a variety of Haffner's routes—to prepare for an even bigger, more dangerous climb up an uncharted, massive waterfall in British Columbia. He discovered the secluded cascade while poking around the

"I'VE KNOWN OVER A DOZEN PEOPLE WHO WERE KILLED WHILE CLIMBING. NOT A DAY GOES BY WHEN I DON'T THINK ABOUT GETTING KILLED. **WHEN I STOP THINKING ABOUT IT, THAT'S WHEN I'LL WORRY."**

ushering Conan O'Brien up a mock ice wall during a visit to the latter's late-night show.

Gadd describes his parents, Ben and Gia, as anti-establishment "backcountry people." When Will was 13, the family moved from Calgary to the mountain town of Jasper, Alberta, about 180 miles northwest of Canmore. "I played basketball,

volleyball and badminton, probably just to piss them off," he says. It was during Will's early teen years that Ben, a winter sports enthusiast, introduced his son to skiing, rock climbing and ice climbing. Eventually Will grew bored of traditional sports, but the ice stuck. "By 16 I wanted to do something exciting and serious," he says, "something that would engage me in real life." In 1985, after two obsessive years of climbing throughout the Canadian Rockies, he tackled Polar Circus. The 1,600-foot waterfall on Cirrus Mountain in Banff National Park was then considered one of the

world's most daunting ice climbs. Gadd worked the route for 18 straight hours, much of it in the dark, in temperatures that hit minus-30°. He made it to the top, both satisfied and finished. "Cirrus taught me that ice climbing is cold, dangerous and masochistic," he says. "I didn't do another serious ice climb for seven years."

Gadd Bag | HOW TO PACK LIKE AN ICE CLIMBING PRO.

Crampons
Sharp steel cleats strapped onto boots give a climber traction on snow, ice and rock. But be careful: The jagged edges can lance your leg.

Rope
Climbers use nylon ropes to catch them if they fall. A good rope is light and strong, stretches to absorb energy in a fall and is dry-treated to prevent water absorption. Ropes are rated by how many times they catch a climber. Even the best ones must be tossed after 10 to 15 falls.

Ice Screws
The four-to-eight-inch-long bolts are twisted into the ice and hold the climber's rope. "If an ice screw doesn't hold a fall, you die," Gadd says. Top-of-the-line screws are light, hollow and sharp, and are made of aircraft-quality steel and titanium.

Ice Tools
Climbers use two of the axlike tools, swinging them overhead to drive the serrated points deep into the ice. The best ice tools function as pick, hammer and grappling hook. They're made of aluminum, carbon and steel and cost $100 to $300.

Headgear
Gadd tops off his plastic-shell helmet with a headlamp. "The only thing worse than ice climbing in the cold is ice climbing in the cold when you can't see." The helmet protects his head from falling ice, while the three-watt LED bulb in the headlamp provides 80 meters of visibility in the dark.

62

445 ESPN The Magazine

CREATIVE DIRECTOR: Siung Tjia. DIRECTOR OF PHOTOGRAPHY: Catriona Ni Aolain. PHOTOGRAPHERS: Christian Pondella, Redbull, Keith Lazzinski. PUBLISHER: The Walt Disney Publishing Company. ISSUE: February 23, 2009. CATEGORY: Photo: Feature: Non-Celebrity Profile (story)

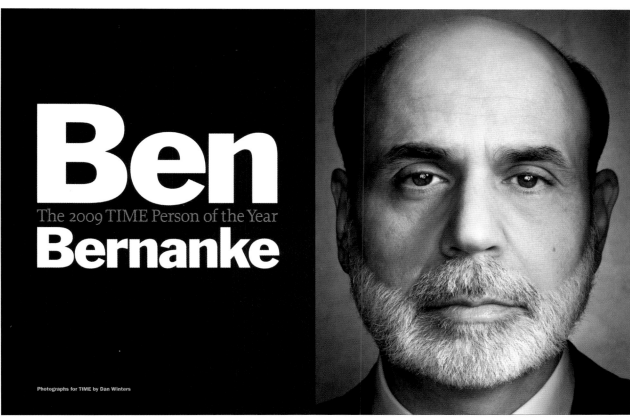

Ben
The 2009 TIME Person of the Year
Bernanke

Photographs for TIME by Dan Winters

446

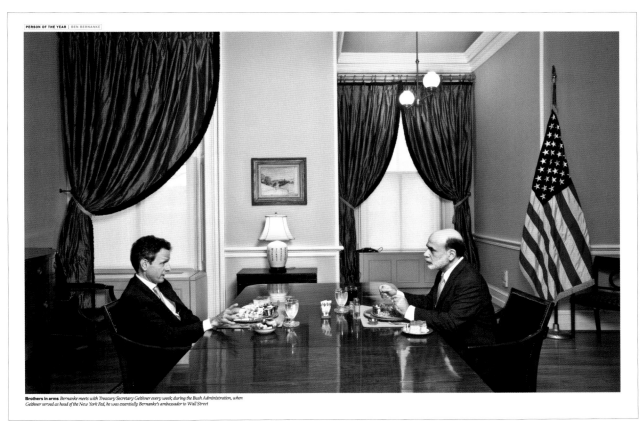

PERSON OF THE YEAR | BEN BERNANKE

Brothers in arms *Bernanke meets with Treasury Secretary Geithner every week; during the Bush Administration, when Geithner served as head of the New York Fed, he was essentially Bernanke's ambassador to Wall Street*

446

ART DIRECTOR: Arthur Hochstein. DEPUTY ART DIRECTOR: D.W. Pine. DIRECTOR OF PHOTOGRAPHY: Kira Pollack. PHOTOGRAPHER: Dan Winters, for TIME.
PUBLISHER: Time Inc. ISSUE: December 28, 2009 - January 4, 2010. CATEGORY: Photo: Feature: Non-Celebrity Profile (story)

228

SECTION:
photography

AWARD:
merit

CATEGORY:
celebrity/entertainment profile

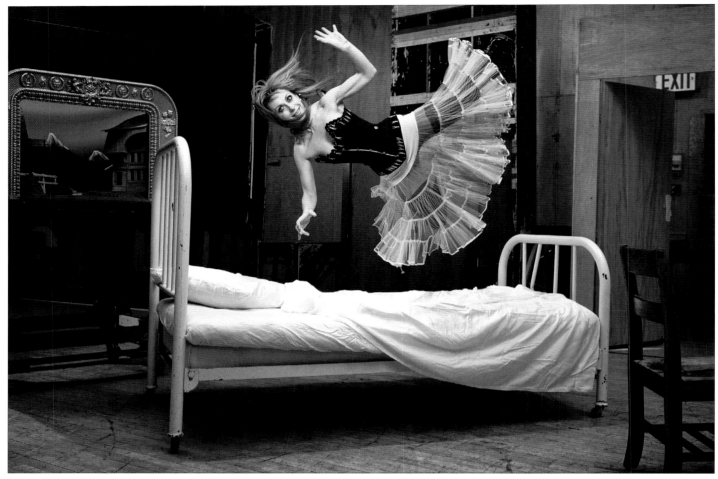

447

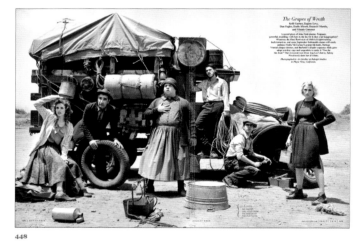

448

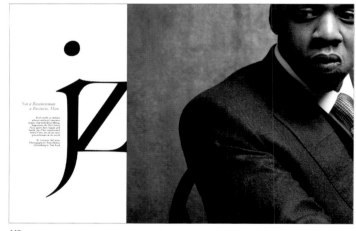

449

447 *The New Yorker*

VISUALS EDITOR: Elisabeth Biondi. PHOTO EDITOR: Honore Brown. PHOTOGRAPHER: Martin Schoeller. STUDIO: Martin Schoeller, LLC. EDITOR-IN-CHIEF: David Remnick. PUBLISHER: Condé Nast Publications Inc. ISSUE: March 2, 2009. CATEGORY: Photo: Feature: Celebrity/Entertainment Profile (single/spread)

448 *Vanity Fair*

DESIGN DIRECTOR: David Harris. ART DIRECTOR: Julie Weiss. DIRECTOR OF PHOTOGRAPHY: Susan White. PHOTOGRAPHER: Art Streiber. PUBLISHER: Condé Nast Publications Inc. ISSUE: August 2009. CATEGORY: Photo: Feature: Celebrity/Entertainment Profile (single/spread)

449 *Best Life*

DESIGN DIRECTOR: Brandon Kavulla. DESIGNER: Brandon Kavulla. DIRECTOR OF PHOTOGRAPHY: Ryan Cadiz. PHOTOGRAPHER: Nino Muñoz. PUBLISHER: Rodale Inc. ISSUE: April 2009. CATEGORY: Photo: Feature: Celebrity/Entertainment Profile (single/spread)

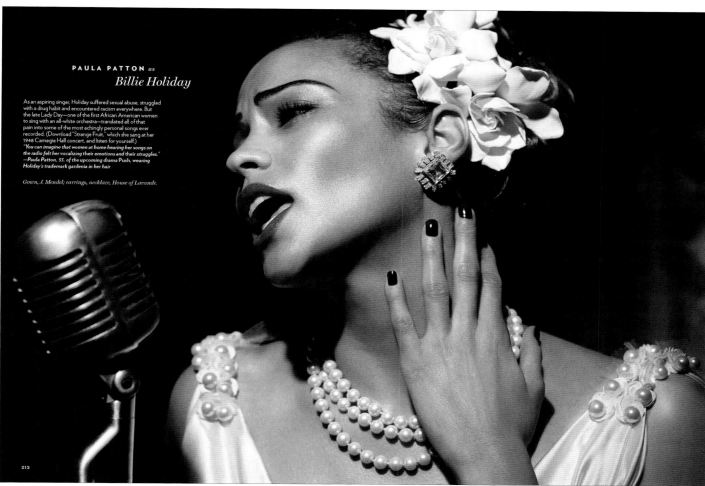

PAULA PATTON *as*

Billie Holiday

As an aspiring singer, Holiday suffered sexual abuse, struggled with a drug habit and encountered racism everywhere. But the late Lady Day—one of the first African American women to sing with an all-white orchestra—translated all of that pain into some of the most achingly personal songs ever recorded. (Download "Strange Fruit," which she sang at her 1948 Carnegie Hall concert, and listen for yourself.) *"You can imagine that women at home hearing her songs on the radio felt her vocalizing their emotions and their struggles."* —Paula Patton, 33, of the upcoming drama *Push*, wearing Holiday's trademark gardenia in her hair

Gown, J. Mendel; earrings, necklace, House of Lavande.

212

450

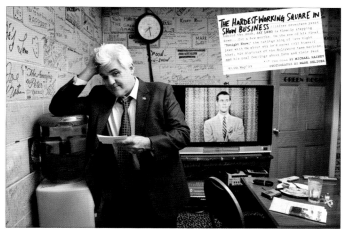

451

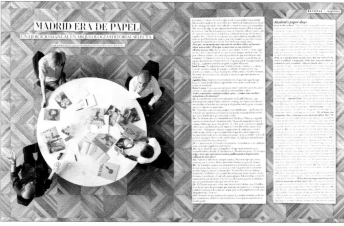

452

450 *Glamour*

DESIGN DIRECTOR: Geraldine Hessler. DIRECTOR OF PHOTOGRAPHY: Suzanne Donaldson. PHOTOGRAPHER: Brigitte Lacombe. PUBLISHER: Condé Nast Publications Inc. ISSUE: April 2009. CATEGORY: Photo: Feature: Celebrity/Entertainment Profile (single/spread)

451 *GQ*

DESIGN DIRECTOR: Fred Woodward. DESIGNER: Chelsea Cardinal. DIRECTOR OF PHOTOGRAPHY: Dora Somosi. PHOTO EDITOR: Krista Prestek. PHOTOGRAPHER: Mark Seliger. CREATIVE DIRECTOR, FASHION: Jim Moore. PUBLISHER: Condé Nast Publications Inc. ISSUE: May 2009. CATEGORY: Photo: Feature: Celebrity/Entertainment Profile (single/spread)

452 *MADRIZ*

CREATIVE DIRECTOR: Louis-Charles Tiar. ART DIRECTOR: Sonia Bilbao. DESIGNER: Quique Ciria. PHOTOGRAPHER: Fernando Maselli. EDITORS-IN-CHIEF: Mónica Escudero, Ruben Pujol. PUBLISHER: Revistas Exclusivas S.L. ISSUE: Autumn 2009 – Winter 2010. CATEGORY: Photo: Feature: Celebrity/Entertainment Profile (single/spread)

230

SECTION:
photography

AWARD:
merit

CATEGORY:
celebrity/entertainment profile

453

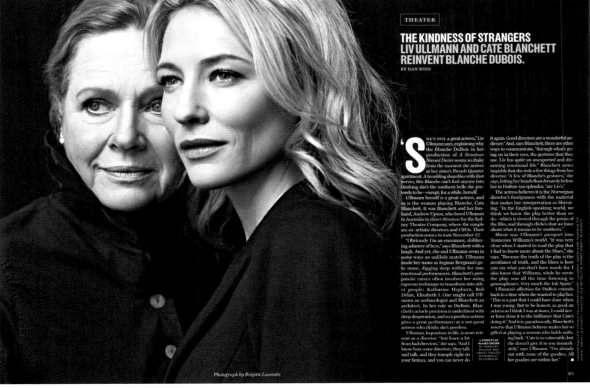

454

453 **New York**

DESIGN DIRECTOR: Chris Dixon. DIRECTOR OF PHOTOGRAPHY: Jody Quon. PHOTO EDITOR: Alex Pollack. PHOTOGRAPHER: Nigel Parry. EDITOR-IN-CHIEF: Adam Moss. PUBLISHER: New York Magazine Holdings, LLC. ISSUE: August 31, - September 7, 2009. CATEGORY: Photo: Feature: Celebrity/Entertainment Profile (single/spread)

454 **New York**

DESIGN DIRECTOR: Chris Dixon. DIRECTOR OF PHOTOGRAPHY: Jody Quon. PHOTO EDITOR: Lea Golis. PHOTOGRAPHER: Brigitte Lacombe. EDITOR-IN-CHIEF: Adam Moss. PUBLISHER: New York Magazine Holdings, LLC. ISSUE: October 26, 2009. CATEGORY: Photo: Feature: Celebrity/Entertainment Profile (single/spread)

A HISTORY *of* DEFIANCE

●

Viggo Mortensen
PUBLISHES WRITERS
no one else will,
DOESN'T MIND
CAMPAIGNING FOR
A LOST CAUSE
(Dennis Kucinich!),
AND IS ABOUT
TO STAR IN A MOVIE
so bleak
FEW THOUGHT
IT COULD
EVER GET MADE.

by DANIEL MIRTH *photograph by* MARC HOM

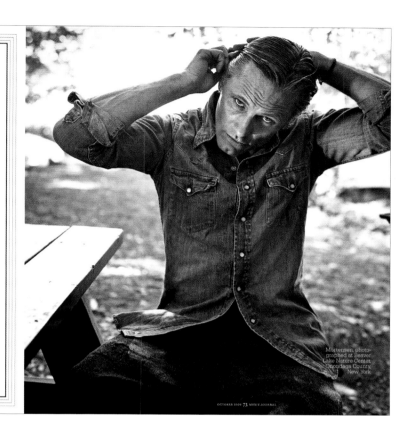

Mortensen, photographed at Beaver Lake Nature Center, Onondaga County, New York

OCTOBER 2009 **73** MEN'S JOURNAL

455

ANOTHER VIEW
SHERRI SHEPHERD'S UPBEAT EMPIRE.
BY EMMA ROSENBLUM

A SHERRI SHEPHERD HUG is an event. She pulls you into her pillowy décolletage, squeezing exuberantly and for a few seconds longer than a good friend might. Make no mistake: She's very, very pleased to see you. "I love hugging the guests, and I love touching people in the audience. I could not exist without being that kind of person," says Shepherd, ex-host of ABC's *The View* and now the star of *Sherri,* her own Lifetime sitcom, in which she essentially plays herself. At a taping for the show, the audience is filled with middle-aged women, all of them calling and responding with near religious zeal. During a scene in which Shepherd's alter ego visits a doctor's office, the crowd simultaneously ooooohs when Sherri kisses her doctor beau, then screams, "Oh no!" when her ex (played by Malcolm-Jamal Warner) and his pregnant mistress walk in the door. After the director yells "Cut," Shepherd flashes her bright smile and waves happily to her fans. "Sherri! Sherri!" the crowd chants.

Two years ago, Shepherd was a former legal secretary turned struggling stand-up comic who played a lot of "black best friends and secretaries" in sitcoms. Since joining *The View* (co-hosted with Barbara Walters, Joy Behar, Whoopi Goldberg, and Elisabeth Hasselbeck), the 42-year-old former Jehovah's Witness has become an upbeat preacher of positivity and endurance with a growing number of pulpits. She has a just-released self-help book, *Permission Slips;* a supporting role in the film *Precious;* and she continues to appear on NBC's *30 Rock* as Angie, Tracy Morgan's wife. This in addition to *The View,* which could just as easily have ended her career, given her epic and humiliating debut in September 2007. "We were discussing creationism versus evolution, and Barbara asked if I thought the Earth was round or flat," says Shepherd. "It was just everything coming at me at once, like I was hearing things underwater, and I said, 'I don't know, I'm just trying to take care of my son!' At the end of the show, Barbara goes, 'Sherri, dear, the Earth is round.' I knew that!" By that evening, Shepherd says she was the second most Googled person in the country. "People hated me. It was on Perez Hilton that I should be fired."

Soon, though, she "started getting e-mails from women saying, 'We don't care if the Earth is round or flat, either—we're just trying to take care of our kids, too.'" Shepherd, who replaced Star Jones after she left in a huff, had discovered her niche. "I think people expected me to be another Star, a brainiac with forceful opinions, but that's not what I brought," says Shepherd. "When Joy said 'bi-partisan' for the first time, I was like, *What the heck is that? Is that a French word?* I didn't know anything about politics, and I wasn't afraid to say I was just learning. I think people like that I'm real." More important, says Walters, who vigorously supported Shepherd in those first tumultuous weeks, she brought "a sweetness to the show. People love hearing about her life. She brings her son Jeffrey to the set and he calls me 'Baba,' which seems appropriate." Shepherd now comfortably inhabits the role of den mother, handling the goofier segments, like on-air bikini waxes, and smiling politely at guests after the other co-hosts have turned on them.

For Shepherd, fame is a therapist's couch. Her painful divorce from actor Jeff Tarpley in 2006, for example, has been fodder for *The View,* her sitcom, and the book (in which she wrote that Tarpley cheated on her with a white woman, who then became pregnant, while Shepherd was pregnant with Jeffrey). Taking a page from the Oprah handbook, she heals through talk. "Every week on *Sherri,* I have to look at the actress who plays the woman my husband got pregnant, and say, 'I wanted a family,

and you messed it up, but I gotta learn to get over it,'" says Shepherd. "I can't keep hating that woman, because that doesn't do anybody any good."

On *30 Rock,* Shepherd also plays an aggrieved wife, though instead of a feckless cheater, she's dealing with Tracy Morgan, playing Tracy Jordan, a version of himself, though the percentage of reality versus fantasy is unclear. "Tina [Fey] had seen me doing a bit on *Ellen* about breast-feeding," says Shepherd. "She was pumping at the time, and liked it, and offered me the part of Tracy's wife. The first episode I did was for Valentine's Day, and they told me I'd be going to rip my clothes off. And I said, 'What!? You know I'm a big girl, right?' I had about twelve White Castle burgers before the scene, I was so nervous, and when I finally met Tracy, I'm standing there in my corset and he goes, 'All right! You're a big girl, we're going to have fun! I like big girls!'"

The association didn't end with the show. In a bizarre coincidence that would fit nicely into a *30 Rock* episode, Shepherd and Morgan ended up living in the same Upper West Side building. "I haven't seen him since he moved out after his apartment burned up. The light from his piranha tank fell and started a fire. Who owns a piranha tank nowadays?" Shepherd asks with a laugh. "Water started streaming into my apartment, so I grabbed Jeffrey and some of my wigs and we got out of there. Tracy still owes me dinner for the time I was displaced."

At a recent taping of *The View,* Shepherd, wearing her signature tight, short skirt and high, high heels, teeters out into the crowd to give hugs during a break. A woman sitting behind me whispers to her friend, "Oh, girl, Sherri is looking good!" (Shepherd recently lost a lot of weight, which naturally became part of *The View.*) In the next segment, she's supportive of Kirk Cameron putting out a pro-creationism ad, and is forgiving of Chynna Phillips for capitalizing on her sister Mackenzie's shocking announcement about their father. "Oh, Sherri, you're so sweet and naive," says Walters. A throwaway remark that gets to the heart of Shepherd's appeal. "On my profile for Twitter, I say, 'I'm Jeffrey's mother, I'm a co-host of *The View,* I'm a Jesus groupie, I'm a karaoke lover, and I'm an all-around sweet person.'" Shepherd tells me after the show. "I own sweetness, and I like it." Then it's time for another hug. ■

> "People expected me to be another Star Jones—a brainiac with forceful opinions. That's not what I brought."

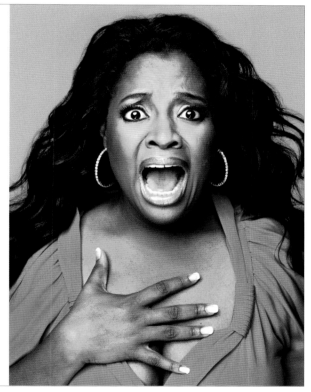

78 NEW YORK | OCTOBER 26, 2009

Photograph by Marco Grob

456

455 *Men's Journal*
CREATIVE DIRECTOR: Paul Martinez. ART DIRECTOR: Damian Wilkinson. DESIGNER: Damian Wilkinson. DIRECTOR OF PHOTOGRAPHY: Michelle Wolfe. PHOTO EDITOR: Michelle Wolfe. PHOTOGRAPHER: Marc Hom. PUBLISHER: Wenner Media LLC. ISSUE: October 2009. CATEGORY: Photo: Feature: Celebrity/Entertainment Profile (single/spread)

456 *New York*
DESIGN DIRECTOR: Chris Dixon. DIRECTOR OF PHOTOGRAPHY: Jody Quon. PHOTO EDITOR: Lea Golis. PHOTOGRAPHER: Marco Grob. EDITOR-IN-CHIEF: Adam Moss. PUBLISHER: New York Magazine Holdings, LLC. ISSUE: October 26, 2009. CATEGORY: Photo: Feature: Celebrity/Entertainment Profile (single/spread)

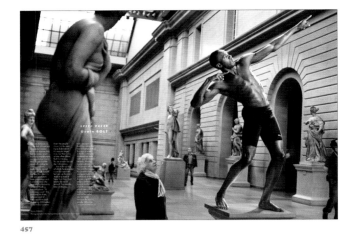

457

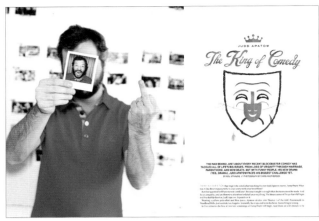

458

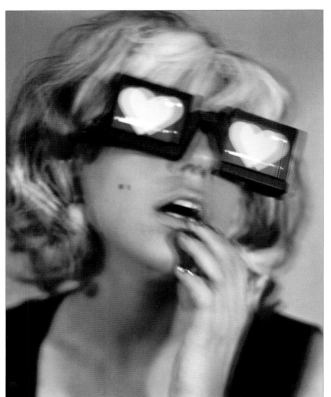

459

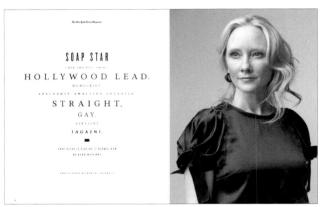

460

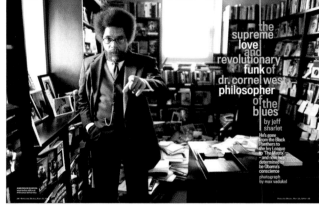

461

457 GQ

DESIGN DIRECTOR: Fred Woodward. DESIGNER: Thomas Alberty. DIRECTOR OF PHOTOGRAPHY: Dora Somosi. PHOTO EDITOR: Krista Prestek. PHOTOGRAPHER: Martin Schoeller. CREATIVE DIRECTOR, FASHION: Jim Moore. PUBLISHER: Condé Nast Publications Inc. ISSUE: December 2009. CATEGORY: Photo: Feature: Celebrity/Entertainment Profile (single/spread)

460 The New York Times Magazine

DESIGN DIRECTOR: Arem Duplessis. ART DIRECTOR: Gail Bichler. DIRECTOR OF PHOTOGRAPHY: Kathy Ryan. PHOTO EDITOR: Joanna Milter. PHOTOGRAPHER: Robert Maxwell. PUBLISHER: The New York Times Company. ISSUE: August 2, 2009. CATEGORY: Photo: Feature: Celebrity/Entertainment Profile (single/spread)

458 Maxim

CREATIVE DIRECTOR: Dirk Barnett. DESIGNER: Dirk Barnett. ILLUSTRATOR: Heads of State. PHOTO EDITOR: Marya Gullo. PHOTOGRAPHER: Chris McPherson. EDITOR-IN-CHIEF: Joe Levy. PUBLISHER: Alpha Media Group. ISSUE: August 2009. CATEGORY: Photo: Feature: Celebrity/Entertainment Profile (single/spread)

461 Rolling Stone

ART DIRECTOR: Joseph Hutchinson. DESIGNER: Steven Charny. DIRECTOR OF PHOTOGRAPHY: Jodi Peckman. PHOTOGRAPHER: Max Vadukul. PUBLISHER: Wenner Media. ISSUE: May 28, 2009. CATEGORY: Photo: Feature: Celebrity/Entertainment Profile (single/spread)

459 The New Yorker

DIRECTOR OF PHOTOGRAPHY: Elisabeth Biondi. PHOTO EDITOR: Honore Brown. PHOTOGRAPHER: Martin Schoeller. STUDIO: Martin Schoeller LLC. PUBLISHER: Condé Nast Publications Inc. CLIENT: The New Yorker. ISSUE: April 27, 2009. CATEGORY: Photo: Feature: Celebrity/Entertainment Profile (single/spread)

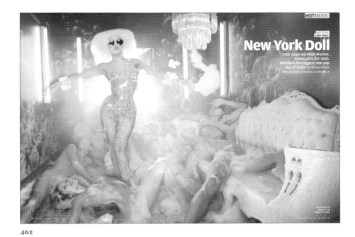

462

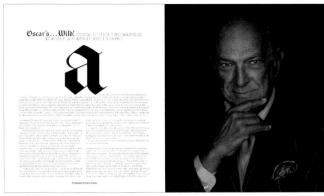

463

464

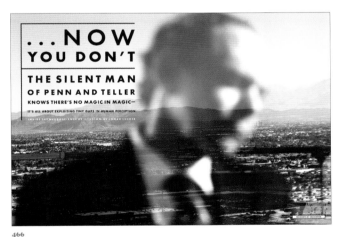

466

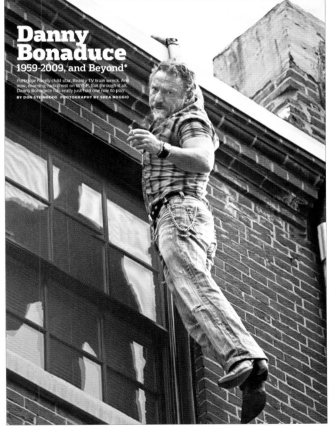

465

462 **Rolling Stone**

ART DIRECTOR: Joseph Hutchinson. DESIGNER: Joseph Hutchinson. DIRECTOR OF PHOTOGRAPHY: Jodi Peckman. PHOTOGRAPHER: David LaChapelle. PUBLISHER: Wenner Media. ISSUE: June 11, 2009. CATEGORY: Photo: Feature: Celebrity/Entertainment Profile (single/spread)

465 **Philadelphia Magazine**

DESIGN DIRECTOR: Michael McCormick. DESIGNER: Jesse Southerland. DIRECTOR OF PHOTOGRAPHY: Zoey Sless-Kitain. PHOTO EDITOR: Jessica Hawkes. PHOTOGRAPHER: Shea Roggio. PUBLISHER: Metrocorp. ISSUE: April 2009. CATEGORY: Photo: Feature: Celebrity/Entertainment Profile (single/spread)

463 **T, The New York Times Style Magazine**

CREATIVE DIRECTOR: David Sebbah. SENIOR ART DIRECTOR: Christopher Martinez. SENIOR PHOTO EDITOR: Judith Puckett-Rinella. PHOTOGRAPHER: Nadav Kander. PUBLISHER: The New York Times Company. ISSUE: February 22, 2009. CATEGORY: Photo: Feature: Celebrity/Entertainment Profile (single/spread)

466 **WIRED**

CREATIVE DIRECTOR: Scott Dadich. DESIGN DIRECTOR: Wyatt Mitchell. ART DIRECTOR: Carl DeTorres. PHOTO EDITOR: Carolyn Rauch. PHOTOGRAPHER: Carlos Serrao. EDITOR-IN-CHIEF: Chris Anderson. PUBLISHER: Condé Nast Publications, Inc. ISSUE: May 2009. CATEGORY: Photo: Feature: Celebrity/Entertainment Profile (single/spread)

464 **T, The New York Times Style Magazine**

CREATIVE DIRECTOR: David Sebbah. SENIOR ART DIRECTOR: Christopher Martinez. PHOTO EDITOR: Scott Hall. PHOTOGRAPHER: Mark Segal. PUBLISHER: The New York Times Company. ISSUE: August 16,2 009. CATEGORY: Photo: Feature: Celebrity/Entertainment Profile (single/spread)

234

SECTION:
photography

AWARD
merit

CATEGORY:
celebrity/entertainment profile

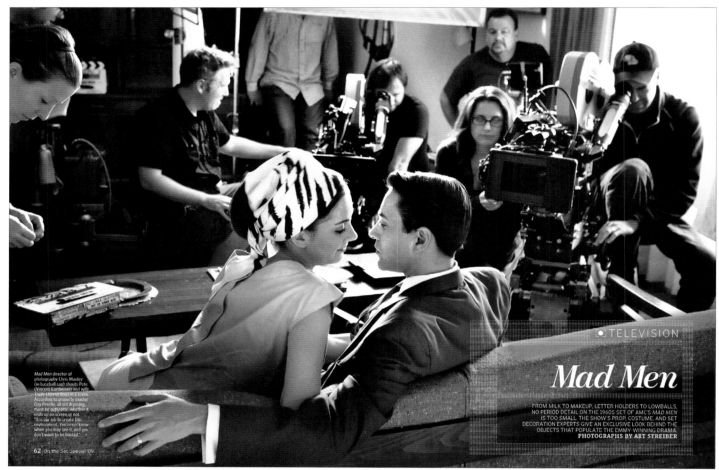

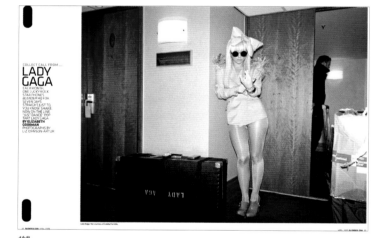

467

468

469

467 **Entertainment Weekly**

DESIGN DIRECTOR: Amid Capeci. ART DIRECTOR:
Heather Haggerty. DESIGNER: Eve Binder. DIRECTOR
OF PHOTOGRAPHY: Lisa Berman. PHOTO EDITORS:
Suzanne Regan, Michael Kochman. PHOTOGRAPHER:
Art Streiber. MANAGING EDITOR: Jess Cagle.
PUBLISHER: Time Inc. ISSUE: October 9, 2009.
CATEGORY: Photo: Feature: Celebrity/Entertainment
Profile (single/spread)

468 **Blender Magazine**

CREATIVE DIRECTOR: Dirk Barnett. DESIGNER:
Dirk Barnett. DIRECTOR OF PHOTOGRAPHY:
David Carthas. PHOTO EDITOR: Rory Walsh.
PHOTOGRAPHER: Liz Johnson-Artur. EDITOR-IN-
CHIEF: Joe Levy. PUBLISHER: Alpha Media Group.
ISSUE: April 2009. CATEGORY: Photo: Feature:
Celebrity/Entertainment Profile (single/spread)

469 **Blender Magazine**

CREATIVE DIRECTOR: Dirk Barnett. DESIGNER:
Dirk Barnett. DIRECTOR OF PHOTOGRAPHY:
David Carthas. PHOTO EDITOR: Chris Ehrmann.
PHOTOGRAPHER: Laetitia Negre. EDITOR-IN-CHIEF:
Joe Levy. PUBLISHER: Alpha Media Group. ISSUE:
March 2009. CATEGORY: Photo: Feature: Celebrity/
Entertainment Profile (single/spread)

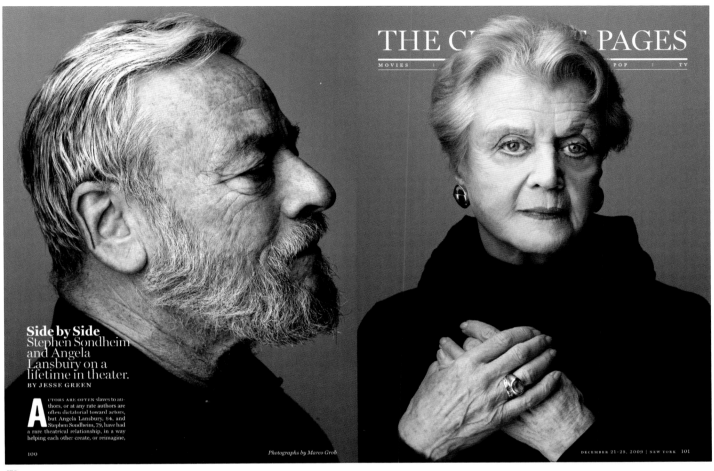

THE C[R]E[ATIVE] PAGES

MOVIES | [...] | POP | TV

Side by Side
Stephen Sondheim
and Angela
Lansbury on a
lifetime in theater.
BY JESSE GREEN

CTORS ARE OFTEN slaves to authors, or at any rate authors are often dictatorial toward actors, but Angela Lansbury, 84, and Stephen Sondheim, 79, have had a rare theatrical relationship, in a way helping each other create, or reimagine,

Photographs by Marco Grob

100

DECEMBER 21-28, 2009 | NEW YORK 101

470

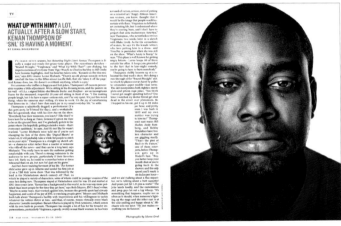

WHAT UP WITH HIM? A LOT, ACTUALLY. AFTER A SLOW START, KENAN THOMPSON OF 'SNL' IS HAVING A MOMENT.
BY EMMA ROSENBLUM

Photographs by Marco Grob

471

DOLLY RIDES AGAIN

The self-anointed Backwoods Barbie takes '9 to 5' to Broadway, and opens up about her famous figure, chauvinist bosses, and keeping it real on the inside while living the life of a "phony"

BY CHRIS WILLMAN
PHOTOGRAPH BY GILLIAN LAUB

472

470 *New York*

DESIGN DIRECTOR: Chris Dixon. DIRECTOR OF PHOTOGRAPHY: Jody Quon. PHOTO EDITOR: Lea Golis. PHOTOGRAPHER: Marco Grob. EDITOR-IN-CHIEF: Adam Moss. PUBLISHER: New York Magazine Holdings, LLC. ISSUE: December 28, 2009. CATEGORY: Photo: Feature: Celebrity/Entertainment Profile (single/spread)

471 *New York*

DESIGN DIRECTOR: Chris Dixon. DIRECTOR OF PHOTOGRAPHY: Jody Quon. PHOTO EDITOR: Lea Golis. PHOTOGRAPHER: Marco Grob. EDITOR-IN-CHIEF: Adam Moss. PUBLISHER: New York Magazine Holdings, LLC. ISSUE: December 28, 2009. CATEGORY: Photo: Feature: Celebrity/Entertainment Profile (single/spread)

472 *Entertainment Weekly*

DESIGN DIRECTOR: Brian Anstey. DESIGNER: Jennifer Laga. DIRECTOR OF PHOTOGRAPHY: Lisa Berman. PHOTO EDITOR: Freyda Tavin. PHOTOGRAPHER: Gillian Laub. MANAGING EDITOR: Jess Cagle. PUBLISHER: Time Inc. ISSUE: May 15, 2009. CATEGORY: Photo: Feature: Celebrity/Entertainment Profile (single/spread)

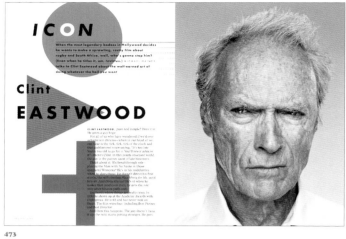

473

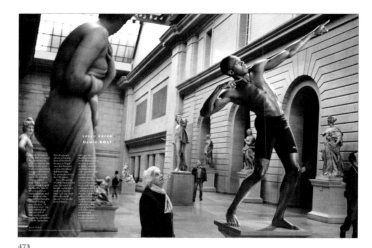

473

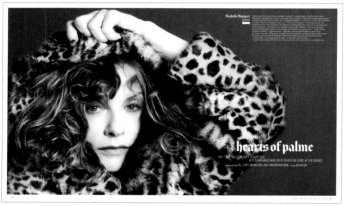

474

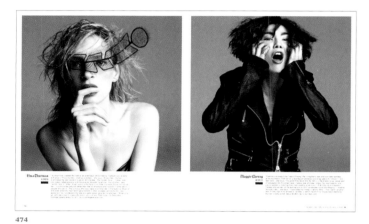

474

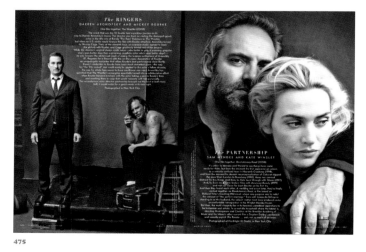

475

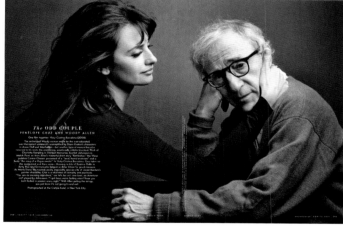

475

473 GQ

DESIGN DIRECTOR: Fred Woodward. DESIGNER: Thomas Alberty. DIRECTOR OF PHOTOGRAPHY: Dora Somosi. PHOTO EDITORS: Krista Prestek, Justin O'Neill, Jesse Lee, Jolanta Bielat, Emily Blank. PHOTOGRAPHER: Martin Schoeller. CREATIVE DIRECTOR, FASHION: Jim Moore. PUBLISHER: Condé Nast Publications Inc. ISSUE: December 2009. CATEGORY: Photo: Feature: Celebrity/Entertainment Profile (story)

474 T, The New York Times Style Magazine

CREATIVE DIRECTOR: David Sebbah. SENIOR ART DIRECTOR: Christopher Martinez. DESIGNER: Natalie Do. DIRECTOR OF PHOTOGRAPHY: Kathy Ryan. PHOTO EDITOR: Scott Hall. PHOTOGRAPHERS: Inez van Lamsweerde, Vinoodh Matadin. PUBLISHER: The New York Times Company. ISSUE: May 31, 2009. CATEGORY: Photo: Feature: Celebrity/Entertainment Profile (story)

475 Fair

DESIGN DIRECTOR: David Harris. ART DIRECTOR: Julie Weiss. DIRECTOR OF PHOTOGRAPHY: Susan White. PHOTOGRAPHER: Annie Leibovitz. PUBLISHER: Condé Nast Publications Inc. ISSUE: March 2009. CATEGORY: Photo: Feature: Celebrity/Entertainment Profile (story)

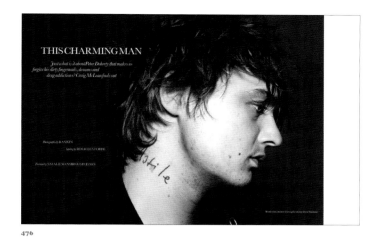

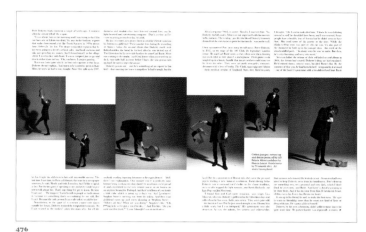

476

476

477

477

478

478

476 Elle Magazine UK

CREATIVE DIRECTOR: Marissa Bourke. ART DIRECTORS: Tom Meredith, Jo Goodby. DESIGNER: Elizabeth Villabona. DIRECTOR OF PHOTOGRAPHY: Rankin. PHOTO EDITOR: Hannah Ridley. PHOTOGRAPHER: Rankin. PUBLISHER: Hachette Filipacchi Magazines, Inc. ISSUE: October 2009. CATEGORY: Photo: Feature: Celebrity/Entertainment Profile (story)

477 GQ

DESIGN DIRECTOR: Fred Woodward. DESIGNER: Anton Ioukhnovets. DIRECTOR OF PHOTOGRAPHY: Dora Somosi. PHOTO EDITOR: Krista Prestek. PHOTOGRAPHER: Mark Seliger. CREATIVE DIRECTOR, FASHION: Jim Moore. PUBLISHER: Condé Nast Publications Inc.. ISSUE: July 2009. CATEGORY: Photo: Feature: Celebrity/Entertainment Profile (story)

478 GQ

DESIGN DIRECTOR: Fred Woodward. DESIGNER: Chelsea Cardinal. DIRECTOR OF PHOTOGRAPHY: Dora Somosi. PHOTOGRAPHER: Martin Schoeller. CREATIVE DIRECTOR, FASHION: Jim Moore. PUBLISHER: Condé Nast Publications Inc.ISSUE: November 2009. CATEGORY: Photo: Feature: Celebrity/Entertainment Profile (story)

238

SECTION:
photography

AWARD:
merit

CATEGORY:
celebrity/entertainment profile (story)

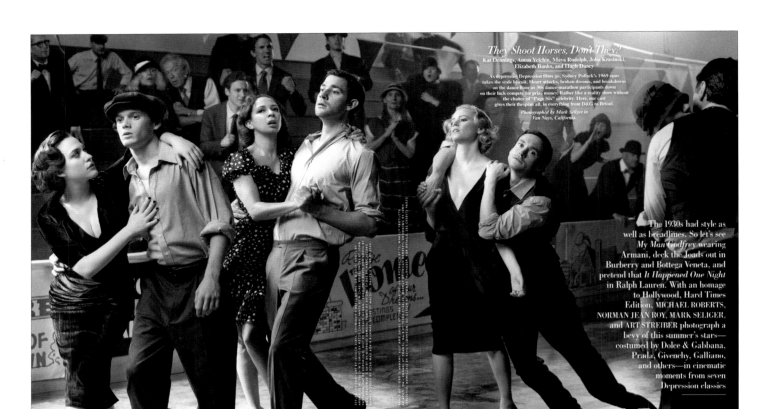

479

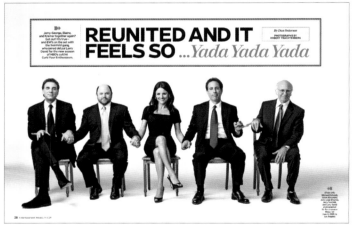

480

480

479 *Vanity Fair*

DESIGN DIRECTOR: David Harris. ART DIRECTOR: Julie Weiss.
DIRECTOR OF PHOTOGRAPHY: Susan White. PHOTOGRAPHERS: Michael
Roberts, Norman Jean Roy, Mark Seliger, Art Streiber. PUBLISHER: Condé
Nast Publications Inc. ISSUE: August 2009. CATEGORY: Photo: Feature:
Celebrity/Entertainment Profile (story)

480 *Entertainment Weekly*

ART DIRECTOR: Heather Haggerty. DESIGNER: Eric Paul.
DIRECTOR OF PHOTOGRAPHY: Lisa Berman. PHOTO EDITOR: Sara Czeladnicki. MANAGING EDITOR: Jess Cagle.
PUBLISHER: Time Inc. ISSUE: September 4, 2009.
CATEGORY: Photo: Feature: Celebrity/Entertainment Profile (story)

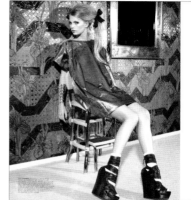

481

481

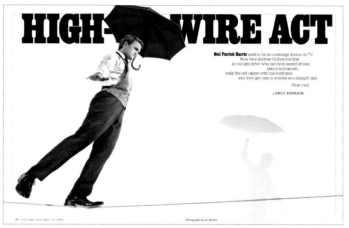
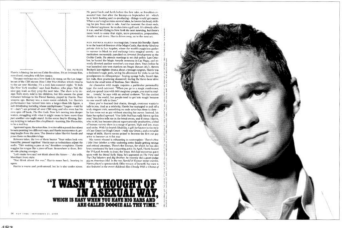

482

482

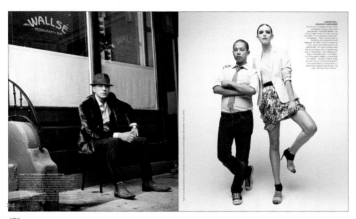
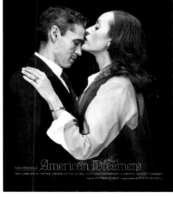
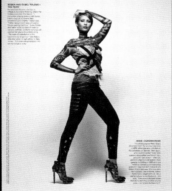

483

483

481 *T, The New York Times Style Magazine*

CREATIVE DIRECTOR: David Sebbah. SENIOR ART DIRECTOR: Christopher Martinez. ART DIRECTOR: Christopher Martinez. SENIOR PHOTO EDITOR: Judith Puckett-Rinella. PHOTOGRAPHER: Raymond Meier. PUBLISHER: The New York Times Company. ISSUE: December 6, 2009. CATEGORY: Photo: Feature: Celebrity/Entertainment Profile (story)

482 *New York*

DESIGN DIRECTOR: Chris Dixon. DIRECTOR OF PHOTOGRAPHY: Jody Quon. PHOTO EDITOR: Lea Golis. PHOTOGRAPHER: Art Streiber. EDITOR-IN-CHIEF: Adam Moss. PUBLISHER: New York Magazine Holdings, LLC. ISSUE: September 21, 2009. CATEGORY: Photo: Feature: Celebrity/Entertainment Profile (story)

483 *T, The New York Times Style Magazine*

CREATIVE DIRECTOR: David Sebbah. SENIOR ART DIRECTOR: Christopher Martinez. DESIGNER: Natalie Do. PHOTO EDITOR: Natasha Lunn. PHOTOGRAPHER: Robert Maxwell. PUBLISHER: The New York Times Company. ISSUE: December 6, 2009 CATEGORY: Photo: Feature: Celebrity/Entertainment Profile (story)

240

SECTION:
photography

AWARD:
merit

CATEGORY:
news/reportage

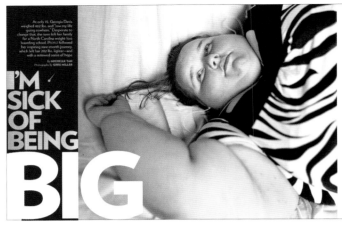

486

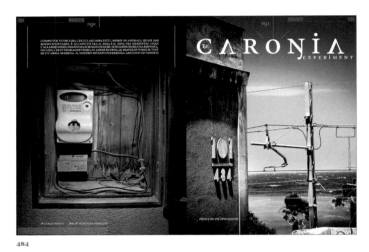

484

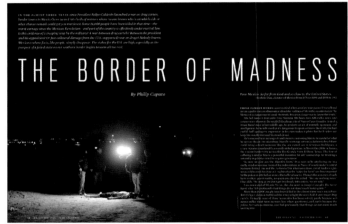

487

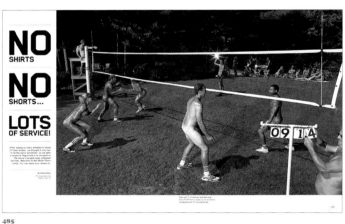

485

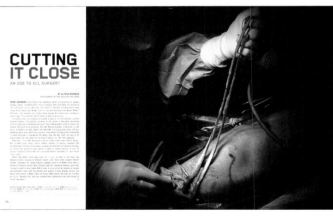

488

484 **WIRED Italy**

ART DIRECTOR: David Moretti. DESIGNERS: David Moretti, Bianca Milani, Daniela Sanziani. PHOTO EDITOR: Francesca Morosini. PHOTOGRAPHER: Marcello Bonfanti. EDITOR-IN-CHIEF: Riccardo Luna. PUBLISHER: Condé Nast Italia. ISSUE: November 2009. CATEGORY: Photo: Cover

485 **ESPN The Magazine**

CREATIVE DIRECTOR: Siung Tjia. ART DIRECTOR: Jason Lancaster. DIRECTOR OF PHOTOGRAPHY: Catriona Ni Aolain. PHOTO EDITOR: Maisie Todd. PHOTOGRAPHER: Naomi Harris. PUBLISHER: The Walt Disney Publishing Company. ISSUE: October 19, 2009. CATEGORY: Photo: Feature: News/Reportage (single/spread)

486 **People**

CREATIVE DIRECTOR: Sara Williams. DESIGNER: Keir Novesky. DIRECTOR OF PHOTOGRAPHY: Chris Dougherty. PHOTO EDITOR: Debbe Edelstein. PHOTOGRAPHER: Greg Miller. EDITOR-IN-CHIEF: Larry Hackett. PUBLISHER: Time Inc. ISSUE: June 22, 2009. CATEGORY: Photo: Feature: News/Reportage (single/spread)

487 **The Atlantic**

ART DIRECTOR: Jason Treat. DESIGNERS: Jason Treat, Melissa Bluey. PHOTO EDITOR: Katie Mathy. PHOTOGRAPHER: Julián Cardona. EDITOR-IN-CHIEF: James Bennet. PUBLISHER: Atlantic Media Company. ISSUE: December 2009. CATEGORY: Photo: Feature: News/Reportage (single/spread)

488 **ESPN The Magazine**

CREATIVE DIRECTOR: Siung Tjia. DIRECTOR OF PHOTOGRAPHY: Catriona Ni Aolain. PHOTO EDITOR: Jennifer Aborn. PUBLISHER: The Walt Disney Publishing Company. ISSUE: October 19, 2009. CATEGORY: Photo: Feature: News/Reportage (single/spread)

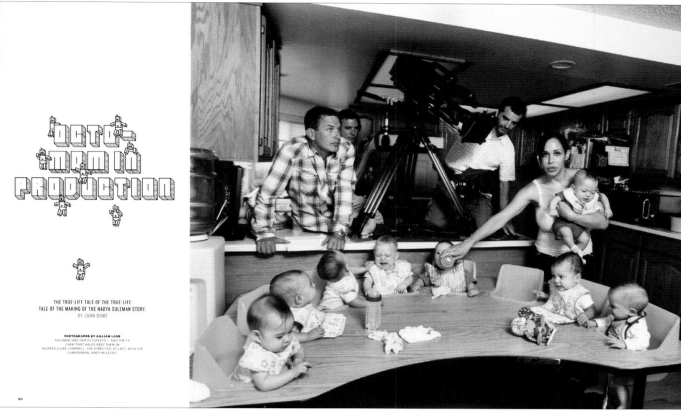

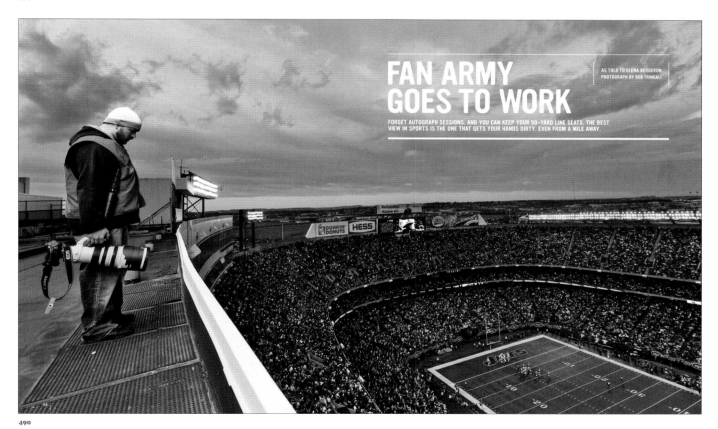

489 *The New York Times Magazine*

DESIGN DIRECTOR: Arem Duplessis. ART DIRECTOR: Gail Bichler.
DESIGNERS: Gail Bichler, Robert Vargas. DIRECTOR OF PHOTOGRAPHY:
Kathy Ryan. PHOTO EDITOR: Joanna Milter. PHOTOGRAPHER: Gillian
Laub. PUBLISHER: The New York Times Company. ISSUE: November 15,
2009. CATEGORY: Photo: Feature: News/Reportage (single/spread)

490 *ESPN The Magazine*

CREATIVE DIRECTOR: Siung Tjia. ART DIRECTOR: Jason Lancaster.
DIRECTOR OF PHOTOGRAPHY: Catriona Ni Aolain. PHOTO EDITORS:
Jim Surber, Maisie Todd. PHOTOGRAPHER: Rob Tringali. PUBLISHER: The
Walt Disney Publishing Company. ISSUE: February 9, 2009. CATEGORY:
Photo: Feature: News/Reportage (single/spread)

242

SECTION:
photography

AWARD:
merit

CATEGORY:
news/reportage (story)

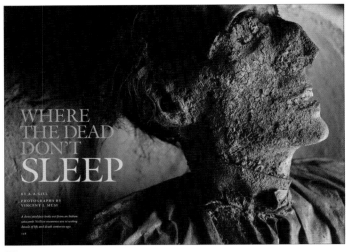

491

491

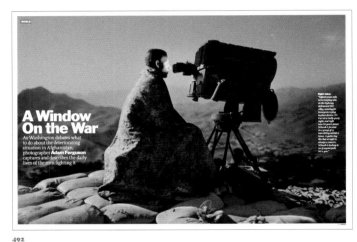

492

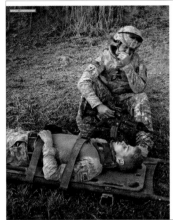

492

493

493

491 **National Geographic**

DESIGN DIRECTOR: David Whitmore. DESIGNER:
David Whitmore. DIRECTOR OF PHOTOGRAPHY:
David Griffin. PHOTO EDITOR: Susan Welchman.
PHOTOGRAPHER: Vincent J. Musi. EDITOR-IN-
CHIEF: Chris Johns. PUBLISHER: National Geographic
Society. ISSUE: February 2009.
CATEGORY: Photo: Feature: News/Reportage (story)

492 **TIME**

ART DIRECTOR: Arthur Hochstein. DEPUTY ART
DIRECTOR: Cynthia A. Hoffman. PHOTOGRAPHER:
Adam Ferguson, VII Mentor Program for TIME.
DEPUTY PHOTO EDITOR: Dietmar Liz-Lepiorz .
PUBLISHER: Time Inc. ISSUE: October 12, 2009.
CATEGORY: Photo: Feature: News/Reportage (story)

493 **Atlanta Magazine**

DESIGN DIRECTOR: Eric Capossela. DESIGNER:
Eric Capossela. PHOTOGRAPHER: Andrea Fremiotti.
EDITOR-IN-CHIEF: Rebecca Burns. PUBLISHER:
Emmis Communications Corp. ISSUE: February 2009.
CATEGORY: Photo: Feature: News/Reportage (story)

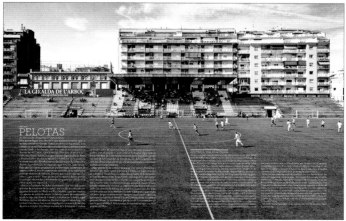

494

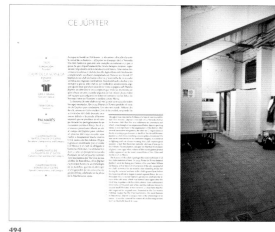

494

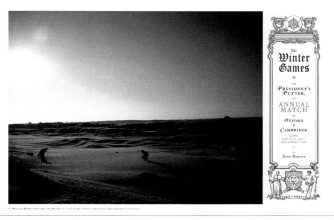

495

495

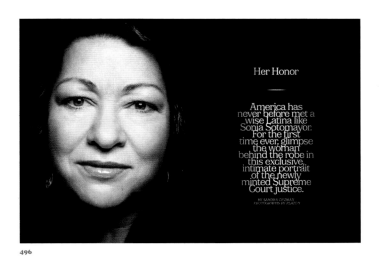

496

497

494 **Barcelonés**

CREATIVE DIRECTOR: Louis-Charles Tiar. ART DIRECTOR: Quique Ciria. DESIGNER: Raül Vicent. PHOTOGRAPHER: Caterina Barjau. EDITORS-IN-CHIEF: Mónica Escudero, Ruben Pujol. PUBLISHER: Revistas Exclusivas S.L. ISSUE: Autumn 2009-Winter 2010. CATEGORY: Photo: Feature: News/Reportage (story)

496 **Latina**

CREATIVE DIRECTOR: Florian Bachleda. DESIGN DIRECTOR: Denise See. DIRECTOR OF PHOTOGRAPHY: George Pitts. PHOTO EDITOR: Jennifer Sargent. STUDIO: FB Design. PUBLISHER: Latina Media Ventures. CLIENT: Latina Magazine. CATEGORY: Photo: Feature: News/Reportage (story)

495 **Golf Digest**

DESIGN DIRECTOR: Ken DeLago. DESIGNER: Marne Mayer. ILLUSTRATOR: Joe McKendry. DIRECTOR OF PHOTOGRAPHY: Christian Iooss. PHOTOGRAPHER: Rolph Gobits. PUBLISHER: Condé Nast Publications Inc.. ISSUE: December 2009. CATEGORY: Photo: Feature: News/Reportage (story)

497 **WIRED**

CREATIVE DIRECTOR: Scott Dadich. DESIGN DIRECTOR: Wyatt Mitchell. PHOTO EDITOR: Carolyn Rauch. PHOTOGRAPHER: Randall Medson. EDITOR-IN-CHIEF: Chris Anderson. PUBLISHER: Condé Nast Publications, Inc. ISSUE: December 2009. CATEGORY: Photo: Feature: News/Reportage (story)

244

SECTION:
photography

AWARD:
merit

CATEGORY:
news/reportage (story)

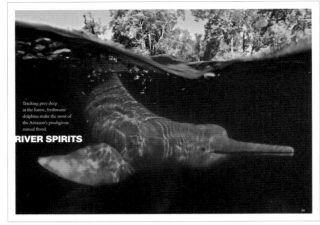

498

498

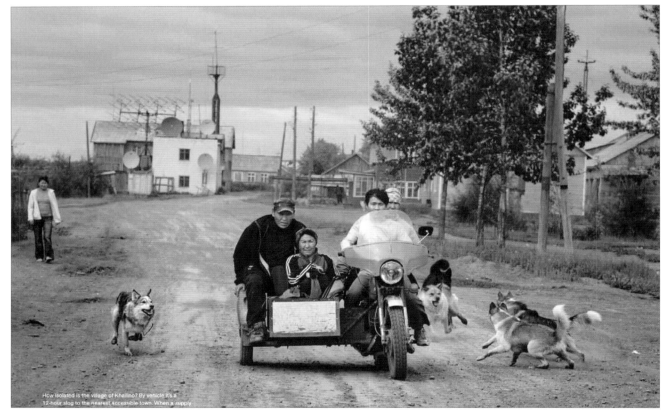

499

498 *National Geographic Society*

DESIGN DIRECTOR: David Whitmore. ART DIRECTOR: John Baxter.
DIRECTOR OF PHOTOGRAPHY: David Griffin. PHOTO EDITOR: Kathy
Moran. PHOTOGRAPHER: Kevin Schafer. EDITOR-IN-CHIEF: Chris Johns.
PUBLISHER: National Geographic Society. ISSUE: June 2009. CATEGORY:
Photo: Feature: News/Reportage (story)

499 *National Geographic Society*

DESIGN DIRECTOR: David Whitmore. DESIGNER: David Whitmore.
DIRECTOR OF PHOTOGRAPHY: David Griffin. PHOTO EDITOR:
Gail Fisher. PHOTOGRAPHER: Randy Olson. EDITOR-IN-CHIEF: Chris Johns.
PUBLISHER: National Geographic Society. ISSUE: August 2009.
CATEGORY: Photo: Feature: News/Reportage (story)

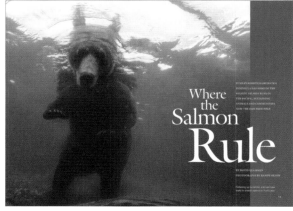

499

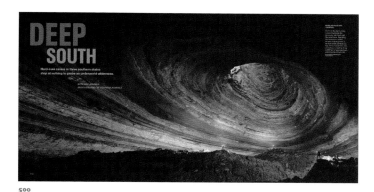

500

500

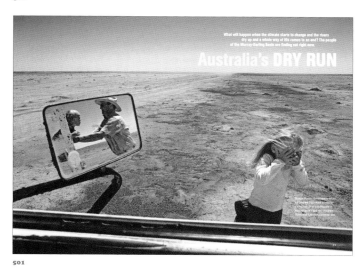

501

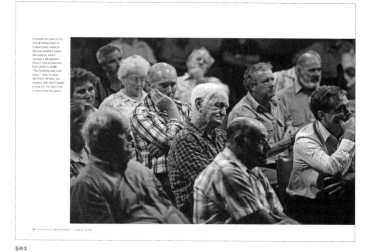

501

502

502

500 **National Geographic Society**

DESIGN DIRECTOR: David Whitmore. DESIGNER: David Whitmore. DIRECTOR OF PHOTOGRAPHY: David Griffin. PHOTO EDITOR: Sadie Quarrier. PHOTOGRAPHER: Stephen Alvarez. EDITOR-IN-CHIEF: Chris Johns. PUBLISHER: National Geographic Society. ISSUE: June 2009. CATEGORY: Photo: Feature: News/Reportage (story)

501 **National Geographic Society**

DESIGN DIRECTOR: David Whitmore. DESIGNER: David Whitmore. DIRECTOR OF PHOTOGRAPHY: David Griffin. PHOTO EDITOR: Laura Lakeway. PHOTOGRAPHER: Amy Toensing. EDITOR-IN-CHIEF: Chris Johns. PUBLISHER: National Geographic Society. ISSUE: April 2009. CATEGORY: Photo: Feature: News/Reportage (story)

502 **National Geographic Society**

DESIGN DIRECTOR: David Whitmore. DESIGNER: David Whitmore. DIRECTOR OF PHOTOGRAPHY: David Griffin. PHOTO EDITOR: Susan Welchman. PHOTOGRAPHER: Pascal Maitre. EDITOR-IN-CHIEF: Chris Johns. PUBLISHER: National Geographic Society. ISSUE: September 2009. CATEGORY: Photo: Feature: News/Reportage (story)

246

SECTION:
photography

AWARD:
merit

CATEGORY:
news/reportage (story)

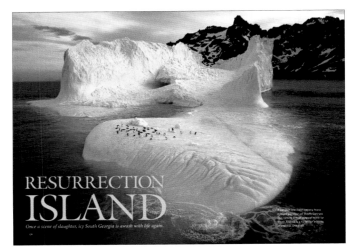

503

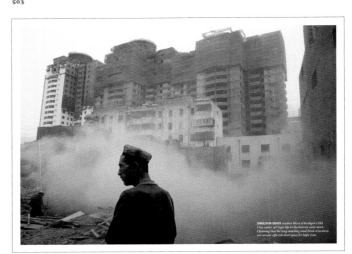

503

504

504

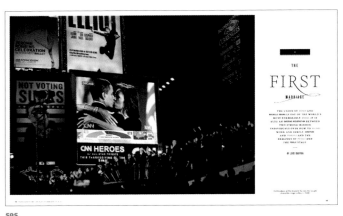

505

505

503 *National Geographic Society*

DESIGN DIRECTOR: David Whitmore. ART DIRECTOR: Elaine Bradley. DESIGNER: David Whitmore. DIRECTOR OF PHOTOGRAPHY: David Griffin. PHOTOGRAPHER: Paul Nicklen. EDITOR-IN-CHIEF: Chris Johns. PUBLISHER: National Geographic Society. ISSUE: December 2009. CATEGORY: Photo: Feature: News/Reportage (story)

504 *National Geographic Society*

DESIGN DIRECTOR: David Whitmore. DESIGNER: David Whitmore. DIRECTOR OF PHOTOGRAPHY: David Griffin. PHOTO EDITOR: Sarah Leen. PHOTOGRAPHER: Carolyn Drake. EDITOR-IN-CHIEF: Chris Johns. PUBLISHER: National Geographic Society. ISSUE: December 2009. CATEGORY: Photo: Feature: News/Reportage (story)

505 *The New York Times Magazine*

DESIGN DIRECTOR: Arem Duplessis. ART DIRECTOR: Gail Bichler. DIRECTOR OF PHOTOGRAPHY: Kathy Ryan. PHOTO EDITOR: Joanna Milter. PHOTOGRAPHERS: Anthony Almeida/Danziger Projects, AP Photo/Obama for America, Marc PoKempner, David Katz, Scott Olsen/Getty Images, Charles Ommanney/Getty Images, Callie Shell/Aurora, Todd Heilsler/The New York Times, Doug Mills/The New York Times, Damon Winter/The New York Times PUBLISHER: The New York Times Company. ISSUE: November 1, 2009. CATEGORY: Photo: Feature: News/Reportage (story)

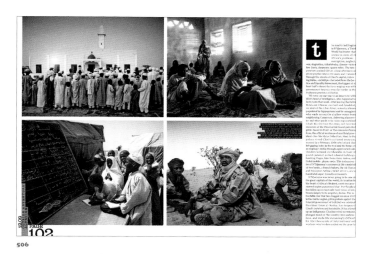

506

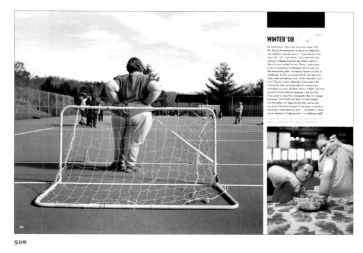

506

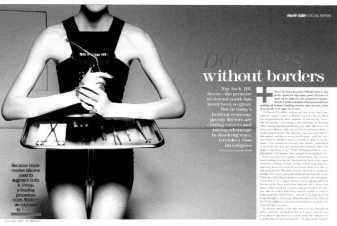

507

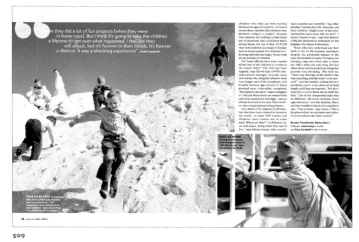

508

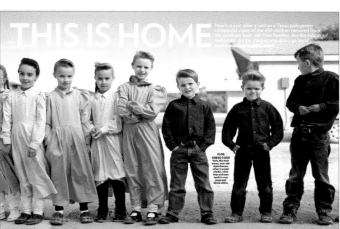

509

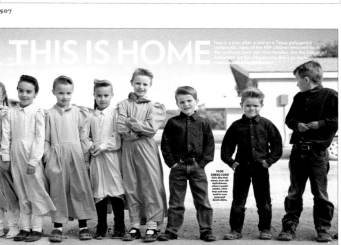

509

506 *Outside*

CREATIVE DIRECTOR: Hannah McCaughey. ART DIRECTORS: John McCauley, Chris Philpot. PHOTO EDITORS: Amy Feitelberg, Amy Silverman. PHOTOGRAPHER: Marco Di Lauro. PUBLISHER: Mariah Media, Inc. ISSUE: December 2009. CATEGORY: Photo: Feature: News/Reportage (story)

507 *Marie Claire*

CREATIVE DIRECTOR: Suzanne Sykes. DESIGN DIRECTOR: Kristin Fitzpatrick. ART DIRECTOR: Shannon Casey. DESIGNER: Elizabeth Schlossberg. DIRECTOR OF PHOTOGRAPHY: Alix Campbell. PHOTO EDITOR: Andrea Volbrecht. PHOTOGRAPHER: Liz Von Hoene. STYLIST: Christina Saratsis. EDITOR-IN-CHIEF: Joanna Coles. PUBLISHER: The Hearst Corporation-Magazines Division.ISSUE: October 2009. CATEGORY: Photo: Feature: News/Reportage (story)

508 *People*

CREATIVE DIRECTOR: Sara Williams. DESIGNER: Keir Novesky. DIRECTOR OF PHOTOGRAPHY: Chris Dougherty. PHOTO EDITOR: Debbe Edelstein. PHOTOGRAPHER: Greg Miller. EDITOR-IN-CHIEF: Larry Hackett. PUBLISHER: Time Inc. ISSUE: June 22, 2009. CATEGORY: Photo: Feature: News/Reportage (story)

509 *People*

CREATIVE DIRECTOR: Sara Williams. DESIGNER: Keir Novesky. DIRECTOR OF PHOTOGRAPHY: Chris Dougherty. PHOTO EDITOR: Karen O'Donnell. PHOTOGRAPHER: David Burnett. EDITOR-IN-CHIEF: Larry Hackett. PUBLISHER: Time Inc. ISSUE: March 23, 2009. CATEGORY: Photo: Feature: News/Reportage (story)

248

SECTION:
photography

AWARD:
merit

CATEGORY:
news/reportage (story)

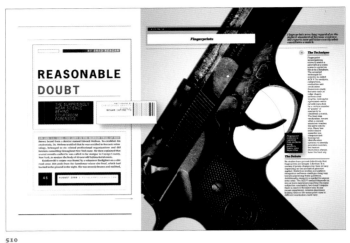

510

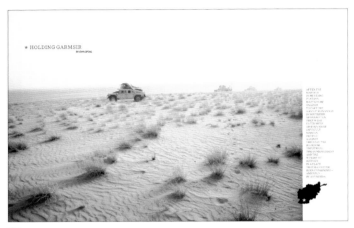

511

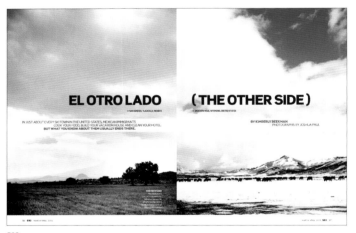

512

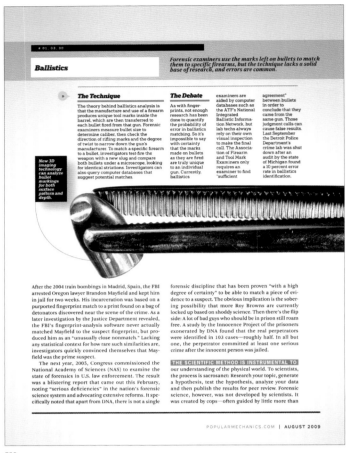

510

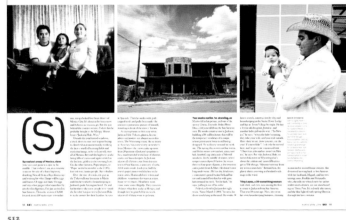

512

510 **Popular Mechanics**

DESIGN DIRECTOR: Michael Lawton. DIRECTOR OF PHOTOGRAPHY: Allyson Torrisi. PHOTOGRAPHER: Christopher Griffith. PUBLISHER: The Hearst. Corporation-Magazines Division. ISSUE: August 2009. CATEGORY: Photo: Feature: News/Reportage (story)

511 **Texas Monthly**

CREATIVE DIRECTOR: T.J. Tucker. DESIGNER: T.J. Tucker. PHOTO EDITOR: Leslie Baldwin. PHOTOGRAPHERS: John Spong, Lucian Read. PUBLISHER: Emmis Publishing. ISSUE: January 2009. CATEGORY: Photo: Feature: News/Reportage (story)

512 **SKI Magazine**

ART DIRECTOR: Eleanor Williamson. DIRECTOR OF PHOTOGRAPHY: Michelle Wolfe. PHOTOGRAPHER: Joshua Paul. EDITOR-IN-CHIEF: Kendall Hamilton/ Greg Ditrinco. PUBLISHER: Bonnier Corporation. ISSUE: March/April 2009. CATEGORY: Photo: Feature: News/Reportage (story)

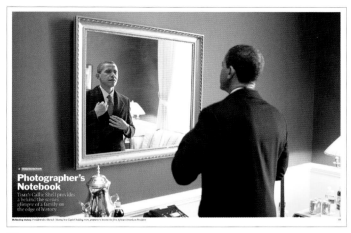

Photographer's Notebook Time's Callie Shell provides a behind-the-scenes glimpse of a family on the edge of history

Reflecting history, President-elect Barack Obama, in a Capitol holding room, prepares to become the first African-American President

513

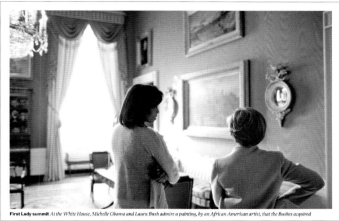

First Lady summit At the White House, Michelle Obama and Laura Bush admire a painting, by an African-American artist, that the Bushes acquired

513

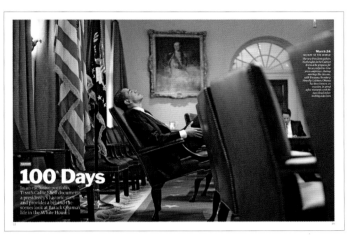

100 Days In an exclusive portfolio, Time's Callie Shell documents a presidency's historic start and provides a behind-the-scenes look at Barack Obama's life in the White House

514

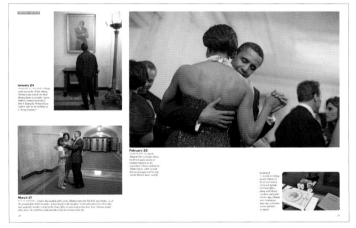

514

THE BRAIN, REVEALED

515

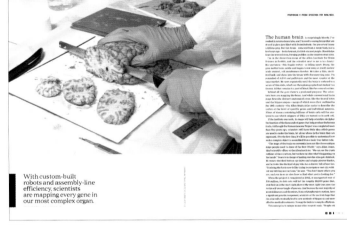

With custom-built robots and assembly-line efficiency, scientists are mapping every gene in our most complex organ.

515

513 **TIME**

ART DIRECTOR: Arthur Hochstein. DEPUTY ART DIRECTOR: D.W. Pine. PHOTO EDITORS: Alice Gabriner, Dietmar Liz-Lepiorz, Leslie dela Vega. PHOTOGRAPHER: Callie Shell — Aurora for TIME . PUBLISHER: Time Inc. ISSUE: February 2, 2009. CATEGORY: Photo: Feature: News/Reportage (story)

514 **TIME**

ART DIRECTOR: Arthur Hochstein. SENIOR ART DIRECTOR: Thomas M. Miller. PHOTO EDITORS: Dietmar Liz-Lepiorz, Leslie dela Vega. PHOTOGRAPHER: Callie Shell — Aurora for TIME . PUBLISHER: Time Inc. ISSUE: May 4, 2009. CATEGORY: Photo: Feature: News/Reportage (story)

515 **WIRED**

CREATIVE DIRECTOR: Scott Dadich. DESIGN DIRECTOR: Wyatt Mitchell. ART DIRECTOR: Maili Holiman. PHOTO EDITOR: Carolyn Rauch. PHOTOGRAPHER: David Clugston. EDITOR-IN-CHIEF: Chris Anderson. PUBLISHER: Condé Nast Publications, Inc.ISSUE: April 2009. CATEGORY: Photo: Feature: News/Reportage (story)

250

SECTION:
photography

AWARD:
merit

CATEGORY:
travel/food/still life

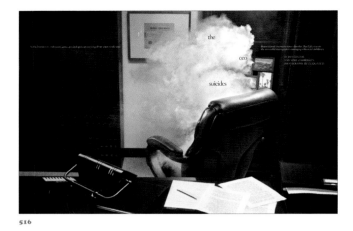

516

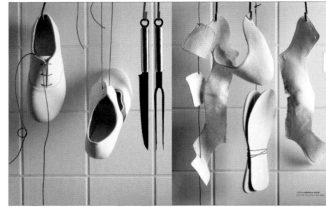

519

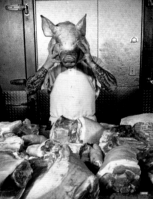

517

520

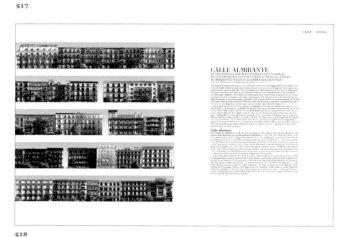

518

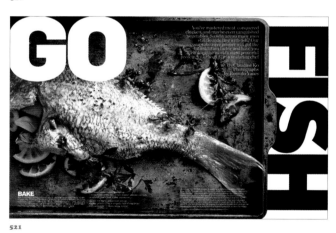

521

516 **Best Life**

DESIGN DIRECTOR: Brandon Kavulla. DESIGNER: Brandon Kavulla. DIRECTOR OF PHOTOGRAPHY: Ryan Cadiz. PHOTO EDITOR: Sarah Adams. PHOTOGRAPHER: Guido Vitti. PUBLISHER: Rodale Inc. ISSUE: April 2009. CATEGORY: Photo: Feature: Travel/Food/Still Life (single/spread)

517 **Best Life**

DESIGN DIRECTOR: Brandon Kavulla. DESIGNERS: Brandon Kavulla, Heather Jones. DIRECTOR OF PHOTOGRAPHY: Ryan Cadiz. PHOTO EDITOR: Jeanne Graves. PHOTOGRAPHER: Dan Forbes. PUBLISHER: Rodale Inc. ISSUE: March 2009. CATEGORY: Photo: Feature: Travel/Food/Still Life (single/spread)

518 **CUT · Leute machen Kleider**

ART DIRECTOR: Lucie Schmid. DESIGNERS: Lucie Schmid, Gabriela Neeb. DIRECTOR OF PHOTOGRAPHY: Lucie Schmid. PHOTOGRAPHER: Gabriela Neeb. STUDIO: Independent Medien-Design. PUBLISHER: moser verlag GmbH. ISSUE: September 18, 2009 ISSUE: 2. CATEGORY: Photo: Feature: Travel/Food/Still Life (single/spread)

519 **MADRIZ**

CREATIVE DIRECTOR: Louis-Charles Tiar. ART DIRECTOR: Sonia Bilbao. DESIGNER: Quique Ciria. PHOTOGRAPHER: Fernando Maselli. EDITORS-IN-CHIEF: Mónica Escudero, Ruben Pujol. PUBLISHER: Revistas Exclusivas S.L. ISSUE: Autumn 2009 - Winter 2010. CATEGORY: Photo: Feature: Travel/Food/Still Life (single/spread)

520 **Men's Health**

DESIGN DIRECTOR: Brandon Kavulla. DESIGNER: Brandon Kavulla. DIRECTOR OF PHOTOGRAPHY: Brenda Milis. DEPUTY DIRECTOR OF PHOTOGRAPHY: Lila Garnett. PHOTOGRAPHER: Nathaniel Welch. PUBLISHER: Rodale Inc. ISSUE: June 2009. CATEGORY: Photo: Feature: Travel/Food/Still Life (single/spread)

521 **Men's Health**

DESIGN DIRECTOR: Brandon Kavulla. DESIGNER: Brandon Kavulla. DIRECTOR OF PHOTOGRAPHY: Brenda Milis. DEPUTY DIRECTOR OF PHOTOGRAPHY: Michelle Stark. PHOTOGRAPHER: Romulo Yanes. PUBLISHER: Rodale Inc. ISSUE: November 2009. CATEGORY: Photo: Feature: Travel/Food/Still Life (single/spread

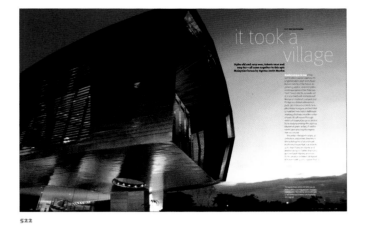

522

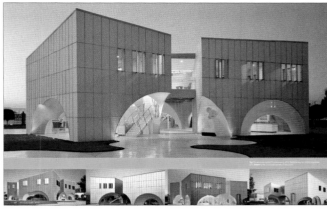

525

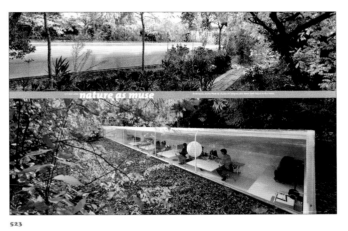

523

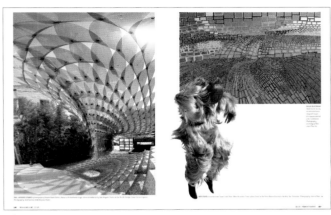

526

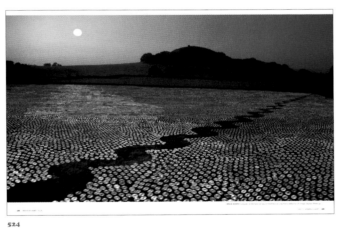

524

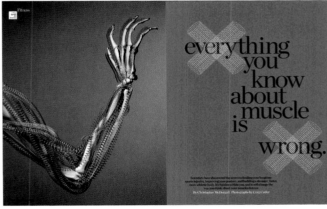

527

522 *Interior Design*

CREATIVE DIRECTOR: Cindy Allen. DESIGNERS: Zigeng Li, Karla Lima, Giannina Macias. PHOTO EDITOR: Helene Oberman. PHOTOGRAPHER: Eric Laignel. PUBLISHER: Reed Business Information. ISSUE: January 2009. CATEGORY: Photo: Feature: Travel/Food/Still Life (single/spread)

523 *Interior Design*

CREATIVE DIRECTOR: Cindy Allen. DESIGNERS: Zigeng Li, Karla Lima, Giannina Macias. PHOTO EDITOR: Helene Oberman. PUBLISHER: Reed Business Information. ISSUE: December 2009. CATEGORY: Photo: Feature: Travel/Food/Still Life (single/spread)

524 *Interior Design*

CREATIVE DIRECTOR: Cindy Allen. DESIGNERS: Zigeng Li, Karla Lima, Giannina Macias. PHOTO EDITOR: Helene Oberman. PHOTOGRAPHER: Paul Rivera/Archphoto. PUBLISHER: Reed Business Information. ISSUE: May 2009. CATEGORY: Photo: Feature: Travel/Food/Still Life (single/spread)

525 *Interior Design*

CREATIVE DIRECTOR: Cindy Allen. DESIGNERS: Zigeng Li, Karla Lima, Giannina Macias. PHOTO EDITOR: Helene Oberman. PHOTOGRAPHER: Stephen Weeks. PUBLISHER: Reed Business Information. ISSUE: December 2009. CATEGORY: Photo: Feature: Travel/Food/Still Life (single/spread)

526 *Interior Design*

CREATIVE DIRECTOR: Cindy Allen. DESIGNERS: Zigeng Li, Karla Lima, Giannina Macias. PHOTO EDITOR: Helene Oberman. PHOTOGRAPHER: Iwan Baan. PUBLISHER: Reed Business Information. ISSUE: July 2009. CATEGORY: Photo: Feature: Travel/Food/Still Life (single/spread)

527 *Men's Health*

DESIGN DIRECTOR: Brandon Kavulla. DESIGNER: Brandon Kavulla. DIRECTOR OF PHOTOGRAPHY: Brenda Milis. DEPUTY DIRECTOR OF PHOTOGRAPHY: Jeanne Graves. PHOTOGRAPHER: Craig Cutler. PUBLISHER: Rodale Inc. ISSUE: October 2009. CATEGORY: Photo: Feature: Travel/Food/Still Life (single/spread)

252

SECTION:
photography

AWARD:
merit

CATEGORY:
travel/food/still life

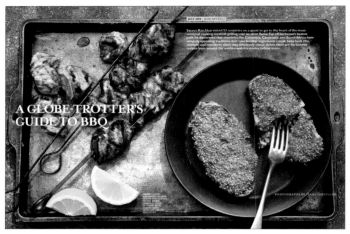

528

529

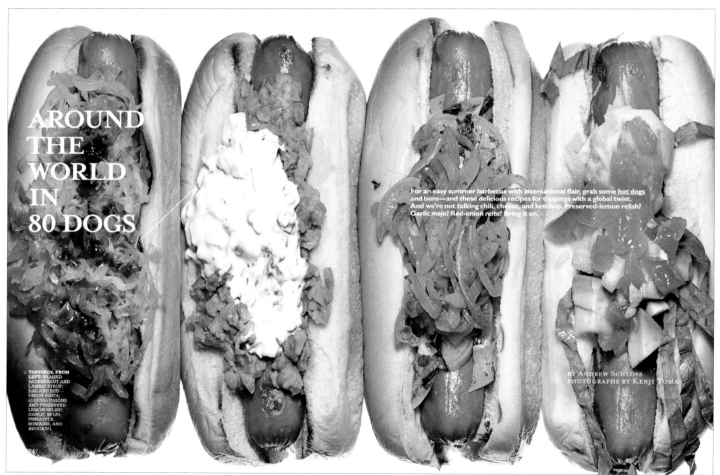

530

528 **Bon Appétit**

DESIGN DIRECTOR: Matthew Lenning. ART
DIRECTORS: Robert Festino, Tom O'Quinn. DESIGNER:
John Muñoz. DIRECTOR OF PHOTOGRAPHY:
Bailey Franklin. PHOTO EDITOR: Angelica Mistro.
PHOTOGRAPHER: Nigel Cox. EDITOR-IN-CHIEF:
Barbara Fairchild. PUBLISHER: Condé Nast Publications,
Inc. ISSUE: August 2009. CATEGORY: Photo: Feature:
Travel/Food/Still Life (single/spread)

529 **Bon Appétit**

DESIGN DIRECTOR: Matthew Lenning. ART
DIRECTORS: Robert Festino, Tom O'Quinn. DESIGNER:
John Muñoz. DIRECTOR OF PHOTOGRAPHY:
Bailey Franklin. PHOTO EDITOR: Angelica Mistro.
PHOTOGRAPHER: Hans Gissanger. EDITOR-IN-
CHIEF: Barbara Fairchild. PUBLISHER: Condé Nast
Publications, Inc. ISSUE: July 2009. CATEGORY: Photo:
Feature: Travel/Food/Still Life (single/spread)

530 **Bon Appétit**

DESIGN DIRECTOR: Matthew Lenning. ART
DIRECTORS: Robert Festino, Tom O'Quinn. DESIGNER:
John Muñoz. DIRECTOR OF PHOTOGRAPHY:
Bailey Franklin. PHOTO EDITOR: Angelica Mistro.
PHOTOGRAPHER: Kenji Toma. EDITOR-IN-CHIEF:
Barbara Fairchild. PUBLISHER: Condé Nast Publications,
Inc. ISSUE: July 2009. CATEGORY: Photo: Feature:
Travel/Food/Still Life (single/spread)

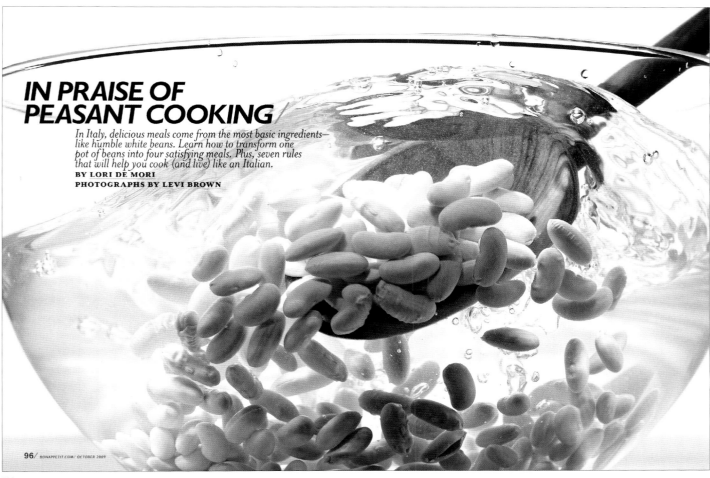

IN PRAISE OF PEASANT COOKING

In Italy, delicious meals come from the most basic ingredients—like humble white beans. Learn how to transform one pot of beans into four satisfying meals. Plus, seven rules that will help you cook (and live) like an Italian.

BY LORI DE MORI

PHOTOGRAPHS BY LEVI BROWN

96/ BONAPPETIT.COM/ OCTOBER 2009

531

532

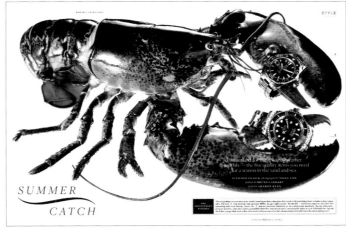

533

531 **Bon Appétit**

DESIGN DIRECTOR: Matthew Lenning.
ART DIRECTORS: Robert Festino, Tom O'Quinn.
DESIGNER: John Muñoz.
DIRECTOR OF PHOTOGRAPHY: Bailey Franklin.
PHOTO EDITOR: Angelica Mistro.
PHOTOGRAPHER: Levi Brown.
EDITOR-IN-CHIEF: Barbara Fairchild.
PUBLISHER: Condé Nast Publications, Inc.
ISSUE: October 2009. CATEGORY: Photo: Feature:
Travel/Food/Still Life (single/spread)

532 **Men's Health**

ART DIRECTOR: Brandon Kavulla. DESIGNERS:
Dena Verdesca, Brandon Kavulla. DIRECTOR
OF PHOTOGRAPHY: Brenda Milis. DEPUTY
DIRECTOR OF PHOTOGRAPHY: Jeanne Graves.
PHOTOGRAPHER: Jamie Chung. PUBLISHER: Rodale
Inc. ISSUE: November 2009. CATEGORY: Photo:
Feature: Travel/Food/Still Life (single/spread)

533 **Men's Journal**

CREATIVE DIRECTOR: Paul Martinez. DESIGNER:
Paul Martinez. DIRECTOR OF PHOTOGRAPHY:
Michelle Wolfe. PHOTO EDITOR: Jennifer Santana.
PHOTOGRAPHER: Nigel Cox. PUBLISHER: Wenner
Media LLC. ISSUE: June 2009. CATEGORY: Photo:
Feature: Travel/Food/Still Life (single/spread)

254

SECTION:
photography

AWARD:
merit

CATEGORY:
travel/food/still life

534

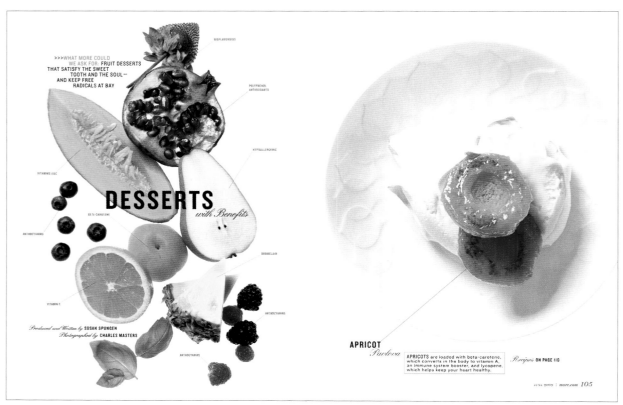

535

534 *Real Simple*

CREATIVE DIRECTOR: Janet Froelich. DESIGN DIRECTOR: Ellene
Wundrok. DESIGNER: Ellene Wundrok. DIRECTOR OF PHOTOGRAPHY:
Casey Tierney. PHOTO EDITOR: Lauren Epstein. PHOTOGRAPHER:
Sang An. PUBLISHER: Time Inc. ISSUE: August 2009. CATEGORY: Photo:
Feature: Travel/Food/Still Life (single/spread)

535 *More*

CREATIVE DIRECTOR: Debra Bishop. DESIGNER: Debra Bishop.
DIRECTOR OF PHOTOGRAPHY: Stacey Baker. PHOTO EDITOR: Natalie
Gialluca. PHOTOGRAPHER: Charles Masters. EDITOR-IN-CHIEF: Lesley
Jane Seymour. PUBLISHER: Meredith Corporation. ISSUE: June 2009
CATEGORY: Photo: Feature: Travel/Food/Still Life (single/spread)

536

537

Lower Manhattan at dusk, as seen from the New Museum, on the Bowery.

538

536 *Travel + Leisure*

CREATIVE DIRECTOR: Nora Sheehan. ART DIRECTORS: Mark Maltais, Katharine Van Itallie. DESIGNER: Katharine Van Itallie. DIRECTOR OF PHOTOGRAPHY: Katie Dunn. PHOTO EDITOR: Wendy Ball. PHOTOGRAPHER: Blasius Erlinger. PUBLISHER: American Express Publishing Co. ISSUE: April 2009. CATEGORY: Photo: Feature: Travel/Food/Still Life (single/spread)

537 *Travel + Leisure*

CREATIVE DIRECTOR: Nora Sheehan. ART DIRECTORS: Mark Maltais, Katharine Van Itallie. DESIGNERS: Nora Sheehan, Mark Maltais. DIRECTOR OF PHOTOGRAPHY: Katie Dunn. PHOTO EDITOR: Katie Dunn. PHOTOGRAPHER: Simon Watson. PUBLISHER: American Express Publishing Co. ISSUE: September 2009. CATEGORY: Photo: Feature: Travel/Food/Still Life (single/spread)

538 *Travel + Leisure*

CREATIVE DIRECTOR: Nora Sheehan. ART DIRECTORS: Mark Maltais, Katharine Van Itallie. DESIGNER: Nora Sheehan. DIRECTOR OF PHOTOGRAPHY: Katie Dunn. PHOTO EDITOR: Katie Dunn. PHOTOGRAPHER: Andrea Fazzari. PUBLISHER: American Express Publishing Co. ISSUE: October 2009. CATEGORY: Photo: Feature: Travel/Food/Still Life (single/spread)

256

SECTION:
photography

AWARD:
merit

CATEGORY:
travel/food/still life (story)

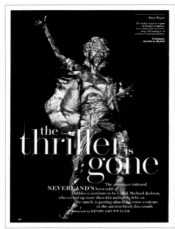

539

539

540

540

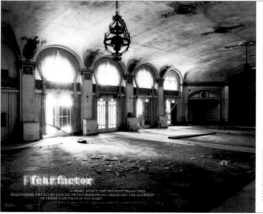

541

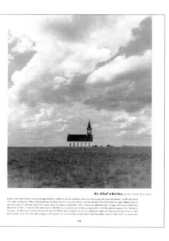

541

539 **Condé Nast Portfolio**

DESIGN DIRECTOR: Robert Priest. ART DIRECTOR: Grace Lee. DESIGNER: Grace Lee. DIRECTOR OF PHOTOGRAPHY: Karen Frank. PHOTO EDITOR: Rossana Shokrian. PHOTOGRAPHER: Henry Leutwyler. STUDIO: Priest and Grace, LLC. PUBLISHER: Condé Nast Publications Inc. ISSUE: April 2009. CATEGORY: Photo: Feature: Travel/Food/Still Life (story)

540 **T, The New York Times Style Magazine**

CREATIVE DIRECTOR: David Sebbah. SENIOR ART DIRECTOR: Christopher Martinez. DESIGNER: Natalie Do. ILLUSTRATOR: Gary Card. SENIOR PHOTO EDITOR: Judith Puckett-Rinella. PHOTOGRAPHER: Ilan Rubin. PUBLISHER: The New York Times Company. ISSUE: May 31, 2009. CATEGORY: Photo: Feature: Travel/Food/Still Life (story)

541 **Texas Monthly**

CREATIVE DIRECTOR: T.J. Tucker. DESIGNER: T.J. Tucker. PHOTO EDITOR: Leslie Baldwin. PHOTOGRAPHER: Todd Hido. PUBLISHER: Emmis Publishing. ISSUE: October 2009. CATEGORY: Photo: Feature: Travel/Food/Still Life (story)

257

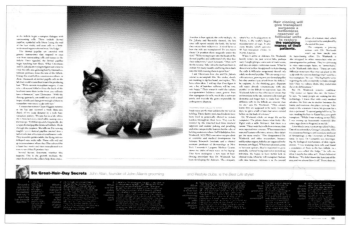

542

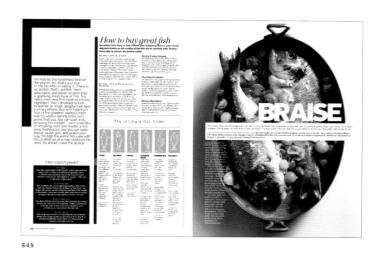

543

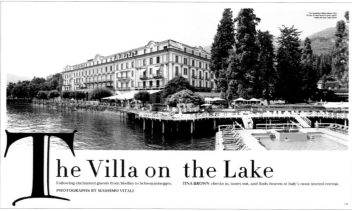

544

The Villa on the Lake

Following enchanted guests from Shelley to Schwarzenegger. TINA BROWN checks in, tunes out, and finds heaven at Italy's most storied retreat.

PHOTOGRAPHS BY MASSIMO VITALI

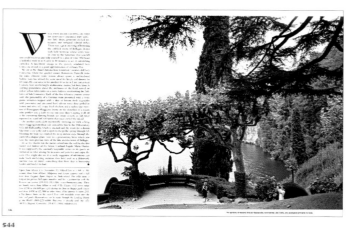

544

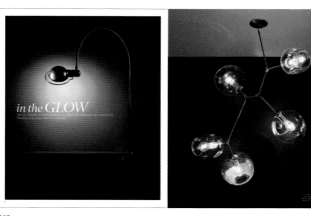

545

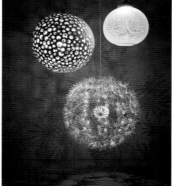

545

542 **Best Life**

DESIGN DIRECTOR: Brandon Kavulla. DESIGNERS: Brandon Kavulla, Heather Jones. DIRECTOR OF PHOTOGRAPHY: Ryan Cadiz. PHOTOGRAPHER: Dan Forbes. PUBLISHER: Rodale Inc. ISSUE: March 2009. CATEGORY: Photo: Feature: Travel/Food/Still Life (story)

544 **Departures**

CREATIVE DIRECTOR: Bernard Scharf. DESIGN DIRECTOR: Adam Bookbinder. PHOTO EDITOR: Jessica Dimson. PHOTOGRAPHER: Massimo Vitali. ASSOCIATE ART DIRECTOR: Lou Corredor. DEPUTY PHOTO EDITOR: Michael Shome. PUBLISHER: American Express Publishing Co. ISSUE: March/April 2009. CATEGORY: Photo: Feature: Travel/Food/Still Life (story)

543 **Men's Health**

DESIGN DIRECTOR: Brandon Kavulla. DESIGNER: Brandon Kavulla. DIRECTOR OF PHOTOGRAPHY: Brenda Milis. DEPUTY DIRECTOR OF PHOTOGRAPHY: Michelle Stark. PHOTOGRAPHER: Romulo Yanes. PUBLISHER: Rodale Inc. ISSUE: November 2009. CATEGORY: Photo: Feature: Travel/Food/Still Life (story)

545 **Elle Décor**

ART DIRECTOR: Florentino Pamintuan. PHOTO EDITOR: Tara Germinsky. PHOTOGRAPHER: Ilan Rubin. PRODUCER: Anita Sarsidi. PUBLISHER: Hachette Filipacchi Media U.S. ISSUE: September 2009. CATEGORY: Photo: Feature: Travel/Food/Still Life (story)

258

SECTION:
photography

AWARD:
merit

CATEGORY:
travel/food/still life (story)

546

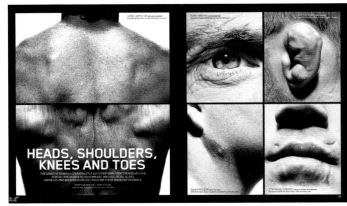

547

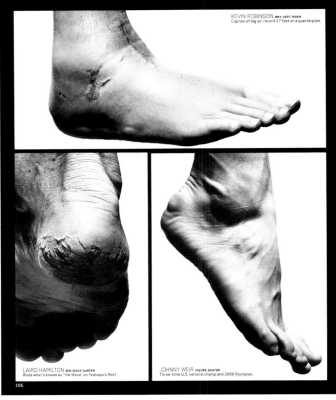

547

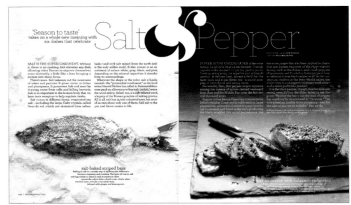

548

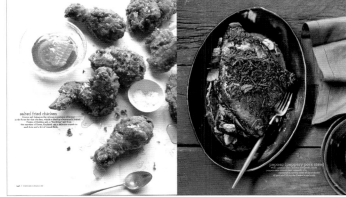

548

546 **Men's Journal**

CREATIVE DIRECTOR: Paul Martinez. DESIGNER:
Paul Martinez. DIRECTOR OF PHOTOGRAPHY:
Michelle Wolfe. PHOTO EDITOR: Jennifer Santana.
PHOTOGRAPHER: Nigel Cox. PUBLISHER: Wenner
Media LLC. ISSUE: June 2009. CATEGORY: Photo:
Feature: Travel/Food/Still Life (story)

547 **ESPN The Magazine**

CREATIVE DIRECTOR: Siung Tjia. ART DIRECTOR:
Jason Lancaster. DIRECTOR OF PHOTOGRAPHY:
Catriona Ni Aolain. PHOTO EDITORS: Amy McNulty,
Bettina Staimen, Maisie Todd. PHOTOGRAPHER:
James Chung. PUBLISHER: The Walt Disney Publishing
Company. ISSUE: October 19, 2009. CATEGORY: Photo:
Feature: Travel/Food/Still Life (story)

548 **Martha Stewart Living**

CREATIVE DIRECTOR: Eric A. Pike. DESIGN
DIRECTOR: James Dunlinson. ART DIRECTOR:
Matthew Axe. DESIGNER: Isabel Abdai. DIRECTOR OF
PHOTOGRAPHY: Heloise Goodman. PHOTOGRAPHER:
Con Poulos. STYLISTS: Ayesha Patel, Christine Albano.
EDITOR-IN-CHIEF: Gael Towey. PUBLISHER: Martha
Stewart Living Omnimedia. ISSUE: October 2009.
CATEGORY: Photo: Feature: Travel/Food/Still Life (story)

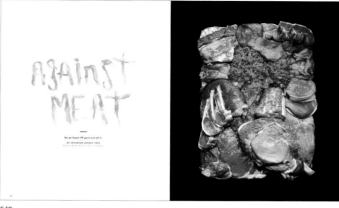

549

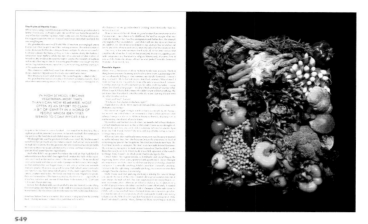

549

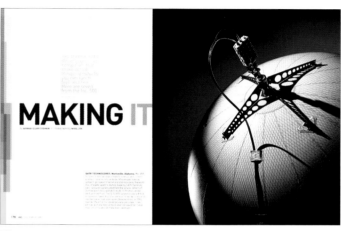

550

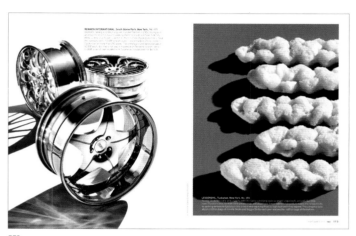

550

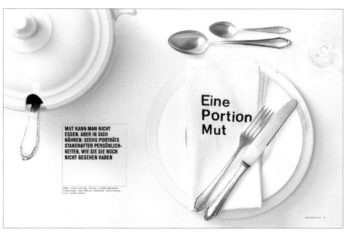

551

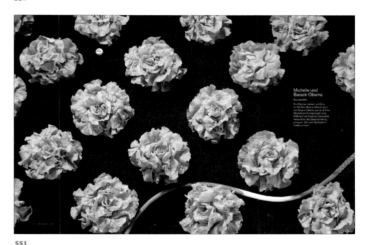

551

549 *The New York Times Magazine*

DESIGN DIRECTOR: Arem Duplessis. DEPUTY ART DIRECTOR: Gail Bichler. DESIGNER: Aviva Michaelov. ILLUSTRATOR: Jacob Magraw-Mickelson. DIRECTOR OF PHOTOGRAPHY: Kathy Ryan. PHOTO EDITOR: Luise Stauss. PHOTOGRAPHER: Mitchell Feinberg . PUBLISHER: The New York Times Company. ISSUE: October 11, 2009. CATEGORY: Photo: Feature: Travel/ Food/Still Life (story)

550 *Inc.*

CREATIVE DIRECTOR: Blake Taylor. DESIGNER: Blake Taylor. DIRECTOR OF PHOTOGRAPHY: Travis Ruse. PHOTOGRAPHER: Nigel Cox. PUBLISHER: Mansueto Ventures. ISSUE: September 2009. CATEGORY: Photo: Feature: Travel/Food/Still Life (story)

551 *Relevance*

CREATIVE DIRECTOR: Diddo Ramm. ART DIRECTOR: Ann-Katrin Sander. DIRECTOR OF PHOTOGRAPHY: Julia Hauschildt. PHOTOGRAPHER: Frank Stöckel. EDITOR-IN-CHIEF: Diddo Ramm. PUBLISHER: DROCC Media. ISSUE: November 2009. CATEGORY: Photo: Feature: Travel/Food/Still Life (story)

260

SECTION:
photography

AWARD:
merit

CATEGORY:
travel/food/still life (story)

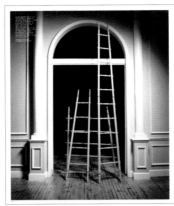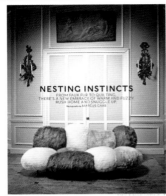

552

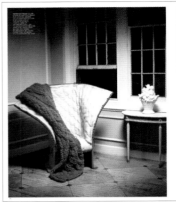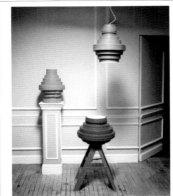

552

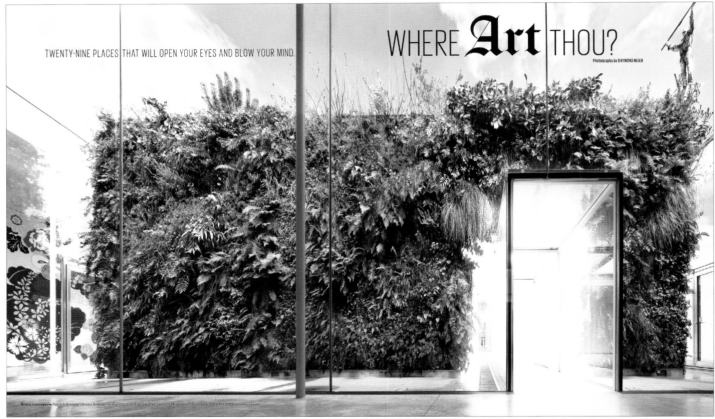

553

552 *T, The New York Times Style Magazine*

CREATIVE DIRECTOR: David Sebbah. SENIOR ART DIRECTOR:
Christopher Martinez. DESIGNER: Natalie Do. PHOTO EDITOR: Scott Hall.
PHOTOGRAPHER: Marcus Gaab. PUBLISHER: The New York Times
Company. ISSUE: October 3, 2009. CATEGORY: Photo: Feature: Travel/
Food/Still Life (story)

553 *T, The New York Times Style Magazine*

CREATIVE DIRECTOR: David Sebbah. SENIOR ART DIRECTOR:
Christopher Martinez. SENIOR PHOTO EDITOR: Judith Puckett-Rinella.
PHOTOGRAPHER: Raymond Meier. PUBLISHER: The New York Times
Company. ISSUE: May 17, 2009. CATEGORY: Photo: Feature: Travel/Food/
Still Life (story)

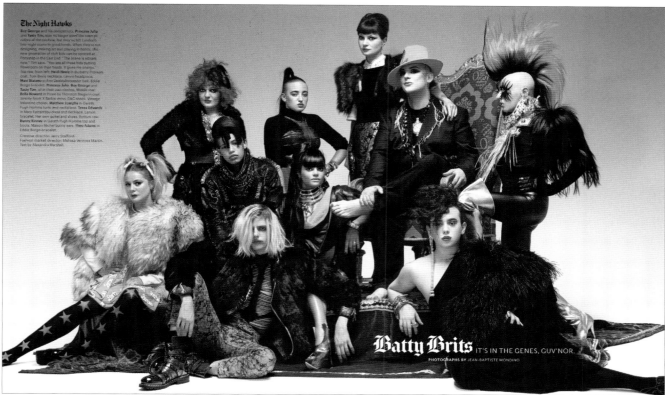

554

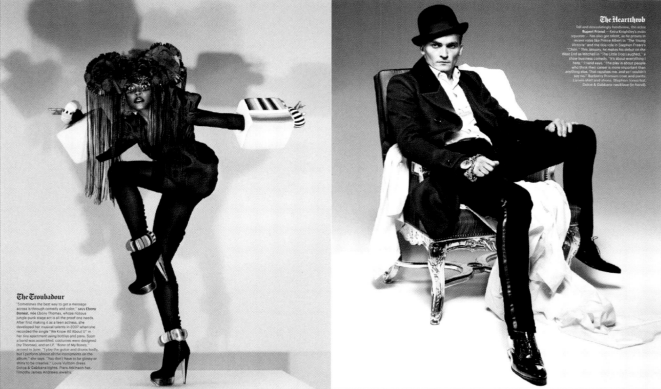

554

554 *T, The New York Times Style Magazine*

CREATIVE DIRECTOR: David Sebbah. SENIOR ART DIRECTOR: Christopher Martinez. DESIGNER: Natalie Do. PHOTO EDITOR: Judith Puckett-Rinella. PHOTOGRAPHER: Jean-Baptiste Mondino. PUBLISHER: The New York Times Company. ISSUE: October 18, 2009. CATEGORY: Photo: Feature: Travel/Food/Still Life (story)

262

SECTION:
photography

AWARD:
merit

CATEGORY:
fashion/beauty/still life

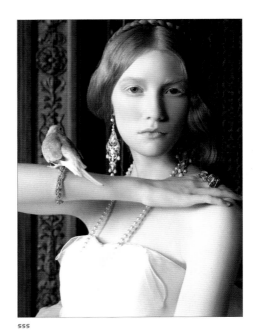

555

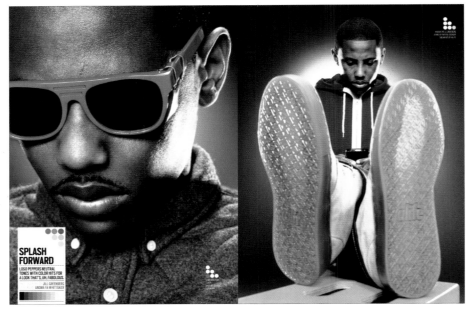

556

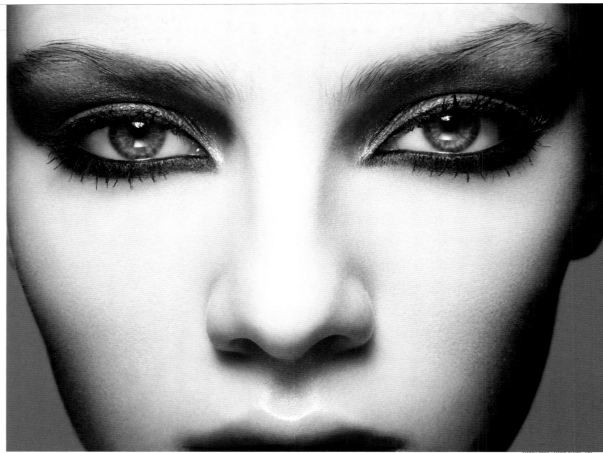

557

555 Brides

CREATIVE DIRECTOR: Gretchen Smelter. ART
DIRECTOR: Nazan Akyavas. DIRECTOR OF
PHOTOGRAPHY: Kristi Drago Price. PHOTO EDITOR:
Kristen Walsh. PHOTOGRAPHER: Caroline Knopf.
EDITOR-IN-CHIEF: Millie Bratten. PUBLISHER: Condé
Nast Publications Inc. ISSUE: February/March 2009
CATEGORY: Photo: Feature: Fashion/Beauty (single/
spread)

556 Complex

DESIGN DIRECTOR: Tim Leong. DIRECTOR OF
PHOTOGRAPHY: Marian Barragan. PHOTOGRAPHER:
Jill Greenberg. PUBLISHER: Complex Media, Inc. ISSUE:
August/September 2009. CATEGORY: Photo: Feature:
Fashion/Beauty (single/spread)

557 Marie Claire

CREATIVE DIRECTOR: Suzanne Sykes.
DESIGN DIRECTOR: Kristin Fitzpatrick.
ART DIRECTOR: Shannon Casey. DESIGNER: Elizabeth
Schlossberg. DIRECTOR OF PHOTOGRAPHY:
Alix Campbell. PHOTO EDITOR: Andrea Volbrecht.
PHOTOGRAPHER: Max Cardelli. STYLIST: Tiffany
Fraser-Steel. EDITOR-IN-CHIEF: Joanna Coles.
PUBLISHER: The Hearst Corporation-Magazines
Division. ISSUE: March 2009. CATEGORY: Photo:
Feature: Fashion/Beauty (single/spread)

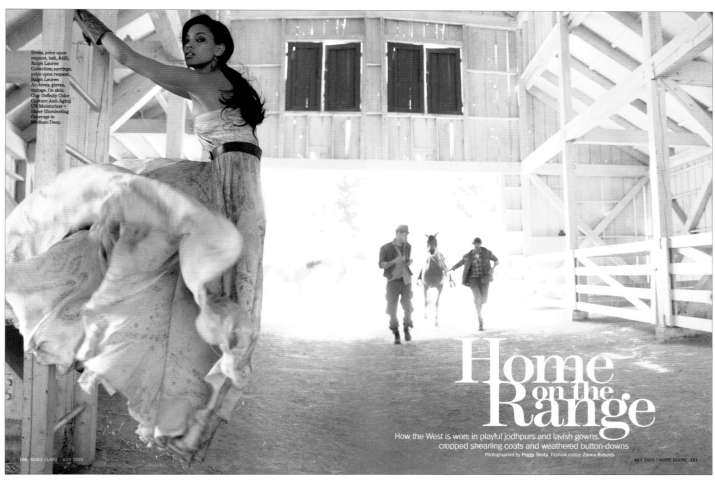

558

559

560

558 Marie Claire

CREATIVE DIRECTOR: Suzanne Sykes.
DESIGN DIRECTOR: Kristin Fitzpatrick.
ART DIRECTOR: Shannon Casey. DESIGNER: Elizabeth
Schlossberg. DIRECTOR OF PHOTOGRAPHY:
Alix Campbell. PHOTO EDITOR: Andrea Volbrecht.
PHOTOGRAPHER: Peggy Sirota. FASHION
EDITOR: Zanna Robert-Rassi. EDITOR-IN-CHIEF:
Joanna Coles. PUBLISHER: The Hearst Corporation-
Magazines Division. ISSUE: July 2009 CATEGORY:
Photo: Feature: Fashion/Beauty (single/spread)

559 More

CREATIVE DIRECTOR: Debra Bishop. DESIGNER:
Debra Bishop. DIRECTOR OF PHOTOGRAPHY:
Jennifer Laski. PHOTO EDITOR: Daisy Cajas.
PHOTOGRAPHER: Nigel Cox. EDITOR-IN-
CHIEF: Lesley Jane Seymour. PUBLISHER: Meredith
Corporation. ISSUE: March 2009. CATEGORY: Photo:
Feature: Fashion/Beauty (single/spread)

560 More

CREATIVE DIRECTOR: Debra Bishop. ART
DIRECTOR: Jose G. Fernandez. DESIGNER: Jenn
McManus. DIRECTOR OF PHOTOGRAPHY:
Stacey Baker. PHOTO EDITOR: Daisy Cajas.
PHOTOGRAPHER: Rodney Smith. EDITOR-IN-
CHIEF: Lesley Jane Seymour. PUBLISHER: Meredith
Corporation. ISSUE: October 2009. CATEGORY: Photo:
Feature: Fashion/Beauty (single/spread)

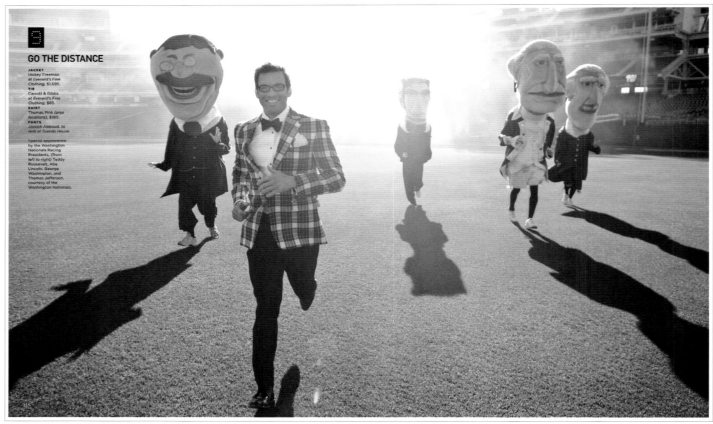

GO THE DISTANCE

JACKET
Hickey Freeman
at Everard's Fine
Clothing, $1,695.
TIE
Carrott & Gibbs
at Everard's Fine
Clothing, $65.
SHIRT
Thomas Pink (area
locations), $180.
PANTS
Joseph Abboud, to
rent at Tuxedo House

Special appearance
by the Washington
Nationals Racing
Presidents, (from
left to right) Teddy
Roosevelt, Abe
Lincoln, George
Washington, and
Thomas Jefferson,
courtesy of the
Washington Nationals.

561

562

563

561 **Washingtonian Bride & Groom**

CREATIVE DIRECTORS: Pum Lefebure, Jake Lefebure.
ART DIRECTOR: Pum Lefebure. DESIGNER: Tim Madle.
PHOTOGRAPHER: Cade Martin. STUDIO: Design Army.
PUBLISHER: Washingtonian. CLIENT: Washingtonian
Bride & Groom. ISSUE: June 2009. CATEGORY: Photo:
Feature: Fashion/Beauty (single/spread)

562 **Best Life**

DESIGN DIRECTOR: Brandon Kavulla. DIRECTOR
OF PHOTOGRAPHY: Ryan Cadiz. PHOTOGRAPHER:
Richard Phibbs. PUBLISHER: Rodale Inc. ISSUE: May
2009. CATEGORY: Photo: Feature: Fashion/Beauty
(single/spread)

563 **Best Life**

DESIGN DIRECTOR: Brandon Kavulla. DESIGNER:
Brandon Kavulla. DIRECTOR OF PHOTOGRAPHY:
Ryan Cadiz. PHOTOGRAPHER: Nino Muñoz.
PUBLISHER: Rodale Inc. ISSUE: April 2009. CATEGORY:
Photo: Feature: Fashion/Beauty (single/spread)

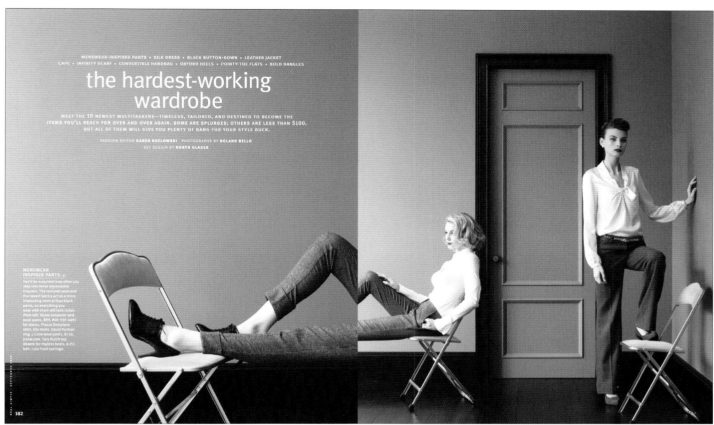

564

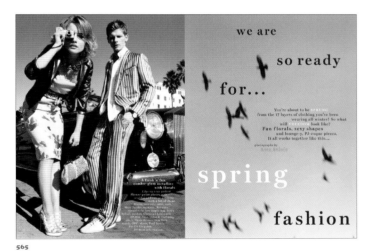

565

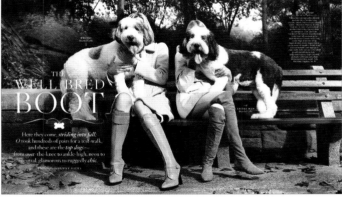

566

564 **Real Simple**

CREATIVE DIRECTOR: Janet Froelich. DESIGNER: Jessica Weit. DIRECTOR OF PHOTOGRAPHY: Casey Tierney. PHOTO EDITOR: Lindsay Dougherty Rogers. PHOTOGRAPHER: Roland Bello. PUBLISHER: Time Inc. ISSUE: September 2009. CATEGORY: Photo: Feature: Fashion/Beauty (single/spread)

565 **Glamour**

DESIGN DIRECTOR: Geraldine Hessler. ART DIRECTOR: Sarah Viñas. DIRECTOR OF PHOTOGRAPHY: Suzanne Donaldson. PHOTOGRAPHER: Koto Bolofo. PUBLISHER: Condé Nast Publications Inc. ISSUE: March 2009. CATEGORY: Photo: Feature: Fashion/Beauty (single/spread)

566 **O, The Oprah Magazine**

DESIGN DIRECTOR: Priest + Grace. ART DIRECTOR: Leslie Richardson. DIRECTOR OF PHOTOGRAPHY: Katherine Schad. PHOTO EDITOR: Christina Weber. PHOTOGRAPHER: Dewey Nicks. CREATIVE DIRECTOR: Adam Glassman. PUBLISHER: The Hearst Corporation-Magazines Division. ISSUE: November 2009. CATEGORY: Photo: Feature: Fashion/Beauty (single/spread)

266

SECTION:
photography

AWARD:
merit

CATEGORY:
fashion/beauty/still life

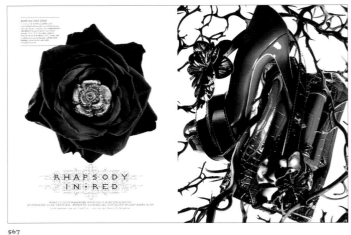

567

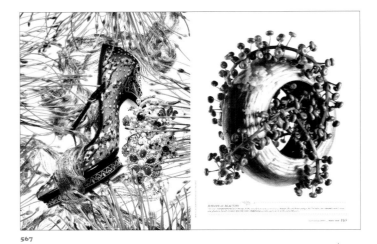

567

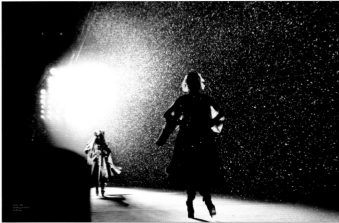

568

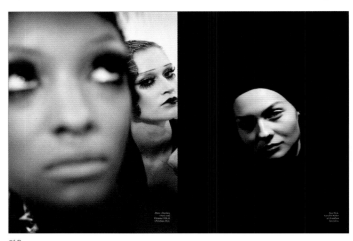

568

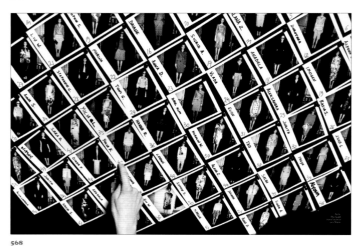

568

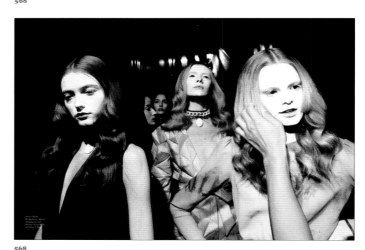

568

567 **More**

CREATIVE DIRECTOR: Debra Bishop. DESIGNER: Debra Bishop.
DIRECTOR OF PHOTOGRAPHY: Stacey Baker. PHOTO EDITOR: Daisy
Cajas. PHOTOGRAPHER: Nigel Cox. EDITOR-IN-CHIEF: Lesley Jane
Seymour. PUBLISHER: Meredith Corporation. ISSUE: September 2009.
CATEGORY: Photo: Feature: Fashion/Beauty (story)

568 **New York**

DESIGN DIRECTOR: Chris Dixon. DIRECTOR OF PHOTOGRAPHY:
Jody Quon. PHOTO EDITOR: Nadia Lachance. PHOTOGRAPHER: Marcus
Bleasdale. FASHION EDITOR: Harriet Mays Powell. EDITOR-IN-CHIEF:
Adam Moss. PUBLISHER: New York Magazine Holdings, LLC. ISSUE: August
24, 2009. CATEGORY: Photo: Feature: Fashion/Beauty (story)

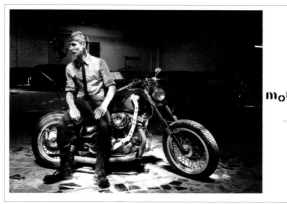

569

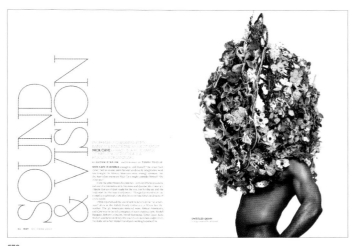

570

571

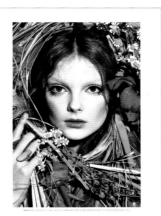

571

569 **Inked**

CREATIVE DIRECTOR: Todd Weinberger. DIRECTOR OF PHOTOGRAPHY: Rebecca Fain. PHOTO EDITOR: Josh Clutter. PHOTOGRAPHER: Michael Dwornik. PUBLISHER: Pinchazo Publishing. ISSUE: August 2009. CATEGORY: Photo: Feature: Fashion/Beauty (story)

570 **Out**

CREATIVE DIRECTOR: David Gray. ART DIRECTOR: Nick Vogelson. DESIGNER: Jason Seldon. DIRECTOR OF PHOTOGRAPHY: Annie Chia. PHOTO EDITOR: Jason Rogers. PHOTOGRAPHER: Terry Tsiolis. EDITOR-IN-CHIEF: Aaron Hicklin. PUBLISHER: Here Media. ISSUE: October 2009. CATEGORY: Photo: Feature: Fashion/Beauty (story)

571 **W**

DESIGN DIRECTOR: Edward Leida. ART DIRECTOR: Nathalie Kirsheh. DESIGNER: Edward Leida. PHOTOGRAPHER: Mario Sorrenti. PUBLISHER: Condé Nast Publications Inc. ISSUE: April 2009. CATEGORY: Photo: Feature: Fashion/Beauty (story)

268

SECTION:
photography

AWARD:
merit

CATEGORY:
trade/corporate

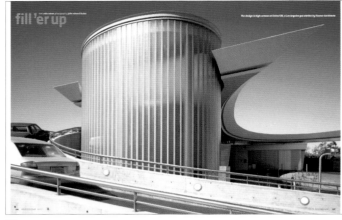

572

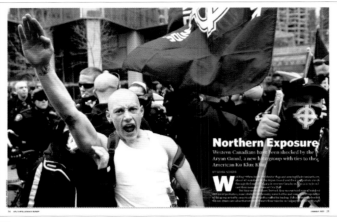

573

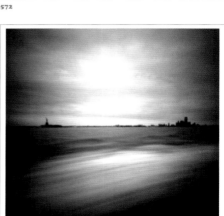

574

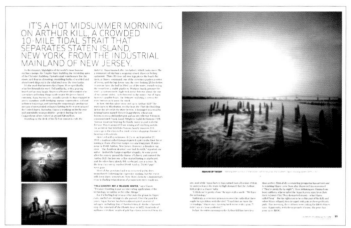

574

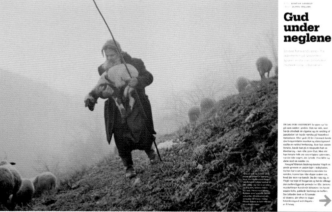

575

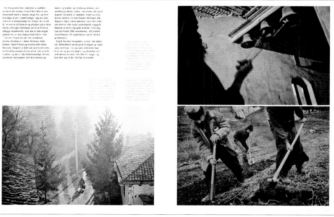

575

572 *Interior Design*

CREATIVE DIRECTOR: Cindy Allen. DESIGNERS: Zigeng Li, Karla Lima, Giannina Macias. PHOTO EDITOR: Helene Oberman. PHOTOGRAPHER: John Edward Linden. PUBLISHER: Reed Business Information. ISSUE: July 2009. CATEGORY: Photo: Cover, Entire Issue, Single/Spread or Story

574 *Hemispheres*

ART DIRECTOR: Rob Hewitt. DESIGNERS: Ellie Clayman, Rob Hewitt. PHOTO EDITOR: Erin Giunta. PHOTOGRAPHER: Stefan Killen. PUBLISHER: Ink Publishing. CLIENT: United Airlines. ISSUE: October 2009. CATEGORY: Photo: Cover, Entire Issue, Single/Spread or Story

573 *Intelligence Report*

DESIGN DIRECTOR: Russell Estes. DESIGNER: Michelle Leland. PHOTOGRAPHER: Jeff McIntosh/AP Images. PUBLISHER: Southern Poverty Law Center. ISSUE: May 29, 2009. CATEGORY: Photo: Cover, Entire Issue, Single/Spread or Story

575 *Ud & Se*

DESIGN DIRECTOR: Torsten Hogh Rasmussen. PHOTOGRAPHER: Kristian Sæderup. EDITOR-IN-CHIEF: Andreas Fugl Thøgersen. PUBLISHER: DSB. ISSUE: April 2009. CATEGORY: Photo: Cover, Entire Issue, Single/Spread or Story

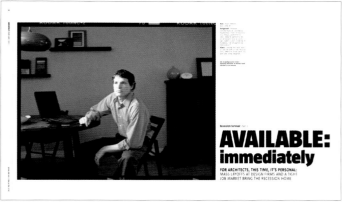

576

AVAILABLE: immediately

FOR ARCHITECTS, THIS TIME, IT'S PERSONAL: MASS LAYOFFS AT DESIGN FIRMS AND A TIGHT JOB MARKET BRING THE RECESSION HOME

576

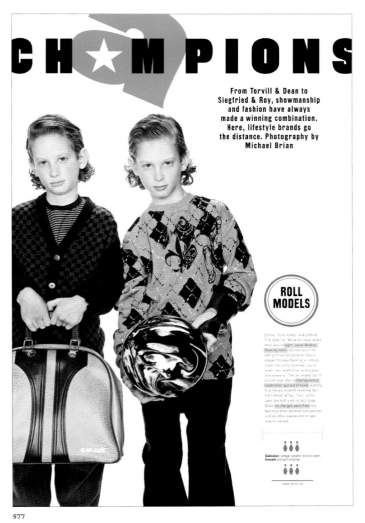

577

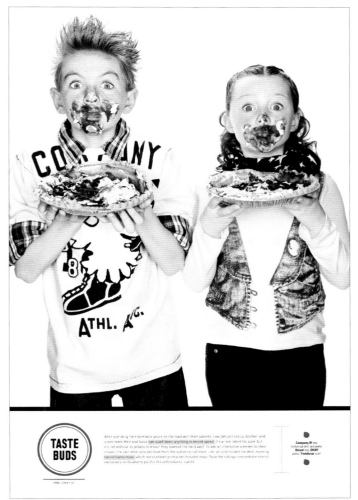

577

576 *Architect Magazine*

ART DIRECTOR: Aubrey Altmann. DESIGNER: Marcy Ryan.
PHOTOGRAPHER: Joe Pugliese. PUBLISHER: Hanley Wood.
ISSUE: FEBRUARY 2009. CATEGORY: Photo: Cover,
Entire Issue, Single/Spread or Story.

577 *Earnshaw's*

CREATIVE DIRECTOR: Nancy Campbell.
ART DIRECTOR: Trevett McCandliss. DESIGNER: Trevett McCandliss.
PHOTOGRAPHER: Michael Brian. EDITOR-IN-CHIEF: Caletha Crawford.
PUBLISHER: Symphony Publishing. ISSUE: April 2009.
CATEGORY: Photo: Cover, Entire Issue, Single/Spread or Story

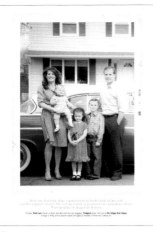

Once Upon a Time... doors were left **unlocked** and **kids** could be left unattended; "Gigi" was the **reigning** high school **musical** and the **hot** reality show was "**American Bandstand**." Jack and Jackie were the exciting young couple in the **White House** and **Lassie** was the pup that had **tongues** wagging; America's next top **model** was Twiggy **and** Sandra Dee was the **girl** next door; **Hula Hoops** and Frisbees made the **world** go 'round and **malt shops** were the center of the universe; moms gathered the **family** together for **dinner** every night and fathers knew best.

578

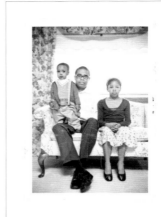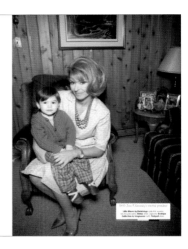

578

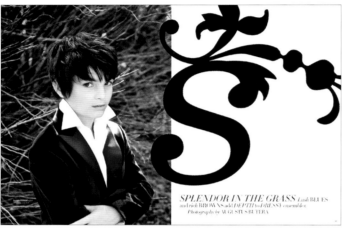

SPLENDOR IN THE GRASS Lush BLUES and rich BROWNS add DEPTH to DRESSY ensembles. *Photography by AUGUSTUS BUTERA*

579

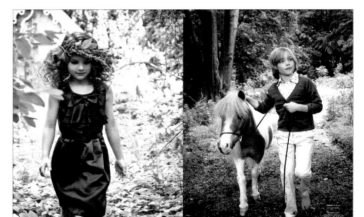

579

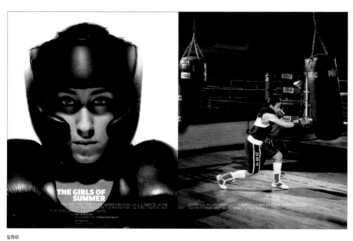

THE GIRLS OF SUMMER

580

580

578 _Earnshaw's_

CREATIVE DIRECTOR: Nancy Campbell. ART DIRECTOR: Trevett McCandliss. DESIGNER: Trevett McCandliss. PHOTOGRAPHER: Augustus Butera. EDITOR-IN-CHIEF: Caletha Crawford. PUBLISHER: Symphony Publishing. ISSUE: May 2009. CATEGORY: Photo: Cover, Entire Issue, Single/Spread or Story

579 _Earnshaw's_

CREATIVE DIRECTOR: Nancy Campbell. ART DIRECTOR: Trevett McCandliss. DESIGNER: Trevett McCandliss. PHOTOGRAPHER: Augustus Butera. EDITOR-IN-CHIEF: Caletha Crawford. PUBLISHER: Symphony Publishing. ISSUE: July 2009. CATEGORY: Photo: Cover, Entire Issue, Single/Spread or Story

580 _Hemispheres_

ART DIRECTOR: Rob Hewitt. DESIGNER: Rob Hewitt. PHOTO EDITOR: Erin Giunta. PHOTOGRAPHER: Thomas Chadwick. EDITOR-IN-CHIEF: Aaron Gell. PUBLISHER: Ink Publishing. ISSUE: December 2009. CATEGORY: Photo: Cover, Entire Issue, Single/Spread or Story

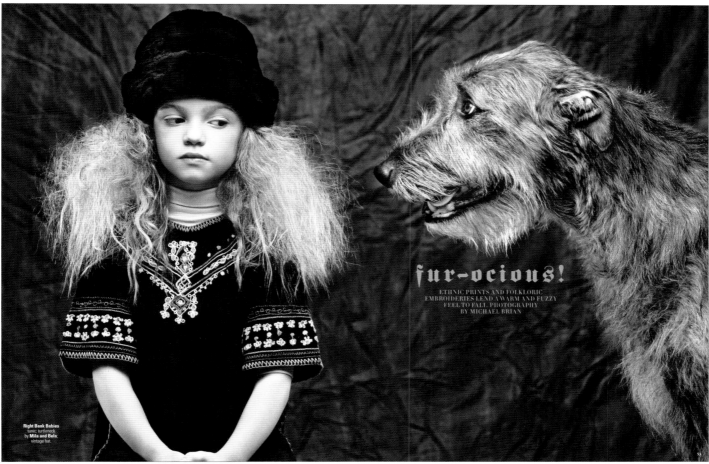

fur-ocious!

ETHNIC PRINTS AND FOLKLORIC
EMBROIDERIES LEND A WARM AND FUZZY
FEEL TO FALL PHOTOGRAPHY
BY MICHAEL BRIAN

Right Bank Babies
tunic, turtleneck
by **Mila and Bela**,
vintage hat.

581

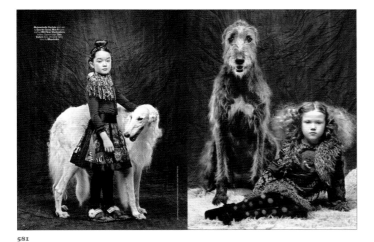

581

LESSONS *LEARNED*
How Shawn
Bergerson's experience
in prior convertible
routs *helped Waterstone
make money* in last
year's rocky market—
*& outperform its
peers today*

By Britt Erica Tunick Photographs by Darin Back

582

581 *Earnshaw's*

CREATIVE DIRECTOR: Nancy Campbell. ART DIRECTOR: Trevett
McCandliss. DESIGNER: Trevett McCandliss. PHOTOGRAPHER: Michael
Brian. PUBLISHER: Symphony Publishing. ISSUE: March 2009. CATEGORY:
Photo: Cover, Entire Issue, Single/Spread or Story

582 *Absolute Return*

ART DIRECTOR: Nathan Sinclair. DESIGNER: Nathan Sinclair. PHOTO
EDITOR: Katie Constans. PHOTOGRAPHER: Darin Back. ISSUE: October
2009. CATEGORY: PHOTO: Cover, Entire Issue, Single/Spread or Story

272

SECTION:
photography

AWARD
merit

CATEGORY
educational/institutional

* **
* COMPUTER REBORN////////// A GANG OF VETERAN ENGINEERS
* BREATHES NEW LIFE INTO THE HULK OF AN OLD MACHINE/////
* BY PHILIP E. ROSS//PHOTOS BY MARK RICHARDS//////////
* ===

583

MANY GOOD THINGS

from the good old days are gone—children playing outside, fruit that tastes better than it looks, luxurious air travel. But how could anyone get nostalgic about yesterday's big-iron computers, which were worse than today's handhelds by every measure?

"There's nothing like your first love," says Ed Thelen, a retired engineer who with 30-odd other people has restored a vintage IBM 1401 computer for the Computer History Museum, in Mountain View, Calif. "It's a mechanical machine: The tape machine has an air sensor, a little rubber diaphragm with contacts on it, and you can see it work. With these modern computers, it's just magic—they've got things a few nanometers long, and you'll never see them."

In the 1401's heyday, in the 1960s, some 9300 units were in use. Together with 6000-odd units of various successor models, by 1967 the 1400 line accounted for half of all the computers in the world. Companies used them mostly to sort things, notably for accounting, payroll, transaction analysis, and inventory control.

The machines have also had cultural resonance. The movie *Dr. Strangelove* (1964), a dark satire on nuclear war, showed a 1401 in one scene. The Icelandic composer Jóhann Jóhannsson wrote the orchestral work *IBM 1401: A User's Manual* (2006), which is available on iTunes.

The machine was a hit because it was simple and inexpensive. The 1401 processed numbers in decimal rather than binary form and accepted numbers of varying digit spans. Companies leased it for US $8600 a month, equivalent to $45 000 today—a bargain for an all-transistor design with stored programs. Such features had been offered only in huge systems costing about six times as much.

The museum got an even better bargain in 2003, when five enthusiasts gave it an old 1401 they'd bought on the

MY MIND IS
GOING, DAVE.

Robert Garner [left], head of the team that restored the IBM 1401, didn't know what a 1401 was when he volunteered to start the project in 2003. He stands next to the CPU, his arm on two tilted-out gates whose cards manage memory and storage. Ron Williams, in charge of the processor restoration, leans on the frame that holds the logic cards. A magnetic core memory [below], the rapid-access medium of the day, stored ones and zeroes in the magnetic fields of little "doughnuts" strung on crossing wires.

BACK TO THE FUTURE: An IBM 1401 system [left] filled a room. Its equivalent now fits in your hand. The CPU operator's panel [below] shows data lines linking registers, switches, and memory.

SEARCHING MEMORY.... SEARCHING...

IBM's 729 magnetic tape drive [left] was one of those iconic things that gave 1960s-era computer systems their look, sound, and feel. Its tape had seven tracks and spun faster than the eye could follow. Joe Preston [left] and Glenn Lea were customer engineers for IBM when the drive was still cutting-edge technology.

583

583 *IEEE Spectrum*

ART DIRECTORS: Mark Montgomery, Brandon Palacio. DESIGNER: Brandon Palacio. PHOTO EDITOR: Randi Silberman. PHOTOGRAPHER: Mark Richards. EDITOR-IN-CHIEF: Susan Hassler. PUBLISHER: IEEE. ISSUE: November 2009. CATEGORY: Photo: Cover, Entire Issue, Single/Spread or Story

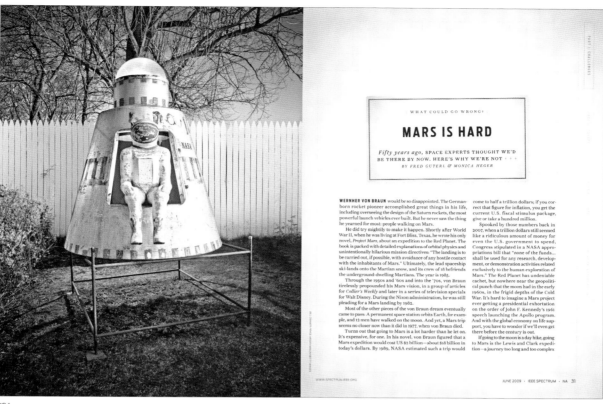

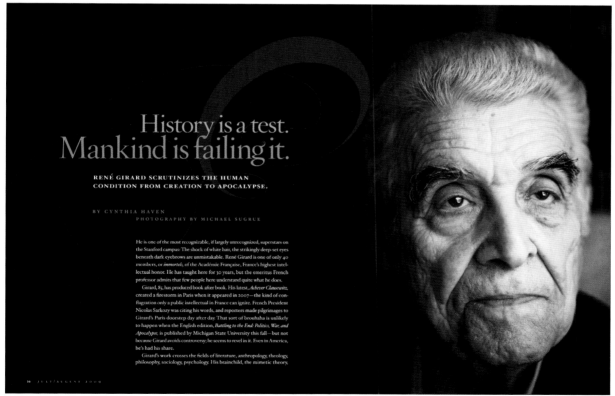

584 **IEEE Spectrum**

ART DIRECTORS: Mark Montgomery, Michael Solita. DESIGNER: Brandon Palacio. PHOTO EDITOR: Randi Silberman. PHOTOGRAPHERS: Bill Cramer, Megan Maloy. PUBLISHER: IEEE. ISSUE: June 2009. CATEGORY: Photo: Cover, Entire Issue, Single/Spread or Story

585 **Stanford Magazine**

ART DIRECTOR: Amy Shroads. ASSOCIATE ART DIRECTOR: Susan Scandrett. DESIGNER: Susan Scandrett. PHOTOGRAPHER: Mike Sugrue. EDITOR-IN-CHIEF: Kevin Cool. PUBLISHER: Stanford University. ISSUE: July/August 2009. CATEGORY: Photo: Cover, Entire Issue, Single/Spread or Story

274

SECTION:
photography

AWARD:
merit

CATEGORY:
photo-illustration

586

586

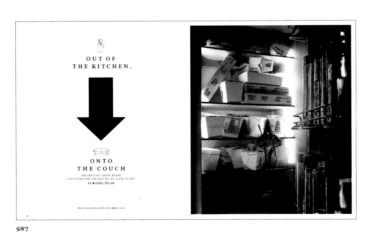

587

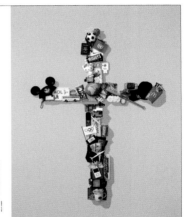

588

586 *Real Simple*

DESIGN DIRECTOR: Ellene Wundrok. ART DIRECTOR: Heath Brockwell. DIRECTOR OF PHOTOGRAPHY: Casey Tierney. PHOTO EDITOR: Susan Getzendanner. PHOTOGRAPHER: Monica Buck. PAPER CONSTRUCTIONIST: Matthew Sporzynski. PUBLISHER: Time Inc. ISSUE: April 2009. CATEGORY: Photo-Illustration: Single/Spread/Story

587 *The New York Times Magazine*

DESIGN DIRECTOR: Arem Duplessis. ART DIRECTOR: Gail Bichler. DEPUTY ART DIRECTOR: Leo Jung. DESIGNER: Leo Jung. ILLUSTRATOR: Erwin Olaf. DIRECTOR OF PHOTOGRAPHY: Kathy Ryan. PHOTO EDITOR: Luise Stauss. PHOTOGRAPHER: Erwin Olaf. PUBLISHER: The New York Times Company. ISSUE: August 2, 2009. CATEGORY: Photo-Illustration: Single/Spread/Story

588 *The Atlantic*

ART DIRECTOR: Jason Treat. DESIGNERS: Jason Treat, Melissa Bluey. PHOTO EDITOR: Katie Mathy. PHOTO-ILLUSTRATOR: Holly Lindem. EDITOR-IN-CHIEF: James Bennet. PUBLISHER: Atlantic Media Company. ISSUE: April 2009. CATEGORY: Photo-Illustration Single/Spread/Story

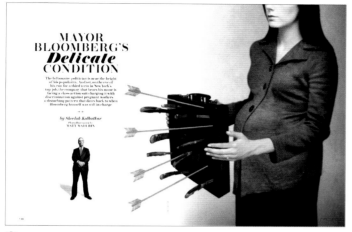

589

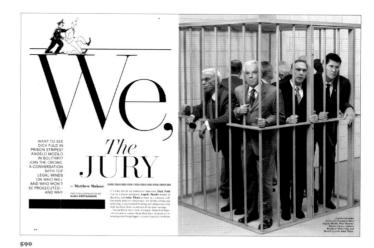

590

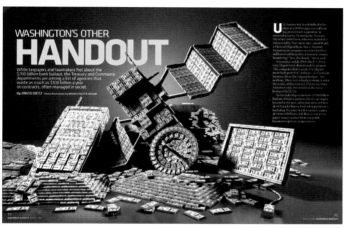

591

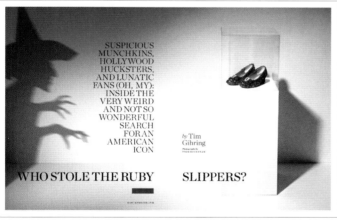

592

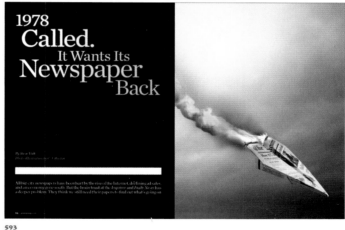

593

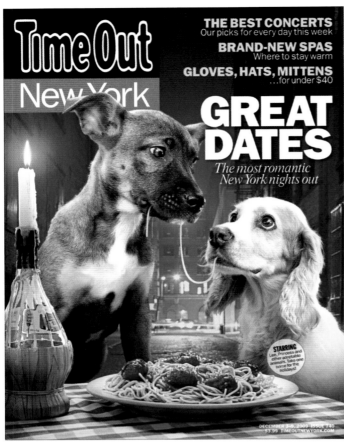

594

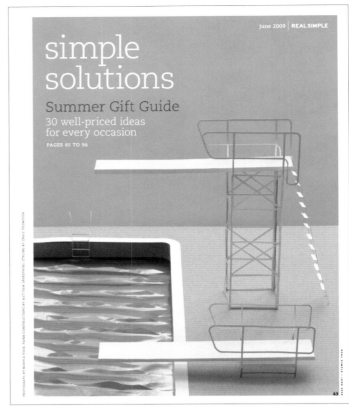

596

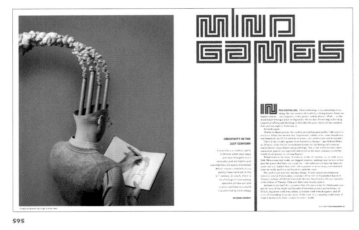

595

597

594 **Time Out New York**

DESIGN DIRECTOR: Adam Logan Fulrath. DIRECTOR OF
PHOTOGRAPHY: Roberto De Luna. PHOTOGRAPHER: Dale May.
PUBLISHER: Time Out New York Partners, L.P. ISSUE: December 3-9, 2009.
CATEGORY: Photo-Illustration: Single/Spread/Story

595 **UCLA Magazine**

DESIGN DIRECTOR: Charles Hess. DESIGNERS: Charles Hess, Alicia
Patel, Janet Park. PHOTO EDITOR: Charles Hess. PHOTOGRAPHER: Hugh
Kretschmer. STUDIO: Chess Design. EDITOR-IN-CHIEF: Jack Feuer.
PUBLISHER: UCLA. CLIENT: UCLA. ISSUE: July 2009. CATEGORY:
Photo-Illustration: Single/Spread/Story

596 **Real Simple**

CREATIVE DIRECTOR: Janet Froelich. DESIGN DIRECTOR:
Ellene Wundrok. ART DIRECTOR: Heath Brockwell. DIRECTOR OF
PHOTOGRAPHY: Casey Tierney. PHOTO EDITOR: Susan Getzendanner.
PHOTOGRAPHER: Monica Buck. PAPER CONSTRUCTIONIST: Matthew
Sporzynski. PUBLISHER: Time Inc. ISSUE: June 2009. CATEGORY: Photo-
Illustration: Single/Spread/Story

597 **Men's Journal**

CREATIVE DIRECTOR: Paul Martinez. DESIGNER: Paul Martinez.
DIRECTOR OF PHOTOGRAPHY: Michelle Wolfe.
PHOTO EDITOR: Jennifer Santana. PHOTOGRAPHER: Phillip Toledano.
PUBLISHER: Wenner Media LLC. ISSUES: January 2009. CATEGORY:
Photo-Illustration: Single/Spread/Story

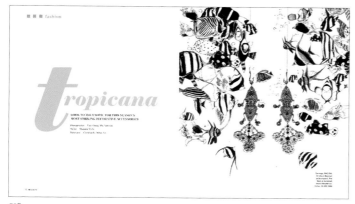

598

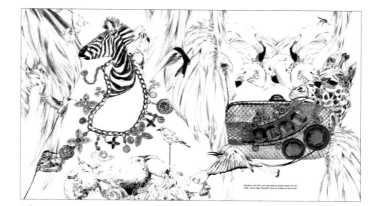

598

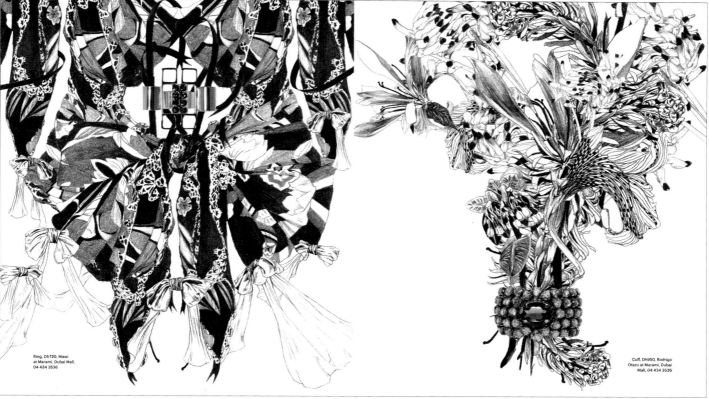

598

598 **M-The National Magazine**

ART DIRECTOR: Kerri Abrams.
ILLUSTRATOR: Christina K/début art.
DIRECTOR OF PHOTOGRAPHY: Clint McLean.
PHOTOGRAPHER: Tina Chang.
PUBLISHER: Abu Dhabi Media Company.
ISSUE: August 15, 2009.
CATEGORY: Photo-Illustration: Single/Spread/Story

Illustration

COVER *SPREAD OR SINGLE PAGE*
ENTIRE STORY

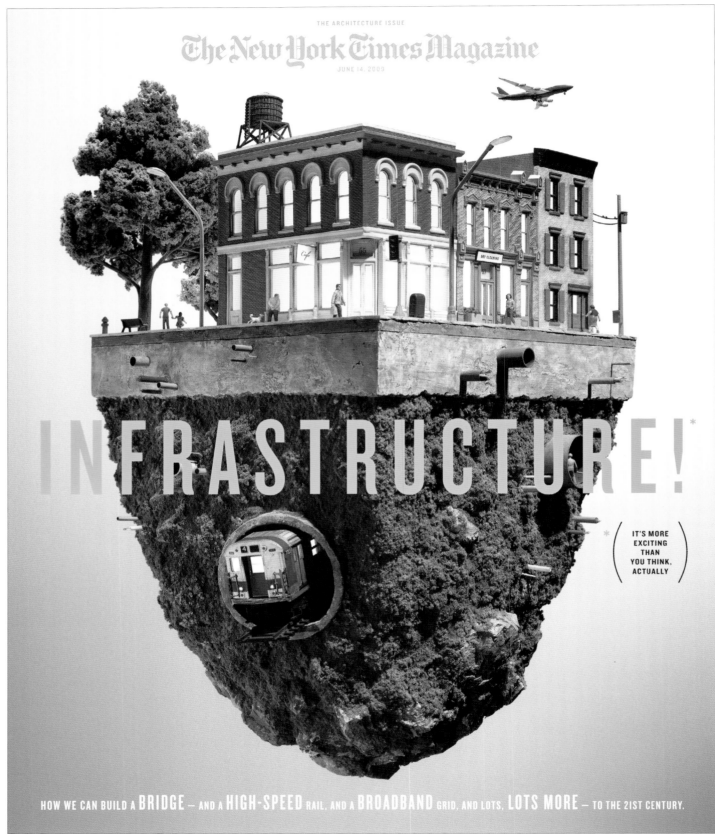

599 **The New York Times Magazine**

DESIGN DIRECTOR: Arem Duplessis. DEPUTY ART DIRECTOR: Gail Bichler. DESIGNER: Leo Jung. ILLUSTRATOR: Thomas Doyle.
DIRECTOR OF PHOTOGRAPHY: Kathy Ryan. PHOTO EDITOR: Luise Stauss. PHOTOGRAPHER: Tom Schierlitz.
PUBLISHER: The New York Times Company. ISSUE: June 14, 2009. CATEGORY: Illustration: Cover

SECTION:
illustration

AWARD:
gold

CATEGORY:
single/spread

281

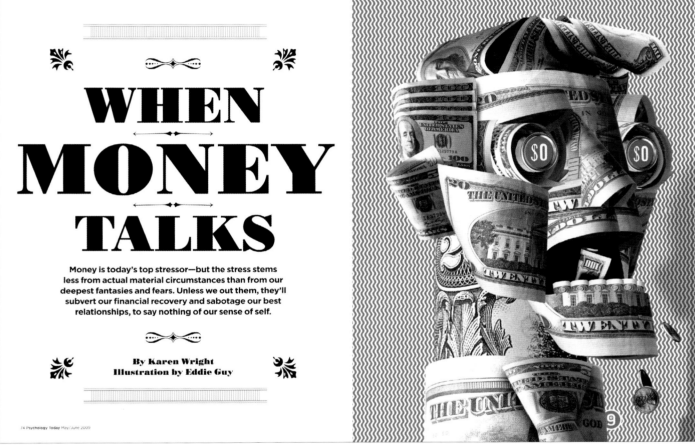

WHEN MONEY TALKS

Money is today's top stressor—but the stress stems less from actual material circumstances than from our deepest fantasies and fears. Unless we out them, they'll subvert our financial recovery and sabotage our best relationships, to say nothing of our sense of self.

By Karen Wright
Illustration by Eddie Guy

74 Psychology Today May/June 2009

600 **_Psychology Today_**

CREATIVE DIRECTOR: Edward Levine. ILLUSTRATOR: Eddie Guy. STUDIO: Levine Design Inc.
PUBLISHER: Sussex Publishers. ISSUE: May/June 2009. CATEGORY: Illustration: Single/Spread

MASTERS 2009 / GOLFDIGEST.COM / 27

/ **OUR GUEST** does **AUGUSTA** and offers
some **THOUGHTS** for chairman **BILLY PAYNE**
Illustrations by **MARK ULRIKSEN** /

FIRST
IMPRESSIONS

by

TOM BROKAW

601

601

601 **Golf Digest**

DESIGN DIRECTOR: Ken DeLago. DESIGNER: Ken DeLago. ILLUSTRATOR: Mark Ulriksen.
PUBLISHER: Condé Nast Publications Inc. ISSUE: April 2009. CATEGORY: Illustration: Story

SECTION:
illustration

AWARD:
silver

CATEGORY:
cover

283

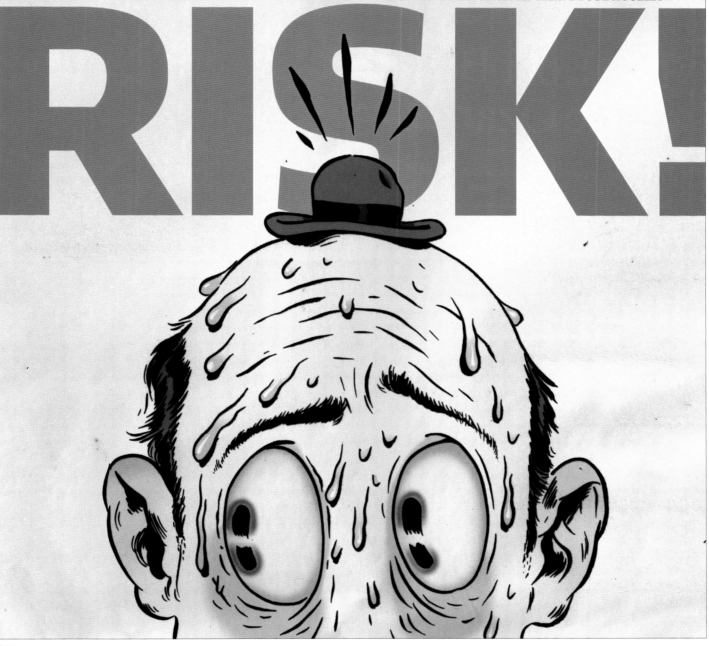

602 *The New York Times Magazine*

DESIGN DIRECTOR: Arem Duplessis. DEPUTY ART DIRECTOR: Gail Bichler. DESIGNER: Ian Allen.
ILLUSTRATOR: Zohar Lazar. PUBLISHER: The New York Times Company. ISSUE: January 4, 2009. CATEGORY: Illustration: Cover

next meeting is scheduled at 7 p.m on Thursday.

The Lost Boy of the Ozarks

After three decades of silence, a reporter reveals the story he was afraid to write.

By Neville Franks

GOODNIGHT HOLLOW, MO —A boy walked into the woods and no one worried. In those days, 5-year-olds skinned squirrels and giggled and a child could open a sow's throat with a single steady swipe. Before they were taught figures, daughters learned how to season steaming possum meat. Sons of slaves plowed the rocky soil and mothers bled to death in childbirth and if a little girl cut her finger, and the cut oozed green and the finger swelled, then her father measured the child and he started nailing together a tidy box of pine.

 In the hidden hollows of Missouri's Ozark Mountains, which is where the boy lived, times were hard. It was 1903 and the boy had just turned 8, but there was game to hunt, hogs to butcher, and there was no pine box or preacher or slab of limestone to

— Illustration by Tomer Hanuka —

603

603 **Backpacker**

DESIGN DIRECTOR: Matthew Bates. ILLUSTRATOR: Tomer Hanuka.
PUBLISHER: Active Interest Media. ISSUE: November 2009. CATEGORY: Illustration: Single/Spread

SECTION:
illustration

AWARD:
silver

CATEGORY:
cover

285

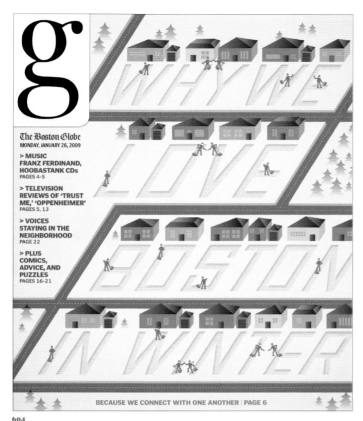

604

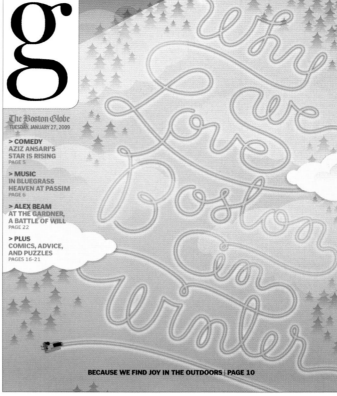

604

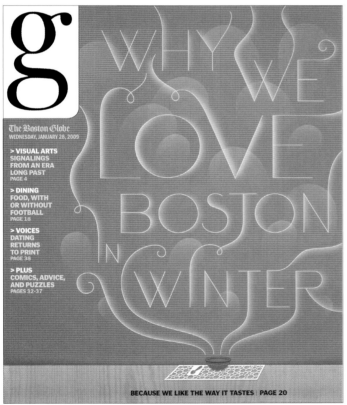

604

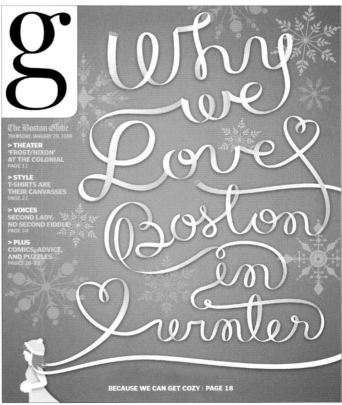

604

604 **The Boston Globe**

DESIGN DIRECTOR: Dan Zedek. ART DIRECTOR: Chin Wang. ILLUSTRATOR: Jessica Hische.
PUBLISHER: The New York Times Co. ISSUE: January 26–31, 2009. CATEGORY: Illustration: Story

SECTION:
illustration

AWARD:
merit

CATEGORY:
cover

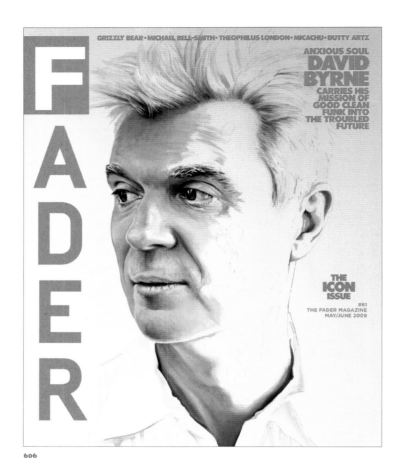

605

606

607

608

609

605 **Rolling Stone**

ART DIRECTOR: Joseph Hutchinson. DESIGNER: Joseph Hutchinson. ILLUSTRATOR: Tim O'Brien. PUBLISHER: Wenner Media. ISSUE: January 22, 2009. CATEGORY: Illustration: Cover

606 **The FADER**

CREATIVE DIRECTOR: Phil Bicker. DESIGNER: Phil Bicker. ILLUSTRATOR: Diego Gravinese. DIRECTOR OF PHOTOGRAPHY: Phil Bicker. PHOTOGRAPHER: Jason Nocito. PUBLISHER: The Fader, Inc. ISSUE: May/June 2009. CATEGORY: Illustration: Cover

607 **The New York Times Magazine**

DESIGN DIRECTOR: Arem Duplessis. ART DIRECTOR: Gail Bichler. ILLUSTRATOR: Ruth Gwily. PUBLISHER: The New York Times Company. ISSUE: December 6, 2009. CATEGORY: Illustration: Cover

608 **The New York Times Magazine**

DESIGN DIRECTOR: Arem Duplessis. ART DIRECTOR: Gail Bichler. DESIGNER: Leo Jung. ILLUSTRATOR: IC4 Design. PUBLISHER: The New York Times Company. ISSUE: June 14, 2009. CATEGORY: Illustration: Cover

609 **The New York Times Magazine**

DESIGN DIRECTOR: Arem Duplessis. ART DIRECTOR: Gail Bichler. DESIGNER: Cathy Gilmore-Barnes. ILLUSTRATOR: Heads of State. PUBLISHER: The New York Times Company. ISSUE: February 1, 2009. CATEGORY: Illustration: Cover

SECTION:
illustration

AWARD:
merit

CATEGORY:
cover

287

610

612

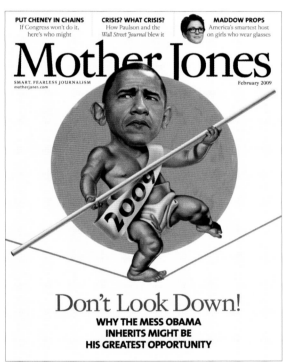

611

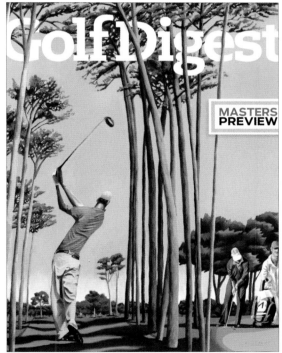

613

610 **Discover Presents Einstein**

CREATIVE DIRECTOR: Michael F. Di Ioia.
ART DIRECTOR: Erik B. Spooner. ILLUSTRATOR: Tim O'Brien.
DIRECTOR OF PHOTOGRAPHY: Rebecca Sky Horne.
PHOTO EDITOR: Randi Slatken.
EDITOR-IN-CHIEF: Corey S. Powell.
ISSUE: Spring 2009. CATEGORY: Illustration: Cover

611 **Mother Jones**

CREATIVE DIRECTOR: Tim J Luddy.
DESIGNER: Tim J Luddy. ILLUSTRATOR: Tim O'Brien.
PUBLISHER: The Foundation for National Progress.
ISSUE: January/February 2009.
CATEGORY: Illustration: Cover

612 **Black Ink**

CREATIVE DIRECTOR: Bernard Scharf.
DESIGN DIRECTOR: Adam Bookbinder.
ILLUSTRATOR: Leanne Shapton.
DIRECTOR OF PHOTOGRAPHY: Jessica Dimson.
PHOTO EDITORS: Michael Shome, Jill Krueger.
PUBLISHER: American Express Publishing.
ISSUE: Spring 2009. CATEGORY: Illustration: Cover

613 **Golf Digest**

DESIGN DIRECTOR: Ken DeLago.
DESIGNER: Ken DeLago. ILLUSTRATOR: Mark Ulriksen.
PUBLISHER: Condé Nast Publications Inc.
ISSUE: April 2009. CATEGORY: Illustration: Cover

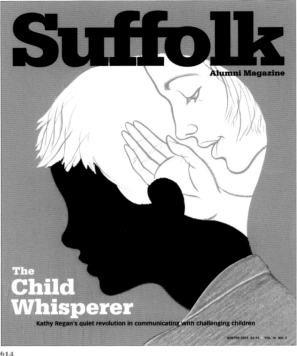

614

615

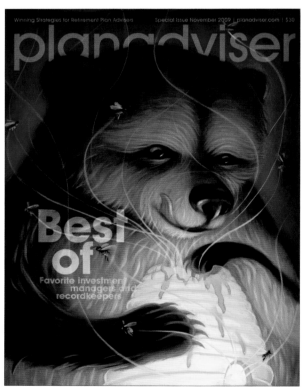

616

617

614 *Suffolk Alumni Magazine*

ART DIRECTOR: Kaajal Asher. ILLUSTRATOR: Alex Nabaum.
EDITOR-IN-CHIEF: Andy Levinsky. PUBLISHER: Suffolk University.
ISSUE: Winter 2009. CATEGORY: Illustration: Cover

615 *QUO*

CREATIVE DIRECTOR: Guillermo Caballero.
DESIGN DIRECTOR: Rodrigo Olmos. DESIGNER: Rodrigo Olmos.
ILLUSTRATOR: Luis Delfín. PHOTO EDITOR: Luis Delfín.
PHOTOGRAPHERS: Luis Delfín, Maximiliano Olvera.
EDITOR-IN-CHIEF: Iván Carillo. PUBLISHER: Grupo Editorial Expansión.
ISSUE: October 2009. CATEGORY: Illustration: Cover

616 *PLANADVISER Magazine*

CREATIVE DIRECTOR: SooJin Buzelli. ART DIRECTOR: SooJin Buzelli.
DESIGNER: Maynard Kay. ILLUSTRATOR: Chris Buzelli.
EDITOR-IN-CHIEF: Nevin Adams. PUBLISHER: Asset International.
ISSUE: November 2009. CATEGORY: Illustration: Cover

617 *Phoenix New Times*

DESIGN DIRECTOR: Michael Shavalier. ART DIRECTOR: Peter M. Storch.
DESIGNER: Jasmine Hobeheidar. ILLUSTRATOR: Jeff Foster.
EDITOR-IN-CHIEF: Rick Barrs. PUBLISHER: Village Voice Media.
ISSUE: May 14–20, 2009. CATEGORY: Illustration: Cover

SECTION:
illustration

AWARD:
merit

CATEGORY:
single/spread

289

618

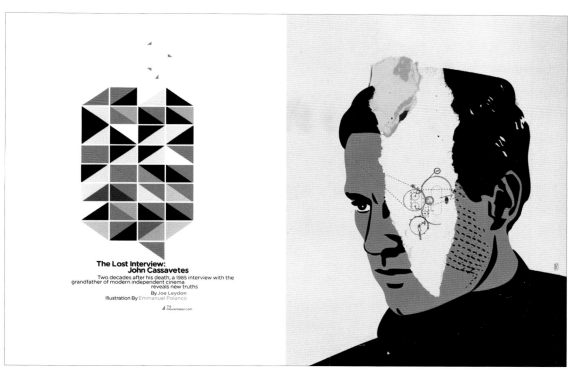

619

618 **_Moviemaker_**

ART DIRECTOR: Rob Hewitt. DESIGNER: Rob Hewitt.
ILLUSTRATOR: Augusto Giovanetti. STUDIO: Curious Outsider.
EDITOR-IN-CHIEF: Timothy E. Rhys.
PUBLISHER: Moviemaker LLC. CLIENT: Moviemaker.
ISSUE: Fall 2009. CATEGORY: Illustration: Single/Spread.

619 **_Moviemaker_**

ART DIRECTOR: Rob Hewitt. DESIGNER: Rob Hewitt.
ILLUSTRATOR: Emmanuel Polanco. STUDIO: Curious Outsider.
EDITOR-IN-CHIEF: Timothy E. Rhys.
PUBLISHER: Moviemaker LLC. CLIENT: Moviemaker.
ISSUE: Winter 2009. CATEGORY: Illustration: Single/Spread.

290

SECTION:
illustration

AWARD:
merit

CATEGORY:
single/spread

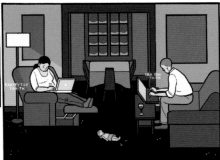

SECTION:
illustration

AWARD:
merit

CATEGORY:
single/spread

291

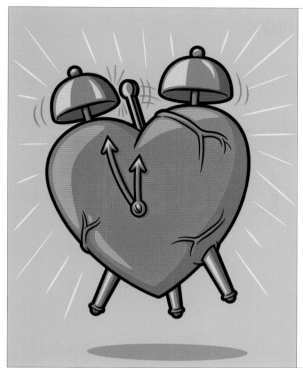

621

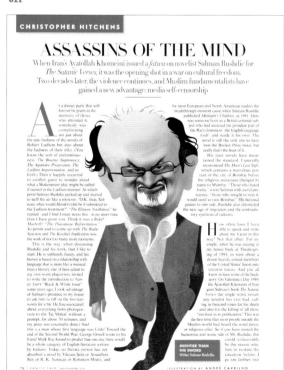

622

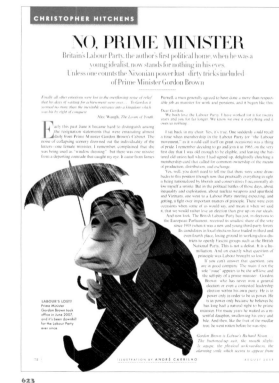

623

620 **WIRED**

CREATIVE DIRECTOR: Scott Dadich. DESIGN DIRECTOR: Wyatt
Mitchell. ILLUSTRATOR: Chris Ware. EDITOR-IN-CHIEF: Chris Anderson.
PUBLISHER: Condé Nast Publications, Inc. ISSUE: May 2009.
CATEGORY: Illustration: Single/Spread

621 **AARP Segunda Juventud**

ART DIRECTOR: Gina Toole Saunders. DESIGNER: Gina Toole Saunders.
ILLUSTRATOR: Christoph Niemann. PUBLISHER: AARP Publications.
ISSUE: Spring 2009. CATEGORY: Illustration: Single/Spread

622 **Vanity Fair**

DESIGN DIRECTOR: David Harris. ART DIRECTOR: Julie Weiss.
DESIGNER: Lee Ruelle. ILLUSTRATOR: André Carrilho.
DIRECTOR OF PHOTOGRAPHY: Susan White.
PUBLISHER: Condé Nast Publications Inc. ISSUE: February 2009.
CATEGORY: Illustration: Single/Spread

623 **Vanity Fair**

DESIGN DIRECTOR: David Harris. ART DIRECTOR: Julie Weiss.
ILLUSTRATOR: André Carrilho. DIRECTOR OF PHOTOGRAPHY:
Susan White. PUBLISHER: Condé Nast Publications Inc. ISSUE: August 2009.
CATEGORY: Illustration: Single/Spread

292

SECTION:
illustration

AWARD:
merit

CATEGORY:
single/spread

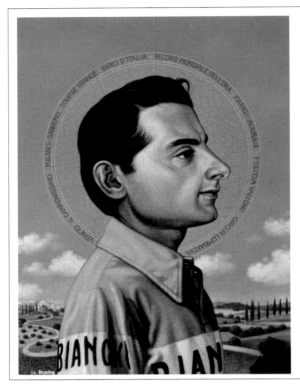
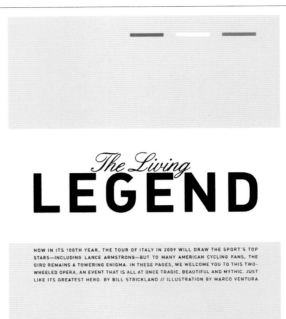

624

625

626

624 **Bicycling Magazine**

DESIGN DIRECTOR: David Speranza.
ART DIRECTOR: Erin Benner.
DESIGNER: Ashley Freeby.
ILLUSTRATOR: Marco Ventura.
DIRECTOR OF PHOTOGRAPHY: Stacey Emenecker.
PHOTO EDITOR: Kaitlin Marron.
PUBLISHER: Rodale.
ISSUE: June 2009.
CATEGORY: Illustration: Single/Spread

625 **Golf Digest**

DESIGN DIRECTOR: Ken DeLago.
DESIGNERS: Ken DeLago, Tim Oliver.
ILLUSTRATOR: Hanoch Piven.
PUBLISHER: Condé Nast Publications Inc.
ISSUE: February 2009.
CATEGORY: Illustration: Single/Spread

626 **Golf Digest**

DESIGN DIRECTOR: Ken DeLago.
DESIGNER: Ken DeLago.
ILLUSTRATOR: Karen Caldicott.
PUBLISHER: Condé Nast Publications Inc.
ISSUE: June 2009.
CATEGORY: Illustration: Single/Spread

SECTION:
illustration

AWARD:
merit

CATEGORY:
single/spread

293

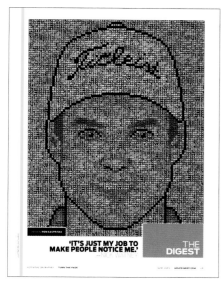

627

629

631

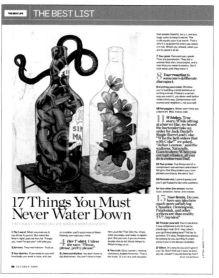
628

630

632

627 _Golf Digest_

DESIGN DIRECTOR: Ken DeLago.
DESIGNER: Marne Mayer.
ILLUSTRATOR: Quickhoney.
PUBLISHER: Condé Nast Publications Inc.
ISSUE: June 2009.
CATEGORY: Illustration: Single/Spread

628 _Men's Health_

DESIGN DIRECTOR: Brandon Kavulla.
ART DIRECTOR: Vikki Nestico.
DESIGNER: Ian Brown.
ILLUSTRATOR: Jason Holley.
DIRECTOR OF PHOTOGRAPHY: Brenda Milis.
PUBLISHER: Rodale Inc.
ISSUE: October 2009.
CATEGORY: Illustration: Single/Spread

629 _Fast Company_

ART DIRECTOR: Dean Markadakis.
DEPUTY ART DIRECTOR: Jana Meier Roberts.
ILLUSTRATOR: Ji Lee.
PUBLISHER: Mansueto Ventures, LLC.
ISSUE: May 2009.
CATEGORY: Illustration: Single/Spread

630 _AARP The Magazine_

DESIGN DIRECTOR: Robert Newman.
ART DIRECTORS: Todd Albertson, Dian Holton.
DESIGNER: Dian Holton.
ILLUSTRATOR: Roberto Parada.
DIRECTOR OF PHOTOGRAPHY: Quentin Nardi.
PUBLISHER: AARP Publications.
ISSUE: May/June 2009.
CATEGORY: Illustration: Single/Spread

631 _Mother Jones_

CREATIVE DIRECTOR: Tim J Luddy.
DESIGNER: Tim J Luddy.
ILLUSTRATOR: Steve Brodner.
PUBLISHER: The Foundation for National Progress.
ISSUE: January/February 2009.
CATEGORY: Illustration: Single/Spread

632 _AARP The Magazine_

DESIGN DIRECTOR: Robert Newman.
ART DIRECTORS: Todd Albertson, Dian Holton.
DESIGNER: Dian Holton.
ILLUSTRATOR: C.F. Payne.
DIRECTOR OF PHOTOGRAPHY: Quentin Nardi.
PUBLISHER: AARP Publications.
ISSUE: January/February 2009.
CATEGORY: Illustration: Single/Spread

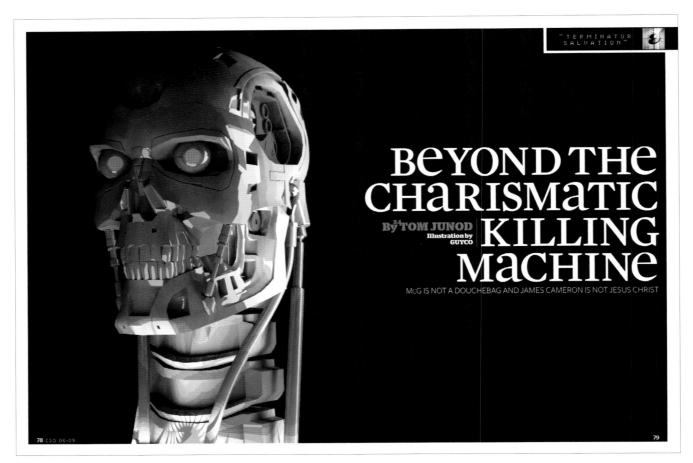

633

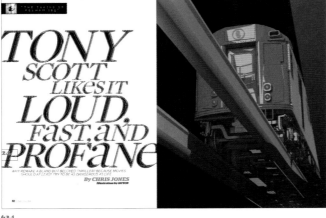

634

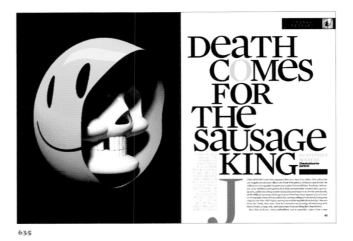

635

633 *Esquire*

DESIGN DIRECTOR: David Curcurito.
ART DIRECTOR: Darhil Crooks.
ILLUSTRATOR: GUYCO.
STUDIO: GUYCO STUDIO.
PUBLISHER: The Hearst Corporation-
Magazines Division.
ISSUE: June 2009.
CATEGORY: Illustration: Single/Spread

634 *Esquire*

DESIGN DIRECTOR: David Curcurito.
ART DIRECTOR: Darhil Crooks.
ILLUSTRATOR: GUYCO.
STUDIO: GUYCO STUDIO.
PUBLISHER: The Hearst Corporation-
Magazines Division.
ISSUE: June 2009.
CATEGORY: Illustration: Single/Spread

635 *Esquire*

DESIGN DIRECTOR: David Curcurito.
ART DIRECTOR: Darhil Crooks.
ILLUSTRATOR: GUYCO.
STUDIO: GUYCO STUDIO.
PUBLISHER: The Hearst Corporation-
Magazines Division.
ISSUE: June 2009.
CATEGORY: Illustration: Single/Spread

SECTION:
illustration

AWARD:
merit

CATEGORY:
single/spread

295

636

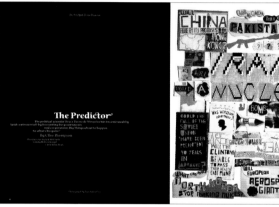

637

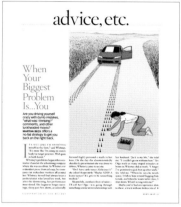

639

640

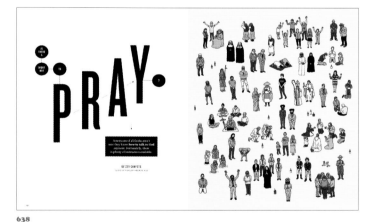

638

641

636 **_Mother Jones_**

CREATIVE DIRECTOR: Tim J Luddy.
ART DIRECTOR: Carolyn Perot.
DESIGNER: Carolyn Perot. ILLUSTRATOR: Jack Unruh.
PUBLISHER: The Foundation for National Progress.
ISSUE: September/October 2009.
CATEGORY: Illustration: Single/Spread.

637 **_The New York Times Magazine_**

DESIGN DIRECTOR: Arem Duplessis.
ART DIRECTOR: Gail Bichler. DESIGNER: Nancy
Harris Rouemy. ILLUSTRATORS: Ted McGrath,
Grady McFerrin, Christopher Silas Neal. DIRECTOR
OF PHOTOGRAPHY: Kathy Ryan. PHOTO EDITOR:
Clinton Cargill. PHOTOGRAPHER: Tom Schierlitz.
PUBLISHER: The New York Times Company.
ISSUE: August 16, 2009.
CATEGORY: Illustration: Single/Spread.

638 **_The New York Times Magazine_**

DESIGN DIRECTOR: Arem Duplessis.
ART DIRECTOR: Gail Bichler.
DESIGNER: Robert Vargas.
ILLUSTRATOR: Andrew Rae.
PUBLISHER: The New York Times Company.
ISSUE: September 20, 2009.
CATEGORY: Illustration: Single/Spread.

639 **_Mother Jones_**

CREATIVE DIRECTOR: Tim J Luddy.
DESIGNER: Tim J Luddy.
ILLUSTRATOR: Roberto Parada.
PUBLISHER: The Foundation for National Progress.
ISSUE: January/February 2009
CATEGORY: Illustration: Single/Spread.

640 **_O, The Oprah Magazine_**

DESIGN DIRECTOR: Kerry Robertson.
DESIGNER: Hervé Kwimo.
ILLUSTRATOR: Guy Billout.
PUBLISHER: The Hearst Corporation-
Magazines Division.
ISSUE: July 2009.
CATEGORY: Illustration: Single/Spread.

641 **_Psychology Today_**

CREATIVE DIRECTOR: Edward Levine.
ILLUSTRATOR: Zohar Lazar.
STUDIO: Levine Design Inc.
PUBLISHER: Sussex Publishers.
ISSUE: May/June 2009.
CATEGORY: Illustration: Single/Spread.

296

SECTION:
illustration

AWARD:
merit

CATEGORY:
single/spread

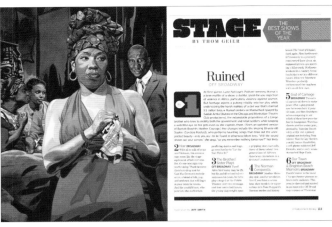

642

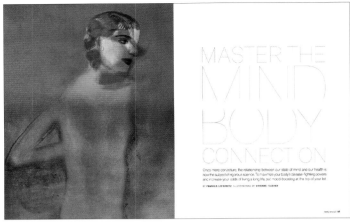
645

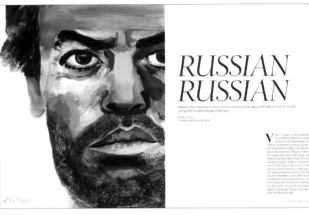
643

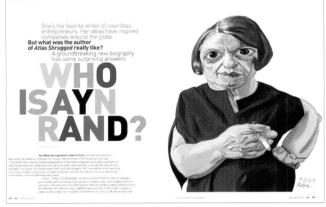
646

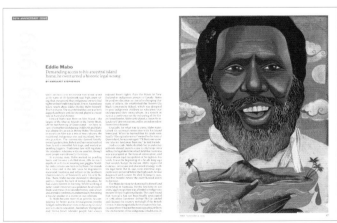
644

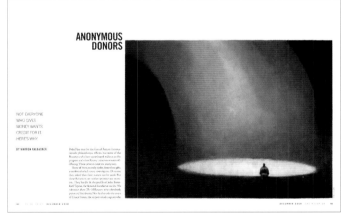
647

642 **Entertainment Weekly**

DESIGN DIRECTOR: Amid Capeci. DESIGNER: Michael Schnaidt.
ILLUSTRATOR: Jeff Smith. DIRECTOR OF PHOTOGRAPHY: Lisa Berman.
MANAGING EDITOR: Jess Cagle. PUBLISHER: Time Inc.
CATEGORY: Illustration: Single/Spread

643 **Listen: Life With Classical Music**

ART DIRECTORS: Alissa Levin, Benjamin Levine.
DESIGNER: Nathan Eames. ILLUSTRATOR: Demetrios Psillos.
STUDIO: Point Five Design. PUBLISHER: Arkivmusic.
CLIENT: Listen: Life With Classical Music. ISSUE: May/June 2009.
CATEGORY: Illustration: Single/Spread

644 **TIME Asia**

INTERNATIONAL ART DIRECTOR: Cecelia Wong.
ART DIRECTOR: May Wong. ILLUSTRATOR: Olaf Hajek.
EDITOR-IN-CHIEF: John Huey. PUBLISHER: Time Inc.
ISSUE: November 9, 2009. CATEGORY: Illustration: Single/Spread

645 **Body + Soul**

CREATIVE DIRECTOR: Eric A. Pike. DESIGN DIRECTOR: Matthew Axe.
ART DIRECTOR: Lauren Saunders. ILLUSTRATOR: Vivienne Flesher.
DIRECTOR OF PHOTOGRAPHY: Heloise Goodman.
PHOTO EDITOR: Erika Preuss. EDITOR-IN-CHIEF: Alanna Fincke.
PUBLISHER: Martha Stewart Living Omnimedia.
ISSUE: September 2009. CATEGORY: Illustration: Single/Spread

646 **Inc.**

CREATIVE DIRECTOR: Blake Taylor. ART DIRECTOR: Sarah Garcea.
ILLUSTRATOR: Phillip Burke. PUBLISHER: Mansueto Ventures.
ISSUE: November 2009. CATEGORY: Illustration: Single/Spread

647 **The Rotarian**

CREATIVE DIRECTOR: Deborah Lawrence. DESIGNER: Deborah Lawrence.
ILLUSTRATOR: Brad Holland. PUBLISHER: Rotary International.
ISSUE: December 2009. CATEGORY: Illustration: Single/Spread

SECTION:
illustration

AWARD:
merit

CATEGORY:
single/spread

297

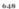

no regrets

As told to ESTHER HAYNES | Illustrated by ANDRE CARRILHO

Sophia Loren
ACTRESS AND
SEX SYMBOL

SOPHIA LOREN'S life reads like a fairy tale. She was born in the 1930s to a struggling single mother in Italy. At 14 she entered beauty contests and later helped support the family by posing for *fumetti*, or photo novels. A few Italian movie producers came calling, but because her earthy brand of beauty was not in fashion, she struggled a bit to break through. Once she did, she was huge, starring with two generations of leading men: Cary Grant, Frank Sinatra, Charlton Heston, Paul Newman, Marlon Brando. Now, at 75, she's appearing with Daniel Day-Lewis in the musical film *Nine*. Here, she remembers and laughs.

I don't regret...
...marrying someone 21 years older (producer Carlo Ponti, who died in 2007). I met my husband when I was fifteen-and-a-half. I was looking for somebody to be my father, because I didn't have one. I felt taken care of, and he taught me so many things—how to set the table and use your fork, this kind of thing—and little by little the sentiment grew. He was the right man at the right time.

...not marrying Cary Grant. Well, when I think about it, I do regret it! [Laughs] Cary was a wonderful person. He was very much in love with me, and I was really young—22 or 23—when I met him. And it was Cary Grant, you know? But I wanted to live in my country. Going to live in America would have changed my life completely.

...posing provocatively for a racy calendar when I was 71. It was so much fun! I was a bit afraid when they asked me. I said, "What kind of pictures?" because [Laughs] let's not joke. "No, no, no, they're classy photographers." So I said, "OK, let's do it." [She appeared in the well-regarded, limited-distribution Pirelli calendar.] It was very joyful. There was always also a kind of vanity in it, of course. But I loved it.

...eating a lot of pasta. I cannot live without eating spaghetti every day. ✦

170 more.com | DECEMBER 2009/JANUARY 2010

More
beauty
MIDLIFE BEAUTY
MASTERY

Ch-Ch-CHANGES!

PROBLEM | *Hot flashes are wrecking your looks*

A sudden *spike* in body temperature can *flatten* your blowout and *melt* your makeup—so *take notes* on these tips

HEAT-DEFYING MOVES
» **Keep your hairstyle simple** Getting a cut that works with your natural texture is your hair's best defense against hot flashes, says New York City salon owner Eva Scrivo. Why? You'll rely less on blow-drying, which can exacerbate or even initiate a hot flash. Plus, having a lower-maintenance do also means that if a hot flash leaves your locks frizzy or limp you can make repairs with your hands, as opposed to employing an arsenal of tools.
» **Dry until you're done** Committed to straight and smooth? Then make sure you dry your hair completely, Scrivo says. "If there's any water left in your hair when you heat up, your strands will revert to their natural texture and become frizzy." If your locks feel cool to the touch after drying, that means there's still water in the hair shafts. When your coif feels room temperature or warmer, you're good to go. »

58 more.com | SEPTEMBER 2009

ILLUSTRATED BY Serge Bloch

no regrets

As told to ESTHER HAYNES | Illustrated by HANOCH PIVEN

Joan Rivers
COMEDIAN/TV HOST/BUSINESSWOMAN
76

JOAN RIVERS has been making people laugh for more than four decades, from her early appearances on *The Tonight Show* to her years of greeting celebrities on the red carpet to her controversial quips on *The Celebrity Apprentice*, which she won this spring. And she's not done yet: Her latest show, TV Land's *How'd You Get So Rich?*, premiered last month. Here, she takes stock with a smile.

I don't regret...
...going into the male-dominated field of comedy. Comedy is the best thing in the world. It's a wonderful way to make a living. Only humans have the ability to laugh at themselves. You never see cows going, "Ooh, do the farmer! Do the farmer!"

...talking about unseemly things. My jokes aren't raunchy. Life is raunchy.

...having a lot of plastic surgery. It's wonderful that it's there for women. And people like to look at better-looking people. I would have loved for [my daughter] Melissa to have been a plastic surgeon. I would have saved a fortune!

...saying Mel Gibson should die. I think Gibson is despicable and crazy. I will never talk to him in a kitchen, because there's an oven in it. I'm afraid of what he might do. [Laughs]

...taking the job as host of *The Late Show* in 1986, going head-to-head with [friend] Johnny Carson. To be given your own show? Of course I don't regret it, but that was also one of the saddest things of my life. You know, you'd think when someone gets to the top, they become noncompetitive. Yet the minute I was a rival, he was there to kill me. That really taught me a lesson.

...critiquing other people's clothes as part of my career. Do you think if you made $20 million a movie you'd care whether I like you in green? I mean, get a grip!

...being on *The Celebrity Apprentice*. I loved proving that at my age I can beat all of you ✦

222 more.com | SEPTEMBER 2009

More } **finance**

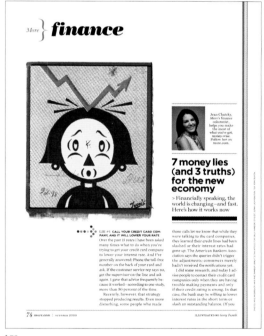

Jean Chatzky, *More's* finance columnist, helps you make the most of what you've got, money-wise. Follow her on more.com.

7 money lies (and 3 truths) for the new economy

> Financially speaking, the world is changing—and fast. Here's how it works now

LIE #1 CALL YOUR CREDIT CARD COMPANY, AND IT WILL LOWER YOUR RATE
Over the past 18 years I have been asked many times what to do when you're trying to get your credit card company to lower your interest rate. And I've generally answered: Phone the toll-free number on the back of your card and ask. If the customer service rep says no, get the supervisor on the line and ask again. I gave that advice frequently because it worked—according to one study, more than 50 percent of the time.

Recently, however, that strategy stopped producing results. Even more disturbing, some people who made those calls let me know that while they were talking to the card companies, they learned their credit lines had been slashed or their interest rates had gone up. The American Bankers Association says the queries didn't trigger the adjustments; consumers merely hadn't received the notifications yet.

I did some research, and today I advise people to contact their credit card companies only when they are having trouble making payments and only if their credit rating is strong. In that case, the bank may be willing to lower interest rates in the short term or slash an outstanding balance. (If you

74 more.com | OCTOBER 2009

ILLUSTRATED BY Gary Taxali

648 ***More***
CREATIVE DIRECTOR: Debra Bishop.
ART DIRECTOR: Claudia de Almeida. DESIGNER: Susanne Bamberger.
ILLUSTRATOR: André Carrilho. EDITOR-IN-CHIEF: Lesley Jane Seymour.
PUBLISHER: Meredith Corporation. ISSUE: December 2009/January 2010.
CATEGORY: Illustration: Single/Spread

649 ***More***
CREATIVE DIRECTOR: Debra Bishop.
ART DIRECTOR: Cybele Grandjean. DESIGNER: Cybele Grandjean.
ILLUSTRATOR: Hanoch Piven. EDITOR-IN-CHIEF: Lesley Jane Seymour.
PUBLISHER: Meredith Corporation. ISSUE: September 2009.
CATEGORY: Illustration: Single/Spread

650 ***More***
CREATIVE DIRECTOR: Debra Bishop.
ART DIRECTOR: Cybele Grandjean. DESIGNER: Jenn McManus.
ILLUSTRATOR: Serge Bloch. EDITOR-IN-CHIEF: Lesley Jane Seymour.
PUBLISHER: Meredith Corporation. ISSUE: September 2009.
CATEGORY: Illustration: Single/Spread

651 ***More***
CREATIVE DIRECTOR: Debra Bishop.
ART DIRECTOR: Cybele Grandjean. DESIGNER: Susanne Bamberger.
ILLUSTRATOR: Gary Taxali. EDITOR-IN-CHIEF: Lesley Jane Seymour.
PUBLISHER: Meredith Corporation. ISSUE: October 2009.
CATEGORY: Illustration: Single/Spread

298

SECTION:
illustration

AWARD:
merit

CATEGORY:
single/spread

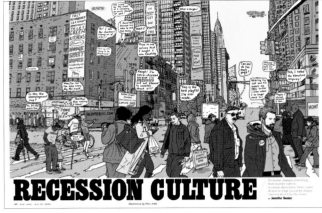

652

655

653

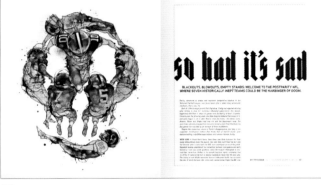

656

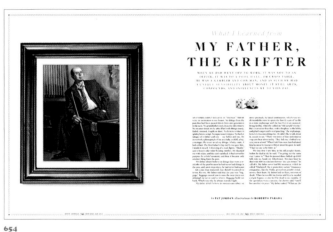

654

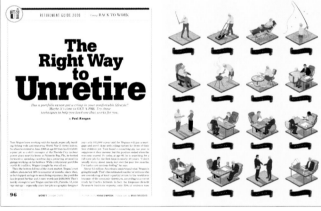

657

652 **New York**

DESIGN DIRECTOR: Chris Dixon.
ART DIRECTOR: Randy Minor. DESIGNER: Randy
Minor. ILLUSTRATORS: Jason Lee, Alice Chung
and Karen Hsu, Mark Korsak, Rodrigo Corral.
DIRECTOR OF PHOTOGRAPHY: Jody Quon.
EDITOR-IN-CHIEF: Adam Moss.
PUBLISHER: New York Magazine Holdings, LLC.
ISSUE: April 13, 2009.
CATEGORY: Illustration: Single/Spread

653 **ESPN The Magazine**

CREATIVE DIRECTOR: Siung Tjia.
ART DIRECTOR: Jason Lancaster.
ILLUSTRATOR: Alex Nabaum.
DIRECTOR OF PHOTOGRAPHY: Catriona Ni Aolain.
PUBLISHER: The Walt Disney Publishing Company.
ISSUE: December 14, 2009.
CATEGORY: Illustration: Single/Spread

654 **Men's Journal**

CREATIVE DIRECTOR: Paul Martinez.
ART DIRECTOR: Damian Wilkinson.
DESIGNER: Damian Wilkinson.
ILLUSTRATOR: Roberto Parada.
DIRECTOR OF PHOTOGRAPHY: Michelle Wolfe.
PUBLISHER: Wenner Media LLC.
ISSUE: December 2009/January 2010.
CATEGORY: Illustration: Single/Spread

655 **New York**

DESIGN DIRECTOR: Chris Dixon.
ART DIRECTOR: Randy Minor.
DESIGNER: Randy Minor. ILLUSTRATOR: Peter Arkle.
DIRECTOR OF PHOTOGRAPHY: Jody Quon.
EDITOR-IN-CHIEF: Adam Moss.
PUBLISHER: New York Magazine Holdings, LLC.
ISSUE: May 18, 2009.
CATEGORY: Illustration: Single/Spread

656 **ESPN The Magazine**

CREATIVE DIRECTOR: Siung Tjia.
ART DIRECTOR: Jason Lancaster.
ILLUSTRATOR: Andrew Zbihlyj.
DIRECTOR OF PHOTOGRAPHY: Catriona Ni Aolain.
PUBLISHER: The Walt Disney Publishing Company.
ISSUE: December 28, 2009.
CATEGORY: Illustration: Single/Spread

657 **Money**

DESIGN DIRECTOR: Kate Elazegui.
DESIGNER: April Bell.
ILLUSTRATOR: Adam Simpson.
PUBLISHER: Time Inc.
ISSUE: October 2009.
CATEGORY: Illustration: Single/Spread

SECTION:
illustration

AWARD:
merit

CATEGORY:
single/spread

299

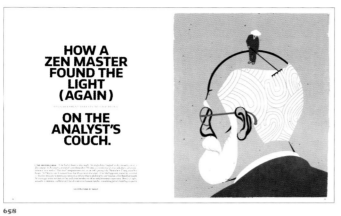

658

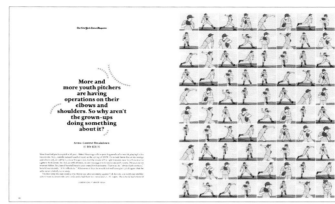

661

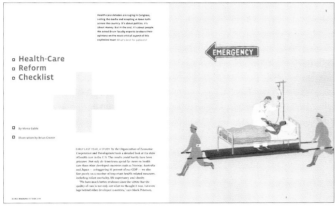

659

662

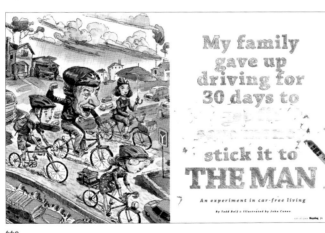

660

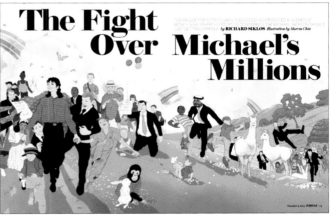

663

658 *The New York Times Magazine*

DESIGN DIRECTOR: Arem Duplessis.
DEPUTY ART DIRECTOR: Gail Bichler.
DESIGNER: Cathy Gilmore-Barnes.
ILLUSTRATOR: Shout.
PUBLISHER: The New York Times Company.
ISSUE: April 26, 2009.
CATEGORY: Illustration: Single/Spread

659 *UCLA Magazine*

DESIGN DIRECTOR: Charles Hess.
DESIGNERS: Charles Hess, Alicia Patel, Janet Park.
ILLUSTRATOR: Brian Cronin.
STUDIO: Chess Design.
EDITOR-IN-CHIEF: Jack Feuer.
PUBLISHER: UCLA.
CLIENT: UCLA.
ISSUE: October 2009.
CATEGORY: Illustration: Single/Spread

660 *Bicycling Magazine*

DESIGN DIRECTOR: David Speranza.
ART DIRECTOR: Erin Benner.
DESIGNER: Ashley Freeby.
ILLUSTRATOR: John Cuneo.
DIRECTOR OF PHOTOGRAPHY: Stacey Emenecker.
PHOTO EDITOR: Kaitlin Marron.
PUBLISHER: Rodale. ISSUE: August 2009.
CATEGORY: Illustration: Single/Spread

661 *The New York Times Magazine*

DESIGN DIRECTOR: Arem Duplessis.
ART DIRECTOR: Gail Bichler.
DESIGNER: Hilary Greenbaum.
ILLUSTRATOR: Marco Cibola.
PUBLISHER: The New York Times Company.
ISSUE: August 9, 2009.
CATEGORY: Illustration: Single/Spread

662 *New York*

DESIGN DIRECTOR: Chris Dixon.
ART DIRECTOR: Randy Minor.
DESIGNER: Stevie Remsberg.
ILLUSTRATOR: Jack Unruh
DIRECTOR OF PHOTOGRAPHY: Jody Quon.
EDITOR-IN-CHIEF: Adam Moss.
PUBLISHER: New York Magazine Holdings, LLC.
ISSUE: October 26, 2009.
CATEGORY: Illustration: Single/Spread

663 *Fortune*

CREATIVE DIRECTOR: John Korpics.
ART DIRECTOR: Deanna Lowe.
DESIGNER: Pete Sucheski.
ILLUSTRATOR: Marcos Chin.
PUBLISHER: Time Inc.
ISSUE: November 9, 2009.
CATEGORY: Illustration: Single/Spread

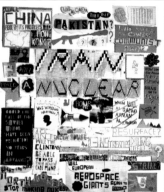

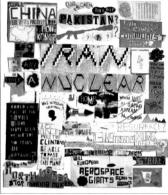

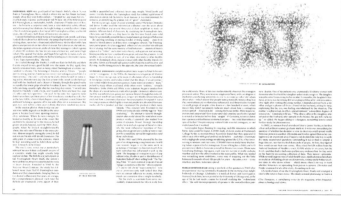

664 **The New York Times Magazine**
DESIGN DIRECTOR: Arem Duplessis.
ART DIRECTOR: Gail Bichler.
DESIGNER: Ian Allen.
ILLUSTRATORS: Zohar Lazar, Christoph Niemann,
Brian Cronin, Adrian Tomine, Gary Taxali,
Seth, Ronald Kurniawan.
PUBLISHER: The New York Times Company.
ISSUE: January 4, 2009.
CATEGORY: Illustration: Story

665 **The New York Times Magazine**
DESIGN DIRECTOR: Arem Duplessis.
ART DIRECTOR: Gail Bichler.
DESIGNER: Nancy Harris Rouemy.
ILLUSTRATORS: Ted McGrath,
Grady McFerrin, Christopher Silas Neal.
DIRECTOR OF PHOTOGRAPHY: Kathy Ryan.
PHOTO EDITOR: Clinton Cargill.
PHOTOGRAPHER: Tom Schierlitz.
PUBLISHER: The New York Times Company.
ISSUE: August 16, 2009. CATEGORY: Illustration: Story

666 **The New York Times Magazine**
DESIGN DIRECTOR: Arem Duplessis.
ART DIRECTOR: Gail Bichler.
DESIGNER: Gail Bichler.
PHOTOGRAPHERS: Carin Goldberg, Julia Hasting,
Catalogtree, Nomoco, Shout, Rumors.
PUBLISHER: The New York Times Company.
ISSUE: September 13, 2009
CATEGORY: Illustration: Story

SECTION:
illustration

AWARD:
merit

CATEGORY:
story

301

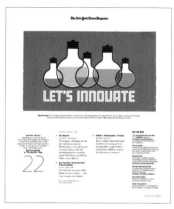

667

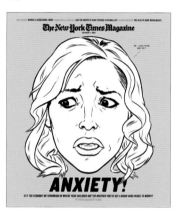

668

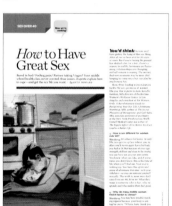

669

669

667 *The New York Times Magazine*

DESIGN DIRECTOR: Arem Duplessis.
DESIGNER: Cathy Gilmore-Barnes.
ILLUSTRATOR: Heads of State.
DEPUTY ART DIRECTOR: Gail Bichler.
PUBLISHER: The New York Times Company.
ISSUE: February 1, 2009.
CATEGORY: Illustration: Story

668 *The New York Times Magazine*

DESIGN DIRECTOR: Arem Duplessis.
ART DIRECTOR: Gail Bichler.
DESIGNERS: Gail Bichler, Leslie Kwok.
ILLUSTRATOR: Mickey Duzyj.
PUBLISHER: The New York Times Company.
ISSUE: October 4, 2009.
CATEGORY: Illustration: Story

669 *More*

CREATIVE DIRECTOR: Debra Bishop.
ART DIRECTOR: Jose G. Fernandez.
DESIGNER: Jose G. Fernandez.
ILLUSTRATOR: Zohar Lazar.
EDITOR-IN-CHIEF: Lesley Jane Seymour.
PUBLISHER: Meredith Corporation.
ISSUE: May 2009.
CATEGORY: Illustration: Story

302

SECTION:
illustration

AWARD:
merit

CATEGORY:
story

670

670

671

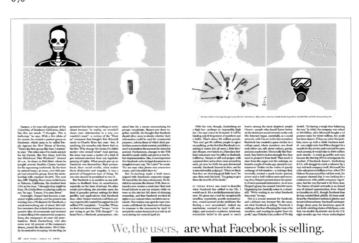

671

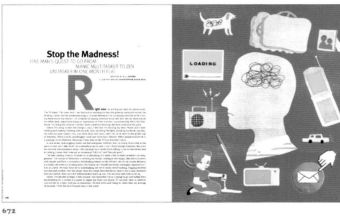

672

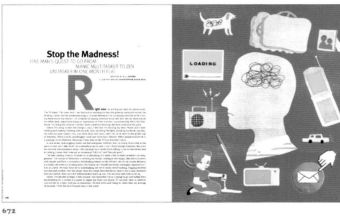

672

670 **O, The Oprah Magazine**

DESIGN DIRECTOR: Priest + Grace.
DESIGNERS: Robert Priest, Grace Lee.
ILLUSTRATOR: Brian Cronin.
DIRECTOR OF PHOTOGRAPHY: Katherine Schad.
PUBLISHER: The Hearst Corporation-
Magazines Division.
ISSUE: November 2009.
CATEGORY: Illustration: Story

671 **New York**

DESIGN DIRECTOR: Chris Dixon. ART DIRECTOR:
Randy Minor. DESIGNER: Randy Minor.
ILLUSTRATORS: Jason Lee, Karen Hsu and Alice Chung,
Mark Korsak, Rodrigo Corral, Alan Dye, Alpha Lubicz,
Jennifer Daniel, Serge Bloch, Michael Gibbs, Seth Labenz
and Roy Rub, Debra Bishop.
DIRECTOR OF PHOTOGRAPHY: Jody Quon.
EDITOR-IN-CHIEF: Adam Moss.
PUBLISHER: New York Magazine Holdings, LLC.
ISSUE: April 13, 2009. CATEGORY: Illustration: Story

672 **Real Simple**

CREATIVE DIRECTOR: Janet Froelich.
DESIGN DIRECTOR: Ellene Wundrok.
DESIGNER: Ellene Wundrok.
PHOTOGRAPHER: Christopher Silas Neal.
PUBLISHER: Time Inc.
ISSUE: September 2009.
CATEGORY: Illustration: Story

SECTION:
illustration

AWARD:
merit

CATEGORY:
story

303

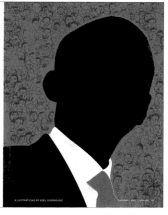

673

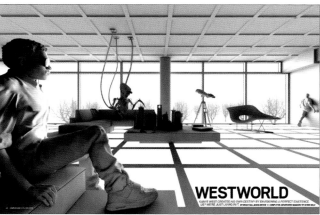

674

675

673 **Essence**

CREATIVE DIRECTOR: Greg Monfries.
ART DIRECTOR: Rodney Trice.
ILLUSTRATOR: Edel Rodriquez.
ASSOCIATE PHOTO EDITOR: Tracey Woods.
PUBLISHER: Time Inc.
ISSUE: November 2009.
CATEGORY: Illustration: Story

674 **Complex**

DESIGN DIRECTOR: Tim Leong.
ILLUSTRATOR: Chris Milk.
PUBLISHER: Complex Media, Inc.
ISSUE: April/May 2009.
CATEGORY: Illustration: Story

675 **New York**

DESIGN DIRECTOR: Chris Dixon.
ART DIRECTOR: Randy Minor.
DESIGNER: Hitomi Sato
ILLUSTRATOR: Christoph Niemann.
DIRECTOR OF PHOTOGRAPHY: Jody Quon.
EDITOR-IN-CHIEF: Adam Moss.
PUBLISHER: New York Magazine Holdings, LLC.
ISSUE: November 16, 2009.
CATEGORY: Illustration: Story

304

SECTION:
illustration

AWARD:
merit

CATEGORY:
story

676

676

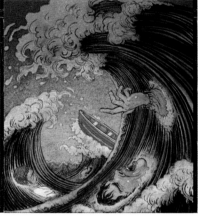

677

677

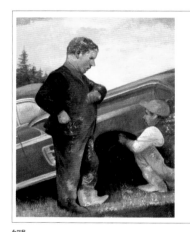

678

678

676 **Runner's World**

DESIGN DIRECTOR: Kory Kennedy.
DEPUTY ART DIRECTOR: Marc Kauffman
ASSISTANT ART DIRECTOR: Lee Williams.
ILLUSTRATOR: Edel Rodriguez.
PHOTO EDITOR: Andrea Maurio.
ASSOCIATE PHOTO EDITOR: Nick Galac.
ASSISTANT PHOTO EDITOR: Meg Hess.
PRODUCTION COORDINATOR: Carly Migliori.
PUBLISHER: Rodale Inc. ISSUE: August 2009.
CATEGORY: Illustration: Story

677 **Outdoor Life**

ART DIRECTOR: Jim Walsh.
DESIGNERS: Shayna Marchese, Allan Castro.
ILLUSTRATOR: Yuko Shimizu.
PHOTO EDITOR: Justin Appenzeller.
PUBLISHER: Bonnier.
ISSUE: March 2009.
CATEGORY: Illustration: Story

678 **Middlebury Magazine**

ART DIRECTOR: Pamela Fogg.
DESIGNER: Pamela Fogg.
ILLUSTRATOR: Gérard Dubois.
EDITOR: Matt Jennings.
PUBLISHER: Middlebury College.
ISSUE: Summer 2009.
CATEGORY: Illustration: Story

SECTION:
illustration

AWARD:
merit

CATEGORY:
story

305

679

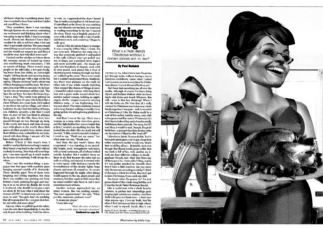

680

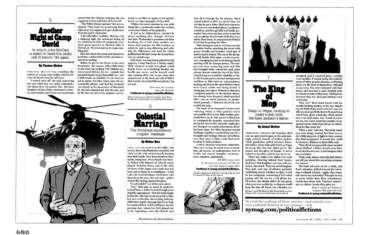

680

681

681

679 **More**

CREATIVE DIRECTOR: Debra Bishop.
ART DIRECTOR: Jose G. Fernandez.
DESIGNER: Jose G. Fernandez.
ILLUSTRATOR: Steve Brodner.
EDITOR-IN-CHIEF: Lesley Jane Seymour.
PUBLISHER: Meredith Corporation.
ISSUE: February 2009.
CATEGORY: Illustration: Story

680 **New York**

DESIGN DIRECTOR: Chris Dixon.
ART DIRECTOR: Randy Minor.
DESIGNER: Hitomi Sato.
ILLUSTRATORS: Andy Friedman, Eddie Guy,
Jeffrey Smith, Dan Goldman.
DIRECTOR OF PHOTOGRAPHY: Jody Quon.
PHOTOGRAPHER: Allison Jackson.
EDITOR-IN-CHIEF: Adam Moss.
PUBLISHER: New York Magazine Holdings, LLC.
ISSUE: November 30, 2009.
CATEGORY: Illustration: Story

681 **Golf Digest**

DESIGN DIRECTOR: Ken DeLago.
DESIGNER: Ken DeLago
ILLUSTRATOR: Dan Winters.
PUBLISHER: Condé Nast Publications Inc.
ISSUE: November 2009.
CATEGORY: Illustration: Story

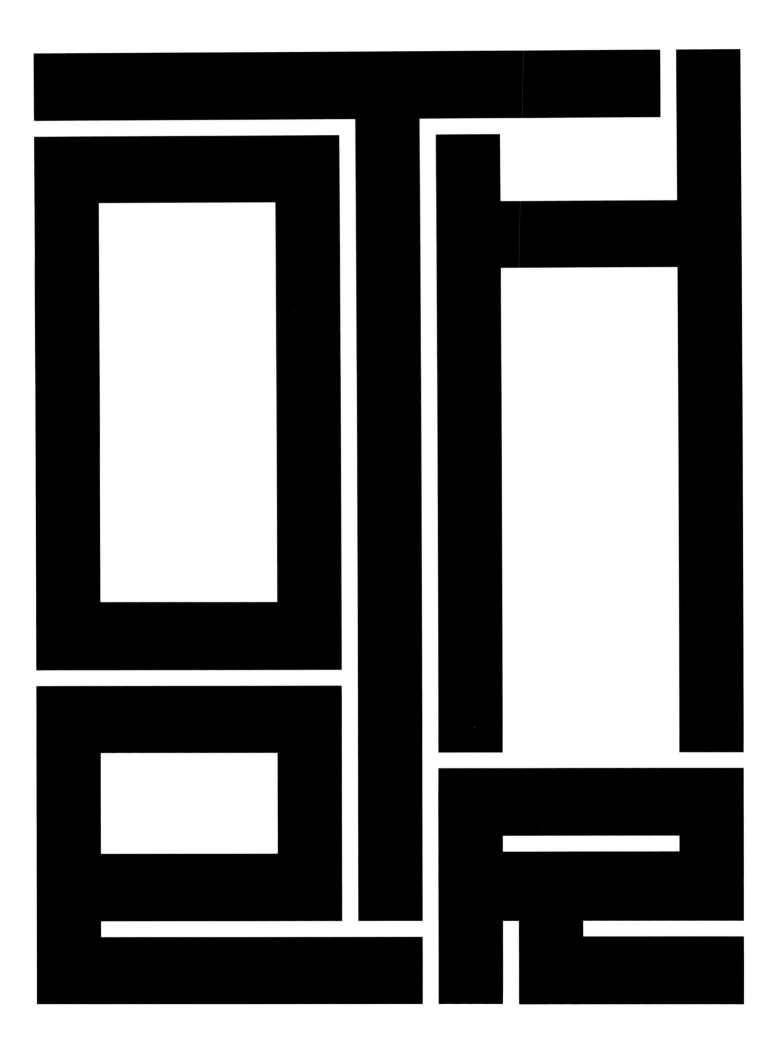

Infographics & Digital
GOLD MEDAL *SILVER MEDAL*
MERIT AWARD

308

SECTION:
infographics

AWARD:
gold

CATEGORY:
story

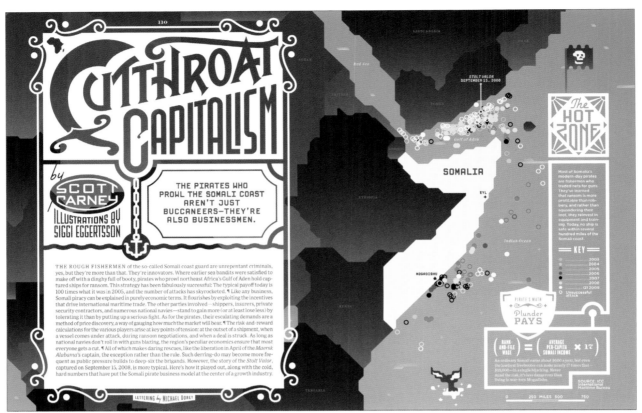

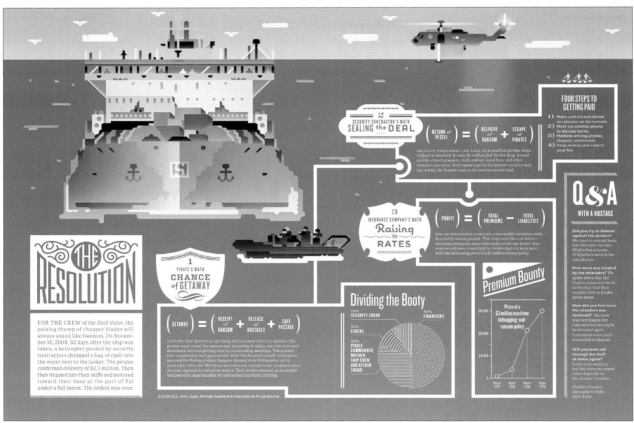

CREATIVE DIRECTOR: Scott Dadich. DESIGN DIRECTOR: Wyatt Mitchell. ART DIRECTOR: Maili Holiman.
DESIGNER: Maili Holiman. ILLUSTRATOR: Siggi Eggertsson. EDITOR-IN-CHIEF: Chris Anderson.
PUBLISHER: Condé Nast Publications, Inc. ISSUE: July 2009. CATEGORY: InfoGraphics: Single/Spread/Story.

SECTION:
infographics

AWARD:
silver

CATEGORY:
story

309

EDITED BY AMANDA KOLSON HURLEY
INFOGRAPHICS BY CATALOGTREE

THINK EVERY ARCHITECT IS ON BOARD TO FIGHT GLOBAL WARMING? **THINK AGAIN.**

A FEW YEARS AGO, the debate in the media and in academia over global warming took a different turn: It stopped being, well, much of a debate. In early 2007, the United Nations' Intergovernmental Panel on Climate Change reported that human activity was, with a likelihood above 90 percent, the main cause of rising temperatures. Just this year, a poll by two scientists indicated that 97.4 percent of climatologists believe human activity has driven global temperature changes. Clashes of opinion on this issue among experts, concluded pollsters Peter Doran and Maggie Kendall Zimmerman, are now "largely nonexistent."

And yet: According to a recent Gallup poll, only 58 percent of the general public is convinced that global warming is caused by man, which means that nearly half of us remain skeptical. We at ARCHITECT figured that, even as the profession espouses the mantra of sustainability, and despite the prominence of climate change–battling organizations like Architecture 2030, there must be some naysayers out there. Right?

In fact, we found more than we anticipated. Turn the page and see for yourself: 33 percent of the 960

design professionals we surveyed this summer said skepticism about climate change was "common" in their professional network, while nearly 13 percent answered that global warming was "a myth."

Surprised, we ran the results to two architect-activists, Edward Mazria of Architecture 2030 and Alexis Karolides of the Rocky Mountain Institute. Mazria took a decidedly glass-half-full view. "That over 70 percent of respondents are committed to or willing to build sustainable buildings is an incredible shift from just a couple of years ago," he commented by e-mail.

What about the architects who think global warming is a hoax—could too much talk about climate change turn them *off* green building? Mazria doesn't think so: "Those few ... risk missing out on one of the greatest economic opportunities in recent history."

Karolides points out that architects are hardwired to value efficiency in design, irrespective of their beliefs about global warming. Also, she notes, the issue might catalyze as many architects as it turns off, imparting urgency to the sustainable agenda. "It gets people motivated to do something," she says. Let's hope so.

SURPRISING SHADES OF GREEN

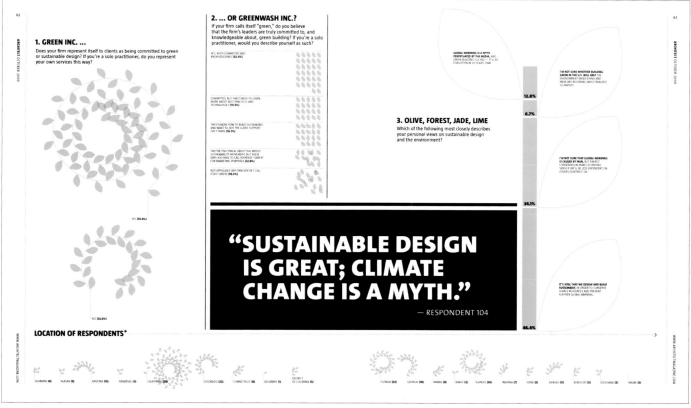

1. GREEN INC. ...

Does your firm represent itself to clients as being committed to green or sustainable design? If you're a solo practitioner, do you represent your own services this way?

2. ... OR GREENWASH INC.?

If your firm calls itself "green," do you believe that the firm's leaders are truly committed to, and knowledgeable about, green building? If you're a solo practitioner, would you describe yourself as such?

3. OLIVE, FOREST, JADE, LIME

Which of the following most closely describes your personal views on sustainable design and the environment?

"SUSTAINABLE DESIGN IS GREAT; CLIMATE CHANGE IS A MYTH."

— RESPONDENT 104

LOCATION OF RESPONDENTS*

683 *Architect*

ART DIRECTOR: Aubrey Altmann. DESIGNER: Marcy Ryan. ILLUSTRATOR: Catalogtree.
PUBLISHER: Hanley Wood. ISSUE: October 2009. CATEGORY: INFOGRAPHICS: Single/Spread/Story.

310

SECTION:
infographics

AWARD:
merit

CATEGORY:
single/spread/story

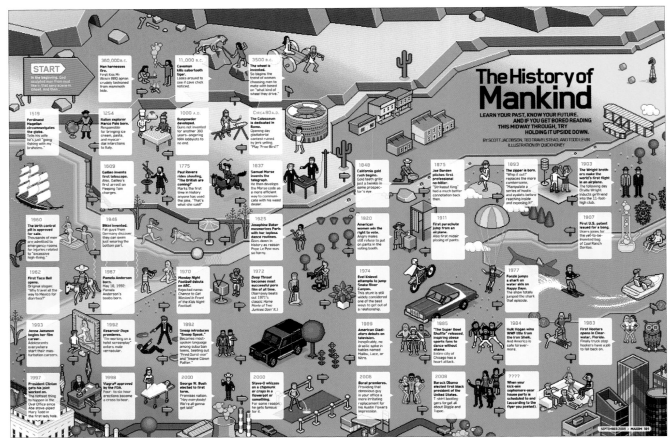

684

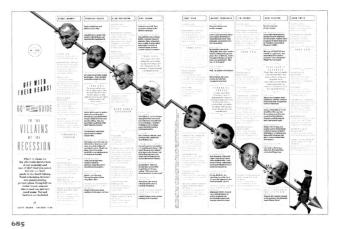

685

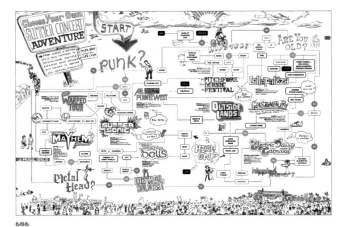

686

684 **Maxim**

CREATIVE DIRECTOR: Dirk Barnett.
DESIGNER: Sean Johnston.
ILLUSTRATOR: QuickHoney.
EDITOR-IN-CHIEF: Joe Levy.
PUBLISHER: Alpha Media Group.
ISSUE: September 2009.
CATEGORY: InfoGraphics: Single/Spread/Story.

685 **GQ**

DESIGN DIRECTOR: Fred Woodward.
DESIGNER: Anton Ioukhnovets.
DIRECTOR OF PHOTOGRAPHY: Dora Somosi.
PHOTO EDITOR: Jolanta Bielat.
PUBLISHER: Condé Nast Publications Inc.
ISSUE: April 2009.
CATEGORY: InfoGraphics: Single/Spread/Story.

686 **Maxim**

CREATIVE DIRECTOR: Dirk Barnett.
DESIGNER: Billy Sorrentino.
ILLUSTRATOR: Chelsea Cardinal.
EDITOR-IN-CHIEF: Joe Levy.
PUBLISHER: Alpha Media Group.
ISSUE: July 2009.
CATEGORY: InfoGraphics: Single/Spread/Story.

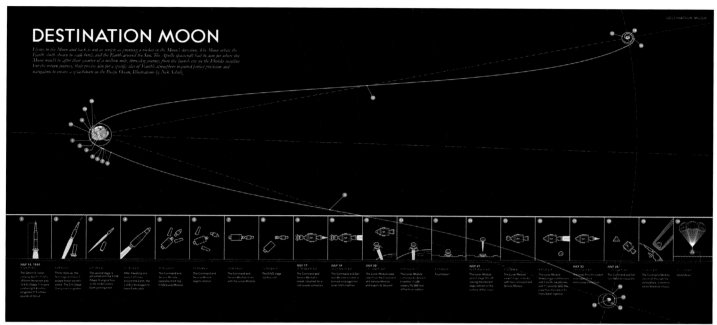

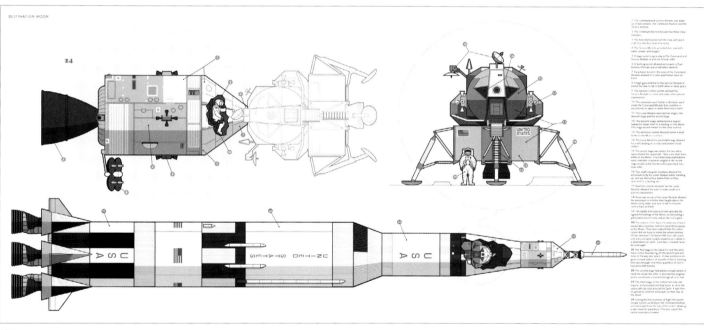

687 *Omega Lifetime*

CREATIVE DIRECTOR: Anders Peter Mejer.
DESIGNER: Anders Peter Mejer.
ILLUSTRATOR: Nik Schulz.
PHOTO EDITOR: Anders Peter Mejer.
STUDIO: Embryo Design.
PUBLISHER: Embryo Design.
CLIENT: Omega SA.
ISSUE: April 2009.
CATEGORY: InfoGraphics: Single/Spread/Story.

312

SECTION:
digital

AWARD:
gold

CATEGORY:
site of the year (without a print component)

689

CREATIVE DIRECTOR: Brian Ellis Martin. DESIGN DIRECTOR: Jennifer Louis. DESIGNERS: Kelly Byrom, Katherine Chase, Sophia Dengo, Matt Hunt, Ryan Kimball, David Muhlhausen, Bryan Perry, Rebecca Rolfe, Christian Sabyan, Matthew Suber, Ken Uzquiano. FRONT END DEVELOPERS: Charles Rawls, Philip Gurley, John Hilton, Michael Edmondson, Michelle Le, Wilson Sheldon, Steve Perkins, Darrell Stephenson, Miguel Garcia, Paul Borrego. USER EXPERIENCE: Toni Pashley, Lori Murphy, Michael Rodriguez, Karyn Lu, Jessica Elliott. STUDIO: HUGE. PUBLISHER: CNN. CATEGORY: Digital: Site of the Year (without a print component).

SECTION:
digital

AWARD:
gold

CATEGORY:
rich media/infographics

313

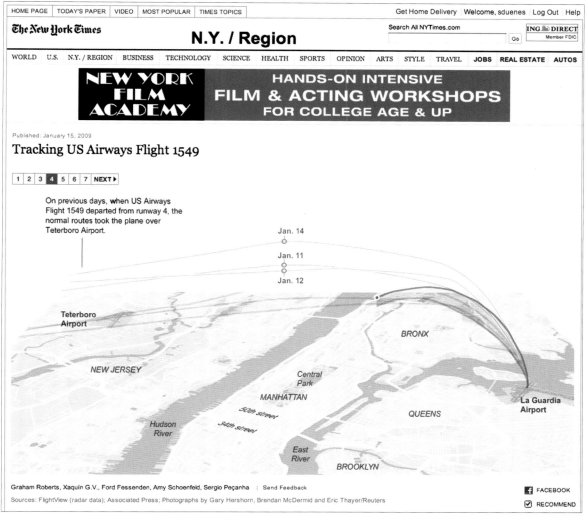

690

690

690

690 **The New York Times**

DESIGN DIRECTORS: Steve Duenes, Matthew Ericson. DESIGNERS: Graham Roberts, Xaquin G.V., Ford Fessenden, Amy Schoenfeld, Sergio Peçanha.
PUBLISHER: The New York Times. ISSUE: January 15, 2009. CATEGORY: Digital: Rich Media / Infographics.

SECTION:
digital

AWARD:
gold

CATEGORY:
site of the year (with print component)

691

691

691

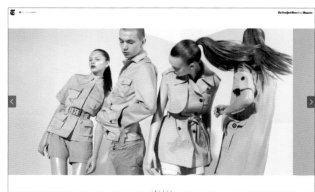

691

691 *T, The New York Times Style Magazine*

CREATIVE DIRECTOR: David Sebbah. ART DIRECTOR: Christopher Martinez. DESIGNER: Heena Ko.
PUBLISHER: The New York Times Company. CATEGORY: Digital: Site of the Year (with print component).

SECTION:
digital

AWARD:
silver

CATEGORY:
illustration

315

692 **CHOW.com**

CREATIVE DIRECTOR: Jeremy LaCroix DESIGNERS: Jackson Puff, Brenda Bitterlich. DIRECTOR OF PHOTOGRAPHY: Christopher Rochelle.
FRONT END DEVELOPERS: Marissa Marquez, Michael Downey. JAVA: Chris Sanborn. PUBLISHER: CBS Interactive.
ISSUE: November 2, 2009. CATEGORY: Digital: Illustration.

316

SECTION:
digital

AWARD:
merit

CATEGORY:
feature story package
site of the year (without a print component)
mobile app

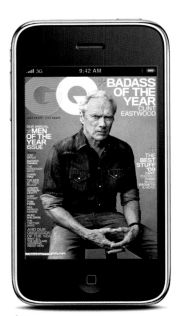

693

695

697

694

696

698

693 **The New York Times Magazine**

DESIGN DIRECTORS: Arem Duplessis, Khoi Vinh.
DESIGNERS: Gail Bichler, Hilary Greenbaum, Andrew
Kueneman, Leslie Kwok, Zach Wise. FRONT END
DEVELOPERS: Nicholas Barajas, Andrew Behrens,
Jon Chretien, Eitan Koningsburg, Noriaki Okada.
MULTIMEDIA EDITOR: Andrew DeVigal.
WEB PRODUCERS: Zahra Sthna, Monica Evanchick.
PUBLISHER: The New York Times Company.
ISSUE: December 10, 2009.
CATEGORY: Digital: Feature story package

694 **CHOW.com**

CREATIVE DIRECTOR: Jeremy LaCroix.
DESIGNERS: Jackson Puff, Brenda Bitterlich.
DIRECTOR OF PHOTOGRAPHY: Christopher Rochelle.
FRONT END DEVELOPERS: Marissa Marquez,
Michael Downey. JAVA: Chris Sanborn.
PUBLISHER: CBS Interactive.
CATEGORY: Digital: Site of the Year
(without a print component)

695 **CHOW.com**

CREATIVE DIRECTOR: Jeremy LaCroix.
DESIGNERS: Jackson Puff, Brenda Bitterlich.
DIRECTOR OF PHOTOGRAPHY: Christopher Rochelle.
FRONT END DEVELOPERS: Marissa Marquez,
Michael Downey. JAVA: Chris Sanborn.
PUBLISHER: CBS Interactive. ISSUE: June 26, 2009.
CATEGORY: Digital: Feature story package

696 **Details.com**

CREATIVE DIRECTORS: Rockwell Harwood,
Scott C. Irwin.
STUDIO: Condé Nast Digital.
PUBLISHER: Condé Nast Publications Inc.
CATEGORY: Digital: Site of the Year
(without a print component)

697 **GQ**

INTERACTION DESIGN DIRECTOR: Sean Brown.
SENIOR SOFTWARE ENGINEER: Robert Haining.
PUBLISHER: Condé Nast Digital.
CLIENT: GQ Magazine. ISSUE: December 2009.
CATEGORY: Digital: Mobile App

698 **Men's Health**

CREATIVE DIRECTOR: Matt Bean.
DESIGNERS: Wilbert G. Gutierrez, Chris Zimnowski.
PUBLISHER: Rodale Inc. ISSUE: July 2009.
CATEGORY: Digital: Mobile App

SECTION:
digital

AWARD:
merit

CATEGORY:
redesign
illustration
interactive tool

317

699

700

701

702

699 *CNN.com*

CREATIVE DIRECTOR: Brian Ellis Martin
DESIGN DIRECTOR: Jennifer Louis
DESIGNERS: Kelly Byrom, Katherine Chase, Sophia
Dengo, Matt Hunt, Ryan Kimball, David Mulhausen,
Bryan Perry, Rebecca Rolfe, Christian Sabyan, Matthew
Suber, Ken Uzquiano.
FRONT END DEVELOPERS: Charles Rawls, Philip
Gurley, John Hilton, Michael Edmondson, Michelle Le,
Wilson Sheldon, Steve Perkins, Darrell Stephenson,
Miguel Garcia, Paul Borrego.
USER EXPERIENCE: Toni Pashley, Lori Murphy,
Michael Rodriguez, Karyn Lu, Jessica Elliott.
STUDIO: HUGE.
PUBLISHER: CNN.
ISSUE: October 2009.
CATEGORY: Digital: Redesign

700 *T, The New York Times Style Magazine*

CREATIVE DIRECTOR: David Sebbah.
ART DIRECTOR: Christopher Martinez.
DESIGNER: Heena Ko.
PUBLISHER: The New York Times Company.
ISSUE: January 2009.
CATEGORY: Digital: Redesign

701 *The Village Voice*

DESIGN DIRECTOR: Ivylise Simones.
ART DIRECTOR: Jesus Diaz.
ILLUSTRATOR: Ward Sutton.
STUDIO: Ward Sutton Impact.
PUBLISHER: Village Voice Media.
ISSUE: September 9-15, 2009.
CATEGORY: Digital: Illustration

702 *Women's Health*

CREATIVE DIRECTOR: Eric Goeres.
DESIGNER: Dylan Assael.
ILLUSTRATOR: Yoco/Dutch Uncle.
PUBLISHER: Rodale Inc.
ISSUE: August 11, 2009.
CATEGORY: Digital: Interactive Tool

318

SECTION:
digital

AWARD:
merit

CATEGORY:
rich media/infographics

703

705

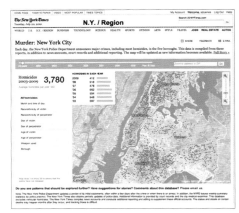

707

704

706

708

703 *The New York Times*

DESIGN DIRECTORS: Steve Duenes, Matthew Ericson.
DESIGNERS: Joe Ward, Xaquín G.V., Sergio Peçanha.
PUBLISHER: The New York Times.
ISSUE: June 25, 2009.
CATEGORY: Digital: Rich Media / Infographics

704 *The New York Times*

DESIGN DIRECTORS: Steve Duenes, Matthew Ericson.
DESIGNERS: Joe Ward, Xaquín G.V., Sergio Peçanha.
PUBLISHER: The New York Times.
ISSUE: August 31, 2009.
CATEGORY: Digital: Rich Media / Infographics

705 *The New York Times*

DESIGN DIRECTORS: Steve Duenes, Matthew Ericson.
DESIGNERS: Hannah Fairfield, Xaquín G.V., James
Glanz, Erin Aigner.
PUBLISHER: The New York Times.
ISSUE: June 23, 2009.
CATEGORY: Digital: Rich Media / Infographics

706 *The New York Times*

DESIGN DIRECTORS: Steve Duenes, Matthew Ericson.
DESIGNERS: Shan Carter, Amanda Cox, Kevin Quealy.
PUBLISHER: The New York Times.
ISSUE: November 6, 2009.
CATEGORY: Digital: Rich Media / Infographics

707 *NYSEmagazine.com*

CREATIVE DIRECTOR: John Godfrey.
DESIGN DIRECTOR: Syndi Becker.
ART DIRECTOR: Julia Michry.
DESIGNERS: Tommy McCall, Sarah Slobin.
PHOTO EDITOR: Victoria Rich.
FRONT END DEVELOPER: Tommy McCall.
PUBLISHER: Time Inc. Content Solutions.
ISSUE: August 2009.
CATEGORY: Digital: Rich Media / Infographics

708 *The New York Times*

DESIGN DIRECTORS: Steve Duenes, Matthew Ericson.
DESIGNERS: Matthew Bloch, Shan Carter, Tyson Evans,
Brian Hamman, Andrew W. Lehren, Angelica Madaglia,
Jo Craven McGinty. PUBLISHER: The New York Times.
ISSUE: November 3, 2009.
CATEGORY: Digital: Rich Media / Infographics

SECTION:
digital

AWARD:
merit

CATEGORY:
**video
photography**

319

709

711

710

712

713

714

709 *CHOW.com*

CREATIVE DIRECTOR: Jeremy LaCroix.
FRONT END DEVELOPERS: Chris Sanborn.
Video Team Meredith Arthur, Eric Slatkin, Blake Smith.
PUBLISHER: CBS Interactive.
ISSUE: April 22, 2009.
CATEGORY: Digital: Video

710 *T, The New York Times Style Magazine*

DIRECTOR OF PHOTOGRAPHY:
Judith Puckett-Rinella.
ONLINE DIRECTOR: Horacio Silva.
DIRECTOR: Greg Brunkalla
EDITOR: Lynn Hirschberg.
PUBLISHER: The New York Times Company.
ISSUE: October 18, 2009.
CATEGORY: Digital: Video

711 *CHOW.com*

CREATIVE DIRECTOR: Jeremy LaCroix.
FRONT END DEVELOPERS: Chris Sanborn.
VIDEO TEAM: Meredith Arthur, Eric Slatkin,
Blake Smith.
PUBLISHER: CBS Interactive.
ISSUE: August 10, 2009.
CATEGORY: Digital: Video

712 *T, The New York Times Style Magazine*

DIRECTOR OF PHOTOGRAPHY: Judith Puckett-Rinella.
ONLINE DIRECTOR: Horacio Silva.
DIRECTOR: Greg Brunkalla.
EDITOR: Lynn Hirschberg.
PUBLISHER: The New York Times Company.
ISSUE: August 16, 2009.
CATEGORY: Digital: Video

713 *The New York Times*

DESIGN DIRECTORS: Steve Duenes, Matthew Ericson.
DESIGNERS: Graham Roberts, Sergio Peçanha,
Alastair Macaulay.
PUBLISHER: The New York Times.
ISSUE: August 1, 2009.
CATEGORY: Digital: Video

714 *T, The New York Times Style Magazine*

CREATIVE DIRECTOR: David Sebbah.
ART DIRECTOR: Christopher Martinez.
DIRECTOR OF PHOTOGRAPHY: Kathy Ryan.
PHOTO EDITOR: Judith Puckett-Rinella.
PHOTOGRAPHER: Olaf Otto Becker.
PUBLISHER: The New York Times Company.
CATEGORY: Digital: Photography

Student Competition

& Spots Competition

322

SECTION:
student

AWARD:
merit

CATEGORY:
design

715

715

716

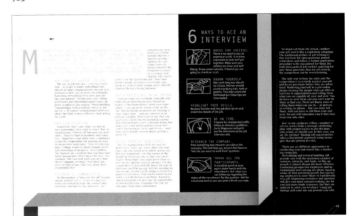

716

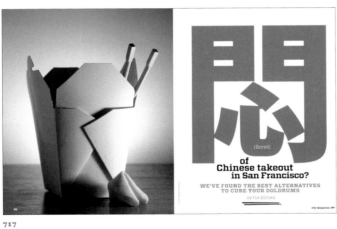

717

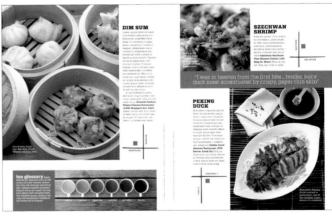

717

FIRST PLACE
715 Elliot Stokes

TITLE: How to Make Connections and
Network Like a Pro.
SCHOOL: The University of Georgia.
INSTRUCTOR: Julie Spivey.

SECOND PLACE
716 Kyle Lewis

TITLE: How to Stand Out Like a Pro.
SCHOOL: Ball State University.
INSTRUCTOR: Ryan J. Sparrow.

THIRD PLACE
717 Derek Eng

TITLE: Bored of Chinese Takeout in San Francisco?
SCHOOL: Ontario College of Art & Design.
INSTRUCTOR: Dominic Ayre.

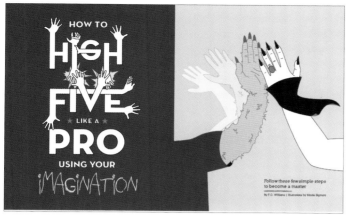

718

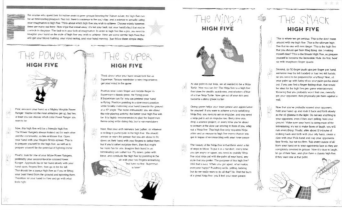

718

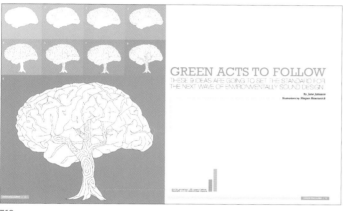

719

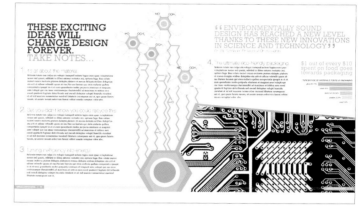

719

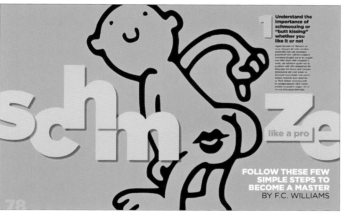

720

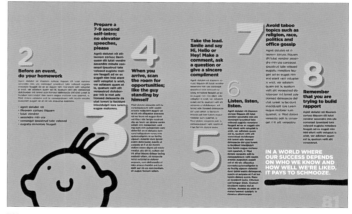

720

FIRST HONORABLE MENTION
718 Nicole Zigmont
TITLE: How to High Five Like A Pro.
SCHOOL: Rochester Institute of Technology.
INSTRUCTOR: Chris Lyons.
ILLUSTRATOR: Nicole Zigmont.

SECOND HONORABLE MENTION
719 Megan Hawranick
TITLE: Green Acts to Follow.
SCHOOL: Ohio University.
INSTRUCTOR: Julie M. Elman.

THIRD HONORABLE MENTION
720 Derek Eng
TITLE: Schmooze Like A Pro.
SCHOOL: Ontario College of Art & Design.
INSTRUCTOR: Dominic Ayre.

324

SECTION:
student

AWARD:
merit

CATEGORY:
photography

721

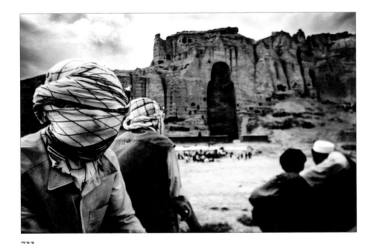

722

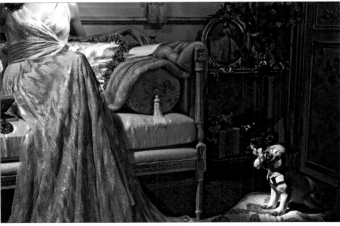

723

FIRST PLACE
721 Nathanael Turner

SCHOOL: Rochester Institute of Technology.
INSTRUCTOR: James Rajotte.

THIRD PLACE
723 Kelsey Wolf

SCHOOL: Messiah College.
INSTRUCTOR: Kathy Hettinga.

SECOND PLACE
722 Yusuke Suzuki

SCHOOL: New England School of Photography.
INSTRUCTOR: Luis Brens.

HONORABLE MENTION
724 Tatiana Gulenkina

SCHOOL: Maryland Institute College of Art.
INSTRUCTOR: Colette Veasey-Cullors.

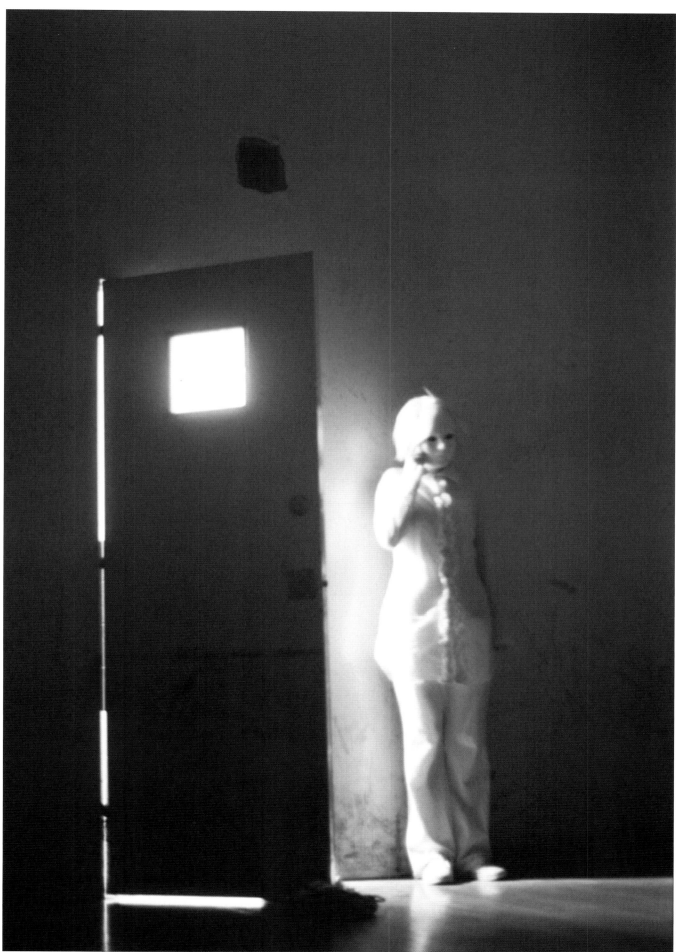

725

731

731

733

726

727

727

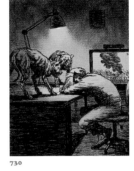

730

735

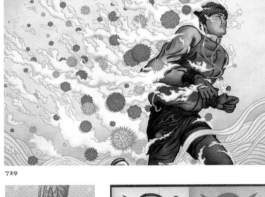

729

736

728

732

734

725 **Erik Sandberg**

TITLE: The Thin Man.
ART DIRECTOR: Erin Benner.
PUBLICATION: Bicycling Magazine.
PUBLISHER: Rodale.
ISSUE: August 2009

726 **Eddie Guy**

TITLE: 50 Thrifty Ideas.
ART DIRECTOR: Todd Albertson
PUBLICATION: AARP The Magazine
PUBLISHER: AARP Publications
ISSUE: May/June 2009

727 **Edel Rodriguez**

TITLE: My Father's Musical Lifeline.
CREATIVE DIRECTOR: Jill Armus.
PUBLICATION: Prevention.
PUBLISHER: Rodale. ISSUE: April 2009

728 **Edel Rodriguez**

TITLE: The Back-up Plan.
DESIGN DIRECTOR: Kory Kennedy.
PUBLICATION: Runner's World.
PUBLISHER: Rodale Inc.
ISSUE: August 2009

729 **Dongyun Lee**

TITLE: Ask the Experts.
DESIGN DIRECTOR: Kory Kennedy.
PUBLICATION: Runner's World.
PUBLISHER: Rodale Inc.
ISSUE: March 2009

730 **David Polonsky**

TITLE: The Bullets in My In-Box.
ART DIRECTOR: Aviva Michaelov.
PUBLICATION: The New York Times,
Week in Review.
PUBLISHER: The New York Times.
ISSUE: January 25, 2009

731 **Kim Rosen**

TITLE: No Need for Speed.
DESIGN DIRECTOR: Kory Kennedy.
PUBLICATION: Runner's World.
PUBLISHER: Rodale Inc.
ISSUE: Various 2009

732 **Carl Wiens**

TITLE: Security: Palm Vein Patterns.
ART DIRECTOR: Elizabeth Lankes.
PUBLICATION: Security Management.
PUBLISHER: ASIS Online.
ISSUE: February 2009

733 **David Plunkert**

TITLE: BRIC's Unbroken.
ART DIRECTOR: John Genzo.
PUBLICATION: Bloomberg Markets.
PUBLISHER: Bloomberg L.P.
ISSUE: January 9, 2009

734 **Gary Taxali**

TITLE: Children of the Corn.
CREATIVE DIRECTOR: Tim J Luddy.
PUBLICATION: Mother Jones.
PUBLISHER: The Foundation for
National Progress.
ISSUE: July/August 2009

735 **Gary Taxali**

TITLE: Should Meeting Content
Be Available to Anyone?
ART DIRECTORS: Mitch Shostak,
Roger Greiner. PUBLICATION: PCMA
Convene. PUBLISHER: Professional
Convention Management Association.
ISSUE: November 2009

736 **Gary Taxali**

TITLE: The Waver's Dilemma.
DESIGN DIRECTOR: Kory Kennedy.
PUBLICATION: Runner's World.
PUBLISHER: Rodale Inc.
ISSUE: February 2009

737

738

738

747

746

738

739

741

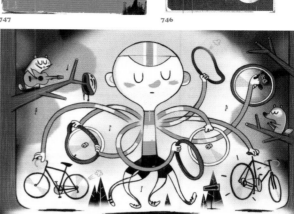

745

740

748

742

743

744

737 Joon Mo Kang

TITLE: Lessons the Teacher Forgot.
ART DIRECTOR: Aviva Michaelov.
PUBLICATION: The New York Times,
Week in Review. PUBLISHER: The New
York Times. ISSUE: May 17, 2009

738 Valero Doval

TITLE: Buzzwords 2009.
ART DIRECTOR: Kelly Doe.
PUBLICATION: The New York Times,
Week In Review. PUBLISHER: The New
York Times. ISSUE: December 20, 2009

739 Rodrigo Corral

TITLE: In the Wilderness, a New
Frontier. ART DIRECTORS: Leanne
Shapton, Kim Bost. PUBLICATION: The
New York Times, Op-Ed. PUBLISHER:
The New York Times Company.
ISSUE: November 17, 2009

740 Henrik Drescher

TITLE: Charles Darwin, Abolitionist.
ART DIRECTOR: Nicholas Blechman.
PUBLICATION: The New York Times,
Book Review.
PUBLISHER: The New York Times.
ISSUE: February 1, 2009

741 Jesse Lefkowitz

TITLE: Double Agency.
ART DIRECTOR: Nicholas Blechman.
PUBLICATION: The New York Times,
Book Review.
PUBLISHER: The New York Times.
ISSUE: Novmber 22, 2009

742 Serge Bloch

TITLE: Wine + Spirits.
ART DIRECTOR: Matthew Lenning.
PUBLICATION: Bon Appétit.
PUBLISHER: Condé Nast Publications,
Inc. ISSUE: November 2009

743 Steve Brodner

TITLE: Outrageous! Worst of America.
ART DIRECTOR: Hannu Lakso.
PUBLICATION: Reader's Digest.
PUBLISHER: Reader's Digest Association.
ISSUE: July 2009

744 João Fazenda

TITLE: Disturbing the Comfortable.
ART DIRECTOR: Nicholas Blechman.
PUBLICATION: The New York Times,
Book Review. PUBLISHER: The New
York Times. ISSUE: November 22, 2009

745 Leo Espinosa

TITLE: Fix a Flat.
DESIGN DIRECTOR: David Speranza.
PUBLICATION: Bicycling Magazine.
PUBLISHER: Rodale.
ISSUE: November 2009

746 The Heads of State

TITLE: Domestic Disturbances.
ART DIRECTOR: Nicholas Blechman.
PUBLICATION: The New York Times,
Book Review.
PUBLISHER: The New York Times.
ISSUE: March 15, 2009

747 The Heads of State

TITLE: Will Books Be Napsterized?.
ART DIRECTOR: Jennifer Daniel.
PUBLICATION: The New York Times,
Sunday Business.
ISSUE: October 4, 2009

748 Russell Charpentier

TITLE: Hybrid Preferreds —
Hybrid and Then Some.
ART DIRECTORS: Syndi Becker,
Julia Michry.
PUBLICATION: U. S. Trust.
PUBLISHER: Time Inc.
Content Solutions

749

750

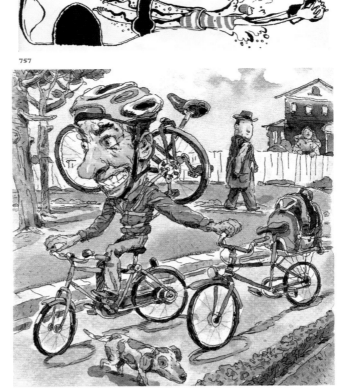

749

756

757

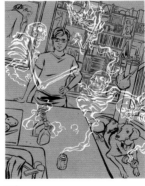

755

758

752

751

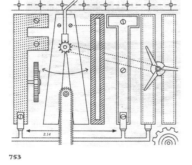

753

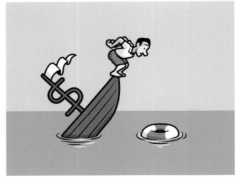

754

749 **John Cuneo**

TITLE: Car Free Living.
DESIGN DIRECTOR: David Speranza.
PUBLICATION: Bicycling Magazine.
PUBLISHER: Rodale.
ISSUE: August 2009

750 **John Cuneo**

TITLE: Bad Times for CEOs.
ART DIRECTOR: Steven Powell.
PUBLICATION: Stanford Business.
PUBLISHER: Stanford Graduate School of
Business. ISSUE: February 2009

751 **Jennifer Daniel**

TITLE: Zero Carbon Emissions.
ART DIRECTOR: Atley G. Kasky.
PUBLICATION: GOOD.is.
PUBLISHER: GOOD.
ISSUE: December 7, 2009

752 **Knickerbocker**

TITLE: Darkness on the Edge of
Monotown. ART DIRECTORS: Leanne
Shapton, Kim Bost. PUBLICATION:
The New York Times, Op-Ed.
PUBLISHER: The New York Times
Company. ISSUE: October 17, 2009

753 **Timothy Goodman**

TITLE: The God Gene.
ART DIRECTOR: Nicholas Blechman.
PUBLICATION: The New York Times,
Book Review. PUBLISHER: The New
York Times. ISSUE: December 27, 2009

754 **Christoph Niemann**

TITLE: When Bankruptcy is Smarter.
ART DIRECTOR: Dian Holton.
PUBLICATION: AARP The Magazine.
PUBLISHER: AARP Publications.
ISSUE: May/June 2009

755 **Christoph Niemann**

TITLE: RSVP.
ART DIRECTOR: Matthew Lenning.
PUBLICATION: Bon Appétit.
PUBLISHER: Condé Nast Publications,
Inc. ISSUE: August 2009

756 **Christoph Niemann**

TITLE: How Big Is Your Credit Card Bill?
ART DIRECTOR: Hannu Lakso.
PUBLICATION: Reader's Digest.
PUBLISHER: Reader's Digest Association.
ISSUE: December 2009

757 **Belle Mellor**

TITLE: Wine + Spirits.
ART DIRECTOR: Matthew Lenning.
PUBLICATION: Bon Appétit.
PUBLISHER: Condé Nast Publications,
Inc. ISSUE: December 2009

758 **Kagan McLeod**

TITLE: Home is for the Weary.
ART DIRECTOR: Kelly Doe.
PUBLICATION: The New York Times,
Week in Review.
PUBLISHER: The New York Times.
ISSUE: September 20, 2009

759

765

766

766

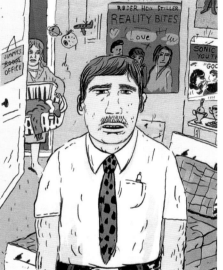

763

764

768

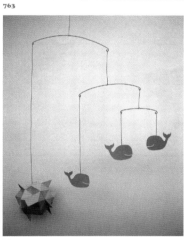

761

767

769

762

770

770

760

759 **Mark Matcho**

TITLE: The Patriot's Guide to Legalization. CREATIVE DIRECTOR: Tim J Luddy. PUBLICATION: Mother Jones. PUBLISHER: The Foundation for National Progress.
ISSUE: July/August 2009

760 **Brian Rea**

TITLE: Identity Loss.
ART DIRECTOR: Nicholas Blechman. PUBLICATION: The New York Times, Book Review. PUBLISHER: The New York Times. ISSUE: August 23, 2009

761 **Brian Rea**

TITLE: American Tourists.
ART DIRECTOR: Nicholas Blechman. PUBLICATION: The New York Times, Book Review. PUBLISHER: The New York Times. ISSUE: December 31, 2009

762 **Brian Rea**

TITLE: Babies Smarter Than You Think.
ART DIRECTOR: Leanne Shapton. PUBLICATION: The New York Times, Op-Ed. PUBLISHER: The New York Times Company. ISSUE: August 16, 2009

763 **Brian Rea**

TITLE: Independence British Style.
ART DIRECTOR: Kim Bost. PUBLICATION: The New York Times, Op-Ed. PUBLISHER: The New York Times Company. ISSUE: July 3, 2009

764 **Jody Hewgill**

TITLE: Behind the Curtain.
ART DIRECTOR: Lisa Lewis. PUBLICATION: Los Angeles. PUBLISHER: Emmis Communications Corp. ISSUE: August 2009

765 **Jody Hewgill**

TITLE: Behind the Mask.
ART DIRECTOR: Steven Banks. PUBLICATION: Los Angeles. PUBLISHER: Emmis Communications Corp. ISSUE: September 2009

766 **Kyle T. Webster**

TITLE: Realizing the Hill Isn't In the Way; It Is the Way.
ART DIRECTOR: Ashley Freeby. PUBLICATION: Bicycling Magazine. PUBLISHER: Rodale.
ISSUE: November 2009

767 **Mark Todd**

TITLE: Living with Parents.
ART DIRECTOR: Jennifer Daniel. PUBLICATION: The New York Times, Week in Review. PUBLISHER: The New York Times. ISSUE: November 29, 2009

768 **Mark Todd**

TITLE: Twitter: A Growing Security Minefield. DEPUTY ART DIRECTOR: Beth Kamoroff. PUBLICATION: PC World. PUBLISHER: PC World Comunications, Inc.
ISSUE: September 2009

769 **Andrea Ventura**

TITLE: Portrait of John Cheever. ART DIRECTOR: Stacey D. Clarkson. PUBLICATION: Harper's Magazine. ISSUE: April 2009

770 **Daniel Zezelj**

TITLE: Interview with a Hit Man.
ART DIRECTOR: Stacey D. Clarkson. PUBLICATION: Harper's Magazine. ISSUE: May 2009

772 772

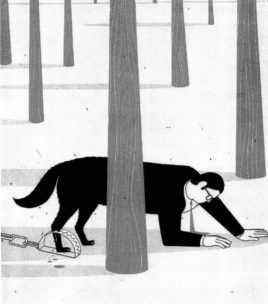

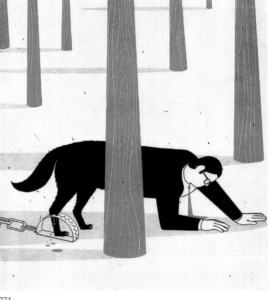

771

778

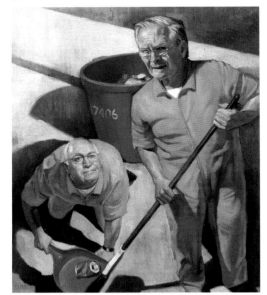

773

776

776

776

774

777

775

771 Shout

TITLE: Irrational Exuberance.
ART DIRECTOR: Nicholas Blechman.
PUBLICATION: The New York Times,
Book Review. PUBLISHER: The New
York Times. ISSUE: April 19, 2009

772 Shout

TITLE: The Worst Times for Your Heart.
CREATIVE DIRECTOR: Jill Armus.
PUBLICATION: Prevention.
PUBLISHER: Rodale.
ISSUE: December 2009

773 Roberto Parada

TITLE: The People v. Dick Cheney.
CREATIVE DIRECTOR: Tim J Luddy.
PUBLICATION: Mother Jones.
PUBLISHER: The Foundation for
National Progress.
ISSUE: January/February 2009

774 Harry Campbell

TITLE: Road Rash.
ART DIRECTOR: Erin Benner.
PUBLICATION: Bicycling Magazine.
PUBLISHER: Rodale.
ISSUE: July 2009

775 Harry Campbell

TITLE: Stress Management.
ART DIRECTOR: John Genzo.
PUBLICATION: Bloomberg Markets.
PUBLISHER: Bloomberg L.P.
ISSUE: July 2009

776 Thomas Allen

TITLE: Decadence at the Frankfurt
Book Fair. ART DIRECTOR: Stacey
D. Clarkson. PUBLICATION: Harper's
Magazine.
ISSUE: March 2009

777 Juliette Borda

TITLE: Medical Emergencies Abroad.
ART DIRECTOR: Maria Stegner.
PUBLICATION: Travel + Leisure.
PUBLISHER: American Express
Publishing Co.
ISSUE: March 2009

778 Superbrothers

TITLE: Ready for More.
DESIGN DIRECTOR: Kory Kennedy.
PUBLICATION: Runner's World.
PUBLISHER: Rodale Inc.
ISSUE: February 2009

Competition Credits

THE SPD ANNUAL JUDGING WEEKEND is a tremendous event bringing together the most experienced and admired creatives working with editorial content today, challenging them to sift through thousands of entries in just a few days to find the best of the best you see featured in this book. In order to accomplish so much, in such a short time, requires the outstanding effort of so many— once again, however, SPD is blessed to have outstanding support from many, and they make it look easy. Debra Bishop, Creative Director, More, and Casey Tierney, Photo Director, Real Simple, (Co-Chairs), Jeremy LaCroix, Creative Director, CBS Interactive (Online Chair), Bruce Ramsay (Magazine of the Year Chair), and Nancy Stamatopoulos (Competition Coordinator) extend an enormous thank-you on behalf of SPD to all the judges and volunteers for their support in making the judging happen this year during a very wintry weekend in January at FIT.

Many thanks also to:

MARY OLENICZAK, ANNE ELMER and the staff in the FIT Facilities Office.
GLENN GLASSER AND HIS TEAM for documenting the judging weekend in still and video (and the candy!), and delighting us all with the portraits at the Gala.
TOM WAGNER for event production of the Gala.
CLAUDIA DE ALMEIDA, STACEY BAKER, NATASHA LUNN, LEONOR MAMANNA, GENEVIEVE MONSMA, FAITH STAFFORD and the More art and photo teams.
LINDSAY ROGERS, LAUREN EPSTEIN, SUSAN GETZENDANNER, BRIAN MADIGAN and RYAN MESINA.
MICHAEL ASH, KENJI AOKI and NATASHA TIBBOTT.
KATE BERRY and NAOMI DE MANANA.
DAVID RHODES, JACQUELINE HOFFNER and RICHARD WILDE of SVA, for providing free summer housing for the winners of the SPD Student Competition.
AMY REDELL of Adobe.
For invaluable help and support throughout the year, LUCY KILLIAN, MIKE LEY and of course, KEISHA DEAN.

Spots

Chair MATTHEW LENNING led the 23rd Annual SPOTS competition, championing the little illustrations that say so much. From hundreds of entries, the judges selected a class of illustrations that do an excellent job of amplifying the editorial message, from a wide spectrum of publications. Winners are featured in a visual index here, and celebrated more extensively in a very limited-edition book published biannually, The SPOTS Book, showcasing both the illustrations and smaller versions of the original editorial pages that featured the work.

Special thanks to this year's judges:

GAIL ANDERSON, Creative Director, Design, Spot Co.
KEN DELAGO, Design Director, Golf Digest.
JOHN GALL, Art Director, Random House.
KORY KENNEDY, Design Director, Runner's World.
AVIVA MICHAELOV, Art Director, Op-Ed Page, The New York Times.
YUKO SHIMIZU, Illustrator.
SARAH VIÑAS, Art Director, Glamour.
ROBERT ZIMMERMAN, drawger.com and illoz.com.

Student Competition

THE STUDENT COMPETITION & THE ADOBE SCHOLARSHIP IN HONOR OF B.W. HONEYCUTT

Established in 1995, this competition honors the life and work of B.W. Honeycutt. It recognizes exceptional design by students with awards and three cash prizes: the Adobe Scholarship in Honor of B.W. Honeycutt, the first-place prize of $2500; second-place prize of $1000; and a third-place prize of $500. The top winners also received summer internships magazines in New York City. Chaired by IAN DOHERTY, Art Director at Food Network Magazine, this juried competition acknowledges the student designer and the teachers who develop their unique talents.

In recognizing the promise of each student, Adobe affirms the creative possibilities inherent in the individual. Throughout its partnership with SPD, Adobe is helping shape the next generation of creative professionals. Together we are building the groundwork that will sustain and further artistic accomplishments within the editorial design community.

Special thanks to the judges:

KRISTIN FITZPATRICK, Design Director, Marie Claire.
CHRIS HERCIK, Creative Director, Sports Illustrated.
JOE HUTCHINSON, Art Director, Rolling Stone.
TIM LEONG, Art Director, WIRED.
MICHAEL MCCORMICK, Design Director, Philadelphia Magazine.

The Society thanks our partner, ADOBE SYSTEMS, INC. for their ongoing support.

Adobe

ADOBE AND THE ADOBE LOGO ARE TRADEMARKS OF ADOBE SYSTEMS INCORPORATED.

The SPD 45th Publication Design Annual was designed and produced by TODD ALBERTSON and TOM BROWN, www.weaponofchoice.ca with designers LESLEY Q. PALMER, DIAN HOLTON, and LISA THÉ.

©2010, The Society of Publication Designers, Inc. All rights reserved. No part of this book may be reproduced in any form without written permission of the copyright owners. All images in this book have been reproduced with the knowledge and prior consent of the artists concerned and no responsibility is accepted by the producer, publisher or printer for any infringements of copyright or otherwise, arising from the contents of this publication. Every effort has been made to insure that credits accurately comply with information supplied.

First published in the United States of America by:
ROCKPORT PUBLISHERS, Inc., 100 Cummings Center, Suite 406-L, Beverly, MA 01915, Tel: 978.282.9590, Fax: 978.283.2742

The SOCIETY of PUBLICATION DESIGNERS

COMMUNITY.
CONVERSATION.
CRAFT.

You hold in your hands one outrageously sexy compilation of the winners of the Society of Publication Designers 45th annual competition. Representing the best work created and printed in the 2009 editorial year, these Rare Specimen join a collection of work that stretches back to the beginnings of SPD in 1965 and today sets a new standard for excellence in visual communication. ◆ Be a permanent part of the community that celebrates the work you do, and the organization that makes these books possible. The Society is comprised of magazine, periodical and web-pub art directors, designers, photo editors, photographers, illustrators, editors and new media artists, all of whom are dedicated to creating, promoting, and rewarding excellence in published editorial design, whatever the platform. Passionate about typography, photography and illustration, web and info-graphics, our members are not just visual artists; we're experienced journalists and absolute partners in the editorial process. We are a nurturing and supportive community and a refuge in a time of much turbulence and shifting ground in our profession. Save money, go online to www.spd.org, make your payment and submit the membership form. ◆ Wasn't that easy? Now let your fine work be recognized. ENTER our 46th annual competition. (It's easy too! Forms and instructions here: **www.spd.org/awards**.) You may win a spot in the next book and possibly a Very Shiny Award you will treasure and can proudly display when the boss comes around. **You should go to www.spd.org and JOIN SPD TODAY.**